INSURING
THE BOTTOM LINE
HOW TO PROTECT YOUR COMPANY FROM LIABILITIES,
CATASTROPHES AND OTHER BUSINESS RISKS

DAVID RUSSELL

MERRITT PUBLISHING, A DIVISION OF THE MERRITT COMPANY
SANTA MONICA, CALIFORNIA

Insuring the Bottom Line
How to protect your company from liabilities, catastrophes and other business risks

First edition, 1996
Copyright © 1996 by Merritt Publishing and David Russell

Merritt Publishing
1661 Ninth Street
Santa Monica, California 90406

For a list of other publications or for more information, please call (800) 638-7597. Outside the United States and in Alaska and Hawaii, please call (310) 450-7234.

All rights reserved. No part of this book may be reproduced, stored in a retrieval system or transcribed in any form or by any means (electronic, mechanical, photocopy, recording or otherwise) without the prior written permission of Merritt Publishing.

Library of Congress Catalogue Number: 96-079501

Russell, David

Insuring the Bottom Line
How to protect your company from liabilities, catastrophes and other business risks.

Includes index.

Pages: 424

ISBN: 1-56343-115-7
Printed in the United States of America.

Acknowledgments

From its infancy in 1994 to the finished product that follows, *Insuring the Bottom Line* represents the efforts of many people. The information and skills accumulated by Merritt Publishing have been brought to bear on every aspect of this project.

First and foremost, I want to thank Jim Walsh for helping bring this book to fruition. Without his help, *Insuring the Bottom Line* would never have made it this far. Other people at Merritt who helped in putting together the book were Cynthia Chaillie, Ginger McKelvey, Mimi Tennant and Megan Thorpe.

I also want to thank Catherine Schneider, Jim Carson, Jerry Olson, and Mona Gardner for the support they have provided—perhaps unknowingly—toward this project as well as my professional development.

Finally, I want to dedicate this book to the Risk Management students at Illinois Wesleyan University, past, present and future. They have provided and will continue to provide me with the motivation to expand what I know and pass it on.

David Russell
Bloomington, Illinois
April 1996

Insuring the Bottom Line is the sixth title in Merritt Publishing's "Taking Control" series, which seeks to help business owners deal with the host of extraordinary risks facing the modern business enterprise. Upcoming titles will cover employee compensation, customer service, making presentations to bankers or investors and other topics. To keep these projects—and the series as a whole—well focused, the editors at Merritt Publishing welcome feedback from readers.

INSURING THE BOTTOM LINE

TABLE OF CONTENTS

Introduction:
Why Businesses Insure .. 1

Chapter One:
Part One—Building and Personal Property 11
Part Two—Commercial Property Causes of Loss 57

Chapter Two:
Business Interruption ... 95

Chapter Three:
Boiler and Machinery ... 113

Chapter Four:
Business Auto ... 129

Chapter Five:
Workers Compensation and Employers Liability 173

Chapter Six:
Crime, Theft and Employee Dishonesty 209

Chapter Seven:
Inland Marine ... 255

Chapter Eight:
General Liability and Product Liability 281

Chapter Nine:
Professional Liability and Directors and Officers' Liability 349

Chapter Ten:
Businessowners Policies .. 377

Chapter Eleven:
Common Policy Conditions .. 405

Conclusion:
How to Buy Business Insurance Well 411

Index .. 419

Introduction

Why Businesses Insure

Risks are changing...and businesses must respond

Since the days when merchant shippers' risk was transferred to syndicates in Edward Lloyd's coffee house, insurance has evolved to provide coverage against most perils faced by insurance buyers. While some exposures, such as damage due to fire, are as threatening today as they were three hundred years ago, other risks such as employment practices liability are very recent developments. Unfortunately, the list of potential threats to the survival of any business grows daily. As the technology envelope expands and the creativity of attorneys increases, the business owner or operator must either take steps to manage these exposures or face the consequences should an unforeseen event occur.

Like most other enterprises that must make a profit to survive, insurers have responded to changes in risk by offering new products to cover new risks, while limiting coverage in existing policies to control their exposure to large, unforeseen exposures. At the beginning of the computer age, who would have imagined that computer manufacturers would be sued by keyboard users for carpal tunnel syndrome? Clearly, no one since carpal tunnel syndrome had not yet been identified as an affliction. Are piano manufacturers next?

The astute businessperson must anticipate what can go wrong and what to do about it before hand. This common sense course of action is referred to as Risk Management. Risk Management is a growing corporate activity since the costs non-compliance with legal requirements such as the Americans with Disabilities Act (ADA) and compliance with restrictive financial covenants demand that someone in management devote full attention to the potential exposures of each part of the firm.

Since no one knows your firm better than you, you must seize this opportunity to minimize the potential costs of complacency. You must ask, "What if...?" and develop an acceptable answer for the question, "What then?" What if your firm experiences a fire? You may have sufficient insurance to rebuild your place of business and replace your inventory. But what if it takes six months to rebuild your building and nine months to receive replacement inventory? Will your com-

petitors have taken all of your customers? How can you retain employees if you cannot pay them for the next six to nine months? These are questions best asked before your business experiences a significant setback. This book can help you ask and answer these questions.

Analyzing the standard policy language

Insuring the Bottom Line provides 1) a general overview of the insurance coverages most businesses should purchase, and 2) a thorough explanation of the protection afforded by each of those coverages using examples and case studies. We use common insurance policy language to analyze and dissect how you can use various policy forms and coverages to protect your unique exposures. While no one, and no book, can prepare you for everything, hopefully this volume will provide some insights that will help you keep yourself prepared and keep unpleasant surprises to a minimum.

A general approach to controlling risks

Risk Management is the identification of exposures to financial loss and selection of techniques to manage those exposures. In most cases, you can begin your own risk management program by listing everything that can go wrong in your business. While this may sound intimidating, there are a few simple ways to evaluate your exposure to losses.

Survey/questionnaire/interview method

Even the best informed president of a company does not know everything that goes on in an enterprise with more than one employee. The larger the organization, the more opportunity for management to be uninformed about potential exposures to loss. With that in mind, management should interview and survey middle managers and employees about what can go wrong with production of goods or services by their department or themselves individually. Not only will interviews and surveys ferret out potentially hidden exposures, but this method gives employees a sense of empowerment that their input is welcome and valued. Moreover, a risk management "sound off" will alert employees that management believes sound risk management is a corporate goal. Without employee support, even the best conceived program is futile.

Once the interview reports and surveys have been returned, the results should be tabulated with frequency-of-mention and severity of loss statistics computed. You should use these statistics to determine which exposures need immediate attention and those that might wait.

Introduction: Why Businesses Insure

Loss history

Examining an insurance history for loss trends

If you want to avoid the mistakes of the past, you must study history. For businesses that have some track record, the risk management process can benefit from an examination of what has gone wrong in the past. Just as Chevrolet examines warranty claims for recurring problems, your business should evaluate its own history of insurance claims, personnel losses, and impairments to net income. A historical record of costly events should be kept starting now, if not already maintained, to permit future analysis of your firm's risk management program. Because of employee turnover, memory may not serve as well as a written record.

A detailed loss history will do more than simply provide you with a list of perils that have affected your business in the past. Many insurers require a loss history before they will evaluate your application for insurance. Insurance underwriters may feel comfortable insuring your business only if they can examine what has happened in the past. Most insurers will provide a detailed claims history even if you intend to move your coverage to a competitor.

Financial statement method

Your financial statements contain nearly everything of consequence about your business transactions. The balance sheet represents a snapshot in time of everything your business owns as well as what it is obligated to pay. The balance sheet is a great place to start evaluating your business risks. An itemized statement of the company's assets—including things such as inventory and recently acquired property—is particularly valuable.

Balance sheet items important to risk management

Assets	Liabilities
Buildings/Plant/Equipment	Accounts Payable
Accounts Receivable	Debt
Notes Receivable	Leases

Finding the useful parts of your financial statement

Unfortunately, no business has the time or personnel to update the company balance sheet on a daily basis. Many businesses create a balance sheet only once a year, even though these businesses experience large seasonal fluctuations in merchandise held for sale. For some types of insurance, businesses are required to keep detailed records as to accounts receivable, inventory and newly acquired property. This way the insurer has a recent record of what may have been lost in the event that a covered loss occurs.

The profit and loss statement provides an easy-to-read source of how the firm performed over a period of time. Many profit and loss statements are accompanied by a sources and uses of funds statement (cash flow statement). These documents are important for two reasons:

1) a detailed statement can keep you better informed about your exposures, and

2) many insurers require these documents before paying a claim.

If a business has business interruption insurance, it must document its losses from an insured event. If records are old or sketchy, the insurer may not pay the entire claim. Lesson: keep good documentation of your business finances.

On-site inspections

Nothing can replace an actual inspection

Even extensive interviews, surveys and financial statement studies may not substitute for seeing the exposures with your own eyes. Simply inspecting your own facilities with an eye for potential exposures will round out your risk management evaluation. Fortunately, many insurers and insurance brokers will provide qualified personnel to assist you with the risk management process. This is particularly true with unique exposures like boilers and machinery. Since large scale production and modern machinery represent potentially large exposure to loss, insurers that write Boiler and Machinery coverage want expert evaluation of any property they insure with these characteristics. These insurer/broker provided engineers can also assist you in making your operations safer. Remember, it is in their interest to avoid claims so the expense they absorb in helping you is for their benefit too.

Implementing a program

After you have identified the sources of potential loss and established goals for your program, you are ready to consider methods for managing your risks. Risk managers usually choose from a menu of five different risk management techniques. They are:

1) retention

2) loss control

3) avoidance

4) non-insurance transfer

5) insurance

The matrix of frequency and severity

The choice of one or a combination of these techniques is dependent on the nature of the risk. Risks are best classified on the basis of their frequency and severity, and the appropriate risk management technique follows logically:

- high frequency/low severity (retention or loss control)
- low frequency/low severity (retention)
- high frequency/high severity (avoidance)
- low frequency/high severity (insurance)

Every business faces a particular combination of these types of risk. A high frequency risk for an ice cream shop in Colorado may be a low frequency risk for a car dealer in New York. However, some generalizations do emerge.

Examples of high frequency/low severity losses can include:
- broken windows
- small auto accidents
- pilferage/inventory shrinkage

Examples of low frequency/low severity losses can include:
- petty cash balance problems
- employee dishonesty

Examples of high frequency/low severity losses can include:
- earthquake damage
- fire damage
- liability lawsuits

Examples of high frequency/high severity losses can include:
- high risk medical procedures
- some types of product liability
- bodily injury claims
- legal defense costs

Retention is best for low severity exposures. Example: A common package carrier retains the risk of breakage during shipping. Because the common carrier can expect some amount of breakage during transit, there is no economic purpose in transferring the cost of shipping damage to an insurance company.

An insurance company is out to make a profit

Remember: The insurance company must make a profit and cover its costs. For this reason, exchanging dollars with the insurance company is a losing proposition. Therefore, small and/or predictable losses do not warrant insurance coverage. Rather, any business should retain small losses and predictable losses and include them in the firm's budget as a cost of doing business.

Loss control is another method of risk management that has the purpose of reducing the frequency and/or severity of loss. The classic

loss control device is the fire sprinkler system. While a sprinkler system will not eliminate the risk of fire, a sprinkler system can contain a fire, reducing the magnitude of the loss. In some cases, a sprinkler system can put a fire out. Other examples of loss control devices include hard hats, burglar alarms, smoke detectors, and employee background checks. Loss control methods are not confined to physical property such as buildings and inventory. Use of credit reports such as Dun and Bradstreet, TRW, Equifax, and Trans Union also qualify as a loss control technique in the area of accounts receivable.

Use of loss control techniques appears to be common sense, yet a number of firms fail to take advantage of this relatively inexpensive risk management technique.

Some companies view retention and aggressive loss control techniques as an economical way to manage the cost of risk. While retaining exposure to any loss is accompanied by potential earnings variability, retention reduces company complacency towards losses that have non-quantifiable and often long-term consequences. As described in a July 1995 article in *Risk Management* magazine, Mattel retains most of the product liability exposure for its extensive line of toys. Mattel's management considered the costs and benefits of several strategies, including comprehensive insurance coverage.

Risk management in the computer era

Computers were intended to reduce monotonous tasks while improving access to business records. With increased reliance on data management systems, businesses rely on the storage integrity of these systems and place themselves at the mercy of hardware and software failures.

High tech approaches to managing risks

Obviously, frequent data backups protect important data from loss and protect the firm from the additional expense associated with re-assembling this data. Most firms with minicomputers perform backup batch jobs on a daily basis. But most small businesses depend on PCs for the bulk of their computing needs. Even with networks, this makes a regular backup schedule more difficult to implement.

Just as an author who totally immerses herself in a writing project may forget to save her work every so often, a good employee who faces multiple deadlines may forget to backup his work. Loss of a precious file under these circumstances as the result of equipment failure, a faulty disk drive, power failure, software bugs, or magnetic erasure could place the employee and the firm at the risk of missing deadlines.

Fortunately, several insurance coverages will reimburse you for the expense associated with recreating lost data files if the loss was caused by a covered event. However, deductibles and the inconvenience of resurrecting these files render backup procedures a far more effective way to protect against data loss.

Risk managing your business to death

Too much risk management can erode profits

As a conclusion to this section on risk management, it should be noted that the business that manages away its risk completely may also manage away its potential for profit. Risk management is by definition a costly process, both in terms of management time and expenditure on insurance and loss control devices. We could make our highways completely safe if we reduced the speed limit to 10 miles per hour. Just as this is impractical, so too is making the modern business a risk-free proposition.

Every business is exposed to changes in economic conditions as well as changes in the market for particular goods and services. These risks cannot be transferred or managed away except through continued success and vigilance vis-a-vis competitors.

The successful risk management program is one that balances the need for expensive loss control equipment and insurance coverage with the limited resources available for risk management activities. If the firm needs capital to expand, how will management feel about spending that capital on risk management projects that don't necessarily carry a tangible return? Company management must be persuaded that some risk management expenditures are as necessary as meeting the payroll.

Risk management simply means preparing for events that are often beyond anyone's control. Adequate preparation can mean the difference between continued success and extinction.

The most common risk management tool: insurance

Insurance is a promise by the insurer to pay a specified amount under certain conditions in the event that the policyholder has a loss.

If reality fit the above simple definition, this would be a very short book. However, insurance contracts have become increasingly complicated due to the increasing number of hazards in modern society, a rapidly changing legal climate, and more sophisticated schemes used to defraud insurers.

One of the purposes of this book is to shed some light on how insurers develop, sell, and support the product we call an insurance policy.

The application

How the application process affects your coverage

Insurance is not offered to everyone who wants to buy it. Businesses that need coverage must apply to the insurance company for coverage. In essence, the applicant makes an offer to the insurer to pay a premium in exchange for coverage. The insurer is under no obligation to accept the application, primarily because an insurance policy is an aleatory contract. In an aleatory contract, the contract parties may exchange unequal values. You agree to pay the insurer a premium and the insurer will pay you nothing if you have no claim, but

the insurer may pay you much more than the premium if you suffer a large covered loss. Because the insurer can lose a substantial amount of money on any single policy, the insurer is careful to evaluate the applicant's risk characteristics. These characteristics help the insurer decide on whether or not to offer coverage and at what price (premium).

How the insurance company evaluates applications

Applications for various types of business insurance are reviewed by underwriters in the insurer's home or regional office. These underwriters evaluate the applications based on company specific guidelines to establish whether or not the applicant's characteristics reflect an exposure the company wants to insure. Different companies have different guidelines; one company may decide not to write coverage to small businesses who sell firearms while another company may market its policies to this niche. Underwriters are the insurance company's best and last defense against insuring unreasonably high risk applicants.

The underwriters size up the risks you pose

While the application is under review, the underwriter attempts to match the applicant's characteristics with an existing pool of policies. If the insurer has an application for a fast-food restaurant with no unique characteristics, it is likely that the underwriter will assign the policy to a category of typical quick serve eateries. If the insurer is interested in issuing more policies in this category, the underwriter will approve the application and set the premium based on the company's pricing schedule. For example, the underwriter might start with a base premium, while adding and subtracting "points" for distinguishing features. For example, an elaborate security system would earn the business a discount from the base premium while a high volume of business might result in a premium penalty (increase).

Assuming that there are a sufficient number of policies in each class, the company can take advantage of what is known as the Law of Large Numbers (LLN). Under the LLN, the insurer knows from experience approximately how many policies will suffer a loss and how severe most of those losses will be. While actual experience may differ from expectation, pooling a large number of policies allows the company to be fairly accurate with its prediction.

In certain cases, an insurance company may not wish to expose itself to a class of risks with an unpredictable loss experience or a class of risks that is too small to take advantage of the LLN. In some cases, the insurer may use reinsurance to pass on a portion of risk to another insurance company.

Example: You own an automobile plant in Oklahoma City with a replacement value of $300,000,000. If you approach an insurance company about property coverage, it is unlikely that the insurer will refuse to quote you a premium for coverage. Rather, the insurer will offer to

issue a policy but will have purchased reinsurance on most of this policy, retaining only the portion of risk with which it can handle. Since a tornado could wipe out the plant tomorrow, the insurer would purchase sufficient reinsurance coverage to limit its exposure to, say, $10,000,000. This type of reinsurance (excess of loss) is similar to an insurance policy with a very large ($1,000,000) deductible.

The use of reinsurance is not made known to the policyholder; if there is a claim, the policyholder presents the claim to the insurer that issued the policy. It is up to the policy issuer to pay the claim and recover amounts that may be due to the primary insurer under reinsurance contracts.

Insurance contracts and exclusions

Over the years, insurance companies have tailored their policies to cover perils that affect most policyholders while eliminating coverage for unusually risky activities or perils that are unique to only a few policyholders. Many insurance contracts used by insurance companies today were developed by the Insurance Services Office (ISO).

An industry group has helped refine insurance coverage

ISO is an industry organization that evaluates the needs of most policyholders and drafts policy forms to accommodate those needs. The policy forms also reflect the industry's need to limit exposure to fraud, exaggerated losses, and catastrophic losses. This book examines the most common ISO forms used by businesses today.

Insurance contracts were never intended to cover anything and everything that could possibly go wrong. Insurance was developed as a means for businesses and individuals to transfer away the uncertainty of events such as fire and windstorms. As the economy became more sophisticated, so too did insurance contracts. Insurers now offer coverage for nearly any random event either through common policies such as the Commercial General Liability (CGL) policy or through additional coverages called endorsements that can be added to standard policies.

In many cases, however, insurers are either unwilling or unable to offer coverage for certain events. These uninsured events are listed under the policy section marked "Exclusions." For example, almost every policy issued today for any risk excludes losses caused by an act of war. While acts of war are extremely unlikely, insurers exclude losses due to war since war causes widespread damage that could quickly exhaust an insurer's ability to pay claims. In this case, the insurer is refusing to bear a risk that would most likely put it out of business and that it could not possibly make. The war exclusion amounts to "truth-in-advertising" clause in the policy.

Other exclusions limit the insurer's exposure to events that may have been caused intentionally or events that dramatically increase the chance of loss.

Example: All insurance policies exclude losses caused by arson, illegal disposal of pollutants, and participation in events such as demolition derbies or stunt routines. Professionals engaged in stunt routines or auto racing can obtain insurance, but these activities are excluded from the standard automobile insurance policy.

The key issues: language and coverage

Language and coverage are what define insurance

Although written in a "simplified" style, unexpected interrelationships between one policy provision and another can occur. The meanings of individual clauses can't be pulled out to stand alone—the entire policy is meant to operate as a whole.

Often the English language is not exact enough for insurance contracts. To prevent conflicting policy interpretations, most policy forms have a "definitions" section that contains specific definitions for all terms that appear in quotation marks. As far as the policy is concerned, the words in quotation marks mean just what this form's definitions say they mean.

Example: The word "stock" as used in a commercial property policy is set in quotation marks. So, we know this word's meaning is limited, as relates to property coverage. It applies to merchandise held in storage or for sale, raw materials and in-process or finished goods, including supplies used in their packing or shipping.

Various provisions in any business insurance policy will restrict what that policy covers.

An important caveat: Read any insurance policy as a whole to determine rights, duties and what is and is not covered. The law says no single part of a policy can be read in isolation so that it contradicts the purpose of the rest of the document.

One last note: This book will give you a working knowledge of the issues that control commercial insurance. It is not a comprehensive legal text. If your business has insurance problems that you don't fully understand, talk to a broker or agent. If you're having problems with an insurance company, talk to a lawyer.

Insuring the Bottom Line gives you the background understanding to ask smart questions and make good decisions about business insurance. And these are the first steps to taking control of business risk—one of the biggest expenses you face.

Chapter One, Part One:

Building and Personal Property

Introduction

Nearly every business has commercial buildings or contents that need to be insured for losses. The Building and Personal Property Coverage Form covers most types of completed commercial buildings or contents or both.

This form can be used to insure most types of commercial property. It is the most frequently used commercial property coverage form. It is a general purpose form used to write coverage for direct loss of buildings, or contents, or both.

"Direct loss" means direct physical loss or damage. Covered causes of loss and the exclusions applicable to this coverage form are found on the causes of loss form(s) indicated in the Declarations Page that precedes the main policy form.

The building and personal property form may be used to provide any or all of the following coverages. A limit of insurance must be shown in the declarations for each type of property covered:

- Coverage A—Building(s)
- Coverage B—Business personal property belonging to you
- Coverage C—Personal property of others

Building coverage means the building or structure described in the Declarations Page. It includes completed additions; permanently installed fixtures, machinery and equipment; outdoor fixtures; and your personal property used for service or maintenance of the building or its premises (such as fire extinguishers, outdoor furniture, floor coverings and appliances used for refrigerating, ventilating, cooking, dishwashing or laundering).

If not covered by other insurance, building coverage also includes additions under construction, building alterations and repairs, and materials, equipment, supplies and temporary structures on or within 100 feet of the described premises used for making additions, alterations or repairs to the building or structure.

The building coverage category provides coverage for more than just

structures. It's important to keep these nonbuilding items in mind when establishing property insurance limits.

For example: ABC Monogram Company is a jobber in the garment industry. ABC machine stitches monograms and logos on bowling shirts. They don't make the shirts; they don't own the shirts. They just apply the monograms. But should 5,000 newly-monogrammed shirts be destroyed in a fire at their shop, ABC's business personal property coverage would cover the value of ABC's labor and materials for the monograms.

Consider another scenario. The shirts, although the property of another company, were in ABC's care, custody, and control when destroyed by fire. If ABC carried coverage for property of others, ABC's insurance company would reimburse Active Sportswear for their loss.

Carefully identify buildings and property to be insured

You need to be careful when you identify the buildings you're insuring under commercial property coverage. The 1992 Missouri state appeals court decision *Dale Kopff v. Economy Radiator Service and Northern Insurance* considered an issue of mutual mistake—when the person buying an insurance policy and the person selling it both contribute to a problem.

In 1985, Dale Kopff applied for insurance coverage on five commercial properties that he owned in the St. Louis area. His insurance broker, Thomas Luepke, filed an application requested coverage for a term beginning September 1, 1985 and ending September 1, 1986. Luepke attached to the application a copy of a form labeled "MP 1205," entitled "Supplemental Declarations Endorsement"—which was referred to as the "brokerage sheet."

This brokerage sheet listed the five commercial properties to be insured, their addresses, the occupancy of the building, and the limits of liability, among other things.

Location number 3 was described as a four-family dwelling, with a requested liability limit of $63,800. Location number 4 was described as a "Merc. & Apt." building, with a requested liability limit of $35,000. This was a commercial building that included a liquor store and offices.

There was, however, an inconsistency between the application Luepke filled out and sent to the insurance company and the attached brokerage sheet. On the application, in the "location information" section, Luepke listed location number 3 as the commercial building and location number 4 as the four-family dwelling.

Under the "property section" of the application, Luepke made a notation to "see attached," referring to the attached brokerage sheet for the rest of the information for the five commercial properties.

Northern Insurance issued an insurance policy to Kopff covering the five commercial properties from September 1, 1985 to September 1,

1986. On the policy, under the heading "Section 1—Property Coverage, Limit of Liability," the notation "see MP 1205" was typed. The next page of the policy was labeled "MP 1205" and listed locations number 3 and number 4 in the confused order.

In August 1986, the commercial building burned down. After the fire, Luepke noticed that the limit on liability in the policy was $63,800. He then notified Northern that "two of the building and rental values have been transposed."

Luepke also notified Kopff, who was unaware of the problem because he had not read the policy since receiving it, of the discrepancy.

Kopff received payment from Northern of $35,000 on his claim for $57,837.70 in damages incurred from the fire. After Northern refused to pay the balance of Kopff's claim, he sued the insurer for breach of contract.

Northern counterclaimed for reformation of the contract to change the policy coverage limits on the commercial building to $35,000 rather than the $63,800 which appeared in the contract.

Ruling in favor of Northern, the court found there was a mutual mistake by the parties and, on that ground, reformed the insurance contract to reflect liability limits of $35,000 on the commercial building and $63,800 on the four-family apartment building. The court dismissed Kopff's claim with prejudice.

On appeal, Kopff argued three points:

1) if a mistake were made, it was unilateral and did not involve the underlying agreement between the parties;

2) even if there were a mutual mistake, the insurer suffered no loss because the premiums were commensurate with the risks insured; and

3) equity rarely allows reformation to an insurer after a claim has been filed if it will result in the denial of coverage.

Seeking reformation of an insurance contract

A court may reform a written contract when the writing evidencing the contract fails to correctly reflect the agreement. The Missouri appeals court considered what must occur in order for this to happen:

> The party seeking reformation must show by clear and convincing evidence that a mistake was made that was both mutual and common to both parties, and it must appear that both parties did what neither intended to do. The party must also show the written contract does not accurately set forth the terms of the agreement actually made—or does not incorporate the true prior intentions of the parties.
>
> ...In contrast, a unilateral mistake is a mistake on the part of only one of the parties, and a unilateral mistake alone is not an adequate basis for reformation.

The trial court had found that, when Kopff prepared the insurance policy, a clerical error was made and the coverage limits for the two properties were transposed. Therefore, the policy as issued was the result of a mutual mistake and did not reflect the intentions of both Kopff and Northern to insure the commercial property to $35,000 and the four-family apartment building to $63,800.

Before obtaining the policy in question, Kopff had had two separate, successive policies covering the buildings in question—from another insurer. Those policies provided coverage of $35,000 on the commercial property and coverage $63,800 on the residential building.

The brokerage sheet attached to the application for coverage sent to Northern by Luepke requested those same coverage levels. The inconsistency in location number of the two properties on the face of the application and on the attached brokerage sheet supported Northern's contention that a transposition had occurred.

The court found this the key point:

> [Kopff] and [the insurance company] were mutually mistaken as to the coverage limits shown in the policy...both assuming the limits were the same as those in the application. The contract did what neither intended it to do. Reformation was appropriate so that the policy accurately reflected the underlying agreement.
>
> ...Even assuming [the insurance company] were negligent in the preparation of the policy and in not discovering the transposition, [Kopff] also was at fault. [His] agent filled out the insurance application incorrectly, and attached the brokerage sheet to it which contained information conflicting with that in the application. [Kopff] also failed to review the application until after the fire had occurred.

Kopff received $35,000, which the court ruled was the amount for which he had intended to insure the building.

Contents coverage

The definition of "personal property" can be a controlling issue

Coverage for business personal property has traditionally been known as "contents" coverage. But it includes more than building contents because it applies to property located in or on the described building, or within 100 feet of the described premises while in a vehicle or out in the open.

Personal property includes furniture and fixtures; machinery and equipment; "stock" (which, as we'll see, can have disputed meaning); all other personal property owned by you and used in your business; labor, materials or services furnished or arranged by you on the personal property of others; and your use interest as a tenant in "improvements and betterments."

The definition of "business personal property" also includes leased

personal property for which you have a contractual responsibility to procure coverage. The value of such leased property is included in the limit of insurance for business personal property. Other methods for insuring leased personal property—by endorsement—also remain available.

"Stock" means merchandise held in storage or for sale, raw materials and in-process or finished goods, including supplies used in their packing or shipping. "Improvements and betterments" of an insured tenant means fixtures, alterations, installations or additions which are made a part of a building which you occupy but do not own, and which are acquired or made at your expense—but cannot legally be removed by you.

Coverage for personal property of others means property of others which is in your care, custody or control. This coverage also applies to property located in or on the described building, or within 100 feet of the described premises while in a vehicle or out in the open. The insurance company's payment for any loss to personal property of others will only be for the account of the owner of such property.

The Commercial Package Policy

In the late 1980s, the Insurance Services Office introduced a modular approach for constructing commercial property insurance policies. Instead of just updating old policies, ISO developed a series of specialized forms, with each form fulfilling a specific policy function. The right combination of forms would create a complete, custom-made policy.

Under this Commercial Package Policy (commonly called CPP) program, every commercial lines policy is made up of a common policy declarations; common policy conditions; and one or more coverage parts.

The coverage for commercial property is, in turn, made up of another set of forms:

1) a property Declarations Page;

2) the property conditions;

3) one or more property coverage forms;

4) one or more causes of loss forms; and

5) any endorsements.

Conditions of coverage and property insured

Property coverage forms establish the conditions for coverage and describe the types or kinds of property insured, e.g., buildings, contents, extra expense, structures in course of construction, glass, leasehold interest, etc.

Each coverage form is designed to insure specific types of property or losses. Coverage forms identify the subject of the insurance, describe

coverages, additional coverages and optional coverages, and state exclusions and conditions.

Under the CPP program, any of the available coverage forms may be issued as part of a monoline policy (consisting of one major kind of coverage, also called a "coverage part"), or may be joined with other coverages to form a package policy (consisting of two or more coverage parts).

In either case, other forms must be attached to complete the policy. A modular approach is taken under which the same forms are used to construct monoline and package policies.

The Building and Personal Property Coverage Form describes the types of property coverages that apply, and establishes the conditions for coverage. A separate set of Commercial Property Conditions (which apply to this form and other property forms) must be attached, along with one or more Causes of Loss forms (which describe the perils insured against). Together, these items complete what is known as a Commercial Property Coverage Part.

The Common Policy Conditions (which apply to all commercial coverages in the program) and Common Policy Declarations (which summarize all the coverages included in a policy) must be attached. These items are used whether or not other coverages are actually included in the policy.

The standard commercial property policy is what's known as a direct damage form. It covers actual damage, directly resulting from a covered peril, to covered property.

Example: If a landlord's building burns down, the destruction of his building is a direct loss and can be covered by this kind of insurance. But the fact that, because his building burned down, the landlord lost his rental income is a different matter. Loss of rents is an indirect loss and not covered by the standard form. (The landlord could insure rental income by adding another property coverage form to his policy—a business income coverage form.)

Purchasing coverage under the Building and Personal Property Coverage Form is not the only way of insuring personal property of others. Another ISO form, the Legal Liability Coverage Form, pays for damages to property of others while at your premises but only if you are found to be legally liable.[1]

The different commercial property forms

Thirteen different commercial property coverage forms are included in the CPP program. Each one can be issued alone or be combined with other property forms on a monoline policy, or can be issued with other coverages as part of a package policy. The 13 coverage forms are:

- building and personal property coverage form,
- builders risk coverage form,

[1] A third—and broader—method of coverage is found under a bailee's customers policy, an inland marine form that includes transit coverage. See more on this kind of coverage in Chapter 5.

- business income coverage form (with extra expense),
- business income coverage form (without extra expense),
- extra expense coverage form,
- leasehold interest coverage form,
- legal liability coverage form,
- glass coverage form,
- condominium association coverage form,
- condominium commercial unit owners coverage form,
- mortgage holders errors & omissions coverage form,
- tobacco sales warehouses coverage form, and
- the standard property form.

In this chapter we'll look at the last—technically, called Form CP 00 10—and most commonly used.

The policy

The policy begins with a Declarations Page, which identifies the named insured covered by the policy and the distinguishing elements of the coverage. Throughout the policy, language will refer back to this Page. The sample Declarations Page on the opposite page should provide a general idea of the information included.

INSURING THE BOTTOM LINE

COMMERCIAL PROPERTY COVERAGE PART
DECLARATIONS PAGE

POLICY NO. **EFFECTIVE DATE** ___/___/___ ☐ "X" IF SUPPLEMENTAL DECLARATIONS IS ATTACHED

NAMED INSURED

DESCRIPTION OF PREMISES

PERM NO.	BLDG. NO.	LOCATION, CONSTRUCTION AND OCCUPANCY

COVERAGES PROVIDED
INSURANCE AT THE DESCRIBED PREMISES APPLLIES ONLY FOR COVERAGES FOR WHICH A LIMIT OF INSURANCE IS SHOWN.

PERM NO.	BLDG. NO.	COVERAGE	LIMIT OF INSURANCE	COVERED CAUSES OF LOSS	COINSURANCE*	RATES

OPTIONAL COVERAGES
IAPPLICABLE ONLY WHEN ENTRIES ARE MADE IN THE SCHEDULE BELOW

PERM NO.	BLDG. NO.	AGREED VALUE EXPIRATION DATE	COVERAGE	AMOUNT	REPLACEMENT COST(x) BUILDING	PERSONAL PROPERTY	INCLUDING "STOCK"

INLFATION GUARD (Percentage) *MOINTHLY LIMIT OF *MAXIMUM PERIOD *EXTENDED PERIOD
BUILSDING Personal Property INDEMNITY (Fraction) OF INDEMNITY (x) OF INDEMNITY (Days)

* APPLIES TO BUSINESS INCEOM ONLY.

MORTGAGE HOLDERS

PERM NO.	BLDG. NO.	MORTGAGE HOLDER NAME AND MAILING ADDRESS

DEDUCTIBLE
$250. EXCEPTIONS

FORMS APPLICABLE
TO ALL COVERAGES

TO SPECIFIC PREMISES/COVERAGES
PREM. NO. BLDG. NO. COVERAGES FORM NUMBER

Copyright, Insurance Services Office, In., 1983, 1984.

Chapter One, Part One: Building and Personal Property

As part of its simplified approach, the policy uses a conversational tone. Throughout the policy, "you" refers to the named insured, and "we" means the insurance company. No "party of the first part" found here.[2]

The coverage form begins with a few simple statements. First it cautions you to read the "entire policy," meaning all parts of the policy in addition to this coverage form.

It then explains that various pronouns (such as "you" and "we") are used to refer to the named insured and the insurance company.

The last statement points out that the coverage form has a specific "definitions" section, and that the meaning of any words that appear in quotation marks can be found in that section.

> **A. COVERAGE**
> We will pay for direct physical loss of or damage to Covered Property at the premises described in the Declarations caused by or resulting from any Covered Cause of Loss.
> 1. Covered Property
> Covered Property, as used in this Coverage Part, means the following types of property for which a Limit of Insurance is shown in the Declarations:
> a. Building, meaning the building or structure described in the Declarations, including
> (1) Completed additions;
> (2) Permanently installed;
> (a) Fixtures;
> (b) Machinery; and
> (c) Equipment;
> (3) Outdoor fixtures;
> (4) Personal property owned by you that is used to maintain or service the building or structure or its premises, including:
> (a) Fire extinguishing equipment;
> (b) Outdoor furniture;
> (c) Floor coverings; and
> (d) Appliances used for refrigerating, ventilating, cooking, dishwashing or laundering;
> (5) If not covered by other insurance:
> (a) Additions under construction, alterations and repairs to the building or structure;
> (b) Materials, equipment, supplies and temporary structures, on or within 100 feet of the described premises, used for making additions, alterations or repairs to the building or structure.

Building coverage applies to more than just your building

This form covers direct physical loss or damage to covered property. Each major coverage applies only if a limit of insurance is shown for that coverage in the declarations.

The first major coverage is for building(s). More than one building or

[2] Other words and phrases that appear in quotation marks have special meaning. Refer to this chapter's discussion of Section H—Definitions in the standard form.

structure may be described in the commercial property declarations. Notice that coverage applies to more than just the building itself—building additions, permanently installed fixtures and equipment, and property used to service the building or premises (such as fire extinguishing and laundering equipment and ventilating systems) are covered as part of building coverage.

Additions under construction and building materials and supplies within 100 feet of the premises are also insured as part of the building coverage, but only if not covered by other insurance.

All of these items are covered because they either become part of, or are directly related to the operation and maintenance of, the building.

> b. Your Business Personal Property located in or on the building described in the Declarations or in the open (or in a vehicle) within 100 feet of the described premises, consisting of the following unless otherwise specified in the Declarations or on the Your Business Personal Property—Separation of Coverage form:
> (1) Furniture and fixtures;
> (2) Machinery and equipment;
> (3) "Stock,"
> (4) All other personal property owned by you and used in your business;
> (5) Labor, materials or services furnished or arranged by you on personal property of others;
> (6) Your use interest as tenant in improvements and betterments. Improvements and betterments are fixtures, alterations, installations or additions:
> (a) Made a part of the building or structure you occupy but do not own; and
> (b) You acquired or made at your expense but cannot legally remove;
> (7) Leased personal property for which you have a contractual responsibility to insure, unless otherwise provided for under Personal Property of Others.

Business personal property includes most types of commercial property owned or used by businesses which are not considered part of the building. This coverage applies to furniture, machinery, equipment, stock or merchandise held for sale, office supplies, and other such items.

If you are a tenant, this coverage also applies to your interest in improvements and betterments made at your expense.

Insuring things that you rent or lease

Leased personal property may also be covered under this section, but only if you have a contractual obligation to insure it and it is not otherwise insured under the coverage for personal property of others.

c. Personal Property of Others that is:
(1) In your care, custody or control; and
(2) Located in or on the building described in the Declarations or in the open (or in a vehicle) within 100 feet of the described premises. However our payment for loss of or damage to personal property of others will only be for the account of the owner of the property.

This coverage applies to personal property of others in your care, custody or control. Any payment for loss will be made only for the account of the owner, which means the coverage is designed to reimburse the owner for the loss. Payment will not be made to the named insured under any circumstances, and payment would not be made if the owner had other insurance and was able to recover under that policy.

2. Property Not Covered
Covered Property does not include:
a. Accounts, bills, currency, deeds, food stamps or other evidences of debt, money, notes or securities. Lottery tickets held for sale are not securities;
b. Animals, unless owned by others and boarded by you, or if owned by you, only as "stock" while inside of buildings;
c. Automobiles held for sale;
d. Bridges, roadways, walks, patios or other paved surfaces;
e. Contraband, or property in the course of illegal transportation or trade;
f. The cost of excavations, grading, backfilling or filling;
g. Foundations of buildings, structures, machinery or boiler if their foundations are below:
(1) The lowest basement floor; or
(2) The surface of the ground, if there is no basement;
h. Land (including land on which the property is located), water, growing crops or lawns;
i. Personal property while airborne or waterborne;
j. Pilings, piers, wharves or docks;
k. Property that is covered under another coverage form of this or any other policy in which it is more specifically described, except for the excess of the amount due (whether you can collect on it or not) from that other insurance;
l. Retaining walls that are not part of the building described in the Declarations ;
m. Underground pipes, flues or drains;
n. The cost to research, replace or restore the information on valuable papers and records, including those which exist on electronic or magnetic media, except as provided in the Coverage Extensions;

Coverage exclusions under the standard property form

The building and personal property coverage form does not cover all types of property, and this section contains exclusions of kinds of property which are not covered.

Exclusions appear in insurance policies for a variety of reasons. Some types of property are simply not insurable—it would be against public policy to insure contraband. Other types of losses are not verifiable—for example, petty cash or currency left on premises.

Yet other types of property are excluded because they are more appropriately insured by other policies or coverage forms—vehicles licensed for road use, for example, should be insured by automobile insurance.

A few exclusions are designed to remove coverage for exposures that reflect a unique hazard that is not included in basic premium rates, but for which separate coverage is available at an additional charge. In some cases, a limited amount of coverage for excluded items is provided elsewhere in the policy. Notice that the cost to research and restore valuable papers and records, and the loss of outside radio or television antennas and signs, are excluded. Limited amounts of coverage for these same exposures are restored by the coverage extensions, and additional amounts of coverage may be added by endorsement or under a separate policy form.

> o. Vehicles or self-propelled machines (including aircraft or watercraft) that:
> (1) Are licensed for use on public roads; or
> (2) Are operated principally away from the described premises. This paragraph does not apply to:
> (a) Vehicles or self-propelled machines or autos you manufacture, process or warehouse;
> (b) Vehicles or self-propelled machines, other than autos, you hold for sale; or
> (c) Rowboats or canoes out of water at the described premises;
> p. The following property while outside of buildings;
> (1) Grain, hay, straw or other crops;
> (2) Fences, radio or television antennas, including their lead-in wiring, masts or towers, signs (other than signs attached to buildings), trees, shrubs or plants (other than "stock" of trees, shrubs or plants) all except as provided in the Coverage Extensions.

Definitions are an important part of any coverage dispute

The 1993 federal appeals court decision *Green Lawn Systems v. American Economy Insurance* illustrates how important the definitions in a business property policy can be.

American Economy issued a commercial package to Green Lawn, a Florida-based construction company installing an irrigation system at a school under construction in the central part of that state.

Green Lawn filed a claim when thieves trespassed on the construction site and stole its property, which included tools, materials to be installed at the site (sprinkler heads, nozzles, valves, tubing, etc.), and two trailers which transported a Ditch Witch and Vermeer Trencher.

American Economy paid the claim for the tools but not the other items. Green Lawn filed lawsuit alleging breach of contract.

The trial court entered a summary judgment in favor of American Economy, concluding that the trailers were not scheduled as part of Green Lawn's policy and, therefore, were not a covered loss. The court also ruled that the materials to be installed at the construction site were stock and, therefore, excluded from the policy. Green Lawn appealed.

The appeals court affirmed the trial court on the issue of the stolen trailers:

> The trial court was correct in ruling that the trailers were required to be listed on either the Schedule for Contractor's Equipment or the Schedule for Motor Truck Cargo Owner's Coverage in order to be a covered loss. Because the trailers were not scheduled, their loss was not covered under the insurance policy.

The next issue was whether the sprinkler heads, nozzles, valves, tubing, etc., were covered under the policy.

"Off-premises" coverage didn't include "stock"

The Building and Personal Property Coverage Form provided coverage for personal property located off-premises but expressly excluded stock from this coverage. The policy defined the term "stock" as "merchandise held in storage or for sale, raw materials and in-process or finished goods, including supplies used in their packing or shipping."

Green Lawn argued that the sprinkler heads, nozzles, etc., were "stored goods" and not stock or merchandise. Because the policy did not define "merchandise," Green Lawn consulted the dictionary for the ordinary meaning of the term, which is: "Goods bought and sold in business; commercial wares." Green Lawn reasoned that it was not in the business of selling merchandise to the public; therefore, the items were not stock.

The appeals court agreed with this argument. It ruled that the policy's definition of "stock" was, at least, ambiguous. More specifically:

> Giving "merchandise" its narrow, ordinary meaning, we conclude the sprinkler heads, nozzles, valves, tubing, etc., would not be considered stock. Instead, they could be considered the insured's personal property located off-premises and would be covered under the policy.

Therefore, the policy would have to cover the loss.

> 3. Covered Causes of Loss
> See applicable Causes of Loss Form as shown in the Declarations.

Just as a policy describes the property which is and is not covered, it must describe the perils, or causes of loss (such as fire, windstorm and explosion) which are and are not covered. Under the current commercial lines program, the covered and excluded causes of loss

INSURING THE BOTTOM LINE

are contained in separate forms. One or more causes of loss forms must be attached to commercial property coverages.[3] The applicable form(s) for each coverage must be indicated in the declarations.

Additional coverages for insured property

> 4. Additional Coverages
> a. Debris Removal
> (1) We will pay your expense to remove debris of Covered Property caused by or resulting from a Covered Cause of Loss that occurs during the policy period. The expenses will be paid only if they are reported to us in writing within 180 days of the date of direct physical loss or damage.
> (2) the most we will pay under this Additional Coverage is 25 percent of:
> (a) The amount we pay for the direct physical loss of or damage to Covered Property; plus
> (b) The deductible in this policy applicable to that loss or damage. But this limitation does not apply to any additional debris removal limit provided in the Limits of Insurance section.
> (3) This Additional Coverage does not apply to costs to:
> (a) Extract "pollutants" from land or water; or
> (b) Remove, restore or replace polluted land or water.

Additional coverages are limited amounts of coverage for specific types of losses or expenses which are provided in addition to the major property coverages.

Coverage is provided for the expenses of removing the debris of covered property which is damaged by a covered cause of loss during the policy period. Debris removal expenses must be reported in writing within 180 days of the date of loss.

Expenses for debris removal can be costly

Removing the consequential debris from a major loss (such as what's left when a building is damaged by fire) can be costly. Provided it's reported within 180 days of the loss, the insurance company will pay up to 25 percent of the total of the following for debris removal: (1) the amount paid for the direct loss plus (2) the deductible.

Example: For an $8,000 loss for which a $500 deductible applies, the insurance company pays $7,500 for the direct loss and an additional $2,000 is available for debris removal expenses.

An additional amount for debris removal is available when the applicable limit is exhausted.

As you will see when we get to the "limits of insurance" section, if the actual debris removal expense exceeds this 25 percent limitation, or if the sum of the direct loss and the debris removal expense exceeds the limit of insurance, the insurance company will pay up to an additional $5,000 at each location (per occurrence) for debris removal expenses.

[3] For a more detailed discussion of the Causes of Loss Form, see Part 2 of this chapter.

The debris removal provision wasn't intended to deal with pollution or provide environmental restoration to land or water. Another additional coverage provision, found later in this section, provides for limited pollution cleanup following a covered direct loss.

The additional coverage for debris removal expense does not apply to the cost of extracting pollutants from land or water, because that is a separate additional coverage.

> b. Preservation of Property
> If it is necessary to move Covered Property from the described premises to preserve it from loss or damage by a Covered Cause of Loss, we will pay for any direct physical loss or damage to that property:
> (1) While it is being moved or while temporarily stored at another location; and
> (2) Only if the loss or damage occurs within 10 days after the property is first moved.

Coverage for preservation of property has traditionally been known as "removal" coverage. When covered property is removed from a premises to protect it from a covered cause of loss, coverage is provided for any direct loss up to 10 days while it is at another location. This coverage is very broad because the loss at the temporary location need not be a covered cause of loss.

Coverage for property removed from a loss site is "all risk"

This coverage offers "all risk" insurance to covered property that is moved from the insured premises in order to protect it from an insured peril there.

Example: To protect her inventory from a fire (a covered cause of loss under her policy), a store owner moves her stock to a nearby vacant garage. Within days of the move, there's a break-in at the garage and everything is stolen. Preservation of property coverage would pay for the theft loss at the temporary location—the garage—even if theft was not a covered cause of loss under the policy.

> c. Fire Department Service Charge
> When the fire department is called to save or protect Covered Property from a Covered Cause of Loss, we will pay up to $1,000 for your liability for fire department service charges:
> (1) Assumed by contract or agreement prior to loss; or
> (2) Required by local ordinance. No Deductible applies to this Additional Coverage.

If the fire department is called to protect covered property from a covered loss, the insurance company will pay up to $1,000 of your liability for fire department service charges if those charges are required by local ordinance or are assumed by contract or agreement prior to the loss—no deductible applies to this coverage.

This coverage is provided as an additional amount of insurance.

Pollution

> d. Pollutant Clean Up and Removal
> We will pay your expense to extract "pollutants" from land or water at the described premises if the discharge, dispersal, seepage, migration, release or escape of the "pollutants" is caused by or results from a Covered Cause of Loss that occurs during the policy period. The expenses will be paid only if they are reported to us in wiring within 180 days of the date on which the Covered Cause of Loss occurs. This Additional Coverage does not apply to costs to test for, monitor or assess the existence, concentration or effects of "pollutants." But we will pay for testing which is performed in the course of extracting the "pollutants" from the land or water. The most we will pay under this Additional Coverage for each described premises is $10,000 for the sum of all covered expenses arising out of Covered Causes of Loss occurring during each separate 12 month period of this policy.

The cost of extracting pollutants from land or water is another additional coverage if the discharge, dispersal, seepage, migration or escape of the pollutants is caused by a covered cause of loss. These expenses will be paid only if reported to the insurance company in writing within 180 days of the date of loss. The maximum payable under this additional coverage is $10,000 for each described premises in any 12-month policy period.

Example: If a fire at your warehouse caused barrels of chemicals to rupture, coverage would be provided for clean up. But no coverage would be provided if an employee knocked over a barrel of chemicals and caused a spill.

A long book could be written about this pollution liability exclusion. Most disputes involve complex issues of chemical, nuclear and other exposures. But it's easier than you might think to get into trouble with pollution risks.

Pollution losses related to a gasoline spill are disputed

The 1993 federal district court decision *W.H. Breshears, Inc. v. Federated Mutual Insurance* offers a useful example of a relatively simple pollution problem.

Federated insured Breshears under a Commercial Package Policy of insurance, containing a "Petro Pac Petroleum Products Distributors Coverage Part" and a "Commercial General Liability Coverage Part." The package also contained a Commercial Umbrella Liability Policy, providing liability coverage in excess of the Commercial General Liability Coverage Part of the Commercial Package Policy.

During the late night and early morning hours of March 3 and 4, 1990, vandals broke into Breshears' commercial building in Modesto, California. Among other things, they caused approximately 6,500 gallons of unleaded gasoline to be released from an above ground storage tank onto the ground.

Federated declined to cover the losses related to the gas spill, citing the package's absolute pollution exclusion.

Breshears sued, arguing Federated was guilty of breach of contract and fraudulent misrepresentation. It sought three things:

- money to cover the costs it had incurred cleaning up the contamination that resulted from the spilled gasoline,
- an order obligating Federated to defend it against all further claims for cleanup arising out of the spill, and
- punitive damages.

Federated countersued, rejecting all of these claims and seeking an order holding it not liable for any claims related to the gas spill—whether the claims were made by Breshears or any of its neighbors. The insurance company seemed particularly concerned about liability claims from companies located near the Breshears store.

The trial court ruled in favor of Federated and against Breshears. It ruled that Federated was entitled to judgment as a matter of law on the claims for insurance coverage, defense and indemnity. In writing this ruling, the court focused on various parts of the policy—including the so-called "Petro Pac Coverage Part," which provided commercial property insurance. This coverage included several important exclusions, including:

> The...coverage does not apply to the costs to extract pollutants from land or water or to remove, restore or replace polluted land or water.

There was no duty to defend contained within this coverage part.

A second coverage part that the court considered was an umbrella liability part of the package that Federated had sold Breshears. This coverage—common to package policies—worked as excess coverage for losses which were bigger than the limits of the standard property coverage.

There was no coverage under this excess part for claims "arising out of or related to" the spill of gasoline from the Breshears' premises. As a result, the court ruled:

> ...there exists no duty on the part of Federated to defend or indemnify Breshears against those claims, as a result of the clear and unambiguous exclusion from coverage contained within the policies' "Pollution Exclusion Endorsement."

Breshears argued that unleaded gasoline was not a "pollutant" as defined in the "Pollution Exclusion Endorsement." At least, it insisted, this was an issue that would have to be determined by a jury.

A court enforces a pollution exclusion

The court didn't agree. It issued a summary judgment in favor of Federated, concluding:

> The evidence submitted...does not render the language of these exclusions reasonably susceptible to more than one interpretation....
>
> The risk of property damage caused by pollution was expressly excluded by the policies, as is any loss, cost or expense arising out of any request, demand or order that any insured, or others, test for, monitor, clean up, remove, contain, treat, detoxify or neutralize, or in any way respond to, or assess the effects of pollutants.

The court upheld the absolute exclusion for pollution damages under this standard coverage. This applied to the relatively simple proposition of gas being spilled at a mechanic's shop and gas station. Even if you're not in some high-tech, chemical-heavy business, you can face a pollution problem. Don't count on your standard policy to cover you.

> 5. Coverage Extensions
> Except as otherwise provided, the following Extensions apply to property located in or on the building described in the Declarations or in the open (or in a vehicle) within 100 feet of the described premises. If a Coinsurance percentage of 80 percent or more or, a Value Reporting period symbol, is shown in the Declarations, you may extend the insurance provided by this Covered Part as follows:

The standard policy extends coverage to several kinds of property

Five extensions of coverage are available under the building and personal property coverage form, but only if a coinsurance percentage of 80 percent or more or a value reporting symbol is shown in the declarations (however, coinsurance[4] does not apply to these extensions).

The five extensions are:

- newly acquired or constructed property,
- personal effects and property of others,
- valuable papers and records,
- property off-premises, and
- outdoor property.

Each of the extensions is additional insurance, which means the amount of insurance provided is "in addition" to the limits shown in the declarations. In most cases, the amounts of insurance extended are small and are provided without charge to cover incidental exposures. There is one exception—coverage for newly acquired or constructed property can be significant, and an additional premium will usually be charged for this coverage.

[4] For a more detailed explanation of the mechanics of coinsurance, see page 42 of this chapter.

Chapter One, Part One: Building and Personal Property

> a. Newly Acquired or Constructed Property
> (1) You may extend the insurance that applies to Building to apply to:
> (a) Your new buildings while being built on the described premises; and
> (b) Buildings you acquire at locations, other than the described premises, intended for:
> (i) Similar use as the building described in the Declarations; or
> (ii) Use as a warehouse.
> The most we will pay for loss or damage under this Extension is 25 percent of the Limit of Insurance for Building shown in the Declarations, but not more than $250,000 at each building.
> (2) You may extend the insurance that applies to Your Business Personal Property to apply to that property at any location you acquire other than at fairs or exhibitions. The most we will pay for loss or damage under this Extension is 10 percent of the Limit of Insurance for Your Business Personal Property shown in the Declarations, but not more than $100,000 at each building.
> (3) Insurance under this Extension for each newly acquired or constructed property will end when any of the following first occurs:
> (a) This policy expires;
> (b) 30 days expire after you acquire or begin to construct the property; or
> (c) You report values to us.
> We will charge you additional premium for values reported from the date construction begins or you acquire the property.

New construction at the same location

For new construction on the same premises or acquired buildings at a different location, the extension is 25 percent of the amount of existing coverage for buildings, subject to a maximum of $250,000 per building.

For business personal property at newly acquired locations (other than fairs or exhibitions), you may extend up to 10 percent of the amount of existing coverage for personal property, subject to a maximum of $100,000 at each new building.

But this automatic extension for newly acquired locations or newly constructed property is temporary—it applies for a maximum of 30 days (but not beyond the policy's expiration or the date you notify the carrier of the new locations).

This extension is not free insurance. It simply allows a policyholder 30 days to update his or her coverage. Additional premium for the new exposure will be calculated from the date of acquisition or beginning of construction.

The additional values must be reported and an additional premium will be charged for this coverage.

> b. Personal Effects and Property of Others
> You may extend the insurance that applies to Your Business Personal Property to apply to:

> (1) Personal effects owned by you, your officers, your partners or your employees. This extension does not apply to loss or damage by theft.
> (2) Personal property of others in your care, custody or control.
> The most we will pay for loss or damage under this Extension is $2,500 at each described premises. Our payment for loss of or damage to personal property of others will only be for the account of the owner of the property.

If personal property coverage is written, you may extend the insurance to cover personal effects of the named insured, officers, partners or employees (but such coverage shall not apply to loss by theft), and to personal property of others in your care, custody or control. The most the insurance company will pay for loss or damage under this extension is $2,500 at each described premises.

The coverage for "personal property of others" is virtually identical to the major coverage having that same name. The extension provides a small amount of coverage without charge for those who may only have an incidental exposure. A business with a more significant exposure should purchase a specific amount of the major coverage.

> c. Valuable Papers and Records—Cost of Research
> You may extend the insurance that applies to Your Business Personal Property to apply to your costs to research, replace or restore the lost information on lost or damaged valuable papers and records, including those which exist on electronic or magnetic media, for which duplicates do not exist. The most we will pay under this Extension is $1,000 at each described premises.

Researching, replacing and restoring lost information

You may also extend personal property coverage to apply to the costs of researching, replacing or restoring the lost information on valuable papers and records which have suffered loss or damage, for which duplicates do not exist. The most the insurance company will pay under this extension is $1,000 at each described premises.

(Note: This restores a limited amount of coverage for this type of loss, which was listed earlier under "property not covered.")

> d. Property Off-Premises
> You may extend the insurance provided by this Coverage Form to apply to your Covered Property, other than "stock," that is temporarily at a location you do not own, lease or operate. This Extension does not apply to Covered Property :
> (1) In or on a vehicle;
> (2) In the care, custody or control of your salespersons; or
> (3) At any fair or exhibition.
> The most we will pay for loss or damage under this Extension is $5,000.

Up to $5,000 of coverage may be extended to apply to covered property (other than "stock") while temporarily off-premises at another location, but not while the property is in or on a motor vehicle, or in

the care, custody or control of your salespeople, or at any fair or exhibition.

> e. Outdoor Property
> You may extend the insurance provided by this Coverage Form to apply to your outdoor fences, radio and television antennas, signs (other than signs attached to buildings), trees, shrubs and plants (other than "stock" of trees, shrubs or plants), including debris removal expense, caused by resulting from any of the following causes of loss if they are Covered Causes of Loss:
> (1) Fire;
> (2) Lightning;
> (3) Explosion;
> (4) Riot or Civil Commotion; or
> (5) Aircraft.
> The most we will pay for loss or damage under this Extension is $1,000, but not more than $250 for any one tree, shrub or plant.

Coverage may be extended to apply to outdoor property, such as outdoor fences, radio and television antennas, signs which are not attached to buildings, and trees, shrubs and plants (other than "stock" held for sale). This extension applies only to losses resulting from the specific perils of fire, lightning, explosion, riot or civil commotion, or aircraft. The most the insurance company will pay for loss under this extension is $1,000, and not more than $250 for any one tree, shrub or plant.

Note: This extension also restores a limited amount of coverage for these items, which were all listed earlier under "property not covered."

> **B. EXCLUSIONS**
> See applicable Causes of Loss Form as shown in the Declarations.

Defining what the policy doesn't cover

Earlier we reviewed the "property not covered" section and mentioned that the items listed were "exclusions" of a sort. Indeed, anything not covered (whether a type of property or a cause of loss) is in fact an exclusion.

Exclusionary language may actually be found in an insuring agreement, or a definition, or any policy provision where an exception or reference is made to something that is not covered. But in property insurance forms the formal term "exclusions" has traditionally been used to mean the causes of loss, or perils, which are not covered.

Under the current commercial lines program, these exclusions are found in the causes of loss forms that apply to the coverages.

For a more detailed discussion of causes of loss forms, see Part 2 of this chapter—beginning on page 57.

C. LIMITS OF INSURANCE
The most we will pay for loss or damage in any one occurrence is the applicable Limit of Insurance shown in the Declarations.

Property insurance limits apply per occurrence. The applicable limit(s) of insurance shown in the declarations is the most the insurance company will pay for all loss or damage resulting from any one occurrence.

For the major coverages of the building and personal property form, the most the insurance company will pay for loss or damage in any one occurrence is the applicable limit of insurance shown in the declarations. One or more limits may be shown, depending upon how the coverage is written.

The building and personal property form may be written on a specific, schedule, or blanket basis.

Specific coverage provides a specific amount of insurance for specific types of property at a specific location—an example would be a form providing insurance amounts of $200,000 for a building and $50,000 for personal property at one location.

Schedule coverage may be used to provide insurance for different types of property at different locations. Various buildings and contents may be itemized on a schedule, and a specific amount of insurance will apply to each. A few items may be scheduled on the declarations page. When longer schedules are involved, the schedule of locations and insurance amounts is usually attached by endorsement.

The mechanics of coverage control what kind of property is insured

Blanket coverage provides a single amount of insurance that applies to all types of property at a single location, or to all types of property at multiple locations. Blanket coverage may be written simply by showing the proper entries on the declarations page. For example, showing a limit of "$1 million" for Coverages "A, B and C" would mean that the single limit applied per occurrence to combined losses under the three major coverages. Another example would be a single limit that applied to all coverages at multiple locations—this allows a retail or manufacturing operation with more than one location to move merchandise or stock between locations without having to adjust insurance limits at each location.

If blanket coverage is written for a large number of different locations, the schedule of locations may have to be attached. Another variation affecting insurance limits is use of reporting forms which allow the amount of insurance to fluctuate during the policy period. Businesses that have large changes in inventory values during the year often use reporting forms to avoid costly overinsurance or problems with underinsurance.

Chapter One, Part One: Building and Personal Property

> The most we will pay for loss or damage to outdoor signs attached to buildings is $1,000 per sign in any one occurrence.

A separate limit, known as a sublimit, of $1,000 applies to outdoor signs attached to buildings. (This differs from the coverage extension for outdoor property, which covers signs not attached to buildings. That coverage has a single $1,000 per occurrence limit, and only covers losses by a few specified perils.)

For signs attached to buildings, the limit applies per sign, and all perils shown in the applicable causes of loss form are covered.

The limits applicable to the Covered Extensions and the Fire Department Service Charge and Pollutant Clean Up and Removal Additional Coverages are in addition to the Limits of Insurance.

> Payments under the following Additional Coverages will not increase the applicable Limit of Insurance:
> 1. Preservation of Property; or
> 2. Debris Removal; but if:
> a. The sum of direct physical loss or damage and debris removal expense exceeds the Limit of Insurance; or
> b. The debris removal expense exceeds the amount payable under the 25 percent limitation in the Debris Removal Additional Coverage
> we will pay up to an additional $5,000 for each location in any one occurrence under the Debris Removal Additional Coverage.

Coverage for property removed to preserve it from loss and for debris removal expenses does not normally increase the applicable limit of insurance. However, if debris removal expense exceeds the 25 percent of loss limitation, or the sum of a loss and the debris removal expense exceeds the limit of insurance, the insurance company will pay up to an additional $5,000 at each location under the debris removal coverage. (By endorsement, you can purchase higher amounts of debris removal coverage.)

> **D. DEDUCTIBLE**
> We will not pay for loss or damage in any occurrence until the amount of loss or damage exceeds the Deductible shown in the Declarations. We will then pay the amount of loss or damage in excess of the Deductible, up to the applicable Limit of Insurance, after any deduction required by the Coinsurance condition or the Agreed Value Optional Coverage.

The deductible means you have to pay something before the insurance company takes over

The insurance company has no obligation to pay for a loss until the amount of loss exceeds the deductible shown in the declarations, and then it agrees to pay only the amount in excess of the deductible (subject to the limits of insurance, and any adjustments required because of coinsurance or the agreed value option). The standard deductible is $250 per occurrence. You have the option of selecting higher deductible amounts, which will reduce the premium charged.

Example: If the limit of insurance is $100,000 and the deductible amount is $500 when a $450 loss occurs, the insurance company will not pay anything.

Example: If the limit of insurance is $100,000 and the deductible amount is $500 when a $10,000 loss occurs, the insurance company would pay $9,500.

Example: If the limit of insurance is $100,000 and the deductible amount is $500 when a $115,000 loss occurs, the insurance company would pay $100,000.

> **E. LOSS CONDITIONS**
> The following conditions apply in addition to the Common Policy Conditions and the Commercial Property Conditions.

A separate form attaches property insurance conditions to the property coverage forms included in the policy (these apply in addition to the common policy conditions). Individual coverage forms also include conditions applicable to specific coverages or losses. Conditions spell out rights and obligations of the parties to the contract, and describe some of the provisions that affect the scope of coverage.

Loss conditions apply in addition to all other conditions that affect the coverage form and the entire policy, and address issues that relate only to commercial property losses.

> 1. Abandonment
> There can be no abandonment of any property to us.

You can't abandon partially damaged property

The abandonment condition states that you may not abandon property to the insurance company. This means that if property is only partially damaged, you have no right to turn it over to the insurance company and demand payment for a total loss. Other conditions give the insurance company the right to "repair, rebuild or replace" any portion of damaged property.

> 2. Appraisal
> If we and you disagree on the value of the property or the amount of loss, either may make written demand for an appraisal of the loss. In this event, each party will select a competent and impartial appraiser. The two appraisers will select an umpire. If they cannot agree, either may request that selection be made by a judge of a court having jurisdiction. The appraisers will state separately the value of the property and amount of loss. If they fail to agree, they will submit their differences to the umpire. A decision agreed to by any two will be binding. Each party will:
> a. Pay its chosen appraiser; and
> b. Bear the other expenses of the appraisal and umpire equally.
> If there is an appraisal, we will still retain our right to deny the claim.

An appraisal condition establishes procedures for having an appraisal

when the parties cannot agree on the value of property or the amount of a loss. Either party may demand an appraisal, and each will share the costs of appraisal.

You must give prompt notice when a loss occurs

> 3. Duties In the Event of Loss or Damage
> a. You must see that the following are done in the event of loss or damage to Covered Property:
> (1) Notify the police if a law may have been broken.
> (2) Give us prompt notice if a law may have been broken.
> (2) Give us prompt notice of the loss or damage. Include a description of the property involved.
> (3) As soon as possible, give us a description of how, when and where the loss or damage occurred.
> (4) Take all responsible steps to protect the Covered Property from further damage by a Covered Cause of Loss. If feasible, set the damaged property aside and in the best possible order for examination. Also keep a record of your expenses for emergency and temporary repairs, for consideration in the settlement of the claim. This will not increase the Limit of Insurance.

The next condition specifies your duties in the event of loss. These include giving prompt notice of loss, providing a description of how and when the loss occurred, protecting property from further damage, permitting the insurance company to inspect property, and submitting a signed proof of loss within 60 days after a request.

> (5) At our request, give us complete inventories of the damaged and undamaged property. Include quantities, costs, values and amount of loss claimed.
> (6) As often as may be reasonably required, permit us to inspect the property proving the loss or damage and examine your books and records. Also permit us to take samples of damaged and undamaged property for inspection, testing and analysis, and permit us to make copies from your books and records.
> (7) Send us a signed, sworn proof of loss containing the information we request to investigate the claim. You must do this within 60 days after our request. We will supply you with the necessary forms.
> (8) Cooperate with us in the investigation or settlement of the claim.
> b. We may examine any insured under oath, while not in the presence of any other insured and at such times as may be reasonably required, about any matter relating to this insurance or the claim, including an insured's books and records. In the event of an examination, an insured's answers must be signed.

The insurance company has the right to examine you under oath and to examine your financial books and records. This right is preserved because financially troubled companies are sometimes suspected of filing fraudulent claims. Conversely, a questionable insurance claim is often a sign of bigger financial problems.

> 4. Loss Payment
> a. In the event of loss or damage covered by this Coverage Form, at our option, we will either:
> (1) Pay the value of lost or damaged property;
> (2) Pay the cost of repairing or replacing the lost or damaged property;
> (3) Take all or any part of the property at an agreed or appraised value; or
> (4) Repair, rebuild or replace the property with other property of like kind and quality.
> b. We will give notice of our intentions within 30 days after we receive the sworn proof of loss.
> c. We will not pay you more than your financial interest in the Covered Property.
> d. We may adjust losses with the owners of lost or damaged property if other than you. If we pay the owners, such payments will satisfy your claims against you for the owners' property. We will not pay the owners more than their financial interest in the Covered Property.
> e. We may elect to defend you against suits arising from claims of owners of property. We will do this at our expense.
> f. We will pay for covered loss or damage within 30 days after we receive the sworn proof of loss, if:
> (1) You have complied with all of the terms of this Coverage Part; and
> (2)(a) We have reached agreement with you on the amount of loss; or
> (b) An appraisal award has been made.

Your rights—and obligations—once a loss has taken place

The loss payment condition specifies the rights and obligations of the insurance company after a covered loss occurs. The insurance company has the option of paying the value of lost or damaged property, paying the cost of repairing or replacing lost or damaged property, or of repairing, rebuilding or replacing property with property of like kind and quality. It may also take possession of any part of the property at an agreed or appraised value. The insurance company must give notice of its intent within 30 days after receiving a sworn statement of loss.

The insurance company may adjust losses with the owners of property, if not you, and may elect at its own expense to defend you against any suits brought by the owners of lost or damaged property.

Within 30 days after receiving a sworn statement of loss, the insurance company will pay for the loss or damage—if you have complied with all coverage conditions and the parties agree on the amount of loss or an appraisal has been made. However, under no circumstances will the insurance company pay more than your financial interest in covered property.

Example: You enter a joint venture with another company that gives you a 20 percent interest in the new entity. The facilities used by this new venture are destroyed by fire. Your insurable interest is only 20 percent of the value of the materials destroyed—and your recovery can't be more than that.

Chapter One, Part One: Building and Personal Property

> 5. Recovered Property
> If either you or we recover any property after loss settlement, that party must give the other prompt notice. At your option, the property will be returned to you. You must then return to us the amount we paid to you for the property. We will pay recovery expenses and the expenses to repair the recovered property, subject to the Limit of Insurance.

The recovered property condition states that either party who recovers property after a loss settlement must notify the other. At your option, an exchange of value may then be made.

Returning the settlement if lost property is recovered

Example: If theft coverage applies and the insurance company pays for a theft of personal property which is later recovered, you may keep the loss settlement amount or request return of the item. If the item is returned, you must repay the amount of the settlement, but if the item is damaged the insurance company will pay for repairs.

> 6. Vacancy
> If the building where loss or damage occurs has been vacant for more than 60 consecutive days before that loss or damage, we will:
> a. Not pay for any loss or damage caused by any of the following even if they are Covered Causes of Loss:
> (1) Vandalism;
> (2) Sprinkler Leakage, unless you have protected the system against freezing;
> (3) Building glass breakage;
> (4) Water damage;
> (5) Theft; or
> (6) Attempted theft.
> b. Reduce the amount we would otherwise pay for the loss or damage by 15 percent.

A vacancy condition applies to loss or damage at buildings which have been vacant for more than 60 days at the time of loss. A building is considered to be vacant when it does not contain enough business personal property for conducting customary business operations. Buildings under construction are not considered to be vacant.

Vacancy limits coverage

If loss occurs when the building has been vacant for more than 60 consecutive days, losses are not covered if caused by vandalism, theft or attempted theft, water damage, building glass breakage, or sprinkler leakage (unless the system has been protected from freezing). Payment for all other covered causes of loss occurring after 60 days of vacancy will be reduced by 15 percent.

Insurance companies exclude vacant properties because they're more prone to risks like vandalism, squatting and arson.

37

Evaluating losses and claims

> 7. Valuation
> We will determine the value of Covered Property in the event of loss or damage as follows:
> a. At actual cash value as of the time of loss or damage, except as provided in b., c., d., e. and f. below.

Actual cash value is a key replacement issue

Most commercial property losses under the building and personal property coverage form are valued and settled on the basis of actual cash value (ACV), which means replacement cost at the time of loss, less depreciation.

Example: If an item of personal property which had depreciated 30 percent due to age was destroyed, and the replacement cost for a new item was $10,000, a policy providing ACV coverage would pay only $7,000 less the deductible.

The 1991 federal district court decision *Stewart Dickler et al. v. CIGNA Property and Casualty et al.* serves as a primer for disputes over replacement cost.

The Wantagh Union Free School District owned several schools in Long Island, outside of New York City. From July 1985 to July 1988, the WUFSD insured its schools and other buildings—including the Sunrise School in the Town of Hempstead—under a package policy issued by CIGNA Property and Casualty.

The policy covered the properties on both replacement cost and actual cash value bases.

It defined replacement cost coverage as "the amount it would take to replace the property of the same kind and quality, determined at the time of the loss." But, this coverage would apply only if the damaged property was actually repaired.

If no repairs were made to the damaged property, the policy provided coverage on an actual cash value basis. This was defined in the policy as "the replacement cost, at the time of the loss, of the property damaged or destroyed, less depreciation."

In 1986, WUFSD determined that Sunrise was surplus and placed it on the market for sale. At that point, Sunrise had not been operated as a public school for several years.

WUFSD notified CIGNA of the changed status of Sunrise. The insurance company knew as early as December 1986 that Sunrise was vacant and that WUFSD was attempting to sell it. The only insurance condition required after Sunrise became vacant was that it's windows and doors be boarded up.

In August 1986, WUFSD contracted to sell Sunrise and the adjoining lands to Stewart Dickler, a local real estate developer. The sale was

subject to voter approval. Dickler agreed he would demolish Sunrise and build a maximum of 21 single family homes on the site.

Closing on the sale was delayed because WUFSD could not initially obtain voter approval. Once voter approval had been obtained, a taxpayer's suit followed—eventually resolved in the school district's favor—which delayed things further.

On June 27, 1988, Sunrise was severely damaged by fire. Certain personal property owned by WUFSD and stored in the school was also damaged or destroyed. The fire damage to Sunrise was in excess of $2,300,000.

By the time of the fire, the real estate market had slumped and Dickler asked that Sunrise be repaired and converted to another reasonably available use—including the possibility of its being used as a senior citizens center.

The sale of Sunrise to Dickler closed in September 1988. WUFSD assigned its rights under its insurance contract to Dickler.

Around the time of the closing, Dickler asked WUFSD to engage a public adjuster to represent his interest regarding the covered losses—and to process claims with CIGNA.

The insurance company refused to consider the loss

CIGNA refused to acknowledge the loss or even to provide Dickler with a copy of the insurance contract. Despite its refusal to adjust the loss with Dickler, the insurance company did adjust the contents loss with WUFSD.

(In this context, and ones like it, to adjust means to evaluate and pay a claim.)

Dickler did not have the financial resources to repair the school and could not obtain financing for the repairs without the loss being adjusted. Instead, he sued CIGNA.

In the meantime, faced with the pressures being exerted by local authorities and the refusal of CIGNA to adjust the loss, Dickler obtained a demolition permit and razed the school. The cost to demolish Sunrise was $185,000, which a company controlled by Dickler paid.

After hearing the testimony presented by Dickler, WUFSD and CIGNA, the trial court found that the replacement cost of Sunrise as of the date of the loss was $7,381,490. The zoning was such that under New York law it could have been converted to an alternative use and not been demolished.

The court quoted long-standing New York case law in the purpose of commercial building insurance:

> The contract of an insurer is not that, if the property is burned, he will pay its market value, but that he will indemnify the assured, that is, save him harmless or put him in as good a condition, so far as practicable, as he would have been in had no fire occurred.

INSURING THE BOTTOM LINE

Insurance companies bear more responsibility than policyholders

Having cited the law, it then made its own analysis of the case at hand:

> Since the insurance company has the power, through the control of settlement, to adversely affect the insureds' interest, it must necessarily bear a legal responsibility for the proper exercise of that power. Thus, the law imposes upon the insurer the obligation of good faith, basically, the duty to consider, in good faith, the insureds' interests as well as its own when making decisions as to the handling of the claim.

Dickler had the right to have the covered loss to Sunrise adjusted fairly and promptly. As a consequence of CIGNA's failure to adjust his claim, Dickler acted reasonably in demolishing the fire-damaged school building. As a result, he could demand the replacement value of the school—rather than the actual cash value of a burned building.

The court concluded that Dickler was entitled to recover compensatory damages in the amount of $7,566,490—the replacement cost of Sunrise plus the cost of demolishing it—from CIGNA.

Full coverage for minor damages

> b. If the Limit of Insurance for Building satisfies the Additional Condition, Coinsurance, and the cost to repair or replace the damaged building property is $2,500 or less, we will pay the cost of building repairs or replacement.
> This provision does not apply to the following even when attached to the building:
> (1) Awnings or floor coverings;
> (2) Appliances for refrigerating, ventilating, cooking, dishwashing or laundering; or
> (3) Outdoor equipment or furniture.
> c. "Stock" you have sold but not delivered at the selling price less discounts and expenses you otherwise would have had.
> d. Glass at the cost of replacement with safety glazing material if required by law.
> e. Tenant's Improvements and Betterments at:
> (1) Actual cash value of the lost or damaged property if you make repairs promptly.
> (2) A proportion of your original cost if you do not make repairs promptly. We will determine the proportionate value as follows:
> (a) Multiply the original cost by the number of days from the loss or damage to the expiration of the lease; and
> (b) Divide the amount determined in (a) above by the number of days from the installation of improvements to the expiration of the lease. If your lease contains a renewal option, the expiration of the renewal option period will replace the expiration of the lease in this procedure.
> (3) Nothing if others pay for repairs or replacement.

If building coverage satisfies any coinsurance requirement, the in-

surance company will pay the full repair or replacement costs for building losses of $2,500 or less (with the exception of certain items such as awnings or floor coverings).

"Stock" sold but not delivered will be valued at the selling price less discounts and expenses you otherwise would have had.

Glass will be valued at the cost of replacement with safety glazing material if such replacement is required by law.

Tenant's improvements and betterments will be valued according to the nature of the repair or replacement efforts following a loss. If you make prompt repairs, ACV will be allowed. If you do not make prompt repairs, the insurance company will only pay for a proportion of the original installation cost. If others pay for repair or replacement for your benefit, the insurance company will pay nothing.

> f. Valuable Papers and Records, including those which exist on electronic or magnetic media (other than prepackaged software programs), at the cost of:
> (1) Blank materials for reproducing the records; and
> (2) Labor to transcribe or copy the records when there is a duplicate.

Losses of valuable papers and records, including computer tapes and disks, will be valued at the cost of blank materials for reproducing the records. The cost of labor to transcribe or copy lost records will be covered only when duplicate records exist.

Coinsurance is a complicated condition

> **F. ADDITIONAL CONDITIONS**
> The following conditions apply in addition to the Common Policy Conditions and the Commercial Property Conditions.
> 1. Coinsurance
> If a Coinsurance percentage is shown in the Declarations, the following condition applies.
> a. We will not pay the full amount of any loss if the value of Covered Property at the time of loss times the Coinsurance percentage shown for it in the Declarations is greater than the Limit of Insurance for the property.
> Instead, we will determine the most we will pay using the following steps:
> (1) Multiply the value of Covered Property at time of loss by the Coinsurance percentage;
> (2) Divide the Limit of Insurance of the property by the figure determined in step (1);
> (3) Multiply the total amount of loss, before the application of any deductible, by the figure determined in step (2); and
> (4) Subtract the deductible from the figure determined in step (3).
> We will pay the amount determined in step (4) or the limit of insurance, whichever is less. For the remainder, you will either have to rely on other insurance or absorb the loss yourself.

The additional conditions also apply in addition to all other conditions that affect the coverage form and the entire policy.

The mechanics of coinsurance

The first additional condition addresses the issue of coinsurance, which is an important concept with respect to property insurance coverages. The purpose of coinsurance is to induce you to maintain an adequate level of insurance in relation to the actual value of covered property. Property insurance rates are based on the expectation that insureds will purchase adequate amounts of insurance to cover expected losses. But most property insurance losses are partial losses. Without a coinsurance requirement, many companies might underinsure. They might underinsure to save on premiums.

If the insurance companies paid partial losses in full when a risk was underinsured, they would lack the premium volume to cover their losses, and basic insurance rates would have to be much higher. Coinsurance helps to broaden the premium base and keep rates down by creating incentives to purchase adequate amounts of coverage, and reducing the obligations of the insurance company when a risk is underinsured.

A customary coinsurance ratio is 80 percent.

Partial recovery for losses is the key negative incentive

A coinsurance penalty (only partial recovery for losses) applies when a risk is underinsured. The first step in determining how this affects losses is to multiply the true value of covered property at the time of loss by the applicable coinsurance percentage (for example, if the true value of a building is $500,000 and an 80 percent coinsurance percentage applies, you need to maintain at least $400,000 of coverage to avoid a coinsurance penalty).

The formula for the application of coinsurance is explained and illustrated in the coverage form. In simple terms, the actual amount of insurance is divided by the required amount, and the result is multiplied by the amount of loss, and then the deductible is subtracted to determine the amount of recovery.

Example: If you had $300,000 of coverage and $400,000 was required when a $100,000 loss occurred, the insurance company would only be obligated to pay $75,000 minus any deductible (three-quarters of the loss).

Review the examples used in the coverage form to see how a penalty applies in cases of underinsurance, and how no penalty applies when the amount of insurance is adequate.

> Example No. 1 (Underinsurance):
> When:
> The value of the property is $250,000
> The Coinsurance percentage for it is 80 percent

Chapter One, Part One: Building and Personal Property

The Limit of Insurance for it is $100,000
The Deductible is $250
The amount of loss is $ 40,000
Step (1): $250,000 × 80 percent = $200,000 (the minimum amount of insurance to meet your Coinsurance requirements)
Step (2): $100,000 ÷ $200,000 = .50
Step (3): $40,000 × .50 = $20,000
Step (4); $20,000 – $250 = $19,750
We will pay no more than $19,750. The remaining $20,250 is not covered.

Example No. 2 (Adequate Insurance):
When:
The value of the property is $250,000
The Coinsurance percentage for it is 80 percent
The Limit of Insurance for it is $200,000
The Deductible is $250
The amount of loss is $40,000
Step (1): $250,000 × 80 percent = $200,000 (the minimum amount of insurance to meet your Coinsurance requirements)
Step (2): $200,000 ÷ $200,000 = 1.00
Step (3): $40,000 × 1.00 = $40,000
Step (4); $40,000 – $250 = $39,750
We will cover the $39,750 loss in excess of the Deductible. No penalty applies.
b. If one Limit of Insurance applies to two or more separate items, this condition will apply to the total of all property to which the limit applies.

Examples of coinsurance issues

Example No. 3:
When:
The value of the property is:
Bldg. at Location No. 1 $ 75,000
Bldg. at Location No. 2 $100,000
Personal Property at Location No. 2 $ 75,000
 $250,000
The Coinsurance percentage for it is 90 percent
The Limit of Insurance for Buildings and Personal Property at Location Nos. 1 and 2 is $180,000
The Deductible is $ 1,000
The amount of loss is Bldg. at Location No. 2 $ 30,000
Personal Property at Location No. 2 $ 20,000
 $ 50,000
Step (1): $250,000 × 90 percent = $225,000 (the minimum amount of insurance to meet your Coinsurance requirements and to avoid the penalty shown below)
Step (2): $180,000 ÷ $225,000 = .80
Step (3): $50,000 × .80 = $40,000
Step (4); $40,000 – $1,000 = $39,000
We will pay no more than $39,000. The remaining $11,000 is not covered.

43

INSURING THE BOTTOM LINE

The second condition specifies the rights and duties of a mortgage holder—the mortgagee who holds the mortgage on insured property. When loss occurs, a mortgage holder is entitled to recovery to the extent of its interest in the property. In cases when a policyholder has failed to comply with the terms of the coverage, a mortgage holder may still be entitled to recovery if it meets certain conditions.

The particular insurance issues that apply to mortgage holders

2. Mortgage Holders
a. The term "mortgage holder" includes trustee.
b. We will pay for covered loss of or damage to buildings or structures to each mortgage holder shown in the Declarations in their order of precedence, as interests may appear.
c. The mortgage holder has the right to receive loss payment even if the mortgage holder has started foreclosure or similar action on the building or structure.
d. If we deny your claim because of your acts or because you have failed to comply with the terms of this Coverage Part, the mortgage holder will still have the right to receive loss payment if the mortgage holder:
(1) Pays any premium due under this Coverage Part at our request if you have failed to do so;
(2) Submits a signed, sworn statement of loss within 60 days after receiving notice from us of your failure to do so; and
(3) Has notified us of any change in ownership, occupancy or substantial change in risk known to the mortgage holder.
All of the terms of this Coverage Part will then apply directly to the mortgage holder.
e. If we pay the mortgage holder for any loss or damage and deny payment to you because of your acts or because you have failed to comply with the terms of this Coverage Part:
(1) The mortgage holder's rights under the mortgage will be transferred to us to the extent of the amount we pay; and
(2) The mortgage holder's right to recover the full amount of the mortgage holder's claim will not be impaired.
At our option, we may pay to the mortgage holder the whole principal on the mortgage plus any accrued interest. In this event, your mortgage and note will be transferred to us and you will pay your remaining mortgage debt to us.
f. If we cancel this policy, we will give written notice to the mortgage holder at least:
(1) 10 days before the effective date of cancellation if we cancel for your nonpayment of premium; or
(2) 30 days before the effective date of cancellation if we cancel for any other reason.
g. If we elect not to renew this policy, we will give written notice to the mortgage holder at least 10 days before the expiration date of this policy.

This section also specifies the insurance company's obligation to notify any mortgage holders in the event of cancellation or nonrenewal of the coverage. Most lenders require insurance coverage as a condition of financing—and may recall a loan if coverage lapses.

> **G. OPTIONAL COVERAGES**
> If shown in the Declarations, the following Optional Coverages apply separately to each item.
> 1. Agreed Value
> a. The Additional Condition, Coinsurance, does not apply to Covered Property to which this Optional Coverage applies. We will pay no more for loss of or damage to that property than the proportion that the Limit of Insurance under this Coverage Part for the property bears to the Agreed Value shown for it in the Declarations.
> b. If the expiration date for this Optional Coverage shown in the Declarations is not extended, the Additional Condition, Coinsurance, is reinstated and this Optional Coverage expires.
> c. The terms of this Optional Coverage apply only to loss or damage that occurs:
> (1) On or after the effective date of this Optional Coverage; and
> (2) Before the Agreed Value expiration date shown in the Declarations or the policy expiration date, whichever occurs first.

A few common optional coverages, which used to be available only by endorsement, are built into the current coverage forms and may be activated by entries on the declarations page.

The commercial property declarations include a space for indicating that certain property has an agreed value. This option may be used for property that has an unusual value, or for which outside forces affect the value for a particular period of time.

Example: A piece of art in your offices may have an investment above what you paid for it. That value may be difficult to determine after a loss has occurred. Therefore, you would want to provide your insurance company with a prearranged value.

Traditionally, the amount of loss used in the above calculations has been the actual cash value of the loss. Today policies are frequently written on a replacement cost basis. Whether the ACV or replacement cost of a loss is used in the formula will depend upon how the coverage is written.

Determining the amount of a commercial property loss

For certain types of property losses, other departures from ACV apply—the "Valuation Clause" of the form describes the special loss determination provisions.

The valuation clause is the condition that determines how the amount of various losses will be determined. Unless changed by optional coverage provisions, all losses will be valued at the ACV at the time of loss.

To discourage insurance companies from overinsuring, states have enacted so-called "valued policy laws" (VPLs) to assure policyholders proportional settlements to the premiums paid.

If a VPL applies or if a valued amount (or prearranged value) has been written, the full limit of insurance for the property will be paid in the event of a total loss. Regardless of the actual cash value of property, a valued policy law or contract stands in place of any valuation clause when a total loss is involved.

When agreed value coverage applies, the full coverage amount written for the property would be paid in the event of a total loss. For a partial loss, the insurance company will pay only the prearranged percentage of the agreed value.

Coinsurance does not apply to any property which is insured on an agreed value basis.

An expiration date applies to agreed value coverage. If the agreed value expiration date passes and is not extended, the option automatically expires and a coinsurance requirement (if any) is reinstated for the affected property.

> 2. Inflation Guard
> a. The Limit of Insurance for property to which this Optional Coverage applied will automatically increase by the annual percentage shown in the Declarations.
> b. The amount of increase will be:
> (1) The Limit of Insurance that applied on the most recent of the policy inception date, the policy anniversary date, or any other policy change amending the Limit of Insurance, times
> (2) The percentage of annual increase shown in the Declarations, expressed as a decimal (example: 8 percent is .08) times
> (3) The number of days since the beginning of the current policy year or the effective date of the most recent policy change amending the Limit of Insurance, divided by 365.
> Example:
> If:
> The applicable Limit of Insurance is $100,000
> The annual percentage increase is 8 percent
> The number of days since the beginning of the policy year (or last policy change) is 146
> The amount of increase is $100,000 × .08 × 146 ÷ 365 = $3,200

The inflation guard automatically increases limits

When elected, the inflation guard option automatically increases the limit of insurance for property to which it applies (it may be applied to either or both buildings and personal property). The increase amount is an annual percentage stated in the declarations (applied pro rata if a loss occurs at mid-term). When you elect the replacement cost option, the phrase "replacement cost without deduction for depreciation" replaces "actual cash value" in the valuation clause.

The inflation guard option may be used for building coverage, personal property coverage, or both. When applicable, it automatically increases the limit of insurance by an annual percentage stated in the declarations.

Normally, the limit is increased on each policy anniversary date. If a loss occurs at mid-term, a pro rata adjustment is made based on the number of days since the beginning of the policy (or any more recent change in the limit of insurance) divided by 365.

> 3. Replacement Cost
> a. Replacement Cost (without deduction for depreciation) replaces Actual Cash Value in the Loss Condition, Valuation, of this Coverage Form.
> b. This Optional Coverage does not apply to:
> (1) Property of others;
> (2) Contents of a residence;
> (3) Manuscripts;
> (4) Works of art, antiques or rare articles including etchings, pictures, statuary, marbles, bronzes, porcelains and bric-a-brac; or
> (5) "Stock," unless the Including "Stock" option is shown in the Declarations.
> c. You may make a claim for loss or damage covered by this insurance on an actual cash value basis instead of on a replacement cost basis. In the event you elect to have loss or damage settled on an actual cash value basis, you may still make a claim for the additional coverage this Optional Coverage provides if you notify us of your intent to do so within 180 days after the loss or damage.
> d. We will not pay on a replacement cost basis for any loss or damage:
> (1) Until the lost or damaged property is actually repaired or replaced; and
> (2) Unless the repairs or replacement are made as soon as reasonably possible after the loss or damage.
> e. We will not pay more for loss or damage on a replacement cost basis than the least of:
> (1) The Limit of Insurance applicable to the lost or damaged property;
> (2) The cost to replace, on the same premises, the lost or damaged property with other property:
> (a) Of comparable material and quality; and
> (b) Used for the same purpose; or
> (3) The amount you actually spend that is necessary to repair or replace the lost or damaged property.

Optional replacement cost coverage may be selected to apply to buildings, or personal property, or both. Coverage for personal property will exclude "stock" unless the "including stock" option is shown in the declarations. When replacement cost coverage is selected, it applies instead of "actual cash value" in the valuation condition with respect to the covered property.

Replacement cost is paid only if actual repairs are made

The insurance company will not pay replacement cost until lost or damaged property is actually repaired or replaced, and such payment will be made only if the repairs or replacements are made as soon as reasonably possible after the loss. The maximum payment under replacement cost coverage may not exceed the smallest of the following amounts:

- the limit of insurance for the affected property, or
- the amount you actually spend to repair or replace the lost or damaged property, or
- the cost to replace (on the same premises) the lost or damaged property with other property, of comparable material and quality, used for the same purpose.

All things considered, valuation remains one of the most common disputes between policyholders and insurance companies. Some people try to inflate loss valuations in order to recover their deductibles. Also, issues like vandalism, vacancy and duties after loss can be serious problems for many businesses—especially smaller ones in less-than-corporate locations. The 1992 federal appeals court decision *Scott Management, Inc. v. Commerce and Industry Insurance* dealt with a useful example of these issues.

From April 1989 through September 1989, Scott Management leased forty-five furnished apartment units at the Meadow Woods Apartments complex to the Culinary School of Washington, D.C. The apartments were to be used as residences for the school's students.

Almost immediately after taking possession of the apartment units, the Culinary School became delinquent in its rental payments. In January 1990, the school filed for protection under Chapter 11 of the United States Bankruptcy Code. That month, Scott Management was granted a writ of possession for the apartments.

After Scott Management evicted the students, it discovered that many of the apartment units had been extensively damaged and the furnishings damaged or sold. As a result of these losses, Scott Management submitted a claim to Commerce and Industry on its property insurance contract for damage to the apartment units, theft of and damage to the furnishings, and loss of rents.

Claims for damage to property and loss of rent

The insurance company refused to pay the claims, so Scott Management sued. At trial, it sought a total recovery of $151,349 under the insurance contract. This amount included a stipulation by Commerce and Industry that the total damage to the apartment units and furnishings was $64,563, a claim for $2,000 for security services incurred in evicting the students, and a claim for $84,786 for loss of rental value. The district court found in favor of Scott Management on all claims except the $2,000 claim for security services.

Commerce and Industry appealed, focusing on the argument that

Scott Management failed to offer any historical evidence of occupancy rates to demonstrate the probable amount of its rental loss. It also claimed that Scott Management had no loss of rental value within the meaning of the insurance contract because more than fifty of its other apartment units in Meadow Woods were vacant at all times during the period when the damaged apartment units were being repaired.

The Rental Value Coverage section of the policy stated, in pertinent part:

> For the purpose of this insurance, "Rental Value" is defined as the sum of:
>
> A. the total anticipated gross rental income from tenant occupancy of the described property as furnished and equipped by the Insured; and
>
> B. the amount of all charges which are the legal obligation of the tenant(s) and which would otherwise be obligations of the Insured; and
>
> C. the fair rental value of any portion of said property which is occupied by the Insured.
>
> In determining Rental Value due consideration shall be given to the rental experience before the date of damage or destruction and the probable experience thereafter had no loss occurred.

Even more, the Time Element General Conditions Section of the policy provided:

> It is a condition of this insurance that if the Insured could reduce the loss resulting from the interruption of business... by making use of other property at the location(s) described herein or elsewhere, such reduction shall be taken into account in arriving at the loss hereunder.

The trial court had reasoned that the policy definition of the term "rental value" did not create a requirement of mitigation of loss by use of other property. However, it had overlooked the provision in the general definitions section of the policy that specifically included rental value as a type of loss covered under the Time Element Coverages.

A landlord has trouble showing historical proof to support a lost rent claim

The appeals court agreed with the insurance company's arguments:

> To recover for loss of rental value of the apartment units while being repaired, Scott Management must show that it was prevented from receiving rent it would otherwise have received. This evidence would include historical proof of occupancy rates and proof based on prior experience of probable occupancy rates from the date of the evictions through the end of the suspension period during which the apartment units were being repaired. In addition, evidence of the vacancy of a significant number of available apartment units in the same complex that were not rented during

the suspension period may be relevant to Scott Management's claim that it sustained a loss of rental value as a result of an inability to lease apartment units formerly occupied by the Culinary School students.

For these reasons, the appeals court overturned the lower court's ruling for Scott Management. However, it did allow the part of the award that covered the theft and loss of the furnishings in the apartments.

> **H. DEFINITIONS**
> 1. "Pollutants" means any solid, liquid, gaseous or thermal irritant or contaminant, including smoke, vapor, soot, fumes, acids, alkalis, chemicals and waste. Waste includes materials to be recycled, reconditioned or reclaimed.

The building and personal property coverage form only includes two definitions, which are rather self-explanatory. However, you should be aware that the additional coverage for pollutant cleanup and removal is only a limited form of property insurance provided for your benefit, and that this form does not provide any pollution liability coverage.

> 2. "Stock" means merchandise held in storage or for sale, raw materials and in-process or finished goods, including supplies used in their packing or shipping.

Properly defining the troublesome term "stock"

By making the proper declaration entries, replacement cost coverage can be written for buildings and personal property of you, including "stock." It may not be written to cover property of others, contents of a residence, manuscripts, works of art, antiques, etchings, statuary, pictures, marbles, bronzes, porcelains and bric-a-brac. Even when coverage is written on a replacement cost basis you may elect to make a claim on an ACV basis—in which case the additional amount can later be claimed, if you notify the insurance company of the intent to claim full replacement cost within 180 days after the loss.

Example: If you make the business decision not to replace property damaged in an insured loss, you might ask for an ACV settlement.

Items classified as "stock" depend upon the type of business insured. For a retail store, stock would include inventory and merchandise held for sale. For a factory, it would include raw materials, work-in-process, finished goods and packaging.

Optional coverages—endorsements

Various endorsements may be used to alter coverage to fit your specific needs. Endorsements may be used to change the nature of recovery, the property which is covered and not covered, and the exclusions found on the causes of loss forms.

One way in which recovery may be affected is by attaching an endorsement that provides functional valuation coverage. When this applies to a loss, it covers the cost to replace property with similar property intended to perform the same function. It is used when replacement with identical property is impossible or unnecessary. Recovery may also be affected by an endorsement providing market value coverage. "Market value" means the selling value of property at the time of loss.

Coverage may be expanded by attaching an additional covered property endorsement. It states that "the following is withdrawn from the Property Not Covered" section of the coverage form, and a schedule of items follows. The schedule is flexible and could be used to add coverage for a number of items.

Other endorsements exist for adding coverage for specific types of property which are not normally covered, or which may be covered on a very limited basis under an extension of coverage. Items such as outside signs and radio and television antennas may be covered by endorsements which remove the items from "Property Not Covered."

A vacancy permit may be attached to a policy to modify the vacancy clause. Normally, losses caused by vandalism or sprinkler leakage would not be covered if they occur after a building has been vacant for more than 60 days. For an additional premium, you can buy back this coverage at specified locations for a specified period of time. The buildings must be scheduled and a permit period must be entered (showing dates "from" and "to"). This allows the underwriter to evaluate the additional risk being assumed—the longer the permitted period of vacancy, the greater the risk. Finally, for each building an "X" would be entered under the excepted causes of loss of vandalism, or sprinkler leakage, or both.

Extending coverage to vacant property

When attached, the endorsement states that the vacancy loss condition does not apply at the locations and during the permit period shown in the schedule. Many of the exclusions found on a coverage form are not cast in stone, and coverage is available providing that a charge is made for it.

An endorsement may be used to add building ordinance coverage, which is normally excluded by the causes of loss form. When attached, coverage is provided for loss or damage caused by enforcement of laws that regulate building repair or construction, or require the demolition of damaged property. Debris removal coverage is also included. This is an important coverage because local building codes can push costs well beyond normal replacement cost.

Example: When a building suffers $100,000 of direct damage, building codes may prohibit the repair or replacement with like property and may require that all new construction incorporate expensive modernizations.

Coverage for damage caused by off-premises power failure may be attached by endorsement. This type of loss is also excluded by causes of loss forms. When coverage is attached, loss or damage to insured property will be covered when utility service is interrupted by a covered cause of loss that does direct damage to water or power services away from your premises.

Value reporting form endorsement

Value reporting is important and appropriate

When a business has fluctuating inventory values during the year, a fixed amount of insurance for personal property would be inappropriate. In order to avoid costly levels of overinsurance, problems with underinsurance, and the inconvenience of continually endorsing policies to change insurance limits, reporting forms were created. The value reporting form allows the level of coverage to float with changing values. Premiums are adjusted at the end of the policy period, based on average values reported.

The value reporting form is an endorsement that may be attached to all commercial property coverage forms for which value reporting is appropriate, except builders risk forms.

The value reporting form covers personal property at locations described in the declarations, and extends "covered property" to include personal property at any of three types of additional locations for which a limit of insurance is shown in the declarations.

Coverage may therefore apply at four different types of locations. Described locations are those shown in the declarations. Reported locations are locations, other than those shown in the declarations, which are reported to the insurance company at the inception of the value reporting coverage period. Acquired locations are locations acquired after inception of the coverage and during the coverage period. Incidental locations are locations other than described, reported and acquired locations, at which the value of insured property is $25,000 or less.

There is one exception to the property that may be covered by the reporting form—personal property at fairs and exhibitions may not be insured by this form.

Although values are reported during the coverage period, it is important that the "limit of insurance" written be based on the highest expected value during that period. The limit is a maximum limit, and in the event of loss or damage the insurance company will not pay more than the written limit even if reported values exceed that limit. During the coverage period, you will have full coverage up to the "limit of insurance" as long as timely and correct reports have been made.

At the beginning of the coverage period, you will be charged an advance premium (also known as "provisional premium"). The final pre-

Chapter One, Part One: Building and Personal Property

mium will be determined after the end of the policy period, based on the average values actually reported. At that time, the insurance company will charge an additional premium (if the advance premium was inadequate), or will return the excess premium (if the advance premium was too high).

The time periods that apply to value reporting systems

You have the option of selecting one of five periods of time for which the values must be reported. The type of period selected will be identified in the declarations by a two-letter code in brackets. The five periods and codes are:

- daily reports (DR)—monthly reports compiled on the last day of each month must show actual values at the end of each day during the month;

- weekly reports (WR)—monthly reports compiled on the last day of each month must show actual values at the end of each week during the month;

- monthly reports (MR)—monthly reports compiled on the last day of each month must show actual values at the end of each month;

- quarterly reports (QR)—quarterly reports compiled on the last day of March, June, September and December must show actual values as of the last day of each month during the reporting period; and

- policy year (PR)—annual reports compiled on the policy anniversary date must show actual values as of the last day of each month during the reporting period.

Although there are five different types of reports, there are only three ways of recording values (daily, weekly, monthly) because quarterly and annual reports must also show values at the end of each month. And there are only three times for submitting reports (monthly, quarterly, and annually) because daily and weekly reports are submitted monthly.

Using time periods to document valuations

All reports must be filed with the insurance company within 30 days after the end of each reporting period and after expiration of the policy term. Each report must show values as of the required report dates, and must show values separately at each location. For incidental locations, reports must also show separately the total values in each state. Accuracy of reports is important—you cannot correct inaccurate reports after a loss has occurred.

In effect, value reporting coverage imposes a 100 percent coinsurance requirement. The endorsement replaces the coinsurance clause of the coverage part to which it is attached with a different provision that applies to the personal property it covers. It states that if values are underreported, the insurance company will not pay a greater proportion of a loss than the amount reported divided by the actual value on the report date.

Example: If the actual value is $60,000 and you report an amount of $40,000, only two-thirds of any loss would be covered by the insurance. You must report actual values even if they exceed the maximum limit of insurance. Although there is no coverage for values in excess of the limit of insurance, reporting the full value is the only way to avoid the coinsurance penalty for underreporting.

In most cases, the actual and reported values at each location are used for the determination of loss settlements. But in the case of locations acquired after the last report made, reported values at all locations would be divided by actual values at all locations as of the last report date.

If reports are made accurately and on time, you will have the benefit of full coverage for loss up to but not to exceed the limit of insurance written. However, penalties apply if reports are delinquent. If a loss occurs before the first report is due, coverage up to the full limit of insurance applies.

If, at the time of loss, you have failed to submit the first required report in a timely manner, the insurance company will not pay more than 75 percent of the amount it otherwise would have paid. Also, it will only pay for loss or damage at locations shown in the declarations—it will not pay for any loss at acquired, reported, or incidental locations.

If a loss occurs after the first report has been made but while any later report is delinquent, the insurance company will not pay more than it would pay at any location based on the last report made, and it will only pay for loss at locations included in the last report before the loss. For example, if the last reported value was $100,000 and you failed to make a report on time after values had grown to $150,000, there will only be $100,000 of coverage until a higher value is actually reported.

A number of other endorsements may be attached to commercial property coverage forms to modify the coverage. This section will review some of the more common endorsements used.

Cancellation changes

The rules an insurance company must follow if it plans to cancel coverage

A "cancellation changes" endorsement must be attached to every commercial property coverage part, unless it is in conflict with state law or is replaced by a special state endorsement that affects the cancellation clause of the common policy conditions. The cancellation clause in the common policy conditions of a commercial policy requires a minimum 10-day notice if the insurance company cancels for nonpayment of premium, and a minimum 30-day notice if the insurance company cancels for any other reason. Because of the special nature of property insurance, this general provision is not considered flexible enough to meet the needs of special situations.

The Insurance Services Office has developed a "cancellation changes" endorsement that affects property coverages only. This is a standard endorsement that must be attached unless superseded by a required state endorsement. The endorsement adds an additional cancellation provision allowing the insurance company to cancel with only five days notice under a number of special circumstances. This shorter notice will be permitted if:

- the building has been vacant or unoccupied for 60 or more consecutive days; or
- after damage by an insured cause of loss, repairs have not been started or contracted for within 30 days; or
- the building has been declared unsafe by a government authority; or
- the building has an outstanding order to be vacated or demolished; or
- fixed or salvageable items have been or are being removed from the building and are not being replaced; or
- heat, water, sewer service or electricity have not been furnished for 30 consecutive days or more (this does not apply during a period of seasonal unoccupancy); or
- property taxes have been outstanding for more than one year following the due date (this does not apply when the taxes are in dispute).

Many states have implemented special cancellation provisions, which alter the standard ISO conditions. In each state where an exception applies, a special state endorsement would be attached instead of the standard cancellation changes endorsement.

Functional valuation endorsements

A change of method—"functional" valuation

Insured property is usually valued at its actual cash value or its replacement cost (if optional replacement cost coverage applies). In some cases, ACV coverage might not be practical and replacement cost coverage might not be economical. Coverage under the building and personal property coverage form and both of the condominium coverage forms may be endorsed to change the method of valuation to "functional" valuation.

Separate endorsements are available for functional building valuation and functional personal property valuation. When attached, these endorsements allow property to be replaced with less costly property that is functionally equivalent to the damaged or destroyed property—similar property that performs the same function when replacement with identical property is impossible or unnecessary. If a loss occurs, this coverage will pay the lesser of the limit of insurance or the cost to repair or replace the building or personal property (or the

damaged portion thereof) with less costly property that is functionally equivalent.

Peak season endorsement

This form increases the limit of insurance for business personal property for specified periods of time to take care of seasonal fluctuations in value.

For example, many merchants have increased inventories during the Christmas season. They may need additional amounts of protection for only 30 to 60 days. Instead of purchasing more coverage than they need for the balance of the year, the peak season endorsement may be used to cover the temporary increases.

Other endorsements

Property insurance coverage forms exclude losses resulting from the enforcement of ordinances or laws, yet these losses can turn into economic losses for a property owner. Ordinance or Law coverage can be added by endorsement. It covers the additional loss caused by the enforcement of laws that regulate building repair or construction. The coverage includes debris removal expenses.

Generally, commercial property forms exclude losses caused by the failure of power or other services when such loss occurs away from your premises. However, for an additional premium you can purchase an endorsement that will cover losses caused by an off-premises interruption of power or other services.

An endorsement is also available to provide coverage for spoilage of perishable stock due to power outage, mechanical breakdown, or contamination. This coverage applies to losses resulting from changes in temperature or humidity, or contamination, resulting from a power outage either on or off the premises, or resulting from mechanical breakdown.

Chapter One, Part Two:

Commercial Property Causes of Loss

Introduction

The Causes of Loss form must be attached to commercial property coverage to indicate which causes of loss, also known as perils, are being insured against. The applicable causes of loss are shown in the declarations section of most policies.

Causes of loss forms identify the perils insured against. There are four variations of causes of loss forms under the program:

- basic form,
- broad form,
- special form, and
- earthquake form.

The first three forms represent a progression of an increasing number of insured perils—"basic" insures against the fewest perils, "broad" provides more coverage than basic, and "special" provides more coverage than "broad."

The terms "basic," "broad" and "special" coverage are used throughout the property insurance field, and you will find that the meaning of the terms is fairly consistent.

At least one Causes of Loss form must be attached to the property coverage part (unless the only coverage written is glass coverage, mortgage holders errors and omissions or the standard property policy—these coverage forms include their own causes of loss). More than one causes of loss form can be attached to the coverage part, with different causes applying to different classes or locations of insured property.

Several endorsements are available to alter the coverage for specific needs. The "Cancellation Changes" endorsement alters the common policy conditions applicable to property coverages. Other endorsements alter the coverage forms or causes of loss forms.

You usually have to select basic, broad or special coverage for each type of property you insure. More than one causes of loss form may

apply to the same policy—for example, you may have special coverage for buildings and basic or broad coverage for personal property.

The earthquake form is always used in conjunction with one of the other forms, because it simply adds coverage for two additional perils. If you want earthquake coverage for buildings, one of the other causes of loss forms plus the earthquake form would have to be attached to building coverage.

The basic causes of loss form

We'll begin with the basic form, which provides the most limited coverage. However, as you will see, even the basic form includes an impressive list of named perils—fire and lightning, a package of perils which used to be known as "extended coverage," vandalism, sprinkler leakage, sinkhole collapse, and volcanic action.

The form is divided into three major sections: (A) Covered Causes of Loss, (B) Exclusions, and (C) a brief Limitation.

> **A. COVERED CAUSE OF LOSS**
> When Basic is shown in the Declarations, Covered Causes of Loss means the following:
> 1. Fire.
> 2. Lightning.

Fire and lightning fall under the basic form

These two perils are self-explanatory—basic coverage will pay for losses caused by fire and/or lightning. Early fire insurance policies only covered fire losses, but that created a problem when a lightning bolt caused damage and started a fire. For that reason, fire insurance policies were modified long ago to cover losses by "fire and lightning," and to treat these two causes of loss almost as if they were a single peril. Today, virtually all property insurance policies that cover fire losses also cover lightning, including damage caused by the direct explosive force of a lightning bolt and any resulting fire.

"Fire" is combustion accompanied by a visible light—a flame, glow or incandescence. Heat or smoke in the absence of such light is not considered to be fire. A "friendly fire" is intentionally set and remains within its container or intended limits. A "hostile fire" or "unfriendly fire" is one that escapes its intended limits or is not started intentionally. A fire in a fireplace is "friendly," but when a spark from it ignites nearby curtains, a hostile fire has started.

In the 1994 federal appeals court decision *J.R. Maffei et al. vs. Northern Insurance Company of New York et al.*, this definition of *hostile fire* was the key issue.

Maffei owned and operated a warehouse facility in Berkeley, California. Outside his warehouse, he stored 39 drums of various chemicals used in the manufacture of dry-cleaning products. Around 6:00 p.m. on September 16, 1989, neighbors noticed a thick whitish-yellow vapor

cloud of smoke emanating from the vicinity of the drums.

The fire department was summoned, and immediately began spraying the drum with water. This produced an explosion of some sort and a much larger thick dense cloud of whitish-yellow smoke. By 10:00 p.m., the cloud had begun to shrink, but the drum was still too hot to touch.

Fire officials retrieved a piece of "molten metal-like material" that appeared to have been ejected from the drum. Experts were unable to examine the drum until 5:30 a.m., because it remained too hot to touch. The lid and walls of the drum were bulged outward. The bottom of the drum was "extremely corroded" and rusted through.

Three lawsuits involving over 40 plaintiffs were filed in state court to recover damages for injuries suffered as a result of exposure to the sulfur dioxide cloud. Maffei tendered the lawsuits to the insurance companies for defense and indemnity.

Northern refused to defend Maffei, claiming that no hostile fire had occurred—therefore the pollution exclusion applied.

Maffei sued Northern for breach of contract, bad faith, and declaratory relief. He argued that a hostile fire had occurred, within the meaning of his commercial package policies, which covered such fires but excluded other pollution claims.

Experts debate about whether a fire occurred

Maffei submitted a declaration of a thermal engineering expert concluding that there had been a fire. The expert testified that sodium hydrosulfite, when exposed to small amounts of moisture, decomposes into flammable sulfur compounds. The heat generated by the decomposition can ignite those compounds and produce emissions of sulfur dioxide gas and smoke. Sodium hydrosulfite is a flammable solid subject to spontaneous combustion.

This expert concluded:

> The composite definition of "fire" is satisfied in all respects by the physical evidence. There was a chemical reaction between a fuel and oxidizer which released heat. Also, a "flame" or cloud of gases was generated. The outer surface of the metal drum was too hot to touch.

Maffei also submitted a declaration of an insurance expert who had experience in the drafting, teaching, and interpretation of commercial general liability and fire clauses. This expert stated that the vapor cloud "constituted a hostile fire" as defined by the policy.

The trial court granted Northern's motion to dismiss Maffei's claim. Maffei appealed.

The appeals court ruled:

> Expert's declaration stating that fire occurred in drum on [Maffei's] property, resulting in discharge of sulphur dioxide, was improp-

erly excluded by district court in ruling on [Northern's] motion for summary judgment in [Maffei's] action for coverage under policies that covered "hostile fires" but excluded other pollution claims....

The specific circumstances of how the fire started had gone unwitnessed. Therefore, scientific deductions from circumstantial evidence were allowable.

The appeals court went on to rule:

> Under California law, if a fire occurred in drum of sodium hydrosulphite on [Maffei's] premises, resulting in discharge of sulphur dioxide, it would fall within definition of "hostile fire," within meaning of policies covering such fires, but excluding other pollution claims, even though fire was contained within drum.

The important thing was that the fire was unintended—and had spread to an unintended location. This made it hostile.

The appeals court concluded:

> The policies covered bodily injury and property damage caused by heat, smoke or fumes from a hostile fire. "Hostile fire" is defined by the policy as one that "becomes uncontrollable or breaks out from where it was intended to be." Beyond that, "fire" is not defined by the policies.

The appeals court reversed the trial court decision and sent the case back to trial with instructions more favorable to Maffei.

Only "hostile fires" are covered by fire insurance. Note that the vandalism coverage does not apply to easily broken glass items, such as windows and signs. Only glass building blocks are covered.

Before moving on, we should point out that generally property insurance will pay for a loss when an insured peril is the proximate cause of the loss.

Proximate cause and concurrent causation are pivotal issues

"Proximate cause" exists when there is an uninterrupted chain of events between the initial cause of the loss and resulting damage. Under the doctrine of *concurrent causation*, if a loss is caused by one peril that is covered and another that isn't, the loss is covered.

Example: If firefighters need to break down a door to enter a burning building, and cause additional water damage while putting out the fire, the broken door and the water damage would be covered as part of the fire loss (since it was the "proximate cause" of such losses).

> 3. Explosion, including the explosion of gases or fuel within the furnace of any fired vessel or within the flues or passages through which the gases of combustion pass. This cause of loss does not include loss or damage by:
> a. Rupture, bursting or operation of pressure relief devices; or
> b. Rupture or bursting due to expansion or swelling of the contents of any building or structure, caused by or resulting from water.

Insured peril as proximate cause

Coverage for explosion generally applies to losses caused by fuel, gases or dust that ignite. It does not apply to losses resulting from the sudden rupture or bursting of devices caused by pressure, water or steam (separate boiler and machinery coverage is available for this exposure).

> 4. Windstorm or Hail, but not including:
> a. Frost or cold weather;
> b. Ice (other than hail), snow or sleet, whether driven by wind or not: or
> c. Loss or damage to the interior of any building or structure, or the property inside the building or structure, caused by rain, snow, sand or dust, whether driven by wind or not, unless the building or structure first sustains wind or hail damage to its roof or walls through which the rain, snow, sand or dust enters.

Coverage is provided for damage caused by the direct force or impact of wind or hail. Interior damage to the building and/or its contents is not covered unless wind or hail first create an opening in the walls or roof (in which case, resulting damage by rain, snow, sand or dust would also be covered).

Example: If you left a window open, there would be no coverage for interior damage caused by wind, hail, rain, snow, sand or dust which entered through the open window.

> 5. Smoke causing sudden and accidental loss or damage. This cause of loss does not include smoke from agricultural smudging or industrial operations.

Smoke damage is covered when it is sudden and accidental, usually as the result of a fire on the premises or at a nearby property. But there is no coverage for smoke originating from agricultural smudging or industrial operations.

> 6. Aircraft or Vehicles, meaning only physical contact of an aircraft, a spacecraft, a self-propelled missile, a vehicle or an object thrown up by a vehicle with the described property or with the building or structure containing the described property. This cause of loss includes loss or damage by objects falling from aircraft.
> We will not pay for loss or damage caused by or resulting from vehicles you own or which are operated in the course of your business.

Damage caused by aircraft, spacecraft, missiles and vehicles, including objects thrown from a vehicle, is covered, but not damage caused by vehicles owned by you or operated by your business.

Example: If a board lying in the road is thrown by the tires of a passing truck against your front door and causes damage, there is coverage. But there would be no coverage if the same damage was caused by one of your trucks.

INSURING THE BOTTOM LINE

> 7. Riot or Civil Commotion, including:
> a. Acts of striking employees while occupying the described premises; and
> b. Looting occurring at the time and place of a riot or civil commotion.
> 8. Vandalism, meaning willful and malicious damage to, or destruction of, the described property.
> We will not pay for loss or damage:
> a. To glass (other than glass building blocks) that is part of a building, structure, or an outside sign; but we will pay for loss or damage to other property caused by or resulting from breakage of glass by vandals.
> b. Caused by or resulting from theft, except for building damage caused by the breaking in or exiting of burglars.

How riots and other civil disturbances affect coverage

Coverage is provided for damage caused by riot, civil commotion, and vandalism and malicious mischief. Under vandalism there is no coverage for damage to glass parts of a building, but resulting damage is covered.

While damage caused by burglars breaking in or exiting is covered, the form states that it does not cover other losses "caused by or resulting from theft"—this makes it clear that vandalism coverage is not coverage for theft of property.

Example: If a rock is thrown through a store window and there is damage to clothing on display, there would be no coverage for the window but there would be coverage for the damaged clothing.

A general note: Though some coverage for broken glass and losses caused by broken glass is offered by standard forms, this coverage is limited. More extensive coverage is provided by endorsement—which costs extra.

Vandalism coverage does not apply to theft losses. However, building damage caused by burglars entering or leaving is covered.

> 9. Sprinkler Leakage, meaning leakage or discharge of any substance from an Automatic Sprinkler System, including collapse of a tank that is part of the system.
> If the building or structure containing the Automatic Sprinkler System is Coverage Property, we will also pay the cost to:
> a. Repair or replace damaged parts of the Automatic Sprinkler System if the damage:
> (1) Results in sprinkler leakage; or
> (2) Is directly caused by freezing.
> b. Tear out and replace any part of the building or structure to repair damage to the Automatic Sprinkler System that has resulted in sprinkler leakage.
> Automatic Sprinkler System means:
> (1) Any automatic fire protective or extinguishing system, including connected:
> (a) Sprinklers and discharge nozzles;

> (b) Ducts, pipes, valves and fittings;
> (c) Tanks, their component parts and supports; and
> (d) Pumps and private fire protection mains.
> (2) When supplied from an automatic fire protective system:
> (a) Non-automatic fire protective system; and
> (b) Hydrants, standpipes and outlets.

An unexpected complexity: indoor sprinkler systems

Damage caused by the leakage or discharge of "any substance" (water, fire retardant chemicals such as halon, etc.) from an automatic fire protective sprinkler system is covered. Under earlier policy forms, this was an optional additional coverage. But in recognition of the fact that the benefits of sprinkler systems in preventing or reducing fire losses outweigh the risks of occasional accidental sprinkler leakage damage, this is now included in basic coverage.

"Automatic sprinkler system" means any automatic fire protective or extinguishing system, including connected sprinklers and discharge nozzles, ducts, pipes, valves and fittings, tanks and their component parts and supports, pumps and private fire protection mains. When supplied by an automatic fire protective system, hydrants, standpipes, outlets, and other non-automatic fire protective systems are considered to be part of the automatic system.

Sprinkler leakage coverage protects covered property from sprinkler leaks. If "covered property" includes the building or structure containing the automatic sprinkler system, the insurance company will pay the cost of repairing or replacing any damaged parts of the sprinkler system when damage is caused by freezing or results in leakage. The insurance company will pay the cost of tearing out and replacing any part of the building to repair damage to a sprinkler system that has leaked.

> 10. Sinkhole Collapse, meaning loss or damage caused by the sudden sinking or collapse of land into underground empty spaces created by the action of water on limestone or dolomite. This cause of loss does not include:
> a. The cost of filling sinkholes; or
> b. Sinking or collapse of land into man-made underground cavities.

Coverage is provided for damage caused by sinkhole collapse, which means land sinking into natural underground cavities. There is no coverage for filling sinkholes, or for collapse into any man-made cavities.

> 11. Volcanic Action, meaning direct loss or damage resulting from the eruption of a volcano when the loss or damage is caused by:
> a. Airborne volcanic blast or airborne shock waves;
> b. Ash, dust or particulate matter; or
> c. Lava flow.

INSURING THE BOTTOM LINE

All volcanic eruptions that occur within any 168-hour period will constitute a single occurrence. This prevents you from making multiple claims from a single eruption.

This cause of loss does not include the cost to remove ash, dust or particulate matter that does not cause direct physical loss or damage to the described property.

Volcanic "action" means loss caused by the airborne blast or shock waves, and by ash, dust or lava, from a volcanic eruption. There is no coverage under this peril for earth movement or damage caused by land shock waves resulting from a volcano (such coverage is available under the earthquake causes of loss form, which appears later in this chapter).

The three major groups of coverage exclusions

> **EXCLUSIONS**
> 1. We will not pay for loss or damage caused directly or indirectly by any of the following. Such loss or damage is excluded regardless of any other cause or event that contributes concurrently or in any sequence to the loss.

The first set of exclusions is identical on the basic, broad and special forms. Many exclusions are intended to eliminate coverage for catastrophic losses that, if included in the policy, could bankrupt the insurance company.

These exclusions are separated into three groups. The first group applies to certain causes of loss regardless of whether any other cause or event contributes to the loss (although exceptions are made for some resulting losses).

> a. Ordinance or Law
> The enforcement of any ordinance or law:
> (1) Regulating the construction, use or repair of any property; or
> (2) Requiring the tearing down of any property, including the cost of removing its debris.

There is no coverage for loss resulting from the enforcement of any ordinance or law regulating construction or repair of property, or requiring demolition of property.

No coverage for bringing a building up to code

Loss by ordinance or law is excluded because property coverage is not intended to cover additional costs that might result from building codes or regulations.

Example: If an older building is damaged, a newer law regulating construction may require replacement with additional features designed to reduce fire or earthquake losses. This additional cost would not be covered.

Ordinance or law coverage may be purchased and added by endorsement.

Insurers will fight any attempt on the part of a policyholder to rebuild to stricter code, since this leaves the policyholder in a better position than he or she was before the loss. A number of high-profile lawsuits on the issue were waged in the early 1990s. Insurance companies usually prevailed.

> b. Earth Movement
> (1) Any earth movement (other than sinkhole collapse), such as an earthquake, landslide, mine subsidence or earth sinking, rising or shifting. But if loss or damage by fire or explosion results, we will pay for that resulting loss or damage.
> (2) Volcanic eruption, explosion or effusion. But if loss or damage by fire or volcanic action results, we will pay for that resulting loss or damage.

Losses caused by earth movement (other than sinkhole collapse) or volcanic eruption (other than volcanic action) are not covered, but any resulting loss by fire or explosion is covered.

> c. Governmental Action
> Seizure or destruction of property by order of governmental authority. But we will pay for acts of destruction ordered by governmental authority and taken at the time of a fire to prevent its spread, if the fire would be covered under this Coverage Part.

Any loss resulting from the seizure or destruction of property by a government authority is not covered, except acts taken at the time of a fire to prevent its spread.

Example: If an entire neighborhood is burning and authorities order demolition of your building to stop the spread of the fire, the loss would be covered.

Seizure or destruction of your property by government agents is not covered

Otherwise, if a government seizes or destroys property, any claim should be made against the government and not against your insurance company.

> d. Nuclear Hazard
> Nuclear reaction or radiation, or radioactive contamination, however caused.
> But if loss or damage by fire results, we will pay for that resulting loss or damage.

There is no coverage for loss caused by any nuclear hazard or contamination, but any resulting fire loss would be covered.

> e. Off-Premises Services
> The failure of power or other utility service supplied to the described premises, however caused, if the failure occurs away from the described premises.

> But if loss or damage by a Covered Cause of Loss results, we will pay for that resulting loss or damage.

Losses caused by off-premises power failure are excluded, but resulting losses by any covered cause of loss are covered.

Example: If a power failure causes meat in a freezer to spoil, there is no coverage for the loss. However, if the same power failure prevented a cooling system from operating and resulted in a fire, the resulting loss would be covered.

> f. War and Military Action
> (1) War, including undeclared or civil war;
> (2) Warlike action by a military force, including action in hindering or defending against an actual or expected attack, by any government, sovereign or other authority using military personnel or other agents; or
> (3) Insurrection, rebellion, revolution, usurped power, or action taken by governmental authority in hindering or defending against any of these.

Losses caused by war or military action are excluded without exception. War risks include declared and undeclared war, civil war, military attack, insurrection, rebellion, revolution, terrorist attack or action taken by any governmental or sovereign authority in hindering or defending against any of these (including expected attack).

This cause of loss is so catastrophic that no coverage is granted for any resulting losses.

Water is a catastrophic cause of loss

> g. Water
> (1) Flood, surface water, waves, tides, tidal waves, overflow of any body of water, or their spray, all whether driven by wind or not;
> (2) Mudslide or mudflow;
> (3) Water that backs up from a sewer or drain; or
> (4) Water under the ground surface pressing on, or flowing or seeping through:
> (a) Foundations, walls, floors or paved surfaces;
> (b) Basements, whether paved or not; or
> (c) Doors, windows or other openings.
> But if loss or damage by fire, explosion or sprinkler leakage results, we will pay for that resulting loss or damage.

The water exclusion applies primarily to flood losses. This exclusion also eliminates coverage for damage caused by underground water that backs up through sewers or drains or seeps through foundations or basements. Coverage for flood, waves, overflow, and mudslide may be obtained under a separate flood policy.

> 2. We will not pay for loss or damage caused by or resulting from;

Chapter One, Part Two: Commercial Property Causes of Loss

When covered causes and excluded causes intersect

The second group of exclusions eliminates coverage for things which are the primary or proximate cause of a loss. This set of exclusions is less restrictive than the first. The statement "regardless of whether any other cause contributes concurrently or in sequence to the loss" does not appear. Exceptions are often made to these exclusions—which means coverage is available—if the excluded cause of loss is triggered by a covered cause of loss.

> a. Artificially generated electrical current, including electric arcing, that disturbs electrical devices, appliances or wires.
> But if loss or damage by fire results, we will pay for that resulting loss or damage.
> b. Rupture or bursting of water pipes (other than Automatic Sprinkler Systems) unless caused by a Covered Cause of Loss.
> c. Leakage or discharge of water or steam resulting from the breaking or cracking of any part of a system or appliance containing water or steam (other than an Automatic Sprinkler System), unless the system or appliance is damaged by a Covered Cause of Loss.

Boiler and machinery coverage is a separate kind of insurance

> d. Explosion of steam boilers, steam pipes, steam engines or steam turbines owned or leased by you, or operated under your control.
> But if loss or damage by fire or combustion explosion results, we will pay for that resulting loss or damage.
> e. Mechanical breakdown, including rupture or busting caused by centrifugal force.
> But if loss or damage by a Covered Cause of Loss results, we will pay for that resulting loss or damage.

Under the basic form, there is no coverage for damage caused by artificially generated current or the bursting of water pipes or discharge of water or steam from any system or appliance (other than an automatic sprinkler system).

The final exclusions in this section refer to losses caused by the explosion of steam boilers, steam pipes, steam engines and turbines, and mechanical breakdown including rupture or bursting by centrifugal force. All of these are boiler and machinery losses and can be covered by a separate coverage form.[1]

> 3. Special Exclusions
> The following provisions apply only to the specified Coverage Forms.

The last group of exclusions applies only to the coverage forms specified. They appear here because for all coverage forms the exclusions are listed in the causes of loss forms.

> a. Business Income (And Extra Expense) Coverage Form, Business Income (Without Extra Expense) Coverage Form, or Extra Expense Coverage Form.
> We will not pay for:

[1] For a more detailed discussion of boiler and machinery insurance, see Chapter 3.

> (1) Any loss caused by or resulting from:
> (a) Damage or destruction of "finished stock", or
> (b) The time required to reproduce "finished stock."
> This exclusion does not apply to Extra Expense.
> (2) Any loss caused by or resulting from direct physical loss or damage to radio or television antennas, including their lead-in wiring, masts or towers.
> (3) Any increase of loss caused by or resulting from:
> (a) Delay in rebuilding, repairing or replacing the property or resuming "operation," due to interference at the location of the rebuilding, repair or replacement by strikers or other person; or
> (b) Suspension, lapse or cancellation of any license, lease or contract. But if the suspension, lapse or cancellation is directly caused by the suspension of "operation," we will cover such loss that affects your Business Income during the "period of restoration."
> (5) Any other consequential loss.

In most cases, business interruption coverage offered by standard property insurance is extremely limited. If you need extended income replacement while your facility is being repaired, you'll have to buy separate, additional insurance.[2]

Losses caused by business shutdown

This exclusion applies only to business income and extra expense coverage forms. These are indirect loss or consequential loss forms, which cover losses of income and additional costs while a business is shut down because of direct damage.

Business income and/or extra expense coverages are designed to cease when repairs are completed and the business operations resume. Therefore, there is no coverage for additional loss due to a delay in resuming operations caused by strikers, or due to suspension, lapse or cancellation of any license, lease or contract (unless caused directly by the suspension of operations).

Some parts of this exclusion address direct damage. There is no coverage for damage or destruction of "finished stock" because that is a direct damage loss (which may be covered under the business and personal property coverage form).

Other portions of the exclusion restrict coverage to the intent of the coverage forms. Generally, these forms are designed to cover consequential losses that result from a suspension of operations caused by a covered cause of loss.

Example: If a building suffers serious fire damage, a business may shut down and lose income while repairs are being made. The loss of income would be covered.

This exclusion also specifies that "any other" consequential loss, beyond what is provided for in the applicable coverage form, is not covered.

[2] For a more detailed discussion of business interruption insurance, see Chapter 2.

Chapter One, Part Two: Commercial Property Causes of Loss

> b. Leasehold Interest Coverage Form
> (1) Paragraph B.1.a., Ordinance or Law; does not apply to insurance under this Coverage Form.
> (2) We will not pay for any loss caused by:
> (a) Your canceling the lease;
> (b) The suspension, lapse or cancellation of any license; or
> (c) Any other consequential loss.

This exclusion applies only to the leasehold interest coverage form. The first part actually gives back some coverage by removing the "ordinance or law" exclusion.

Example: If you lease your building and government agents seize the building from its owner, any resulting loss—the costs of a move, an increase in the rent pay somewhere else, etc.—will be covered.

But there is no coverage for loss caused by you canceling a lease, or by the suspension, lapse or cancellation of any license, or for any other consequential loss beyond what is provided in the coverage form.

> c. Legal Liability Coverage Form
> (1) The following Exclusions do not apply to insurance under this Coverage Form:
> (a) Paragraph B.1.a., Ordinance or Law;
> (b) Paragraph B.1.c., Governmental Action;
> (c) Paragraph B.1.d., Nuclear Hazard;
> (d) Paragraph B.1.e., Power Failure; and
> (e) Paragraph B.1.f., War and Military Action.
> (2) Contractual Liability
> We will not defend any claim or "suit," or pay any damages that you are legally liable to pay, solely by reason of your assumption of liability in a contract or agreement.
> (3) Nuclear Hazard
> We will not defend any claim or "suit," or pay any damages, loss, expense or obligation, resulting from nuclear reaction or radiation, or radioactive contamination, however caused.

Liability details and nuclear threats

A number of the exclusions contained in the basic causes of loss form are not applicable to legal liability coverage, so the first part of this exclusion simply removes some exclusions with respect to legal liability coverage only.

The next paragraph establishes a contractual liability exclusion for legal liability coverage. This means that the insurance company will not pay for losses that you suffer because you intentionally assume someone else's liability. Example: If you offer a performance guarantee in order to get an account, losses you sustain by failing to perform are not covered.

> **LIMITATION**
> We will pay for loss of animals only if they are killed or their destruction is made necessary.

Limited coverage for animals and pets

The basic causes of loss form concludes with a brief limitation. In the building and personal property coverage form, animals are listed as "property not covered," unless the animals are stock held for sale or are owned by others and boarded by you. This limitation specifies that, to the extent that animals are covered, the insurance company will pay for loss of animals only if they are killed or their destruction is necessary.

The broad causes of loss form

This form includes all of the causes of loss covered by the basic form, but adds four additional causes of loss and one additional coverage. The broad form has two fewer exclusions than the basic form, because the additional perils specifically apply to these causes of loss. One exclusion, earth movement, is modified to provide coverage for any resulting breakage of glass. All other provisions, including the special exclusions that apply to specific coverage forms and the limitation for the loss of animals, are identical on the basic and broad forms.

The broad form provides broader coverage than the basic form. This form is divided into four major sections: (A) Covered Causes of Loss, (B) Exclusions, (C) Additional Coverage—Collapse, and (D) the brief Limitation for loss of animals.

Since most of the covered causes of loss and exclusions are the same as those contained in the basic form, which is presented in its entirety in this chapter, we will only review the additional causes of loss and discuss the differences in the exclusions.

> **A. COVERED CAUSES OF LOSS**
> When Broad is shown in the Declarations, Covered Causes of Loss means the following:

Another unexpected complexity: broken glass

The first 11 perils listed on the broad causes of loss form are identical to those contained in the basic form. The additional broad form perils are reviewed here.

> 12. Breakage of Glass that is a part of a building or structure. This cause of loss does not include breakage of neon tubing attached to the building or structure.
> We will not pay more than:
> a. $100 for each plate, pane, multiple plate insulating unit, radiant or solar heating panel, jalousie, louver or shutter; or
> b. $500 in any one occurrence.

The broad form provides a limited amount of coverage for breakage of building glass, other than neon tubes. The insurance company will only pay up to $100 per plate, pane or panel, and up to $500 for any one occurrence.

> 13. Falling Objects.
> But we will not pay for loss or damage to:
> a. Personal property in the open; or
> b. The interior of a building or structure, or property inside a building or structure, unless the roof or an outside wall of the building or structure is first damaged by a falling object.

Internal damage caused by a falling object must occur after related external damage

Coverage is provided for damages caused by falling objects to buildings and contents, but interior damage—and damage to personal property in buildings—is covered only if the falling object first damages the roof or an outside wall. Personal property in the open is not covered.

Under the separate "aircraft" peril, coverage is already provided for damage caused by objects falling off of aircraft, or by spacecraft or a self-propelled missile. The "falling objects" peril applies to many other types of falling objects—for example, something that falls off a taller building, or a limb falling from a tree. If a tree falls on your building and rain subsequently damages furniture inside, that loss would be covered.

> 14. Weight to Snow, Ice or Sleet.
> But we will not pay for loss or damage to:
> a. Gutters and downspouts; or
> b. Personal property outside of buildings or structures.

Damage caused by the weight of snow, ice or sleet is covered, but not damage to gutters and downspouts or personal property out in the open.

> 15. Water Damage, meaning accidental discharge or leakage of water or steam as the direct result of the breaking or cracking of any part of a system or appliance containing water or steam, other than an Automatic Sprinkler System. If the building or structure containing the system or appliance is Covered Property, we will also pay the cost to tear out and replace any part of the building or structure to repair damage to the system or appliance from which the water or steam escapes. We will not pay:
> a. The cost to repair any defect that caused the loss or damage;
> b. For loss or damage caused by or resulting from continuous or repeated seepage or leakage that occurs over a period of 14 days or more; or

> c. For loss or damage caused by or resulting from freezing, unless:
> (1) You do your best to maintain heat in the building or structure; or
> (2) You drain the equipment and shut off the water supply if the heat is not maintained.

Both the basic and broad causes of loss forms include coverage for "sprinkler leakage" from an automatic fire protective sprinkler system. Under the broad form, the "water damage" peril adds coverage for damage caused by the discharge or leaking of water or steam from other types of systems and appliances.

If the building is covered, the cost to tear out and replace part of the building in order to repair the sprinkler system is covered, as well as the cost of repairing the system itself.

Loss caused by continuous or repeated seepage or leakage occurring for a period of 14 days or more is not covered, because this is considered a reasonable period during which you are expected to detect such problems and take action before additional damage occurs. The insurance company will not pay for losses which have become worse due to neglect of the building or premises.

Losses caused by freezing of a system or appliance will not be covered unless you took reasonable steps to either maintain heat in the building or drain the system. Once again, certain losses should be anticipated (such as pipes freezing in an unheated building in the winter), and the insurance company will not pay for losses caused by neglect.

In the case of water damage, if the building or structure containing a system or appliance is "covered property," the insurance company will also pay the cost to tear out and replace any part of the building or structure to repair damage to the system or appliance from which water or steam escapes. But it will not pay the cost of repairing or replacing the system or appliance itself. These losses are covered under a boiler and machinery form.[4]

No coverage for earth movement—other than a sinkhole

> **B. EXCLUSIONS**
> b. Earth Movement
> (1) Any earth movement (other than sinkhole collapse), such as an earthquake, landslide, mine subsidence or earth sinking, rising or shifting. But if loss or damage by fire or explosion results, we will pay for that resulting loss or damage.
> (2) Volcanic eruption, explosion or effusion. But if loss or damage by fire, breakage of glass or volcanic action results, we will pay for that resulting loss or damage.

In the first set of exclusions, only the second paragraph of exclusion b. differs on the broad form. In addition to covering resulting losses by fire or volcanic action, the broad form also covers breakage of glass following a volcanic eruption.

[4] For a more detailed discussion of boiler and machinery coverage, see Chapter 3.

Chapter One, Part Two: Commercial Property Causes of Loss

2. We will not pay for loss or damage caused by or resulting from:
a. Artificially generated electrical current, including electric arcing, that disturbs electrical devices, appliances or wires. But if loss or damage by fire results, we will pay for that resulting loss or damage.
b. Explosion of steam boilers, steam pipes, steam engines or steam turbines owned or leased by you, or operated under your control.
But if loss or damage by fire or combustion explosion results, we will pay for that resulting loss or damage.
c. Mechanical breakdown, including rupture or bursting caused by centrifugal force.
But if loss or damage by a Covered Cause of Loss results, we will pay for that resulting loss or damage.

These exclusions are identical to exclusions found on the basic form, but in this section we find only three exclusions instead of five.

The broad form drops two of the basic form exclusions. It does not exclude "rupture or bursting of water pipes" or "leakage or discharge of water or steam resulting from breaking or cracking" of a system or appliance. These two exclusions are eliminated because the broad form specifically covers water damage involving the breaking or cracking of any part of a system or appliance containing water or steam.

All remaining exclusions on the broad form are the same as basic form exclusions.

The meaning of "collapse" requires its own section

C. ADDITIONAL COVERAGE—COLLAPSE
We will pay for loss or damage caused by or resulting from risks of direct physical loss involving collapse of a building or any part of a building caused only by one or more of the following:
1. Fire; lightning; explosion; windstorm or hail; smoke; aircraft or vehicles; riot or civil commotion; vandalism; leakage from fire extinguishing equipment; sinkhole collapse; volcanic action; breakage of building glass; falling objects; weight of snow, ice or sleet; water damage; all only as insured against in this Coverage Part;
2. Hidden decay;
3. Hidden insect or vermin damage;
4. Weight of people or personal property;
5. Weight of rain that collects on a roof;
6. Use of the defective material or methods in construction, remodeling or renovation if the collapse occurs during the course of the construction, remodeling or renovation.
We will not pay for loss or damage to the following types of property, if otherwise covered in this Coverage Part, under items 2., 3., 4., 5. and 6. unless the loss or damage is a direct result of the collapse of a building:
outdoor radio or television antennas, including their lead-in wiring, masts or towers; awnings; gutters and downspouts; yard fixtures; outdoor swimming pools; fences; piers, wharves and docks; beach or diving

> platforms or appurtenances; retaining wall; walks, roadways and other paved surfaces.
> Collapse does not include settling, cracking, shrinkage, bulging or expansion.
> This Additional Coverage will not increase the Limits of Insurance provided in this Coverage Part.

In addition to listing perils, the broad form adds an additional coverage, which does not increase the limits of insurance provided by the coverage part. The insurance company agrees to pay for loss or damage caused by or resulting from direct physical loss involving collapse of a building or part of a building.

"Collapse" does not include settling, cracking, shrinkage, bulging or expansion.

The collapse coverage is slightly broader than other broad form coverage, because it applies to collapse caused by any of the 15 broad form perils or any of the following five additional perils:

- hidden decay,
- hidden insect or vermin damage,
- weight of people or personal property,
- weight of rain that collects on a roof,
- use of defective materials or methods in construction, remodeling or renovation, if the collapse occurs during the course of the construction, remodeling or renovation.

Some external items are only covered if destroyed by pieces of the building

With respect to the five additional perils, the insurance company will pay for loss or damage to the following items only if the loss is a direct result of the collapse of a building: outdoor antennas and their lead-in wires, masts, towers, awnings, gutters and downspouts, yard fixtures, outdoor swimming pools, fences, piers, wharves, docks, diving platforms, retaining walls, walks, roadways and other paved surfaces.

Example: Loss of a building which collapses due to hidden decay or insect damage would be covered. Loss of a television antenna or outdoor swimming pool which collapses due to hidden decay or insect damage would not be covered (these items are covered only if the damage is caused by part of a building that collapses).

The wording of this additional coverage is designed to eliminate a problem known as concurrent causation—a term used to refer to a situation where two or more perils occur at the same time or in sequence to cause a loss. The issue arose when insurance companies were challenged to pay earthquake losses under collapse coverage. Many property insurance forms used to list "collapse" as a peril insured against. At the same time, the forms excluded losses caused by earth movement and earthquake coverage was not automatically included. But when claims were filed under collapse coverage, some

courts held for the policyholders, on the grounds that losses due to building collapse were suffered regardless of whether an earthquake was a concurrent or contributing cause.

Since the insurance companies never intended to automatically provide earthquake coverage, the policy forms were modified to clarify intent. Collapse coverage was set aside as an "additional coverage" that applies only to losses caused by specified perils (which do not include earth movement).

The special form

The Causes of Loss—Special Form provides the very broadest coverage of all. It covers all risks that are not excluded. On the special form, exclusions and limitations are particularly important because there are no named perils and it is the exclusions and limitations that shape the coverage. It is important to remember that all causes of loss forms contain exclusions.

The special form offers the broadest coverage

Unlike the other causes of loss forms, this is not a named perils form—it covers risks of direct physical loss which are not otherwise excluded or limited by the form. The special form does not list any covered causes of loss and, because of the nature of the coverage, it contains many more exclusions and limitations. Since there are no stated perils to describe or define the coverage, a number of definitions and exceptions are intermingled with the exclusions and limitations. This form also has a separate definitions section which attempts to clarify the coverage.

In addition to providing special causes of loss coverage, this form contains the same additional coverage for collapse as the broad form, and adds two additional coverage extensions. The special form is divided into six major sections: (A) Covered Causes of Loss, (B) Exclusions, (C) Limitations, (D) Additional Coverage—Collapse, (E) Additional Coverage Extensions and (F) Definitions.

The special causes of loss form does include provisions which are not found on the other forms. While some special form exclusions are the same as basic and broad form exclusions, and the intent of some coverages is virtually identical, in many cases the same policy provisions have been rearranged.

Direct loss caused by a specific peril does not necessarily mean that the peril was the only factor damaging insured property. When a specific peril is the "proximate cause" of a loss, courts have held that the peril in question caused the loss. For example, loss from water damage, chemicals, firefighters breaking down a door, or smoke may be a direct loss caused by fire if an uninterrupted chain of events existed between the fire and the loss.

INSURING THE BOTTOM LINE

The "all risk" format means no perils are listed

> **A. COVERED CAUSES OF LOSS**
> When Special is shown in the Declarations, Covered Causes of Loss means RISKS OF DIRECT PHYSICAL LOSS unless the loss is:
> 1. Excluded in Section B., Exclusions; or
> 2. Limited in Section C., Limitations;
> that follow.

Although the special form includes a "covered causes of loss" section, it does not list any perils. Instead, it simply states that it covers risks of direct physical loss unless excluded or limited by other sections that follow.

At one time, special coverage forms referred to "all risks of loss" and were known as "all risk" coverage forms. Insurance companies have since dropped the word "all" from insuring agreements and descriptions of covered causes of loss, because these forms always contained exclusions and the concept of "all risks" was misleading.

> **B. EXCLUSIONS**
> 1. We will not pay for loss or damage caused directly or indirectly by any of the following. Such loss or damage is excluded regardless of any other cause or event that contributes concurrently or in any sequence to the loss.
> a. Ordinance or Law
> The enforcement of any ordinance or law:
> (1) Regulating the construction, use or repair of any property; or
> (2) Requiring the tearing down of any property, including the cost of removing its debris.
> b. Earth Movement
> (1) Any earth movement (other than sinkhole collapse), such as an earthquake, landslide, mine subsidence or earth sinking, rising or shifting. But if loss or damage by fire or explosion results, we will pay for that resulting loss or damage.
> (2) Volcanic eruption, explosion or effusion. But if loss or damage by fire, building glass breakage or volcanic action results, we will pay for that resulting loss or damage.
> Volcanic action means direct loss or damage resulting from the eruption of a volcano when the loss or damage is caused by:
> (a) Airborne volcanic blast or airborne shock waves;
> (b) Ash, dust or particulate matter; or
> (c) Lava flow.
> All volcanic eruptions that occur within any 168 hour period will constitute a single occurrence.
> Volcanic action does not include the cost to remove ash, dust or particulate matter that does not cause direct physical loss or damage to the described property.

These first two exclusions are virtually identical on the basic, broad and special forms. The only difference is that "volcanic action" is a

Chapter One, Part Two: Commercial Property Causes of Loss

specified peril on the basic and broad forms and it is defined in the causes of loss section. Since the special form does not specify perils, the same definition has simply been added to the earth movement exclusion.

The special form—like the broad form—covers glass breakage

Although all forms exclude direct loss by volcanic eruption, the special form (like the broad form) will cover resulting glass breakage in addition to damage by fire or volcanic action.

> c. Governmental Action
> Seizure or destruction of property by order of governmental authority. But we will pay for acts of destruction ordered by governmental authority and taken at the time of a fire to prevent its spread, if the fire would be covered under this Coverage Part.
> d. Nuclear Hazard
> Nuclear reaction or radiation, or radioactive contamination, however caused.
> But if loss or damage by fire results, we will pay for that resulting loss or damage.
> e. Off-Premises Services
> The failure of power or other utility service supplied to the described premises, however caused, if the failure occurs away from the described premises.
> But if loss or damage by a Covered Cause of Loss results, we will pay for that resulting loss or damage.
> f. War and Military Action
> (1) War, including undeclared or civil war;
> (2) Warlike action by a military force, including action in hindering or defending against an actual or expected attack, by any government, sovereign or other authority using military personnel or other agents; or
> (3) Insurrection, rebellion, revolution, usurped power, or action taken by governmental authority in hindering or defending against any of these.
> g. Water
> (1) Flood, surface water, waves, tides, tidal waves, overflow of any body of water, or their spray, all whether driven by wind or not;
> (2) Mudslide or mudflow;
> (3) Water that backs up from a sewer or drain; or
> (4) Water under the ground surface pressing on, or flowing or seeping through;
> (a) Foundations, walls, floors or paved surfaces;
> (b) Basements, whether paved or not; or
> (c) Doors, windows or other openings.
> But if loss or damage by fire, explosion or sprinkle leakage results, we will pay for that resulting loss or damage.

The remaining exclusions in this first group of exclusions (items c. through g.) are identical on the basic, broad and special forms. Refer to our review of the basic form if you wish to examine our comments.

2. We will not pay for loss or damage caused by or resulting from any of the following:

a. Artificially generated electric current, including electric arcing, that disturbs electrical devices, appliances or wires.
But if loss or damage by fire results, we will pay for that resulting loss or damage.

b. Delay, loss of use or loss of markets.

c. Smoke, vapor or gas from agricultural smudging or industrial operations.

d. (1) Wear and tear;
(2) Rust, corrosion, fungus, decay, deterioration, hidden or latent defect or any qualify in property that causes it to damage or destroy itself;
(3) Smog;
(4) Settling, cracking, shrinking or expansion;
(5) Insects, birds, rodents or other animals;
(6) Mechanical breakdown, including rupture or bursting caused by centrifugal force. However, this does not apply to any resulting loss or damage caused by elevator collision;
(7) The following causes of loss to personal property:
(a) Dampness or dryness of atmosphere;
(b) Changes in or extremes of temperature; or
(c) Marring or scratching.
But if loss or damage by the "specified causes of loss" or building glass breakage results, we will pay for that resulting loss or damage.

e. Explosion of steam boilers, steam pipes, steam engines or steam turbines owned or leased by you, or operated under your control. But if loss or damage by fire or combustion explosion results, we will pay for that resulting loss or damage. We will also pay for loss or damage caused by or resulting from the explosion of gases or fuel within the furnace of any fired vessel or within the flues or passages through which the gases of combustion pass.

Within items a. through e. of the second group of exclusions we find three exclusions that also appeared on the broad form—artificial current (a.), mechanical breakdown (d.6) and explosion of steam boilers (e). A number of other statements have been moved from the covered causes of loss section of the other forms.

Smoke from agricultural or industrial operations is not covered

Under the basic form, where smoke is a covered peril, coverage does not apply to smoke from agricultural smudging or industrial operations—here this is stated as an exclusion (c.).

Where explosion is a covered peril on the basic form, it is explained that it includes explosion of gas or fuel within a furnace or fired vessel—here this is stated as an exception to the steam boiler exclusion (e.).

Because the special form covers losses which are not excluded, we also find a number of additional exclusions that apply to loss or damage caused by such things as smog, wear and tear, rust, corrosion,

loss of use, delay or loss of market, insects, birds, rodents or other animals, dampness, dryness, changes in temperature, marring or scratching. Many of these types of losses occur gradually over time and are expected. In some cases, steps may be taken to prevent or reduce such damage.

Generally, property insurance is designed to cover unexpected and accidental losses—not the costs of maintenance and normal wear and tear.

> f. Continuous or repeated seepage or leakage of water that occurs over a period of 14 days or more.
> g. Water, other liquids, powder or molten material that leaks or flows from plumbing, heating, air conditioning or other equipment (except fire protective systems) caused by or resulting from freezing, unless:
> (1) You do your best to maintain heat in the building or structure; or
> (2) You drain the equipment and shut off the supply if the heat is not maintained.
> h. Dishonest or criminal act by you, any of your partners, employees, directors, trustees, authorized representatives or anyone to whom you entrust the property for any purpose:
> (1) Acting alone or in collusion with others; or
> (2) Whether or not occurring during the hours of employment.
> This exclusion does not apply to acts of destruction by your employees; but theft by employees is not covered.
> i. Voluntary parting with any property by you or anyone else to whom you have entrusted the property if induced to do so by any fraudulent scheme, trick, device or false pretense.

No insurance for water damage caused by leaks more than 2 weeks old

Coverage for water damage under the special form is similar to coverage under the broad form, but it is not stated as a peril. We find two exclusions (items f. and g.) that impose the same limitation on continuous or repeated seepage over 14 days, and the same requirement to maintain heat or drain systems in order to have coverage for losses caused by freezing. These are reasonable requirements. The insurance company will not pay for losses that result from your neglect or carelessness.

Example: There is no coverage for water damage caused by leakage over a period of more than 14 days because the problem should have been discovered and acted upon during that time.

The special form is the only causes of loss form that includes some coverage for theft losses, but coverage applies only to losses caused by others.

The next two exclusions (items h. and i.) eliminate coverage for losses caused by dishonest acts you—or a partner or employee—might commit, or by voluntary parting with property. These losses are best covered by separate crime forms.[5]

[5] For a more detailed discussion of coverage for these kinds of losses, see Chapter 6.

> j. Rain, snow, ice or sleet to personal property in the open.
> k. Collapse, except as provided below in the Additional Coverage for Collapse. But if loss or damage by a Covered Cause of Loss results at the described premises, we will pay for that resulting loss or damage.
> l. Discharge, dispersal, seepage, migration, release or escape of "pollutants" unless the discharge, dispersal, seepage, migration, release for escape is itself caused by any of the "specified causes of loss." But if loss or damage by the "specified causes of loss" results, we will pay for the resulting damage caused by the "specified causes of loss."

Losses to personal property out in the open caused by the elements of rain, snow or sleet are not covered.

Losses due to collapse, except as provided in the additional coverage for collapse, are not covered. This wording appears to protect the insurance company from being forced into providing broader coverage than intended (the collapse coverage is actually the same as it is on the broad form).

More on the matter of "proximate cause"

The last exclusion in this section (item l.) removes coverage for loss caused by the release or escape of pollutants, unless caused by one of the "specified causes of loss" (this is defined later, but essentially means the broad form perils). The purpose of this exclusion is to "lock in" coverage for this type of loss only when an intended covered cause of loss is the "proximate cause" of the loss. Since the special form does not list covered causes of loss, it is necessary to specify certain perils to eliminate unintended loopholes in the contract.

Example: If a fire on your premises caused a barrel of dye to rupture and the dye caused additional damage, the additional loss would be covered because fire (a specified cause of loss) was the proximate cause of the loss. But if the same barrel of dye was leaking due to corrosion (not a specified cause of loss), there would be no coverage for resulting damage.

> 3. We will not pay for loss or damage caused by or resulting from any of the following. But if loss or damage by a Covered Cause of Loss results, we will pay for that resulting loss or damage.
> a. Weather conditions. But this exclusion only applies if weather conditions contribute in any way with a cause or event excluded in paragraph 1. above to produce the loss or damage.
> b. Acts or decisions, including the failure to act or decide, of any person, group, organization or governmental body.
> c. Faulty, inadequate or defective:
> (1) Planning, zoning, development, surveying, siting;
> (2) Design, specifications, workmanship, repair, construction, renovation, remodeling, grading, compaction;
> (3) Materials used in repair, construction, renovation or remodeling; or
> (4) Maintenance;
> of part or all of any property on or off the described premises.

Because the special form provides extremely broad coverage, this next group of exclusions is designed to close the door on some possible additional loopholes in the contract.

There is no coverage for losses caused by weather conditions, if weather conditions contribute to a cause of loss which is specifically excluded by the first group of exclusions.

Example: Losses caused by off-premises power failures aren't covered by your policy. You submit a claim for loss due to power failure but argue that the power failure was the result of weather conditions. You argue that the loss—therefore—should be covered. In effect, you would be trying to substitute one cause of loss for another. There would be no coverage.

This group of exclusions also eliminates coverage for losses resulting from acts or decisions of any individual or government body, and faulty planning, design, materials or maintenance. Example: If your building collapses as a result of faulty architectural design, the policy will not cover this loss.

Coverage is intended to apply to unpredictable, fortuitous and accidental causes of loss (such as fire, explosion, wind or hail)—not to losses caused by the actions or errors and omissions committed by individuals or government entities. However, you may have a legitimate case for liability claims against such individuals or entities when such losses occur.

> 4. Special Exclusions
> The following provisions apply only to the specified Coverage Forms.

The last group of exclusions applies only to the coverage forms which are specified (business income, extra expense, leasehold interest, and legal liability coverages). These are identical on the basic, broad and special forms. Refer to our review of the basic form if you wish to examine these exclusions and our comments about them in detail.

> **C. LIMITATIONS**
> 1. We will not pay for loss of or damage to:
> a. Steam boilers, steam pipes, steam engines or steam turbines caused by or resulting from any condition or event inside such equipment. But we will pay for loss of or damage to such equipment caused by or resulting from an explosion of gases or fuel within the furnace of any fired vessel or within the flues or passages through which the gases of combustion pass.
> b. Hot water boilers or other water heating equipment caused by or resulting from any condition or event inside such boilers or equipment, other than an explosion.
> c. The interior of any building or structure, or to personal property in the building or structure, caused by or resulting from rain, snow sleet, ice, sand or dust, whether driven by wind or not, unless:

> (1) The building or structure first sustains damage by a Covered Cause of Loss to its roof or walls through which the rain, snow, sleet, ice, sand or dust enters; or
> (2) The loss or damage is caused by or results from thawing of snow, sleet or ice on the building or structure.

Other coverage limitations under the special form

The special form includes a number of "limitations." Unlike the exclusions, this section does not begin by stating that there is no coverage for loss or damage "caused by or resulting from" the following items. Instead, it states that the insurance company will not pay for "loss of or damage to" the following items. These provisions limit coverage for certain types of property, rather than causes of loss.

The first two paragraphs (1.a. and b.) specify that there is no coverage for damage to steam boilers, steam pipes or turbines, hot water boilers and similar items caused by any internal event or condition. Generally, this means pressure explosions or mechanical breakdowns of the type which are covered by boiler and machinery insurance. An exception is made for explosions of gases or fuel within fired vessels (such losses are also covered by the basic and broad forms under the "explosion" peril).

Coverage for damage to building interiors and contents caused by rain, snow, sleet, ice, sand or dust is expanded on the special form, because it applies whenever the building is first damaged by any "covered cause of loss." On the basic and broad forms such interior coverage applies only when the building is first damaged by "wind or hail" only.

> d. building materials and supplies not attached as part of the building or structure, unless held for sale by you, caused by or resulting from theft, except as provided in C.5.a. below.
> e. Property that is missing, where the only evidence of the loss or damage is a shortage disclosed on taking inventory, or other instances where there is no physical evidence to show what happened to the property.
> f. Gutters and downspouts caused by or resulting from weight of snow, ice or sleet.
> g. Property that has been transferred to a person or to a place outside the described premises on the basis of unauthorized instructions.

There is no theft coverage for building materials and supplies not attached to buildings, unless such property is held for sale by you, because the property is easily removed.

Example: Loose building materials—such as 2 x 4's stolen from an insured office building that's being remodeled—would not be covered, but such materials stolen from an insured hardware or building supply store would be covered. (Note: A separate limitation applies when builders risk coverage is written.)

Chapter One, Part Two: Commercial Property Causes of Loss

Some coverage is offered for "mysterious disappearance"

The special form does provide some coverage for mysterious disappearance, which means property which is missing although there is no evidence of a burglary and nobody witnessed the theft. But there is no coverage for missing property when the only evidence of loss is an inventory shortage. Example: A missing computer or other office machine would be covered, because the absence of the item would be immediately apparent.

Damage to gutters and downspouts caused by the weight of snow, ice or sleet is not covered by the special form. The coverage that is provided for these items is similar to what is provided by the broad form, where the same limitation appears as an exception to a covered peril.

The next limitation states that there is no coverage for property that has been transferred outside of the premises on the basis of unauthorized instructions. This is intended to limit the theft coverage to actual theft of property from the premises, and to exclude certain losses (such as those arising from computer fraud) which should be covered by fidelity bonds or crime coverage forms.

> 2. We will not pay more for loss of or damage to glass that is part of a building or structure than $100 for each plate, pane, multiple plate insulating unit, radiant or solar heating panel, jalousie, louver or shutter. We will not pay more than $500 for all loss of or damage to building glass that occurs at any one time.
> This Limitation does not apply to loss or damage by the "specified causes of loss," except vandalism.

Coverage for glass parts of a building is expanded under the special form, because the limitation of $100 per plate and $500 per occurrence applies only to losses by vandalism or unspecified perils. Glass losses caused by any of the remaining specified perils (such as fire or windstorm) are not subject to this limitation.

> 3. We will not pay for loss of or damage to the following types of property unless caused by the "specified causes of loss" or building glass breakage:
> a. Valuable papers and records, such as books of account, manuscripts, abstracts, drawings, card index systems, film, tape, disc, drum, cell or other data processing, recording or storage media, and other records.
> b. Animals, and then only if they are killed or their destruction is made necessary.
> c. Fragile articles such as glassware, statuary, marbles, chinaware and porcelains, if broken. This restriction does not apply to
> (1) Glass that is part of a building or structure;
> (2) Containers of property held for sale; or
> (3) Photographic or scientific instrument lenses.
> d. Builders' machinery, tools, and equipment you own or that are entrusted to you, while away from the premises described in the Declarations, except as provided in paragraph C.5.b. below.

INSURING THE BOTTOM LINE

How the policy handles losses stemming from "specified" causes

This next set of limitations is designed to limit coverage for various types of property to losses resulting from the "specified causes of loss" or building glass breakage (together these are the same as the 15 broad form perils). This includes valuable papers and records, a number of fragile items, and builders machinery or equipment while away from the premises. (Note: A separate limitation applies when builders risk coverage is written.)

In this section we also find the same limitation for loss of animals that appears on the basic and broad forms—animals are covered only if killed or destruction becomes necessary.

> 4. For loss or damage by theft, the following types of property are covered only up to the limits shown:
> a. $2,500 for furs, fur garments and garments trimmed with fur.
> b. $2,500 for jewelry, watches, watch movements, jewels, pearls, precious and semi-precious stones, bullion, gold, silver, platinum and other precious alloys or metals. This limit does not apply to jewelry and watches worth $100 or less per item.
> c. $2,500 for patterns, dies, molds and forms.
> d. $250 for stamps, tickets, including lottery tickets held for sale, and letters of credit.

Limitations that apply to theft losses

While the special form is the only causes of loss form that provides theft coverage, the coverage for various classes of property is limited to specified amounts. Generally, these are items which may have a high value and reflect an above-average exposure to theft losses. A business person with a significant exposure of this type, such as a jeweler or furrier, should purchase separate insurance under crime coverage forms or one of the special inland marine forms designed for such risks.

Note: These limitations apply only to theft losses—loss of jewelry, watches or furs by fire or other accidental peril is not subject to limitation. In any event, valuable items should be listed separately to ensure full coverage.

> 6. We will not pay the cost to repair any defect to a system or appliance from which water, other liquid, powder or molten material escapes. But we will pay the cost to repair or replace damaged parts of fire extinguishing equipment if the damage:
> a. results in discharge of any substance from an automatic fire protection system; or
> b. Is directly caused by freezing.

This final limitation provides coverage similar to the combination of the sprinkler leakage and water damage perils as stated in the broad form. The insurance company will pay the cost to repair or replace damaged parts of fire extinguishing equipment if the damage results in sprinkler leakage or is caused by freezing. However, it will not pay

the cost to repair any other system or appliance from which water, liquid, powder or other material escapes. Again, these losses should be covered by boiler and machinery insurance.

> **D. ADDITIONAL COVERAGE—COLLAPSE**
> We will pay for loss or damage caused by or resulting from risks of direct physical loss involving collapse of a building or any part of a building caused only by one or more of the following:
> 1. The "specified causes of loss" or breakage of building glass, all only as insured against in this Coverage Part;
> 2. Hidden decay;
> 3. Hidden insect or vermin damage;
> 4. Weight of people or personal property;
> 5. Weight of rain that collects on a roof;
> 6. Use of defective material or methods in construction, remodeling or renovation if the collapse occurs during the course of the construction, remodeling or renovation.
> We will not pay for loss or damage to the following types of property, if otherwise covered in this Coverage Part, under items 2., 3., 4., 5. and 6. unless the loss or damage is a direct result of the collapse of a building:
> outdoor radio or television antennas, including their lead-in wiring, masts or towers; awnings, gutters and downspouts; yard fixtures; outdoor swimming pools; fences; piers,
> wharves and docks; beach or diving platforms or appurtenances; retaining walls; walks, roadways and other paved surfaces.
> Collapse does not include settling, cracking, shrinkage, bulging or expansion.
> This Additonal Coverage will not increase the Limits of Insurance provided in this Coverage Part.

The additional coverage for collapse is virtually identical to the same coverage provided by the broad form. Refer to our review of collapse coverage, including our discussion of the issue of "concurrent causation," in the broad form section of this manual for a more complete examination of this topic.

> **E. ADDITIONAL COVERAGE EXTENSIONS**
> 1. Property In Transit. This Extension applies only to your personal property to which this form applies.
> a. You may extend the insurance provided by this Coverage Part to apply to your personal property (other than property in the care, custody or control of your salespersons) in transit more than 100 feet from the described premises. Property must be in or on a motor vehicle you own, lease or operate while between points in the coverage territory.
> b. Loss or damage must be caused by or result from one of the following causes of loss:
> (1) Fire, lightning, explosion, windstorm or hail, riot or civil commotion, or vandalism.

INSURING THE BOTTOM LINE

> (2) Vehicle collision, upset or overturn. Collision means accidental contact of your vehicle with another vehicle or object. It does not mean your vehicle's contact with the road bed.
> (3) Theft of an entire bale, case or package by forced entry into a securely locked body or compartment of the vehicle. There must be visible marks of the forced entry.
> c. The most we will pay for loss or damage under this extension is $1000.
> This Coverage Extension is additional insurance. The Additional Condition, Coinsurance, does not apply to this Extension.

The special form provides two extensions of coverage.

An extension for property in transit

The first extension is for property in transit. This is a limited amount of coverage, up to $1,000 per loss, provided as additional insurance. It applies to your covered personal property while in transit more than 100 feet away from the insured premises while in or on a motor vehicle, but not property in the care, custody or control of salespersons. The coverage applies only to loss by the perils of fire, lightning, explosion, windstorm, hail, riot, civil commotion, vandalism, vehicle collision, upset or overturn, or theft of an entire bale, case or package by forced entry into a securely locked body or compartment on which there are visible marks of forced entry.

> 2. Water Damage, Other Liquids, Powder or Molten Material Damage. If loss or damage caused by or resulting from covered water or other liquid, powder or molten material damage loss occurs, we will also pay the cost to tear out and replace any part of the building or structure to repair damage to the system or appliance from which the water or other substance escapes.

Dealing with water damage and other liquid losses

The second coverage extension applies to water damage or damage by "other liquids, powders, or molten materials." The cost of tearing out and replacing part of the building to repair damage to the system or appliance from which the water or other substance escaped is also covered. This is similar to coverage for water damage under the broad form, although the special form refers to other substances and related provisions (relating to repair of fire extinguishing equipment and losses caused by freezing) are scattered throughout the special form.

> **F. DEFINITIONS**
> "Specified Causes of Loss" means the following: Fire; lightning; explosion; windstorm or hail; smoke; aircraft or vehicles; riot or civil commotion; vandalism; leakage from fire extinguishing equipment; sinkhole collapse; volcanic action; falling objects; weight of snow, ice or sleet; water damage.
> 1. Sinkhole collapse means the sudden sinking or collapse of land into underground empty spaces created by the action of water on limestone or dolomite. This cause of loss does not include:

Chapter One, Part Two: Commercial Property Causes of Loss

> a. The cost of filling sinkholes; or
> b. Sinking or collapse of land into manmade underground cavities.
> 2. Falling objects does not include loss or damage to;
> a. Personal property in the open; or
> b. The interior of a building or structure, or property inside a building or structure, unless the roof or an outside wall of the building or structure is first damaged by a falling object.
> 3. Water damage means accidental discharge or leakage of water or steam as the direct result of the breaking or cracking of any part of a system or appliance containing water or steam.

The special form has a brief definitions section which defines specified perils. The phrase "specified causes of loss" is used repeatedly throughout the form to limit certain areas of coverage to the broad form package of perils (the perils listed plus breakage of building glass are the same as the 15 broad form perils). Additional statements define sinkhole collapse, coverage for falling objects, and water damage. These same statements are found in the causes of loss section of the broad form.

Because it covers all losses which are not excluded, the special form contains additional exclusions eliminating coverage for loss or damage caused by or resulting from:

Additional exclusions that apply to the special form

- smog;
- wear and tear;
- delay, loss of use, or loss of market;
- insects, birds, rodents or other animals;
- release, discharge or dispersal of contaminants or pollutants (unless caused by a "specified" cause of loss);
- settling, cracking, shrinking or expansion;
- rain, snow, ice or sleet damage to personal property in the open;
- smoke, vapor or gas from agricultural smudging or industrial operations (needed because the form does not describe the "smoke peril" which includes this limitation);
- rust, corrosion, fungus, decay, deterioration, hidden or latent defect, or "inherent vice" (any quality in property that causes it to damage itself or self-destruct over time);
- damage to personal property caused by dampness or dryness of atmosphere, changes in or extremes of temperature, marring or scratching;
- dishonest or criminal acts of the named insured, or any of your partners, employees, directors, trustees, authorized representatives, or anyone entrusted with your property

(theft by employees is not covered, but an act of destruction by employees is covered);

- voluntary parting with any property if induced to do so by any fraudulent scheme, trick, device or false pretense;
- collapse, except as provided for in the additional coverage for collapse;
- discharge, dispersal, seepage, migration, release or escape of pollutants, unless caused by one of the "specified causes of loss";
- weather conditions if the weather conditions contribute in any way with a loss caused by building ordinance, earth movement, government action, power failure, or major water risks (flood, etc.);
- acts or decisions, including failure to decide, of any person, group, organization or government body; and
- faulty, inadequate or defective planning, zoning, development, surveying, siting, design, specifications, workmanship, repair, construction, renovation, remodeling, grading, compaction, maintenance, or materials used in repair, construction, renovation, or remodeling.

Many of the additional exclusions found on the special form make exceptions for resulting losses caused by any of the 15 broad form perils, and such additional losses are covered. Most of these exclusions apply to losses which occur with the normal passage of time or should be prevented by the insured.

The earthquake form

How insurance companies deal with earthquakes

The Causes of Loss—Earthquake Form must be used in conjunction with one or more of the other causes of loss forms, because it does not provide a complete package of perils. It is a named peril form used to add optional coverage for two additional causes of loss—earthquake and volcanic eruption.

Since the scope of the coverage being provided is narrowly defined to begin with, this form has fewer exclusions than the other forms. It also includes special provisions for earthquake deductibles, which apply to earthquake losses instead of the standard or optional deductibles that apply to other types of losses. The earthquake form is divided into four major sections: (A) covered causes of loss, (B) exclusions, (C) limitation and (D) deductible.

> **A. COVERED CAUSES OF LOSS**
> When Earthquake is shown in the Declarations, Covered Causes of Loss means the following:
> 1. Earthquake.

> 2. Volcanic Eruption, meaning the eruption, explosion or effusion of a volcano.
> All Earthquake shocks or Volcanic Eruptions that occur within any 168-hour period will constitute a single Earthquake or Volcanic Eruption. The expiration of this policy will not reduce the 168-hour period.

Coverage is provided for two causes of loss—earthquake and volcanic eruption. The other causes of loss forms cover "volcanic action," which means damage by the airborne shock waves or ash, dust or lava flow from a volcano, but under the earth movement exclusion they specifically exclude coverage for damage caused by the land shock waves of a volcanic eruption or explosion. Such coverage is provided by this form.

An important aspect of this coverage is that all earthquake or volcanic shocks occurring within a 168-hour period are considered to be a single event, and this period is not reduced by policy expiration. The reason for this provision is that earth movements are frequently clustered, with strong aftershocks being related to an original shock. If each tremor were treated as a separate event, it might be difficult to determine how much damage was caused by each and to separate the losses for the purpose of applying deductibles.

> **B. EXCLUSIONS**
> 1. We will not pay for loss or damage caused directly or indirectly by any of the following. Such loss or damage is excluded that contributes concurrently or in any sequence to the loss.
> a. Ordinance or Law
> The enforcement of any ordinance or law:
> (1) Regulating the construction, use or repair of any property; or
> (2) Requiring the tearing down of any property, including the cost of removing its debris.
> b. Governmental Action
> Seizure or destruction of property by order of governmental authority.
> c. Nuclear Hazard
> Nuclear reaction or radiation, or radioactive contamination, however caused.
> d. Off-Premises Services
> The failure of power or other utility service supplied to the described premises, however caused, if the failure occurs away from the described premises.
> But if loss or damage by a Covered Cause of Loss results, we will pay for that resulting loss or damage.
> e. War And Military Action
> (1) War, including undeclared or civil war;
> (2) Warlike action by a military force, including action in hindering or defending against an actual or expected attack, by any government, sovereign or other authority using military personnel or other agents; or

INSURING THE BOTTOM LINE

> (3) Insurrection, rebellion, revolution, usurped power, or action taken by government authority in hindering or defending against any of these.
> 2. We will not pay for loss or damage caused by or resulting from:
> a. Artificially generated electrical current, including electric arcing, that disturbs electrical devices, appliances or wires.
> b. Fire, explosion (other than volcanic explosion), landslide, mine subsidence, tidal wave, flood, mudslide or mudflow, even if attributable to an Earthquake or Volcanic Eruption.
> c. Any Earthquake or Volcanic Eruption that begins before the inception of this insurance.

Narrow definition means fewer exclusions are needed

There are fewer exclusions on this form because the coverage is narrowly defined. For example, there is no need for an earth movement exclusion, because that coverage is specifically provided by this form.

Most of the remaining exclusions (ordinance or law, governmental action, nuclear hazard, off-premises power failure, and war) are essentially the same as those found on the basic form. But if you compare this form to the basic form, you will find that many of them are briefer—there is no need to make exception for resulting losses by fire or other causes of loss, because those perils are not covered by this form.

However, there are two exclusions (items 2.b. and 2.c.) which are unique to the earthquake form. Losses due to fire, explosion, tidal wave, flood and other causes will not be covered even if resulting from an earthquake or volcanic eruption. The reason for this entry is that you should have separate coverage for such exposures (resulting fires or explosions would be covered by the basic, broad or special causes of loss forms; and separate flood insurance policies are available to cover tidal waves, floods or mudslides).

The exclusion of an earthquake or volcanic eruption that begins before the effective date of the insurance is an important provision because of the earlier provision stating that all shocks within a 168-hour period will be treated as a single event. This prevents a policyholder from buying coverage after an initial land shock has occurred, and attempting to recover for losses by attributing them to aftershocks.

> 3. Special Exclusions
> The following provisions apply only to the specified Coverage Forms.

The last group of exclusions, the special exclusions that apply only to specific coverage forms, are identical to those that appear on the other causes of loss forms and are not repeated here. Refer to our review of these exclusions in the basic causes of loss section of this manual if you wish to examine these provisions in detail or our comments about them.

Chapter One, Part Two: Commercial Property Causes of Loss

Stucco is covered if an earthquake occurs

C. LIMITATION
We will not pay for loss of or damage to exterior masonry veneer (except stucco) on wood frame walls caused by or resulting from Earthquake or Volcanic Eruption. The value of such veneer will not be included in the value of Covered Property or the amount of loss when applying:
1. The Deductible applicable to this form; or
2. The Additional Condition, Coinsurance, applicable to this Coverage Part.
This limitation does not apply if:
a. The premises description in the Declarations specifically states "Including Masonry Veneer"; or
b. Less than 10% of the total outside wall area is faced with masonry veneer (excluding stucco).

The earthquake form includes a limitation stating that it will not pay for loss or damage to exterior masonry veneer (except stucco) on wood frame walls caused by earthquake or volcanic eruption. However, this limitation will not apply if the declarations specifically state "including masonry veneer," or less than 10 percent of the total outside wall area is faced with masonry veneer.

D. DEDUCTIBLE
1. The following is applicable to all Coverage Forms except:
(1) Business Income (And Extra Expense) Coverage Form;
(2) Business Income (Without Extra Expense) Coverage Form;
(3) Extra Expense Coverage Form.
The Deductible, if any, in this Coverage Part is replaced by the following with respect to Earthquake and Volcanic Eruption:
We will subtract a sum from the amount of loss or damage in any one occurrence.
a. The sum we subtract from each separate item will be a percentage of its value. The applicable percentage is shown in the Declarations.
b. This Deductible applies separately to the following:
(1) Each building or structure;
(2) The contents of each building or structure; and
(3) Personal property in the open.
Example:
When: The value of the property is $100,000
The Earthquake Deductible is 5%
The amount of loss is $20,000
Step (a): $100,000 × 5% = $5,000
Step (b): $20,000 − $5,000 = $15,000
The most we will pay is $15,000. The remaining $5,000 is not covered because of the Deductible.
2. The following is applicable only to the Coverage Forms specified below:
(1) Business Income (And Extra Expense) Coverage Form;
(2) Business Income (Without Extra Expense) Coverage Form;

> (3) Extra Expense Coverage Form.
> For buildings over 4 stories in height we will only pay for loss you sustain after the first 168 hours after direct physical loss or damage caused by or resulting from Earthquake or Volcanic Eruption.

How earthquake deductibles work

The earthquake form includes special earthquake deductible provisions. For all coverage forms except business income and extra expense coverages, the earthquake deductible will be a percentage of the insured property's value. The applicable percentage must be stated in the declarations, and will be applied separately to (1) each building or structure, (2) the contents of each building or structure, and (3) personal property in the open.

Example: If earthquake coverage applies to a building valued at $100,000 which contains personal property valued at $40,000, and if the deductible is shown as 5 percent, the amount of the deductibles would be $5,000 for the building and $2,000 for the contents regardless of the amount of loss. So if an earthquake caused $20,000 of building damage and $10,000 of damage to the contents, the insurance company would pay a total of $23,000 ($15,000 plus $8,000) and you would have to assume a $7,000 loss (the sum of the deductibles).

As a result of catastrophic earthquake losses in the early 1990s, insurance companies have sought to increase these deductibles dramatically. If you're considering this coverage, you should prepare to pay more than 5 percent.

In the case of business income and/or extra expense coverages, the earthquake form excludes coverage for the first 168 hours of loss, but only for buildings over four stories in height.

Recent amendments to the earthquake form define all earthquake shocks or volcanic eruptions occurring within a 168-hour period as a single event. The 168-hour period is not affected by policy expiration, which means that an expiring policy would continue to cover shocks or eruptions following an event that "begins" while the policy is in effect.

This does not present a problem when new forms are renewed. But it leaves a coverage gap when new forms are first used to replace earlier forms which terminated coverage at expiration. Because all events during any 168-hour period are treated as a single event, and because the form excludes events that begin before the effective date, aftershocks or eruptions during the first seven days of a policy period may not be covered if the event began prior to inception.

The problem is solved by attaching an "earthquake inception extension endorsement" when one of the new forms is first issued. It replaces the exclusion of events that begin before inception with a statement saying that loss or damage that occurs on or after the inception

of the insurance is covered if the series of earthquakes or volcanic eruptions began within 168 hours prior to the inception date.

After the earthquake causes of loss form has been used to cover a risk, the endorsement is not needed at renewal.

INSURING THE BOTTOM LINE

Chapter Two:

Business Interruption

Introduction

Imagine that you are the owner of a computer store that has just suffered a fire. The building, inventory, and business records are a total loss. Initially you are relieved because you are covered for all of the losses to property. However, your business was profitable and the contractor says that it will be at least six months before the building is reconstructed. How will you replace the income stream that was destroyed by the fire? Welcome to the world of business interruption insurance.

Standard commercial property policies provide protection against direct losses—actual physical damage to or destruction of property. The perils that cause direct damage can also cause consequential, or indirect, losses which result from the disrupting effects of property damage. Various indirect coverages are available, and the need for them is considerable.

For many businesses, the monetary value of an indirect loss can easily exceed the amount of the underlying direct loss. For example, a relatively small property loss in a critical area of business operations can bring activity to a stop and lead to a loss of sales and customers. Insurance against indirect losses falls into two general categories.

Time element coverages make up the most important group of consequential loss coverages. The term "time element" means that the amount of the loss is directly linked to the time it takes to repair, rebuild, or restore the damaged property. The most popular and most frequently written time element coverages protect against loss of income when a business is interrupted and protect against the extra expenses that may be incurred when a business attempts to continue its operations following a property loss.

Business interruption insurance is designed to cover many of the costs associated with temporary loss of access to office space, customer traffic, or the ability to satisfy customer needs.

The business income coverage form

Coverage for business interruption losses is now written on the business income coverage form. The form includes a number of coverages and coverage options, which provide companies with a flexible package of time element coverages.

Loss of income due to suspension of "operations"

Coverage applies to the actual loss of business income sustained due to suspension of "operations," and to extra expenses incurred to avoid or minimize a suspension of "operations," during a "period of restoration." The suspension of operations must be caused by a direct physical loss of, or damage to, property at your premises (including personal property in the open or in a vehicle within 100 feet of the premises) caused by or resulting from a covered cause of loss.

The covered causes of loss and exclusions that apply to the underlying direct losses that produce the indirect losses are those shown on the applicable causes of loss form shown in the declarations.

This insurance applies to losses and expenses related to an interruption of normal business operations. Operations mean your business activities at the premises described in the declarations (and the "tenantability" of the premises if rental value coverage is being written). Only losses incurred during a period of restoration are covered.

The period of restoration begins on the date that the direct physical loss to property occurs, and it ends on the date that the damaged property "should be" repaired, rebuilt or replaced "with reasonable speed" and similar quality. You are not required to repair or replace the damaged property with speed, but the insurance company may limit the period of coverage if you do not use "reasonable speed" to restore the property when it could be restored.

Expiration of the policy will not cut short the period of restoration. The period of restoration does not include any increased period required due to any law regulating construction, use or repair, or requiring demolition of property, nor which requires you to test for, monitor, clean up, remove, contain, detoxify or neutralize the effect of pollutants.

Key definitions that shape time element coverage

Rental value means total anticipated rental income from tenant occupancy of the described premises, all other charges which are the legal obligation of tenants but which would otherwise be your obligations, and the fair rental value of any portion of the premises occupied by you.

The most the insurance company will pay for loss in any one occurrence is the applicable limit of insurance shown in the declarations.

The business income and extra expense form includes five types of coverages. Four of these are identified as "additional coverages," but since none of the additional coverages increase the limit of insurance, they can all be considered together. The five coverages are:

- business income (three options are available regarding rental value);
- extra expense;
- civil authority (two weeks maximum);
- alterations and new buildings; and
- extended business income (maximum 30 days).

Business income coverage pays the actual losses of business income, which is defined as net income (net profit or loss before income taxes) plus continuing operating expenses. Gross revenue is not covered because many expenses (i.e., electricity, heat) may be discontinued while the business is shut down. Continuing expenses (taxes, rent, debt payments) are covered because the net profit or loss is what is left after continuing expenses are paid. If the revenue to cover continuing expenses is not replaced, it reduces the net income.

Net income and operating expenses are covered

For example, a business having monthly revenue of $500,000 and total expenses of $200,000 has a monthly net income of $300,000. But the insurable business income amount is greater if there are continuing expenses. If $100,000 of the expense continues during a shutdown, you would need to recover $400,000 to be indemnified—$400,000 minus $100,000 for continuing expenses, equals $300,000 of net income. Note that "net income" is defined as net "profit" or "loss."

If a business is operating at a loss, it would suffer the same loss after being indemnified by the insurance (if net income was -$100,000 and continuing expenses were $300,000, it would recover only $200,000).

The purpose of the business income coverage is to restore you to the position that would have existed had there been no disruption of operations.

Extra expense coverage insures against the necessary extra expenses incurred during a period of restoration that would not have been incurred had there been no underlying direct property loss. Expenses incurred to avoid or minimize the suspension of operations are covered.

If business operations can be continued, expenses at the described premises or at a replacement premises or temporary location are covered. Expenses to repair or replace any property, or for research to replace or restore lost information on damaged records, will be covered to the extent that it reduces the amount of loss otherwise payable under this coverage part.

If business is interrupted because a civil authority prohibits access to the described premises as a result of direct physical loss or property damage at a location other than the described premises due to a

covered cause of loss, the lost income will be covered for a period of up to two weeks.

Actual losses of business income due to direct physical damage to new buildings or structures, or alterations or additions to existing buildings or structures, or machinery, equipment, supplies or building materials located on or within 100 feet of the described premises are covered. The direct loss must result from a covered cause of loss.

Losses resulting from damage to machinery, equipment, supplies and building materials are covered only if such items are being used in construction, alterations or additions, or are incidental to the occupancy of new buildings. If a direct loss delays the start of your operations, the period of restoration under this coverage will begin on the date operations would have begun if the direct loss had not occurred. After a period of restoration, there is coverage for an extended business income loss for a period that begins on the date property is actually repaired, rebuilt or replaced and operations are resumed.

This extended period ends on the earlier of (1) the date 30 consecutive days after it begins, or (2) the date you restore the business to the condition that would have existed if no direct loss or damage had occurred. This coverage reflects a recognition of the fact that a business may lose customers and markets during a shutdown, and that revenues may not reach previous levels immediately when operations are resumed.

Three types of business interruption coverage

A company has three options for the type of business income coverage that applies. One or more options may be selected if coverage applies at different locations. The options in effect are indicated by entries in the declarations. Business income coverage may be written to consist of:

- Option 1—Business income coverage including rental value
- Option 2—Business income coverage other than rental value
- Option 3—Rental value coverage exclusively

When option 1 is selected, the term "business income" will include "rental value." When option 2 is selected, the term "business income" will mean only "business income." When option 3 is selected, the term "business income" will mean only "rental value." Your choices will be determined by whether or not you have a rental value exposure, and whether it is the only type of business income exposure.

Many companies have a rental value exposure. If you own a building occupied by tenants, and if a direct loss results in a loss of rental income, the lost rental income could be covered as a business income loss. If you are an owner/occupant of a building, and if a direct loss makes the building uninhabitable and makes it necessary to rent alternative facilities, the rent could be covered as an extra expense. You would also recover rental income as a business income loss. If

you are a tenant, and if a direct loss makes the premises uninhabitable but the lease requires the tenant to continue paying rent, the rent at a temporary replacement facility could be covered as an extra expense.

But a caveat: Insurance companies will often investigate these claims doggedly before paying. They are very sensitive about providing "windfalls" for policyholders.

And they have some cause to worry about this. The 1992 federal appeals court decision *Prudential LMI Commercial Insurance Co. v. Colleton Enterprises* shows how some businesses try to turn business interruption coverage into a financial windfall.

Some businesses try to turn this coverage into a windfall

In 1987 Prudential issued Colleton a casualty insurance policy covering an Econo Lodge motel located near Charleston, South Carolina. The policy provided business interruption coverage in a section titled "Physical Damage to and Loss of Use of Motel Property."

This section explicitly stated:

> When the insurance in this policy covers earnings, such insurance shall cover the loss of earnings sustained, less operating costs which do not necessarily continue during the necessary interruption of business, caused directly by the insured perils in this Section of the policy resulting in loss or damage to real or personal property at the described locations during the term of this policy.
>
> In determining loss hereunder, due consideration shall be given to...the earnings of the business before the date of damage or destruction and to the probable earnings thereafter, had no loss occurred....

In the same section, the policy provided the definition of earnings:

> net profit plus expense, taxes, interest, rents and all other operating expenses earned by the business.

In September 1989, Hurricane Hugo caused extensive damage to the Econo Lodge and the surrounding area. Colleton made the following claim under the policy:

> Damage to building ... $271,231.32
>
> Damage to signs ... $2,300.00
>
> Damage to contents ... $149,247.25
>
> Lost earnings (expenses, tax, interest and other
>
> operating expenses earned by the business).. $194,308.00
>
> Net lost earnings .. $192,254.00

Prudential paid all portions of the claim except the request for net profit or net lost earnings. Prudential took the position that it need not indemnify Colleton for lost profits because the Econo Lodge had recorded losses in excess of $350,000 during the 32-month period preceding Hugo and because the class of profits claimed—probable earnings resulting from accommodating the burgeoning demand due to the hurricane—was not covered under the policy.

Colleton sued Prudential. At trial, the two sides narrowed the question for the court with two important factual stipulations. First, that Hurricane Hugo had caused the damage at the Econo Lodge; second, that if the court found Colleton's lost profit claim covered under the terms of the policy, Colleton should be awarded $192,254, the amount of net profit the Econo Lodge would have realized—if it had been able, after the hurricane, to accommodate the increased demand for motel rooms that the occurrence of that peril caused.

The district court ruled in favor of Colleton in the sum of $192,254. In other words, it held that Colleton should recover profits it would have realized had the Econo Lodge been able to accommodate the influx of repair people and construction workers in the Charleston area during the months after the hurricane.

Prudential appealed.

The policyholder was indemnified against lost income after a hurricane

Before moving to the facts of the case, the appeals court reiterated the parameters of business interruption insurance:

> The insurance provisions at issue provide what is termed "business interruption" or "use and occupancy" coverage. Generally, business interruption insurance "is designed to do for the insured in the event of business interruption caused by [an insured peril], just what the business itself would have done if no interruption had occurred—no more...."

The appeals court concluded that the lower court had misapprehended the only legal issue presented to it: whether Colleton's specific claim for net profit loss was covered by the terms of the policy.

Prudential had already indemnified Colleton in the amount of $194,308 for "expenses, tax, interest and other operating expenses earned by the business." The question put was whether in addition to recouping these "operating expenses," Colleton should also be indemnified for a "net profit," beyond those expenses, that it was prevented from earning as a result of the hurricane.

The parties agreed that Colleton had established the first three elements of a business interruption claim for lost earnings. The only question was whether the specific lost profits claimed by Colleton qualified for coverage under a fourth requirement: Namely, did the lost opportunity to house the influx of temporary residents after the hurricane constitute a loss of earnings recognizable under a policy

that is designed to return the Econo Lodge to the position it would have occupied had the hurricane not occurred?

The most critical guidance on this issue was found in the policy provision that "in determining [earnings] loss...due consideration shall be given to...the earnings of the business before the date of damage or destruction and to the probable earnings thereafter, had no loss occurred."

The most critical language bearing upon the specific issue in the case was the clause, "had no loss occurred."

Had the hurricane not occurred, there would have been no rush of repair workers. The appeals court could not allow this:

> To allow the claim therefore would be to confer a windfall upon the insured rather than merely to put it in the earnings position it would have been in had the insured peril not occurred. Business interruption insurance of the type in issue here is not intended to provide such windfall coverage.

The court concluded, therefore, that Prudential would not have to pay the lost profit claim.

Coinsurance condition

Business income coverage is usually written with a coinsurance requirement. If a coinsurance percentage is shown in the declarations, the coinsurance condition applies in addition to the common policy conditions and commercial property conditions.

Coinsurance does not apply to some parts of time element coverage

Coinsurance only applies to the business income coverages—it does not apply to extra expense coverage. The amount of insurance required to be carried to satisfy the coinsurance condition is the coinsurance percentage multiplied by the sum of (1) the net income and (2) all operating expenses that would have been earned by your operations during the current policy year had no loss occurred.

The form does not say "policy year"—it says during the 12 months following inception or the last anniversary date, which means the "current" policy year. An appropriate annual amount of insurance must be estimated.

Note that the amount of insurance must anticipate net income and "all" expenses, but that loss payments will only be for net income and "continuing" expenses. The reason for this discrepancy is that before a loss occurs it is difficult to estimate which expenses will continue.

Some analysts have complained that the approach forces companies to buy limits of insurance that exceed the expected loss of business income (the excess amount is equal to the noncontinuing expenses). But others have pointed out that the difference is offset by the additional coverages which are built-in to the form. Furthermore, insur-

INSURING THE BOTTOM LINE

ers factor these unusually high limits into their pricing decisions—keeping down the ratio of premium to dollar of coverage.

Another offsetting factor is that this coverage (unlike property coverage) may be written with relatively low coinsurance percentages—50 percent is usually acceptable. With 50 percent coinsurance, the limit of insurance will only need to exceed the expected loss of income by an amount equal to half the noncontinuing expenses. The coinsurance formula and application of any penalty is essentially the same for business income as it is for property coverages, except that business income coverage is not written with a deductible.

The formula and examples of adequate and inadequate insurance are as follows:

Several formulas for determining adequate coverage

$$\frac{\text{Insurance carried}}{\text{Insurance required}} \times \text{loss} = \text{Covered amount*}$$

*(subject to limit of insurance)

Example 1—Adequate Insurance

Coinsurance percentage	50 percent
Annual net income plus all expenses	$300,000
Limit of insurance	150,000
Insurance required	150,000
Amount of loss	100,000

$$\frac{\$150,000 \text{ carried}}{\$150,000 \text{ required}} = \frac{1}{1} \times \$100,000 = \$100,000$$

(Insurer pays $100,000)

Example 2—Inadequate Insurance

Coinsurance percentage	50 percent
Annual net income plus all expenses	$960,000
Limit of insurance	400,000
Insurance required	480,000
Amount of loss	300,000

$$\frac{\$400,000 \text{ carried}}{\$480,000 \text{ required}} = \frac{6}{5} \times \$300,000 = \$250,000$$

(Insurer pays $250,000)

Chapter Two: Business Interruption

One of the significant contrasts to property coverages is that a 50 percent coinsurance percentage is not unreasonable for business income coverage. In effect it provides full coverage for six months, and most businesses can restore full operations within that time. In the first example above, net income and expenses are about $25,000 a month. The $100,000 loss reflects a four-month shutdown and it is fully recovered. If the shutdown had continued for six months, the full amount of a $150,000 loss would also be fully recovered. But if the shutdown had continued for seven months, the loss would have been $175,000 and only $150,000 (the policy limit) would be recovered.

Loss conditions

Loss is determined by the net income before the direct physical loss occurred

The amount of a business income loss will be determined based on the net income of the business before the direct physical loss occurred and the likely net income of the business if no loss had occurred. Operating expenses, including payroll expenses, necessary to resume operations at the same quality of service existing before the direct loss occurred will be taken into account by the insurance company.

The insurance company will also consider other relevant information, including your financial records, accounting procedures, bills, invoices, vouchers, deeds, liens, and contracts. The amount of incurred extra expenses will be determined based on all necessary expenses that reduce the business income loss that would otherwise be sustained, and all expenses during the period of restoration that exceed the normal operating expenses that would have been incurred had no direct loss occurred. The insurance company will deduct from such expenses the salvage value of any property bought for temporary use during the period of restoration, and any extra expense paid by other insurance that is not written on the same basis as this coverage.

The insurance company will make loss payment within 30 days after receiving a sworn statement of loss, if all coverage terms have been complied with and the insurance company and policyholder agree on the amount of loss or an appraisal award has been made. Either party may call for an appraisal if they cannot agree.

Your duties in the event of loss are similar to those that apply to coverage for buildings and personal property: prompt notice is required, the police must be notified if a law has been broken, you must cooperate with the insurance company, property must be protected from further loss, and a signed sworn statement of loss must be submitted within 60 days after the insurance company requests it.

An insured business has to resume operations as quickly as possible

However, there is an additional requirement that applies to business income and extra expense coverage—you must resume all or part of the business operations "as quickly as possible." This is required because the size of the loss is directly related to the time the business is not fully operating.

There is a loss condition that imposes a limitation on business income (but not extra expense) losses resulting from the direct physical loss of or damage to electronic media and records. Electronic media and records are defined as data and data systems: electronic data processing, recording or storage media, such as films, tapes, discs, drums or cells, including the data stored on such media, and programming records used for electronic data processing or electronically controlled equipment.

The insurance company will not pay for loss of business income caused by loss or damage to media and records after the longer of:

- 60 consecutive days after the date of direct physical loss or damage, or
- the period, beginning on the date of direct loss, necessary to repair, rebuild or replace with reasonable speed and similar quality property other than media or records which suffered loss or damage in the same occurrence.

The form includes two examples to clarify the intent of the limitation. In the case of damage to a computer, which is replaced three months later, coverage applies for the three months—but not beyond the date the computer is replaced, even if it takes another month to restore the lost data. In the case of loss of data processing programming records, which are replaced two-and-one-half months later, coverage applies only for 60 consecutive days—there is never coverage beyond 60 days unless something other than media and records (such as your building) was damaged and it takes longer to repair or replace that thing.

Miscellaneous consequential loss coverages

The following coverages serve special needs. Most of them are not time element coverages, because the size of the losses discussed is not related to the time it takes to repair or replace property. Not all companies offer these coverages, and when they are written the insurance company is likely to use its own policy forms.

In some cases, the loss of valuable papers can be considered a direct loss. But the loss of accounts receivable may produce direct and indirect losses. Property coverages may cover the cost of blank media and the cost of labor to transcribe the records, if the information can be recovered from another source. If the information cannot be recovered, and receivables cannot be collected because the debtors are unknown, traditional property insurance will not cover the lost revenue. Special coverage is available to protect against such losses.

Parts of pairs or sets can have extra value

Items which are an integral part of pairs or larger matched sets have an unusual value relationship. The loss of any one part may reduce the value of the remaining part(s). Such risks are particularly present in the jewelry and clothing businesses.

Suppose a large clothing store sells men's suits, and the pants are valued at $35 while the jackets are valued at $65. If a fire destroys 1,000 pairs of pants, a direct damage policy would pay $35,000 for the direct loss of the pants. But this leaves the store with 1,000 jackets that could not be sold for $65 without matching pants. Instead, they might be marked down to $40 and sold to an outlet that sells sports coats. Due to the loss of the pants, the store has suffered a $25,000 consequential loss on the jackets. Special consequential loss forms can be used to protect against such losses.

Profits insurance

Manufacturers may purchase insurance to cover the risk of lost profit on finished goods. When finished stock is damaged or destroyed, the direct loss will be settled on the basis of ACV or the manufacturer's replacement costs for the materials. The difference between the recovery amount and the price at which the finished goods could have been sold is therefore at risk. Coverage to protect the profits of finished goods may be sold under a variety of names—it may be called "profits" insurance, "market value of finished goods," etc.

The 1994 U.S. appeals court decision *Polytech, Inc. v. Affiliated FM Insurance Co.* considered the mechanics of business interruption coverage in a heated profits dispute.

On July 22, 1988, an explosion and fire completely destroyed the production facilities of Polytech, Inc., a manufacturer of cast acrylic plastic sheets located in Owensville, Missouri. Polytech was insured with Affiliated FM Insurance Company against loss or damage by fire, under a policy and its accompanying endorsements.

One of the endorsements to the insurance policy provided coverage to Polytech for business interruption losses resulting from fire. The endorsement, which described the terms of the business interruption coverage, covered Polytech's loss of "gross earnings" and "expenses" that result directly from the business interruption. Polytech filed a claim with Affiliated for business interruption coverage seeking the full coverage limits of $633,600. Affiliated refused payment on the claim.

Polytech sued Affiliated to recover under coverage for business interruption losses resulting when fire destroyed insured's production facilities. It alleged a breach of contract and vexatious refusal to pay the insurance proceeds.

A dispute over the loss value of unfinshed goods

Affiliated moved for summary judgment and argued that Polytech's claim for business interruption losses was wholly speculative as a matter of law. It argued that Polytech's claim of business interruption damages was unsupported by the record. It also argued that Polytech had previously run up significant losses and that its projected profits were unduly speculative.

The federal district court in Missouri denied Affiliated's motion for summary judgment, and granted Polytech's motion for summary judgment. The court found that, while the business interruption insurance coverage was not—strictly speaking—a "valued policy" under contract law, the coverage constituted a valued policy. The court entered judgment for the full amount of the business interruption coverage in favor of Polytech.

Affiliated appealed, arguing that the district court had erred by finding that the Missouri "valued policy statutes" prevented it from contesting the value of Polytech's business interruption claim.

The federal appeals court cited Missouri insurance law, which provided:

> In all suits brought upon policies of insurance against loss or damage by fire..., the [insurance company] shall not be permitted to deny that the property insured thereby was worth at the time of the issuing of the policy the full amount insured therein on said property....

Affiliated argued that the quoted section of law did not apply because it related only to real property—and business interruption losses do not qualify as real property.

The appeals court agreed:

> [The relevant Missouri law] applies only to real property. "Real property" is defined...as real estate, lands, or premises. [G]ross earnings and expenses which the business interruption coverage of the policy insures do not constitute real property. Hence, we conclude that the district court erred in applying [the law] in this case.

The manufacturer failed to show proof of lost profits

It concluded that none of the Missouri valued policy statutes were intended to extend to business interruption insurance policies. Accordingly, it reversed the lower court on this issue.

However, the appeals court also rejected Affiliated's request for a summary judgment dismissing Polytech's claims. The dispute would have to go to trial again in the lower court.

In this context, the appeals court allowed that Polytech might still have a legitimate claim under the disputed coverage:

> As noted above, this business interruption policy endorsement insured Polytech against loss of gross earnings resulting from the

business interruption. Affiliated argued that under the definitions in the policy, the coverage is essentially for lost profits. We have previously considered very similar language in business interruption policies and found that where there is a loss of gross earnings, the jury should award damages for the actual loss sustained, which is the difference between the net profit the business would have received without the interruption and the net profit actually received.

Under Missouri law, "[t]o obtain a damage award for lost profits at trial, [plaintiffs] must produce evidence that provides an adequate basis for estimating lost profits with reasonable certainty. Proof of actual facts which present a basis for a rational estimate of damages without resorting to speculation is required."

Both sides had provided substantial evaluation of the potential income and earnings of Polytech—had it continued to operate. Polytech presented evidence on changes in its business operation and practices that it says would have resulted in future profitability. Affiliated presented evidence from its accountants who concluded that Polytech would remain unprofitable and, therefore, would suffer no business interruption loss.

The appeals court concluded that this evidence created genuine issues of material fact that would have to be considered by a jury.

The appeals court summed up its ruling by stating: "The issue of lost profits really comes down to a problem of proof, and the trial judge should evaluate the evidence as it comes in to determine if there is enough evidence to send the issue to the jury."

The parties settled privately, rather than face another trial.

Other means to the same end

Optional coverage under property form can create time element coverage

The standard commercial property policy declarations page contains a space for entering a number of days for an extended period of indemnity, which gives a business a chance to get back on its feet following a business income loss. This optional coverage is the same as the additional coverage for extended business income, which provides up to 30 days of coverage after operations are resumed.

If the optional coverage applies, the number of days shown in the declarations is substituted for the number "30" in the text of the coverage form.

A declarations entry may be used to activate optional coverage for a maximum period of indemnity, which suspends the coinsurance clause and limits the loss period covered to 120 days. Under this option, the most the insurance company will pay for loss of business income is the lesser of the limit of insurance in the declarations or the actual loss sustained during the 120 days immediately following the direct loss or damage. This option may be attractive to business

owners who believe that the maximum possible period of business interruption could not exceed four months.

A declarations entry may also be used to activate a monthly limit of indemnity, which also suspends the coinsurance clause. When this option applies, the most the insurance company will pay for loss of business income during each period of 30 consecutive days during the loss period is the limit of insurance multiplied times the fraction shown in the declarations.

You may select 1/3, 1/4 or 1/6 as the applicable fraction, which in effect provides the option of choosing coverage for three, four or six months. For example, if you determined that the maximum monthly income loss could not exceed $40,000 and the maximum possible period of interruption could not exceed three months, it would be appropriate to buy $120,000 of coverage with the 1/3 option and no coinsurance requirement. Coverage is limited to a maximum recovery amount per month, but the coverage period could be extended until the limit of insurance is exhausted.

Business income coverage may be written on an optional agreed value basis by making an entry in the declarations and attaching a work sheet showing financial data for your operations during the previous 12 months and estimated data for the 12 months immediately following the effective date. The agreed value should be at least equal to the expected net income and operating expenses multiplied by the coinsurance percentage shown in the declarations. You must submit a new agreed value and work sheet within 12 months of the effective date and whenever a change in the limit of insurance for business income is requested.

The mechanics of making a time element claim

While agreed value applies, the coinsurance clause is suspended, but coinsurance will be automatically reinstated if you do not submit a new agreed value and work sheet when required. The limit of insurance should be as high as the agreed value because a penalty (proportional loss payment) will be applied if the limit is less than the agreed value.

The advantage of agreed value is that it can be used to lock in full coverage for losses (up to the limit of insurance) during the policy period, whereas a coinsurance penalty might be imposed under traditional coverage if business income grows more than expected. For example, suppose a business purchases $200,000 of coverage with a 50 percent coinsurance percentage because it expects annual net income and expenses to total $400,000. If the actual income and expenses have grown to $500,000 when a loss occurs, only part of the loss will be covered because a limit of $250,000 would be needed to avoid the penalty. If the policy had been written with an agreed value of $200,000 and a limit of insurance of at least $200,000, all losses would be covered in full up to that amount.

The standard business interruption form also shares a few common

property insurance conditions, such as a liberalization clause, and an appraisal clause.

A liberalization clause states that any revision which would "broaden the coverage...without additional premium" will immediately and automatically apply to the coverage part if the revision is adopted by the insurance company during the policy period or within 45 days prior to the effective date.

Example: A change in the insurance company's rating guidelines that would allow more coverage for companies in your industry would add that coverage to you—even without notice.

This clause eliminates the need to endorse policies every time a change favorable to you is made involving no premium increase.

An appraisal clause will sometimes be referred to as an "arbitration clause." Technically, there is some difference between appraisal and arbitration—but the two concepts are similar.

The 1995 federal district court decision *Michael Childs et al. v. State Farm Fire and Casualty* considered the arbitration clause of a business interruption policy.

In August 1992, Hurricane Andrew caused a disputed amount of damage to Michael Childs's insured businesses and property. Childs and two of his companies—aircraft service firms located in southern Florida—made claims against State Farm for more than $2 million.

State Farm contested the amount, although it did advance Childs more than $525,000 to cover his losses. Childs filed suit, arguing that State Farm had breached the terms of the insurance policies that provided coverage for loss to property and for "loss of income as a result of interruption to business operations."

State Farm answered that one of the general conditions of the business interruption coverage outlined how disputed losses would be handled—and that it had abided by those terms. Indeed, Condition 4 of the insurance policies provided that:

The effects of a policy's appraisal clause

If we and you disagree on the value of the property or the amount of loss, either may make written demand for an appraisal of the loss. In this event, each party will select a competent and impartial appraiser. Each party will notify the other of the selected appraiser's identity within 20 days after receipt of the written demand for an appraisal. The two appraisers will select an umpire. If the appraisers cannot agree upon an umpire within 15 days, either may request that selection be made by a judge of a court having jurisdiction. The appraisers will state separately the value of the property and amount of loss. If they fail to agree, they will submit their differences to the umpire. A decision agreed to by any two will be binding.

Each party will:

a. pay its chosen appraiser; and

b. bear the other expenses of the appraisal umpire equally.

If we submit to an appraisal, we will still retain our right to deny the claim.

Courts have generally ruled that this "appraisal clause" in insurance policies has the same legal weight—that is, a lot—as arbitration clauses in other kinds of contracts.

In December 1994, following Condition 4, State Farm requested an appraisal of Childs's losses. It also agreed that it was:

> willing to be bound by any decision reached by the conclusion of the appraisal process as set forth under the terms and conditions of the subject policies.

State Farm argued that, instead of submitting to this appraisal and arbitration, Childs filed the lawsuit. The insurance company asked the court to order Childs to comply with the procedures in Condition 4, and to suspend the lawsuit pending the conclusion of the arbitration process.

Childs argued that the last line of the appraisal agreement—giving the insurance company the right to deny the claim, in any case—disqualified the whole section. There was some precedent on his side. Another federal court had ruled that the same language in another policy had made the arbitration agreement unenforceable, because there was no "mutuality of obligation" on the parts of the parties.

Neither side can reserve the right to ignore an appraisal

In other words, because the court held that the last clause gave the insurance company the option to reject the amount of the appraisal—but gave the policyholder no similar right to reject the ultimate conclusion of the appraiser—the arbitration procedure created by the insurance policy was inherently unfair and unenforceable.

The court disagreed with Childs's position for three reasons:

> First, Childs had himself agreed to submit to the appraisal procedures outlined in the policy. He could not "hold in reserve the right to later argue that the appraisal process is unfair if [he is] not happy with the amount of the appraisal."

> Second, State Farm had agreed to be bound by the ultimate appraisal from this process. "Thus, because there is now mutuality of obligation, [the earlier court's objection] no longer applies."

> Finally, that earlier court had been the only one which had taken the position that the final clause of Condition 4 made the appraisal requirement unenforceable.

So, the court ruled that:

> ...because the court is satisfied that no substantial issue exists as to the making of the agreement or provision, and that, therefore,

the arbitration/appraisal agreement of the insurance policies is enforceable, the Court is obligated to compel mediation in this matter.

Finally, it ordered Childs to file, on the first day of each month until a settlement was reached, a status report regarding the appraisal proceedings. Failure to file any of these reports would result in a dismissal of the entire proceeding.

This last order is common to situations in which one party to a contract tries to break an arbitration clause. Courts tend to weigh that side down with procedural burdens. This is a good reason not to move to a lawsuit until you've exhausted the appraisal process.

Chapter Three:

Boiler and Machinery

Introduction

Steam power was a driving force in the Industrial Revolution. By the mid-1800s, American factories were finding many new applications for steam boilers and steam engines. Unfortunately, early designs and the alloys used in the production of steam vessels at the time suffered from deficiencies. Frequent boiler explosions resulted in loss of lives, severe injuries, and substantial amounts of property damage. It became evident that loss prevention was the best solution to the problem, so a group of engineers formed a specialized company which offered inspection services linked to insurance coverage.

Boiler and machinery insurance (B&M) policies were first sold in this country during the 1860s. Coverage originated with the Hartford Steam Boiler Inspection and Insurance Company, which continues to dominate the field—it writes only B&M coverage and accounts for more than one-third of all B&M premiums in this country.

Boiler and machinery insurance includes property and liability coverages, but it is so highly specialized that many carriers do not write it because it requires specialized underwriters, loss control engineers, and claims adjusters.

Today, regardless of the insurance carrier providing the B&M coverage, a substantial portion of each premium dollar is still used for inspection and loss control services. Due to the emphasis on inspection and the advance of sophisticated manufacturing processes, boiler explosions now rarely occur. However, when such an explosion does occur, damage to all property within range is usually severe and the total cost of the loss can be very high.

Over time the boiler and machinery field expanded to embrace many different types of mechanical devices. Steam boilers were followed by other pressure vessels, motors, pumps, refrigeration systems, and eventually air conditioning systems and compressors. These emerged as unique exposures, and the experts in the boiler field were better prepared to evaluate the risks than were traditional underwriters.

Boiler and machinery coverage is needed to fill gaps left by major forms of property and liability coverage. Typical property coverages

insure against loss by combustion "explosion," but not the explosion of "steam boilers, steam pipes, steam turbines, or steam engines if owned by, leased by, or operated under the control of the insured."

Property coverages also commonly exclude losses caused by mechanical breakdown, including rupture or bursting caused by centrifugal force. General liability insurance might cover some injuries caused by a boiler explosion, but the policy forms exclude damage to property "owned, occupied, rented, or used by" you, and property in your "care, custody, or control."

Boiler and machinery policies are specifically designed to cover loss to your property and damage to the property of others.

Policy modernization

Boiler and machinery insurance as a monoline coverage

Boiler and machinery coverage may be written as a monoline policy or as part of a commercial package policy. Some companies write the coverage on separate policies. B&M coverage was an optional part of Special Multi-Peril (SMP) policies.

Boiler and machinery forms were included in the recent commercial lines policy and rating simplification project conducted by the Insurance Services Office, and the coverage may now be written on the new commercial forms. Individual companies may use variations of the forms, but the coverage is generally similar. This discussion will focus on the ISO forms.

If you have boiler and machinery exposures, you would be wise to include the coverage as part of a commercial package. Having all commercial coverages written on the same policy minimizes duplications or gaps in coverage. Having all commercial coverages written by the same carrier minimizes disputes when a loss occurs—since a package is usually designed to provide comprehensive coverage.

Policy construction

Naturally, for boiler and machinery coverage to be in effect, at least one of the coverage parts must be a boiler and machinery coverage part.

Whether boiler and machinery coverage is issued as a monoline policy or as part of a package, a boiler and machinery coverage part will consist of:

- a B&M declarations page,
- a B&M coverage form,
- one or more object definition forms (with the general B&M coverage form only),
- any applicable endorsements.

Unlike other property and liability coverages, there is no separate boiler and machinery conditions page, because conditions are built in to the coverage forms.

Several different B&M coverage forms

There are three B&M coverage forms. One is a general form that is used to insure most business and industrial risks. Two are for smaller risks that have more limited types of exposures. The three coverage forms are:

- the Boiler & Machinery Coverage Form,
- the Small Business B&M Coverage Form, and
- the Small Business B&M Broad Coverage Form.

The two small business forms are similar, although the broad form has some additional coverages and higher sublimits for various coverages. The small business forms are available only for risks for which 80 percent of the replacement value of the insured property does not exceed $5 million. Small business forms are typically used to insure apartment buildings, office buildings, restaurants and retail stores. The small business forms are not available for any manufacturing or processing risks, or risks having high pressure boilers. Such risks must use the general form.

Boiler and machinery declarations

Each available coverage form has its own declarations page. Although there are minor differences in the wording and appearance of the different declarations pages, each one includes a place for the following information:

- policy number,
- insurer name,
- producer name,
- named insured,
- mailing address of named insured,
- policy period,
- limit of insurance,
- premium,
- deductible,
- description of business,
- mortgage holder and address,
- loss payee and address,
- schedule showing locations and descriptions of objects,

- forms applicable to the coverage part, and
- countersignature.

In addition to this vital information, the declarations may include some information about special coverages that may apply, and the types of objects which are insured.

Insuring agreement

Coverages and extensions under the insuring agreement

The boiler and machinery insuring agreement agrees to pay for direct damage to covered property caused by a covered cause of loss, which means an accident to an object shown in the declarations. All coverage applies only while an insured "object" is actually "in use or connected ready for use" at the location specified in the policy. The major coverages and extensions of coverage are:

- loss to your property,
- loss to property of others in your care, custody or control, for which you are legally liable,
- expediting expenses (limited to $5,000),
- automatic coverage for newly acquired locations (for 90 days),
- defense against suits for property damage, and
- supplementary payments.

Property is insured on a replacement cost basis, unless actual cash value coverage is wanted (it may be changed to ACV by endorsement). Property may be repaired or replaced with property of like kind, capacity, size and quality. The insurance will not pay any extra costs if you repair or replace property with property of a better kind or quality, or of larger capacity. Property coverage does not apply to loss to any obsolete or useless property.

Applying expediting expenses to the damage

When covered property is damaged, expediting expenses are the reasonable extra costs to make temporary repairs, or to expedite permanent repairs or replacement. The coverage for expediting expenses is not an additional amount of insurance.

Automatic coverage for new locations extends the insurance to newly-acquired property for 90 days, but only if the "object" at the new location is of the same type that would be included in the object definition form attached to the policy. You must report the new location within 90 days and agree to pay the additional premium.

Under supplementary payments, the insurance company agrees to pay expenses related to defense costs. For all claims and suits defended, the insurance company will pay in addition to the policy limit all expenses it incurs, the cost of bonds to release attachments, reasonable expenses incurred by you (including loss of earnings up to $100 a day), costs taxed against you in a suit, pre-judgment interest

awarded against you on the part of the judgment paid by the insurance company, and all interest on judgments against you after entry of the judgment and before it is paid by the insurance company.

Optional coverages

Boiler and machinery coverage forms no longer include coverage for bodily injury liability.

Endorsements may be used to cover indirect losses resulting from a boiler and machinery loss. Coverage may be added for business interruption, or extra expenses, or combined business interruption and extra expenses.

Miscellaneous endorsements may be used to raise sublimits for certain coverages, to remove exclusions, or to extend the insurance or modify coverage in other ways.

Definition of accident

How this kind of insurance defines "accident"

Under boiler and machinery coverage, "accident" means the sudden and accidental breakdown of an object, or a part thereof, resulting in physical damage to the object that necessitates repair or replacement. However, the policy specifies that "accident" does not mean depletion, deterioration, corrosion, erosion, wear-and-tear, leakage at valves or joints or fittings, breakdown of any vacuum tube or gas tube or brush, breakdown of any computer or EDP equipment, breakdown of any structure or foundation supporting an "object," or the functioning of any safety or protective device.

If an accident causes other accidents, all related accidents will be treated as one accident. All accidents occurring at a single location at the same time, and having the same cause, will be considered to be one accident.

An "object" means equipment shown in the B&M declarations. One or more object definition endorsements must be attached to the coverage. Each endorsement groups a type of similar objects, and provides specific definitions of what is and is not an insured object. The six object definition endorsements are:

- Pressure and refrigeration objects (including boilers, fired vessels, electric steam generators, steam piping and valves, unfired vessels, refrigerating and air conditioning vessels and piping, small compressing and refrigerating units, air conditioning units),

- Mechanical objects (including engines, pumps, compressors, fans, blowers, gear wheels, enclosed gear sets, wheels and shafting, deep-well pumps, miscellaneous machines),

- Electrical objects (including rotating electrical machines, transformers, induction feeder regulators, miscellaneous electrical apparatus, solid state rectifier units),

- Turbine objects (including turbines, combustor and other parts of a gas turbine unit, components on any shaft of a driving turbine, mechanical or hydraulic governing mechanisms),
- Comprehensive coverage (excluding production machinery) defines all insurable boiler and machinery objects which can be covered excluding coverage for production machinery, and
- Comprehensive coverage (including production machinery) defines all insurable boiler and machinery objects which can be covered including coverage for production machinery.

The definition of an insured "object" causes some disputes

B&M claims often turn on highly technical definitions of words like "object" and even "corrosion." The 1993 federal district court decision *Occidental Chemical Corp. v. American Manufacturers Mutual Insurance* considered a common exclusion to B&M coverage. But even a common B&M exclusion can turn on technicalities.

Occidental Chemical (OCC), a division of Occidental Petroleum Corporation, operated a chemical plant in North Carolina. In June 1983, American Manufacturers issued an accidental insurance policy which covered OCC.

The policy, entitled a "General Boiler and Machinery Policy," insured "Objects" as defined in Endorsement No. 117:

> "Object" shall mean any boiler, any fired or unfired vessel normally subject to vacuum or internal pressure other than static pressure of contents, any refrigerating system, any piping with its accessory equipment, and any mechanical or electrical machine or apparatus which generates, controls, transmits, transforms or utilizes mechanical or electrical power, but...
>
> Object shall not mean or include...
>
> ...Any structure, foundation or setting (other than a bed plate of a machine) supporting or housing such Object; or any oven, kiln (including bull gear) or furnace or any insulation or refractory material....

In January 1983, while the policy was in effect, damage was sustained to the trunnion assemblies associated with the No. 3 Kiln in OCC's North Carolina facility.

Both OCC and American Manufacturers agreed that the value of the damage, exclusive of interest, was more than $380,000. But they didn't agree on—and ended up suing each other over—the question of whether the trunnion assemblies were covered under the policy.

The federal court admitted that this was a technicality, writing in its analysis:

> When is a trunnion not a kiln? This riddle, which has plagued not

a single man or woman throughout the ages, is nonetheless the crux of these cross-motions....

To put the dispute into context, a brief discussion of kilns and trunnions is necessary.

OCC's kiln was what was known as a "rotary kiln," which involved a long, narrow cylindrical tube (240 feet by 15 feet in diameter, in this case) which rested at a slight incline. Substances were heated as they slid down the rotating tube.

Because an item of this size and shape which must rotate could not rest on the ground or simple supports, mechanisms to support it while allowing it to rotate freely were required. So, the tube was encircled in three places by rings, unsually known as "tires."

These tires, in turn, rested on trunnion assemblies, which provided counter-rotating rollers to enable the tube to rotate freely. Again the court tried to make common sense of this complexity:

>...in a rough analogy, the system resembles a hot dog rotating on a grill with rollers at a sports arena.

OCC argued that the trunnion assembly was an "object" as defined in the policy. Therefore, no exclusions applied.

Can a covered object be part of an excluded item?

American Manufacturers, while not disputing that a trunnion assembly was an "object," claimed that it was part of a kiln and was thus excluded from coverage. It also argued that, even if it were found not to be part of a kiln, a trunnion assembly was a "structure, foundation or setting," and thus—again—excluded.

Insurance law generally holds that terms of an insurance policy that aren't otherwise defined should be understood as a layperson would understand them. The trouble with the OCC case was that a layperson would be unlikely to know what a "trunnion assembly" was. So, the court decided:

>It is appropriate to examine the language of the Policy as would a layperson who is knowledgeable about kilns and trunnion assemblies; what is to be guarded against is addressing the issue from the standpoint of one peculiarly knowledgeable about insuring such items or litigating such coverage.

>...The $384,000 question is therefore: would a layperson understand the word "kiln" to include the trunnion assemblies on which the cylindrical tube rests?

Purchase documents for OCC's kiln discussed the trunnion assemblies as part of an entire, single unit—in contrast to the motor which was sold separately.

Curtis Pearson, OCC's insurance broker, also testified that in his numerous inspections of other rotary kilns he had never seen one without trunnion assemblies.

The court concluded:

> Without operating trunnion assemblies, the kiln might function, but it would clearly not function as a rotary kiln and its usefulness would be significantly diminished. There is no doubt that a layperson, having viewed the No. 3 kiln and learned its functions and design, would consider the trunnion assemblies to be a part of it within the plain meaning of the Policy.
>
> ...OCC's arguments that the trunnion assemblies are wholly separate items are not persuasive.

The court ruled in favor of the insurance company and refused to grant coverage for the damage caused by the fire at OCC's North Carolina plant.

Limits of insurance

Cleanup, repair or replacement of property under B&M coverage

The B&M form states that it will not pay more than the applicable limit of insurance shown in the declarations for all direct damage to covered property, resulting from any "one accident." Coverage is written as a single limit of insurance per accident, and it is usually written with a deductible.

The loss or expenses to clean up, repair or replace property will be covered only if the damage or contamination resulted from an insured accident to an insured object.

Example: If your boiler explodes and destroys your building, the building is covered—but coverage is also provided for damage to any other property caused by this accident, such as furniture or office equipment.

The insurance company will subtract the deductible amount shown in the declarations from the amount it would otherwise pay as a result of direct damage to covered property resulting from an accident. If more than one object is involved in one accident, only the highest deductible will apply.

Exclusions

Boiler and machinery coverage forms will usually exclude losses or expenses caused by or resulting from any of the following:

- ordinance or law,
- nuclear hazard,
- war and military action,
- explosion other than explosion of a steam boiler, steam generator, steam piping, steam turbine, steam engine, gas turbine, or moving or rotating machinery caused by mechanical breakdown or centrifugal force,

- fire or explosion that occurs at the same time as an accident or ensues from it,
- an accident that results from a fire or explosion,
- water or other means used to extinguish a fire,
- lightning, if that cause of loss is covered by another insurance policy,
- flood (but if an "accident" results from a flood, the damage caused by the accident will be covered),
- an "accident" to any "object" while it is being tested, and
- an accident caused directly or indirectly by earth movement.

Note that explosions are excluded except for the types of explosions B&M coverage is designed to cover. Fire and other perils are excluded because such coverage should be provided by other insurance. Most policies will also exclude indirect losses and loss caused by lack of power, light, heat, steam or refrigeration, or by a delay or interruption of business, but these exclusions are removed whenever business interruption and/or extra expense coverage is attached to the B&M coverage.

All-risk property insurance complicates some B&M claims

Other insurance issues dominate many B&M coverage disputes. The relationship between all-risk property insurance and boiler and machinery coverage can be particularly complicated. The 1995 federal district court decision *Lexington Insurance v. Reliance Insurance* dealt with this confusion.

The dispute arose from a 1992 boiler failure at a Texas plant belonging to Arcadian Corporation. Arcadian is a Tennessee-based producer of nitrogen fertilizers and chemicals. It operates a number of industrial boiler facilities at its manufacturing plants throughout the south. Mechanical failures of boilers are a familiar part of the chemical manufacturing business.

Total costs associated with the failure at the Arcadian plant reached the insured limit of $5 million.

Arcadian was insured under both a Boiler and Machinery policy issued by Reliance Insurance Company and all-risk policies issued by Lexington and others. A dispute arose among the insurers as to whether the loss was covered under the Reliance Boiler and Machinery policy, the all-risk policies, or all of the policies.

Because of this dispute, Arcadian invoked the Loss Adjustment endorsement contained in each of the policies. Thus, Reliance, Lexington and the excess carriers each paid a pro rata share of the $5 million loss in accordance with the endorsement.

Lexington—which paid the largest portion of the pro rata settlement—then petitioned the federal court in Louisiana to compel an arbitra-

tion with Reliance. During oral argument, both sides informed the court that they had filed a separate lawsuit, pending in a Texas state court.

Therefore, the federal court chose to abstain from any decision on the matter. It defended this decision not to decide on several points:

First, this is a suit for property, specifically, $5 million.

Second, the federal forum is not only inconvenient but this court does not have jurisdiction over all the insurers [several of which were based in Texas].

Third, and most important to this case, is this Court's desire to avoid piecemeal litigation. In order for this entire matter to be resolved, Lexington must not only arbitrate with Reliance but the excess carriers as well.

Fourth, the order in which the court obtains jurisdiction also supports abstention. The federal forum acquired jurisdiction subsequent to the Texas state court. It seems that Texas law, not federal law, will be applied to this litigation.

Lastly, this Court has no reason to believe that the state court proceeding is inadequate to protect Lexington's rights.

Coverage may be suspended when an object is found to be in—or exposed to—danger

Lexington, Reliance and the excess insurance companies involved in the case ended up settling their dispute privately. People familiar with the situation said that Lexington's all-risks policy still bore a bigger portion of the costs than Reliance's B&M policy.

One of the unique things about boiler and machinery insurance is that the insurance company or any representative of the insurance company may immediately suspend the insurance whenever an "object" is found to be in, or exposed to, a dangerous condition. Advance notice is not required. The suspension will take effect as soon as written notice is delivered to or received in the mail by you. Such suspension shall only apply to the particular object, and once in effect the suspension can be lifted only by an endorsement for that object.

The small business B&M coverage form

Many of the provisions found on the small business boiler and machinery coverage form are the same as those found on the general B&M coverage form. The coverages, exclusions, application of limits of insurance and deductibles, supplementary payments, and general conditions and definitions are essentially the same. However, there are important differences in four key areas — eligibility, coverage extensions, limits of insurance and object definitions.

Eligibility is limited to small businesses for which 80 percent of the replacement cost of the insured property does not exceed $5 million.

Regardless of the value of insured property, any risk involving manufacturing or processing, or having a high-pressure boiler, is not eligible for coverage under the small business coverage form. Risks of this sort must be covered under the general B&M form.

The small business boiler and machinery coverage form has the same type of coverage for covered property, and the same extensions of coverage for expediting expenses, defense of suits, and supplementary payments as the general form. But there are two differences in the coverage extensions:

It does not include an extension of coverage for newly acquired locations.

It always includes business interruption and extra expense coverage for boilers and pressure vessels. (These coverages also apply to air conditioning and air compressing units only if the word "covered" is indicated for property damage and for business interruption and extra expense for these objects in the declarations.)

The small business form adds exclusions to business interruption coverage

Because the business interruption and extra expense coverage is given automatically, the small business form adds a few exclusions to limit the coverage. The form will not pay for interruption of a business that would not or could not have been carried on if the accident had not occurred, or for your failure to use all reasonable means to resume business operations, or for the part of any loss resulting from cancellation or suspension of a contract which results in business being suspended beyond the time business would have resumed if the contract had remained in force.

Under the section "Limits of Insurance," the small business B&M form provides whatever single limit of coverage per accident is shown in the declarations.

Coverage for business interruption and extra expense insurance is equal to 25 percent of the limit of insurance written, and this coverage is an additional amount of insurance, beyond the limit shown in the declarations.

The small business form does not specifically refer to sublimits for damage or cleanup of hazardous substances, or for ammonia contamination.

Another significant difference is that the small business forms do not require attachment of an "objects definition form." The definitions of covered objects are included in the forms. On the small business boiler and machinery coverage form, there are two categories of "objects"—boiler and pressure vessels, and air conditioning units.

The small business B&M broad form

This form is similar to the regular small business form, except that it provides broader coverages and some additional coverages. Many of

the provisions are the same as those found on the general form or the small business B&M coverage form. Once again, there are some key differences in the areas of eligibility, coverage extensions, limits of insurance, and object definitions.

Eligibility is generally the same as under the other small business form: manufacturing and processing risks are ineligible, and only risks where 80 percent of the replacement cost of insured property does not exceed $5 million are eligible. However, a broader class of risks is eligible, because the broad form has a more extensive listing of "objects" which may be insured.

Under coverage extensions, the broad form has broader business interruption and extra expense coverage than the other small business form, because it is all provided automatically and is not limited as being applicable to specific types of objects.

The broad form also provides an optional coverage for spoilage of perishable goods following an insured accident. This is an optional coverage and it applies only if a limit is shown for it in the declarations. This coverage pays only when the spoilage results from lack of power, light, heat, steam or refrigeration caused by an accident to an insured object or to a transformer or electrical apparatus located on or within 500 feet of the location, and owned by a public utility company which uses it to supply power to that location.

Once again, exclusions limit the business interruption coverage by stating that there is no coverage for any interruption that would have occurred without the accident, or for any loss resulting from your failure to use all reasonable means to resume operations, or loss because of cancellation of a contract which extends the business interruption.

The "spoilage" exclusion

The usual power interruption exclusion does not apply to coverage for loss by "spoilage," but an additional exclusion does apply to that coverage—the insurance company will not pay for loss resulting from your failure to use all reasonable means to protect perishable goods from damage following an accident.

The broad form also provides the business interruption and extra expense coverage as an additional amount of insurance, equal to 25 percent of the limit of insurance shown in the declarations.

Spoilage coverage, if it applies, is also an additional amount of insurance, which is subject to its own limit regardless of what other coverages apply.

The broad form does increase three sublimits which are contained within the general limit of insurance shown on the declarations. The sublimits for expediting expenses, ammonia contamination, and water damage are each increased to $25,000. (The limit for damage or cleanup related to contamination by hazardous substances remains at $5,000.)

The broad form specifically lists objects which are covered

In contrast to the other small business form, the small business broad form has a longer list of objects which may be insured, including:

- any boiler,
- any fired or unfired vessel subject to vacuum or internal pressure other than weight of contents,
- any refrigerating or air conditioning system,
- any piping and its accessory equipment,
- any compressor, pump, engine, turbine, motor, generator, gear set, fan or blower, including shafts and any coupling, clutch, wheel or bearing on that shaft,
- any transformer or electrical distribution equipment, and
- any other mechanical or electrical equipment used for maintenance or service of the premises, but not used for processing or manufacturing.

The form goes on to state specifically that "object" does not mean any oven, stove or furnace, insulating material, computer or data processing equipment, equipment for lighting or advertising, equipment which is experimental or used for testing, or any sewer piping, underground gas piping, or piping which is part of a sprinkler system. Equipment used for processing or manufacturing, and vehicles, elevators, escalators, conveyors and cranes are also excluded. Once again, coverage for these more complex exposures must be sought under the general B&M form.

The important point to remember about B&M insurance is that it turns on technical definitions. The 1995 federal district court decision *Fairhaven Power v. Hartford Steam Boiler Inspection & Insurance* dealt with a fairly common—and very technical—B&M dispute.

Fairhaven was a facility that generated power for Pacific Gas & Electric in northern California. Its power generating process relied on a machine called a "boiler," an essential component of which is a "mud drum."

A mud drum is a large metal cylinder that produces steam from chemically treated water. Every April and November, Fairhaven shut down and inspected the mud drum for cracks or leaks. Fairhaven performed less elaborate tests of the drum on daily and biweekly bases.

In November 1990, Fairhaven decided to replace approximately 484 tubes attached to the mud drum because the tubes were worn. It hired a local contractor to remove the tubes and hot weld new tubes to the tube bores. A post-repair inspection indicated that the procedure had been done properly.

In November 1991, Hartford Steam Boiler (HSB) wrote Fairhaven an insurance policy covering property and B&M damage.

Several months later, Fairhaven discovered that the welding from the 1990 repair had caused stress corrosion cracking to develop in the drum. Fairhaven shut the boiler down on April 4, 1992 for a regular inspection. On April 10, 1992, in the course of a hydrostatic test (which forced water through the boiler at greater than normal pressures), the mud drum sprang a match-head sized leak.

No one had previously observed any defects or problems with the mud drum. The leak caused the drum to be unsafe and therefore unsuitable for operation.

Fairhaven spent $856,452 to replace the mud drum, and could not resume operations until May 23, 1992. It claimed this amount and more—arguing that the delay also meant the loss of $1,289,224 in profits.

HSB refused to cover these claims, so Fairhaven sued—claiming that the insurance company had breached its insurance contract.

The court began its analysis by reading the disputed B&M sections of the policy.

The policy stated that it did not insure against:

> ...any defect or fault in material, workmanship, or design, or design, and any previous conditions including, but not limited to, turbine rotor bowing that has occurred prior to the Policy effective date. However, if insured loss or damage directly results as a consequence of the defective or faulty material, workmanship, or design excluded above, the Company shall be liable for said consequences. The Company shall be liable for only those costs which are in addition to the costs of rectifying such defect or fault had the loss or damage not occurred.

> This exclusion shall not apply to the mechanical or electrical breakdown of...any boiler....

These B&M sections protected against "an Accident to an Object." The parties agreed that the mud boiler was an "Object" under the policy. These sections defined an accident as:

> ...a sudden and accidental breakdown of the Object, or a part thereof, which manifests itself at the time of its occurrence by physical damage to the Object that necessitates repair or replacement of the Object or part thereof; but Accident shall not mean:

> A. depletion, deterioration, corrosion or erosion of material;

> B. wear and tear....

What the term "accident" does not mean under this coverage

Another important section of the policy was the "Boiler and Machinery Definition Endorsement." This provision added some text to the policy's definitions sections.

The endorsement contained a different discussion of what "Accident

shall not mean" under the B&M coverage. It excluded certain kinds of explosions, fires, and breakdowns of structures supporting the Object. It did not mention corrosion.

Fairhaven admitted that corrosion was a cause of the leak, but it argued that the welding was the "efficient proximate cause," or the cause that sets the other causes in motion.

But the court ruled that the welding was not the "efficient proximate cause" of the damage:

> ...the welding itself did no immediate harm. Moreover, the welding was not a "risk." Although negligent welding might be a "risk" against which a reasonable insured might wish to be protected, Fairhaven insists that the welding was done properly.
>
> Thus, its position appears to be that accelerated corrosion is an inevitable consequence of routine maintenance. That is not a "risk"; it is normal wear and tear, which is another excluded event. Because both identified events are excluded, the efficient proximate cause theory does not apply.

Courts have been reluctant to define the term "sudden"

According to the policy, a covered accident had to be "sudden and accidental." The policy defined neither term. However, the court noted that "while courts have been reluctant to define the word *sudden* precisely, they have emphasized that it does not mean *gradual*. Thus, a *sudden* event must occur over a relatively short period of time."

Both HSB and Fairhaven focused on the other's failure to furnish evidence that the corrosion in the case had occurred gradually. Each side assumed that the other had the burden. The court ruled that because "sudden" was part of the definition of "accident," the issue was one of coverage. Therefore, it was Fairhaven's burden to show the so-called accident was sudden.

Fairhaven observed that previous inspections did not uncover any defects. Therefore, it argued, it must have been a recent development.

HSB denied that there had been a breakdown. It argued that a breakdown required that a disabling problem arise while a machine was operating. Fairhaven's boiler had been shut down for inspection. But the court took a different approach, ruling that:

> The mud drum was operating at the time of the leak, albeit as part of a test. The leak created the risk of an explosion, and effectively rendered the drum (and hence the boiler) inoperable. This ambiguous term [namely, "breakdown"]—which HSB could have defined in the policy, but did not—can reasonably be construed in favor of Fairhaven, and should be.

HSB then argued that even if the leak was a covered "breakdown," the "breakdown" did not cause the damage. Rather, it was simply one symptom of the larger problem, corrosion, which necessitated repairs.

The court didn't agree:

> ...it appears from the arguments of the parties that the boiler was safe to operate, despite some corrosion, so long as there was no leak. Thus, the policy's causation requirement was met.

The court concluded that:

> 1) HSB is obligated to provide insurance coverage for the damages Fairhaven incurred to replace its damaged boiler mud drum and all consequential business interruption losses...,
>
> 2) HSB breached its obligations under the policy by failing to pay damages incurred by Fairhaven to replace the boiler mud drum and all resulting business interruption losses, and
>
> 3) as a consequence of HSB's breach of its obligations under the policy, HSB is liable to reimburse Fairhaven for the costs of replacing its boiler mud drum and all resulting business interruption losses.

In this case, the technicalities worked for the policyholder. If you're considering B&M insurance, make sure you have a strong command of the technical details of your facility. If you're not sure how your plant would be defined, invest some money in a quality broker or agent who can come out and inspect your operations from an insurance company's perspective.

Chapter Four:

Business Auto

Introduction

Nearly every business operates at least one car to conduct deliveries, transport employees, or perform essential tasks away from the office. If vehicles are a part of your business, commercial automobile coverage should be a part of your insurance portfolio. Fortunately, commercial auto coverage is similar to personal auto coverage and can be purchased as part of a commercial package policy.

The business auto coverage form is a general purpose policy used to write automobile insurance for most types of business vehicle risks. It is used to insure company cars, vans, trucks and other vehicles for many types of businesses, including those that own and supply company cars to employees, those that use vans and trucks to haul their own goods, those that transport passengers, and those that lease vehicles to others.

Businesses may have automobile exposures arising out of owned, leased, rented, or borrowed vehicles. At one time, the basic automobile policy was used to insure most of these risks. The basic policy only provided coverage for autos which were specifically scheduled on the policy, but coverage for hired cars and non-owned autos could be added by endorsement. At a later date, comprehensive automobile liability coverage was introduced, and it became very popular among businesses having large and continually changing fleets.

During recent decades, automobile coverages were commonly attached to a general liability policy jacket. A policyholder could select basic or comprehensive auto liability coverage, and either could be issued with or without one of the available auto physical damage coverage parts.

In 1978, the business auto policy (BAP) was introduced. It was written in a more personalized, simplified style than earlier policies. The BAP was very successful in replacing the earlier policies and coverage parts which were frequently attached to general liability insurance, and it quickly became the most widely sold form of commercial automobile insurance. Similar policy forms for unique perils such as garage risks and trucking risks were also introduced.

In the mid-1980s, commercial automobile coverages were overhauled as part of the "Commercial Lines Policy and Rating Simplification Project" implemented by the Insurance Services Office. New forms were introduced to make the coverages fully compatible with other coverages that may be included in a commercial package policy.

The declarations page depends on whether auto coverage is separate or part of a package

When automobile insurance is written as part of a commercial package, the policy must include the common policy declarations and the common policy conditions. When written as a monoline policy, the common policy declarations are not needed. In either case, the commercial auto coverage part will consist of:

- one or more commercial auto declarations forms,
- one or more commercial auto coverage forms,
- any endorsements that may apply, and
- automobile coverage forms.

Different coverage forms have been designed for different types of commercial automobile exposures. A policy may include one or more of the following:

- Business Auto Coverage Form,
- Business Auto Physical Damage Coverage Form,
- Garage Coverage Form,
- Truckers Coverage Form, and
- Motor Carrier Coverage Form.

Two variations of the business auto coverage form are available for special types of risks. The garage coverage form is used to insure garage risks, such as service and repair shops, which have a premises-operations exposure and have temporary possession of customers' cars. The truckers coverage form is used to insure vehicles for trucking businesses that haul goods for others, and which frequently exchange trailers with other businesses.

One other form, the business auto physical damage coverage form, is also available for businesses that only have a physical damage exposure. However this isn't often the case. Example: If you had cars on permanent static display, you might only face a physical damage risk. In most cases, if you drive a car you have at least some liability risks.

Since the coverage provided by this form is identical to the physical damage coverage included in the business auto coverage form, we do not review this form separately.

A modular approach is usually taken under which the same forms are used to construct monoline and package policies. The business auto coverage form describes the automobile coverages and establishes conditions that apply only to these coverages. If a particular

business also has garage or trucking operations, the additional coverage forms may be attached. Together, the automobile coverage forms complete what is known as a Commercial Auto Coverage Part.

ISO's standards business auto coverage forms were revised in 1990 and again in 1993. These new coverage forms may be issued as monoline policies or as part of a commercial package. Because business auto coverage policies are usually based on standardized ISO forms, the coverages written by different companies are easy to compare.

Declarations

Special declarations forms have been developed for use with the business auto coverage form.

There are two variations of the declarations for each coverage—one for use when issued as part of a package policy, and one for use when coverage is issued as a monoline policy. One or the other must always be used. Most of the information is the same on the two forms. The only difference is found in "item one," which shows the general policy information.

The essential information for defining auto coverage terms

Both variations of the declarations identify the named insured, the policy number and the form of business (corporation, partnership, etc.). When coverage is written as part of a package, the business auto coverage form declarations is used. It is the shorter of the two forms, and does not duplicate information which is shown on the common policy declarations. When coverage is written as a monoline policy, the business auto declarations is used. In "item one" this form has additional information showing the mailing address of the named insured, the identity of the insurance company and the producer, and the policy period. This additional information is necessary to make the monoline coverage a complete insurance contract.

The business auto declarations are lengthy and are divided into six sections. The declarations show the vehicles insured and the coverages provided, along with rates, premiums, deductibles and other information typically found on policy declarations. When numerous vehicles are insured, separate schedules of the vehicles may be attached. The information is grouped in the following ways:

- Item One—General information about the risk
- Item Two—Coverages, coverage symbols, limits of liability and the premium for each coverage
- Item Three—Schedule of owned autos
- Item Four—Schedule of hired or borrowed autos
- Item Five—Schedule for non-ownership liability
- Item Six—Schedule of gross receipts or mileage for liability coverage for public auto or leasing rental concerns

Various sections of the declarations will be completed as appropriate for the coverages being written. If a particular coverage does not apply, that section will be left blank.

The policy

The business auto coverage form is divided into five distinct sections. The sections of the coverage form are:

- Section I—Covered autos
- Section II—Liability coverage
- Section III—Physical damage coverage
- Section IV—Business auto conditions
- Section V—Definitions

Provisions for two common coverages, medical payments and uninsured motorists coverage, are not included in the coverage form. These are options which do appear on the declarations page, but endorsements must be attached to put the coverages into effect.

> Various provisions in this policy restrict coverage. Read the entire policy carefully to determine rights, duties and what is and is not covered. Throughout this policy the words "you" and "your" refer to the Named Insured shown in the Declarations. The words "we," "us" and "our" refer to the Company providing this insurance.
> Other words and phrases that appear in quotation marks have special meaning. Refer to Section V—Definitions.

You have to read the "entire policy," not isolated parts

The coverage form begins with a few simple statements. First it cautions you to read the "entire policy," meaning all parts of the policy in addition to this coverage form. It then explains that various pronouns (such as "you" and "we") are used to refer to the named insured and the insurance company. The last statement points out that the coverage form has a specific "definitions" section, and that the meaning of any words that appear in quotation marks can be found in that section.

The policy provisions that follow are organized numerically and alphabetically. Roman numerals are used to designate the major sections of the form, and letters and numbers are used to designate respective subsections.

> **SECTION I:**
> **COVERED AUTOS**
> Item two of the Declarations shows the "autos" that are covered "autos" for each of your coverages. The following numerical symbols describe the "autos" that may be covered "autos." The symbols entered next to a coverage on the Declarations designate the only "autos" that are covered "autos".

Chapter Four: Business Auto

A. DESCRIPTION OF COVERED AUTO DESIGNATION SYMBOLS
SYMBOL DESCRIPTION
1 Any "auto".
2 Owned "autos" only. Only those "autos" you own (and for Liability Coverage any "trailers" you don't own while attached to power units you own). This includes those "autos" you acquire ownership of after the policy begins.
3 Owned Private Passenger "Autos" Only. Only the private passenger "autos" you own. This includes those private passenger "autos" you acquire ownership of after the policy begins.
4 Owned "Autos" Other Than Private Passenger "Autos" Only. Only those "autos" you own that are not of the private passenger type (and for Liability Coverage any "trailers" you don't own while attached to power units you own). This includes those "autos" not of the private passenger type you acquire ownership of after the policy begins.
5 Owned "Autos" Subject To No-Fault. Only those "autos" you own that are required to have No-Fault benefits in the state where they are licensed or principally garaged. This includes those "autos" you acquire ownership of after the policy begins provided they are required to have No-Fault benefits in the state where they are licensed or principally garaged.
6 Owned "Autos" subject to a Compulsory Uninsured Motorists Law. Only those "autos" you own that because of the law in the state where they are licensed or principally garaged are required to have and cannot reject Uninsured Motorists Coverage. This includes those "autos" you acquire ownership of after the policy begins provided they are subject to the same state uninsured motorists requirement.
7 Specifically Described "Autos." Only those "autos" described in Item Three of the Declarations for which a premium charge is shown (and for Liability Coverage any "trailers" you don't own while attached to any power unit described in Item Three).
8 Hired "Autos" Only. Only those "autos" you lease, hire, rent or borrow. This does not include any "autos" you lease, hire, rent, or borrow from any of your employees or partners or members of their households.
9 Nonowned "Autos" Only. Only those "autos" you do not own, lease, hire, rent or borrow that are used in connection with your business. This includes "autos" owned by your employees or partners or members of their households but only while used in your business or your personal affairs.

The policy uses "symbols" to designate what kind of cars are covered under the various parts of the policy.

Symbols help define covered vehicles

Section I of the coverage form lists the nine symbols which may be used to identify "covered autos," and describes each one. Business auto coverage applies only to those autos which are identified as "covered autos" in the declarations by entry of the appropriate numerical symbol(s) after each coverage purchased.

Coverage may be tailored to your needs by selection of the appropriate symbols. Different symbols may be used for different coverages.

If no symbol is shown for a particular coverage, then that coverage is not provided. More than one symbol may be shown for a given coverage if there is no conflict or overlap between the symbol descriptions—for example, the same coverage could apply to "owned autos" and "hired autos" (symbols 2 and 8).

The broadest coverage available is reflected by symbol 1, because "any auto" includes all owned, hired, and nonowned autos. You may purchase the most narrow coverage by using symbol 7 and requesting that a coverage apply only to "specifically described autos." It is not uncommon for a policyholder to purchase liability coverage for "any auto," and to purchase physical damage coverage only for some specifically described autos. Liability insurance—of any kind—is the most important type to secure because liability risks pose the greatest threat to a business's financial well-being.

Symbols 3 and 4 would be used if you wanted a particular coverage to apply only to owned private passenger autos or to owned autos other than private passenger autos. Symbols 5 and 6 can be used to activate no-fault benefits and compulsory uninsured motorists coverage for owned autos which are required to have such benefits in the state where they are licensed or principally garaged.

Hired autos includes all autos you lease, hire, rent, or borrow, but not autos owned by employees or members of their households. Nonowned autos include all autos you do not own, lease, hire, or borrow which are used in connection with the business, including autos owned by employees or members of their households while being used in your business.

Some symbols only apply to specific kinds of insurance

Certain symbols may be used only with specific types of coverage. Symbols 1, 2, 3, 4, 7, 8 and 9 may be used to designate liability coverage. But liability is the only coverage for which symbol 1 may be used, because other coverages cannot apply to "any auto"—no-fault benefits, medical payments, uninsured motorists and physical damage coverages are not available for "nonowned autos."

Symbols 2, 3, 4, 7 and 8 may be used to designate physical damage coverages. Symbol 5 may only be used to designate no-fault benefits. Symbol 6 may only be used to designate uninsured motorists coverage for certain vehicles for which the coverage is mandatory, but broader uninsured motorists coverage for all owned vehicles (whether the coverage is mandatory or voluntary) may be provided by showing symbol 2 for this coverage.

Business auto policies extensively define coverage

The issue of which cars—and which people—are covered by a commercial auto policy can be very complicated. Unlike personal auto policies, business auto policies go to great lengths to define coverage. The 1993 federal appeals court decision *Volkswagen of America, Greg*

Harmon et al. v. Hartford Casualty Insurance illustrates how the issues of corporate ownership and structure can complicate the definition of "covered auto" in a commercial auto policy.

While on partnership business, a truck owned by Dexter Rogers collided with Greg Harmon's automobile. Harmon suffered serious injuries which resulted in the amputation of one of his legs.

Hartford—which had written the commercial coverage for the Rogers partnership—denied coverage for the accident on the ground that its policy provided coverage only for nonowned autos and for hired autos, and that the truck in question was owned by one of the partners.

The Rogers partnership had a separate commercial policy issued by Cal-Farm Insurance Co., which listed Rogers's truck as a covered auto and which provided coverage for business and personal use. Cal-Farm ultimately paid Harmon $100,000, its policy limit. Harmon wasn't satisfied with this amount.

Harmon reached a settlement with Dexter Rogers and Pamela Lourence, who had driven the truck. He received a judgment of $1.4 million against Rogers and Lourence, who assigned him their rights under the Hartford policy. Harmon then sued the insurance company.

A separate schedule defined which autos were covered

The trial court rejected Harmon's suit, ruling that Hartford's denial of coverage was appropriate. The Rogers partnership's insurance policy contained a common schedule of coverages and covered autos that stated:

> This policy provides only those coverages for which a charge is shown in the premium column below. Each of these coverages will apply only to the autos shown as covered autos. Autos are shown as covered autos for a particular coverage by the entry in the covered auto column below, next to the name of the coverage....

The entries in the covered auto column indicated that the policy provided auto coverage for "hired autos only" and "nonowned autos only." This coverage applied to:

> Only those autos you do not own, lease, hire, or borrow which are used in connection with your business. This includes autos owned by your employees or members of their households but only while used in your business or your personal affairs....

Looking for an ambiguity that would create coverage

Harmon argued that the "you" in that definition referred only to the Rogers Partnership—not any specific member of the partnership. He argued that the trial court's summary dismissal of his case was therefore improper, because a dispute remained as to whether the truck involved in the accident was owned by Dexter Rogers personally or by the partnership.

However, the appeals court cited a separate endorsement to the policy

which excluded partner-owned autos from coverage. This endorsement stated:

> If you are a partnership, no auto owned by any of your partners or members of their households is a covered auto for the LIABILITY INSURANCE unless the policy is endorsed to cover that auto as a covered auto and the proper premium is charged.

Therefore, the appeals court ruled, the factual dispute concerning ownership of the truck was irrelevant. The truck was excluded from coverage under the policy either as an auto owned by the partnership—as the policy stated—or as an auto owned by one of the partners—as the endorsement stated.

Harmon argued that these two sections conflicted and created an ambiguity in the policy. And, as you should now know, an ambiguity in a policy will usually create a presumption of coverage.

But the appeals court hammered down against this argument:

> [Harmon] seeks to cloud the clear meaning of this policy by introducing an issue of ambiguity where none exists.
>
> Although an ambiguous policy must be read to favor coverage, [Harmon's] argument fails on two distinct grounds.

A court refuses to extend the definition of "insured auto"

> First, [his] construction of the nonowned auto provision as extending coverage beyond employee-owned autos runs counter to the plain meaning of the policy when read as a whole. In the Schedule for Non-Ownership Liability, the "rating basis" for nonowned auto coverage is the number of employees and the premium is based on an estimate of 10 employees. To find that this coverage was meant to extend beyond employees to other persons, including the partners, would require a strained interpretation of the policy.
>
> Second, [the disputed endorsement], which excludes partner-owned autos from coverage, states clearly at the heading of the page:
>
> "THIS ENDORSEMENT CHANGES THE POLICY. PLEASE READ IT CAREFULLY."
>
> If there is a conflict in meaning between this endorsement and the body of the policy with regard to coverage of partner-owned vehicles, the endorsement controls.

So, the appeals court affirmed the trial court's grant of summary judgment in favor of Hartford.

> B. OWNED AUTOS YOU ACQUIRE AFTER THE POLICY BEGINS
> 1. If symbols 1, 2, 3, 4, 5 or 6 are entered next to a coverage in Item Two of the Declarations, then you have coverage for "autos" that you acquire of the type described for the remainder of the policy period.

2. But, if symbol 7 is entered next to a coverage in Item Two of the Declarations, an "auto" you acquire will be a covered "auto" for that coverage only if:

a. We already cover all "autos" that you own for that coverage or it replaces an "auto" you previously owned that had that coverage; and

b. You tell us within 30 days after you acquire it that you want us to cover it for that coverage.

C. CERTAIN TRAILERS, MOBILE EQUIPMENT AND TEMPORARY SUBSTITUTE AUTOS

If Liability Coverage is provided by this Coverage Form, the following types of vehicles are also covered "autos" for Liability Coverage:

1. "Trailers" with a load capacity of 2,000 pounds or less designed primarily for travel on public roads.

2. "Mobile equipment" while being carried or towed by a covered "auto".

3. Any "auto" you do not own while used with the permission of its owner as a temporary substitute for a covered "auto" you own that is out of service because of its:

a. Breakdown;
b. Repair;
c. Servicing;
d. "Loss"; or
e. Destruction.

Newly acquired autos are automatically covered until the end of the policy term if symbols 1, 2, 3, 4, 5 or 6 are entered next to a coverage.

If symbol 7 is entered next to any coverage, a newly acquired auto will be automatically insured under that coverage for 30 days only if it is a replacement auto, or the insurance company already insures all autos owned by you for that coverage. To continue coverage for a newly acquired auto when "specifically described autos" are insured, the vehicle must be reported to the insurance company before the end of the 30-day period.

Extensions to auto coverage

For liability coverage only, "owned autos" is automatically extended to include small trailers, "mobile equipment" while it is being carried or towed by a covered auto, and any auto that is a temporary substitute for a covered auto that is out of service because of its breakdown, repair, servicing, loss or destruction. When symbols 2, 4 or 7 apply, liability coverage also applies to any nonowned trailers while attached to power units owned by the named insured or specifically described in the declarations (this provision is stated in the coverage symbol descriptions).

These extensions of the definition of "covered auto" are given because the above situations do not significantly change the liability exposure. Small trailers are covered because the exposure is minimal. Nonowned trailers of any size, and mobile equipment, are covered for liability while being towed or carried by a covered auto because they become an extension of the covered auto. The driver of the covered

auto is in control, and in the event of an accident it would be difficult to separate injury or damage caused by each unit separately. Temporary substitute autos are covered because they replace a covered auto and the exposure is essentially unchanged.

> **SECTION II:**
> **LIABILITY COVERAGE**
> A. COVERAGE
> We will pay all sums an "insured" legally must pay as damages because of "bodily injury" or "property damage" to which this insurance applies, caused by an "accident" and resulting from the ownership, maintenance or use of a covered "auto".
> We will also pay all sums an "insured" legally must pay as a "covered pollution cost or expense" to which this insurance applies, caused by an "accident" and resulting from the ownership, maintenance or use of covered "autos". However, we will only pay for the covered pollution cost or expense" if there is either "bodily injury" or "property damage" to which this insurance applies that is caused by the same "accident."
> We have the right and duty to defend any "suit" asking for such damages or a "covered pollution cost or expense." However, we have no duty to defend "suits" for "bodily injury" or "property damage" damage or a "covered pollution cost or expense" not covered by this Coverage Form. We may investigate and settle any claim or "suit" as we consider appropriate. Our duty to defend or settle ends when the Liability Coverage Limit of Insurance has been exhausted by payment of judgments or settlements.

The policy defines "damages" which are covered

This is a typical insuring agreement for liability insurance coverage. The insurance company agrees to pay sums that you become legally obligated to pay "as damages" because of bodily injury or property damage. The injury or damage must result from an accident and arise out of an insured automobile exposure.

Remember, an automobile can do a great deal of harm and property damage to others. These are the exposures which can jeopardize the financial strength and management focus of any business.

The insurance also applies to "covered pollution cost or expense," but this is an extremely limited type of coverage. As you will see when you review the policy definitions, this applies only to a demand or order to clean up, remove or neutralize pollution caused by the escape of substances (such as fuel or motor oil) that escape from an automobile's normal operating systems. There is no coverage for any pollution resulting from the escape of any substances being transported, stored, treated or processed in or upon a covered auto.

Example: If your business transports a drum of pesticide in a pickup truck and that pesticide is spilled on the highway, the cost of clean-up would not be covered.

Business auto liability coverage is usually written with a single limit

Chapter Four: Business Auto

of liability (split limits are available by endorsement). Up to that limit, the insurance company agrees to pay your legal obligations for damages caused by a covered accident resulting in bodily injury or property damage, to pay your legal obligations for covered pollution cost resulting from a covered accident, and to defend, investigate, and settle suits and claims. The duty to defend and settle ends when the limit of insurance has been exhausted by payment of judgments or settlements. There is no duty to provide a defense for any bodily injury or property damage not covered by the coverage form.

The final paragraph in this section spells out the insurance company's right and duty to defend suits and to investigate and settle claims. However, there is no duty to defend suits or claims for damages which are not covered by the policy form, or to defend after the limit of liability has been exhausted by the payment of claims.

Some experts have argued that the insurance company is obligated to defend you regardless of the amount of money spent on settlements. However, you can't count on this.

> 1. WHO IS AN INSURED
> The following are "insureds":
> a. You for any covered "auto".
> b. Anyone else while using with your permission a covered "auto" you own, hire or borrow except:
> (1) The owner or anyone else from whom you hire or borrow a covered "auto". This exception does not apply if the covered "auto" is a "trailer" connected to a covered "auto" you own.
> (2) Your employee if the covered "auto" is owned by that employee or a member of his or her household.
> (3) Someone using a covered "auto" while he or she is working in a business of selling, servicing, repairing, parking or storing "autos" unless that business is yours.
> (4) Anyone other than your employees, partners, a lessee or borrower or any of their employees, while moving property to or from a covered "auto".
> (5) A partner of yours for a covered "auto" owned by him or her or a member of his or her household.
> c. Anyone liable for the conduct of an "insured" described above but only to the extent of that liability.

Who is insured against liability claims

This section clarifies who is insured by the liability coverage. To the extent that coverage is not limited by exclusions, an "insured" includes:

- the named insured for any covered auto;
- the owner or anyone else from whom a trailer is hired or borrowed and connected to an auto owned by the named insured;

- anyone while using with permission a covered auto owned, hired, or borrowed by the named insured (except for the five excluded classes below); and
- anyone liable for the conduct of an insured person, but only to the extent of that liability.

The following five classes of people are not insured for liability exposure under the business auto coverage part:

- the owner or anyone else from whom the named insured hires or borrows a covered auto;
- employees of the named insured, if the covered auto is owned by that employee or a member of that employee's household;
- anyone using a covered auto while working in a business of selling, servicing, repairing, or parking autos if it is not the named insured's business;
- anyone other than the named insured's employees, a lessee or borrower or any of their employees, while moving property to or from a covered auto;
- a partner of the named insured's, for any covered auto owned by that partner or a member of his or her household.

The people who aren't covered for liability

These exclusions are designed to preclude automatic coverage for the exposures of others which should properly be insured elsewhere. For example, if an employee uses a personal auto in the business of the named insured, the business auto coverage could cover the liability of the employer for use of the auto (symbol 1 or 9 must apply). It would not cover the employee or a family member if named in a suit as the owner or driver. Of course, such an owner should have protection under their own personal auto policy.

In all of these cases the "named insured" would have liability coverage for any accidents that occur, but the owners or operators of such vehicles would not be covered under your business auto liability coverage if they were named in a suit or claim—they should have their own liability insurance for these exposures.

The 1992 federal district court decision *National American Insurance Co. v. Central States Carriers* illustrates how complex auto ownership issues—including liability—can be.

In June 1988, near Lafayette, Indiana, a semi tractor driven by Dwight Smith collided with an automobile driven by Rob Travis. Travis was killed. Smith, who had been driving under the influence of alcohol, was incarcerated.

Smith—an employee of Central States—had been scheduled to drive to Chicago on the morning of June 6, 1988. Because he was to leave early, he took the tractor on the evening before. On his way home, he

drove the tractor to Lafayette and spent the evening drinking heavily at several local taverns. It was after the festivities—on his way home—that Smith hit Travis.

The ownership of the truck Smith was driving was a complicated matter. There was a lease between the truck's corporate owner and Wanco Transportation—which, in turn, had loaned it to Central States. The lease provided, among other things, that Wanco would have exclusive control and complete responsibility over the leased equipment, and that Wanco would secure liability insurance. Wanco did obtain insurance from Industrial Indemnity, Inc.

Wanco did not take actual physical possession of the truck pursuant to the lease, nor did Wanco ever designate freight to be hauled under the lease. Had the load been successfully hauled, Wanco, Central States, and Sculley Trucking—the actual owner of the truck—would each have received a percentage of the revenue.

Travis's widow filed suit against Smith, Central States Carriers and Wanco Transportation. That lawsuit was settled before trial with the payment of $250,000 plus attorney fees by Central States' insurer, National American Insurance Co.

However, National American wasn't happy about paying. It sued Wanco and Industrial Indemnity, seeking indemnity for the settlement under the theory of subrogation. It argued that it had been forced to pay the settlement because government-mandated truck ownership rules had obscured true ownership and liability.

A complicated case of who actually owned the truck

Once the settlement had been paid, the issue of who was ultimately responsible arose. National American chose Wanco and Industrial Indemnity. The court was inclined to agree:

> Dwight Smith's accident assertedly became Wanco's, and therefore Industrial Indemnity's, problem because Wanco was the lessee of the tractor at the time of the collision.

The lease between Sculley Trucking and Wanco contained government-required statements that Wanco would "have exclusive possession, control, and use of the equipment for the duration of the lease," and "shall assume complete responsibility for the operation of the equipment for the duration of the lease." This was the confusing language to which National American had alluded.

What's more, the court concluded that government rules weren't the only confusing part of the story:

> ...evidence indicated that business operations among Sculley Trucking, Central States, and Wanco were rather relaxed: the trucks were all stored on the same lot, Central States' drivers were sometimes assigned to Wanco trucks, and profits were apportioned among all three companies. Though Wanco did not zealously control its leased tractor...the evidence does not show that

this was anything but a bona fide lease which the court does not need to disturb.

Given the court's determination that Wanco—as lessee of the truck—was liable, the next question was whether the truck was covered by Wanco's Industrial Indemnity policy.

The Industrial Indemnity policy covered vehicles which are "hired" or "owned autos." The definition of "hired" includes autos which were leased, hired, rented or borrowed. The truck Dwight Smith drove was therefore a "covered auto."

The next question was whether Wanco's leased truck was covered when Central States was using it. The Industrial Indemnity policy provided that the following were insureds:

> You for any covered "auto."

> Anyone else while using with your permission a covered "auto" you own, hire or borrow except:

> ...The owner or anyone else from whom you hire or borrow a covered "private passenger type auto."

> ...Anyone other than your employees, partners, a lessee or borrower or any of their employees, while moving property to or from a covered "auto."

> ...A partner of yours for a covered "private passenger type auto" owned by him or her or a member of his or her household.

An insurance company tries desperately to find an exception

None of the above exceptions were applicable. However, Industrial Indemnity pointed to policy language which specifically excepted from coverage:

> ...the owner or anyone else from whom you hire or borrow a covered "auto" that is not a "trailer" while the covered "auto"...is being used exclusively in your business as a "trucker"....

Industrial Indemnity argued that this language eliminated Central States as an insured entity because the truck was not being used exclusively in Wanco's business. But the court didn't agree with this interpretation:

> Wanco leased the truck from Sculley Trucking, not from Central States, which was the borrower....

> Sculley Trucking's elimination from insured status is irrelevant.... Central States remains within the definition of "insured" as "anyone else while using with your permission a covered "auto" you own, hire or borrow...."

Since the vehicle was a "covered auto" and Central States was an "insured," Industrial Indemnity was liable for claims arising from Rob Travis's death.

Chapter Four: Business Auto

The court ruled that Industrial Indemnity should have paid the $225,000 to settle the litigation. It ordered Industrial Indemnity to reimburse National American that amount. It also ordered Industrial Indemnity to pay National American $7,981.35 in legal costs incurred defending Central States.

Coverage extensions come in addition to standard liability limits

2. COVERAGE EXTENSIONS
a. Supplementary Payments. In addition to the Limit of Insurance, we will pay for the "insured":
(1) All expenses we incur.
(2) Up to $250 for cost of bail bonds (including bonds for related traffic law violations) required because of an "accident" we cover. We do not have to furnish these bonds.
(3) The cost of bonds to release attachments in any "suit" we defend, but only for bond amounts within our Limit of Insurance.
(4) All reasonable expenses incurred by the "insured" at our request, including actual loss of earning up to $100 a day because of time off from work.
(5) All costs taxed against the "insured" in any "suit" we defend.
(6) All interest on the full amount of any judgment that accrues after entry of the judgment in any "suit" we defend; but our duty to pay interest ends when we have paid, offered to pay or deposited in court the part of the judgment that is within our Limit of Insurance.
b. Out-of-State Coverage Extensions.
While a covered "auto" is away from the state where it is licensed we will:
(1) Increase the Limit of Insurance for Liability Coverage to meet the limits specified by a compulsory or financial responsibility law of the jurisdiction where the covered "auto" is being used. This extension does not apply to the limit or limits specified by any law governing motor carriers of passengers or property.
(2) Provide the minimum amounts and types of other coverages, such as no-fault, required of out-of-state vehicles by the jurisdiction where the covered "auto" is being used.
We will not pay anyone more than once for the same elements of loss because of these extensions.

Two types of liability coverage extensions are provided. First, the insurance company agrees to make a number of supplementary payments in addition to amounts which are subject to the limit of insurance. These include expenses incurred by both you and the insurance company, the cost of certain bonds, costs taxed against you, and interest on final judgments.

The second extension is for out-of-state coverage. To the extent that the laws of another state where a covered auto is being used require minimum amounts of liability coverage which are higher than your policy limit, or require other types of coverage such as no-fault benefits, the policy will automatically provide the minimum amounts and types of coverages.

A caveat: For most businesses, minimum coverage limits leave significant exposure to various liabilities. You'll probably want to carry liability coverage in excess of state minimums. If you decide to absorb the risk and carry only state minimums, your agent or broker may ask you to sign a waiver indictating that you understand that this coverage is modest.

Liability exclusions

Expected or intended liabilities aren't covered

B. EXCLUSIONS
This insurance does not apply to any of the following:
1. EXPECTED OR INTENDED INJURY
"Bodily injury" or "property damage" expected or intended from the standpoint of the "insured."
2. CONTRACTUAL
Liability assumed under any contract or agreement.
But this exclusion does not apply to liability for damages:
a. Assumed in a contract or agreement that is an "insured contract" provided the "bodily injury" or "property damage" occurs subsequent to the execution of the contract or agreement; or
b. That the "insured" would have in the absence of the contract or agreement.
3. WORKERS COMPENSATION
Any obligation for which the "insured" or the "insured's" insurer may be held liable under any workers compensation, disability benefits or unemployment compensation law or any similar law.
4. EMPLOYEE INDEMNIFICATION AND EMPLOYER'S LIABILITY
"Bodily injury" to:
a. An employee of the "insured" arising out of and in the course of employment by the "insured"; or
b. The spouse, child, parent, brother or sister of that employee as a consequence of paragraph a. above.
This exclusion applies:
(1) Whether the "insured" may be liable as an employer or in any other capacity; and
(2) To any obligation to share damages with or repay someone else who must pay damages because of the injury.
But his exclusion does not apply to "bodily injury" to domestic employees not entitled to workers compensation benefits or to liability assumed by the "insured" under an "insured contract."
5. FELLOW EMPLOYEE
"Bodily injury" to any fellow employee of the "insured" arising out of and in the course of the fellow employee's employment.

No coverage for liabilities assumed under contract

The liability section of the business auto coverage form lists 12 exclusions. Exclusions generally appear in insurance policies to remove coverage for three types of losses: 1) losses which are not insurable, 2) losses which should be covered by other types of insurance coverage, and 3) losses which result from an above-average exposure and

for which coverage is not provided automatically, but for which optional coverage may be available at an additional cost. Most of the liability exclusions fall into the first two categories.

The first exclusion eliminates coverage for expected or intended losses, because they are not insurable. Coverage applies only to unexpected and accidental injury or damage.

On the surface the contractual liability exclusion may be misleading—it eliminates coverage for liability assumed under contract, but it does not apply to an "insured contract." As you will see when you review the definitions, the meaning of an "insured contract" is actually very broad, and many contracts or agreements are covered.

The next three exclusions relate to injuries to employees and others which are part of your workers compensation and employers liability exposures. Auto liability insurance is designed to cover injuries to third parties who do not work for you. Injuries to employees, even when caused by a fellow employee, which arise out of and in the course of employment should be covered by workers compensation insurance.[1]

The numerous business functions that cannot create auto coverage liability

6. CARE, CUSTODY OR CONTROL
"Property damage" to or "covered pollution cost or expense" involving property owned or transported by the "insured" or in the "insured's" care, custody or control. But this exclusion does not apply to liability assumed under a sidetrack agreement.

7. HANDLING OF PROPERTY
"Bodily injury" or "property damage" resulting from the handling of property:
a. Before it is moved from the place where it is accepted by the "insured" for movement into or onto the covered "auto" ; or
b. After it is moved from the covered "auto" to the place where it is finally delivered by the "insured."

8. MOVEMENT OF PROPERTY BY MECHANICAL DEVICE
"Bodily injury" or "property damage" resulting from the movement of property by a mechanical device (other than a hand truck) unless the device is attached to the covered "auto".

9. OPERATIONS
"Bodily injury" or "property damage" arising out of the operation of any equipment listed in paragraphs 6.b. and 6.c. of the definition of "mobile equipment."

10. COMPLETED OPERATIONS
"Bodily injury" or "property damage" arising out of your work after that work has been completed or abandoned.
In this exclusion, your work means:
a. Work or operations performed by you or on your behalf; and
b. Materials, parts or equipment furnished in connection with such work or operations.
Your work includes warranties or representations made at any time

[1] For a more detailed discussion of workers compensation insurance, see Chapter 5.

> with respect to the fitness, quality, durability or performance of any of the items included in paragraphs a. or b. above.
>
> Your work will be deemed completed at the earliest of the following times:
>
> (1) When all of the work called for in your contract has been completed.
> (2) When all of the work to be done at the site has been completed if your contract calls for work at more than one site.
> (3) When that part of the work done at a job site has been put to its intended use by any person or organization other than another contractor or subcontractor working on the same project.
>
> Work that may need service, maintenance, correction, repair or replacement, but which is otherwise complete, will be treated as completed.

There is no coverage for damage involving property owned or being transported by you, or to property in your care, custody or control. These exposures should be covered by commercial property coverages. Liability insurance is designed to cover your legal obligation for damages suffered by others.

Injury or damage resulting from the handling of property before it is accepted for loading onto a covered auto, or after it is unloaded from a covered auto, is excluded because this is part of your general liability exposure and is not an automobile liability exposure.

Automobile liability coverage applies while property is being loaded or unloaded manually or by a hand truck, but not by any mechanical device (such as a forklift) which is not attached to the auto. This is another general liability exposure.

Forklifts, cherry pickers and other specialty vehicles are not covered

Injury or damage arising out of the "operation" of certain types of "mobile equipment" is excluded because it is a general liability exposure. This applies to self-propelled vehicles upon which cherry pickers or similar devices are mounted to raise and lower workers, or which have permanently attached equipment such as air compressors, pumps and generators used for spraying, welding and other purposes.

An exception to the definition of "mobile equipment" states that these vehicles are considered to be "autos," and they are insured under auto liability coverage while they are being driven to and from job sites.

Example: A back-hoe driven on public roads for a brief distance between two job sites would be covered for liability under this coverage. But as soon as it is being "operated" for its intended purpose, the risk shifts to a general liability exposure.

(A similar exception in the exclusions of the general liability coverage form is made to pick up the coverage where the auto liability coverage ends.)

Injury or damage arising out of your "completed operations" is excluded because this is another general liability exposure. Example: If the back-hoe were driven to a construction site on which a building was completed and later collapsed, the resulting loss would not be covered even though insured vehicles had been used in its construction.

An important exclusion: pollution liability linked to cargo or other transported goods

11. POLLUTION
"Bodily injury" or "property damage" arising out of the actual, alleged or threatened discharge, dispersal, seepage, migration, release or escape of "pollutants":
a. That are, or that are contained in any property that is:
(1) Being transported or towed by, handled, or handled for movement into, onto or from, the covered vehicle;
(2) Otherwise in the course of transit by or on behalf of the "insured"; or
(3) Being stored, disposed of, treated or processed in or upon the covered "auto";
b. Before the "pollutants" or any property in which the "pollutants" are contained are moved from the place where they are accepted by the "insured" for movement into or onto the covered "auto"; or
c. After the "pollutants" or any property in which the "pollutants" are contained are moved from the covered "auto" to the place where they are finally delivered, disposed of or abandoned by the "insured."
Paragraph a. above does not apply to fuels, lubricants, fluids, exhaust gases or other similar "pollutants" that are needed for or result from the normal electrical, hydraulic or mechanical functioning of the covered "auto" or its parts, if:
(1) The "pollutants" escape, seep, migrate, or are discharged, dispersed or released directly from an "auto" part designed by its manufacturer to hold, store, receive or dispose of such "pollutants"; and
(2) The "bodily injury," "property damage," or "covered pollution cost or expense" does not arise out of the operation of any equipment listed in paragraphs 6.b. and 6.c. of the definition of "mobile equipment."
Paragraphs b. and c. above of this exclusion do not apply to "accidents" that occur away from premises owned by or rented to an "insured" with respect to "pollutants" not in or upon a covered "auto" if:
(1) The "pollutants" or any property in which the "pollutants" are contained are upset, overturned or damaged as a result of the maintenance or use of a covered "auto"; and
(2) The discharge, dispersal, seepage, migration, release or escape of the "pollutants" is caused directly by such upset, overturn, or damage.
12. WAR
"Bodily injury" or "property damage" due to war, whether or not declared, or any act or condition incident to war. War includes civil war, insurrection, rebellion or revolution. This exclusion applies only to liability assumed under a contract or agreement.

The final liability exclusions remove coverage for most forms of pollution and for any injury or damage resulting from acts of war.

The pollution exclusion is designed to reinforce the other policy language describing the limited coverage for "pollution cost or expense" and the related definitions. Nearly all forms of pollution liability resulting from substances being transported, towed by, stored or processed in or upon a covered auto are excluded. These risks are designed to be covered under a pollution liability endorsement—or separate environmental impairment liability insurance. An exception is made for the escape of certain substances, such as fuel and motor oil, from the normal operating systems of a covered auto.

Any injury or damage resulting from war or any act of war is excluded because war is a catastrophic peril and is usually not insurable. Although it is unlikely that this cause of loss and your automobile liability exposure would overlap, a war exclusion is commonly found in many types of insurance policies.

The single limit that usually applies to all auto coverage

> C. LIMIT OF INSURANCE
> Regardless of the number of covered "autos," "insureds," premiums paid, claims made or vehicles involved in the "accident," the most we will pay for the total of all damages and "covered pollution cost or expense" combined, resulting from any one "accident" is the Limit of Insurance for Liability Coverage shown in the Declarations.
> All "bodily injury," "property damage," and "covered pollution cost or expense" resulting from continuous or repeated exposure to substantially the same conditions will be considered as resulting from one "accident."

Business auto liability coverage is usually written with a single limit of insurance that applies per accident. This section states that the limit shown in the declarations is the most the insurance company will pay for "all damages" resulting from any one accident, regardless of the number of covered autos, insureds, claims made, or vehicles involved. (But any covered supplementary payments will be paid in addition to the limit of insurance.)

Although we often think of an automobile "accident" as something that occurs suddenly, as in the case of collision, the term also includes repeated exposure to the same conditions. The last paragraph clarifies that continuous or repeated exposure to substantially the same conditions is considered to be "one accident." This eliminates the possibility of a claimant seeking damages in excess of the limit of insurance on the basis of repeated exposure.

Example: Your overloaded truck continuously drives by a nearby business and eventually causes $300,000 of structural damage to the building from repeated ground vibrations. Your limit of coverage is $100,000. The claimant sues for the entire $300,000 and argues that your truck passed by on at least three occasions. Although this accidental damage may be covered, the most the insurance company will pay is $100,000 because it is a single accident.

No one is entitled to receive duplicate payments for the same elements of loss under the liability coverage and under any medical payments, uninsured motorists, or underinsured motorists coverage endorsements attached to the coverage part.

Physical damage coverage

Coverage for physical damage to a covered vehicle

> **SECTION III:**
> **PHYSICAL DAMAGE COVERAGE**
> A. COVERAGE
> 1. We will pay for "loss" to a covered "auto" or its equipment under:
> a. Comprehensive Coverage. From any cause except:
> (1) The covered "auto's" collision with another object; or
> (2) The covered "auto's" overturn.
> b. Specified Causes of Loss Coverage. Caused by:
> (1) Fire, lightning or explosion;
> (2) Theft;
> (3) Windstorm, hail or earthquake;
> (4) Flood;
> (5) Mischief or vandalism; or
> (6) The sinking, burning, collision or derailment of any conveyance transporting the covered "auto".
> c. Collision Coverage. Caused by:
> (1) The covered "auto's" collision with another object; or
> (2) The covered "auto's" overturn.
> 2. Towing.
> We will pay up to the limit shown in the Declarations for towing and labor costs incurred each time a covered "auto" of the private passenger type is disabled. However, the labor must be performed at the place of disablement.
> 3. Glass Breakage—Hitting a Bird or Animal—Falling Objects or Missiles.
> If you carry Comprehensive Coverage for the damaged covered "auto," we will pay for the following under Comprehensive Coverage:
> a. Glass breakage;
> b. "Loss" caused by hitting a bird or animal; and
> c. "Loss" caused by falling objects or missiles.
> However, you have the option of having glass breakage caused by a covered "auto's" collision or overturn considered a "loss" under Collision Coverage.

Three separate insuring agreements

Under the physical damage section, the business auto coverage form agrees to pay for loss to a covered auto or its equipment under any of three separate insuring agreements—comprehensive coverage, specified causes of loss, and collision coverage. Each coverage applies only if one or more coverage symbols and a premium are shown in the declarations.

When comprehensive coverage applies, it will pay for loss from any cause—including theft—except collision with another object or over-

turn of the vehicle (which is the definition of collision coverage). Comprehensive coverage is written with a deductible, but the deductible will not apply to loss caused by fire or lightning (this provision is stated in the declarations and in the physical damage deductible provision, and does not appear here in the coverage agreements).

When specified causes of loss coverage applies, the coverage will only pay for loss caused by any of the perils specified in the agreement. A $25 deductible applies only to loss by vandalism or mischief (this provision is stated in the declarations and does not appear in the coverage form).

When collision coverage applies, it will pay for loss caused by collision with another object or the overturn of the auto. Note that "collision" does not necessarily mean collision with another vehicle—collision with a tree or a bridge is a covered collision. This coverage is written with a deductible.

Coverage for towing and labor costs

The physical damage section includes an agreement for towing and labor costs which are incurred when a covered auto is disabled. This coverage is optional. The amount of coverage for each disablement of an auto will be the limit shown in the declarations.

Special provisions apply to glass breakage, hitting a bird or animal, and damage caused by falling objects or missiles. If an auto is insured for comprehensive coverage, the insurance company will pay under the "comprehensive coverage" for glass breakage and loss by hitting a bird or animal, or loss caused by falling objects or missiles. This usually works to your advantage, because comprehensive is usually written with a lower deductible than collision coverage. However, you are given the option of having glass breakage paid as a collision loss—this removes a possible double deductible if glass breakage and other damage result from a collision.

> 4. Coverage Extension. We will pay up to $15 per day to a maximum of $450 for transportation expense incurred by you because of the total theft of a covered "auto" of the private passenger type. We will pay only for those covered "autos" for which you carry either Comprehensive or Specified Causes of Loss Coverage. We will pay for transportation expenses incurred during the period beginning 48 hours after the theft and ending, regardless of the policy's expiration, when the covered "auto" is returned to use or we pay for its "loss."

Extensions are available for transportation expenses

The physical damage section automatically includes an extension of coverage for transportation expenses incurred as a result of the total theft of private passenger vehicles, but only if such vehicles are covered for theft losses (comprehensive or specified causes of loss coverage). When applicable, after a 48-hour waiting period, the coverage will begin to pay up to $15 a day for transportation expenses, subject to a maximum payment of $450.

Chapter Four: Business Auto

> B. EXCLUSIONS
> 1. We will not pay for "loss" caused by or resulting from any of the following. Such "loss" is excluded regardless of any other cause or event that contributes concurrently or in any sequence to the "loss."
> a. Nuclear Hazard.
> (1) The explosion of any weapon employing atomic fission or fusion; or
> (2) Nuclear reaction or radiation, or radioactive contamination, however caused.
> b. War or Military Action.
> (1) War, including undeclared or civil war.
> (2) Warlike action by a military force, including action in hindering or defending against an actual or expected attack, by any government, sovereign or other authority using military personnel or other agents; or
> (3) Insurrection, rebellion, revolution, usurped power or action taken by governmental authority in hindering or defending against any of these.
> 2. Other Exclusions.
> a. We will not pay for "loss" to any of the following:
> (1) The decks or other sound reproducing equipment unless permanently installed in a covered "auto".
> (2) Tapes, records or other sound reproducing devices designed for use with sound reproducing equipment.
> (3) Sound receiving equipment designed for use as a citizens' band radio, two-way mobile radio or telephone or scanning monitor receiver, including its antennas and other accessories, unless permanently installed in the dash or console opening normally used by the "auto" manufacturer for the installation of a radio.
> (4) Equipment designed or used for the detection or location of radar.
> b. We will not pay for "loss" caused by or resulting from any of the following unless caused by other "loss" that is covered by this insurance:
> (1) Wear and tear, freezing, mechanical or electrical breakdown.
> (2) Blowouts, punctures or other road damage to tires.

Losses caused by nuclear hazards or war are excluded because these are catastrophic exposures.

Equipment in a covered auto that is not covered

Certain items, such as tape decks, CB radios, and other sound receiving equipment, are not covered unless permanently installed in the auto (portable or detachable devices are too easily removed). Tapes and records are not covered because they are easily lost, misplaced or removed. Equipment designed for radar detection is not covered because it suggests that the driver intends to violate speed laws, which is a practice the insurance companies want to discourage.

Maintenance type losses, such as wear and tear, mechanical breakdown, and tire damage, are not covered because these are expected as a consequence of using an automobile and do not result from accidents. An exception is made when these losses result from another covered cause of loss—if tires rupture due to a covered collision, the tire loss would be covered.

INSURING THE BOTTOM LINE

> C. LIMIT OF INSURANCE
> The most we will pay for "loss" in any one "accident" is the lesser of:
> 1. The actual cash value of the damaged or stolen property as of the time of the "loss"; or
> 2. The cost of repairing or replacing the damaged or stolen property with other property of like kind and quality.
> D. DEDUCTIBLE
> For each covered "auto," our obligation to pay for, repair, return or replace damaged or stolen property will be reduced by the applicable deductible shown in the Declarations. Any Comprehensive Coverage deductible shown in the Declarations does not apply to "loss" caused by fire or lightning.

The deductions applicable under physical damage coverage

The most the insurance company will pay for loss resulting from any one accident is the lesser of the actual cash value of the loss or the cost of repairing or replacing the damaged or stolen property. Recovery for physical damage losses will be reduced by any applicable deductible(s) shown in the declarations. However, any comprehensive coverage deductible shown in the declarations does not apply to loss caused by fire or lightning.

Conditions

> SECTION IV:
> BUSINESS AUTO CONDITIONS
> The following conditions apply in addition to the Common Policy Conditions:
> A. LOSS CONDITIONS
> 1. APPRAISAL FOR PHYSICAL DAMAGE LOSS
> If you and we disagree on the amount of "loss," either may demand an appraisal of the "loss." In this event, each party will select a competent appraiser. The two appraisers will select a competent and impartial umpire. The appraisers will state separately the actual cash value and amount of "loss." If they fail to agree, they will submit their differences to the umpire. A decision agreed to by any two will be binding. Each party will:
> a. Pay its chosen appraiser; and
> b. Bear the other expenses of the appraisal and umpire equally.
> If we submit to an appraisal, we will still retain our right to deny the claim.

General conditions that apply to business auto coverage

The business auto coverage form includes a number of loss conditions and general conditions that apply to the automobile insurance in addition to the common policy conditions.

The business auto conditions are divided into two sections—loss conditions and general conditions. These apply in addition to the common policy conditions (which apply to all coverages in the commercial package policy program).

The first loss condition provides for appraisal in the event that you and the insurance company disagree over the amount of a loss. It is virtually identical to the appraisal condition found on property insurance forms. Either party may request an appraisal. Each party will then select a competent appraiser, and the two appraisers will select an impartial umpire. The appraisers will separately state the actual cash value and amount of loss, and if they disagree the differences will be submitted to the umpire. Agreement by any two will be binding. You and the insurance company will each pay their own appraiser and share the costs of the umpire.

> 2. DUTIES IN THE EVENT OF ACCIDENT, CLAIM, SUIT OR LOSS
> a. In the event of "accident," claim, "suit" or "loss," you must give us or our authorized representative prompt notice of the "accident" or "loss." Include:
> (1) How, when and where the "accident" or "loss" occurred;
> (2) The "insured's" name and address; and
> (3) To the extent possible, the names and addresses of any injured persons and witnesses.
> b. Additionally, you and any other involved "insured" must:
> (1) Assume no obligation, make no payment or incur no expense without our consent, except at the "insured's" own cost.
> (2) Immediately send us copies of any request, demand, order, notice, summons or legal paper received concerning the claim or "suit."
> (3) Cooperate with us in the investigation, settlement or defense of the claim or "suit."
> (4) Authorize us to obtain medical records or other pertinent information.

This condition specifies your duties in the event of an accident, claim, suit or loss. These duties obligate you to keep the insurance company informed and limit further losses as much as possible.

You have to give the insurance company "prompt notice" when a loss occurs

You must give the insurance company "prompt notice" of any accident or loss. Notice must include your name and address, "how, when and where" the accident or loss occurred, and to the extent possible the names and addresses of any injured persons and witnesses.

Every involved insured is required to assume no obligation, make no payment and incur no expense without the consent of the insurance company—except at your own cost. Copies of any demand, notice, summons or legal paper received concerning a claim or suit must be immediately sent to the insurance company.

Every insured person must cooperate with the insurance company in the investigation, settlement or defense of the claim or suit.

With respect to physical damage losses only, you must notify the police if there has been a theft, and must take reasonable steps to protect the auto from further damage.

INSURING THE BOTTOM LINE

In the event of bodily injury, the insurance company is authorized to obtain medical information, and each insured when requested is required to submit to a medical examination at the insurance company's expense. In the event of loss to a covered auto, you must promptly notify the police if the vehicle or any of its equipment has been stolen. You must also take reasonable steps to protect the auto from further damage, and permit the insurance company to inspect the auto and records proving loss before its repair or disposition. When requested, you must agree to be examined under oath and to sign a statement of answers given concerning the loss.

> 3. LEGAL ACTION AGAINST US
> No one may bring a legal action against us under this Coverage Form until:
> a. There has been full compliance with all the terms of this Coverage Form; and
> b. Under Liability Coverage, we agree in writing that the "insured" has an obligation to pay or until the amount of that obligation has finally been determined by judgment after trial. No one has the right under this policy to bring us into an action to determine the "insured's" liability.
> 4. LOSS PAYMENT—PHYSICAL DAMAGE COVERAGES
> At our option we may:
> a. Pay for, repair or replace damaged or stolen property;
> b. Return the stolen property, at our expense. We will pay for any damage that results to the "auto" from the theft; or
> c. Take all or any part of the damaged or stolen property at an agreed or appraised value.
> 5. TRANSFER OF RIGHTS OF RECOVERY AGAINST OTHERS TO US
> If any person or organization to or for whom we make payment under this Coverage Form has rights to recover damages from another, those rights are transferred to us. That person or organization must do everything necessary to secure our rights and must do nothing after "accident" or "loss" to impair them.

A brief condition addresses legal action against the insurance company. No one may take legal action against the insurance company under the coverage form until there has been full compliance with the terms of the coverage form. Under the liability insurance, no one may take legal action until the insurance company has agreed that you have an obligation to pay, or until the amount of that obligation has been determined by judgment after trial.

Transfer of the rights of recovery

With regard to physical damage loss payment, the insurance company has the option to pay for, repair or replace the damaged or stolen property. If stolen property is recovered, the insurance company may return it and will pay for any damage resulting from the theft. The insurance company has the option to take all or part of any damaged or stolen property at an agreed or appraised value.

The final loss condition, transfer of rights of recovery, is a standard subrogation clause. To the extent that any payment is made to or on behalf of any person or organization under the coverage, any rights to recover damages from another party shall be transferred to the insurance company. The person or organization must do everything necessary to secure these rights, and must do nothing after an accident or loss to impair them.

B. GENERAL CONDITIONS

1. BANKRUPTCY

Bankruptcy or insolvency of the "insured" or the "insured's" estate will not relieve us of any obligations under this Coverage Form.

2. CONCEALMENT, MISREPRESENTATION OR FRAUD

This Coverage Form is void in any cause of fraud by you at any time as it relates to this Coverage Form. It is also void if you or any other "insured," at any time, intentionally conceal or misrepresent a material fact concerning:

a. This Coverage Form;
b. The covered "auto" ;
c. Your interest in the covered "auto" ; or
d. A claim under this Coverage Form.

3. LIBERALIZATION

If we revise this Coverage Form to provide more coverage without additional premium charge, your policy will automatically provide the additional coverage as of the day the revision is effective in your state.

4. NO BENEFIT TO BAILEE—PHYSICAL DAMAGE COVERAGES

We will not recognize any assignment or grant any coverage for the benefit of any person or organization holding, storing or transporting property for a fee regardless of any other provision of this Coverage Form.

How the policy works when other insurance comes into play

5. OTHER INSURANCE

a. For any covered "auto" you may own, this Coverage Form provides primary insurance. For any covered "auto" you don't own, the insurance provided in this Coverage Form is excess over any other collectible insurance. However, while a covered "auto" which is a "trailer" is connected to another vehicle, the Liability Coverage this Coverage Form provides for the "trailer" is:

(1) Excess while it is connected to a motor vehicle you do not own.
(2) Primary while it is connected to a covered "auto" you own.

b. For Hired Auto Physical Damage coverage any covered "autos" you lease, hire, rent or borrow is deemed to be a covered "auto" you own. However, any "auto" that is leased, hired, rented or borrowed with a driver is not a covered "auto".

c. Regardless of the provisions of paragraph a. above, this Coverage Form's Liability Coverage is primary for any liability assumed under an "insured contract."

d. When this Coverage Form and any other Coverage Form or policy covers on the same basis, either excess or primary, we will pay only our share. Our share is the proportion that the Limit of Insurance of our

Coverage Form bears to the total of the limits of all the Coverage Forms and policies covering on the same basis.

The general conditions begin with a brief statement to the effect that your bankruptcy will not relieve the insurance company from its obligations under the coverage form.

No coverage if a claim is in any way fraudulent

The next condition provides that the coverage will be void in the event of fraud by the named insured, or in the event of intentional concealment or misrepresentation of a material fact by "any insured" concerning the coverage form, a covered auto, insurable interest in a covered auto, or a claim under the coverage form.

A liberalization clause is included as a matter of convenience for both you and the insurance company. It states that any revision to the policy form that provides more coverage without additional premium will automatically be provided as soon as the revision takes effect in your state (thus, there is no need to issue an endorsement to update the form).

With respect to physical damage coverage, the insurance will provide no benefit to a bailee who takes temporary possession of a covered auto. Bailees, such as auto repair shops or storage facilities, should carry their own insurance to cover customers' vehicles.

When a covered auto is a trailer connected to another vehicle, liability coverage will be "primary" when it is connected to a vehicle you own and "excess" when connected to a vehicle you do not own. If the coverage from any another coverage form or policy provides insurance on the same basis, either primary or excess, the insurance company will pay only its proportional share.

In the event that other insurance applies, coverage will be "primary insurance" for covered autos which you own. All liability coverage for liability assumed under an "insured contract" will always be "primary insurance." Insurance for covered autos which you do not own will be "excess" over any other collectible insurance. Autos hired or borrowed by you are considered "owned" for physical damage coverage.

Various layers of coverage create complex auto risks

The 1991 Ohio appeals court case *Lloyd Scott and Motorists Mutual Insurance v. Mt. Orab Ford* shows how various layers of coverage can affect business automobile risk. Of course not all businesses have the same auto risks that an auto dealer has—but this case is still relevant to many of the risks you might face.

In December 1987, Lloyd Scott rented a Thunderbird from Mt. Orab Ford. According to the rental agreement, Mt. Orab Ford promised that the car was covered by an automobile liability insurance policy with limits of $100,000 per person/$300,000 per accident.

While he was driving the rented Thunderbird, Scott was involved in a collision for which he was sued for damages. At the time of the acci-

dent, Scott was the named insured in a personal automobile policy issued by Motorists, which provided liability limits of $100,000 per person/$300,000 per accident.

Mt. Orab Ford maintained a policy through Clarendon National Insurance, which provided liability insurance for certain covered autos in the amount of $12,500 per person/$25,000 per accident. The policy also contained an excess and umbrella liability provision which provided a single, maximum limit of $1,000,000 per occurrence.

The respective insurance companies each thought the other should cover the accident. Numerous lawsuits followed.

A dispute occurs after an accident involving a rental car

Scott and Motorists Mutual Insurance Company sued Mt. Orab Ford Mercury, Inc. They wanted Mt. Orab either to provide the insurance warranted on the rental agreement or to indemnify Motorists for any amount paid as the result of negligence.

Mt. Orab Ford, in turn, sued Clarendon National Insurance Company. The dealership claimed that Clarendon should cover any sustained loss as a result of the accident.

The trial court concluded that the policy with limits of $12,500 per person/$25,000 per accident provided primary coverage. It then held that the Motorists policy with limits of $100,000 per person/$300,000 per accident provided excess coverage to the Clarendon primary coverage. Finally, it ruled that Clarendon's umbrella provision provided excess coverage upon the exhaustion of the Clarendon primary coverage and the Motorists excess coverage.

Motorists appealed, making two arguments against the trial court's ruling:

- the trial court erred in its judgment declaring the order of liability of the multiple contracts of insurance issued to Scott, and
- the trial court erred by rejecting Motorists' claim that it was a third party beneficiary of the contract to procure insurance executed between Ford and Scott.

Motorists argued that its policy, which covered Scott as a named insured, became applicable only upon the exhaustion of the Clarendon primary and umbrella coverages.

Clarendon, on the other hand, argued that its umbrella coverage did not apply because Scott was not an insured person under that policy.

The appeals court ruled that, at the time of the accident, Scott was driving a covered auto—a customer rental—with Mt. Orab Ford's permission pursuant to the rental agreement. Therefore, it concluded that Scott was an insured person under both of Clarendon's policies.

Having determined that Clarendon's umbrella coverage applied, the appeals court next reconsidered the order of liability between the

Conflicts between umbrella coverage and underlying auto coverage

Clarendon umbrella provision and Scott's personal policy. It looked at the specific contract language employed by Motorists and Clarendon.

The Clarendon umbrella stated:

> If other valid and collectible insurance with any other insurer is available to the Assured covering a loss also covered by this policy, other than insurance that is specifically stated to be excess of this policy, the insurance afforded by this policy shall be in excess and shall not contribute with such other insurance. Nothing herein shall be construed to make this policy subject to the terms, conditions and limitations of other insurance.

The Motorists policy stated:

> If there is other applicable liability insurance we will pay only our share of the loss. Our share is the proportion that our limit of liability bears to the total of all applicable limits. However, any insurance we provide for a vehicle you do not own shall be excess over any other collectible insurance.

The language in each policy was clear. Clarendon's "other insurance" clause stated that its umbrella coverage was excess to all other collectible insurance except that which specifically stated that it was excess.

Motorists' policy specifically stated that it was "excess over any other collectible insurance." Thus, the exception in the Clarendon "other insurance" clause applied and rendered the umbrella coverage applicable before the Motorists coverage.

The court ruled that, "the Motorists policy does not apply to the loss until the Clarendon primary and umbrella provisions are exhausted respectively."

The appeals court ruled that the trial court "erred in holding that Clarendon's umbrella policy provided excess coverage upon the exhaustion of the Clarendon primary coverage and the Motorists excess coverage."

Therefore, Clarendon's policies were ruled to be primary—and Motorists to be excess.

The premium is based on your estimated expenses

6. PREMIUM AUDIT
a. The estimated premium for this Coverage Form is based on the exposures you told us you would have when this policy began. We will compute the final premium due when we determine your actual exposures. The estimated total premium will be credited against the final premium due and the first Named Insured will be billed for the balance, if any. If the estimated total premium exceeds the final premium due, the first Named Insured will get a refund.
b. If this policy is issued for more than one year, the premium for this

> Coverage Form will be computed annually based on our rates or premiums in effect at the beginning of each year of the policy.
> 7. POLICY PERIOD, COVERAGE TERRITORY
> Under this Coverage Form, we cover "accidents" and "losses" occurring:
> a. During the policy period shown in the Declarations; and
> b. Within the coverage territory.
> The coverage territory is:
> a. The United States of America;
> b. The territories and possessions of the United States of America;
> c. Puerto Rico; and
> d. Canada.
> We also cover "loss" to or "accidents" involving a covered "auto" while being transported between any of these places.
> 8. TWO OR MORE COVERAGE FORMS OR POLICIES ISSUED BY US
> If this Coverage Form and any other Coverage Form or policy issued to you by us or any company affiliated with us apply to the same "accident," the aggregate maximum Limit of Insurance under all the Coverage Forms or policies shall not exceed the highest applicable Limit of Insurance under any one Coverage Form or policy. This condition does not apply to any Coverage Form or policy issued by us or an affiliated company specifically to apply as excess insurance over this Coverage Form.

Business auto coverage is subject to premium audit, which means that the initial premium is an estimated premium and that the final premium is determined at the end of the policy period based on actual exposures.

Example: If you acquire additional vehicles during the policy term, the final premium would be determined based upon the actual number of vehicles, dates of acquisition, values and other rating factors that apply to the coverage. If the policy is written for a period more than one year, the actual premium will be computed annually.

Geographical limits apply to the insurance

The insurance applies only to accidents and losses occurring during the policy period and within the coverage territory. The policy period is the period shown in the declarations. The coverage territory is the United States of America including its territories and possessions, plus Puerto Rico and Canada. Coverage also applies to covered autos while being transported between any places included in the coverage territory.

A caveat: Travel in Mexico is not covered. If you need auto coverage in Mexico, you must buy additional insurance.

The final condition addresses insurance under two or more coverage forms or policies issued by the same insurance company. When such duplicate insurance applies, the maximum limit of insurance under all coverage forms will not exceed the highest limit under any appli-

cable coverage or policy. (But this does not apply to coverage specifically written to apply as excess over the business auto coverage.)

Definitions

> **SECTION V—DEFINITIONS**
> A. "Accident" includes continuous or repeated exposure to the same conditions resulting in "bodily injury" or "property damage."
> B. "Auto" means a land motor vehicle, trailer or semitrailer designed for travel on public roads but does not include "mobile equipment."
> C. "Bodily injury" means bodily injury, sickness or disease sustained by a person including death resulting from any of these.
> D. "Covered pollution cost or expense" means any cost or expense arising out of:
> 1. Any request, demand or order; or
> 2. Any claim or "suit" by or on behalf of a governmental authority demanding that the "insured" or others test for, monitor, clean up, remove, contain, treat, detoxify or neutralize, or in any way respond to, or assess the effects of "pollutants."
> "Covered pollution cost of expense" does not include any cost or expense arising out of the actual, alleged or threatened discharge, dispersal, seepage, migration, release or escape of "pollutants."
> a. That are, or that are contained in any property that is:
> (1) Being transported or towed by, handled, or handled for movement into, onto or from the covered "auto";
> (2) Otherwise in the course of transit by or on behalf of the "insured";
> (3) Being stored, disposed of, treated or processed in or upon the covered "auto"; or
> b. Before the "pollutants" or any property in which the "pollutants" are contained are moved from the place where they are accepted by the "insured" for movement into or onto the covered "auto"; or
> c. After the "pollutants" or any property in which the "pollutants" are contained are moved from the covered "auto" to the place where they are finally delivered, disposed of or abandoned by the "insured."
> Paragraph a. above does not apply to fuels, lubricants, fluids, exhaust gases or other similar "pollutants" that are needed for or result from the normal electrical, hydraulic or mechanical functioning of the covered "auto" or its parts, if:
> (1) The "pollutants" escape, seep, migrate, or are discharged, dispersed or released directly from an "auto" part designed by its manufacturer to hold, store, receive or dispose of such "pollutants;" and
> (2) The "bodily injury," "property damage" or "covered pollution cost or expense" does not arise out of the operation of any equipment listed in paragraphs 6.b. or 6.c. of the definition of "mobile equipment."
> Paragraphs b. and c. above do not apply to "accidents" that occur away from premises owned by or rented to an "insured" with respect to "pollutants" not in or upon a covered "auto" if:
> (1) The "pollutants" or any property in which the "pollutants" are contained are upset, overturned or damaged as a result of the mainte-

A lot of language relating to pollution and when it is covered

Chapter Four: Business Auto

> nance or use of a covered "auto" ; and
> (2) The discharge, dispersal, seepage, migration, release or escape of the "pollutants" is caused directly by such upset, overturn or damage.

The business auto coverage form includes a definitions section which defines key terms applicable to the automobile insurance. Since many of these are self-explanatory, we will only comment briefly on the definitions, placing slightly more emphasis on the few longer and more complex definitions.

Important definitions that affect auto coverage

"Accident" includes continuous or repeated exposure to these same conditions resulting in bodily injury or property damage.

"Auto" for the purposes of automobile insurance means land motor vehicles designed for use on public roads. Usually these are vehicles subject to licensing and registration—but not always. The term "auto" does not include "mobile equipment"—these terms are mutually exclusive, because mobile equipment exposures are covered by general liability insurance. However, as noted earlier, a back-hoe would be considered an auto when driven on a public road, en route to a job site.

"Bodily injury" includes injury, sickness or disease, including death resulting from any of these conditions.

Although the definition of "covered pollution cost or expense" is very detailed, it is designed to reinforce other policy language and exclusions related to this limited coverage. The intent is to provide only a very limited coverage for the cleanup and removal of pollution resulting from certain substances (such as fuel or motor oil) that escape from an automobile's normal operating systems as the result of an accident.

There is no coverage for any pollution resulting from the escape of any substances being transported, stored, treated or processed in or upon a covered auto. As noted earlier, escape of pollutants other than those used to drive the vehicle would fall under other coverage.

> E. "Insured" means any person or organization qualifying as an insured in the Who Is An Insured provision of the applicable coverage. Except with respect to the Limit of Insurance, the coverage afforded applies separately to each insured who is seeking coverage or against whom a claim or "suit" is brought.
> F. "Insured contract" means:
> 1. A last of premises;
> 2. A sidetrack agreement;
> 3. Any easement or license agreement, except in connection with construction or demolition operations on or within 50 feet of a railroad;
> 4. An obligation, as required by ordinance, to indemnify a municipality, except in connection with work for a municipality;
> 5. That part of any other contract or agreement pertaining to your busi-

161

The various kinds of contractual liability issues

ness (including an indemnification of a municipality in connection with work performed for a municipality) under which you assume the tort liability of another to pay for "bodily injury" or "property damage" to a third party or organization. Tort liability means a liability that would be imposed by law in the absence of any contract or agreement;

6. That part of any contract or agreement entered into, as part of your business, pertaining to the rental or lease, by you or any of your employees, of any "autos". However, such contract or agreement shall not be considered an "insured contract" to the extent that it obligates you or any of your employees to pay for "property damage" to any "autos" rented or lease by you or any of your employees.

An "insured contract" does not include that part of any contract or agreement:

a. That indemnifies any person or organization for "bodily injury" or "property damage" arising out of construction or demolition operations, within 50 feet of any railroad property and affecting any railroad bridge or trestle, tracks, roadbeds, tunnel, underpass or crossing; or

b. That pertains to the loan, lease, or rental of an "auto" to you or any of your employees, if the "auto" is loaned, leased or rented with a driver; or

c. That holds a person or organization engaged in the business of transporting property by "auto" for hire harmless for your use of a covered "auto" over a route or territory that person or organization is authorized to serve by public authority.

G. "Loss" means direct and accidental loss or damage.

"Insured" means any person or entity who qualifies as an insured in the "who is an insured" section of applicable coverage provisions. Coverage applies separately to each insured, but this does not increase the limit of insurance for any one accident.

As mentioned earlier, "insured contract" is actually a broad term and the coverage form does provide many types of contractual liability coverage. Liability assumed under a lease of premises, sidetrack agreement, easement agreement, agreement to indemnify a municipality when required by law, agreement related to the rental or lease of automobiles, and other agreements related to your business operations may be covered.

Exceptions to the definition of "insured contract"

But there are some specific exceptions to what is an insured contract. An "insured contract" does not include that part of any contract or agreement that (1) indemnifies a person or organization for BI or PD resulting from construction or demolition operations within 50 feet of any railroad property which affects a railroad bridge, tunnel, trestle, tracks, road bed, underpass, or crossing; (2) pertains to the loan, lease or rental of an auto to the named insured if the auto is loaned, leased or rented with a driver, or (3) that holds a person or organization engaged in the business of transporting property by auto for hire harmless for your use of an auto over a route or territory that person or organization is authorized to serve by public authority.

H. "Mobile equipment" means any of the following types of land vehicles, including any attached machinery or equipment:
1. Bulldozers, farm machinery, forklifts and other vehicles designed for use principally off public roads;
2. Vehicles maintained for use solely on or next to premises you own or rent;
3. Vehicles that travel on crawler treads;
4. Vehicles, whether self-propelled or not, maintained primarily to provide mobility to permanently mounted:
a. Power cranes, shovels, loaders, diggers, or drills; or
b. Road construction or resurfacing equipment such as graders, scrapers or rollers.
5. Vehicles not described in paragraphs 1., 2., 3., or 4. above that are not self-propelled and are maintained primarily to provide mobility to permanently attached equipment of the following types:
a. Air compressors, pumps and generators including spraying, welding, building cleaning, geophysical exploration, lighting and well servicing equipment; or
b. Cherry pickers and similar devices used to raise or lower workers.
6. Vehicles not described in paragraphs 1., 2., 3. or 4. above maintained primarily for purposes other than the transportation of persons or cargo. However, self-propelled vehicles with the following types of permanently attached equipment are not "mobile equipment" but will be considered "autos" :
a. Equipment designed primarily for:
(1) Snow removal;
(2) Road maintenance, but not construction or resurfacing; or
(3) Street cleaning;
b. Cherry pickers and similar devices mounted on automobile or truck chassis and used to raise or lower workers; and
c. Air compressors, pumps and generators, including spraying, welding, building cleaning, geophysical exploration, lighting or well servicing equipment.

Heavy equipment—even though you can drive it—is not covered

I. "Pollutants" means any solid, liquid, gaseous or thermal irritant or contaminant, including smoke, vapor, soot, fumes, acids, alkalis, chemicals and waste. Waste includes materials to be recycled, reconditioned or reclaimed.
J. "Property damage" means damage to or loss of use of tangible property.
K. "Suit" means a civil proceeding in which damages because of "bodily injury," "property damage," or "covered pollution cost or expense," to which this insurance applies are alleged. "Suit" includes an arbitration proceeding alleging such damages or "covered pollution cost or expense" to which you must submit or submit with your consent.
L. "Trailer" includes semitrailer.

"Loss" means loss or damage which is both direct and accidental.

The difference between covered autos and "mobile equipment"

The definition of "mobile equipment" is rather detailed, but it generally applies to motorized equipment which is not designed or intended for travel on public roads. Such things as bulldozers, forklifts, and road construction equipment are not subject to registration, and are not covered by automobile insurance (they are covered by general liability insurance). However, exceptions are made for some types of self-propelled vehicles which have "permanently attached" equipment and are designed for use on public roads.

Snow plows and street cleaning equipment which perform their intended operations on public roads are insured as "autos" under this coverage form. Vehicles with other types of equipment mounted on auto or truck bodies may be insured as "autos" while traveling to job sites but, as stated earlier (see the liability exclusions), auto liability coverage terminates as soon as the special equipment is being operated (at this point the risk shifts to a general liability exposure).

The definition of "mobile equipment" is identical on the business auto and general liability coverage forms. This allows the two coverages to fit together precisely, and removes any doubt about which coverage applies to "autos" and which applies to "mobile equipment." Both forms specify that certain self-propelled vehicles are not mobile equipment and will be considered to be autos. This group of self-propelled vehicles includes those with permanently attached equipment designed primarily for snow removal, road maintenance other than construction or resurfacing, or street cleaning. Cherry pickers and similar devices used to raise or lower workers are "autos" if they are mounted on an automobile or truck chassis.

"Pollutants" include solids, liquids, gases, and other substances which are capable of causing pollution damage.

Covered pollution cost or expense means costs arising out of any request, demand or order, or claim or suit by a governmental authority demanding that you test for, monitor, clean up, remove, contain, treat, detoxify or neutralize, or respond to or assess the effects of pollutants. It does not include the cost of pollutants in property being transported or towed by, handled into, onto, or from the covered auto, or otherwise in the course of transit by you, or being stored, disposed of, treated or processed in or on the covered auto. Also excluded are pollutants released before the property is moved to the place where they are accepted by you for movement into the covered auto, and after the pollutants are delivered by you. This exclusion does not apply to fuels, lubricants, fluids, exhaust gases, or other pollutants necessary for or resulting from the normal operation of a covered auto or its parts.

"Damage" includes the loss of use of tangible property

"Property damage" means not only direct damage to property, but loss of use of tangible property as well.

Example: Your truck which is involved in a collision topples over and blocks the entrance to a store parking lot. The insured driver is liable

for the accident. Although the store suffered no actual property damage, it loses sales because customers cannot reach the premises. The store owner would have a legitimate automobile liability property damage claim against you on the basis of loss of use.

"Suit" means a civil proceeding in which damages because of bodily injury, property damage, or covered pollution cost or expense, to which the insurance applies are alleged. The term "suit" also means an arbitration proceeding or alternative dispute resolution proceeding in which damages are claimed and to which you must submit with the insurance company's consent.

The final definition found on the business auto coverage form specifies that the term "trailer" includes a semitrailer.

Endorsements

Because the business auto coverage form uses a flexible system of coverage symbols, it has eliminated the need for a number of endorsements which once were common.

Endorsements are no longer needed to add coverage for non-owned autos and hired cars. However, business auto coverage still leaves a few gaps which can only be closed by endorsement when the coverages are needed. This section will review the most frequently used endorsements.

Medical payments coverage isn't automatic—you have to request it

Commercial auto coverage forms do not automatically include medical payments coverage. Commercial auto declarations forms have a space to enter a limit and premium for medical payments, but the coverage applies only when the auto medical payments coverage endorsement is attached to the policy.

Medical payments coverage is written with a limit of insurance per person, per accident. Necessary medical and funeral expenses resulting from accidental bodily injury and incurred within three years of the accident date are covered. When the named insured is an individual, the named insured and all family members are covered while occupying or when struck by any auto. For all insured businesses, coverage applies to anyone occupying a covered auto or a temporary substitute for a covered auto. Coverage does not apply to injuries to your employees if the injury arises out of and in the course of their employment, but domestic employees not eligible for workers compensation are covered.

Commercial auto coverage forms do not automatically include uninsured motorists coverage. Commercial auto declarations forms have a space to enter a limit and premium for uninsured motorists coverage, but the insurance applies only when an uninsured motorists coverage endorsement is attached to the policy.

Generally, the coverage pays amounts which an "insured" is legally entitled to recover from the owner or driver of an "uninsured motor

vehicle" because of bodily injury sustained in an accident. Unless altered by state requirements, "uninsured motor vehicle" means any of the following:

- a vehicle which at the time of accident is not covered by a bodily injury liability policy or bond;

- a vehicle which at the time of accident is covered by a bodily injury liability policy or bond, but the coverage limit is less than the minimum amount required by the financial responsibility law of the state where the vehicle is principally garaged;

- a vehicle which at the time of accident is covered by a bodily injury liability policy or bond, but the insuring or bonding company denies coverage or becomes insolvent; and

- a hit-and-run vehicle whose owner or operator cannot be identified.

This coverage varies from one state to the next because of differences in statutory requirements. In most states it applies only to bodily injury, but some states permit or require it to include property damage coverage. In some states, the definition of "uninsured" motor vehicle includes an "underinsured" vehicle.

Coverage for company cars given as perqs

Commercial auto coverage may also be extended by endorsement to insure the nonbusiness exposures of named individuals who may not own an automobile and may not carry personal auto insurance. Some company executives are issued company cars. Business auto coverage insures their exposure while using those vehicles, and it may cover them while using any other vehicles in the course of business activities. But business auto coverage would not insure them while using other autos for personal activities. For example, it would not cover use of a rental car while on a personal vacation.

By attaching a "Drive Other Car" endorsement, the business auto coverage can be amended to provide personal-type automobile insurance for named individuals. The endorsement changes the liability coverage to insure the named individual and spouse while using any non-owned auto for both business and personal use. It changes the physical damage coverage to make any non-owned "private passenger vehicle" a "covered auto" when used by the named individual or spouse. If medical payments and uninsured motorists coverage are part of the business auto coverage, the "Who Is An Insured" section is expanded to include the named individual and any "family member" who is a resident of the same household. However, coverage will not apply to any auto owned by the named individual or a family member—such owned autos must be specifically insured outside of the business coverage.

Sole proprietors who operate a business may extend business auto coverage to provide personal auto insurance for immediate family

members. The proprietor, as named insured, might be covered for use of any auto, but family members would not normally have that protection—particularly for the personal use of non-owned autos. An "Individual Named Insured" endorsement may be used to add family coverage to business auto insurance. It removes the "fellow employee" exclusion with respect to family members, because family members often work for a family business. It changes the liability coverage to apply to all family members who are residents of the same household. Physical damage coverage is provided for family members using a "private passenger auto" owned by the named insured, and non-owned autos are also covered but coverage for a non-owned trailer is limited to $500.

Providing broad coverage for all autos

Normally, the business auto coverage form would not cover a partner of the named insured's for liability while using an auto owned by that partner or a member of his or her household. This problem may be resolved by endorsing the policy to name the partnership as the named insured with respect to liability coverage. When this endorsement is attached, the liability exposure of individual partners would be covered while using their own cars or those owned by members of their family.

If a business has broad coverage for "all autos," it would be covered in any suit arising out of an accident involving owned, hired, borrowed, or non-owned autos, including autos owned by employees while used for business purposes. Although the employees are insured under the business auto liability section while driving autos owned by the business, they are not insured while driving their own cars in the course of business. If a suit against a business also named an employee as the driver and owner of a vehicle, the business auto coverage would only protect the business. If the employee had personal auto coverage, it would provide some protection. But claims resulting from a business-related accident might involve amounts well above the employee's coverage limits. Employees can be protected under the business auto coverage by attaching the "Employees as Additional Insureds" endorsement. It states that any employee is an insured person while using an auto the business does not own, hire, or borrow, when the autos are used in the business or personal affairs of the named insured.

This coverage insures employees for the business use of their own autos or autos owned by family members. It does not protect other family members who may own a vehicle being used by an employee.

Family drivers can be a big issue—especially for small businesses. The 1992 federal district court decision *Ohio Casualty Insurance Co. v. Gail Aron* considered the distinctions between personal and business auto policies.

Making distinctions between personal and business auto insurance

In April 1989, Gail Aron was in a car accident with an underinsured motorist. As a result of the accident, Aron sustained bodily injuries. The 1988 Oldsmobile that Aron was driving at the time of the accident was owned by her father, Werner Aron.

The car was insured by Ohio Casualty, under a personal auto insurance policy in which Werner Aron was the named insured. Pursuant to the personal auto insurance policy, Gail Aron received $200,000 in underinsured motorists benefits from Ohio Casualty.

However, Ohio Casualty had issued Werner Aron more than one auto insurance policy. In January 1989, the insurance company had issued a "Business Auto Policy" to his company, Werner Auto Electric.

Under the business auto policy, there was one vehicle specifically described as a "covered auto." This vehicle was a 1987 Ford van owned by Werner Auto Electric.

Although Werner Aron's two policies would seem to be easily distinguished, some confusion followed. Aron and his daughter argued that the business auto policy should have covered her accident. (Apparently, they believed it would absorb the claim with less impact on its premiums than the personal auto policy.)

Ohio Casualty Insurance Company sought a determination in court that it was not obligated to provide underinsured motorist benefits to Gail Aron under its business auto insurance policy.

Aron, on the other hand, sought a declaratory judgment from the court that she was entitled to the underinsured motorists coverage provided in the business auto policy.

The general principles for interpreting policies of insurance are well established under Pennsylvania law. The 1983 state supreme court decision *Standard Venetian Blind Co. v. American Empire Insurance* had ruled:

> Where a provision of a policy is ambiguous, the policy provision is to be construed in favor of the insured and against the insurer, the drafter of the agreement. Where, however, the language of the contract is clear and unambiguous, a court is required to give effect to that language.

The federal appeals court considered the business auto policy which Ohio Casualty issued to Werner Auto Electric, pursuant to which Gail Aron claimed that she was entitled to underinsured motorist benefits. It focused on the following language:

> "You" and "your" mean the person or organization shown as the named insured in the declarations.

> The above quoted definition of "you" from "PART I—WORDS AND PHRASES WITH SPECIAL MEANING," is clear that "you" means the "organization shown as the named insured in the declarations."

In the uninsured and underinsured motorists endorsement, it was clear that "You" referred to the business entity Werner Auto Electric. The court wrote that:

> It would strain a court's imagination to determine that Gail Aron was a family member of the business entity Werner Auto Electric.

At the time of the accident, Gail Aron was driving the Oldsmobile on personal business and was not acting as an agent or an employee of her father's business. Further, she had never been a corporate officer or an employee of Werner Auto Electric.

The court concluded:

> ...there is no ambiguity in the Business Auto Policy and, therefore, Gail Aron is not entitled to underinsured motorist benefits under this Business Auto Policy. This is not a case for applying that principle of Pennsylvania law which provides that an insurer will not be allowed to use the explicit language of a policy to defeat the reasonable expectations of the insured. There is no basis for a claim that the reasonable expectations of the insured have in any way been defeated by this Court's interpretation that Gail Aron is not entitled to benefits from the underinsured motorist coverage under the Business Auto Policy.

Covering leased autos

It issued the declaratory judgment in favor of Ohio Casualty and rejected the Arons' arguments. Gail Aron would have to rely on her father's personal auto policy for her coverage.

Other forms of business auto coverage

If you drive leased automobiles, an endorsement may be used to provide liability and physical damage coverages for the interests of the lessor as an additional insured.

An endorsement may be used to add coverage for specified hired autos as if they were covered autos owned by the named insured. When attached to a policy, the hired autos scheduled in the endorsement will be treated as if they were covered automobiles owned by the named insured.

Example: You use a limousine service frequently to transport employees to and from the airport. A hired auto endorsement will supplement any coverage provided by the limo service.

An endorsement may be added to a policy to provide coverage for scheduled items of mobile equipment. When attached, the items scheduled will be treated as covered autos and not mobile equipment.

This endorsement may be used to establish deductible amounts for bodily injury liability and property damage liability. Separate deductibles may be shown for bodily injury on a per person and a per accident basis. The property damage deductible will always apply per

INSURING THE BOTTOM LINE

accident. When applicable, damages otherwise payable under the policy are reduced by the appropriate deductible amounts.

A common question: how much rental cost will be reimbursed?

A rental reimbursement coverage endorsement may be attached to a policy to cover expenses incurred for the rental of another auto because of loss to a covered auto which is shown in the schedule. This coverage applies to expenses beginning 24 hours after a physical damage loss, and continuing for the number of days it takes to reasonably repair or replace the covered auto or for the number of days shown in the schedule. No deductible applies to this coverage.

A variety of other endorsements may be used to alter business auto coverage. The traditional single limit of liability may be changed to split limits, and physical damage coverage can be changed from an actual cash value basis to a stated amount of insurance for specified vehicles. An endorsement may be used to alter the pollution exclusion and provide broadened pollution coverage. Other endorsements alter physical damage exclusions and provide comprehensive coverage for such things as citizens band radios and sound reproduction equipment.

Miscellaneous incidental exposures which are not usually covered may often be added to the policy by endorsement. Of course, additional endorsements almost always result in additional premiums.

Truckers coverage form

Businesses that have to deal with major trucking and other land transportation issues sometimes use a complex mixture of specialized auto coverages. We'll briefly consider these kinds of insurance.

Another modernized coverage form has been designed for truckers who are engaged in the business of transporting goods for others. It also follows the simplified wording, style and format of business auto coverage, but modifies a number of provisions to better shape the coverage to the needs of truckers. For example, the business auto coverage form does not provide liability coverage for the owner of an auto hired or borrowed from an employee (or member of the employee's family) by the insured company. The comparable limitation on the truckers policy refers only to private passenger autos. This means that the policy covers an employee who owns a commercial vehicle and furnishes it to the named insured for use in the trucking business. This would apply to businesses that use so-called "owner/operators" of large trucks.

The motor carrier coverage form is a variation of traditional truckers coverage developed to reflect certain changes in motor carrier regulation. It has been described as an underwriting alternative for some carriers, and it may provide more appropriate coverage for some insureds. However, the differences between truckers coverage and motor carrier coverage are very minor and very subtle.

Variations on standard truck coverage

This form does not define the term "trucker." Instead, it has a definition for motor carrier, which means any person or organization providing transportation by auto in the furtherance of a commercial enterprise. One distinction that can be drawn between this definition and the definition of "trucker" found in the truckers form is that a "trucker" is someone engaged in the business of transporting property by auto for hire while a "motor carrier" may be engaged in the transporting of property or passengers.

As with the other commercial auto forms, this form has its own set of coverage symbols.

On the motor carrier coverage form we find some minor variations in wording in the "Who Is An Insured" section and in the "Other Insurance" condition. In many places, the term "motor carrier" appears instead of the word "trucker."

In most other respects the motor carrier and trucker forms are the same. The liability coverage, coverage extensions, and exclusions are the same. Trailer interchange coverage and physical damage coverage are the same. Most of the policy conditions and definitions are the same.

Commercial carrier regulation

Special regulations apply to commercial carriers of both passengers and cargo because of the risk of common carrier accidents. To protect the interest of the general public, state and federal laws have created minimum financial responsibility requirements for commercial carriers. These requirements may be met by purchasing insurance or obtaining a surety bond guaranteeing payment in amounts which at least equal the minimum limits. In some cases, full or partial self-insurance may be permitted, if the carrier provides the necessary financial data to demonstrate the ability to fully or partially self-insure.

Liability insurance is required for trucks that carry hazardous materials

Federal rules for common carriers were established by the Motor Carrier Act of 1980, which took effect in 1981. It has since been amended to increase the financial responsibility limits required. Enforcement of the requirements falls under the jurisdiction of the Department of Transportation.

The act requires minimum liability coverage for carriers of certain hazardous substances. In addition to the direct injury and damage that can be caused by a collision involving a commercial carrier, hazardous substances pose a special threat. Some substances carry a special risk of fire and explosion. Others might release poisonous gases. Toxic wastes and radioactive substances might endanger people and pollute the environment. Many substances which pose no immediate short-term risk to humans might still carry a long-term risk to the environment. Liability regulations serve two purposes: first, they provide some degree of protection to the public by providing funds

INSURING THE BOTTOM LINE

for actual damage claims; second, the existence of the requirements creates financial incentives and serves as a reminder to common carriers to follow safety standards.

Liability can result from negligence—often defined after the fact

The federal law requires a single limit of liability which will apply to all payments for bodily injuries, property damage and environmental restoration resulting from negligence in the maintenance, operation or use of motor vehicles subject to the act. It is not necessary for the type of motor vehicle "accident" we normally think of to occur for liability to be imposed. "Negligence" could result from failure to close a valve, resulting in leakage of fluids or gases.

The required coverage is designed to pay for "public liability"—it does not apply to injuries to the carrier's employees or loss of the cargo being carried. Coverage is usually obtained by attaching an endorsement (MCS-90) to a policy providing commercial auto or truckers coverage. The endorsement has been developed by the Department of Transportation, and not all insurance carriers are willing to provide it. Commercial coverage forms exclude nearly all forms of pollution, and when insurers are unwilling to write the "environmental restoration" coverage the commercial carrier will have to look to other markets. Some states have a commercial automobile assigned risk pool, which may provide the coverage. Residual market mechanisms and the surplus lines market may have to be explored in order to obtain coverage.

The required limits vary by size of the vehicle and the type of commodity being carried. Materials are classified by listings under Title 49 of the Code of Federal Regulations (CFR). The minimum liability requirements are:

- $750,000 for the transportation of non-hazardous property;

- $1 million for the transportation of oil listed in 49 CFR 172.101; hazardous wastes, materials, or substances defined in 49 CFR 171.8 and listed in 49 CFR 172.101 but not included in the next category;

- $5 million for the transportation of hazardous substances as defined in 49 CFR 171.8 and designated by the letter "E" in 49 CFR 172.101, and transported in cargo tanks, portable tanks, or hopper-type vehicles with capacities in excess of 3,500 water gallons; all bulk class A and B explosives; poison gas (poison A); liquified compressed gas or compressed gas transported in tanks or hoppers with capacities in excess of 3,500 gallons; or highway route-controlled radioactive materials as defined in 49 CFR 173.455.

For a more detailed account of the classifications and requirements, you should consult the Federal Motor Carrier Act.

Chapter Five:

Workers Compensation and Employers Liability

Introduction

Every state in the union requires that employers pay for on-the-job injuries. Under workers compensation law, employers are strictly responsible for the costs of any employee injuries that arise out of any employment related injury regardless of fault.

Workers compensation insurance is relatively new—its concept originated during the industrial revolution in Europe, and Wisconsin passed the first successful U.S. workers compensation law in 1911.

Since the mid-1800s, there has been a gradual and progressive transformation of the legal relationship between employers and employees. At the beginning of the period, the only recourse available to workers who were injured on the job was to seek damages under a system of common law (case law) liability. That system favored employers and made it very difficult for an injured worker to obtain an award.

Courts eventually recognized that an employer did have certain obligations to employees. To satisfy these obligations, the employer was expected to provide:

- a safe place to work,
- safe equipment and tools,
- reasonably competent fellow servants,
- enforcement of safety rules, and
- reasonable warnings about job dangers.

If an employer violated any of these obligations, there might be a basis for establishing negligence. But the burden of proof still fell fully on the injured employee. More significantly, an employer, even if negligent, could invoke certain legal defenses.

Court decisions had created three basic defenses which could relieve an employer of legal liability:

- fellow servant rule,

- contributory negligence, and
- assumption of risk.

The fellow servant rule held that if an injury was caused by the negligence of a fellow employee, it was not the result of negligence of the employer, who was therefore relieved of responsibility. Under the principle of contributory negligence, an injured employee who was even partially responsible for the injury lost all right to collect damages. The assumption of risk defense was based on the idea that an employee knew in advance the risks of a particular job, and was presumed to be paid for assuming those risks. These interpretations of the law were extremely harsh from the employee's point of view. In some cases, negligence of an employer might create the defense—by hiring incompetent fellow workers, more injuries might be blamed on fellow servants. In other cases, the nature of a job would virtually preclude liability—the more hazardous the job, the more likely it was that assumption of risk would be raised as a defense.

The modern industrial society increased the risk of work-related injury

As the industrial revolution created more hazardous jobs, and drew more and more people off the land and into factories, industrial accidents occurred more frequently. Toward the end of the nineteenth century, the courts grew more sympathetic toward employees. States began enacting employers liability laws, which modified the common law defenses. Gradually, the class of "fellow servants" was narrowed, to exclude managers and supervisors—the negligence of a "boss" would no longer release the employer. Contributory negligence was replaced by comparative negligence, which would allow a partially responsible injured party to claim partial damages. To the extent that common law defenses are raised today, they have been altered by modifications at the turn of the century.

Two other developments were significant at that time. Survivors of a deceased worker were given the right to continue a claim for damages, and many states began to declare the signed release agreements illegal. The legal environment for employees had improved somewhat, but injured workers still had to prove negligence before they could collect any damages for job injuries.

After 1900, a growing number of industrial deaths and injuries helped to fuel public policy changes. Workers compensation systems were spreading in Europe, and the concept gained popularity in the U.S. New theories were being constructed to justify providing financial relief to injured workers and their families. Since industrial injuries were inevitable and negligence did not always exist, advocates argued that victims should be compensated even if employers were not directly responsible. This reflected an effort to break away from the common law system of legal liability. The effort would establish a form of absolute liability—the obligation to compensate injured workers without regard to fault or negligence.

The arrival of workers compensation laws drastically altered the legal

relationship between employer and employee. In the past, each tried to prove the negligence of the other in order to secure or avoid payment. Under the new laws, employers accepted liability for work-related injury or death regardless of fault. In most situations, employees no longer have to prove negligence and have given up their right to file suit, but they are now entitled to benefits. Some classes of employees are exempt from the laws, and suits may still be filed for damages which are not covered by the compensation law. In those cases which do fall outside the law, the three common law defenses are still available to the employers.

Today, under a statutory (written law) system, workers receive compensation for job-related injuries without having to challenge an employer, and regardless of whether or not the employer was at fault. Statutory workers compensation benefits are the exclusive remedy for many types of work-related injuries, but they guarantee that benefits will be paid. It took a major shift in social priorities and public policies to bring about the change.

Most workers are covered by workers comp insurance

The early workers compensation laws applied only to very hazardous occupations. Over the years the scope of the laws has expanded to embrace more and more occupational groups. Every state has some exempt classifications, but it is estimated that about 90 percent of the nation's employees now fall under workers compensation laws. Although the exemptions are not the same in all states, the following classes of employees are typically exempt:

- certain farm and agricultural workers,
- charitable organization workers,
- domestic employees and casual labor,
- newspaper vendors, and
- outworkers (those who take articles home for cleaning or repair).

In some states, the hours worked or wages earned determine whether or not an employee is exempt. Employers are not required to provide insurance or compensation benefits for exempt employees, but it is often recommended that they do. The fact that a worker is outside the law does not preclude legal claims against the employer. Benefits may always be voluntarily provided by purchasing workers compensation insurance to cover exempt employees.

Principals who use contractors, and contractors who sublet work to subcontractors, should secure certificates of workers compensation insurance from the parties they work with. Principals may be held liable for the employees of contractors who fail to meet obligations under the law, and contractors can be held liable if their subcontractors fail to meet their obligations. In the absence of proper coverage at the lower levels, the responsible party might have to provide ben-

efits. If an insurance company provides additional benefits, it may add the payroll of subcontractors when it calculates a final premium, and the principal or contractor might face a substantial and unexpected additional charge.

A final caveat: Because an employer must provide these benefits and because the benefits are so liberal, the system is ripe for being abused. Cottage industries have sprung up to service injured employees, some of whom use the injury as a means to an extended paid vacation. Legions of unscrupulous lawyers, chiropractors, and doctors have made a living signing off on questionable claims and "soft tissue" injuries that are difficult to disprove. Since workers compensation was designed to settle claims rather than dispute them, questionable claims are paid at substantial cost to the employer.

The policy

The policy text reviewed in the following pages is that of the 1992 edition of the Workers Compensation and Employers Liability Policy developed by the National Council on Compensation Insurance (NCCI). This policy form is used by insurance companies in most states.

The standard policy has undergone several revisions

Since the first workers compensation policy was introduced, the standard policy form has been revised three times—in 1954, in 1982, and again in 1991. The latest policy revision did not make major changes in coverage, but did modify some policy provisions and add a few others to clarify the intent of the coverage. The latest policy, which carries a 1991 copyright, went into effect April 1, 1992. In its current form, the policy has eight parts:

- Information page
- General section
- Part I—Workers compensation
- Part II—Employers liability
- Part III—Other states insurance
- Part IV—Duties if injury occurs
- Part V—Premium
- Part VI—Conditions

Under each coverage part, the insurance applies to accidental bodily injury, death, or disease, occurring during the policy period and caused or aggravated by the conditions of employment by you. The insurance company agrees to provide a legal defense, and to investigate and settle all claims and suits covered by the insurance.

Supplementary payments are also provided, including coverage for appeal bonds, bonds to release attachments, interest on judgments, claim expenses, litigation costs taxed against you, and your expenses

(other than loss of earnings) incurred at the insurance company's request. The insurance company has subrogation rights if anyone other than you is liable for a covered injury. If any other insurance applies, the insurance company will only pay its share of claims and costs—subject to any limits of liability, all shares will be equal until a loss is paid.

In contrast to most other forms of commercial casualty insurance, workers compensation and employers liability coverage contributes equal shares when other insurance applies. Most other coverages contribute proportionally based upon the respective limits of insurance.

> **GENERAL AGREEMENT**
> In return for the payment of the premium and subject to all terms of this policy, we agree with you as follows:

This insurance has three separate coverage parts

The Workers Compensation and Employers Liability Insurance Policy has three separate and distinct coverage parts. The provisions described in the General Agreement and General Section apply to all three.

> **GENERAL SECTION**
> A. The Policy
> This policy includes at its effective date the Information Page and all endorsements and schedules listed there. It is a contract of insurance between you (the employer named in Item 1 of the Information Page) and us (the insurer named on the Information Page). The only agreements relating to this insurance are stated in this policy. The terms of this policy may not be changed or waived except by endorsement issued by us to be part of this policy.

In addition to providing basic definitions, this section establishes the makeup of the insuring contract: the policy's information page, the policy form, and all endorsements and schedules. After issuance, the policy's conditions can be changed only by written endorsements issued by the insurance company.

The Information Page (called a declarations page on most other insurance policies) lists the particulars of a specific policy. Among the important parts of an information page:

- Item 1 shows your name and address, and the type of business (individual, partnership, corporation) you manage. A space is provided to list any operations conducted at locations other than your policy address.

- Item 2 shows the policy period, which begins at 12:01 A.M. standard time at the policy address.

- Item 3.A. includes space for listing all of the states in which

workers compensation coverage is to apply—states in which you have operations should be listed.

- Employers liability coverage limits are to be entered in item 3.B. Basic limits are $100,000 per accident for injuries, $100,000 per employee for disease, and $500,000 aggregate (annually) for disease. Higher limits may be purchased.

- Item 3.C. includes space for listing additional states in which you might have a future exposure. The optional "other states" coverage will automatically begin only if the additional states are included in item 3.C.

- Space for listing job classifications and codes, estimated payrolls, rates, and estimated premiums is provided under item 4. Premiums may be paid monthly, quarterly, semi-annually, or annually.

For this coverage the declarations page is called "information page"

It is on this information page that you'll find your name, the name of your insurance company, the policy's term, a list of covered states, the employers liability limits, classifications, schedules of rates, and advanced premiums.

> B. Who Is Insured
> You are insured if you are an employer named in Item 1 of the Information Page. If that employer is a partnership, and if you are one of its partners, you are insured, but only in your capacity as an employer of the partnership's employees.

The employer named in the policy is the insured. If the employer is a partnership, all partners are also insured.

> C. Workers Compensation Law
> Workers Compensation Law means the workers or workmen's compensation law and occupational disease law of each state or territory named in item 3.A. of the Information Page. It includes any amendments to that law which are in effect during the policy period. It does not include any federal workers or workmen's compensation law, any federal occupational disease law or the provisions of any law that provide nonoccupational disability benefits.

The term "workers compensation law," as used in the policy means just those laws passed by the states or territories specifically listed on the policy's information page under item 3.A. There is no coverage for claims brought under federal statutes such as the U.S. Longshore and Harbor Workers Compensation Act unless endorsements adding the coverage are attached.

One of the major problems with workers compensation insurance is that it's regulated heavily—and, in many cases, badly. This problem surfaces in several ways, particularly as relates to key issues like policy cancellation.

The 1992 Florida appeals court decision *Curtis-Hale, Inc. et al. v. James Geltz and Aetna Casualty & Surety* shows how difficult comp liabilities can be.

Curtis-Hale was a major building contractor in Florida; James Geltz was one of its many subcontractors.

In August 1987, in response to a promotional mailing, Geltz contacted Anthony Brooks of the Brooks-Starling-Ruiz Agency to obtain workers comp coverage. Geltz purchased coverage with an effective policy period of August 1987 to August 1988. Brooks-Starling procured comp coverage for Geltz by going through the state's assigned risk pool. Aetna was the carrier that ultimately wrote the policy for Geltz.

Geltz entered a Premium Finance Agreement initially with Premium Assignment Corporation and later with Capitol Premium Plan, Inc. Problems arose from dishonored checks and nonpayment of the premiums for Geltz's policy. In late November 1987, Aetna issued a Notice of Termination which would terminate the policy in 30 days. But Geltz replaced the dishonored check and Aetna issued a Reinstatement Notice.

Curtis-Hale had a business practice of requiring subcontractors to submit a Certificate of Insurance at the time of signing the subcontractual agreement. That was to ensure that subcontractors insured their own risks of loss for accidents incurred by employees of the subcontractors.

In March 1988, five months before Geltz started work on a project for Curtis-Hale, Curtis-Hale requested a Certificate of Insurance. That certificate, issued by Brooks-Starling on March 28, 1988, showed the effective date of Geltz's policy as August 27, 1987, and the policy expiration date as August 27, 1989 (rather than the accurate 1988).

Under the heading "Cancellation," the certificate stated "should any of the above described policies be canceled before the expiration date thereof, the issuing company will endeavor to mail 10 days written notice to the certificate holder...but failure to mail such notice shall impose no obligation or liability of any kind upon the company, its agents or representatives."

A policy was cancelled for lack of premium payment

Ultimately, a request was made for Geltz's policy to be canceled because of a continuing failure to pay premium installments to Capitol Premium. Aetna issued a Notice of Termination, dated April 12, 1988, with an April 14, 1988, postmark, stating that the policy would be terminated as of May 12, 1988.

Because the cancellation date was not 30 days or more from the postmarked date, the notice failed to meet the requirements set forth in state law:

> No contract or policy of insurance issued by a carrier under this

chapter shall expire or be canceled until at least 30 days have elapsed after a notice of cancellation has been sent to the [Division of Workers' Compensation] and to the employer in accordance with the provisions of [state law].

...When the notice of termination is sent by mail, the 30 days will be calculated from the 1st day following the date of mailing as evidenced by postmark.

Aetna's cancellation notice, postmarked April 14, sought termination on May 12, 1988—only 28 days later.

On September 12, 1988, one of Geltz's employees was injured within the course and scope of his employment. Geltz was a subcontractor for Curtis-Hale, the general contractor. Because Geltz no longer had workers comp coverage, Curtis-Hale was required to provide the comp benefits. In the context of the comp claim, Geltz's employee was Curtis-Hale's employee.

Arguing over the details of a policy cancellation

A flurry of lawsuits followed. Curtis-Hale sued Geltz and Aetna, arguing that Geltz's policy had been improperly canceled. If so, then Aetna would be liable for the injury.

Geltz took up this theory, arguing that because of the failure to provide the statutory 30-day period, the termination notice was void—so the Aetna policy remained in effect and he was covered at the time of the September 1988 injury.

Aetna, on the other hand, argued that its delay merely delayed the effective cancellation date the two additional days—to May 14. And, even if there'd been no problems, the policy was due to lapse in late August—a month before the accident occurred.

The Florida court agreed with Aetna:

We find Aetna's position is convincing and comports with the legislative intent of [Florida law] to provide reasonable notice to the insured party. The record indicates that, during the intervening four months from the effective cancellation date to the date of the accident, Geltz received sufficient notice of policy cancellation to satisfy the statutory requirements and to enable him to seek insurance coverage elsewhere.

...the effective date of cancellation was May 14, 1988.

Curtis-Hale was liable for the injury to Geltz's employee. It would have to sue Geltz separately if it wanted to be made whole on its losses.

> D. State
> State means any state of the United States of America, and the District of Columbia.

Although it doesn't say so here, the standard policy can provide cov-

erage in U.S. territories as well as in U.S. states and in Washington D.C.

> E. Locations
> This policy covers all of your workplaces listed in Items 1 or 4 of the Information Page; and it covers all other workplaces in Item 3.A. states unless you have other insurance or are self-insured for such workplaces.

States and territories where coverage applies must be listed in the information page's item 3.A.

> **PART ONE**
> **WORKERS COMPENSATION INSURANCE**
> A. How This Insurance Applies
> This workers compensation insurance applies to bodily injury by accident or bodily injury by disease. Bodily injury includes resulting death.
> 1. Bodily injury by accident must occur during the policy period.

There are no exclusions under the workers comp part

Now we've come to the first of the three coverage parts—workers compensation insurance. You'll find no exclusions in this section, a rarity in insurance policies. But remember that it's the state's compensation laws, not the policy, that determine when and what benefits are payable.

Workers compensation coverage applies to bodily injuries and diseases "arising out of and in the course of employment." Covered losses must be work-related (losses that are non-work-related are not covered by workers compensation).

Any covered bodily injury must be accidental, and the term includes death resulting from the accident. Only occupational diseases, which are unique to the occupation, are covered. A cause-and-effect relationship must exist between the job and the disease, and ordinary diseases suffered by the general public are not covered. The law is different in each state, but usually benefits are not provided if the injury or disease is intentionally caused by the employee, or results from intoxication on the job, or occurs during activities which are not part of the job.

You'll note that nowhere does the policy actually define the term, bodily injury. This is not an oversight. State legislatures and courts—not the policy—determine what is and what is not a compensable injury. Today, unlike forty years ago, workers comp policies commonly pay emotional and mental stress claims as well as those for physical injuries.

> 2. Bodily injury by disease must be caused or aggravated by the conditions of your employment. The employee's last day of last exposure to the conditions causing or aggravating such bodily injury by disease must occur during the policy period.

This section also stipulates that, in order to receive benefits under a specific policy, an employee's last exposure to a disease-causing or disease-aggravating condition must occur during that policy's term.

The "last exposure" provision can complicate claims

What's the intent of this provision? Let's look at an example—at Natural Weave Textile Mill and an employee named Joe. In the thirty years that Natural Weave's been in business, the company has had a dozen different workers comp carriers. Joe, who has "always been a textile worker," is now leaving Natural Weave. He contracted brown lung disease (byssinosis) caused by the years of inhaling raw cotton and linen fibers. Which insurance company pays Joe's benefits? The "last exposure" provision rules that the insurance policy in effect when Joe was last exposed to raw textiles—when he left the company—pays.

> B. We Will Pay
> We will pay promptly when due the benefits required of you by the workers compensation law.

We find here one of the insurance world's shortest and clearest insuring agreements. What will the insurance company pay? Those benefits required by a covered state's workers comp laws. When will the benefits be paid? Promptly.

Workers compensation laws usually provide for the payment of four types of benefits:

- medical benefits,
- income benefits,
- death benefits, and
- rehabilitation benefits.

The four types of benefits paid under comp coverage

Medical benefits are provided without limit in every state. An injured or diseased employee is entitled to receive all necessary medical and surgical treatment to cure or relieve the condition. Certain maximums or limits may apply to a type of care or a particular medical item, but overall benefits are unlimited.

Income benefits are paid to employees who suffer work-related disabilities. A waiting period (usually three to seven days) applies before benefits for loss of wages begin. If the disability continues beyond a longer period (usually two to four weeks), retroactive benefits will be paid for the initial waiting period.

A disability may be total (making employment impossible) or partial (resulting in a reduced ability to work, or a need to perform alternative work). Either type of disability may be temporary or permanent. For permanent total disability or temporary total disability, the benefit is a percentage of weekly wages, subject to stated minimum and maximum dollar amounts. Within each state, the percentage is the

same for either type of total disability (66-2/3 percent is most common). However, for permanent total disability the dollar maximum and the benefit period are usually greater (benefits for permanent total disability often continue to age 65, while benefits for a temporary total disability may be limited to a maximum number of weeks).

People with partial disabilities are able to perform some work, so the laws provide a benefit equal to a percentage of the wage loss (difference between earnings before and after the accident). In addition to benefits for lost wages, nearly every state provides scheduled benefits for specific permanent partial disabilities, such as loss of limbs, sight, or hearing. Usually these benefits are paid in addition to any other income benefits.

How death benefits work

Death benefits are provided by every state, and there are two types of payments. Each state provides a modest burial allowance, which is a maximum dollar amount (usually within the $1,000 to $5,000 range). Each state also provides weekly income payments for a surviving spouse and/or children. Weekly benefits are usually a percentage of the deceased worker's wages, subject to stated minimum and maximum dollar amounts, and a time limit. Some states have an aggregate payment limit. A surviving spouse may receive benefits for life, or until remarriage. Surviving children generally receive benefits until age 18 or 19, and until age 22 or 23 if they are still in school.

Rehabilitation benefits are provided by all states. Some states have set up a special fund to provide these benefits, while others have not. Rehabilitation services are now recognized as a valuable tool for reducing workers compensation costs and returning disabled employees to their jobs as soon as possible. Rehabilitation may include therapy, vocational training, devices such as wheelchairs, and the costs of travel, lodging and living expenses while being rehabilitated. Various states impose weekly limits, maximum limits, and special limits for specific types of rehabilitation.

> C. We Will Defend
> We have the right and duty to defend at our expense any claim, proceeding or suit against you for benefits payable by this insurance. We have the right to investigate and settle these claims, proceedings or suits.
> We have no duty to defend a claim, proceeding or suit that is not covered by this insurance.
> D. We Will Also Pay
> We will also pay these costs, in addition to other amounts payable under this insurance, as part of any claim, proceeding or suit we defend:
> 1. reasonable expenses incurred at our request, but not loss of earnings;
> 2. premiums for bonds to release attachments and for appeal bonds in bond amounts up to the amount payable under this insurance;

INSURING THE BOTTOM LINE

> 3. litigation costs taxed against you;
> 4. interest on a judgment as required by law until we offer the amount due under this insurance; and
> 5. expenses we incur.

The insurance company will not only provide claim defense, it will pay reasonable costs and expenses of that defense. The catch in this portion of the policy is that the insurance company has the right to settle a claim without your consent. Let's say you, as an employer, are pretty sure your company's last comp claim has little basis—after all, it was just a minor slip-and-fall. You can tell the insurance company you doubt your employee really experienced a serious back strain, but the insurance company doesn't need your permission to pay the claim.

> E. Other Insurance
> We will not pay more than our share of benefits and costs covered by this insurance and other insurance or self-insurance. Subject to any limits of liability that may apply, all shares will be equal until the loss is paid. If any insurance or self-insurance is exhausted, the shares of all remaining insurance will be equal until the loss is paid.
> If other insurance or self-insurance covers the same loss, all coverages share equally in payment of losses.
> F. Payments You Must Make
> You are responsible for any payments in excess of the benefits regularly provided by the workers compensation law including those required because:
> 1. of our serious and willful misconduct;
> 2. You knowingly employ an employee in violation of law;
> 3. You fail to comply with a health or safety law or regulation; or
> 4. You discharge, coerce or otherwise discriminate against any employee in violation of the workers compensation law.
> If we make any payments in excess of the benefits regularly provided by the workers compensation law on your behalf, you will reimburse us promptly.

Penalties that employers sometimes have to pay

State laws commonly require that higher benefits be paid for certain losses as a form of penalty to be paid by the employer. Benefits are often increased if a loss results from the serious or willful misconduct of the employer (for example, failing to provide required safety equipment). A number of states require that double benefits be paid for injury to a minor who is employed illegally.

These extra payments are not covered by a workers compensation policy, and the additional amount must be borne by the employer. If the insurance company makes such payments, the policy requires reimbursement from you.

Let's look at examples. An employer ignores a state law requiring safety guards on buzz saws, and an employee looses a hand. Or a

painting contractor hires a fourteen-year-old in violation of state labor laws, and the kid (definitely a minor) breaks an arm falling off the scaffolding. Both these cases could result in fines and/or penalties which are not insured.

> G. Recovery From Others
> We have your rights, and the rights of persons entitled to the benefits of this insurance, to recover our payments from anyone liable for the injury. You will do everything necessary to protect those rights for us and to help us enforce them.

Commonly called subrogation, this clause acts as a form of reimbursement to the insurance company. If a third party is found negligent of the employee's injury, the insurance company pays comp benefits to the injured worker, and then assumes the right to recover its payments from the responsible party. Under this process, the injured worker can't collect from both the insurance company and the negligent party.

Example: Your secretary, while taking your company's deposits to the bank, is hit by a speeding car. If the insurance company pays your secretary workers comp benefits, the insurance company has the right to seek recovery of its payments from the negligent driver. Under this principle, the secretary is limited in how she can pursue a claim against the driver.

> H. Statutory Provisions
> These statements apply where they are required by law.

Statutory provisions apply automatically to any claim

Some general provisions apply automatically when required by law.

> 1. As between an injured worker and us, we have notice of the injury when you have notice.
> Notice of an injury given by a worker to the employer has the same legal effect as notice given to the insurer.
> 2. Your default or the bankruptcy or insolvency of you or your estate will not relieve us of our duties under this insurance after an injury occurs. Bankruptcy of the employer does not relieve the insurance company of its obligation to pay benefits.
> 3. We are directly and primarily liable to any person entitled to the benefits payable by this insurance. Those persons may enforce our duties; so may an agency authorized by law. Enforcement may be against us or against you and us.
> The insurance company assumes the obligations of the employer to pay benefits. Action may be taken against the employer, or the insurance company, or both, to collect benefits.
> 4. Jurisdiction over you is jurisdiction over us for purposes of the workers compensation law. We are bound by decisions against you under that law, subject to the provisions of this policy that are not in conflict with that law.

Legal obligations of the employer, and judgments against the employer, become obligations of the insurance company.

5. This insurance conforms to the parts of the workers compensation law that apply to:

a. benefits payable by this insurance; or

b. special taxes, payments into security or other special funds, and assessments payable by us under that law.

Statutory benefits and any special taxes, payments, and assessments that are required by the workers compensation law are covered by the insurance.

6. Terms of this insurance that conflict with the workers compensation law are changed by this statement to conform to that law.

Nothing in these paragraphs relieves you of your duties under this policy. Any terms of the policy which conflict with law are automatically changed to comply with the law.

Your bankruptcy does not relieve the insurance company from obligation

These provisions declare that the insurance company and insured are one and the same with regard to notice of injury given by a worker, and with respect to matters of legal jurisdiction. Bankruptcy of the employer will not relieve the insurance company of its policy obligations. The insurance company agrees to be directly and primarily liable to anyone entitled to workers comp insurance benefits.

PART TWO
EMPLOYERS LIABILITY INSURANCE
A. How This Insurance Applies

This employers liability insurance applies to bodily injury by accident or bodily injury by disease. Bodily injury includes resulting death.

1. The bodily injury must arise out of and in the course of the injured employee's employment by you.

2. The employment must be necessary or incidental to your work in a state or territory listed in Item 3.A. of the Information Page.

3. Bodily injury by accident must occur during the policy period.

4. Bodily injury by disease must be caused or aggravated by the conditions of your employment. The employee's last day of last exposure to the conditions causing or aggravating such bodily injury by disease must occur during the policy period.

5. If you are sued, the original suit and any related legal actions for damages for bodily injury by accident or by disease must be brought in the United States of America, its territories or possessions, or Canada.

The employers liability part protects you from common law risks

Employers liability coverage protects against a variety of common law exposures. It is needed to fill gaps in the compensation coverage and to cover claims which are not subject to the compensation laws. Although an employee gives up the right to sue in exchange for workers compensation benefits, not all employees come under the law. Those not covered may sue. In recent years, successful suits against employers have also been filed by spouses and children of injured workers. Employers liability insurance covers these claims if the original

suit is brought in the United States, its territories or possessions, or Canada.

As in part one, the coverage here applies only to bodily injury (which includes accident, disease, or death) that occurs during the policy period and is job-related. The injury must occur in a covered state or territory listed on the policy's information page. And, as in part one, the employers liability section stipulates that an employee's last exposure to a disease-causing or disease-aggravating condition must occur during the policy's term.

But we now see how the two coverages differ. Benefits in part one respond to the statutory workers compensation laws of a state. Part two, employers liability insurance, responds only to suits, legal actions, brought against the insured employer. These legal actions must be initiated in the United States, its territories or possessions, or Canada.

> B. We Will Pay
> We will pay all sums you legally must pay as damages because of bodily injury to your employees, provided the bodily injury is covered by this Employers Liability Insurance.

The coverages under employers liability insurance are based on negligence under common law. Here the insurance company agrees only to pay the damages or amounts for which the insured employer is found to be legally liable, provided they are covered by the policy. This insuring agreement, more detailed than that found in part one, is typical of liability insurance contracts.

> The damages we will pay, where recovery is permitted by law, include damages:
> 1. for which you are liable to a third party by reason of a claim or suit against you by that third party to recover the damages claimed against such third party as a result of injury to your employee;

Coverage is not limited to claims made by employees

Employers liability coverage is not limited to claims filed by injured employees. One such example is found in third-party-over suits. These actions arise when an injured worker sues and collects from a third party for a work-related injury. The third party then seeks damages from the insured employer. Sound confusing? Let's look at an example: J.D. operates the widget machine on Prefab Company's assembly line. For the fifth time in so many days, the widget machine malfunctions, this time badly injuring J.D. Although it's a work-related injury, J.D. sues a third party, Widget Manufacturing, who made the machine and collects damages. Widget Manufacturing, in an effort to recoup its loss, sues the insured employer, Prefab Company, alleging negligence in permitting the continued use of an unsafe machine.

> 2. for care and loss of services; and
> 3. for consequential bodily injury to a spouse, child, parent, brother or sister of the injured employee;
> provided that these damages are the direct consequence of bodily injury that arises out of and in the course of the injured employee's employment by you; and

An employer may also be held liable for damages payable to an injured worker's family members. The policy states it will pay damages "for care and loss of services," a term commonly translated as damages for loss of consortium, resulting from an employee's work-related injury. The policy also pays damages for "consequential" bodily injury to immediate family members. For example, a Massachusetts court awarded damages to the wife and children of an injured worker for their mental anguish caused by seeing him as a helpless quadriplegic.

> 4. because of bodily injury to your employee that arises out of and in the course of employment, claimed against you in a capacity other than as employer.

This clause refers to the dual capacity theory. In these cases, you may be liable to an injured worker in a manner separate from your role as the worker's employer. For example, a truck's faulty tire, a tire manufactured by Bigstone Tire Company, causes a job-related truck accident that injures a Bigstone driver. That driver could claim workers comp benefits plus product liability damages from Bigstone who is both the driver's employer and the manufacturer of the defective tire.

> C. Exclusions
> This insurance does not cover:
> 1. liability assumed under a contract. This exclusion does not apply to a warranty that your work will be done in a workmanlike manner;

This coverage part does come with exclusions

Unlike the workers compensation section, the employers liability portion of the policy specifically lists twelve exclusions—circumstances in which coverage does not apply.

Coverage for specified common forms of contractual liability is provided by the commercial general liability policy or separate contractual liability insurance. It's not the intent of employers liability insurance to duplicate that coverage. But, as an exception to this exclusion, the policy does provide coverage under the warranty that your work is performed in a workmanlike manner.

> 2. punitive or exemplary damages because of bodily injury to an employee employed in violation of law;
> 3. bodily injury to an employee while employed in violation of law with

> your actual knowledge or the actual knowledge of any of your executive officers;

Remember our earlier example. The fourteen-year-old painter's helper fell from the scaffolding. There, the policy's workers comp section didn't insure penalty payments. This part of the policy excludes both punitive damage coverages and bodily injury for an incident involving an employee you knowingly hired illegally. No help is intended for employers who willingly violate the law.

> 4. any obligation imposed by a workers compensation, occupational disease, unemployment compensation, or disability benefits law, or any similar law;

With this exclusion, the policy reminds us of the purpose of the employers liability section. It's not to provide coverage under statutory workers comp laws—that's done by part one of the policy. Nor is it to respond to unemployment, disability, or other similar laws. Separate insurance and benefit programs address these needs.

> 5. bodily injury intentionally caused or aggravated by you;

Coverage does not apply to damages you cause intentionally

Employers liability insurance was developed to protect you for damages arising out of accidental occurrences, not for deliberate, willful acts.

> 6. bodily injury occurring outside the United States of America, its territories or possessions, and Canada. This exclusion does not apply to bodily injury to a citizen or resident of the United States of America or Canada who is temporarily outside these countries;

Injuries occurring outside of the U.S. or Canada are excluded, unless the employee is a citizen who is only temporarily outside of these jurisdictions.

> 7. damages arising out of coercion, criticism, demotion, evaluation, reassignment, discipline, defamation, harassment, humiliation, discrimination against or termination of any employee, or any personnel practices, policies, acts or omissions;

In recent years, a host of claimants (especially those recently reprimanded or fired) have sought damages from their employers (or ex-employers) for on-the-job stress or mental anguish. This 1992 edition of the NCCI policy clearly excludes coverage under the employers liability section for work-related acts of coercion, criticism, demotion, discrimination, etc. The exclusion doesn't actually say that mental stress is not a bodily injury. It simply says the specific acts listed are excluded.

The workers comp section doesn't contain a similar exclusion, leaving it to a state's courts and compensation laws to determine when compensation benefits are payable.

Psychiatric disabilities are a major problem in workers comp cases. In fact, some injured workers have argued that the claims process itself causes mental anguish. The 1992 Pennsylvania state court decision *Luis and Laura Santiago v. Pennsylvania National Mutual Insurance* offers a memorable example.

A typically difficult psychiatric disability claim

Luis Santiago was employed as a Quality Control Technician at United Contamination Control. On October 13, 1986, Santiago suffered a work-related injury to his left wrist. He was diagnosed as having a ganglion cyst on his wrist. After surgery was performed upon his wrist, Santiago began a physical therapy program. Santiago received weekly disability benefits pursuant to the Workmen's Compensation Act, and continued to receive these benefits.

As a result of his injury, Santiago developed a psychiatric condition known as Reflex Sympathetic Dystrophy (RSD). In his complaint, Santiago alleged that RSD is usually caused by a direct injury to a nerve and is accompanied by varying "psychological and psychiatric conditions" including emotional instability, anxiety, and social withdrawal. Santiago sought psychiatric care in 1987. In September of 1989, Santiago left his wife in order to deal with his condition outside the pressures of marriage.

Since 1987, Santiago's psychiatric reports have indicated depression and chronic suicidal thoughts, apparently aggravated by Santiago's physical pain, his inability to work, and his sense of frustration and helplessness. On several occasions, beginning in July of 1989, Santiago was hospitalized for psychiatric care.

Santiago's employer maintained workmen's compensation insurance coverage through Pennsylvania National Mutual Casualty Insurance Company. Pennsylvania National paid for Santiago's psychiatric treatment until August of 1989, at which time Pennsylvania National terminated payment. As a result of termination of payment for psychiatric care, Santiago filed a claim petition with the Workmen's Compensation Bureau on February 26, 1990.

In their complaint, Mr. and Mrs. Santiago alleged that Thomas Murray of Ringler Associates, Inc., informed their lawyer that he had been "commissioned by the Defendant [Pennsylvania National] to work out a structured settlement for wages for Plaintiff, Luis Santiago."

Santiago's lawyer and Murray entered into settlement negotiations in February of 1990. Negotiations continued for approximately three weeks.

During all times relevant hereto, Murray was acting as an authorized agent of Pennsylvania National and had said that he had authority to

settle the wage claim. During the negotiating period, Murray presented several offers made by the insurance company for proposed settlements concerning Santiago's wages, but at no time discussed the issue of psychiatric bills.

At the end of the negotiating period, Santiago accepted an offer made by Murray on behalf of Pennsylvania National. Soon thereafter, a lawyer for Pennsylvania National told Santiago and his lawyer that Murray did not have authority to settle. The settlement agreement would not be acceptable unless Santiago would voluntarily agree to waive any claim for present and future psychiatric treatment.

Santiago believed this condition rendered the agreement impracticable. His lawyer informed Pennsylvania National that Santiago was unable to accept the offer with this condition.

In March of 1990, Santiago sought emergency medical care at Lower Bucks Hospital for the pain in his arm. While there, Santiago attempted to hang himself behind a door to an empty room. As a result of attempting to take his own life, Santiago was immediately admitted to Montgomery County Emergency Services for psychiatric care. He was discharged approximately one month later.

In his discharge summary, Dr. Oscar Saldana noted that Santiago claim[ed] that all his emotional problems would not exist if it weren't for the excruciating pain he felt continuously on his left shoulder.... His depression seems to have lasted for at least four years following the accident that gave way to his present medical condition.

Claiming comp coverage for suicidal tendencies

Santiago filed a lawsuit alleging that the suicide attempt was the result of exacerbated depression caused by the collapse of the anticipated settlement agreement with Pennsylvania National. He also alleged fraud, misrepresentation, negligent infliction of emotional distress and intentional infliction of emotional distress.

He also argued that the lawyer's representations that Murray lacked authority to settle the claim were made with the intent to deceive, and that the insurance carrier exhibited bad faith in the handling of this claim.

Santiago requested punitive damages for Pennsylvania National's bad faith conduct. His wife sued for loss of consortium. A trial court dismissed their claims. The Santiago's appealed.

The state appeals court considered the case more carefully:

> We are presented with the question of whether a plaintiff may assert causes of action sounding in intentional tort against a workers compensation insurance carrier based upon the improper handling of a workers compensation claim.

Santiago argued that Pennsylvania National initiated settlement negotiations and had knowledge of his fragile psychological state. He claimed that through Murray's representations, and later through

the company's representations that Murray had no authority, he was induced to settle his claim on less than favorable terms.

Additionally, Santiago argued that Pennsylvania National knew or should have known that the breakdown in the settlement agreement would aggravate his condition.

He sought redress for injuries which he claimed he had suffered as a result of Pennsylvania National's fraudulent and bad faith conduct. He argued that this conduct was outside the scope of the state's workers comp laws. So, he argued that he should be entitled to pursue this common law claim against the carrier.

The appeals court didn't agree.

> The Workmen's Compensation Act is the sole and exclusive means of recovery against employers for all injuries arising out of accidents occurring within the course of employment.
>
> It is sufficiently clear in this case that the allegedly tortious acts of Pennsylvania National are "completely intertwined" with Santiago's original compensable injury....Although the alleged tortious acts of the carriers occurred after Santiago's work-related injury, they were not independent of it.
>
> Santiago, therefore, must operate within the framework of the statute and is precluded, under the exclusivity provision, from seeking redress in tort against the insurance carrier.

The court rejected Santiago's claim.

Employers liability coverage doesn't apply in some jurisdictions

8. bodily injury to any person in work subject to the Longshore and Harbor Workers' Compensation Act (33 USC Sections 901-950), the Nonappropriated Fund Instrumentalities Act (5 USC Sections 8171-8173), the Outer Continental Shelf Lands Act (43 USC Sections 1331-1356), the Defense Base Act (42 USC Sections 1651-1654), the Federal Coal Mine Health and Safety Act of 1969 (30 USC Sections 910-942), any other federal workers or workmen's compensation law or other federal occupational disease law, or any amendments to these laws;

9. bodily injury to any person in work subject to the Federal Employers' Liability Act (45 USC Sections 51-60), any other federal laws obligating an employer to pay damages to an employee due to bodily injury arising out of or in the course of employment, or any amendments to those laws;

10. bodily injury to a master or member of the crew of any vessel;

11. fines or penalties imposed for violation of federal or state law; and

12. damages payable under the Migrant and Seasonal Agricultural Worker Protection Act (29 USC Sections 1801-1872) and under any other federal law awarding damages for violation of those laws or regulations issued thereunder, and any amendments to those laws.

These last five exclusions limit the jurisdiction of employers liability insurance. Like the workers compensation part of the policy, this section won't automatically pay compensation or damages in response to any federal or maritime or admiralty compensation laws. And fines or penalties for violations of these laws, as well as those of a state, are excluded.

Here we see an important role of endorsements. Suppose your company has federal as well as state exposures. A simple endorsement to the standard policy can add the needed coverages (both workers compensation and employers liability)—at an added cost, of course.

Covering maritime employers liability issues

What are these federal acts? The exclusion names the most common. Let's look at just one—the U.S. Longshore and Harbor Workers Compensation Act (USL&HW Act). Maritime employees who work on U.S. navigable waters and their adjoining piers or docks fall under this federal act. Their duties can vary from stevedoring and freight handling to boat building and harbor work. Some employees may come under both state laws and those of the USL&HW Act. For example, customhouse brokers or some electronics repairmen frequently board ships in connection with their shore-side jobs.

(As a note here, the USL&WH Act doesn't cover all boat or ship-related duties. Seamen, those who have the job of operating a U.S. commercial vessel in navigable waters, fall under a different federal law, called the Jones Act.)

> D. We Will Defend
> We have the right and duty to defend, at our expense, any claim, proceeding or suit against you for damages payable by this insurance. We have the right to investigate and settle these claims, proceedings and suits.
> We have no duty to defend a claim, proceeding or suit that is not covered by this insurance. We have no duty to defend or continue defending after we have paid our applicable limit of liability under this insurance.
> E. We Will Also Pay
> We will also pay these costs, in addition to other amounts payable under this insurance, as part of any claim, proceeding, or suit we defend:
> 1. reasonable expenses incurred at our request, but not loss of earnings;
> 2. premiums for bonds to release attachments and for appeal bonds in bond amounts up to the limit of liability under this insurance;
> 3. litigation costs taxed against you;

The employers liability defense provisions are nearly identical to those found in the workers compensation section. The insurance company will both provide defense for a claim and pay the reasonable costs and expenses of that defense. These expenses are paid in addition to

any amounts that are subject to policy limits. And, as with most liability policies, the insurance company has the right to settle a claim without your consent.

However, employers liability has an additional condition in its defense provisions. Unlike workers comp, employers liability has specific maximum limits of coverage. Once the insurance company has paid out that amount in damages, they don't have to provide further defense for employers liability.

> 4. interest on a judgment as required by law until we offer the amount due under this insurance; and
> 5. expenses we incur.
> F. Other Insurance
> We will not pay more than our share of damages and costs covered by this insurance and other insurance or self-insurance. Subject to any limits of liability that apply, all shares will be equal until the loss is paid. If any insurance or self-insurance is exhausted, the shares of all remaining insurance and self-insurance will be equal until the loss is paid.

If more than one kind of insurance applies, each contributes an equal share

The "other insurance" clause for employers liability coverage is nearly the same as that for workers compensation. If other insurance applies, each contributes equal shares until the loss is paid or the insurance is exhausted.

> G. Limits of Liability
> Our liability to pay for damages is limited. Our limits of liability are shown in Item 3.B. of the Information Page. They apply as explained below.
> 1. Bodily injury by Accident. The limit shown for "bodily injury by accident—each accident" is the most we will pay for all damages covered by this insurance because of bodily injury to one or more employees in any one accident.
> A disease is not bodily injury by accident unless it results directly from bodily injury by accident.

We've already established that workers compensation pays benefits based on a state's statutory workers comp laws. Because each covered state determines the amount to be paid, the policy doesn't show a maximum for workers comp benefits. But the policy's information page does list maximum payable amounts for employers liability. These limits are the most the insurance company will pay for damages during the policy's term.

Item 3.B. of the information page shows three separate limits for employers liability damages. The first, for bodily injury by accident, applies "per accident" regardless of the number of employees injured in the same accident.

> 2. Bodily Injury by Disease. The limit shown for "bodily injury by disease—policy limit" is the most we will pay for all damages covered by

> this insurance and arising out of bodily injury by disease, regardless of the number of employees who sustain bodily injury by disease. The limit shown for "bodily injury by disease—each employee" is the most we will pay for all damages because of bodily injury by disease to any one employee.
> Bodily injury by disease does not include disease that results directly from a bodily injury by accident.
> 3. We will not pay any claims for damages after we have paid the applicable limit of our liability under this insurance.

Disease claims must relate directly to a work condition

The final two limits apply to damages arising from bodily injury by disease. One limit shows the most the policy will pay for disease to any one employee. The other gives the policy limit, called an annual aggregate, for all damages arising from disease during the policy's term.

The standard policy's basic employers liability limits of $100,000 per accident for injuries, $100,000 per employee for disease, and $500,000 annual aggregate for disease can be increased for an additional charge (or premium). Many employers often obtain even greater employers liability protection by purchasing additional layers of coverage through a commercial umbrella or excess liability policy.

Example: A group of employees suffers asbestosis—the lung disease linked to inhaling absestos fibers—and sues for damages. The standard policy will limit any settlements per employee as well as per the group. $500,000 wouldn't go very far in this kind of lawsuit, so a commercial umbrella or excess liability policy would be essential.

> H. Recovery From Others
> We have your rights to recover our payment from anyone liable for an injury covered by this insurance. You will do everything necessary to protect those rights for us and to help us enforce them.

The policy again confirms the insurance company's rights of recovery or reimbursement (subrogation rights). Remember the secretary who was hit by a speeding car while taking the company's deposits to the bank? We said the insurance company had the right to attempt to recover any workers comp benefits paid to the secretary from the negligent driver. The same subrogation principle applies to employers liability damages paid by the insurance company.

> I. Actions Against Us
> There will be no right of action against us under this insurance unless:
> 1. You have complied with all the terms of this policy; and
> 2. The amount you owe has been determined with our consent or by actual trial and final judgment.
> This insurance does not give anyone the right to add us as a defendant in an action against you to determine your liability. The bankruptcy or insolvency of you or your estate will not relieve us of our obligations under this Part.

Parameters for how you can see your insurance company

INSURING THE BOTTOM LINE

No one has the right to take legal action against the insurance company: (1) unless you have done all that the policy requires of you and (2) until the final amount of damages is determined. The fact that the insurance company provides you with coverage doesn't make it a co-defendant in a claim against you.

> **OTHER STATES' WORKERS COMPENSATION INSURANCE**
> A. How This Insurance Applies
> 1. This other states insurance applies only if one or more states are shown in Item 3.C. of the Information Page.
> 2. If you begin work in any one of those states after the effective date of this policy and are not insured or are not self-insured for such work, all provisions of the policy will apply as though that state were listed in Item 3.A. of the Information Page.
> 3. We will reimburse you for the benefits required by the workers compensation law of that state if we are not permitted to pay the benefits directly to persons entitled to them.

How other state workers comp laws can affect your coverage

Now we've come to the last of the three coverage parts—other states insurance.

This section of the policy replaces the Broad Form All States Endorsement which used to be used with earlier policy forms. The coverage is still optional. It automatically provides compensation coverage in additional states, but only if the additional states are referred to in item 3.C. and you inform the carrier as soon as work begins in any new state. The policy cannot cover exposures in the six jurisdictions where monopolistic state funds operate—Nevada, North Dakota, Ohio, Washington, West Virginia, and Wyoming. So, if you anticipate exposures in any of those states, arrangements will have to be made with the appropriate state fund.

If you have a work exposure on the effective date of the policy in any state which is not listed in item 3.A, there will not be any coverage in that state unless the insurance company is notified within 30 days.

But what happens if you open a new office in a state not listed in 3.A., and a claim occurs there immediately—before you notify the insurance company of the new location? The other states insurance coverage automatically extends coverage to additional states where operations begin midterm, but only if these new states are listed on the information page, under item 3.C.

To prevent overlooking a state, many insurance professionals recommend writing the following phrase under 3.C.: "all states except Nevada, North Dakota, Ohio, Washington, West Virginia, Wyoming and the states [already] listed in item 3.A. of the information page." But you must be certain the insurance company is licensed to write in these additional states.

Why, in the last paragraph, did we say "all states except Nevada,

North Dakota, Ohio, Washington, West Virginia, and Wyoming"? Except for Wyoming, state-operated compensation funds have monopolies (exclusive control) over the writing of workers comp in these states. Wyoming's state fund has near control; private insurance companies may write coverage there only for occupations for which workers comp is optional. So, if new operations are planned in any of these states, the employer will have to arrange coverage with the specific state fund.

> 4. If you have work on the effective date of this policy in any state not listed in Item 3.A. of the Information Page, coverage will not be afforded for that state unless we are notified within thirty days.

This clause reinforces the intent of other states insurance: to provide incidental coverage for new operations that begin midterm only. Here the policy says there's no coverage for a work exposure that existed on the policy's effective date in a state not listed in item 3.A. unless notice is given to the insurance company within 30 days of the policy's inception.

> B. Notice
> Tell us at once if you begin work in any state listed in Item 3.C. of the Information Page.

You have to inform your insurance company as soon as you begin work in a new state

You have an obligation to inform the insurance company as soon as work begins in a new state. The insurance company will then delete that state from 3.C. (other states insurance) and add it under 3.A.

> **PART FOUR:**
> **YOUR DUTIES IF INJURY OCCURS**
> Tell us at once if injury occurs that may be covered by this policy. Your other duties are listed here.

Part four of the policy lists your duties when injuries occur, emphasizing the need for early notification to the insurance company. To ensure that all parties respond quickly to injuries, many states have established penalties for not meeting a prescribed timetable.

For example, in California, a worker should notify his employer of an injury within 30 days; the employer must give the worker a claim form within a day of receiving notice; and the first payment for benefits must be made within 14 days of the employer's knowledge of the injury.

You are obligated to inform the insurance company "at once," and to promptly give the insurance company all names and addresses of injured persons and witnesses, all legal notices and demands, and any other necessary information.

> 1. Provide for immediate medical and other services required by the workers compensation law.
> 2. Give us or our agent the names and addresses of the injured persons and of witnesses, and other information we may need.
> 3. Promptly give us all notices, demands and legal papers related to the injury, claim, proceeding or suit.
> 4. Cooperate with us and assist us, as we may request, in the investigation, settlement or defense of any claim, proceeding or suit.
> 5. Do nothing after an injury occurs that would interfere with our right to recover from others.
> 6. Do not voluntarily make payments, assume obligations or incur expenses, except at your own cost.

Your duties once an injury has occurred

The other duties, all fairly self-explanatory, are designed to facilitate the company's handling of claims while minimizing expense.

When injury occurs, you must notify the insurance company, provide any medical services required by the workers compensation law, give the insurance company or agent names and addresses of injured persons and witnesses, cooperate with and assist the insurance company in investigating and settling the claim or suit, and do nothing to interfere with the insurance company's right to recover from others. Additionally, you may not voluntarily make payments, assume obligations, or incur expenses except at your own cost.

This section is the tool that many workers comp carriers use when they suspect fraudulent claims are taking place. Some companies will use this tool aggressively.

While you should want your comp insurer to investigate fraud, some insurance companies use fraud as an excuse to resist claims. And even those that aren't sneaky about resisting payments can be foolish about looking for fraud where it's not.

The 1992 Florida supreme court decision *Billy G. Sibley v. Adjustco, Inc.* is an example of how aggressively some insurance companies investigate suspected fraud.

Some insurance companies use fraud as an excuse not to pay

In the initial workers compensation proceeding, a state comp judge—in some states these people are called "referees"—found that Billy Sibley suffered an acute myocardial infarction caused by unloading his truck. As a result of Sibley's condition, the judge found a 50 percent permanent partial disability in accordance with the opinions of the treating physicians.

Sibley's employer tried to argue that his actions weren't an ordinary part of his job—and, therefore, shouldn't be covered by its comp insurance.

The workers comp judge made an express finding concerning this issue. He focused on the conduct of William Adams, an adjuster for the comp insurance company:

> I have thoroughly reviewed and considered the statement which was taken by William Adams, an adjuster, employed by the employer and its carrier.
>
> It is my finding that the statement was taken while Sibley was under less than optimum physical condition and that he was at that time not completely aware of his surroundings nor fully cognizant of the implications and ramifications of the questions being posed to him by the adjuster.
>
> I do not find that the statement as transcribed is of credible value and appears to a large degree to have been edited by the interviewer and does not contain all of the facts and circumstances surrounding the occurrence of the heart attack or of the matters discussed at the time of the taking of the statement as testified to by the claimant and by his wife who was present at the time of the taking of the statement.
>
> I, therefore, specifically reject the statement as having substantial weight and merit and of having any credible value in the findings of compensability herein.

Sibley promptly sued Adjustco. His complaint alleged that, while he was hospitalized in a heavily sedated condition, his statement was taken by Adams. Furthermore, this statement was inaccurate and had been edited in material respects and that, because of Adams' fraudulent acts, the carrier refused to pay Sibley workers compensation benefits.

An injured worker alleges intentional behavior

Sibley's complaint charged that such acts were intentional misconduct. The insurance carrier moved to dismiss the action. The trial court granted the insurance carrier's motion, concluding that Florida workers comp law required a criminal conviction before a civil claim of fraud could be made.

State law provided, in pertinent part:

> Any person who...prepares or makes any written or oral statement that is intended to be presented to any employer, insurance company, or self-insured program in connection with, or in support of, any claim for payment or other benefit pursuant to any provision of this chapter, knowing that such statement contains any false or misleading information concerning any fact or thing material to such claim...shall be guilty of a felony of the third degree....
>
> The provisions of this subsection shall also apply with respect to any employer, insurer, self-insurer, adjusting firm, or agent or representative thereof who intentionally injures, defrauds, or deceives any claimant with regard to any claim. Such claimant shall have the right to recover the damages provided in this subsection.

On appeal, the supreme court held that the statute requiring crimi-

nal conviction as precedent to a civil action was only an "alternative course of action rather than exclusive cause of action."

So, the law didn't prevent Sibley from suing without first obtaining criminal adjudication of guilt. He could proceed.

> **PART FIVE:**
> **PREMIUM**
> A. Our Manuals
> All premium for this policy will be determined by our manuals of rules, rates, rating plans and classifications. We may change our manuals and apply the changes to this policy if authorized by law or a governmental agency regulating this insurance.

In part five, the policy gives us a look at its pricing structure: it defines elements used in premium development. All premiums for the policy will be determined by the insurance company's manual of rules, rates, and classifications.

> B. Classifications
> Item 4 of the Information Page shows the rate and premium basis for certain business or work classifications. These classifications were assigned based on an estimate of the exposures you would have during the policy period. If your actual exposures are not properly described by those classifications, we will assign proper classifications, rates and premium basis by endorsement to this policy.

The elements of premium calculation

For workers compensation rating purposes, all occupations are divided into classifications. Similar employments are grouped so that each class reflects exposures common to them all. Some jobs are inherently more dangerous than others, and the classification system attempts to bring equity to the rating system.

The classifying of a risk, more than any other factor, governs the workers comp premium. Classifications and rates, based on expected work exposures, are listed on the policy's information page. From them estimated premiums are developed. But the insurance company can correct inaccurate policy classifications by endorsement.

> C. Remuneration
> Premium for each work classification is determined by multiplying a rate times a premium basis. Remuneration is the most common premium basis. This premium basis includes payroll and all other remuneration paid or payable during the policy period for the services of:

The premium basis used with most classifications is remuneration. (Remuneration includes payroll and other forms of payment such as commissions, bonuses, employer-provided room and board, etc.) Simply multiply the premium basis by the rate to obtain the premium for that classification.

Let's look at an example of an office risk with an anticipated annual payroll of $300,000. Let's assume the rate for the appropriate classification, Clerical—8810, is $.40 per $100 of payroll. The formula for determining the premium for this class is $300,000/100 or 3000 (premium basis) x $.40 (rate) = $1,200 (estimated annual premium).

> 1. all your officers and employees engaged in work covered by this policy; and

Payroll for all covered officers and employees is used to compute premium, but most states have established minimum and maximum reportable payrolls for each executive officer.

> 2. all other persons engaged in work that could make us liable under Part One (Workers Compensation Insurance) of this policy. If you do not have payroll records for these persons, the contract price for their services and materials may be used as the premium basis. This paragraph 2 will not apply if you give us proof that the employers of these persons lawfully secured their workers compensation obligations.

If subcontractors are not insured, the prime contractor is liable

The laws of most states make a contractor liable for compensation benefits for injured employees of an uninsured subcontractor. And insurance companies require premium for this added exposure. Unless the insured contractor collects, as proof of coverage, certificates of workers comp insurance from each sub, the contractor can expect an additional premium charge to cover subcontracted work. In these cases, the contract price for the sub's services and materials may be used as the premium basis.

> D. Premium Payments
> You will pay all premium when due. You will pay the premium even if part or all of a workers compensation law is not valid.

To prevent cancellation of the policy for nonpayment, you must pay all premiums, even estimated premiums, when due.

> E. Final Premium
> The premium shown on the Information Page, schedules, and endorsements is an estimate. The final premium will be determined after this policy ends by using the actual, not the estimated, premium basis and the proper classifications and rates that lawfully apply to the business and work covered by this policy. If the final premium is more than the premium you paid to us, you must pay us the balance. If it is less, we will refund the balance to you. The final premium will not be less than the highest minimum premium for the classifications covered by this policy.

Final policy premiums are determined—based on actual rates, classifications, and premium basis—after the policy's expiration. If the

final premium is more than the estimated premium previously paid, you must pay the additional premium. If the final premium is less than the estimated premium, the insurance company will refund the balance. However, each policy is subject to a minimum premium.

> If this policy is canceled, final premium will be determined in the following way unless our manuals provide otherwise:
> 1. If we cancel, final premium will be calculated pro rata based on the time this policy was in force. Final premium will not be less than the pro rata share of the minimum premium.
> 2. If you cancel, final premium will be more than pro rata; it will be based on the time this policy was in force, and increased by our short-rate cancellation table and procedure. Final premium will not be less than the minimum premium.

If the insurance company cancels the policy, the final premium and any premium adjustment will be determined on a pro rata basis (proportional, based on the time the policy has actually been in effect). If you cancel, the final premium and adjustment will be determined on a short rate basis (a slightly higher charge, or penalty, is imposed to cover initial policy writing costs).

> F. Records
> You will keep records of the information needed to compute premium. You will provide us with copies of those records when we ask for them.

Final premiums are based on actual payroll exposures—as opposed to a policy limit, because there is no policy limit. The limit is determined by state law. The policy requires you to keep payroll records and other information necessary to accurately compute premium and to give the insurance company copies if requested.

The insurance company has the right to audit your books

> G. Audit
> You will let us examine and audit all your records that relate to this policy. These records include ledgers, journals, registers, vouchers, contracts, tax reports, payroll and disbursement records, and programs for storing and retrieving data. We may conduct the audits during regular business hours during the policy period and within three years after the policy period ends. Information developed by audit will be used to determine final premium. Insurance rate service organizations have the same rights we have under this provision.

The insurance company has the right to examine and audit your records to the extent that they relate to the policy. (This right is also extended to rate service organizations.) These records can be in a variety of forms, from ledgers to computer data. The audits, made in regular business hours, can occur during the policy period and within three years of its expiration.

The final audit billing should never be a "surprise" to you, yet audits often develop unexpected additional premiums. Using wrong classifications, underestimating payroll, not keeping complete accounting records—all can result in additional premiums at audit.

> **PART SIX:**
> **CONDITIONS**
> A. Inspection
> We have the right, but are not obliged to inspect your workplaces at any time. Our inspections are not safety inspections. They relate only to the insurability of the workplaces and the premiums to be charged. We may give you reports on the conditions we find. We may also recommend changes. While they may help reduce losses, we do not undertake to perform the duty of any person to provide for the health or safety of your employees or the public. We do not warrant that your workplaces are safe or healthful or that they comply with laws, regulations, codes or standards. Insurance rate service organizations have the same rights we have under this provision.

In this last part, we find a number of specific policy conditions.

The insurance company can also inspect your workplace

The inspection provision clearly states that the insurance company and rate service organization have the right to inspect your workplace for underwriting and rating considerations. But these inspections aren't to be considered safety inspections. It's not the insurance company's intent to make sure that you operate a safe workplace.

> B. Long Term Policy
> If the policy period is longer than one year and sixteen days, all provisions of this policy will apply as though a new policy were issued on each annual anniversary that this policy is in force.

Most policies are written for one-year terms. This clause states that, in any policy written for a term longer than one year and sixteen days, the provisions apply as if a new policy were issued at each annual policy anniversary. For an application of this condition, let's look at the policy limit for disease for employers liability insurance. The "policy aggregate limit" becomes an annual aggregate limit.

> C. Transfer of Your Rights and Duties
> Your rights or duties under this policy may not be transferred without our written consent.
> If you die and we receive notice within thirty days after your death, we will cover your legal representative as insured.

Only by the insurance company's written consent can the policy be assigned to another. On your death, your legal representative can be covered, provided the insurance company is notified within thirty days.

> D. Cancellation
> 1. You may cancel this policy. You must mail or deliver advance written notice to us stating when the cancellation is to take effect.

You may cancel the policy at any time by providing proper notice. The insurance company may cancel by giving at least 10 days advance written notice (cancellation notice requirements may vary by state.) The policy will terminate on the day and hour specified in any cancellation notice.

> 2. We may cancel this policy. We must mail or deliver to you not less than ten days advance written notice stating when the cancellation is to take effect. Mailing that notice to you at your mailing address shown in Item 1 of the Information Page will be sufficient to prove notice.
> 3. The policy period will end on the day and hour stated in the cancellation notice.
> 4. Any of these provisions that conflict with a law that controls the cancellation of the insurance in this policy is changed by this statement to comply with the law.
> E. Sole Representative
> The insured first named in Item 1 of the Information Page will act on behalf of all insureds to change this policy, receive return premium, and give or receive notice of cancellation.

The first named insured shown on the information page will be the sole representative for the purpose of acting on behalf of all other insured parties to change the policy, receive return premiums, and to give or receive notice of cancellation. This simplifies the obligations of the parties when there are multiple businesses, affiliates and/or subsidiaries covered by the same policy.

Common endorsements

Assigned risk plans offer coverage to employers who can't find any other kind

A standard policy's terms and conditions may be changed by the attachment of written endorsements issued by the insurance company. A policy's jurisdiction can be broadened to include coverage for employees who fall under federal or maritime laws; a policy's term can be shortened to attain an established anniversary date for experience rating—all by endorsements.

The coverage provided by the standard workers compensation and employers liability policy will not meet the needs of every insured. Various endorsements are available to adjust the coverage for special needs.

One practical coverage is voluntary compensation for employees who are normally exempt from the law. You may not be required to provide the coverage, but voluntary benefits may be an act of goodwill and may prevent lawsuits under the employers liability section of the policy.

Example: If you use unpaid interns at your company, you may want to provide benefits for them in the event that they are injured. This will help you avoid a civil lawsuit, which might be more costly.

You should remember that certain workers fall under federal jurisdiction no matter where they work. Those who load, unload, build or repair ships are covered by the U.S. Longshore and Harbor Workers Compensation Act. Miners may require Federal Black Lung Compensation insurance. A workers compensation policy will not automatically provide any of these benefits, and an employer faces a risk that required benefits under federal law may be substantially higher than state benefits provided by the policy. Endorsements are available for each of these exposures. For example, the Longshore and Harbor Workers Endorsement extends coverage under a compensation policy so that it will pay the benefits required by federal law.

Other exposures exist outside of the area of statutory benefits. Masters and members of the crew of ocean vessels are protected by a section of the Merchant Marine Act, which is known as the Jones Act. The law permits an injured seaman to elect to sue the employer for damages and to have a jury trial. Insurance is provided under the employers liability section of a standard workers compensation policy, but when the exposure exists the insurance company usually requires attachment of the Maritime Coverage Endorsement, which actually limits the insurance and adds a few more exclusions to the policy. If an employer does not want an injured seaman to have to sue for damages after being injured on the job, the employer can purchase the Voluntary Compensation Maritime Coverage Endorsement, which voluntarily provides the statutory benefits of the worker's home state. As is the case with voluntary compensation coverage for other workers, this approach is a matter of goodwill and may prevent lawsuits.

Workers comp issues for employees who work abroad

The foreign coverage endorsement makes the workers compensation policy 24-hours per day/7-days per week coverage. It also covers an endemic disease characteristic to the area as an occupational disease, and includes the option to buy repatriation coverage, or the additional amount it would take to return the person to the United States.

Assigned risk plans

In some states, workers compensation assigned risk plans have been established to guarantee that employers who have had difficulty in finding coverage will be able to obtain insurance. The assigned risk plan is actually an insurance pool, where risks are shared by participating insurance companies. Participation by authorized carriers in the state may be mandatory or voluntary. An applicant may need to show evidence of having attempted to obtain coverage, and having been rejected, before becoming eligible for insurance through the pool. Risks submitted to the pool may be assigned to a single carrier, or

may be shared proportionally by all participating carriers. The requirements will vary from state-to-state, and the pools do not exist in every state. However, you should be aware that this mechanism exists, and that its purpose is to make coverage available for difficult to place risks.

Workers compensation rating

Basic rates for workers compensation insurance are based upon a system of job classifications and manual rates. Job classification codes have been established for each type of job description. Separate job descriptions and classification codes exist for similar types of jobs if there are significant differences in the risk factors present. For each job classification code there is a manual rate. Naturally, the rates are higher for high-risk occupations (such as construction and manufacturing) than for low-risk occupations (such as clerical office work and service work).

The premium base for each job classification is payroll. Basic premiums are determined by multiplying the manual rate for each job classification code by each $100 of payroll for that classification.

Job classifications and experience ratings affect the price you pay

Smaller employers generally pay the manual rates. Larger employers are subject to experience rating, which allows for adjustments of the premium based on actual loss experience. Each employer's actual losses for past years is used in determining an experience rating factor, which is multiplied by the basic premium to arrive at the experience rated premium. In this manner, an employer who has been able to control and minimize losses pays an actual premium which is lower than the basic premium, while an employer who has had above average losses pays an actual premium which is higher than the basic premium.

Employers may choose to participate in a retrospective rating plan, which uses a formula to adjust the premium after the end of the policy period. A retrospective rating formula has a number of elements, including a minimum and maximum premium percentage, and a stop loss for individual losses.

Each of these elements allows you to assume a greater or lesser amount of the risk, which tends to push the provisional premium in the opposite direction (the greater the risk assumed by the employer, the lower the premium, and vice versa). The minimum and maximum premium levels represent a floor and a ceiling on how far the final retrospective premium can be adjusted.

For example, a minimum of 75 percent and a maximum of 125 percent means that you could get back as much as 25 percent of the provisional premium, or could end up paying as much as 25 percent more than the provisional premium. The stop loss represents a limit on how much of any individual loss will be used in the calculation of the final premium. For example, if the stop loss is $25,000 and a

$40,000 loss is paid, only $25,000 of the loss will be used in the premium calculation. After the policy expires, individual losses (subject to the stop loss limit) will be added together and used in the retrospective rating calculation. A separate stop loss may apply to aggregate losses. The formula, which includes basic premiums, limited losses, and loadings for company expenses and premium taxes, will produce the final premium (subject to the plan's minimum and maximum limits).

Many companies are now using managed health care networks (HMOs PPOs, etc.) to help restrain the growth of workers comp insurance costs. These networks use volume purchasing and careful scrutiny of expense—commonly referred to as *utilization review*—to hold down medical costs. By channeling injured employees to these networks, you can limit the temptation of employees and health care providers to collude in fraudulent schemes.

24-hour coverage

Employers can purchase a combination of traditional health insurance and workers compensation insurance so that coverage is provided under the same policy regardless of whether the employee's injury or illness is work-related. Advantages include the elimination of duplicate benefits, and the fact that there is no need to first establish whether a claim is work-related before determining coverage (this would also reduce related litigation expenses). There are administrative cost savings as well, since only one source coordinates and delivers the insurance benefits.

Some disadvantages to 24-hour coverage include differences in the underlying insurance benefits (for example, medical benefits are provided without limit and without deductibles or copayments under workers compensation insurance, but not under regular health insurance policies). Also, there may be conflict with conversion privileges, preexisting condition exclusions, dispute resolution, and waiting periods. Finally, there may be legal barriers such as conflicts with ERISA and some state laws to be resolved when this combination coverage is contemplated.

INSURING THE BOTTOM LINE

Chapter Six

Crime, Theft and Employee Dishonesty

Introduction

If you've been in business for any length of time, you've probably had some experience with crime. You probably also know that crime risks can take all kinds of shapes—blatant matters like thieves robbing retail outlets at gun point and subtler matters like inventory shrinkage that's never adequately explained.

Crime insurance provides a vital form of protection for business organizations—and individuals. Modern society suffers from a serious crime rate, and many felonious acts involve the theft of money, securities, or other property.

While insurance cannot eliminate the problem—and may, in some instances, even contribute to it—coverage can protect policyholders against financial losses resulting from the dishonest acts of others.

Criminals have grown more sophisticated and there is no way to fully safeguard property from thieves. Loss control efforts help reduce the risk of some types of losses. Before accepting a risk, underwriters may require the installation of new locks, alarms, and other security devices. But not all theft losses involve breaking and entering, or confrontations with armed criminals. Some losses are more difficult to control. Certain crimes are not easily detected when they occur—particularly when committed by someone having access to a premises or charged with handling money.

Many different types of dishonest acts may be the subject of crime insurance. Some policies even provide coverage for loss by "mysterious disappearance," which might not have been caused by a criminal act. However, losses generally fall into one of the following categories of dishonest acts:

- employee dishonesty,
- forgery,

INSURING THE BOTTOM LINE

- burglary,
- robbery, and
- theft.

Commercial crime coverages may be written as a monoline policy or as part of a commercial package policy. Crime forms were included in the recent policy and rating simplification program conducted by the Insurance Services Office, and the coverages may now be written on the new commercial forms. One of the unique things about the commercial crime program is that jurisdiction is jointly shared by ISO and the Surety Association of America (SAA). Four of the coverages are written on SAA forms rather than ISO forms, but SAA and ISO forms may be attached to the same policy.

The various crime coverage forms can be combined in numerous ways

Modernization has brought a considerable reduction in the number of crime forms and endorsements—more than 500 forms have been replaced by about 175 forms in the simplified program. Most of these forms are endorsements. There are only 17 major coverage forms in the new program, which may be combined in different ways under any of 10 coverage plans which are currently available. Although the forms have been simplified, the coverages available under the new program are virtually the same as those available under the earlier forms.

Each of the 17 coverage forms in the program is designated by a letter. The names of the available coverage forms are:

- Form A—Employee dishonesty (blanket or schedule options),
- Form B—Forgery or alteration,
- Form C—Theft, disappearance and destruction,
- Form D—Robbery and safe burglary (property other than money and securities),
- Form E—Premises burglary,
- Form F—Computer fraud,
- Form G—Extortion,
- Form H—Premises theft and robbery outside premises (property other than money and securities),
- Form I—Lessees of safe deposit boxes,
- Form J—Securities deposited with others,
- Form K—Liability for guests' property—safe deposit box,
- Form L—Liability for guests' property—premises,
- Form M—Safe depository liability,
- Form N—Safe depository direct loss,

- Form O—Public employees dishonesty—per loss,
- Form P—Public employees dishonesty—per employee, and
- Form Q—Robbery and safe burglary—money and securities.

In the later parts of this chapter, we will consider Forms C and A, respectively. However, Forms D and E—which we won't consider in depth here—are also applicable to almost any business.

Any combination of the available crime forms included in the same policy completes what is known as a Commercial Crime Coverage Part. The same coverage forms are used to construct monoline policies (consisting only of crime coverages) and package policies (consisting of crime coverages combined with other commercial coverages).

Common coverage conditions usually apply to this insurance

Whether crime coverages are issued as a monoline policy or as part of a package, a crime coverage part must be attached to the common conditions of the commercial lines program. The common declarations page is to be used if a package policy is written, but if a monoline crime policy is written a crime declarations page may be used as the only declarations. In either case, the crime coverage part will consist of:

- crime declarations page (Form A or B),
- crime general provisions form and/or safe depository provisions form,
- one or more crime coverage forms, and
- any applicable endorsements.

The crime declarations show the policy number, applicable coverage forms, limits of insurance, deductible amounts and endorsements which are attached to the coverage part. There are two variations of the crime declarations page.

Declarations Form A is to be used when crime coverages are being issued as a monoline policy. In addition to the other information, it has a place for the named insured's name and address, the policy period, and the identity of the insurance company and the producer. This is the only difference between forms A and B. When crime coverage is issued as a monoline policy with Declarations Form A, it is not necessary to attach the Common Policy Declarations.

Declarations Form B is to be used when crime coverages are being issued as part of a package policy. It does not identify the named insured, insurance company or producer, but that information will be found on the Common Policy Declarations.

Insurance for specific kinds of property against specific kinds of peril

The policy

Crime insurance policies cover specific types of property against loss by specific perils. For example, burglary and robbery are specific perils. Whether or not a loss is covered may depend upon whether a burglary or robbery, as defined by the policy, has been committed.

> Throughout this policy the words "you" and "your" refer to the Named insured shown in the DECLARATIONS. The words "we", "us" and "our" refer to the company providing this insurance.
> Words and phrases in quotation marks are defined in the policy.

The coverage form begins with a few simple statements. First it cautions you to read the "entire policy," meaning all parts of the policy in addition to the crime forms.

It then explains that various pronouns (such as "you" and "we") are used to refer to the named insured and the insurance company.

Words that appear in quotation marks have specific definitions in the policy. These may be found in the general provisions or in the individual coverage forms.

> Unless stated otherwise in any Crime Coverage Form, DECLARATIONS or endorsement, the following General Exclusions, General Conditions and General Definitions apply to all Crime Coverage Forms forming part of this policy.

General provisions apply to all crime forms

The general provisions will apply to all crime coverages unless exceptions appear elsewhere in the policy.

> A. GENERAL EXCLUSIONS: We will not pay for loss as specified below:
> 1. Acts Committed by You or Your Partners: Loss resulting from any dishonest or criminal act committed by you or any of your partners whether acting alone or in collusion with other persons.

The insurance is designed to cover losses which are not expected and cannot be fully eliminated, such as theft by employees, burglars or robbers. Intentional criminal acts by a named insured or partner are not covered.

The 1995 federal district court decision *Redux, Ltd. v. Commercial Union Insurance* considered the definition of *criminal act* in some detail.

Redux made a claim on its commercial property policy—written by Commercial Union—for losses suffered following a fire that occurred at its place of business in Kansas City, Kansas. Commercial Union suspected that the fire had been started intentionally. It denied the claim, citing the policy's criminal acts exclusion, and disputed the nature and extent of the damages claimed.

An insurance company denies a claim based on its definition of "criminal act"

Redux sued, arguing that CU couldn't deny coverage based on the criminal act exclusion because the term "criminal act" referred only to crimes for which an owner, employee or representative of Redux had been convicted or with respect to which a person had pled guilty in a criminal proceeding. No such outcome had occurred in relation to the Kansas City fire. No one connected with Redux had even been charged of criminal wrongdoing.

CU argued that the term "criminal act" did not require a formal adjudication of criminal guilt, but rather would operate to deny coverage when it was shown that Redux's employee committed acts which would satisfy the statutory or common-law elements of the crime asserted.

The court was persuaded by CU's interpretation of "criminal act." It wrote:

> The plain and ordinary meaning of the term is something more than a crime for which there has been a conviction or entry of a guilty plea. The court finds that the plain meaning of the term "criminal act" does not require an adjudication in a court of law. Thus, the term shall be construed in this case in its ordinary sense to include acts which would amount to or constitute a crime, namely the crime of arson, under the law of Kansas.

Commercial Union took the case a step further, though. It sought a determination to show that it had not misrepresented a material fact related to coverage. It contended that, unlike most insurance policies which "exclude" coverage when there has been fraud, its policy specifically conditioned coverage upon the lack of fraud.

The court didn't follow the insurance company this far. It refused to give CU the determination it sought.

The policy stated:

> We will not pay for loss or damage caused by or resulting from any of the following...Dishonest or criminal act by you, any of your partners, employees, directors, trustees, authorized representatives or anyone to whom you entrust property for any purpose....

The court ruled that this paragraph placed conditions that were too broad on the coverage. It wrote:

> ...even if a formal adjudication of guilt were necessary to make an act "criminal" under the policy, it appears that CU could...argue the applicability of that portion of the policy prohibiting coverage for "dishonest" acts. Committing arson in an attempt to fraudulently procure insurance proceeds, if proved, would be a "dishonest" act.

CU had to be content with its ability to deny Redux coverage pending—at least—a civil court determination that no one at the company was involved in setting the fire.

INSURING THE BOTTOM LINE

> 2. Governmental Action: Loss resulting from seizure or destruction of property by order of governmental authority.

Governmental action is not covered under this policy

Loss resulting from the execution of an order by any government body is not covered.

Example: If the police seize illegal drugs or stolen property which you were holding for sale, the loss is not a covered crime loss under the policy.

> 3. Indirect Loss: Loss that is an indirect result of any act or "occurrence" covered by this insurance including, but not limited to, loss resulting from:
> a. Your inability to realize income that you would have realized had there been no loss of, or loss from damage to, Covered Property.
> b. Payment of damages of any type for which you are legally liable. But, we will pay compensatory damages arising directly from a loss covered under this insurance.
> c. Payment of costs, fees or other expenses you incur in establishing either the existence or the amount of loss under this insurance.

There is no coverage for indirect, or consequential, losses that result from other losses.

Example: As a result of merchandise being stolen just before a big sale, you lose expected revenues. The value of the merchandise lost may be covered, but the additional loss of income is not.

> 4. Legal Expenses: Expenses related to any legal action.

Direct losses as described by the coverage forms are covered, but any related legal expenses are not.

> 5. Nuclear: Loss resulting from nuclear reaction, nuclear radiation or radioactive contamination, or any related act or incident.
> 6. War and Similar Actions: Loss resulting from war, whether or not declared, warlike action, insurrection, rebellion or revolution, or any related act or incident.

Looting after a nuclear disaster would not be covered

Losses resulting from nuclear hazards and acts of war are excluded under many types of insurance coverages because they are catastrophic exposures.

Example: If looting followed a nuclear explosion or insurrection, it would not be covered because the primary cause of loss is excluded.

> B. GENERAL CONDITIONS
> 1. Consolidation—Merger: If through consolidation or merger with, or purchase of assets of, some other entity:
> a. Any additional persons become "employees"; or

b. You acquire the use and control of any additional "premises"; any insurance afforded for "employees" or "premises" also applies to those additional "employees" and premises," but only if you:
a. Give us written notice within 30 days thereafter; and
b. Pay us an additional premium.

Additional employees or premises acquired by purchase or merger will be automatically covered for 30 days. You must give written notice and pay an additional premium within the 30-day period in order for coverage to continue.

The Crime General Provisions are attached to every policy that includes crime coverages, regardless of whether it is a monoline or package policy. These provisions apply to all crime coverages which are part of the policy, and apply only to the crime coverage part. Having a separate form for general provisions reduces redundancy by eliminating the need to attach the same provisions to each coverage form.

Many conditions applicable to crime forms are similar to those found on other commercial forms. Various conditions describe the policy period, policy territory, your duty to keep records, terms for legal actions against the insurance company, treatment of loss when other insurance applies (commercial crime coverage will apply as excess), and the insurance company's subrogation rights when losses are paid. Key provisions which have a more specific application to the crime coverages are reviewed below.

You have to notify the insurance company about changes in your operations

Like other specialized commercial insurance coverages, crime policies are impacted by fine points of technical language. "Notice" given to the insurance company about changes in your operation can be important. The 1994 federal court decision *Norman Newman, Trustee in Bankruptcy of Wallace & Orth, Inc. v. Hartford Insurance Company of Illinois* offers one good example of this kind of dispute.

Orner, Shayne, & Reizner, Inc. (OSRI) was incorporated as an Illinois corporation in 1971. Ray Riezner was OSRI's sole shareholder, and continued to be so at all relevant times.

OSRI conducted its property management business under the names OSRI, Wallace & Orth, and Wallace & Orth, Inc. From January 1986 through September 1989, OSRI's Evanston, Illinois, office operated under the names "Wallace & Orth" and "Wallace & Orth, Inc." Meanwhile, OSRI's Chicago office operated under the name "OSRI."

Although OSRI sometimes conducted business as "Wallace & Orth, Inc.," Wallace & Orth, Inc. was not a separately incorporated entity prior to September 1989. Gross receipts were included on OSRI's corporate income tax returns, regardless of whether they were generated from business transacted in the name of OSRI, Wallace & Orth, or Wallace & Orth, Inc.

In December 1987, Hartford issued a crime policy which listed OSRI

as named insured. An endorsement to the policy listed three additional named insureds: Wallace & Orth, a Division of Orner, Shayne & Reizner, Inc.; Orner, Shayne & Reizner Deferred Benefit Plan; and O.S.R. Disbursement Corp.

The policy provided coverage for losses caused by employee dishonesty, forgery or alteration, and theft, disappearance and destruction. It set forth certain general exclusions and general conditions that were applicable to all three coverages.

The policy also contained certain restrictions on changes in insurance and the transfer of rights and duties under the policy. Among its common conditions:

> This policy contains all the agreements between you and us concerning the insurance afforded.... If the terms are changed, the changes will be shown in an endorsement issued by us and made a part of this policy.

> ...Your rights and duties under this policy may not be transferred without our written consent except in the case of death of an individual Named Insured.

In September 1989, Ray Reizner incorporated a new Illinois corporation by the name of Wallace & Orth, Inc. (WOI). He was again the sole shareholder. WOI filed its own federal and state income tax returns separate from those filed by OSRI.

Changes in a company's structure obscure coverage issues

At least one asset and liability of OSRI appeared to have been assumed by or assigned to WOI. The new company's 1990 federal income tax return listed "Due Orner Shayne & R $471,890" as an asset of WOI, and "Due Management Acct $478,155" as a liability. Neither entry had appeared on its 1989 tax return.

OSRI employed John J. Butler from 1976 to February 1990. In the late 1980s, Butler was made a vice president of OSRI. In that role, he was responsible for running OSRI's Chicago office. OSRI also employed Butler's son Michael Butler and a comptroller named Gerald Smith.

Between 1986 and 1990, a number of checks were written on OSRI's property management account to "J.B. Jamison" and "Vernon Plumbing." Many of the checks were cashed at currency exchanges near OSRI's Chicago office. According to the eventual bankruptcy trustee, Jamison's endorsement on a number of the checks was "probably" forged by Butler.

By January 1990, Riezner had sold the WOI and its assets—principally, two buildings on Michigan Avenue on Chicago's North Side—to a group headed by John Butler.

In August 1990, Riezner signed and submitted to Hartford a proof of loss for $1,048,344. He executed the proof of loss as "President of Wallace & Orth, a division of Orner, Shayne & Reizner." The form

stated that the loss was incurred as a result of the dishonesty of John Butler, Michael Butler and Gary Smith.

WOI filed for bankruptcy protection in 1991. WOI's bankruptcy trustee sued Hartford, seeking a declaratory judgment that the insurance company was obligated to pay WOI a portion of any claim paid to Riezner under the crime policy.

WOI's trustee argued that he was entitled to pursue a claim because one of the assets WOI had allegedly assumed from Riezner's companies was a claim under the crime policy.

According to the trustee, when Reizner spun off the Michigan Avenue buildings and other assets into the independent WOI, the new company assumed all of the liabilities created by the alleged thefts—and therefore the right to make claims against Hartford.

The court disagreed, writing:

> After reviewing the language of the Policy, we are left with no other choice than to conclude that [WOI's trustee] lacks standing to pursue this claim against Hartford.
>
> ...the language of the Policy is anything but ambiguous.
>
> Paragraph 12 of the Crime General Provisions Form states "[T]his insurance is for your [the named insured's] benefit only. It provides no rights or benefits to any other person or organization."
>
> Paragraph F of the Common Policy Conditions states that "[the named insured's] rights and duties under this policy may not be transferred without our written consent...."

The court concluded that only named insureds were entitled to receive benefits or have any rights under the Hartford policy. Any purported transfer of rights was unenforceable unless Hartford consented in writing.

No Illinois corporation by the name of "Wallace & Orth, Inc." was listed on the policy as a named insured. This fact outweighed all of the bankruptcy trustee's arguments for allowing a transfer of interest in the policy. The court wrote:

The failure to list a new company as a named insured outweighed any transfer of coverage

> Despite [the trustee's] allegation that WOI assumed the OSRI division's assets and liabilities, [he] has not produced any evidence of a written sale or assignment agreement between OSRI and WOI.
>
> ...The fact that WOI listed its claim under the Hartford policy on its bankruptcy schedules proves nothing. The 1990 tax returns are even less compelling in this context, as we can make no inferences about whether Reizner actually "spun off" Wallace & Orth into WOI from the mere fact that one asset and one liability appear to have been assumed by WOI.

> ...The most that can be inferred from the tax returns is that WOI assumed from OSRI a claim held by OSRI in the amount of $471,890 and a liability due from OSRI to the owners of the managed properties in the amount of $478,155.

The court dismissed the bankrupt company's charges against Hartford. Still, it admitted there was a sense of inequity in the conclusion. Riezner may have passed two troubled properties on to a new corporate entity while making a claim for money embezzled from them under his ownership. The court acknowledged the possibility that the WOI bankruptcy trustee might, in time, be able to put together a better case:

> ...because of the harshness of the result and the Court's discomfort with the apparent triumph of form over substance, we invite [the WOI trustee] to seek reconsideration of this matter....

Two years later, the trustee hadn't been able to bring anything substantive to court.

> 2. Coverage Extensions: Unless stated otherwise in the Coverage Form, our liability under any Coverage Extension is part of, not in addition to, the Limit of Insurance applying to the Coverage or Coverage Section.

In this coverage, an extension counts toward a policy limit

Unless otherwise specified in a coverage form, any extension of coverage provided is part of the applicable limit of insurance and is not additional insurance.

> 3. Discovery Period for Loss: We will pay only for covered loss discovered no later than one year from the end of the policy period.

Crime coverages are subject to a "discovery period," because losses are not always immediately apparent, but a limitation applies. In order for a loss to be covered, it must be discovered no later than one year after the end of the policy period.

Example: An employee embezzles funds during the policy period, which ends on December 31, 1994. If the employer has employee dishonesty insurance, the loss will be covered if discovered before the end of 1995. There is no coverage if discovered at a later date.

> 4. Duties in the Event of Loss: After you discover a loss or a situation that may result in loss of, or loss from damage to, Covered Property you must:
> a. Notify us as soon as possible.
> b. Submit to examination under oath at our request and give us a signed statement of your answers.
> c. Give us a detailed, sworn proof of loss within 120 days.
> d. Cooperate with us in the investigation and settlement of any claim.

Most crime forms require you to inform the police of a loss

In the event of loss, your duties include notifying the insurance company as soon as possible, submitting to an examination under oath and signing a statement of the answers given, providing a sworn proof of loss within 120 days, and cooperating with the investigation and settlement of claims. Combined with the one-year discovery period, the 120-day reporting period gives you up to sixteen months from the time of loss to provide official notification that a crime has occurred.

Of course, the insurance company would prefer to know a crime loss has occurred immediately. In many cases, the company will want to know a crime loss has occurred even if you don't intend to file a claim.

Although the general provisions do not say so, most of the individual forms add a requirement that you also notify the police.

> 5. Joint Insured
> a. If more than one Insured is named in the DECLARATIONS, the first named Insured will act for itself and for every other Insured for all purposes of this insurance. If the first named Insured ceases to be covered, then the next named Insured will become the first named Insured.
> b. If any Insured or partner or officer of that Insured has knowledge of any information relevant to this insurance, that knowledge is considered knowledge of every Insured.
> c. An "employee" of any Insured is considered to be an "employee" of every Insured.
> d. If this insurance or any of its coverages is cancelled or terminated as to any Insured, loss sustained by that Insured is covered only if discovered no later than one year from the date of that cancellation or termination.
> e. We will not pay more for loss sustained by more than one Insured than the amount we would pay if all the loss had been sustained by one Insured.

This section clarifies the intent of the policy when there are multiple "insureds." The policy refers to the "first named insured" because commercial policies frequently have more than one named insured, due to subsidiary and affiliated companies being covered. Under the policy, the first named insured acts for all insured parties.

For the purposes of the insurance, knowledge of any insured person (or partner or officer) is treated as knowledge by all insured parties, and an employee of any insured is treated as an employee of every insured person.

Cancellation of coverage for any insured establishes a loss discovery period of one year from the date of cancellation.

Losses suffered by multiple insured parties do not increase the amount of insurance. The most the insurance company will pay is the amount that it would pay if all losses were suffered by one insured.

INSURING THE BOTTOM LINE

6. **Legal Action Against Us:** You may not bring any legal action against us involving loss:
a. Unless you have complied with all the terms of this insurance; and
b. Until 90 days after you have filed proof of loss with us; and
c. Unless brought within 2 years from the date you discover the loss.

You may not sue the insurance company to recover for a loss unless all policy provisions have been satisfied and proof of loss has been filed for at least 90 days. No suit may be brought more than two years after a loss is discovered.

When a loss is covered under more than one coverage

7. **Loss Covered Under More Than One Coverage of This Insurance:** If two or more coverages of this insurance apply to the same loss, we will pay the lesser of:
a. The actual amount of loss; or
b. The sum of the limits of insurance applicable to those coverages.

If two or more coverages apply to the same loss, the insurance company will pay the actual amount of loss or the total of the applicable limits of coverages—whichever is less.

8. **Loss Sustained During Prior Insurance**
a. If you, or any predecessor in interest, sustained loss during the period of any prior insurance that you or the predecessor in interest could have recovered under that insurance except that the time within which to discover loss had expired, we will pay for it under this insurance, provided:
(1) This insurance became effective at the time of cancellation or termination of the prior insurance; and
(2) The loss would have been covered by this insurance had it been in effect when the acts or events causing the loss were committed or occurred.
b. The insurance under this Condition is part of, not in addition to, the Limits of Insurance applying to this insurance and is limited to the lesser of the amount recoverable under:
(1) This insurance as of its effective date; or
(2) The prior insurance had it remained in effect.

Under certain conditions, the insurance company will pay under the current policy for a loss that occurred under prior insurance when the loss could have been recovered except for expiration of the discovery period under the prior insurance. This applies only when the current policy took effect on the date the prior policy terminated and the same type of loss is covered by the current policy. This feature provides seamless coverage across time, as long a crime policy is renewed immediately upon expiration.

The most the insurance company will pay under this provision is the amount of coverage under the current policy on its effective date or under the prior policy had it remained in effect—whichever is less.

Crime coverage applies in excess of "insufficient" other coverage

> 9. Loss Covered Under This Insurance and Prior Insurance Issued by Us or Any Affiliate: If any loss is covered:
> a. Partly by this insurance; and
> b. Partly by any prior cancelled or terminated insurance that we or any affiliate had issued to you or any predecessor in interest.
> the most we will pay is the larger of the amount recoverable under this insurance or the prior insurance.

If a loss is covered partly by the current policy and partly by a prior policy issued by the same insurance company, the most that will be paid is the amount of recovery under the current policy or the prior policy—whichever is larger.

> 10. Non-Cumulation of Limit of Insurance: Regardless of the number of years this insurance remains in force or the number of premiums paid, no Limit of Insurance cumulates from year to year or period to period.

The amount of insurance for each policy year is a separate limit.

Example: If you discover a loss related to a crime that spanned two policy years, you can't claim a loss larger than the single limit applicable in either year. In other words, you can't combine the limits of two separate periods to obtain greater coverage than any one. If the limits applicable in one year are lower than those applicable in another, you may have to live with the lower limits.

> 11. Other Insurance: This insurance does not apply to loss recoverable or recovered under other insurance or indemnity. However, if the limit of the other insurance or indemnity is insufficient to cover the entire amount of the loss, this insurance will apply to that part of the loss, this insurance will apply to that part of the loss, other than that falling within any deductible amount, not recoverable or recovered under the other insurance or indemnity. However, this insurance will not apply to the amount of loss that is more than the applicable Limit of Insurance shown in the Declarations.

Generally, coverage will not apply to any loss that is also covered by another policy. However, if the amount of the other insurance is insufficient, this coverage will apply as excess over the other insurance. It will not pay any deductible amounts or the amount of loss that exceeds the limit of insurance shown in the declarations.

Example: You have a $12,000 loss and another policy that provides $5,000 of coverage above a $500 deductible. This policy has a $10,000 limit, so it will only pay $4,500 ($10,000 minus $5,500).

> 12. Ownership of Property; Interests Covered: The property covered under this insurance is limited to property:
> a. That you own or hold; or

INSURING THE BOTTOM LINE

b. For which you are legally liable. However, this insurance is for your benefit only. It provides no rights or benefits to any other person or organization.

The property and interests covered by crime insurance are limited to property that you own or hold, or for which you are legally liable. The insurance is not designed to benefit any other person or organization.

13. Policy Period
a. The Policy Period is shown in the DECLARATIONS.
b. Subject to the Loss Sustained During Prior Insurance condition, we will pay only for loss that you sustain through acts committed or events occurring during the Policy Period.

The insurance company will only pay for losses that occur during the policy period shown in the declarations, and losses covered under the "prior insurance" condition.

14. Records: You must keep records of all Covered Property so we can verify the amount of any loss.

You are obligated to keep records to verify the amount of any covered losses.

15. Recoveries
a. Any recoveries, less the cost of obtaining them, made after settlement of loss covered by this insurance will be distributed as follows:
(1) To you, until you are reimbursed for any loss that you sustain that exceeds the Limit of Insurance and the Deductible Amount, if any;
(2) Then to us, until we are reimbursed for the settlement made;
(3) Then to you, until you are reimbursed for that part of the loss equal to the Deductible Amount, if any.
b. Recoveries do not include any recovery:
(1) From insurance, suretyship, reinsurance, security or indemnity taken for our benefit; or
(2) Of original "securities" after duplicates of them have been issued.

What happens when stolen property is recovered

After the insurance company pays for a loss, if property is recovered it will be distributed first to you for amounts above the limit of insurance, then to the insurance company up to the amount of any settlement, and then to you to reimburse any deductible assumed.

Example: You have a $20,000 loss of money and coverage of $10,000 above a $500 deductible. After the insurance company pays its $10,000 limit, the full $20,000 is recovered. The first $9,500 goes to you to compensate for the uninsured loss. The next $10,000 goes to the insurance company to reimburse it for its settlement. The final $500 goes to you to reimburse the deductible.

Example: In the same case of a $20,000 loss, $10,000 of coverage and a $500 deductible, $15,000 is recovered after the insurance company pays its policy limit. You are entitled to the first $9,500. The remaining $5,500 goes to the insurance company.

> 16. Territory: This insurance covers only acts committed or events occurring within the United States of America, U.S. Virgin Islands, Puerto Rico, Canal Zone, or Canada.
> 17. Transfer of Your Rights of Recovery Against Others to Us: You must transfer to us all your rights of recovery against any person or organization for any loss you sustained and for which we have paid or settled. You must also do everything necessary to secure those rights and do nothing after loss to impair them.

Transferring your right to recovery

To the extent that any payment is made under the coverage, any rights you have to recover damages from another party are transferred to the insurance company. This is known as a subrogation clause.

Example: After settlement of a theft loss, the guilty party is found. The stolen funds have been squandered, but the thief has other assets. The insurance company has the right to take legal action to recover its payment. Any recoveries will be distributed as described under the "recoveries" paragraph above.

> 18. Valuation—Settlement
> a. Subject to the applicable Limit of Insurance provision we will pay for:
> (1) Loss of "money" but only up to and including its face value. We may, at our option, pay for loss "money" issued by any country other than the United States of America:
> (a) At face value in the "money" issued by that country; or
> (b) In the United States of America dollar equivalent determined by the rate of exchange on the day the loss was discovered.

Because of the nature of crime insurance, the valuation clause is important. All losses are subject to the limit(s) of insurance written.

Loss of money will be paid at face value, but loss of a foreign currency may be paid at its face value in that other currency or in the American dollar equivalent determined by the exchange rate on the day the loss was discovered (the value of a property loss in another country may be paid in the same manner).

> (2) Loss of "securities" but only up to and including their value at the close of business on the day the loss was discovered. We may, at our option:
> (a) Pay the value of such "securities" or replace them in kind, in which event you must assign to us all your rights, title and interest in and to those "securities";
> (b) Pay the cost of any Lost Securities Bond required in connection

> with issuing duplicates of the "securities." However, we will be liable only for the payment of so much of the cost of the bond as would be charged for a bond having a penalty not exceeding the lesser of the:
> i. Value of the "securities" at the close of business on the day the loss was discovered; or
> ii. Limit of Insurance.

A loss of securities will be paid at their value at the close of business on the day the loss was discovered, but the insurance company has the option of replacing them in kind or purchasing a lost securities bond in connection with issuing duplicate securities.

> (3) Loss of, or loss from damage to, "property other than money and securities" or loss from damage to the "premises" for not more than the:
> (a) Actual cash value of the property on the day the loss was discovered;
> (b) Cost of repairing the property or "premises"; or
> (c) Cost of replacing the property with property of like kind and quality. We may, at our option, pay the actual cash value of the property or repair or replace it.
> If we cannot agree with you upon the actual cash value or the cost of repair or replacement, the value or cost will be determined by arbitration.

Value of loss may be determined by arbitration

Loss or damage to a premises or property other than money and securities will be paid at its actual cash value on the date the loss was discovered, or (at the insurance company's option) the cost of repairing or replacing the property. The value or cost will be determined by arbitration if you and the insurance company cannot agree.

If you are interested in replacement value coverage, your insurance company may be willing to sell you a customized endorsement providing this—at additional cost.

> b. We may, at our option, pay for loss of, or loss from damage to, property other than "money":
> (1) In the "money" of the country in which the loss occurred; or
> (2) In the United Stated of America dollar equivalent of the "money" of the country in which the loss occurred determined by the rate of exchange on the day the loss was discovered.
> c. Any property that we pay for or replace becomes our property.

If property other than money and securities is lost or damaged in another country, the insurance company has the option of paying for the loss in the currency of that other country or in the U.S. dollar equivalent as determined by the exchange rate on the date the loss was discovered.

The insurance company has the right to take possession of any property it pays for or replaces.

> C. GENERAL DEFINITIONS
> 1. "Employee" means:
> a. Any natural person:
> (1) While in your service (and for 30 days after termination of service); and
> (2) Whom you compensate directly by salary, wages or commissions; and
> (3) Whom you have the right to direct and control while performing services for you; or
> b. Any natural person employed by an employment contractor while that person is subject to your direction and control and performing services for you excluding, however, any such person while having care and custody of property outside the "premises."
> But "employee" does not mean any:
> (1) Agent, broker, factor, commission, merchant, consignee, independent contractor or representative of the same general character; or
> (2) Director or trustee except while performing acts coming within the scope of the usual duties of an employee.

The final section of the general provisions contains four definitions that apply to all crime coverages.

The definition of "employee"— a critical matter

An "employee" means a natural person who works for and is paid by you, and whom you have the right to direct and control, including temporary personnel provided by an employment contractor or agency. But this term does not include an independent contractor, or any directors or officers of your company while acting beyond the scope of an employee's usual duties.

The 1994 federal district court decision *Colson Services Corp. v. Insurance Company of North America* shows why it's important to distinguish agents from employees when it comes to making claims under crime policies.

Beginning in April 1986, Colson acted as transfer agent and collection and paying agent for various clients. To receive and hold funds it collected on behalf of its clients, Colson maintained accounts with the trust department of the National Bank of Washington (NBW). Pursuant to its agreements with certain clients, Colson was permitted to use the balances of its clients' funds in these accounts to make short-term investments.

Distinguishing agents from employees when making a claim

One of Colson's clients, the Small Business Administration, authorized Colson to make conservative overnight investments with the money held on its behalf. The agreement between SBA and Colson provided that "no single investment that is not a direct obligation of the U.S. Government shall exceed $2.5 million," and that all nongovernmental obligations would be rated AAA by approved agencies.

In addition, Colson agreed to indemnify SBA for any costs, liabilities, and expenses arising from Colson's negligence, breach of authority, breach of contract, or bad faith.

Colson authorized NBW to decide which overnight investments would be made with the funds in accordance with certain guidelines. In practice, Colson gave NBW wide discretion in choosing which investments to make. Among the investments made by NBW on behalf of Colson were overnight purchases of commercial paper issued by Washington Bancorporation (WBC), NBW's corporate parent.

A bank makes an improper investment

Washington Bancorporation commercial paper was not an approved investment pursuant to Colson's agreement with SBA because it was neither a government obligation nor was it AAA-rated.

During the first four months of 1990, Colson received frequent confirmation slips disclosing NBW's investments. The confirmation slips stated that "as agent we have sold to you" various securities, including the WBC commercial paper.

For six weeks ending in May 1990, WBC was reporting losses and its ratings were declining. On May 4, 1990, NBW used $9.1 million from the Colson accounts to purchase WBC commercial paper. On May 7, 1990, WBC defaulted on its commercial paper obligations. On August 1, 1990, WBC filed for bankruptcy, and on August 10, 1990, NBW was placed in FDIC receivership.

Throughout this period, Colson had maintained a commercial crime policy with the Insurance Company of North America (INA). In late 1990, Colson filed a claim for $4,327,771.87 with INA, under the crime policy's Theft, Disappearance and Destruction Coverage Form.

(Although Colson's total loss was $11,786,762.68, it had received $7,458,990.81 in a settlement with the FDIC. It sought to recover the balance from INA.)

INA claimed that the loss wasn't covered under the policy and refused to pay. Colson sued.

INA asked for a summary judgment dismissing the charges. The insurance company made several arguments in defense of its refusal to pay:

- that Colson was not covered for that loss pursuant to two exclusions in the policy;
- that the loss did not result from a theft,
- that the loss did not involve "money or securities," as required under the policy, and
- that Colson failed to provide an adequate notice of the loss in accordance with the policy.

In addition, INA contended that even if Colson's loss could otherwise

be covered by the policy as a theft of money or securities, Colson cannot recover because the policy expressly excluded losses resulting from any dishonest act committed by any of Colson's "authorized representatives."

A dispute focuses on whether services were provided

The insurance company argued that NBW, in making Colson's overnight investments, was "performing services for" Colson as its "authorized representative." Therefore, Colson's loss—which resulted from NBW's dishonest act of purchasing worthless commercial paper—was expressly excluded from coverage under the policy.

On this matter, the court ruled:

> ...the dictionary definition of the term "authorized representative" would encompass an entity like NBW, which was given the authority by Colson to act as Colson's agent in choosing which investments to make each day with the money held in the Account.

This conclusion was supported by Colson's Custody Agreement with NBW, which outlined Colson's understanding of its relationship with NBW with respect to the Account. The agreement provided:

> [Colson] desires to establish a Custody Account with [NBW] for the purpose and upon the terms and conditions hereinafter set forth; and [Colson] does hereby constitute and appoint [NBW] as its Custodian, with full power and authority to do and perform all acts and things necessary and incidental to carrying out this Agreement....

In addition, in response to a complaint Colson had filed against the FDIC, INA alleged that "NBW acted as [Colson]'s agent and broker and had a fiduciary duty with respect to the...Account funds."

Colson, however, argued that:

> [NBW] had contracted...only to provide certain limited services, namely to receive and hold certain funds, to disburse those funds as instructed by Colson, and to invest the undisbursed portion of those funds overnight in accordance with Colson's guidelines.

From this, Colson concluded that NBW had not been acting as its authorized representative when it made the investments. The court didn't agree:

> Colson's interpretation of the term "authorized representative," however, was far too limited and cannot be said to be in accordance with the expectations of an ordinary businessman. Indeed, according to Colson's limited definition, no representative of Colson could ever fit under the Policy's exclusion for "authorized representatives" because Colson could simply contend that any act of dishonesty committed by that representative had not been authorized.

INSURING THE BOTTOM LINE

Dishonest acts performed by authorized agents aren't covered

Because the loss suffered by Colson fell under the exclusion for dishonest acts committed by its authorized representatives, INA's motion for dismissal of Colson's charges was supported. Colson had to be content with its settlement with the FDIC.

> 2. "Money" means:
> a. Currency, coins and bank notes in current use and having a face value; and
> b. Travelers checks, register checks and money orders held for sale to the public.
> 3. "Property Other Than Money and Securities" means any tangible property other than "money" and "securities" that has intrinsic value but does not include any property listed in any Crime Coverage Form as Property Not Covered.

Money includes coins, currency, bank notes, travelers checks, and registered checks and money orders held for sale.

Money, property other than money and securities

"Property other than money and securities" means all forms of tangible property other than money and securities except that which is listed as "property not covered" in the coverage forms.

> 4. "Securities" means negotiable and non-negotiable instruments or contracts representing either "money" or other property and includes:
> a. Tokens, tickets, revenue and other stamps (whether represented by actual stamps or unused value in a meter) in current use; and
> b. Evidences of debt issued in connection with credit or charge cards, which cards are not issued by you:
> but does not include "money."

Securities include negotiable and non-negotiable instruments (such as stocks and bonds), and other items such as tokens, tickets, stamps and evidences of debt, but does not include money.

Other definitions

There are several other definitions that impact crime coverage. These include:

"Banking premises" means the interior of that portion of any building occupied by a banking institution or similar safe depository.

Other definitions that impact crime

"Burglary" means the taking of property from inside the premises by a person unlawfully entering or leaving the premises as evidenced by marks of forcible entry or exit. Visible marks or damage at the point of entry or exit are needed to confirm the burglary.

"Custodian" means the named insured, any of your partners, or any employee, while having care and custody of insured property inside the premises, but it does not include any person while acting as a watchperson or a janitor.

"Extortion" means the surrender of property away from the premises as a result of a threat communicated to you to do bodily harm to you or an employee, or to a relative or invitee of either, who is or allegedly is being held captive.

"Messenger" means the named insured, any of your partners or employees while having care and custody of property outside the premises.

"Occurrence" means all loss whether caused by one or more persons, or involving a single act or a series of related acts.

"Premises" means the interior of that portion of any building occupied by you for the purpose of conducting business.

"Robbery" means taking property from the care and custody of a person by someone who has caused or threatened to cause bodily harm, or who has committed an obviously unlawful act which the victim witnessed.

"Safe burglary" means the taking of property from within a locked safe or vault by a person unlawfully entering the safe or vault as evidenced by visible marks of forced entry upon its exterior, and it also means the removal of a safe from the premises.

"Theft (larceny)" means any act of stealing. Theft is a broad category. It includes all of the more narrowly defined acts of stealing, such as burglary and robbery, and goes beyond them in scope.

"Watchperson" means any person you retain to have care and custody of property inside the premises, and who has no other duties.

Common endorsements

Cancellation and nonrenewal

In many states the law requires some minor modification of the commercial crime cancellation and nonrenewal provisions. In some cases, the number of days required for advance notice is altered. In other cases, statutory provisions concerning permitted grounds for cancellation must be attached. These changes are made by attaching a state-specific endorsement to the coverage part.

Policy changes endorsement

A general purpose "policy changes" endorsement may be used to make changes which are not specifically addressed by any preprinted form. The policy changes endorsement has a space for policy number, effective date, named insured and coverage parts affected. Otherwise it is blank. It has an open box titled "Changes," but has no preprinted text.

Miscellaneous endorsements

Various endorsements exist to modify crime coverage in specific ways.

An endorsement to exclude specific property may be used to schedule property which is not to be covered. Other endorsements may be used to include vandalism in some of the coverages, or to include robbery of a janitor in premises burglary coverage. Miscellaneous endorsements are available to increase coverage limits for specified property, to limit coverage for specified property or portions of the premises, and to exclude coverage for specified persons, premises, or types of property.

Theft, disappearance and destruction insurance

The Theft, Disappearance and Destruction Coverage Form provides a common type of commercial crime insurance. It protects you against a broad range of exposures to the loss to money and securities which arise from external threats of loss, such as burglary and robbery. However, coverage applies both inside and outside of the premises. This form is frequently issued in conjunction with employee dishonesty coverage, which protects against internal threats of loss.

This form provides two major coverages (for loss inside and outside the premises) and three extensions of coverage. Although only "money and securities" is described under "covered property," two of the extensions cover other losses or damage caused during a covered crime. The coverages and extensions of coverage are:

- coverage for "money and securities" inside the "premises" or a "banking premises," and

- coverage for "money and securities" outside the "premises" while in the care and custody of a "messenger."

The policy

This form provides theft insurance, which is broader than burglary or robbery coverage because "theft" includes all acts of stealing. It also provides more than crime coverage. Since it covers disappearance or destruction of covered property, it will cover some losses that do not result from theft or attempted theft.

> **THEFT, DISAPPEARANCE AND DESTRUCTION COVERAGE FORM**
> A. COVERAGE—We will pay for loss of Covered Property resulting directly from the Covered Causes of Loss.
> 1. Section 1. Inside the Premises
> a. Covered Property: "Money" and "securities" inside the "premises" or a "banking premises."
> b. Covered Causes of Loss
> (1) "Theft"
> (2) Disappearance
> (3) Destruction

Coverage is provided for money and securities while inside the pre-

Chapter Six: Crime, Theft and Employee Dishonesty

mises or a banking premises, when loss is caused by theft, disappearance or destruction.

> c. Coverage Extensions
> (1) Containers of Covered Property: We will pay for loss of, and loss from damage to, a locked safe, vault, cash register, cash box or cash drawer located in the "premises" resulting directly from an actual or attempted:
> (a) "Theft" of; or
> (b) Unlawful entry into those containers.

Coverage is provided for loss or damage to "containers" of covered property, meaning a locked safe, vault, cash register or drawer inside the premises, as a result of theft or unlawful entry.

> (2) Premises Damage: We will pay for loss from damage to the "premises" or its exterior resulting directly from an actual or attempted "theft" of Covered Property if you are the owner of the "premises" or are liable for damage to it.

Coverage for damage to the premises caused by theft

In addition to theft coverage, damage to the premises as a result of theft or attempted theft will be covered only if you own the premises or are liable for damage to it.

> 2. Section 2—Outside the Premises
> a. Covered Property. "Money" and "securities" outside the "premises" in the care and custody of a "messenger."
> b. Covered Causes of Loss
> (1) "Theft"
> (2) Disappearance
> (3) Destruction

Coverage is provided for money and securities outside the premises while in the care of a messenger, when loss is caused by theft, disappearance or destruction.

Examples: Coverage would be provided if a messenger was held up, or if a messenger was involved in an automobile accident and money disappeared or was destroyed and there was no evidence of theft.

> c. Coverage Extension
> Conveyance of Property By Armored Motor Vehicle Company: We will pay for loss of Covered Property resulting directly from the Covered Causes of Loss while outside the "premises" in the care and custody of an armored motor vehicle company.
> But, we will pay only for the amount of loss that you cannot recover.
> (1) Under your contract with the armored motor vehicle company; and
> (2) From any insurance or indemnity carried by, or for the benefit of customers of, the armored motor vehicle company.

INSURING THE BOTTOM LINE

Coverage is provided for money and securities outside the premises while in the care of an armored vehicle company. This coverage applies only to the extent that you cannot recover a loss under any contract with the armored vehicle company or any insurance it has.

Example: When an armored car is held up, $20,000 of your money is lost. If the armored car company has insurance that will pay its customers up to $15,000 for any one loss, your policy will only cover $5,000 of the loss (minus any deductible).

> **B. LIMIT OF INSURANCE**
> The most we will pay for loss in any one "occurrence" is the applicable Limit of Insurance shown in the Declarations.
> **C. DEDUCTIBLE**
> We will not pay for loss in any one "occurrence" unless the amount of loss exceeds the Deductible Amount shown in the Declarations. We will then pay the amount of loss in excess of the Deductible Amount, up to the Limit of Insurance. In the event more than one Deductible Amount could apply to the loss, only the highest Deductible Amount may be applied.

The limit of insurance and deductible(s) are shown in the declarations. The limit is the most the insurance company will pay for any one occurrence of loss. No loss is payable unless it exceeds the deductible, and then only the amount in excess of the deductible is payable.

If more than one deductible amount could apply to the same loss situation, only the highest deductible will apply.

Exclusions to theft, disappearance and destruction coverage

> D. ADDITIONAL EXCLUSIONS, CONDITION AND DEFINITIONS. In addition to the provisions in the Crime General Provisions, this Coverage Form is subject to the following:
> 1. Additional Exclusions: We will not pay for loss as specified below:
> a. Accounting or Arithmetical Errors or Omissions: Loss resulting from accounting or arithmetical errors or omissions.

Various exclusions and conditions apply to this coverage form in addition to those specified in the Crime General Provisions.

Loss resulting from accounting errors or omissions is excluded because this is not a crime.

> b. Acts of Employees, Directors, Trustees or Representatives: Loss resulting from any dishonest or criminal act committed by any of your "employees," directors, trustees or authorized representatives:
> (1) Acting alone or in collusion with other persons; or
> (2) While performing services for you or otherwise.

Losses resulting from criminal acts of employees, directors or trust-

Chapter Six: Crime, Theft and Employee Dishonesty

ees are excluded under this form (but such coverage is available under the Employee Dishonesty Coverage Form).

The 1995 federal district court decision *Stella Jewelry v. Naviga Belgamar through Penem International* is a great example of a colorful issue: the policy exclusion for "mysterious disappearance."

New York-based Stella claimed that a loss had occurred in the amount of at least $100,000 in May 1993. Judah Rosenberg, president of the company, travelled to Dallas, Texas, that month with two bags of jewelry. He stored the two bags at the home of a Rabbi Jacobson outside Dallas for one night.

Rosenberg returned the next day to retrieve the two bags. He parked his car on the circular driveway of Rabbi Jacobson's house, about 10 feet from the nearest door. After collecting the jewelry, Rosenberg approached his car and placed a nylon bag containing the smaller bags on the ground next to his foot—in order to make room in the car's trunk. When he bent down to pick up this bag, it was gone.

Rosenberg stated that "about 10 seconds" elapsed from the moment he placed the bag on the ground until he turned to pick it up. During this interval, he did not see or hear anything. He made a report to the Dallas Police Department and notified his insurance broker of the incident.

European insurance company Naviga, Stella's commercial package insurer, refused to reimburse the claim for the jewelry. It cited the policy exclusion for "Loss resulting from mysterious disappearance." Rosenberg and Stella sued.

The policy Naviga issued to Stella protected against "All Risks of Physical Loss or Damage." Under this type of policy, "[t]he insured need only prove the existence of the all risks policy, and the loss of the covered property."

In an all risks policy, once the insured company has established such a loss, the burden shifts to the insurer to show that an exclusion to the policy prevents recovery.

"Mysterious disappearance" is generally interpreted as a factual circumstance in which a reasonable person could not infer, based on the evidence presented, the manner in which the reported loss occurred.

A court excludes the "mysterious disappearance" theory

Naviga argued that adequate support existed for its refusal to reimburse Stella's claim because of the exclusion for "mysterious disappearance" based on Rosenberg's failure to see or hear anything during the 10-second interval in which the loss allegedly took place as he stood in a suburban driveway.

The court didn't like this response:

> Naviga seeks to play both ends against the middle.

233

INSURING THE BOTTOM LINE

> ...Loss from theft was not excluded from coverage under the Policy. The facts as testified to by the only witness...bespeak only of theft, albeit a mysterious theft with no evidence of a thief.
>
> ...This mysteriousness exclusion really relates to the credibility of testimony by Stella's president. There is no evidence from which one could deduce that the nylon bag had blown away or been lost in any other manner than by theft. Under those circumstances no reasonable jury could reach the conclusion that the loss occurred otherwise.

The court granted Stella's request for summary judgment excluding the defense of mysterious disappearance. But it granted the request with the understanding that Stella would confine its argument at trial to the thesis that the evidence demonstrated a theft occurred in accordance with its theory.

The dispute was eventually settled privately—like many cases of this sort.

> c. Exchange or Purchases: Loss resulting from the giving or surrendering of property in any exchange or purchase.

Loss resulting from giving up property in an exchange or purchase is excluded because no theft has been committed (although deception may have been involved). Also, you voluntarily participated.

Example: You agree to exchange one type of securities for another with a broker, and later discover that the securities you've received are nearly worthless.

> d. Fire: Loss from damage to the "premises" resulting from fire, however caused.

Fire losses are excluded because no theft is involved. Although some types of "destruction" are covered, you should keep money and securities in fireproof containers.

Loss of money in a money-operated device is not covered

> e. Money Operated Devices: Loss of property contained in any money operated device unless the amount of "money" deposited in it is recorded by a continuous recording instrument in the device.

Loss from any money operated device (vending machine, currency change machine, coin operated equipment, etc.) is excluded unless the machine is equipped with a device that records deposits. Without such device there is no way to verify the amount of a loss.

> f. Transfer or Surrender of Property
> (1) Loss of property after it has been transferred or surrendered to a person or place outside the "premises" or "banking premises":
> (a) On the basis of unauthorized instructions; or

> (b) As a result of a threat to do:
> i. Bodily harm to any person; or
> ii. Damage to any property.
> (2) But, this exclusion does not apply under Coverage, Section 2. to loss of Covered Property while outside the "premises" or "banking premises" in the care and custody of a "messenger" if you:
> (a) Had no knowledge of any threat at the time the conveyance began; or
> (b) Had knowledge of a threat at the time the conveyance began, but the loss was not related to the threat.

Loss of property after it has been surrendered outside the premises or a banking premises on the basis of unauthorized instructions or due to a threat to do bodily harm or property damage is excluded under this form (but such coverage is available under the Extortion Coverage Form).

The exclusion of property after it has been transferred out of the premises does not apply to messenger coverage if you did not know of the threat at the time the property was transferred, or if you knew of a threat but the loss was not related to the threat. In either case, a robbery of the messenger would be covered. But when a threat is communicated to you for the purpose of extorting property, the crime becomes a subject for coverage under another specific crime coverage form.

This exclusion does not apply to property in the care of a messenger if you had no knowledge of any threat or the loss was not related to a known threat.

> g. Vandalism: Loss from damage to the "premises" or its exterior or to containers of Covered Property by vandalism or malicious mischief.

Vandalism is not covered by this insurance

Damage to a premises or containers of covered property caused by vandalism or malicious mischief is excluded (but such coverage is available under commercial property coverage forms).

> h. Voluntary Parting of Title to or Possession of Property: Loss resulting from your, or anyone acting on your express or implied authority, being induced by any dishonest act to voluntarily part with title to or possession of any property.

Loss resulting from voluntarily parting with any property is excluded, even if induced by dishonest acts, because no criminal force was involved.

> 2. Additional Condition
> Duties in the Event of Loss: If you have reason to believe that any loss of, or loss from damage to, Covered Property involves a violation of law, you must notify the police.

In addition to the general conditions that apply, if you believe that any loss involves a violation of law, the police must be notified.

> 3. Additional Definitions
> a. "Banking premises" means the interior of that portion of any building occupied by a banking institution or similar safe depository.

Banking premises means the inside of a bank or safe depository building. Money and securities are covered while in such premises.

> b. "Messenger" means you, any of your partners or any "employee" while having care and custody of the property outside the "premises."

Messenger means you and any partner or employee who has custody of property outside the premises. Money and securities are covered while in the care of a messenger.

> c. "Occurrence" means an:
> (1) Act or series of related acts involving one or more persons; or
> (2) Act or event, or a series of related acts or events not involving any person.

An occurrence means each separate loss situation, even if each situation involves more than one person or a series of related acts.

> d. "Premises" means the interior of that portion of any building you occupy in conducting your business.

Premises means the interior portion of a building occupied by you for business purposes. If your company occupies one office on the fifth floor of a building, only that office is the "premises."

> e. "Theft" means any act of stealing.

The final point: "theft" includes all acts of stealing

As mentioned earlier, theft includes all acts of stealing and is broader than the more limited terms of "burglary" or "robbery." However, the theft coverage provided by this form is subject to various exclusions (employee dishonesty, extortion, etc.).

Note that the exclusions eliminate coverage for losses which are not crimes, or which should be covered by other types of insurance, or which are covered by one of the other crime forms. You will find that some of these exclusions are repeated on other crime forms.

Employee dishonesty

Employee dishonesty coverage is one of the most common types of commercial crime insurance. It protects you against the internal exposure to loss when employees have access to money, securities, and other covered property. It is frequently issued in conjunction with

other coverage forms, such as burglary, robbery, and theft that protect against external threats of loss.

The extent of an employer's exposure to employee dishonesty losses depends upon the type of business. The risk appears greater when employees handle large volumes of money or merchandise having high values. But even among service industries there can be a significant exposure to losses of office supplies, equipment, and company funds. This is why employee dishonesty insurance is an important commercial crime coverage.

This coverage form is one of four forms in the commercial crime program that falls under the jurisdiction of the Surety Association of America (SAA). In effect, the coverage is a fidelity bond. It provides coverage for losses resulting from employee dishonesty, and it covers money, securities, and property other than money and securities.

You have two options for coverage—it may be written on a blanket basis or on a schedule basis. When written on a blanket basis, the limit of insurance applies "per loss" regardless of how many employees contributed to the loss. When written on a schedule basis, the limit of insurance applies "per employee" or "position" and the definition of "occurrence" is changed to mean all loss caused by "each employee." Schedule coverage may be written on a "name schedule" or "position schedule" basis. (These coverages are virtually the same as the schedule and blanket fidelity bonds discussed at the end of this section.)

The policy

We have chosen to review the Employee Dishonesty Coverage—Blanket Form because of its greater flexibility and more common usage.

Most of the different crime coverage forms (including the Employee Dishonesty Coverage Form) must be accompanied by a Crime General Provisions Form; this is the document that contains the general crime policy exclusions, conditions, and definitions. The Employee Dishonesty Coverage Form contains additional exclusions, conditions, and definitions as well as other coverage specific information.

> A. COVERAGE
> We will pay for loss of, and loss from damage to, Covered Property resulting directly from the Covered Cause of Loss.
> 1. Covered Property: "Money," "securities," and "property other than money and securities."
> 2. Covered Cause of Loss: "Employee dishonesty."

Defining "property" under this coverage

The insurance company agrees to pay for loss or damage to covered property resulting from a covered cause of loss. Covered property includes "money," "securities," and "property other than money and securities" (these terms are defined in the crime general provisions).

The only covered cause of loss is "employee dishonesty" (this term is defined later in this form).

Crime insurance involves some unorthodox claims and settlement practices. The 1995 federal district court ruling *T.S.I. Holdings and New Progress, Inc. v. John Buckingham and Cincinnati Insurance Company* dealt with the issues created by dishonest executives and complex corporate structures.

TSI was a holding company for a number of different subsidiaries, including New Progress—a manufacturer of refined fuel tank trucks. John Buckingham had been hired by TSI in June of 1991 to be its president and to oversee several of the subsidiaries, including New Progress.

Dishonest executives and complex corporate structure

As president of TSI, Buckingham was responsible for the financial affairs of all subsidiaries and for the financial structure of TSI as a whole. He also held various positions within New Progress and other subsidiaries of TSI.

Buckingham received all of his pay by means of a paycheck issued to him by TSI. In turn, the subsidiaries—including New Progress—would pay a management fee to TSI.

Throughout Buckingham's tenure, New Progress was the named insured under a commercial crime insurance policy issued by Cincinnati Insurance. Cincinnati would pay for losses that resulted directly from "employee dishonesty" as defined in the policy.

New Progress contended that, from approximately October 1991 through July 1992, Buckingham improperly drew checks on the New Progress corporate bank account totalling almost $200,000 to pay for personal expenses and to provide cash for his personal use.

New Progress also contended that during this period Buckingham improperly used a New Progress American Express card to pay for his own personal expenses. The card had an unpaid balance of more than $30,000 in July 1992.

New Progress filed a proof of loss with Cincinnati for $230,111.73—the amount it claimed as damages resulting from Buckingham's conduct. Cincinnati denied coverage of New Progress' claim.

During the same time period, TSI and its subsidiaries were the named insureds under another crime insurance policy issued by the Federal Insurance Company. TSI filed a Proof of Loss with Federal arising out of Buckingham's actions. Federal "loaned" TSI and New Progress $216,000. Accompanying paperwork described the payment as:

> a loan without interest repayable only in the event and to the extent of any recovery TSI and/or New Progress...may make from any persons, corporations, insurance companies, or other parties causing or liable for any losses resulting from the defalcation of John C. Buckingham...."

Crime losses have unpredictable outcomes

This procedure, known as a loan receipt, occurs with some frequency in crime cases. Because crime losses have unpredictable outcomes—sometimes charges are substantiated, sometimes they aren't—insurance companies often keep the option of repayment open by loaning a settlement to an insured party.

TSI Holdings and New Progress sued Buckingham and Cincinnati Insurance to recover under the commercial crime policy Cincinnati had written. The complaint consisted of breach of fiduciary duty claims and a breach of promissory note claim against Cincinnati and a racketeering claim against Buckingham (who promptly filed for bankruptcy protection).

New Progress sought recovery from Cincinnati under the policy in the amount of the $200,000 policy limit. New Progress also asked for reasonable attorney's fees due to Cincinnati's "vexatious and unreasonable" handling of its claim.

In defense of its refusal to pay, Cincinnati made several points:

- that Buckingham had the authority to use the checks and credit card in the manner he did, on the understanding that he would repay New Progress out of his year-end bonus;
- that the board of directors of New Progress never instructed or directed Buckingham to undertake or perform any specific work for New Progress;
- that New Progress's corporate parent had recovered the full amount of any loss under the Federal Policy—and therefore New Progress had sustained no insurable loss;
- that the monies received by New Progress through the Federal loan receipt were not a loan, but a payment of the full amount of the loss New Progress may have sustained; and
- that the loan receipt should be dismissed as a sham and, therefore, Federal—not New Progress—was the real party in interest in any lawsuit that might follow.

New Progress disagreed with all of these points. It argued that Buckingham had taken direct instructions from the board of directors—and that the loan receipt was a legitimate loan.

The first question the court addressed was whether Buckingham was an employee—as defined in the Cincinnati Policy—of New Progress.

In order to show that Buckingham was a covered employee under the Cincinnati Policy, New Progress had to prove that Buckingham satisfied each of three elements contained in the policy definition:

- that Buckingham was in the service of New Progress;
- that New Progress compensated him directly by salary, wages or commissions; and

The CEO of the corporate parent isn't a covered employee of the subsidiary

- that New Progress had the right to direct and control Buckingham while he performed services for New Progress.

The court ruled that the facts demonstrated that New Progress did not directly compensate Buckingham:

> ...it was not reasonable to maintain that the payment of a management fee from New Progress to TSI constituted "direct compensation by salary or wages" to Mr. Buckingham. Certainly, within the plain and ordinary meaning of the word "directly," such payments are not "without divergence from the source" or "without any intervening agency or instrumentality."

New Progress argued that Buckingham should have been considered a covered employee based on statements and definitions contained in application forms Cincinnati had provided. New Progress claimed the application forms showed that:

> 1) New Progress and Cincinnati intended Buckingham to be a covered employee; and

> 2) the fact that the word "directly" did not appear in the application's definition of an employee makes the Policy language, which contains the word "directly" in its employee definition, ambiguous.

However, the court found that—as a matter of law—New Progress could not rely on its application papers to dispute unambiguous terms in the policy.

Because it determined Buckingham not to be a covered employee as defined by the policy, the court ruled Cincinnati's denial of New Progress' claim was not vexatious and unreasonable.

The fact that Buckingham didn't count as an employee under the policy made everything else moot. New Progress's charges against Cincinnati were dismissed.

> 3. Coverage Extension
> Employees Temporarily Outside Coverage Territory: We will pay for loss caused by any "employee" while temporarily outside the territory specified in the Territory General Condition for a period not more than 90 days.

Normally coverage applies only in the defined coverage territory (U.S.A., U.S. Virgin Islands, Puerto Rico, Canal Zone and Canada). But coverage is provided for loss caused by an employee who is temporarily outside of this territory for not more than 90 days.

> B. LIMIT OF INSURANCE
> The most we will pay for loss in any one "occurrence" is the applicable Limit of Insurance shown in the Declarations.

The limit of insurance and deductible are shown in the declarations.

The limit is the most the insurance company will pay for any one occurrence of loss.

> C. DEDUCTIBLE
> 1. We will not pay for loss in any one "occurrence" unless the amount of loss exceeds the Deductible Amount shown in the Declarations. We will then pay the amount of loss in excess of the Deductible Amount, up to the Limit of Insurance.

Because of the non-cumulation of limit of insurance condition (found in the Crime General Provisions form) the coverage limit may not accrue from year to year.

Example: If for six years you carried coverage with a limit of $80,000 and discovered that an employee had been stealing $80,000 per year for each of the six years, you could only receive the policy limit of $80,000 even though you had suffered a total loss of $480,000.

A loss isn't paid unless it exceeds the deductible

No loss is payable unless it exceeds the deductible, and then only the amount in excess of the deductible is payable.

> 2. You must:
> a. Give us notice as soon as possible of any loss of the type insured under this Coverage Form even though it falls entirely within the Deductible Amount.
> b. Upon our request, give us a statement describing the loss.

You must furnish a statement of loss whenever it is requested, and must give notice of a loss even if it does not exceed the deductible. The insurance company requires notification of losses that fall under the policy's deductible amount—losses for which they will make no payment—so that they can identify and exclude from coverage the employee who committed the dishonest act. This also gives the insurance company a better idea of the size and shape of the risks it faces.

> D. ADDITIONAL EXCLUSIONS, CONDITIONS AND DEFINITIONS:
> In addition to the provisions in the Crime General Provisions, this Coverage Form is subject to the following:

Conditions specific to this kind of crime coverage

The Crime General Provisions form outlines the exclusions, conditions, and definitions common to most crime coverages. These are additional exclusions, conditions, and definitions specific to the Employee Dishonesty Coverage Form.

> 1. Additional Exclusions: We will not pay for loss as specified below:
> a. Employee Cancelled Under Prior Insurance: loss caused by any "employee" of yours, or predecessor in interest of yours, for whom similar prior insurance has been cancelled and not reinstated since the last such cancellation.

In addition to the general crime exclusions, coverage Form A has two additional exclusions.

No coverage is provided for loss caused by any employee for whom prior similar insurance has been cancelled, if such coverage was never reinstated.

> b. Inventory Shortages: loss, or that part of any loss, the proof of which as to its existence or amount is dependent upon:
> (1) An inventory computation; or
> (2) A profit and loss computation.

No coverage is provided for a loss which is revealed or shown only by an inventory or profit and loss calculation. This prevents coverage of accounting errors or claims submitted to bolster a company's financial condition in the wake of bad performance.

Example: You have never had any knowledge or awareness of any shortages of merchandise or revenue. Since inventory and financial records do not balance, a loss is claimed. There is no coverage.

> 2. Additional Condition
> Cancellation As To Any Employee: This insurance is cancelled as to any "employee":
> a. Immediately upon discovery by:
> (1) You; or
> (2) Any of your partners, officers or directors not in collusion with the "employee";
> of any dishonest act committed by that "employee" whether before or after becoming employed by you.

The employee dishonesty form contains a condition that immediately cancels coverage for any employee upon discovery by you, or a partner, officer or director, of any dishonest act committed by that employee either before or after becoming your employee.

Acts committed before someone worked for you can still suspend coverage

The last note is worth repeating: This condition applies even if the act was committed prior to employment by you.

The issue of prior knowledge of employee problems comes up often in employee theft or dishonesty cases. The 1993 federal district court ruling *Cooper Sportswear Manufacturing v. Hartford Casualty* offers a good illustration.

Hartford issued a comprehensive dishonesty, disappearance and destruction insurance policy to Cooper in March 1988. The company, which manufactures and imports leather coats, jackets and other sportswear, maintained its executive offices, warehouse, manufacturing facilities and outlet store in the same Newark, New Jersey, location.

By letter dated July 5, 1988, Cooper notified its insurance broker

that it had discovered that one of its employees "committed dishonest acts against our company."

Cooper's claim ultimately involved James Pagnotta, an employee of 40 years who served as the manager of the company's warehouse. Pagnotta allegedly stole from the company cash and merchandise worth more than the $500,000 Hartford policy limit.

In November 1990, Hartford denied the claim. It cited several reasons, including its determination that Pagnotta's dishonest acts were excluded from the policy—because Cooper had possessed information about Pagnotta's dishonesty before the inception of the policy.

Cooper sued, alleging that the Hartford policy covered its loss up to the $500,000 limit. Hartford in its third-party complaint sought judgment against Pagnotta, should Hartford be found liable for Cooper's loss.

The court began its analysis by considering Sections 7 and 15 of the Hartford policy:

> The coverage...shall not apply to any Employee from and after the time that the Insured or any partner or officer thereof not in collusion with such Employee shall have knowledge or information that such Employee has committed any fraudulent or dishonest act in the service of the Insured or otherwise, whether such act be committed before or after the date of employment by the Insured.
>
> ...Insuring Agreement I shall be deemed canceled as to any Employee: (a) immediately upon discovery by the Insured, or by any partner or officer thereof not in collusion with such Employee, of any fraudulent or dishonest act on the part of such Employee....

Hartford produced evidence showing that prior to the inception of the policy Sidney Cooper, the company's secretary-treasurer, had substantial information suggesting that Pagnotta may have committed fraudulent and dishonest acts. In particular, it submitted an internal memorandum of Norman Jaspan Associates, Inc., a private investigation firm retained by Cooper.

An employee allegedly sold stock improperly from inventory

The memo described a meeting the previous day between Sidney Cooper and several Jaspan representatives to discuss "information which had surfaced implicating James Pagnotta."

According to the memo, Sidney Cooper told Jaspan representatives of several instances where Pagnotta's honesty had been called into question by other employees. These employees had corroborated each other's allegations that Pagnotta had improperly sold—or simply taken—company inventory.

According to the memo, Cooper asked the Jaspan representatives for two undercover "placements" within the factory: a woman to work in the warehouse and retail store and a male warehouseman. From the

context of the memo, it was clear that Cooper intended that these two undercover Jaspan employees keep an eye on Pagnotta.

In summary, the memo showed that, while Cooper's insurance application with Hartford was pending, Sidney Cooper had substantial information about—if not certain knowledge of—Pagnotta's commission of dishonest acts.

A company investigates charges—and then dismisses them as "rumors"

The company did not dispute the authenticity of the Jaspan memo. Nor did it dispute that Sidney Cooper said what the memo indicated he had said. Instead, it characterized the information as mere "unsubstantiated rumors."

The court, however, ruled that:

> The fact that Cooper asked Jaspan Associates to send two undercover operatives to watch Pagnotta at the warehouse indicated that Cooper, far from discounting this information, was taking it very seriously. The memo further demonstrates that Cooper's information about Pagnotta's dishonesty concerned a series of acts, not an isolated incident.

This information was enough to trigger the exclusionary effects of the policy. As a legal matter, the policy never applied to Pagnotta when it took effect in March 1988.

The court granted Hartford's motion to dismiss Cooper's charges because of its undisclosed knowledge of the offending employee's dishonesty.

> b. On the date specified in a notice mailed to you. That date will be at least 30 days after the date of mailing.
> The mailing of notice to you at the last mailing address known to us will be sufficient proof of notice. Delivery of notice is the same as mailing.

The insurance company may terminate coverage for any employee by giving you at least 30 days advance notice.

> 3. Additional Definitions
> a. "Employee Dishonesty" in paragraph A.2. means only dishonest acts committed by an "employee," whether identified or not, acting alone or in collusion with other persons, except you or a partner, with the manifest intent to:
> (1) Cause you to sustain loss; and also
> (2) Obtain financial benefit (other than employee benefits earned in the normal course of employment, including: salaries, commissions, fees, bonuses, promotions, awards, profit sharing or pensions) for:
> (a) The "employee"; or
> (b) Any person or organization intended by the "employee" to receive that benefit.

that it had discovered that one of its employees "committed dishonest acts against our company."

Cooper's claim ultimately involved James Pagnotta, an employee of 40 years who served as the manager of the company's warehouse. Pagnotta allegedly stole from the company cash and merchandise worth more than the $500,000 Hartford policy limit.

In November 1990, Hartford denied the claim. It cited several reasons, including its determination that Pagnotta's dishonest acts were excluded from the policy—because Cooper had possessed information about Pagnotta's dishonesty before the inception of the policy.

Cooper sued, alleging that the Hartford policy covered its loss up to the $500,000 limit. Hartford in its third-party complaint sought judgment against Pagnotta, should Hartford be found liable for Cooper's loss.

The court began its analysis by considering Sections 7 and 15 of the Hartford policy:

> The coverage...shall not apply to any Employee from and after the time that the Insured or any partner or officer thereof not in collusion with such Employee shall have knowledge or information that such Employee has committed any fraudulent or dishonest act in the service of the Insured or otherwise, whether such act be committed before or after the date of employment by the Insured.
>
> ...Insuring Agreement I shall be deemed canceled as to any Employee: (a) immediately upon discovery by the Insured, or by any partner or officer thereof not in collusion with such Employee, of any fraudulent or dishonest act on the part of such Employee....

Hartford produced evidence showing that prior to the inception of the policy Sidney Cooper, the company's secretary-treasurer, had substantial information suggesting that Pagnotta may have committed fraudulent and dishonest acts. In particular, it submitted an internal memorandum of Norman Jaspan Associates, Inc., a private investigation firm retained by Cooper.

An employee allegedly sold stock improperly from inventory

The memo described a meeting the previous day between Sidney Cooper and several Jaspan representatives to discuss "information which had surfaced implicating James Pagnotta."

According to the memo, Sidney Cooper told Jaspan representatives of several instances where Pagnotta's honesty had been called into question by other employees. These employees had corroborated each other's allegations that Pagnotta had improperly sold—or simply taken—company inventory.

According to the memo, Cooper asked the Jaspan representatives for two undercover "placements" within the factory: a woman to work in the warehouse and retail store and a male warehouseman. From the

context of the memo, it was clear that Cooper intended that these two undercover Jaspan employees keep an eye on Pagnotta.

In summary, the memo showed that, while Cooper's insurance application with Hartford was pending, Sidney Cooper had substantial information about—if not certain knowledge of—Pagnotta's commission of dishonest acts.

A company investigates charges—and then dismisses them as "rumors"

The company did not dispute the authenticity of the Jaspan memo. Nor did it dispute that Sidney Cooper said what the memo indicated he had said. Instead, it characterized the information as mere "unsubstantiated rumors."

The court, however, ruled that:

> The fact that Cooper asked Jaspan Associates to send two undercover operatives to watch Pagnotta at the warehouse indicated that Cooper, far from discounting this information, was taking it very seriously. The memo further demonstrates that Cooper's information about Pagnotta's dishonesty concerned a series of acts, not an isolated incident.

This information was enough to trigger the exclusionary effects of the policy. As a legal matter, the policy never applied to Pagnotta when it took effect in March 1988.

The court granted Hartford's motion to dismiss Cooper's charges because of its undisclosed knowledge of the offending employee's dishonesty.

> b. On the date specified in a notice mailed to you. That date will be at least 30 days after the date of mailing.
> The mailing of notice to you at the last mailing address known to us will be sufficient proof of notice. Delivery of notice is the same as mailing.

The insurance company may terminate coverage for any employee by giving you at least 30 days advance notice.

> 3. Additional Definitions
> a. "Employee Dishonesty" in paragraph A.2. means only dishonest acts committed by an "employee," whether identified or not, acting alone or in collusion with other persons, except you or a partner, with the manifest intent to:
> (1) Cause you to sustain loss; and also
> (2) Obtain financial benefit (other than employee benefits earned in the normal course of employment, including: salaries, commissions, fees, bonuses, promotions, awards, profit sharing or pensions) for:
> (a) The "employee"; or
> (b) Any person or organization intended by the "employee" to receive that benefit.

How the policy defines "employee dishonesty"

The term "employee dishonesty" means any dishonest act committed by an employee acting alone or with others with the intent to cause loss or to obtain illegal financial benefit for the employee or others. This covered cause of loss does not include acts which involve you or any partner (acts by the named insured and partners are excluded in the Crime General Provisions).

> b. "Occurrence" means all loss caused by, or involving, one or more "employees," whether the result of a single act or series of acts.

Embezzlement may occur as an isolated incident or over a long period of time. An occurrence under this form means each separate loss situation, whether the loss is the result of a single act or a series of acts, committed by one person or more than one.

Example: Two employees of an appliance store have been stealing merchandise, acting in collusion. Upon discovery, it appears that 28 appliances with a total value of $14,000 have been taken over three months. This is a single loss occurrence.

Fidelity bonds

Insuring employee honesty with bonds

Most businesses face some risk that losses may result from the dishonesty (infidelity) of employees. Such losses can amount to huge sums. Occasionally an employee may attempt to steal a large sum of money or a considerable amount of merchandise. Other losses may result from repeated incidents over a long period of time. If an employee has been skimming small amounts of money or merchandise for years, the total loss can be a staggering amount by the time it is discovered. These are the types of losses covered by a fidelity bond. Since an employee is personally liable for his or her own dishonest acts, an insurance company that makes payment under a fidelity bond always has the right to seek recovery from the employee responsible for loss.

Coverage for dishonesty and forgery is available under two different types of contracts. One approach is to obtain the coverage through an insurance policy, and policies covering dishonesty have been available. The other approach is to obtain the protection through an instrument known as a fidelity bond. There are differences between the fields of insurance and fidelity bonding, but they share many characteristics. In fact, the differences are so minor that fidelity bond forms and insurance coverages can now be included as part of the same commercial contract.

Although the field of bonding includes both fidelity and surety bonds, only the surety bonds actually fit the technical definition of bonds. In theory, there are three parties to any bond, and this fact sets bonds apart from insurance. An insurance policy is drawn between two parties—you and your insurance company. In contrast, every bond involves:

- a principal—the party who has agreed to fulfill an obligation,
- an obligee—the party for whose benefit the bond is written, and to whom payment is made if the principal defaults, and
- a guarantor—the surety or insurance company providing the bond and agreeing to pay damages if the principal defaults.

In the surety field, it is the principal who applies for and pays for a bond, and three parties are clearly involved in forming the contract. This is not always true with fidelity bonds. Many fidelity bonds are issued to cover losses resulting from employee dishonesty.

A fidelity bond will pay the employer if a bonded employee steals company funds, but it is the employer (obligee) who arranges for the bond and pays the premium. The employees (principals) may not even know that a bond is in effect, so they are not parties to the formation of the contract. This is what makes fidelity bonds so much like insurance. The terminology found on fidelity bonds also reflects the similarities to insurance—many fidelity bonds contain an "insuring agreement" and make references to the "insured" (terms that are not used with surety bonds). Fidelity bonds are often called "dishonesty insurance" rather than bonds, and the same coverages have been available under traditional insurance policies.

Distinguishing fidelity bonds from surety bonds

A typical fidelity bond agrees to indemnify the "insured" (the employer) for losses resulting from employee dishonesty. It covers direct loss of money or other personal property belonging to you or for which you are legally liable. The coverage is broad and it applies to losses caused by larceny (theft), embezzlement, and forgery. It also applies to losses by misappropriation, wrongful abstraction, or any other dishonest or fraudulent acts.

Coverage usually applies to acts which are committed during the bond period. Fidelity bonds are usually continuous and do not have an expiration date. They have an inception date, and remain in effect until canceled.

An entire bond may be canceled at any time by the employer or the insurance company. If the insurance company cancels, a minimum period of advance written notice is required. Some bonds require at least 15 days notice. Others require 30 days notice.

Coverage under a bond also terminates as soon as you learn about an employee's dishonesty

Coverage for an individual employee terminates when employment ends or shortly thereafter. Many bonds extend coverage for 30 days because a newly-terminated employee may retain a key or continue to have access to the premises.

On most bonds, coverage for an individual employee automatically terminates as soon as the employer becomes aware that the employee has participated in a dishonest act which is or could be the basis of a

claim. The act need not occur during the bond period. If the employer discovered that an employee once committed such an act, even if it occurred before the bond period or before being hired, coverage would no longer apply to that employee. This exclusion is written into the contract to prevent giving a second chance to one who has committed the kind of acts covered by the bond.

Fidelity bonds covering employee dishonesty may be written on any of the following forms:

- individual bond,
- Employee Dishonesty—Name schedule bond,
- Employee Dishonesty—Position schedule bond, and
- Employee Dishonesty—Blanket bond.

An individual bond covers a single named employee for a specific limit of liability. If an employer had only one employee, or only one employee with access to funds or valuable property, an individual bond might cover the exposure. A name schedule bond covers several specific individuals who are named on the bond, and allows you to list a separate limit of liability for each employee on the schedule. New employees who replace scheduled employees are automatically covered for 30 days, but the coverage is limited to a few thousand dollars. A position schedule bond is similar to a name schedule bond, except that it covers listed positions and does not mention the employees by name. A different limit may apply to each position, but the same amount of coverage will apply to all members of a given position.

Making sure the bond covers the right employees

There are obvious drawbacks to the individual, name schedule, and position schedule bonds. Each leaves open the possibility that a loss may be caused by a person not covered by the bond. If a loss is discovered but the dishonest employee is not identified, each of these bonds would leave you with the difficult task of trying to determine which employee(s) caused the loss. The name schedule and position schedule bonds are rarely, if ever, used since the 1986 changes. These problems may be avoided by purchasing a blanket bond.

An employee dishonesty blanket bond covers all employees, and the limit of liability applies on a per loss basis regardless of the number of employees involved. Names and positions are not identified on the bond and new employees are automatically covered. If a loss is discovered but you cannot identify the employee(s) involved, the loss is covered by the bond. "Employee" means a natural person while acting in your service, but the definition does not include corporate directors or trustees who do not also serve as regular company officers or employees. The discovery period on an employee dishonesty blanket bond is one year.

Surety bonds

Surety bonds guarantee that specific obligations will be fulfilled. The obligation may involve meeting a contractual commitment, paying a debt, or performing certain duties. Usually, a bond is written for a definite amount, which is known as the bond penalty. Each bond is a written contract between three parties. Two of the parties obligate themselves to meet a commitment to the third party. If the commitment is not met, a sum of money, up to but not exceeding the full penalty, becomes payable as damages.

Early forms of suretyship were practiced thousands of years ago. Simple surety arrangements between individuals were made when one person's personal promise failed to provide another with adequate security.

Surety bonds make uncertain situations a little more reliable

For example, a creditor might not be willing to lend money to a debtor unless some security was provided by someone else. Centuries ago, the other party was usually a friend or relative, who might place personal property in the hands of the creditor until the debtor repaid the loan. In more extreme cases, the debtor might leave a family member in the custody of the creditor—a practice which did not guarantee repayment of the loan, although it certainly increased incentives to avoid default.

Corporate suretyships were first formed in the 1800s. Prior to that time, individual arrangements were risky and there were no guarantees that the assets of a backer would satisfy the obligation. Once organizations began to specialize in issuing surety bonds, formal contracts backed up by corporate assets became available to meet a wide variety of business and individual needs. Surety bonds are now routinely required by business interests, courts, government bodies, and public agencies as a means of reducing or transferring the risks of transactions and proceedings.

A typical surety bond identifies all three parties to the contract and spells out their relationship and obligations. On every bond, the parties are:

> A principal—the party who has agreed to fulfill the obligation, which is the subject of the bond.

> An obligee—the party for whose benefit the bond is written. If the principal defaults on the obligation, damages are payable to the obligee.

> A guarantor or surety—the surety providing the bond for a fee. The surety joins with the principal in guaranteeing fulfillment of the obligation, and agrees to pay damages if the principal defaults.

It is the principal who purchases the bond. In the case of a construction contract bond, the principal would be the building contractor who agrees to meet certain building specifications and to complete

the work within a specified time period. The obligee would be the property owner or party for whom the building is being constructed. The obligee might require the appropriate bonds as a condition for awarding the construction contract. The surety or guarantor is the surety company or insurance company issuing the bond.

The roles played by the three parties to a surety bond

Under a typical bonding agreement, the principal and surety bind themselves "jointly and severally" along with their "heirs, executors, administrators, and successors" to the obligation described in the bond. This means that once the bond has been executed and delivered to the obligee, any default gives the obligee the right to seek recovery from the principal and the surety, or from either party individually.

The primary responsibility falls upon the principal, because no action can be taken on the bond until default occurs. Once default occurs, damages will have to be paid by the principal and/or the bond company. To the extent that the surety pays any damages, it acquires the obligee's right of recovery against the principal. The subrogation rights of the surety are established by law and supported by the language on a bond application.

The actual obligation under the bond will be stated in the contract, and it will vary depending on the purpose of the bond. Many bonds have a provision that begins with: "The condition of this obligation is...." Different forms are available for bid bonds, performance bonds, payment bonds, and other bonds.

Suretyship and insurance

Most surety bonds are issued by insurance carriers, although there are some specialty bonding companies operating. Suretyship and insurance do share some characteristics (such a transfer of risk, a promise of indemnity, and marketing through the agency system), but in many respects the two fields are distinct.

A major contrast is found in the fact that a surety bond is a contract between three parties, while insurance policies are two-party agreements. Liability insurance provides third-party coverage (payment to a third party), but the third party is unknown and only two parties form the contract.

Another significant contrast is that losses are not expected in the surety field. With insurance, some losses are expected with respect to any large number of similar risks, and a portion of the premium is set aside to pay losses. Each surety bond applicant is reviewed individually, no pooling of risks occurs, no portion of the premium is set aside for losses, and no surety would knowingly issue a bond for a principal likely to default. Premiums on bonds are actually service fees—modest charges made for use of the surety's backing to establish financial responsibility.

INSURING THE BOTTOM LINE

A surety does not expect or intend to pay losses

Sharp differences between the surety and insurance fields can be found with respect to the application of the principles of indemnity and subrogation rights. Sureties frequently require principals to enter into written contracts of indemnity, under which the principal agrees to indemnify the surety for any losses or costs under a bond. Even in the absence of such an agreement, a surety who makes payments for a principal has a right to be indemnified under common law. As a result, the principal must indemnify the surety for losses, and the surety has subrogation rights against the principal who purchased the bond.

With insurance, the insurer agrees to indemnify the insured or another party on behalf of the insured, and the insurer gains subrogation rights against third parties but not against the policyholder. In terms of risk of loss, a surety bond is designed to protect the bonding company while an insurance policy is designed to protect the insurance buyer.

Since a surety does not expect or intend to pay losses, and because premiums do not fund loss reserves, the surety field relies on careful underwriting. A bond underwriter will want to investigate all factors that might prevent a successful completion of the principal's obligations. In the case of a contractor seeking a performance bond for construction projects, the past experience and technical abilities of the contractor should be examined to determine the principal's general capability for doing the work. In order to determine reliability, the underwriter should review the contractor's character and reputation. Financial capabilities are important, because if the contractor lacks the assets or cash flow to meet commitments a default could occur. Project conditions, general economic conditions, labor relations, and other factors should be looked into.

Other insurance uses of bonds

Contract bonds are issued to guarantee performance of the terms and provisions of written contracts. The principals on these instruments are usually construction contractors, although the field does embrace other types of contracts. For the building of dams, bridges, roads, and tunnels, bonds are usually required by government entities. For building construction, the obligee is more frequently a private entity but may be a government agency. There are many different types of contract bonds. Some of the most common are bid bonds, performance bonds, payment bonds, completion bonds, and supply bonds. A number of these bonds may be required to guarantee different aspects of a single construction project.

The construction industry uses bonds often

Construction projects are usually awarded to a contractor who submits the lowest bid. Governments and private owners usually require contractors to submit a bid bond along with their bid. The bond guarantees that if the bidder is awarded the contract two things will occur—the bidder will actually sign and accept the contract, and a performance bond will be issued.

If the successful bidder defaults on either account, the obligee may use as much of the bid bond penalty as necessary to cover resulting losses and expenses. Extra expenses are incurred if a project must be rebid or if the job must be awarded to the next highest bidder. Under some bid bonds, the entire bond amount will be forfeited if a default occurs, regardless of the amount of actual costs and expenses related to default. The same surety that issues a bid bond usually expects to write the performance bond if the principal's bid is accepted.

Various uses for performance bonds and completion bonds

A performance bond guarantees the owner (obligee) that the contractor (principal) will complete the original contract as drawn. If the contractor fails to complete the work, the surety may at its own expense engage another contractor to complete the work. If the obligee engages another contractor, expenses will be reimbursed by the surety. If the original contractor fails to complete work on time, the surety will cover any losses related to the delay in construction.

Payment bonds, which are also known as labor and material bonds, guarantee that a principal will complete and deliver the work free and clear of liens or encumbrances. These bonds assure the owner that if the contractor does not pay all the bills for labor and materials used for the project, the property will nonetheless be turned over without attachments.

It is not unusual for a single bond to contain both the performance and the labor and material payment clauses.

When a contractor borrows money to fund a construction project, the lender may require a guarantee that the project will be carried out and the contractor will be paid for the work. A completion bond guarantees the lender (obligee) that the contractor-borrower will apply the funds to the project and complete the project free of any liens or encumbrances.

A supply bond guarantees that a supplier will faithfully furnish supplies, materials, finished products, or equipment according to the terms of a supply contract. If a contractor were to require such a bond from a supplier, the contractor would be the obligee rather than the principal. A supply bond might insulate a contractor from the consequences of a default resulting from an interruption of supplies.

For example, a building contractor might be unable to complete a project if expected electrical or plumbing supplies did not arrive. A default on the building contract might trigger payment under the contractor's performance bond, and the surety would then seek recovery from the contractor. If the contractor had a supply bond from the supplier, the contractor's losses and expenses would ultimately be paid by the supply bond.

Supply bonds are frequently written to guarantee non-construction supply contracts. Any business that depends on a steady supply of

materials, components, or finished goods may require a supply bond from its suppliers. Manufacturers and finishers are particularly vulnerable to business losses resulting from supply interruptions.

Under our legal system, certain types of privileges are available only when a bond or other security has been furnished. Judicial bonds fall into two broad categories—court or litigation bonds, and fiduciary bonds.

Defendants in criminal cases often have to post bail bonds

Most people are familiar with bail bonds. Someone arrested on a criminal charge may be held until trial, unless they furnish the required bail. When a bail bond is issued, the person released is the principal and agrees to appear in court at a given time and place. The government entity (municipal, state, federal) in whose court the defendant must appear is the obligee. If the principal fails to appear, the bond amount becomes payable and is forfeited as a penalty. Bail bonds usually require collateral (cash, a deed, or some other property) to protect the surety. Surety companies and insurers consider bail bonds to be a rather undesirable class of business, and much of the market is left to organizations that specialize in underwriting and issuing bail bonds.

Courts cannot afford to operate on the assumption that everyone who initiates legal action will be able to pay court costs and legal fees if they lose the case. A plaintiff is therefore required to furnish various bonds related to lawsuits and other legal actions before the courts will proceed. A cost bond guarantees that the plaintiff (principal) will pay court costs and any damages to the defendant if the plaintiff loses the case.

When judgments for damages and/or costs are awarded, the party charged with paying the judgment may appeal the case to a higher court. Appeal bonds guarantee that the judgment will be paid if affirmed, and that the costs of the appeal will also be paid.

In certain cases, a party to a legal action secures a court order to attach the assets of another party. The court will not issue the order until an attachment bond is furnished. The bond guarantees that if the action to attach the property was wrongful, any damages suffered by the other party will be paid.

A plaintiff may seek an injunction against another party, but courts require that an injunction bond be furnished before granting any injunction. This bond is similar to the attachment bond, because it guarantees that damages to a defendant will be paid if it is later decided that the injunction should not have been issued.

Fiduciary bonds encourage proper behavior

A fiduciary is someone who has a legal right to handle the affairs of others, and the duty to do so responsibly. Usually, a fiduciary supervises money and property for another. Fiduciary bonds guarantee that a fiduciary will faithfully perform duties and act in the best interests of the person being represented. Bonds are often required,

Chapter Six: Crime, Theft and Employee Dishonesty

because fiduciaries usually represent parties that are protected by the legal system. But fiduciary bonds are available even when they are not required by a court.

Bonds are available for administrators and executors of estates. An administrator is appointed by a court to administer the estate of someone who has died without leaving a will. An executor is named in the will of a deceased person, and is charged with carrying out the terms of the will according to law.

Guardians may need to be bonded because they are often appointed by courts to handle the affairs of people who are incapable of doing so for themselves. Someone may become a guardian of a minor or a person who is physically or mentally incapacitated.

Fiduciary bonds are also issued to receivers in bankruptcy cases and to various trustees. Receivers may be responsible for collecting assets and paying debts according to legal priorities. Trustees often hold assets and make long-term investment decisions under powers granted by a trust agreement.

Many local, state, and federal laws require that a bond be furnished before someone can obtain a license or permit to engage in a particular activity. There is a wide variety of license and permit bonds, but they fall into two general categories. First, there are those designed to guarantee that laws and regulations of a particular business or activity are followed—funeral directors, private detectives, and real estate brokers must be bonded. Such bonds might cover losses if members of the public sue the licensing agency because a principal has failed to fulfill obligations. The second group of bonds is designated to guarantee that certain taxes are paid—certain bonds are required in relation to the sales of gasoline, liquor, and tobacco products.

Various other uses of bonds

Public official bonds are designed to guarantee that elected public officials perform duties faithfully and honestly. Public officials may be held liable for any misuse of public funds, and public damage might result if an official fails to fulfill obligations. Bonds are often required in advance as a condition of being eligible to hold public office.

Lost instrument bonds, also known as securities bonds, guarantee that if securities or valuable papers handled by the principal are lost, destroyed, or stolen, the owner of the securities will be indemnified. These bonds usually contain a provision calling for reimbursement if lost securities turn up after payment has been made under the bond.

Various motor vehicle bonds may be issued. Individuals may furnish bonds to establish proof of financial responsibility. Certain bonds may be required of those who apply to become motor vehicle dealers.

Workers compensation self-insurers bonds are required in the states that permit employers to self-insure compensation benefits. Since

workers are entitled to benefits by law if they are injured while on-the-job, states want to make sure that self-insurers have established appropriate programs and that benefits will be paid. The self-insurers bond guarantees that the benefits will be paid.

CHAPTER SEVEN:

INLAND MARINE

Introduction

Marine coverages are a unique and specialized type of insurance. Inland marine insurance evolved out of ocean marine insurance, which is one of the oldest types of insurance. For centuries, ocean passenger and cargo ships were the leading form of long-distance transportation, and marine coverages were initially designed to protect ships and cargo. With the rise of other transportation systems (such as railroads, motor vehicles, and air carriers), there came a growing need for insurance specifically designed to cover inland risks. Inland marine coverages were developed in response to these changing conditions.

The word "marine" can be misleading, because inland marine coverage may have no relationship to risks at sea, on water, or even near water. The term actually says more about the origin and history of the field than the actual nature of the commercial inland marine field today.

Marine insurance has often been called "transportation" insurance, because its core consists of risks involving property which is being moved from one point to another—all types of imports and exports, shipments and cargo.

The 1995 federal district court decision *Caldor, Inc. v. A-P-A Transport Corp. v. The North River Insurance Co.* offers a complicated but relevant example of an inland marine insurance dispute.

North River Insurance and A-P-A Transport Corp. asked for a summary judgment regarding whether an inland marine insurance policy issued by North River to A-P-A provided coverage with respect to merchandise belonging to Caldor. The merchandise had been stolen from four trailers stored on property owned by A-P-A in North Bergen, New Jersey. The property was known as the 91st Street Annex.

Space in the 91st Street Annex was used as a parking lot for trailers. Caldor, a department store chain, leased some space in the lot from A-P-A. Pursuant to this lease, A-P-A entered into a Security Agreement providing security protection for Caldor property and instituting rules for A-P-A security guards to record each Caldor tractor

A complicated inland marine dispute

trailer's number, license plate number, its driver's name and credentials, and "the seal number on the trailer when applicable or note if the trailer is empty...."

A-P-A bought inland marine insurance to protect property in its lot. Paragraph 1(A) of this insurance policy read:

> This policy covers the legal liability of the Insured as a Motor Common Carrier...under filed Tariff, a bill of lading, shipping receipt, delivery receipt or under contract whether written or oral for physical loss of or damage to, shipments of lawful goods and merchandise, which is the property of others, while in the care, custody and control of the Insured or while in the custody of connecting carriers in the due course transit.

North River argued that it had no liability for the loss of the Caldor trailers under Paragraph 1(A) because the paragraph concerns only A-P-A's liability as a Motor Common Carrier.

Following this argument, any A-P-A liability related to the 91st Street Annex would arise only from its role as landlord or as a provider of security services under the lease or the Security Agreement.

However, paragraph 1(B) of the inland marine policy read:

> This policy covers lawful goods and merchandise which is the property of others while in the custody or control of the Insured at the Insured's terminal locations whether the property is in or on vehicles or otherwise at such locations. Coverage is provided at terminal locations for all risks of direct physical loss of, or damage to, the property covered from any external cause, except as excluded herein.

The policy listed A-P-A's insured terminal locations. This list did not include the 91st Street Annex. However, two addresses listed were for parcels on 88th Street contiguous to the 91st Street location.

A-P-A argued that its policy covered the 91st Street Annex since the North River never denied that the parcel leased to Caldor was contiguous and part of a single, completely fenced in and guarded location. Also, a notation in North River's files stated that the North River manager responsible for inland marine policies had acknowledged that coverage under the policy extended to the entire complex.

North River argued that the scope of the policy could not be determined by note—which it argued was inadmissible as evidence in a court proceeding because it was hearsay (one manager had noted what another manager had said).

North River also relied on the deposition of David O'Dowd, director of insurance for A-P-A, who stated that the 91st Street property—although contiguous—was divided by a railway and had only one point of entrance and egress on 91st Street. O'Dowd said the property was used for parking and not for the storage of goods and merchandise.

To begin its analysis, the court focused on the insurance policy:

> It seems clear that by virtue of Paragraph 1(B) coverage was contemplated for goods and merchandise beyond those in the custody of the Insured as a Motor Common Carrier or Air Freight Carrier and those goods "in the due course transit."
>
> ...However, Paragraph 1(B) only contemplated coverage for goods and merchandise of others while in the custody and control of A-P-A at its listed terminal locations. Such terminals consisted of large warehouses with many loading and unloading bays for trucks as well as a bonded warehouse for customs clearance.

The court ruled that issues of fact remained as to the definition of a terminal location under the policy. These issues would have to include the prior use of the 91st Annex as part of a covered terminal location for the storage of goods and merchandise for others. They would also have to consider the need for notice to North River of any change in operations at a terminal location and the contiguous area.

The case would have to go to trial. Rather than face a jury, North River and A-P-A settled their dispute privately soon after.

Regulation and non-regulation

This chapter will not deal with the broad inland marine field, much of which is treated as an unregulated form of insurance for which there are no standard policy forms.

Some forms of inland marine insurance are not standardized

The commercial inland marine coverage part of a commercial package policy consists only of regulated coverages for which ISO policy forms have been filed with state Insurance Departments. Generally, coverages which are the subject of this chapter involve insurance for special types of equipment and merchandise, customers' property, and information items in which business enterprises have an interest.

Since marine coverages are largely unregulated, many commercial inland marine forms and rates are not filed and are not subject to state filing requirements. In those areas, individual companies are free to develop their own forms and rates as long as they are consistent with general statutory guidelines. The Insurance Services Office does file forms, rules and rates for 13 classes of commercial inland marine risks, and these classes were part of the commercial lines modernization and simplification project. Individual companies may or may not use the ISO forms.

Coverage for filed classes of commercial inland marine risks may be issued on ISO forms (with some company variations permitted) as a monoline policy or as part of a commercial package policy. In either case, the common policy declarations and common policy conditions must be attached to a policy that includes a commercial inland marine coverage part.

Components of the coverage

The commercial inland marine coverage part which is used to construct a policy consists of:

- commercial inland marine declaration page(s),
- commercial inland marine conditions,
- one or more commercial inland marine coverage forms, and
- any endorsements that may apply.

Multiple declarations pages may be used in complex situations

With this kind of insurance, multiple declarations pages may be issued because a company may use declarations to show information about the entire inland marine coverage part. It may also use separate declarations pages for each coverage form attached.

An advisory commercial inland marine declarations page includes space for the name and address of the named insured, the identity of the insurer and producer, the policy number and effective date, policy period, information about the forms included in the coverage part, and the premium for the entire coverage part. This is common information which is typically found on a declarations page.

An advisory declarations page has also been issued for each coverage part in the program. Each of these declarations pages has a place for the policy number, effective date, premium for the particular coverage form, and the applicable limits of insurance. Following this general information, the appearance and content of the forms are different. Most forms have a minimum deductible of $250. Each form describes different types of covered property. Different limits or sublimits may be shown for property away from the premises, or in transit, or while inside and outside of buildings. Each separate declarations page is designed to support the structure of the applicable coverage.

The commercial inland marine conditions apply in addition to the common policy conditions and any applicable conditions included in the individual inland marine coverage forms. There are two groups of conditions—loss conditions and general conditions.

Among the loss conditions, the first states that there can be no abandonment of insured property to the insurer.

Your duties after a loss has occurred

Your duties in the event of loss are similar to what is found on other property forms. You must:

- notify the police if a law has been broken;
- give the insurer prompt notice of the loss, and describe the property involved;
- as soon as possible, give the insurer a description of how, when and where the loss occurred;
- take all reasonable steps to protect the property from fur-

ther damage, set damaged property aside if feasible, and keep a record of expenses related to the loss;

- make no statement that assumes any obligation or admits any liability without consent of the insurer;
- permit the insurer to inspect the property and records proving loss;
- if requested, submit under oath to questioning by the insurer on matters relating to the claim, with all answers signed by you;
- within 60 days after receipt of a request from the insurer, send a signed, sworn statement of loss containing the information requested (forms will be supplied by the insurer);
- promptly send the insurer any legal papers or notices received concerning the loss;
- cooperate with the investigation or settlement of the claim.

The next condition concerns insurance under two or more coverages. If two or more of the policy's coverages apply to the same loss, the insurer will not pay more than the actual amount of loss.

The insurance company has to make good within 30 days

Loss payment will be paid, or the insurance company will "make good" on the claim, within 30 days after reaching agreement with you, or the date of entry of a final judgment, or the date an appraisal award is filed. The insurance company is not liable for any part of a loss that has been paid or made good by others.

If you have other insurance covering the same loss as insurance under this coverage part, the insurer will pay only the "excess" over what you should have received from the other insurance whether collectible or not.

If a loss involves only part of any pair, set or parts, the insurer may repair or replace any part to restore the pair or set to its value before the loss, or pay the difference between the value of the pair or set before and after the loss. In case of loss to any part of property consisting of several parts when complete, the insurer will only pay for the value of the lost or damaged part.

In the event of loss involving property of others in your care, custody or control, the insurance company has the privilege to adjust with the owner. The insurer may settle with the owners of the property, and will provide a defense at its own cost for any legal proceedings brought against you.

Any recovery or salvage on a loss will accrue entirely to the benefit of the insurer, until the sum it has paid has been made up.

Another condition calls for the reinstatement of limit after a loss. The limit of insurance will not be reduced by payment of any claim, ex-

cept for a total loss of a scheduled item, in which event the insurer will refund the unearned premium on that item.

If any person or organization for whom the insurer makes payment under the insurance has rights to recover damages from another party, those rights of recovery are transferred to the insurer. The person or organization for whom payments are made must do everything necessary to secure these rights of recovery, and must do nothing after loss to impair these rights.

General conditions

Common conditions to all forms of inland marine coverage

The general conditions are brief and are all common conditions in the property insurance field.

The commercial inland marine coverage part will be void in any case of fraud by the named insured relating to the insurance. It is also void if the named insured intentionally committed concealment or misrepresentation of a material fact concerning this coverage part, the covered property, or the named insured's interest in covered property.

No one may take legal action against the insurer under the inland marine coverage part unless there has been full compliance with all the terms of the coverage part, and the action is brought within two years after you first have knowledge of the loss.

The coverage will provide no benefit to a bailee. No person or organization, other than the named insured, having custody of covered property will benefit from the insurance.

The policy period is that shown in the declarations, and the coverage only applies to "loss" commencing during the policy period.

A valuation clause says that, in the event of loss, the value of property will be determined as of the time of loss, and the value will be the least of the following amounts:

- the actual cash value of that property,
- the cost of reasonably restoring that property to its condition immediately before loss, and
- the cost of replacing that property with substantially identical property.

The 1994 federal district court decision *Arthur Sulzer v. Northern Contractors Co. v. Reliance Insurance Co.* offers a reasonable example of inland marine conditions. It also shows why this kind of coverage is called inland marine insurance.

In May 1991, Arthur Sulzer's barge—the UNCLE BOB—capsized at pier 124 on the Delaware River in Philadelphia, Pennsylvania. The barge was leased to Northern Contractors through a Charter Party Agreement.

Chapter Seven: Inland Marine

The UNCLE BOB, a steel work barge of all welded construction with a cargo capacity of approximately 600 tons, was used by Northern to store excess coal.

The Charter Party Agreement between Sulzer and Northern provided:

> [Northern] shall keep the equipment always safely afloat, in good repair and condition....
>
> [Northern] will at all times while the vessel is under charter to him exercise care that the vessel will not be overloaded or improperly loaded....

A leased barge takes on water and capsizes

The first time that the barge took on water was in early April 1991. At that time, Sulzer wanted to pump the water out—but a pump was unavailable. Instead, Sulzer asked Northern to remove some coal from the barge. Northern removed 50 tons of coal and pumped water out until the barge had stabilized.

Less than a month later, the Coast Guard notified Sulzer that the barge was listing and sitting low on the water. Efforts to stabilize the barge at that point were unsuccessful. Within a day of the Coast Guard notice, the UNCLE BOB had capsized.

Inspection revealed several small holes on the bottom of the barge. This caused a progressive and continuous flooding of the cargo holds. All parties involved agreed that these holes had been caused by normal wear and tear. They had developed due to normal metal corrosion and exposure to the wave action of passing ships and tug boats.

At the time of the loss, the barge was covered under an inland marine policy issued to Northern by Reliance. The policy provided for limits up to $290,000 and insured against "all risks of direct physical loss of or damage to the property covered from any external cause except as provided elsewhere in this Policy."

Northern made a claim under the policy. Reliance denied the claim citing two exclusions in the policy which it alleged applied to this case.

When damages couldn't be recovered, Sulzer sued Northern—alleging both a breach of the Charter Party and negligence. He claimed Northern was liable for the repairs and other damages to the UNCLE BOB, pursuant to the terms of the Charter Party Agreement.

Northern argued Reliance was liable under the terms of its inland marine policy to cover the damages incurred to the barge. So, Northern named Reliance as a third-party defendant in Sulzer's case.

The court first considered the Charter Party Agreement:

> As there is no dispute that the barge did indeed take on water and capsize, it is clear that Northern breached the terms of the Charter Party when it failed to keep the barge "always safely afloat."

INSURING THE BOTTOM LINE

> ...Northern was on notice that the barge was taking on water and failed to repair the cause. At this point, it need not be addressed whether or not the barge was unevenly or improperly loaded because, when the barge capsized, the Charter Party was breached.

So, the court granted a summary judgment for Sulzer against Northern for the breach of the Charter Party Agreement on the issue of Northern's failure to keep the barge afloat.

The court next turned to the insurance company's denial of Northern's claim. Reliance had denied coverage based on two exclusions in the all risk inland marine policy issued to Northern.

The insurance company tries to enforce an exclusion relating to normal wear and tear

The court considered these exclusions:

> An "all risk" policy covers only damages or losses considered "fortuitous events." A "fortuitous" event is "an event which so far as the parties to the contract are aware, is dependent on chance." It is generally accepted that wear and tear was not a fortuitous event and therefore not an insured risk.

In the policy, Reliance had specifically addressed wear and tear in the exclusion section. The exclusion stated:

> This Policy does not insure against:

> ...Wear and tear, gradual deterioration, inherent vice, latent defect, freezing or extremes of temperature, mechanical or electrical breakdown or failure unless fire or explosion ensues, and then only for such loss or damage caused by such ensuing fire or explosion.

However, the court found the language of the exclusion was ambiguous. It ruled that the phrase "unless fire or explosion ensues" might have modified either the entire exclusion or only the "mechanical or electrical breakdown or failure" portion of the exclusion.

It went on to suggest how the exclusion should have been written:

> In short, if Reliance wanted to unambiguously exclude losses caused by wear and tear, it could have clearly expressed this intention with words such as "This policy does not ensure against wear and tear, gradual deterioration..., and excludes losses or damages caused by wear and tear and gradual deterioration...."

Reliance also argued that, since there was no fire or explosion in Sulzer's case, there was no coverage for the loss or damage. But the court didn't agree.

Because Reliance omitted the "talismanic" language, the court found the exclusion ambiguous and granted another summary judgment for Sulzer against Reliance.

Reliance made one last point: Sulzer and Northern hadn't done everything they could to save the UNCLE BOB from sinking. Indeed, the inland marine policy excluded:

Loss or damage occasioned by the neglect of the insured to use all reasonable means to save and preserve the property at and after any disaster insured against or when the property is endangered by fire in neighboring premises or when the insured has notice of any impending disaster.

Sulzer argued that this exclusion did not apply to the case. The court couldn't come to any conclusion. Once the capsize of the barge happened, there was nothing Northern could do to mitigate the damage "at or after the disaster." However, the court could not make a determination about whether Northern did all it could do from the time it had notice of the "impending disaster" until the barge actually capsized. This issue would have to go to trial.

Sulzer had won two of three claims in his lawsuit. The third was a draw at the summary judgment stage—it would have to go to trial. Reliance offered him a settlement, which he accepted.

Thirteen coverage forms

Inland marine coverage is broader than other transportation coverages

Although transportation insurance might provide a more accurate impression of the nature of risks insured by inland marine policies, the actual definition of inland marine insurance is even broader. It covers moveable property whether or not it is ever moved. In addition to property being transported or which has the potential of being moved, the field includes insurance for instruments of communication and transportation which may have a permanent fixed location. Marine coverages are used to insure such things as bridges, tunnels, piers, pipelines, power transmission lines and towers, and radio and television communications equipment.

New simplified forms have been designed for 13 different types of risk. The commercial inland marine coverage part may include one or more of the following coverage forms:

- accounts receivable,
- camera and musical instrument dealers,
- commercial articles,
- commercial fine arts,
- equipment dealers,
- film coverage,
- floor plan merchandise,
- jewelers block,
- mail coverage,
- physicians and surgeons equipment,
- signs (signs, lamps and mechanical parts),

- theatrical property, and
- valuable papers and records.

Many of these commercial inland marine coverage forms have the same names as the earlier coverages and forms they replaced. However, the modernized forms have been simplified and coverage has been broadened—all coverages in the program are now written on an "all risk" type basis rather than a named perils basis. Each form covers risks of direct physical loss except for perils which are excluded, and each form lists its own exclusions.

Accounts receivable coverage form

A/R coverage is important to many businesses

Accounts receivable coverage is an important protection for many businesses. It covers sums due to you from customers which are uncollectible due to loss, damage, or destruction of accounts receivable records. The coverage also applies to expenses to reestablish the records, if possible, and collection expenses which are in excess of normal. In addition, interest charges on any loan required to offset uncollectible amounts pending payment of the insurance proceeds will be covered.

A caveat: This coverage is not intended to provide relief in the event that debtor defaults on an account due to you.

The form contains an additional coverage for loss of records involving collapse of a building or structure. It applies only to collapse caused by fire or lightning, extended coverage perils, breakage of glass, falling objects, weight of snow, ice or sleet, water damage, hidden decay or insect or vermin damage, weight of people or personal property, weight of rain that collects on a roof, or use of defective building materials or methods if collapse occurs during construction or remodeling. (Note: this additional coverage is found on all the coverage forms except the Mail Coverage Form, and on each form it covers against loss by the same perils.)

The form contains an extension of coverage for loss of records when removed from the premises to protect them from imminent danger of loss. The removal coverage applies only if you give written notice of the removal within 10 days.

The covered causes of loss are "risks of direct physical loss" to accounts receivable records except those risks which are excluded. Any loss that requires an audit of records or inventory computation to prove its factual existence is not covered. The form also excludes coverage for loss caused directly or indirectly or resulting from any of the following:

Excluded losses under the A/R coverage

- government action,
- nuclear hazard,
- war and warlike action,

- delay, loss of use, loss of market or other consequential loss,
- dishonest acts by you, your employees or representatives, or anyone entrusted with property (this does not apply to a carrier for hire),
- alteration, falsification, concealment or destruction of records to conceal wrongful acts,
- bookkeeping, accounting or billing errors,
- electrical or magnetic injury, disturbance or erasure of electronic recordings (except that direct loss caused by lightning is covered),
- voluntary parting with any property if induced to do so by any fraudulent scheme, trick, device or false pretense, and
- unauthorized instructions to transfer property to any person or any place.

Any of the following causes (but if loss by a covered cause of loss results, that additional loss will be covered):

1) weather conditions;

2) acts or decisions, or the failure to act or decide, of any person, group, organization or government body;

3) faulty, inadequate or defective planning, zoning, development, design, workmanship, repair, construction, building materials, or maintenance; and

4) collapse, other than as provided in the additional coverage.

Special valuation guidelines

A special valuation condition replaces the standard clause in the commercial inland marine conditions form because of the unique nature of the property (accounts receivable) being insured. If you cannot accurately establish the amount of accounts receivable outstanding at the time of loss, the average monthly amounts receivable for the preceding 12-month period will be used, and that amount will be adjusted for normal fluctuations in the amount receivable or demonstrated variance from the average for the month in which the loss occurred. However the amount receivable is determined, the following amounts will be subtracted from the total:

- the amount of accounts for which there is no "loss,"
- the amount of accounts which you are able to reestablish and collect,
- an amount to allow for probable "bad debts" which you are normally unable to collect, and
- all unearned interest and service charges.

The accounts receivable form includes a coinsurance clause which requires insurance for at least 80 percent of the amount of accounts

receivable at the time of loss, or else there will be a penalty. If the insurance carried is less than 80 percent of the value of the accounts at the time of loss, the insurance will only pay the proportion of the loss that the limit of insurance bears to 80 percent of the total value of the accounts. The coinsurance clause does not apply to property in transit, which may be covered if a limit of insurance for it is shown in the declarations.

To the extent that any loss is paid by the insurer, any later recovery of amounts receivable must be returned to the insurer.

Camera and musical instrument dealers coverage

A separate form for camera and musical instrument dealers

This form is used by camera and musical instrument dealers to cover stock and to protect customers' property while in the insured's care and custody for repair, adjustment or cleaning. Covered property includes:

- the insured's stock in trade, consisting principally of cameras or musical instruments and related equipment and accessories, and
- similar property of others in the insured's care, custody and control.

Property not covered includes property that has been sold and delivered to customers, accounts, bills, currency, deeds, evidences of debt, money, notes or securities, furniture, fixtures, office supplies, improvements and betterments, machinery and tools, patterns, dies, molds, models, property in the mail (unless by registered mail or government insured mail), and contraband, or property in the course of illegal transportation or trade.

An additional coverage is provided for loss involving collapse of a building or structure. It applies to loss caused by the perils specifically identified on the form.

An extension of coverage is provided for theft damage to buildings. The insurance will pay for damage caused directly by theft or attempted theft to that part of any building containing covered property, or equipment within the building which is used to maintain or service the building, but only if you own the building or are legally liable for the damage to it. This extension does not cover damage caused by fire, or damage to glass or to lettering or artwork on glass.

Covered causes of loss are risks of direct physical loss to covered property except what is excluded. The form excludes loss caused by or resulting from any of the following:

Losses excluded under the special form's causes of loss section

- earthquake,
- government action,
- nuclear hazard,
- war and military action,

- water, flood, surface water, waves, tides, overflow of a body of water, or spray whether wind driven or not,
- theft from an unattended vehicle (unless locked and there are visible signs of forced entry),
- marring, scratching, exposure to light, breakage of tubes, bulbs, lamps or articles made largely of glass (except lenses),
- delay, loss of use, loss of market or other consequential loss,
- unexplained disappearance,
- shortage found upon taking inventory,
- dishonest acts by you, or your employees or representatives, or anyone entrusted with the property (except this does not apply to a carrier for hire),
- processing or work upon the property,
- artificially generated electrical current creating a short circuit or other electrical disturbance within an article covered by the insurance (but direct loss caused by any resulting fire or explosion is covered),
- voluntary parting with any property if induced to do so by any fraudulent scheme, trick, device or false pretense, and
- unauthorized instructions to transfer property to any person or any place.

Familiar causes of loss are excluded

The form also excludes any of the following causes (but if loss by a covered cause of loss results, that additional loss will be covered):

1) weather conditions;

2) acts or decisions, or the failure to act or decide, of any person, group, organization or government body;

3) faulty, inadequate or defective planning, zoning, development, design, workmanship, repair, construction, building materials, or maintenance;

4) collapse, other than as provided in the additional coverage; and

5) wear and tear, any quality in the property that causes it to damage or destroy itself, hidden or latent defect, gradual deterioration, depreciation, mechanical breakdown, insects, vermin, rodents, corrosion, rust, dampnesses, cold, or heat.

The limits of insurance and the deductible applicable to this coverage will be shown in the declarations.

A number of additional conditions are found on the camera and musical instrument dealers form. A valuation condition replaces the standard commercial inland marine valuation clause. The value of "un-

sold property" will be the least of (1) the ACV of that property, (2) the cost to reasonably restore it to its condition immediately before the loss, or (3) the cost of replacing it with substantially identical property.

How the policy values covered property

The value of "sold property" which is not yet delivered to customers will be the net selling price after discounts and allowances. The value of "property of others" in your care, custody or control will be the lesser of (1) the amount for which you are liable, plus the value of labor and materials you have added, or (2) the ACV of the property, including labor and materials added by you. The value of "negatives, positives or prints" will be the cost of unexposed film or developing paper, including labor or materials added by you during the developing.

A standard coinsurance clause applies and requires insurance equal to at least 80 percent of the value of insured property at the time of loss. If a lower amount of insurance is carried, the penalty is the standard proportional reduction in recovery.

You are required to keep accurate records and inventory figures and to retain these records for at least three years after the policy period ends. The records must consist of an itemized inventory of the stock in trade, records of all purchases and sales, records of property of others in your care, custody or control, and records of property you send to others for any purpose. A physical inventory of stock is required at least once every 12 months.

A final condition refers to protective safeguards which may be required and which you may have stated were in effect at one or more locations when the coverage began. If you fail to keep such protective safeguards in working condition at a location, or in operation when the business is closed, coverage for which the safeguards apply will be automatically suspended at that location, until the equipment or services are back in operation.

Example: If you say that a burglar alarm will be used at an insured location, the insurance company may deny claims for losses that occur when the alarm is not in service.

Commercial articles coverage

In contrast to the dealers' coverage just reviewed, a commercial articles coverage form may be used to insure the interests of the owner of commercial cameras, musical instruments and related equipment. Covered property includes cameras, projection machines, films and related equipment and accessories, musical instruments and related equipment and accessories, and similar property of others that is in your care, custody or control.

Common buyers of commercial articles coverage might include musical groups or wedding photographers—both of which frequently transport valuable equipment.

Within this class of "covered property," the only property not covered is contraband, and property in the course of illegal transportation or trade.

Coverage for the collapse of a building

An additional coverage is provided for loss involving collapse of a building or structure, when caused by the perils specified. This form does not include any extensions of coverage.

Covered causes of loss are all risks of direct physical loss to covered property except what is excluded. The form excludes loss caused by or resulting from the same actions and hazards that apply to the accounts receivable coverage.

The limits of insurance and the deductible applicable to this coverage will be shown in the declarations.

This form includes a coinsurance clause, but it is different than the one found on most of the other forms. It states that all items that are covered but not individually listed and described must be insured for their total value at the time of loss, in order to avoid a penalty. If not insured for total value at the time of loss, the penalty is that the insurer will only pay the proportion of the loss that the limit of insurance in the declarations bears to the total value of these items at the time of loss.

A condition addresses additional acquired property, which will be automatically covered for up to 30 days, if it is a type of property already covered by the form. In the event of loss, the insurance company will pay the lesser of 25 percent of the limit of insurance shown in the declarations for that type of property, or $10,000. You are required to report any additional acquired property within 30 days and to pay the additional premium for it. If not reported, coverage automatically ends after 30 days.

Commercial fine arts coverage

The commercial fine arts coverage form may be used to cover fine arts owned by you or in your care, custody, and control. Property while on exhibition at fairgrounds or expositions is excluded, as is contraband or illegally transported property. Extensions are provided for newly-acquired property for up to 30 days, for the lesser of 25 percent of the total limit of insurance or $10,000, provided the acquisition is reported within 30 days and you pay any additional premiums due.

In addition to the exclusions that apply to the other coverages discussed in this section, the fine arts coverage also excludes breakage of art glass, windows, statuary, glassware, etc. unless caused by a covered cause of loss like fire, lightning, explosion, etc.

Complicated coverage for fine art

It's difficult to assign value to fine art objects. Valuation of covered property is determined according to its description in the declarations or, if not described in the declarations, the least of:

- the actual cash value of the property,
- the cost of reasonably restoring the property to its condition before the loss,
- the cost of replacing the property with substantially identical property, and
- property value is determined as of the time of loss.

This form takes other special measures to compensate for the valuation difficulties posed by fine art. It includes a coinsurance clause, and a condition that covered property will be packed and unpacked by competent parties.

Finally, there are loss conditions regarding pairs, sets, or parts. If a total loss of any items that are part of a pair or set that is individually listed and described in the declarations occurs, the full limit for the pair or set will be paid, and you will surrender the remaining items of the pair or set to the insurance company. If a loss occurs to a part of a pair or set not shown in the declarations occurs, the insurer may repair or replace the item to restore the pair or set to its full value, or may pay the difference between the value of the pair or set before and after the loss.

Equipment dealers coverage

An equipment dealers coverage form may be used to cover the interest of a dealer of mobile equipment and construction equipment. Covered property means the dealer's stock in trade consisting principally of mobile agricultural and construction equipment, and similar property of others in your care, custody or control.

Property not covered includes automobiles, motor trucks, motorcycles, aircraft, watercraft; accounts, bills, currency, deeds, money, notes, securities, evidences of debt; property while in the course of manufacture; property leased, rented or sold; furniture, fixtures, office supplies, improvements and betterments, machinery, tools, fittings, patterns, dies, molds and models; property of others described in the declarations; and contraband, or property in the course of illegal transportation or trade.

Coverage for most of these items should be purchased by means of other kinds of insurance.

An additional coverage is provided for loss involving collapse of a building or structure. It applies to loss caused by the perils specifically identified on the form.

An extension for debris removal

This form includes three extensions of coverage. The first is for debris removal, and it is similar to the coverage provided by commercial property forms. The insurer will pay expenses to remove the debris of covered property which is damaged by a covered cause of loss, subject to a limit of 25 percent of the amount paid for direct physical loss

Chapter Seven: Inland Marine

plus the amount of the deductible. However, if the sum of the debris removal expense and the direct loss exceeds the limit of insurance, or if the total debris removal expense exceeds the 25 percent limitation, the insurer will pay up to an additional $5,000 per occurrence for debris removal costs.

The second extension applies to pollution cleanup and removal expenses. The insurer will pay expenses to extract pollutants from land or water if the release or discharge of the pollutants results from a covered cause of loss during the policy period. But the most the insurer will pay under this extension is $10,000 for all such expenses arising during each separate 12-month period of coverage under the policy.

The third extension applies to theft damage to buildings. The insurer will pay for damage caused directly by theft or attempted theft to that part of any building containing covered property, or equipment within the building which is used to maintain or service the building, but only if you own the building or are legally liable for the damage to it. This extension does not cover damage caused by fire, or damage to glass or to lettering or artwork on glass.

Covered causes of loss are risks of direct physical loss to covered property except what is excluded. The exclusions are consistent with the ones found in the other coverage forms.

A number of particular conditions are found on the equipment dealers form.

More special language that applies to valuation

A valuation condition replaces the standard commercial inland marine valuation clause. The value of "unsold property" will be the least of (1) the ACV of that property, or (2) the cost to reasonably restore it to its condition immediately before the loss, or (3) the cost of replacing it with substantially identical property. The value of "sold property" which is not yet delivered to customers will be the net selling price after discounts and allowances.

The value of "property of others" in your care, custody or control will be the lesser of (1) the amount for which you are liable, plus the value of labor and materials you have added, or (2) the ACV of the property, including labor and materials added by you.

A standard coinsurance clause applies and requires insurance equal to at least 80 percent of the value of insured property at the time of loss. If a lower amount of insurance is carried, the penalty is the standard proportional reduction in recovery.

You are required to keep accurate records and inventory figures and to retain these records for at least three years after the policy period ends. The records must consist of an itemized inventory of the stock in trade, records of all purchases and sales, records of property of others in your care, custody or control, and records of property you

send to others for any purpose. A physical inventory of stock is required at least once every 12 months.

This form also has a condition regarding protective safeguards which may be required and which you may have stated were in effect at one or more locations when the coverage began. If you fail to keep such protective safeguards in working condition at a location, or in operation when the business is closed, coverage for which the safeguards apply will be automatically suspended at that location, until the equipment or services are back in operation.

Floor plan coverage

This form is used to insure merchandise for sale which is financed up to the time it is sold. It may be used to insure the single interest of the dealer who holds the merchandise for sale, or the single interest of the lender, or their dual interest. Coverage may also be provided for property in transit.

Covered property is property of the dealer which is at risk and specified in the declarations, and property at risk which is specifically encumbered to a secured lender named in the declarations.

Property not covered is any property after the named insured's interest in it ceases, property after it is sold and delivered or otherwise disposed of, and contraband or property in the course of illegal transportation or trade.

The floor plan coverage form provides the standard additional coverage for collapse, when caused by the perils specified. It does not include any extensions of coverage.

As with the other inland marine coverage forms, covered causes of loss are all risks of direct physical loss to covered property except what is excluded. The form uses exclusions consistently with the other inland marine coverage forms.

A coinsurance penalty applies to this coverage

The limits of insurance and the deductible applicable to this coverage will be shown in the declarations. This form does not include a coinsurance condition but the reporting requirement imposes a form of coinsurance penalty.

This form contains a number of additional conditions. One applies to transit coverage in the event of cancellation. If the policy is canceled, property already in transit will be covered until it reaches its destination.

A valuation clause states that in the event of loss, the value of "unsold property" will be the least of (1) the cost of reasonably restoring the property to its condition immediately before the loss, or (2) the cost of replacing the property with substantially identical property, or (3) the purchase price to the dealer, including transportation charges. The value of "sold property" will be the net selling price after

allowances and discounts. A loss limitation applies to property insured on a "single interest" basis—the insurer will only pay the proportion of the loss that your interest bears to the total value of the property.

When coverage is written on a dual interest basis, the protection given a secured lender will not be impaired by failure of another party to comply with policy provisions, if the lender has diligently tried to comply with all provisions.

You are required to take a physical inventory at least once every 12 months, and must keep detailed business records of inventory, payments, purchases, sales and property of others held, and retain these records for at least three years after the policy ends.

This is a reporting form, and you must file reports of values within 30 days after the end of each month. Premiums will be computed according to monthly rates. The insurance company is not liable for loss in excess of the amount of insurance written, even if reported values exceed the limit of insurance. If you have not filed any report at the time of a loss, the insurance is only liable for 90 percent of the limit of insurance written. If you fail to make a report when required, the insurance is only liable for the amount last reported. The penalty for underreporting values is a proportional reduction in recovery for any loss.

Jewelers block coverage

A special form for jewelry stores and dealers

The jewelers block coverage form is similar to coverage for other dealers (camera and musical instruments, or equipment dealers), because it covers the insured's merchandise held for sale and customers' property. But it has some additional features as well, such as multiple types of transit coverage and coverage for property in showcases. Covered property includes:

- the insured's stock in trade, consisting of jewelry, precious and semi-precious stones, precious metals and alloys, and other stock used in the business,
- such property which is sold but not yet delivered,
- similar property of others not in the jewelry trade, when such property is in the insured's care, custody and control, and
- similar property of others in the jewelry trade, when such property is in the insured's care, custody and control (but only to the extent of money actually advanced by the insured, or the insured's legal liability for the property).

Property not covered includes all of the following types of property:

- property sold under a deferred sales payment agreement after it leaves the insured's premises,

- property while at any exhibition promoted or financially assisted by a public authority or trade association,
- property while exhibited in showcases away from the insured's premises,
- property while worn by any officer, director, employee, agent, member or messenger of the business or any organization engaged in the jewelry trade, or by any of their family members, relatives, or friends (but watches worn solely for purposes of adjustment are covered),
- property in transit by mail (unless sent by U.S. Postal Service Registered Mail),
- property in transit by express carriers,
- property in transit by railroads, waterborne or air carriers (but property accompanied by a traveling person and transported by passenger parcel or baggage services may be covered),
- property in transit by motor carriers (but shipments by a carrier operating exclusively as a merchant's parcel delivery service, or by an armored car service, or by parcel transportation or baggage services of passenger bus lines may be covered), and
- contraband, or property in the course of illegal transportation or trade.

Property in transit may be covered

Note that various types of property in transit "may" be covered. The declarations of the jewelers block form includes places for entering a limit of insurance for each of the following: "registered mail," "armored car," "merchants parcel delivery service," and "railroads, passenger bus lines, waterborne or air carriers." Each coverage will apply only if a limit of insurance is shown in the declarations.

The jewelers block coverage form provides the standard additional coverage for collapse, when caused by the perils specified.

An extension of coverage is provided for theft damage to buildings. The insurance will pay for damage caused directly by theft or attempted theft to that part of any building containing covered property, or equipment within the building which is used to maintain or service the building, but only if the insured owns the building or is legally liable for the damage to it. This extension does not cover damage caused by fire, or any damage to glass or to lettering or artwork on glass.

The jewelers block form also provides two coverage options. The first option is for show windows—if a limit of insurance is shown in the declarations, it will cover loss of covered property from show windows at the premises from theft or attempted theft involving the smash-

ing or cutting of the show windows. The other option is for money coverage—if a limit is shown in the declarations, it will cover the loss of money by theft from locked safes or vaults at the premises, when the safes or vaults have been broken open.

The jewelers block has a special valuation condition which replaces the standard commercial inland marine valuation clause. The value of property does not include any antique or historical value, and it will be the least of the following amounts:

- the actual cash value of the property,
- the cost to reasonably restore it to its condition immediately before the loss,
- the cost of replacing it with substantially identical property, or
- the lowest figure put on the property in the insured's inventories, stock books, stock papers or lists existing as of the time of loss.

You have to keep promised safeguards in place

A standard clause about protective safeguards says that the insurance will be suspended if safeguards stated to be in effect when the coverage began are not kept in working condition or operation. A typical records and inventory clause requires a physical inventory at least once every 12 months, and detailed records of inventory, purchases, sales, property of others, and property away from the premises to be kept and retained for at least three years after expiration of the policy.

One additional condition on the jewelers block coverage form does not appear on any of the other inland marine forms—it is titled changes in premises. It states that, unless the insurer agrees in writing, it does not cover property where the risk of loss has been materially increased by changes in the premises, or property located in expansions to the premises shown in the declarations.

Mail coverage

Property is only insured when in the custody of a government postal service

Banks, trust companies, insurance companies, security brokers, fiduciaries, and various transfer agents have a need for mail coverage. When sent by first class, certified, express or registered mail, covered property includes bonds, stock certificates, certificates of deposit and other securities, coupons if attached to bonds, postage and revenue stamps, money orders, checks, drafts, notes, bills of lading, warehouse receipts and other commercial papers, and other documents and papers of value except unsold travelers checks and money. Covered property also includes, only when sent by registered mail, bullion, platinum and other precious metals, currency, unsold travelers checks, jewelry, watches, precious and semi-precious stones and other similar property.

A special provision describing when coverage applies states that property is covered only when in the care, custody and control of a government postal service, and while in transit by a common carrier or messenger to and from a government post office. Property continues to be covered until it is delivered to the addressee at the address shown on the package, or delivered to the proper address in the event of an error in the address shown or removal of the addressee, or returned to the premises of the sender in the event of non-delivery.

Because the form is so specific about the types of property covered and when coverage applies, the statement about property not covered is brief: covered property does not include contraband or property in the course of illegal transportation or trade.

The mail coverage form includes one extension of coverage for errors and oversight. If the value of any mailing was not recorded properly, because of error or oversight, the insurer will pay the actual value of the property in the event of loss if promptly notified after discovery of the error or oversight. However, payment will not be for more than the limit of insurance shown in the declarations. If the value of property in any one shipping exceeds the limit of insurance, the insurer will only pay the proportion of a loss that the limit of insurance bears to the actual value.

Covered causes of loss are risks of direct physical loss except for causes which are excluded. Because the types of property covered and application of coverage have already been well-defined and limited, this form provides broad "all risk" coverage while property is in the custody of the postal service. There are only three exclusions—the insurer will not pay for loss caused directly or indirectly by:

- government action,
- weapons, including atomic weapons, mines and torpedoes, or
- war and military action.

The most the insurer will pay for loss in any one occurrence is the applicable limit of insurance shown in the declarations. Separate limits may be entered for each type of mail service, and for any single addressee on one day. In the event of loss, the value of covered property will be its actual value, but not less than its market value, on the date of mailing. Coverage is always written on a reporting basis, and reports must be made within 30 days after the end of each reporting period shown in the declarations.

Physicians and surgeons equipment coverage

Special coverage for valuable medical equipment

Individuals in the medical or dental profession (not hospitals, schools or institutions) may cover valuable medical and dental equipment, materials, supplies and even office equipment and furniture by purchasing a physicians and surgeons equipment coverage form. Cov-

ered property includes your medical and dental equipment, materials, supplies and books usual to the medical or dental profession (at your option, similar property of others may also be insured), office equipment, including furniture and fixtures, and your interest in improvements and betterments.

Within the classification of covered property, the only property not covered is radium and contraband or property in the course of illegal transportation or trade.

This physicians and surgeons equipment form includes an additional coverage for loss by collapse, and an extension of coverage for theft damage to buildings. Covered causes of loss are all risks of direct physical loss to covered property except what is excluded.

The appropriate limits of insurance and the deductible applicable to this coverage will be shown in the declarations. This form includes an 80 percent coinsurance requirement at the time of loss to avoid a penalty on recovery.

Signs coverage

Insuring neon signs

A special form exists for insuring the value of signs, including neon, fluorescent, automatic or mechanical signs. On the sign coverage form, covered property means the named insured's signs and similar property of others in the care, custody or control of the named insured. The only signs not covered are contraband and property in the course of illegal transportation or trade.

The sign coverage form provides the standard additional coverage for collapse, when caused by the perils specified. It does not include any extensions of coverage.

Covered causes of loss are risks of direct physical loss to covered property except what is excluded. The form excludes the causes of loss prohibited by the accounts receivable coverage form—and most of the forms in this section.

The appropriate limits of insurance and the deductible applicable to this coverage will be shown in the declarations. This form includes a 100 percent coinsurance requirement for all covered property, except property in transit.

Theatrical property coverage

This form is used to cover theatrical property which is used or intended to be used in specific theatrical productions. Covered property includes the named insured's scenery, costumes and theatrical properties, and similar property of others which is in the care, custody or control of the named insured, or on which the named insured has made partial payments. All covered property is property to be used or intended for use in a production which is identified in the declarations—productions must be identified.

Property not covered includes buildings and their improvements and betterments; vehicles (unless actually used on the stage in the covered production); jewelry comprised of precious stones, metals or alloys; accounts, bills, currency, deeds, money, documents, transportation or admission tickets, notes, securities and evidences of debt; animals; contraband, or property in the course of illegal transportation or trade.

The theatrical property coverage form provides an additional coverage for collapse of a building. It does not provide any extensions of coverage.

The limits of insurance and the deductible applicable to this coverage will be shown in the declarations. This form includes an 80 percent coinsurance requirement at the time of loss to avoid a penalty in recovery.

Valuable papers and records coverage

An important special coverage for papers and records

Nearly every business relies on records or documents that would have to be reconstructed after loss or destruction, or which might be irreplaceable. Valuable papers and records coverage protects against the loss of such documents. Generally, the insurance would pay to replace or reconstruct the lost records. Covered property means valuable papers and records that are the named insured's property or the property of others in the care, custody or control of the named insured. "Valuable papers and records" means inscribed, printed or written documents, manuscripts or records, including abstracts, books, deeds, drawings, films, maps or mortgages. It does not include money or securities, converted data, programs or instructions used in data processing operations, or the material on which such data is recorded.

"Property not covered" means property not specifically declared and described in the declarations—if such property cannot be replaced with other property of like kind and quality. It also includes property held as samples or for delivery after sale, property in storage away from the premises shown in the declarations, and contraband and property used in illegal transportation or trade.

The valuable papers and records form provides the standard additional coverage for collapse, when caused by the perils specified. It also includes an extension of coverage for removal of property to protect it from imminent danger of loss. You must give the insurance company written notice of the removal within 10 days.

In addition to the familiar causes of loss and exclusions, this coverage does not cover losses caused by the following factors:

- errors or omissions in processing or copying (but direct loss caused by any resulting fire or explosion is covered),

- electrical or magnetic injury, disturbance or erasure of electronic recordings, and
- voluntary parting with any property if induced to do so by any fraudulent scheme, trick, device or false pretense.

The appropriate limits of insurance and the deductible applicable to this coverage will be shown in the declarations. This form does not include a coinsurance condition.

A special condition requires you to keep all valuable papers and records in receptacles that are described in the declarations at all times when the records are not being used and while the business is closed.

Endorsements

Inland marine coverage can be modified further by endorsement

Various endorsements may be attached to the inland marine coverage part or to one or more of the coverage forms to alter the coverage. Most of those in use tend to be of two types—state amendatory endorsements, and those which modify a specific coverage form.

Among the endorsements attached because of state requirements, the most common policy provisions altered are "cancellation" requirements, the treatment of "other insurance," when "legal action" can be taken against the insurer, and when "loss payments" will be made.

A number of standard endorsements have been designed to modify the individual coverage forms. Usually these endorsements specifically identify a particular coverage form. These endorsements are used to describe additionally covered property, to schedule or list property, to alter deductibles or create special deductibles for specific coverages, and to change reporting forms into non-reporting or vice versa.

Some endorsements limit or broaden a particular type of coverage (for example, the "Exclusion of Named Customers" endorsement which may be attached to the accounts receivable form, and the "Negotiable Securities Under Air Bill" endorsement which may be attached to the mail coverage form).

INSURING THE BOTTOM LINE

Chapter Eight:

General Liability and Product Liability

Introduction

Liability is legal responsibility for damage to another party's person or property. If an accident occurs on your premises for which your business is found liable, you can expect to owe money damages to the person whose person or property was harmed.

Because accidents or injuries are difficult to predict and damage awards can be enormous, liability insurance is perhaps the most important coverage for any business. A multi-million dollar judgment can disrupt—if not bankrupt—many businesses. These judgments are entirely possible in today's lawsuit-happy environment.

General liability insurance protects an insured person or company from a wide variety of exposures. This insurance usually covers legal obligation arising out of injuries or damage suffered by members of the public, customers, tenants and others. Coverage is established by insuring agreements, which tend to be quite broad.

Because general liability insuring agreements are so broad, the exclusions are particularly important in shaping the coverage.

Considerable changes have been made in commercial general liability (CGL) forms and terminology as the result of ISO's Commercial Lines Policy and Rating Simplification Program. The term "CGL" is still with us, but there has been a significant change in what it stands for. It used to mean "comprehensive general liability" coverage. The word "comprehensive" has been dropped from the program, because it was misleading and suggested that nearly everything was covered by a CGL policy—in fact, many plaintiff's attorneys attempted to use the term "comprehensive" to extend coverage to absurd lengths.

CGL forms are now "commercial" general liability forms, and they provide a broader range of coverages than the older "comprehensive" general liability forms.

In the past, the commercial liability field consisted of a number of sublines, and a separate coverage part (policy form) existed for each. There were two variations of premises and operations exposure—one for owners, landlords and tenants (OL&T) and one for manufacturers

and contractors (M&C). A separate form existed for liability resulting from products and completed operations. Insured parties who had special exposures resulting from contracts could purchase contractual liability coverage. Those who hired contractors or subcontractors could be protected from liability for the acts of those they hired by purchasing owners and contractors protective liability (OCP) insurance.

The comprehensive general liability policy included all of the just mentioned coverages except contractual liability coverage which was limited to certain "incidental" contracts. An insured business could obtain contractual liability coverage and pick up a wide range of additional coverages by purchasing a broad form CGL endorsement.

All of the above forms and coverages have been replaced by the general liability program. A commercial general liability policy now automatically provides all of these coverages unless endorsements are used to exclude exposures. Under the program, sublines have been consolidated. There are only two major sublines. One is a broad premises/operations subline that includes all the coverages that used to be provided by the OL&T, M&C, OCP, contractual liability and broad form CGL endorsement forms. The other subline is for products and completed operations.

The CGL program is very flexible. Various endorsements may be used to remove coverages. Endorsements may be used to eliminate coverage for products and completed operations, advertising injury, personal and advertising injury, medical payments, or fire legal liability. Other endorsements may be used to exclude various coverages for liability arising out of scheduled locations only, while preserving the coverage elsewhere. An endorsement may also be used to reduce the broad contractual liability coverage to a more limited coverage for incidental contracts.

Separate forms are available for companies that have very limited and specific exposures. There is a form that provides only the products and completed operations insurance. Another form provides owners and contractors protective coverage, and it is used when an owner or contractor requires a contractor or subcontractor to provide coverage for a specific job, which can only be done by issuing the coverage as a separate policy.

Occurrence versus claims-made

The critical delay between an occurrence and a filed claim

Originally general liability covered accidents—sudden, unexpected events that happened at a specific time and location. Under the current general liability forms, the concept of accident has been expanded to include continuous or repeated exposure to conditions that result in bodily injury or property damage that was neither expected nor intended (by you).

These older occurrence policies covered events that happened be-

tween the effective date and the expiration date of the policy. Regardless of when a claim was made, the policy in effect at the time of exposure to the injurious condition was the one that would respond to the claim, whether or not the same carrier was providing the coverage.

Several insurance companies issued occurrence policies for asbestos manufacturers in the 1940s and 1950s. Forty years later, these insurers are still paying millions of dollars in claims and legal defense costs for policies under which they collected only a few thousand dollars in premiums. Needless to say, these insurance companies are not excited about writing occurrence policies in the future.

Because the delay between the occurrence and filing of a claim resulted in difficulty in developing premiums adequate to anticipate claims that had been incurred but not reported (IBNRs), insurance companies developed so-called "claims-made" coverage for risks with a long delay—sometimes called long tailed exposures.

Basically, the occurrence form pays for (or covers) injury or damage that *happens* during the policy period, while the claims-made form responds to claims *filed* during the policy period.

One purpose of introducing the claims-made form was to create a precise claim trigger that would prevent the stacking of limits. An occurrence form covers injury or damage that occurs during the policy period, even if the claim is made three, four, or five years later.

A problem with stacking claims

Some courts decided that a loss resulting from a cause that occurred during two or more policy periods meant that two or more sets of policy limits applied.

For example, if your company had $1 million of coverage in each of three separate years in which an occurrence contributed to a loss, a court might require the insurance company to pay up to $3 million for a single loss. This is the problem of "stacking." In contrast, a claims-made form covers claims that are first made during the policy period. If you continually renew claims-made coverage with a $1 million occurrence limit, a single loss can only be charged to one policy.

The claims-made coverage provided a precise claim trigger that made it possible for insurance companies to determine when coverage began and which policy should respond. Under the occurrence form, the policy or coverage in effect at the time the incident happens responds. Under the claims-made form, coverage in effect at the time the claim is reported responds.

Other features of the claims-made form are that it reduces the time that records must be kept for future claims, and it is more inflation proof than occurrence coverage. Suppose an accident happened during 1988 and the claim was not made until 1996. With occurrence coverage, the loss would be charged to the policy in effect in 1988 and the claim would be paid under that policy. Also suppose that you

had a $250,000 per occurrence limit during 1988 but gradually increased the amount to $1 million by 1996 because of inflationary trends. With occurrence coverage, there would only be $250,000 of coverage available for a loss that occurred in 1988. If claims-made coverage applied, the same loss would be charged to the policy in effect during 1996, there would be $1 million of coverage available, and the claim would be paid under the more recent policy.

The claims-made form also has an additional section and a few necessary differences in its conditions. The written provisions of the claims-made form differ from the occurrence form only in the following three areas:

- coverage A and B insuring agreements,
- CGL conditions (added provisions), and
- additional section—extended reporting periods.

Claims which trickle in after the end of a policy period create an exposure known as a claims tail. Tail coverage is automatically built into the insuring agreements of occurrence forms. This is not the case with claims-made forms, and the forms would be unacceptable if they left policyholders exposed to serious insurance gaps which could not be covered. Extended reporting periods were created to solve the problems of coverage terminations and transitions back to occurrence coverage.

Most policy provisions under the two CGL coverage forms are identical. The insuring agreements differ slightly, because the coverage trigger is different under claims-made coverage. There are a few differences in the claims-made conditions, and the claims-made form has an additional section concerning extended reporting periods. We will review the claims-made coverage form because most of the claims-made provisions are additional provisions, and the remaining policy provisions, conditions and exclusions are the same on both forms.

The CGL coverage forms are part of the commercial lines Package Policy Program. Under this program, any of the available coverage forms may be issued as part of a monoline policy (consisting of one major kind of coverage, called a "coverage part"), or may be joined with other coverages to form a package policy (consisting of two or more coverage parts).

In either case, the common policy conditions (which apply to all commercial coverages in the program) and common policy declarations (which summarize all the coverages included in a policy) must be attached to complete the policy. These items are used regardless of whether or not other coverages are actually included in the policy.

Determining rates for mature risks

Premiums for claims-made coverage

Initially, claims-made coverage is less expensive than occurrence coverage. During the first four years of claims-made coverage, various

multipliers are used to reduce the annual premium if the retroactive date has not been advanced. For the first year of claims-made coverage, premiums will be significantly lower than premiums for an equal amount of occurrence coverage. The premiums will increase progressively until the fifth year, when claims-made coverage is considered to be "mature" and full premiums will be charged. If the retroactive date is advanced, the new date will be used to determine when claims-made coverage started.

The reason for lower premiums is that rates are determined for "mature" risks. "Occurrence" coverages are written on a mature basis, and all the claims that arise out of a coverage period are eventually carried back to an original occurrence policy. But when "claims-made" insurance is written, the claims are carried forward to the policy year in which the claim is made. Fewer claims are expected to be paid during the first year than in the second (when claims arising out of two annual periods could be reported), and fewer are expected during the second year than in the third. Claims aren't expected in the early years of this coverage because the coverage simply hasn't been in place long enough to be used.

Claims-made coverage fully matures in its fifth year (when claims arising out of five annual periods could be reported), because most claims are expected to be received and recorded within five years.

If you later return to occurrence coverage, the lower initial premiums could be offset—a hefty premium can be charged for the unlimited tail coverage needed to fully protect your company.

The lower initial premiums are one potential source of problems. You might be over-eager to grab what looks like a bargain, without fully understanding the implications. You need to understand how and why premiums will go up, and that an expensive "tail" might have to be purchased some day in the future.

The CGL policy

Buying liability coverage

General liability coverage may be issued as a monoline policy or as part of a commercial package policy (CPP). In either case, the policy must include the common policy declarations and the common policy conditions. In addition, it must have a general liability coverage part, which consists of:

- the CGL declarations page,
- a general liability coverage form,
- the broad form nuclear energy liability exclusion endorsement, and
- any other endorsements that may apply.

In the declarations page, the insurance company "declares" the facts of the policy: The name of the person or organization who is insured

is shown. The policy number here identifies the policy indisputably—like your social security number identifies you; the date when the coverage begins and when it ends; the name of the insurance company and the producer—the organization that sells the policy to you; the charge, or premium, for the period the policy covers, and the amounts—or limits—the policy will pay.

The declarations page may also show a retroactive date, before which no coverage applies.

Using a retroactive date in a liability policy

A retroactive date is a mechanism that defines when coverage begins. It is most useful for creating a clean division between occurrence and claims-made coverage, but it has other applications. A retroactive date is not required. "None" may be entered on the declarations. If a retroactive date is to apply, it must be shown on the CGL declarations.

When claims-made coverage is written without a retroactive date, duplicate coverage may exist. All claims-made during the policy term may be covered even if they are also covered by earlier occurrence forms. However, the claims-made coverage would apply as excess over any earlier occurrence policies that cover the same loss.

Usually, when an occurrence policy is renewed by a claims-made policy, the retroactive date will be the effective date of the claims-made policy. This eliminates overlapping coverage. For example, a risk that transfers from occurrence coverage to claims-made coverage on January 1, 1996 is likely to carry a retroactive date of January 1, 1996. Any claim resulting from an occurrence prior to January 1, 1996 would fall back on an earlier occurrence policy, and the claims-made form would only cover claims resulting from occurrences on or after January 1, 1996.

In the absence of a major change in the risk or a shift to a different insurance company, the same retroactive date should be continued on claims-made renewals to avoid gaps in coverage. If the above policy is renewed on January 1, 1997 while retaining the January 1, 1996 retroactive date, a claim made on April 1, 1997 for an injury that occurred during 1996 would be covered by the 1997 policy. If the retroactive date had been advanced to January 1, 1997, a claim reported during 1997 for an occurrence in 1996 would not be covered by the 1997 policy (because the occurrence happened before the retroactive date), or by the 1996 policy (because the claim was not reported before the end of that policy period), or any earlier occurrence forms (because the loss happened after those policies expired).

Before the retroactive date can be advanced, the insurance company must obtain from the first named insured written consent and acknowledgment that you have been informed of the right to buy the extended reporting period.

An additional section that extends reporting periods

Claims-made CGL forms have an additional section providing for "extended reporting periods," also referred to as "ERPs." The insuring

agreement limits coverage to claims first made "during the policy period." When claims-made forms are continuously renewed by other claims-made forms, the agreement does not present any problems—whenever a claim is made, it will be charged against current coverage. But coverage gaps would result if the coverage were to be renewed on an "occurrence" form, or if a retroactive date were moved forward at renewal, or if the insurance were permanently discontinued (a possibility when an insured busines fails). In such cases, future claims from past operations could not be charged against any future "occurrence" policy, nor would any "claims-made" coverage exist at the time the claim is made.

Claims-made coverage has been designed so that transitions between "occurrence" and "claims-made" coverage can be managed without gaps or duplications of coverage. Proper use of a retroactive date and ERPs will prevent situations where a loss is covered by two different policies or is not covered at all.

The policy form

Commercial general liability (CGL) insurance protects a business from a variety of business liability exposures arising out of its premises, operations, products and completed operations. The major coverages apply to bodily injury, property damage, personal injury, and advertising injury claims.

The policy itself discusses occurrence and claims-made basis at length

The CGL coverage forms are organized into sections. The occurrence form has five sections and the claims-made form has six, the only difference being an additional section for extended reporting periods on the claims-made form. The coverage forms are organized in the following way:

- Coverages—Section I
- Who is an insured—Section II
- Limits of insurance—Section III
- CGL conditions—Section IV
- Definitions—Section V on "occurrence" form; Section VI on "claims-made"
- Extended reporting periods—Section V on "claims-made" only

Section I of both forms describes all of the following coverages:

- Coverage A—Bodily injury (BI) and property damage (PD) liability
- Coverage B—Personal and advertising injury liability
- Coverage C—Medical payments
- Supplementary payments—Coverages A and B

Each of the coverages has an insuring agreement and a list of exclusions.

> Various provisions in this policy restrict coverage. Read the entire policy carefully to determine rights, duties and what is and is not covered.
> Throughout this policy the words "you" and "your" refer to the Named Insured shown in the Declarations, and any other person or organization qualifying as a Named Insured under this policy. The words "we," "us" and "our" refer to the Company providing this insurance.
> The word "insured" means any person or organization qualifying as such under Who Is An Insured (Section II).
> Other words and phrases that appear in quotation marks have special meaning. Refer to Definitions (Section VI).

In the policy preamble, the definition of "you" has been expanded to include "any other person or organization qualifying as a Named Insured under the policy." This gives "Named Insured" status to newly acquired organizations.

> **SECTION I—COVERAGES**
> COVERAGE A. BODILY INJURY AND PROPERTY DAMAGE LIABILITY
> 1. Insuring Agreement.
> a. We will pay those sums that the insured becomes legally obligated to pay as damages because of "bodily injury" or "property damage" to which this insurance applies. We will have the right and duty to defend any "suit" seeking those damages. We may at our discretion investigate any "occurrence" and settle any claim or "suit" that may result. But:
> (1) The amount we will pay for damages is limited as described in Limits of Insurance (Section III); and
> (2) Our right and duty to defend end when we have used up the applicable limit of insurance in the payment of judgments or settlements under Coverages A or B or medical expenses under Coverage C.
> No other obligation or liability to pay sums or perform acts or services is covered unless explicitly provided for under Supplementary Payments—Coverages A and B.

The insuring agreement defines the duties of the insurance company under the policy. The insurance company must defend you in any suit seeking damages and pay any judgment arising out of the suit for bodily injury or property damage. It may also investigate any occurrence and settle a resulting claim or suit if it wishes to do so.

A claim is not a claim until it is reported

The damages it will pay will not exceed the limits of liability shown in the policy and the insurance company's obligation to defend you ends when the limits of liability are used up in payment of claims under Coverage A (bodily injury and property damage), Coverage B (personal injury and advertising liability), or Coverage C (medical pay-

ments). The only payments it is responsible for above the policy limits of liability are those described in supplementary payments.

> b. This insurance applies to "bodily injury" and "property damage" only if:
> (1) The "bodily injury" or "property damage" is caused by an "occurrence" that takes place in the "coverage territory";
> (2) The "bodily injury" or "property damage" did not occur before the Retroactive Date, if any, shown in the Declarations or after the end of the policy period; and
> (3) A claim for damages because of the "bodily injury" or "property damage" is first made against any insured, in accordance with paragraph c. below, during the policy period or any Extended Reporting Period we provide under Extended Reporting Periods (Section V).
> c. A claim by a person or organization seeking damages will be deemed to have been made at the earlier of the following times:
> (1) When notice of such claim is received and recorded by any insured or by us, whichever comes first; or
> (2) When we make settlement in accordance with paragraph 1.a. above.

On the claims-made form, a claim is deemed to be first made when notice of the claim is received by you or by the insurance company, whichever comes first. All claims for damages because of "bodily injury" to the same person, including damages claimed by any person or organization for care, loss of services, or death resulting at any time from the "bodily injury" will be deemed to have been made at the time the first of these claims is made against any insured person.

A "first made" claim

Under the claims-made policy form coverage is provided only if the bodily injury or property damage takes place in the coverage territory and does not occur before the retroactive date or after the end of the policy period. In addition to the injury or damage occurring within these dates, a claim must be first made during the policy period or during any extended reporting period. A claim is deemed to be "first made" when notice of the claim is received by you or the insurance company or when it is settled by the insurance company, whichever comes first.

The only difference between Coverage A as provided by the claims-made form and the occurrence form is the coverage "trigger." The occurrence form covers injury or damage that occurs during the policy period regardless of when the claim is made.

> 2. Exclusions.
> This insurance does not apply to:
> a. "Bodily injury" or "property damage" expected or intended from the standpoint of the insured. This exclusion does not apply to "bodily injury" resulting from the use of reasonable force to protect persons or property.

Coverage A exclusions on the claims-made form and occurrence form are identical. There are no differences.

If you intentionally injure another person or damage property of others, there is no coverage under the policy. The word "intentionally" means an act which is expected or intended to cause injury to a person or damage to property. However, this exclusion does not apply if the injury or damage is the result of using reasonable force to protect persons or property.

Exclusions shape coverage and serve a number of purposes. Some exclusions eliminate coverage for things which are not considered insurable—such as intentional acts on your part. Exclusions are also used to eliminate coverage which is properly the subject of other types of insurance—CGL coverage does not apply to losses which should be covered by property insurance, automobile insurance, and workers compensation. Finally, exclusions are often used to remove coverage which is available, but which is not given automatically because it is not universally needed or it needs to be underwritten and rated separately—such as liquor liability and pollution liability coverages.

The 1992 federal district court decision *Commercial Union Insurance v. Sky, Inc. and Kimberly Cluck* handled a common "expected or intended" behavior issue—sexual harassment.

A case involving actions that were "expected or intended"

Kimberly Cluck, a former employee of Arkansas-based Sky, Inc., sued her former employer, alleging sexual harassment. Cluck claimed that, while she was an employee, she suffered sexual harassment from another Sky employee.

Cluck charged that the harassment arose out of and in the scope of her employment with Sky—thus constituting a violation of Title VII of the Civil Rights Act of 1964.

As a result of Cluck's complaint, Sky requested that Commercial Union provide a defense in the sexual harassment action. Sky contended that the liability policy it had purchased from CU provided coverage for any damages that arose from Cluck's claims.

CU denied any duty to defend and filed a lawsuit against Sky and Cluck. It sought a declaration from the court that:

1) it had no duty to defend Sky in the case filed by Cluck, and

2) the insurance policy issued by CU to Sky provided no coverage as a matter of law for any liability which may result in that action.

A key reason that CU argued it had no duty to defend was that sexual harassment, by definition, is an intended action. The CGL policy excluded coverage for losses caused by "expected or intended" behavior.

Sky answered CU's lawsuit, contending that:

1) an insurer has an obligation to defend its insured within coverage limits of the policy whether or not a duty to pay exists under the policy;

2) the injuries alleged by Kimberly Cluck were either "bodily injury" or "personal injury" as defined in CU's policy; and

3) the Sky employee who had allegedly harassed Cluck was an additional insured under the insurance policy.

Cluck also responded to the motion agreeing—ironically—with Sky's defense. She agreed that her complaint alleged "bodily injury" within the meaning of the insurance policy sufficient to invoke coverage and that the "expected or intended from the standpoint of the insured" clause did not exclude coverage because the actions of the allegedly harassing employee were not expected or intended within the meaning of the policy.

The CGL policy between CU and Sky provided coverage for two perils. Coverage A provided insurance for bodily injury and property damage liability and Coverage B provided for personal and advertising injury liability. Coverage A contains the following relevant language concerning coverage:

> We will pay those sums that the insured becomes legally obligated to pay as damages because of "bodily injury" or "property damage" to which this insurance applies. No other obligation or liability to pay sums or perform acts or services is covered unless explicitly provided for under SUPPLEMENTARY PAYMENTS—COVERAGES A AND B. This insurance applies only to "bodily injury" and "property damage" which occurs during the policy period. The "bodily injury" or "property damage" must be caused by an "occurrence." The "occurrence" must take place in the "coverage territory."

Is sexual harassment anything but expected and intended?

Cluck alleged that her coworker engaged in "numerous incidents of sexual harassment," both "verbal and physical." In no instance did Cluck contend that his actions were anything other than intended. And the court ruled:

> ...it strains the imagination to speculate how a pattern of sexual overtures and touching can be "accidental." There is likewise no contention that [the alleged harasser] was incapable of forming intent. Thus, the court must determine whether these alleged intentional acts...constitute a "bodily injury" resulting from an "occurrence."

Without determining whether the alleged sexual harassment constituted "bodily injury" (and the court believed from the Cluck's testimony that it did not), the court concluded that any injury alleged to have been sustained by Cluck was not the result of an "occurrence" as defined by the policy.

Sexual harassment was not an "occurrence" as defined by the policy

The court held, therefore, that Coverage A of the policy issued to Sky did not provide coverage for liabilities incurred as the result of a sexual harassment lawsuit. As a result, CU had no duty to defend Sky in the action brought by Cluck.

Sky and Cluck also contended that coverage might exist under Coverage B of the policy, which contained the following relevant language:

> We will pay those sums that the insured becomes legally obligated to pay as damages because of "personal injury" or "advertising injury" to which this insurance applies. No other obligation or liability to pay sums or perform acts or services is covered unless explicitly provided for under SUPPLEMENTARY PAYMENTS—COVERAGES A AND B.

They argued that the actions taken with respect to Cluck constituted "personal injuries" covered by the policy. The court noted that personal injury, as related to the policy, was defined as:

> injury, other than "bodily injury," arising out of one or more of the following offenses: false arrest, detention or imprisonment; malicious prosecution; wrongful entry into, or eviction of a person from a room, dwelling or premises that the person occupies; oral or written publication of material that slanders or libels a person or organization or disparages a person's or organization's goods, products or services; or oral or written publication of material that violates a person's right of privacy.

The court concluded:

> It is clear from a mere reading of the complaint that this was not a "slander" or "false imprisonment" lawsuit. In fact, those terms were not even used and no facts pled to support such causes of action. Furthermore, there was no notice that Cluck intended to pursue such actions. This case had been pled as a Title VII sexual harassment lawsuit and that was what it was.

Each allegation made by Cluck arose out of the alleged acts of sexual harassment. Her allegations were not mutually exclusive; they were related and interdependent. Without the underlying sexual harassment claim there would have been no alleged "personal injury" and no basis for a suit against Sky for imprisonment, defamation, outrage or negligent supervision.

Employment practices liability coverage is more applicable to sexual harassment claims

So, the court declared that no coverage for sexual harassment existed under CU's CGL policy. Therefore, the insurance company had no duty to defend Sky.

In matters such as sexual harassment and other forms of workplace discrimination, you can seek more comprehensive protection through separate coverage—such as employment practices liability insurance.[1]

[1] For more detailed discussion of employment practices liability coverage, see Merritt Publishing's 1994 book *Rightful Termination* and its 1995 book *Mastering Diversity*.

> b. "Bodily injury" or "property damage" for which the insured is obligated to pay damages by reason of the assumption of liability in a contract or agreement. This exclusion does not apply to liability for damages:
> (1) Assumed in a contract or agreement that is an "insured contract" provided the "bodily injury" or "property damage" occurs subsequent to the execution of the contract or agreement; or
> (2) That the insured would have in the absence of the contract or agreement.

This exclusion is designed to prevent the policyholder from assuming exposure beyond normal business agreements. If you fail to read the fine print and sign a contract that says you will be responsible for any bodily injury or property damage, you're out of luck. The insurance company will not pay for any such damage that might occur.

But some contracts you sign are considered "insured contracts" — which are covered. These include: lease of premises agreements, sidetrack, construction, or demolition agreements with railroads, indemnification agreements with municipalities in connection with work done for them, elevator maintenance agreements, and the assumption of the tort liability of another party. Since this definition is quite broad, the policy actually does cover many types of contractual liability. However, in order to be covered, the contract or agreement must be made prior to the occurrence of any bodily injury or property damage.

The policy also covers liability you would have even if no contract or agreement existed, because the policy would have covered the loss anyway and the agreement does not increase the exposure.

> c. "Bodily injury" or "property damage" for which any insured may be held liable by reason of:
> (1) Causing or contributing to the intoxication of any person;
> (2) The furnishing of alcoholic beverages to a person under the legal drinking age or under the influence of alcohol; or
> (3) Any statute, ordinance or regulation relating to the sale, gift, distribution or use of alcoholic beverages.
> This exclusion applies only if you are in the business of manufacturing, distributing, selling, serving or furnishing alcoholic beverages.

No coverage for liquor liability under the standard policy

The liquor liability exclusion applies only to an insured business that is in the business of manufacturing, distributing, selling, serving or furnishing alcoholic beverages, such as a brewery, liquor store, bar or restaurant where drinks are served. For these companies, a separate liquor liability coverage form is available and a premium will be charged for the coverage because of the greater exposure.

However, the policy does cover the incidental liquor liability exposure of a company that is not in the business of making, supplying, serv-

ing or selling drinks. An insured building owner who leases a premises to someone engaged in the business of selling drinks would be covered if sued as the owner of the premises. An insured business which provided financial services and consists only of clerical offices would be covered for its liquor liability exposure if it provided beer at a company picnic or served drinks at a holiday party.

Another example: One of your employees drinks too much at the office Christmas party. The employee is involved in an accident on his way home and sues you because you provided the drinks. The court rules that you precipitated your employee's drunkenness and finds for the employee. The insurance company will pay the damages the court awards to the employee.

Of course, the insurance company will not pay damages if you are held legally responsible for getting someone drunk; or for giving liquor to someone under age or who is already drunk, or if you sell, distribute or give alcohol to someone in violation of any law.

> d. Any obligation of the insured under a workers compensation, disability benefits or unemployment compensation law or any similar law.
> e. "Bodily injury" to:
> (1) An employee of the insured arising out of and in the course of employment by the insured; or
> (2) The spouse, child, parent, brother or sister of that employee as a consequence of (1) above.
> This exclusion applies:
> (1) Whether the insured may be liable as an employer or in any other capacity; and
> (2) To any obligation to share damages with or repay someone else who must pay damages because of the injury.
> This exclusion does not apply to liability assumed by the insured under an "insured contract."

Exclusions d. and e. pertain to the relationship between general liability coverage and various statutory benefits which an employer is required to provide.

Exclusion d. is designed to prevent payment under the general liability coverage for obligations an insured employer might have under workers compensation laws, disability benefit laws, and similar laws. Generally, these are statutory obligations, such benefits are paid without regard to fault or negligence, and separate forms of insurance coverage are available for these exposures. In contrast, CGL coverage is intended to be "legal liability" insurance.

Injuries to family members of employees are not covered

Exclusion e. relates more specifically to employee injuries and consequential injuries to family members of employees. There is no coverage for injury suffered by an employee in the course of employment, and no coverage for injury to a family member, such as a spouse who claims psychological trauma as a result of injury to the employee.

These types of injuries would be covered by a workers compensation and employers liability policy, and an employer should carry that kind of insurance.

> f. (1) "Bodily injury" or "property damage" arising out of the actual, alleged or threatened discharge, dispersal, seepage, migration, release or escape or pollutants:
> (a) At or from any premises, site or location which is or was at any time owned or occupied by, or rented or loaned to, any insured;
> (b) At or from any premises, site or location which is or was at any time used by or for any insured or others for the handling, storage, disposal, processing or treatment or waste;
> (c) Which are or were at any time transported, handled, stored, treated, disposed of, or processed as waste by or for any insured or any person or organization for whom you may be legally responsible; or
> (d) At or from any premises, site or location on which any insured or any contractors or subcontractors working directly or indirectly on any insured's behalf are performing operations:
> (i) If the pollutants are brought on or to the premises, site or location in connection with such operations by such insured, contractor or subcontractor; or
> (ii) If the operations are to test for, monitor, clean up, remove, contain, treat, detoxify or neutralize, or in any way respond to, or assess the effects of pollutants.
> Subparagraphs (a) and (d)(i) do not apply to "bodily injury" or "property damage" arising out of heat, smoke or fumes from a hostile fire.
> As used in this exclusion, a hostile fire means one which becomes uncontrollable or breaks out from where it was intended to be.
> (2) Any loss, cost or expense arising out of any:
> (a) request, demand or order that any insured or others test for, monitor, clean up, remove, contain, treat, detoxify or neutralize, or in any way respond to, or assess the effects of pollutants; or
> (b) claim or suit by or on behalf of a governmental authority for damages because of testing for, monitoring, cleaning up, removing, containing, treating, detoxifying or neutralizing or in any way responding to or assessing the effects of pollutants.
> Pollutants means any solid, liquid, gaseous or thermal irritant or contaminant, including smoke, vapor, soot, fumes, acids, alkalis, chemicals and waste. Waste includes materials to be recycled, reconditioned or reclaimed.

Exclusion f. eliminates coverage for virtually all types of pollution exposures.

Another section devoted to the definition of "hostile fire"

With respect to a premises, site or location owned or occupied by, rented to, or used by an insured business, or on which work is performed for that company by contractors or subcontractors, any injury or damage resulting from the heat, smoke or fumes of a hostile fire is not excluded as pollution damage. A "hostile fire" is one which

is out of control or breaks out of the area to which it was intended to be confined.

Example: If you are burning some old paper trash and the fire spreads beyond the fire-break, any resulting environmental damage will not be covered.

Again, pollution poses complicated risks

The pollution exclusion is a very broad one that applies to bodily injury or property damage arising out of the discharge, migration, release or escape of pollutants. It applies to any premises, site or location owned or occupied by, rented to, or used by an insured business, or which at any time was used for the handling, storage, disposal, processing or treatment of waste. This exclusion also applies to activities by others for whom you may be responsible, and to work performed by contractors or subcontractors on behalf of an insured business.

Part (2) of the pollution exclusion specifies that, in addition to excluding injury and damage, there is no coverage for the costs of testing, monitoring, cleaning up, removing or neutralizing pollutants, and no coverage for any claims or suits brought against you by any government entity for damages related to pollution cleanup or removal.

Pollution coverage is not granted automatically because the nature of the exposure depends upon your operations, and the wide variation in possible exposures cannot be reflected by average rates. Separate pollution liability coverage forms are available for pollution exposures. Pollution risks are underwritten and rated separately.

While the "absolute" pollution exclusion should have resolved coverage disputes, there is still litigation over its application to environmental claims under CGL policies. CGL coverage may also be inapplicable if the claim is not a "suit" or does not seek "damages" as those terms are defined in the policy.

The pollution exclusion in standard CGL policies is a hotly disputed issue. Its ultimate fate is anyone's guess: There are almost as many judicial interpretations of the provision as there are pollution incidents.

Most property/casualty insurance companies sell separate environmental impairment liability (EIL) insurance which covers pollution risks. As a result they work hard to keep pollution claims out of CGL coverage. However, EIL insurance remains nonstandard—so not many companies buy it. Most policyholders try to claim coverage for pollution risk under CGL policies.

> g. "Bodily injury" or "property damage" arising out of the ownership, maintenance, use or entrustment to others of any aircraft, "auto" or watercraft owned or operated by or rented or loaned to any insured. Use includes operation and "loading or unloading."
> This exclusion does not apply to:

(1) A watercraft while ashore on premises you own or rent;
(2) A watercraft you do not own that is:
(a) Less than 26 feet long; and
(b) Not being used to carry persons or property for a charge;
(3) Parking an "auto" on, or on the ways next to, premises you own or rent, provided the "auto" is not owned by or rented or loaned to you or the insured;
(4) Liability assumed under any "insured contract" for the ownership, maintenance or use of aircraft or watercraft; or
(5) "Bodily injury" or "property damage" arising out of the operation of any of the equipment listed in paragraph f.(2) or f.(3) of the definition of "mobile equipment" (Section VI.8)

Coverage is excluded for "autos" (as defined in the policy), watercraft, and aircraft that you own, use, maintain or entrust to others. The exclusion also states that the word "use" not only means the operation of the auto, watercraft, or aircraft but includes the loading or unloading of any of them.

Liability coverage does extend to boats, planes and certain other vehicles

There are several situations which are exempt from the exclusion and for which coverage is provided:

1. Watercraft which are ashore and on premises that you own or rent are covered.

2. Watercraft not owned by you are also covered if they are less than 26 feet long and are not being used to carry property or persons for a charge.

3. Parking an auto on your premises or on the "ways" adjoining (i.e., alleys, streets, roads, etc.) is covered if the auto is not owned, rented, or loaned to you. This exception allows coverage for parking facilities in connection with your business.

4. Coverage is also included for contractual liability involving watercraft and aircraft if the contract is within the definition of an "insured contract" under the policy. Note, however, that "autos" are not included because contractual liability for autos is covered under most auto policies.

5. Some self-propelled vehicles with permanently mounted equipment are defined as "autos" under the policy and not as "mobile equipment." Cherry pickers, generators, air compressors, spraying, and well-digging equipment are types of equipment which are mounted on truck bodies to move the equipment from location to location. Coverage for these "autos" is to be provided by an automobile policy. However, when these vehicles are not being operated and are stationary while the mounted equipment is in use, coverage is provided under this policy for the operation of the equipment mounted on these vehicles.

INSURING THE BOTTOM LINE

> h. "Bodily injury" or "property damage" arising out of:
> (1) The transportation of "mobile equipment" by an "auto" owned or operated by or rented or loaned to any insured; or
> (2) The use of "mobile equipment" in, or while in practice or preparation for, a prearranged racing, speed or demolition contest or in any stunting activity.

"Mobile equipment" as defined in the policy is covered under most circumstances, but coverage under this policy is not provided while mobile equipment is being transported by another vehicle that is owned or operated by, or rented or loaned to any insured person. A common occurrence is when a fork lift (which is mobile equipment) is transported by a truck carrying a load of material which will be unloaded at a destination. If the fork lift breaks loose while being transported and runs into parked cars, there is no coverage under this policy. Coverage would have to be provided under the policy covering the truck doing the hauling.

Part h.(2). excludes mobile equipment while used in racing or speed contests or other types of exhibition or stunting contests, or while practicing for them. An example of this would be "tractor pulls," which often take place at fairs, and other similar events using farm equipment.

> i. "Bodily injury" or "property damage" due to war, whether or not declared, or any act or condition incident to war. War includes civil war, insurrection, rebellion or revolution. This exclusion applies only to liability assumed under a contract or agreement.

How a war risk might apply to your company

You would not normally have any liability arising out of war, insurrection, and similar occurrences; however, note that this exclusion only applies to liability assumed under contract or agreement. You would not specifically assume liability for war, etc., but it is possible that you could assume liability under a contract with such broad language that it would include almost any occurrence. This exclusion would then apply under those circumstances.

> j. "Property damage" to:
> (1) Property you own, rent, or occupy;
> (2) Premises you sell, give away or abandon, if the "property damage" arises out of any part of those premises;
> (3) Property loaned to you;
> (4) Personal property in the care, custody or control of the insured;
> (5) That particular part of real property on which you or any contractors or subcontractors working directly or indirectly on your behalf are performing operations, if the "property damage" arises out of those operations; or
> (6) That particular part of any property that must be restored, repaired or replaced because "your work" was incorrectly performed on it.

Chapter Eight: General Liability and Product Liability

No coverage for property that you have rented or borrowed

This exclusion eliminates or restricts coverage for damage to property that is owned by, used by, loaned to, rented to, or is or has been in your care, custody or control. It also restricts coverage for damage with respect to property manufactured, worked on, or constructed by you.

Parts (1), (3), and (4) pertain to property which you are using or own or which belongs to others. Coverage for property that falls into these categories can be covered by other forms of insurance, such as building and personal property policies, inland marine policies, or legal liability property insurance forms.

Part (2) excludes coverage for property damage to premises that you no longer own or exercise any control over, which have been called "alienated premises." Note that this exclusion does not apply to bodily injury arising out of the alienated premises, nor does it apply to damage to property other than to the alienated premises. The purpose of this is to exclude coverage for repairs to the premises, which should have been made by you prior to its sale or other disposition. An exception to this exclusion is made further down, which provides that it does not apply if the premises are "your work" and they were never occupied, rented, or held for rental by you. This exception provides coverage for building contractors, etc., who construct buildings solely for the purpose of resale.

No coverage for faulty workmanship or improperly installed devices

Parts (5) and (6) of the exclusion are related. Part (5) excludes coverage for damage to a particular part of real property you, contractors, or subcontractors are working on. Part (6) excludes damage to any property that must be restored, repaired, or replaced because of improperly performed work by you. Under part (5), if an improperly installed gas heater explodes and not only demolishes the gas heater but causes severe damage to the building, the policy would cover the damage to the building but not replacement of the gas heater. Part (6) excludes coverage for faulty workmanship, and excludes coverage to replace, repair, or restore property because your work was not performed correctly. Again note that the exclusion only pertains to the particular part that was worked on, and not damage to other property that results. Further, this exclusion does not apply to the products or completed operations hazard.

Parts (3), (4), (5), and (6) do not apply to railroad sidetrack agreements. Railroad sidetrack agreements are covered contracts under the policy, and these exclusions would nullify such agreements if they were applicable.

The 1990 federal appeals court decision *Maryland Casualty Co. v. George Wayne Reeder et al.* considered CGL endorsements which extend coverage to subcontractors.

Samuel Pearlman purchased three adjoining parcels of vacant land in Carlsbad, California, in 1972. Pearlman formed Roundtree, Ltd., a partnership which in turn formed a joint venture with Twelve Trees

Corporation. The joint venture was named Roundtree Condominiums. DMF Construction, Inc. was retained as a general contractor to construct condominiums on the three parcels.

At various stages between 1980 and 1985, Pearlman, Roundtree, Ltd., Twelve Trees, Roundtree Condominiums and DMF were each named insureds on a series of CGL policies issued by Maryland Casualty Company. Some of the policies included a broad form property damage endorsement.

Condo owners file suit against contractor and subcontractors

Between 1984 and 1987 separate purchasers of the condominiums and the homeowners association filed three lawsuits against Pearlman, Roundtree, Ltd., Roundtree Condominiums, Twelve Trees and DMF. The buyers alleged the condominium units had been damaged by soil subsidence.

The first complaint alleged the condominium was "suffering from severe cracks in the walls and settling of the slab." The second complaint alleged several units "have been damaged to the extent that they are rendered valueless."

In the third complaint, the homeowners association alleged the soil subsidence had caused:

> cracking and separation in the concrete floor slabs, foundations, retaining walls, interior and exterior walls and ceilings, and exterior concrete patio areas and walkways at affected Condominium Units and Common Areas within the Project.

When Pearlman and the other defendants made a claim for legal defense costs under the CGL policy, Maryland Casualty denied coverage. It argued that it had no duty to indemnify or to defend the defendants against the lawsuits brought by the condo owners.

Maryland countersued the condo owners and the developers, arguing the damage suffered by the condo owners was not "property damage" within the meaning of its policies. Maryland also argued that coverage was barred by the terms of exclusions in its policies that eliminated coverage for property damage arising out of "work performed for or participation in a joint venture which was not itself a named insured under the policy."

The trial court found the work performed exclusion applicable and granted Maryland's motion. The Pearlman group and the condo owners appealed.

Maryland's liability policy provided broad definitions of property damage and personal injury and stated in its insuring clause the company would pay damages for which the insured became liable as a result of property damage or personal injury. The clause was followed by 17 exclusions which detailed the circumstances in which Maryland would not cover personal injury or property damage claims.

The insurance company focused on two of these exclusions in its denial of coverage for the condo claims.

First, Maryland policies excluded coverage for "property damage to work performed by or on behalf of the named insured arising out of the work or any portion thereof, or out of materials, parts, or equipment furnished in connection therewith." This language would eliminate coverage for most of the claims-made by the condo owners and their association.

The court defines the "work performed" exclusion

The appeals court pointed out that the terms of this "work performed" exclusion were drafted by the ISO. The ISO explained that the exclusion was intended to "exclud[e] only damages caused by the named insured to his own work. Thus...[t]he insured would have coverage for damage to his work arising out of a subcontractor's work [and t]he insured would have coverage for damage to a subcontractor's work arising out of the subcontractor's work."

Second, the Maryland policy eliminated coverage for "property damage to the named insured's products arising out of such products or any part of such products." It then defined "named insured's products" as:

> goods or products manufactured, sold, handled or distributed by the named insured or by others trading under his name, including any container thereof [other than a vehicle], but "named insured's products" shall not include a vending machine or any property other than such container, rented to or located for use of others but not sold.

Maryland argued the entire condominium project was its named insureds' product and thus coverage of the claims-made against them is barred by the exclusion.

The court did not accept Maryland's broad interpretation of the products exclusion. By making no distinction between the "products" and the "work performed" Maryland ignored the fact that the policy itself made each category of commercial activity the subject of a separate exclusion.

In general, Maryland's interpretation ignored that the "works performed" exclusion, unlike the "products exclusion," was altered by the broad form endorsement to provide coverage for services supplied by subcontractors. The appeals court observed: "If one exclusion was narrowed and the other was not, logic suggests there must be some difference between them."

Finally, the appeals court concluded:

> ...our review of...the policies with the broad form endorsement discloses the insureds are identified as "Roundtree Ltd., a California partnership, & DMF Construction, Inc., A Joint Venture." Because claims for property damage were made against the named

insureds and none of the exclusions Maryland relied upon eliminate coverage as a matter of law, the summary judgment entered in Maryland's favor is reversed.

The decision was notable because the court looked to industry publications as the standard on how the industry defined the policy language in the ISO forms. One attorney involved in the litigation said, "In this case, the court simply followed what the industry had been saying all along, even though Maryland was pushing for something else....Broad forms tend to expand coverage for insureds."

> k. "Property damage" to "your product" arising out of it or any part of it.

Your product isn't covered for damage it causes to itself

This excludes damage to your product which arises from the product itself.

Example: A faulty connection in an electrical appliance you produce causes a short-circuit that in turn destroys the appliance and, in addition, damages a customer's property. The damage to the appliance would not be covered, but the property damage would be covered.

It is important to note that this exclusion applies if the damage arises "out of any part of it," which means that if a small switch on a large machine malfunctions and causes the damage, coverage is denied for the entire machine and not just for the switch.

> l. "Property damage" to "your work" arising out of it or any part of it and included in the "products-completed operations hazard."

This exclusion does not apply if the damaged work or the work out of which the damage arises was performed on your behalf by a subcontractor.

This excludes property damage to "your work" that arises out of "your work" or any part of it, which is included under the products/completed operations hazard. The exclusion does not apply to work in progress, since this would come under the premises-operations hazard and not the completed operations hazard. It does not apply to damage which arises out of the work of a subcontractor, whether the damage be to your work or the work of the subcontractor or another subcontractor. This is because you are responsible for a subcontractor's work—but you cannot be expected to monitor all of a subcontractor's work as carefully as your own.

> m. "Property damage" to "impaired property" or property that has not been physically injured arising out of:
> (1) A defect, deficiency, inadequacy or dangerous condition in "your product" or your work; or
> (2) A delay or failure by you or anyone acting on your behalf to perform a contract or agreement in accordance with its terms.

This exclusion does not apply to the loss of use of other property arising out of sudden and accidental physical injury to "your product" or "your work" after it has been put to its intended use.

"Impaired property" means tangible property that cannot be used or is less useful because it incorporates your product or work which is defective, or because you have failed to fulfill the terms of a contract or agreement, when such property can be restored to use by repair, replacement or removal of your product or work, or by fulfilling the terms of the agreement. This exclusion applies to damage to impaired property or other property that has not been physically injured, arising out of a defect in your product or work or a failure to perform.

You have a duty to repair defective products

The purpose of this exclusion is to remove coverage for damages which could be avoided by repair or replacement of your defective product or work, or by your performance of—or failure to perform—an agreement. This includes claims for loss of use.

Example: The exclusion might apply if you supplied defective components for another manufacturer's appliance which would not be sold with the defect, or if an insured contractor failed to complete a project on time and another party lost rental income or sales opportunities as a result. You should be responsible for repair, replacement or performance when such action could eliminate the claim for damages.

However, an exception to the exclusion states that it does not apply to loss of use of other property resulting from a sudden injury to your product or work after it has been put to its intended use. If a piece of equipment could not be used because your component exploded after it had been used for awhile, there would be coverage for a loss of use claim.

> n. Damages claimed for any loss, cost or expense incurred by you or others for the loss of use, withdrawal, recall, inspection, repair, replacement, adjustment, removal or disposal of:
> (1) "Your product";
> (2) "Your work"; or
> (3) "Impaired property";
> if such product, work, or property is withdrawn or recalled from the market or from use by any person or organization because of a known or suspected defect, deficiency, inadequacy or dangerous condition in it.

No coverage for product recalls and other product issues

This provision excludes any costs involved in the recall of products from the marketplace because of some known or suspected defect. It has in the past been known as the "sistership exclusion" because of its origin in the aircraft industry, when a defect in one aircraft would cause the recall of its "sisterships" for inspection and repair as necessary. In these cases of recall, note that there has been no actual bodily injury or property damage caused by the recalled products and that the recall is a remedial or preventative action and not a

INSURING THE BOTTOM LINE

claim arising from an actual defect in a product. There is an exclusion of "impaired property" because your product may be the suspected defective component of another product being recalled. It may be the maker of the main product who initiates the recall, and not you; therefore, the word "others" is part of the exclusion.

> Exclusions c. through n. do not apply to damage by fire to premises rented to you. A separate limit of insurance applies to this coverage as described in Limits of Insurance (Section III).

An exception applies to all of the exclusions except the first two. All other exclusions (c. through n.) do not apply to fire damage to a premises rented by you. General liability coverage does provide fire legal liability insurance up to the fire damage limit shown in the declarations.

Exclusion a. is not waived because it applies to damage "expected or intended," and the policy will not cover arson. Exclusion b. is not waived because it applies to obligations assumed under contract other than an insured contract. Although a lease is an "insured contract," the definition of that term specifically excludes any obligation to indemnify a person for fire damages to a premises rented by you (but the contractual liability exclusion does not apply to liability you would have had in the absence of a contract). This means that the policy will pay for fire damage if you are negligent, but will not pay if the obligation to pay for damages is assumed under contract and negligence is not involved.

> COVERAGE B. PERSONAL AND ADVERTISING INJURY LIABILITY
> 1. Insuring Agreement.
> a. We will pay those sums that the insured becomes legally obligated to pay as damages because of "personal injury" or "advertising injury" to which this coverage part applies We will have the right and duty to defend any seeking those damages. We may at our discretion investigate any "occurrence" or offense and settle any claim or "suit" that may result. But:
> (1) The amount we will pay for damages is limited as described in Limits of Insurance (Section III); and
> (2) Our right and duty to defend end when we have used up the applicable limit of insurance in the payment of judgments or settlements under Coverage A or B or medical expenses under Coverage C.
> No other obligation or liability to pay sums or perform acts or services is covered unless explicitly provided for under Supplementary Payments—Coverages A and B.

Claims arising out of advertising liability

The insuring agreement for Coverage B reads the same as for Coverage A, with the single exception that the words "personal injury" and "advertising liability" replace the words "bodily injury" and "property damage."

A separate sublimit applies to Coverage B, and it is also subject to the general aggregate limit. The insurance company's duty to defend you ceases when either of these limits is used up by payment of claims under Coverage A, B, or C. Personal injury is not the same as bodily injury, and includes such things as false arrest, libel, slander, and invasion of privacy.

> b. This insurance applies to:
> (1) "Personal injury" caused by an offense arising out of your business, excluding advertising, publishing, broadcasting or telecasting done by or for you;
> (2) "Advertising injury" caused by an offense committed in the course of advertising your goods, products or services;
> but only if:
> (1) The offense was committed in the "coverage territory";
> (2) The offense was not committed before the Retroactive Date, if any, shown in the Declarations or after the end of the policy period; and
> (3) A claim for damages because of the "personal injury" or "advertising injury" is first made against any insured, in accordance with paragraph c. below, during the policy period or any Extended Reporting Period we provide under Extended Reporting Periods (Section V).
> c. A claim made by a person or organization seeking damages will be deemed to have been made at the earlier of the following times:
> (1) When notice of such claim is received and recorded by any insured or by us, whichever comes first; or
> (2) When we make settlement in accordance with paragraph 1.a. above.

All claims for damages because of "personal injury" or "advertising injury" to the same person or organization as a result of an offense will be deemed to have been made at the time the first of those claims is made against any insured parties.

Claims arising out of personal injury liability

Personal injury and advertising injury are mutually exclusive exposures. "Personal injury" applies to an offense arising out of your business activities other than advertising, publishing or broadcasting. "Advertising injury" applies to an offense arising out of advertising your goods, products or services. This coverage is designed to cover the incidental advertising liability exposure of an insured business that advertises its own goods and services, and it does not apply to an insured business that is in the advertising, publishing or broadcasting business (as you will see when we examine the exclusions).

The only difference between Coverage B as provided by the claims-made form and the occurrence form is the coverage trigger. Occurrence coverage applies to an offense committed during the policy period (regardless of when the claim is made). In contrast, claims-made coverage applies only if the offense was not committed before the retroactive date (if any) or after the end of the policy period, and only if the claim is made during the policy period or any extended reporting period provided by the insurance company.

INSURING THE BOTTOM LINE

> 2. Exclusions.
> This insurance does not apply to:
> a. "Personal injury" or "advertising injury":
> (1) Arising out of oral or written publication of material if done by or at the direction of the insured with knowledge of its falsity;
> (2) Arising out of oral or written publication of material whose first publication took place before the Retroactive Date, if any shown in the Declarations;
> (3) Arising out of the willful violation of a penal statute or ordinance committed by or with the consent of the insured; or
> (4) For which the insured has assumed liability in a contract or agreement. This exclusion does not apply to liability for damages that the insured would have in the absence of the contract or agreement.
> b. "Advertising injury" arising out of:
> (1) Breach of contract, other than misappropriation of advertising ideas under an implied contract;
> (2) The failure of goods, products or services to conform with advertised quality or performance;
> (3) The wrong description of the price of goods, products or services; or
> (4) An offense committed by an insured whose business is advertising, broadcasting, publishing or telecasting.

Coverage B exclusions on the claims-made and occurrence forms are identical with the exception of a single reference to the "retroactive date" in one of the exclusions. This is necessary because of the difference in the coverage triggers under the two forms.

Exclusions that are similar to expected or intended exclusions in other insurance

The first set of exclusions applies to both the personal injury and advertising injury coverages. Items a.(1) and a.(3) are similar to the "expected or intended" exclusion found under Coverage A—here there is no coverage for injury arising out of publication of material which is known to be false by you, or which is a willful violation of a penal statute or ordinance. In item a.(2) we find a reference to the "retroactive date"—there is no coverage for injury arising out of material first published before any retroactive date shown (in contrast, the occurrence form excludes coverage for material first published before the beginning of the policy period). Item a.(4) is a contractual liability exclusion. Here there is no reference to, and no coverage for, an "insured contract," but once again the exclusion does not apply to liability you would have had in the absence of a contract or agreement.

The second set of exclusions applies only to advertising injury. Under item b.(1), there is no coverage for breach of contract, but injury arising out of misappropriation of advertising ideas under an implied contract is covered. Under item b.(2), there is no coverage for failure of a product or service to perform as advertised (you might be obligated to replace the product or refund the purchase price, but the purchaser has not really suffered any additional injury or damages). Item b.(3) excludes injury resulting from errors in the description of a

price for goods or services (here the prospective purchaser has been misinformed, but has not suffered any injury).

Item b.(4) excludes coverage for an offense committed by an insured business in advertising, broadcasting, publishing or telecasting. As mentioned earlier, the CGL form is designed only to cover the incidental advertising liability exposure of an insured business that advertises its own goods and services, and will not cover an advertising agency or newspaper that is in the business of advertising for others.

Separate professional liability coverage is available for advertisers, broadcasters and publishers.

> COVERAGE C. MEDICAL PAYMENTS
> 1. Insuring Agreement.
> a. We will pay medical expenses as described below for "bodily injury" caused by an accident:
> (1) On premises you own or rent;
> (2) On ways next to premises you own or rent; or
> (3) Because of your operations;
> provided that:
> (1) The accident takes place in the "coverage territory" and during the policy period;
> (2) The expenses are incurred and reported to us within one year of the date of the accident; and
> (3) The injured person submits to examination, at our expense, by physicians of our choice as often as we reasonably require.
> b. We will make these payments regardless of fault. These payments will not exceed the applicable limit of insurance. We will pay reasonable expenses for:
> (1) First aid at the time of an accident;
> (2) Necessary medical, surgical, x-ray and dental services, including prosthetic devices; and
> (3) Necessary ambulance, hospital, professional nursing and funeral services.

Liability coverage also includes medical payments

Medical payments coverage provides payment for reasonable medical expenses without regard to legal responsibility for the injury. It is intended to mitigate possible bodily injury claims by providing voluntary coverage for medical expenses of an injured person without any question of liability. The injury must occur on your premises or adjoining ways, or as a result of your operations even if they occur away from the premises. The accident causing the injury must take place during the policy period and within the coverage territory; therefore, coverage is on an "occurrence" basis on both the "claims-made" and the "occurrence" forms.

Further restrictions require that the medical expenses be incurred and reported to the insurance company within a one-year period from the date of the accident, and that the injured person must submit to

reasonable requests to be examined by a physician at company expense.

Up to the applicable limit of insurance per person, general liability medical expenses are paid regardless of fault. The coverage applies to reasonable expenses for first aid administered at the time of the accident, necessary medical, surgical, x-ray and dental services resulting from the accidental injuries, necessary ambulance, hospital, and professional nursing services, and funeral services if death results from the injuries.

> 2. Exclusions.
> We will not pay expenses for bodily injury:
> a. To any insured.
> b. To a person hired to do work for or on behalf of any insured or a tenant of any insured.
> c. To a person injured on that part of premises you own or rent that the person normally occupies.
> d. To a person, whether or not an employee of any insured, if benefits for the "bodily injury" are payable or must be provided under a workers compensation or disability benefits law or a similar law.
> e. To a person injured while taking part in athletics.
> f. Included within the "products-completed operations hazards."
> g. Excluded under Coverage A.
> h. Due to war, whether or not declared, or any act or condition incident to war. War includes civil war, insurrection rebellion or revolution.

Medical payments coverage does not apply to injury to any insured party, any person hired to work for an insured business, any person (such as a tenant) who is injured on that part of the insurance company's premises that such person normally occupies, any person for whom benefits for the same injury are payable or required under any workers compensation or disability benefits law, or any person injured while taking part in athletics.

Injuries which would be included under the products-completed operations hazard limit (which appears in detail below), and any injuries resulting from war or an act of war, are excluded. Under item g., all of the exclusions that apply to bodily injury under Coverage A also apply to medical payments coverage.

An insurance company denies medical payments under a CGL policy

The 1994 Ohio appeals court decision *Lovetta Hammond v. Grange Mutual Casualty Co.* involved a fairly shocking denial of CGL medical payments coverage.

Lovetta Hammond suffered a fractured hip as a result of a fall on the premises of Executive Hair Designs, a hair styling salon, in May 1991. At the time of the injury, Hammond was ninety years old.

Executive Hair Designs was covered by a policy of insurance issued by Grange Mutual Casualty Co. The policy provided for $5,000 in

Chapter Eight: General Liability and Product Liability

medical payments for persons injured in the course of business operations, and without regard to liability on the part of Executive Hair Designs.

After the incident at the salon, Grange obtained a statement from Hammond regarding her injuries and the manner in which they were incurred. In June 1991, Marlena Keynes—Hammond's daughter—was contacted by a senior claims adjuster for Grange.

The adjuster said he discussed the medical payments coverage with Keynes; she said that the existence of such coverage was never disclosed to her.

In August 1991, the adjuster sent a letter to Hammond in which he stated:

> I must respectfully inform you that Grange Mutual Casualty is not in a position to reimburse you for your medical expenses.
>
> We feel that there was no liability on the part of our insured. Their premises were inspected. There were no defects in the carpet or linoleum in the area where you fell.

The adjuster claimed that this letter was intended only to express Grange's position that there was no liability for negligence on the part of Executive Hair Design, rather than to deny the existence of medical payments coverage.

Keynes said that she and her mother interpreted this letter, in particular the reference to medical expenses, as a direct refusal by Grange to provide any reimbursement whatsoever to Hammond. They decided to sue.

A month after Hammond received Grange's letter, her lawyer contacted the company by phone—at which time Grange disclosed the medical payments coverage. Hammond's lawyer presented a detailed summary of her medical expenses to Grange by letter on October 16, 1991. The summary stated that he was authorized by his client to pursue a bad faith action against Grange and made a settlement demand covering both the potential bad faith claim and any liability claims arising out of the fall.

Grange responded that there was no liability on the part of Executive Hair Designs, but tendered full medical payment coverage of $5,000.

Hammond filed a lawsuit in November 1991, alleging breach of contract, bad faith, fraud, and intentional infliction of emotional distress. The trial court overruled Grange's motion for summary judgment and the case went to trial in September 1992.

Fraud and breach of duty are the only claims that stand

All of Hammond's complaints were dismissed except for the claims of fraud and breach of duty of good faith and fair dealing. The jury returned a verdict for Hammond. It concluded there had been bad faith but no fraud. The court subsequently awarded minimal legal fees and no punitive damages to Hammond.

Hammond and Grange both appealed the verdicts. The appeals court condemned the denial of medical benefits by a CGL insurance company:

> If potential medical payments claimants may be rebuffed by an insurer who simply denies the existence of such coverage or fails to disclose it, this imposes a needless additional cost and delay on claimants in verifying the existence of coverage and may lead some claimants, who take the insurer's nondisclosure at face value, to forego medical payment reimbursement altogether.
>
> Such conduct, as illustrated in this case, also leads to costly litigation. We therefore hold that a duty of good faith and fair dealing exists from an insurance company to potential medical payments claimants under a policy issued to a party other than the claimant, where liability is not a prerequisite to medical payments coverage.

So, the appeals court concluded that the trial court did not err in allowing such an action to proceed to the jury.

The appeals court rejected Grange's contention that it paid the medical bills without delay when presented with a demand letter in October 1991. It concluded:

> Although Grange did tender within six days full payment of the medical payments coverage, Hammond could hardly have been expected to submit bills earlier than this because she remained unaware of the medical payments coverage.
>
> ...Although the jury was not provided with interrogatories which would permit us to ascertain when the failure to disclose medical payments coverage was deemed to have occurred, the bad faith presumedly dates from, at the latest, [Grange]'s letter of August 13, 1991, denying any obligation..., since this was the last contact prior to Hammond engaging counsel in this case.

The appeals court ruled that, although Grange did tender medical payments limits shortly after Hammond submitted her medical bills, the delay in submission was entirely attributable to Grange's failure to disclose promptly the medical payments coverage.

Supplementary expenses covered by liability insurance

SUPPLEMENTARY PAYMENTS—COVERAGES A AND B
We will pay, with respect to any claim or "suit" we defend:
1. All expenses we incur.
2. Up to $250 for cost of bail bonds required because of accidents or traffic law violations arising out of the use of any vehicle to which the Bodily Injury Liability Coverage applies. We do not have to furnish these bonds.
3. The cost of bonds to release attachments, but only for bond amounts within the applicable limit of insurance. We do not have to furnish these bonds.

Chapter Eight: General Liability and Product Liability

4. All reasonable expenses incurred by the insured at our request to assist us in the investigation or defense of the claim or "suit," including actual loss of earnings up to $100 a day because of time off from work.
5. All costs taxed against the insured in the "suit."
6. Prejudgment interest awarded against the insured on that part of the judgment we pay. If we make an offer to pay the applicable limit of insurance, we will not pay any prejudgment interest based on that period of time after the offer.
7. All interest on the full amount of any judgment that accrues after entry of the judgment and before we have paid, offered to pay, or deposited in court the part of the judgment that is within the applicable limit of insurance.
These payments will not reduce the limits of insurance.

Supplementary payments cover certain expenses and costs in addition to payments made under Coverages A and B and do not reduce the limits of liability. Coverage is included for expenses incurred by the insurance company such as costs of investigating a claim, costs of bail bonds related to traffic laws (while the policy doesn't cover autos directly, mobile equipment might be involved in an accident involving traffic laws), and bonds to release attachment. While the premiums for these bonds will be paid, the insurance company does not have to furnish them.

Reasonable expenses of an insured person, including loss of earnings up to $100 per day, will be reimbursed but only if the expense or time off work is at the request of the insurance company. Costs of a suit which are charged to you, such as court costs, depositions, transcripts, and legal fees, will be paid. Prejudgment interest on the amount of a judgment the insurance company is required to pay, as well as interest accruing after a judgment, will be paid; however, the insurance company will not pay interest on a judgment which accrues after it makes an offer to settle for the policy limits and the offer is rejected.

SECTION II—WHO IS AN INSURED

How the policy defines covered people and companies

1. If you are designated in the Declarations as:
a. An individual, you and your spouse are insureds, but only with respect to the conduct of a business of which you are the sole owner.
b. A partnership or joint venture, you are an insured. Your members, your partners, and their spouses are also insureds, but only with respect to the conduct of your business.
c. An organization other than a partnership or joint venture, you are an insured. Your executive officers and directors are insureds, but only with respect to their duties as your officers or directors. Your stockholders are also insureds, but only with respect to their liability as stockholders.

This section defines specifically the persons or organizations who are

named insureds under the policy in addition to the named insured shown on the declarations. The extension to unnamed insureds depends upon the type of business organization or entity shown in the declarations. If the named insured is an individual, the spouse is also an insured. A partnership or joint venture includes the partners and their spouses as insureds, while a corporation includes officers and directors as insureds with respect to their duties performed for the corporation, and stockholders with respect to their liability that arises as a result of being stockholders.

Coverage for individuals, partners, and joint venturers is limited to their liability arising out of the conduct of the insured business.

> 2. Each of the following is also an insured:
> a. Your employees, other than your executive officers, but only for acts within the scope of their employment by you. However, no employee is an insured for:
> (1) "Bodily injury" or "personal injury" to you or to a co-employee while in the course of his or her employment or the spouse, child, parent, brother or sister of that co-employee as a consequence of such "bodily injury" or "personal injury," or for any obligation to share damages with or repay someone else who must pay damages because of the injury; or
> (2) "Bodily injury" or "personal injury" arising out of his or her providing or failing to provide professional health care services; or
> (3) "Property damage'" to property owned or occupied by or rented or loaned to that employee, any of your other employees, or any of your partners or members (if you are a partnership or joint venture).
> b. Any person (other than your employee) or any organization while acting as your real estate manager.
> c. Any person or organization having proper temporary custody of your property if you die, but only:
> (1) With respect to liability arising out of the maintenance or use of that property; and
> (2) Until your legal representative has been appointed.
> d. Your legal representative if you die, but only with respect to duties as such. That representative will have all your rights and duties under this Coverage Part.

Part 2.a. of the Who Is An Insured section applies to employees other than executive officers (officers are included as insureds under part 1.c.).

Your employees count as insureds under CGL coverage

Employees are insureds with respect to their acts which fall within the scope of their employment.

An example: The secretary to the president of your company, while escorting a visitor to the president's office, accidentally allows a heavy door to close on the visitor's hand. The secretary is insured under this policy for her liability for the injury to the visitor.

However, an employee is not an insured for any injury suffered by a co-worker or any consequential injury suffered by a member of such co-worker's family. Also, an employee is not an insured for any injury arising out of providing or failing to provide professional health care services, or for damage to any property owned or occupied by or rented or loaned to that employee, other employees, or any of your partners or partnership members.

Any person (other than an employee) or organization is an insured while acting as the named insured's real estate manager.

Under parts 2.c. and 2.d., if the named insured dies, any person or organization having custody of your property will be an insured with respect to liability arising out of that property until a legal representative is appointed, and a legal representative will be an insured with respect to performing such duties.

> 3. With respect to "mobile equipment" registered in your name under any motor vehicle registration law any person is an insured while driving such equipment along a public highway with your permission. Any other person or organization responsible for the conduct of such person is also an insured, but only with respect to liability arising out of the operation of the equipment, and only if no other insurance of any kind is available to that person or organization for this liability. However, no person or organization is an insured with respect to:
> a. "Bodily injury" to a co-employee of the person driving the equipment; or
> b. "Property damage" to property owned by, rented to, in the charge of or occupied by you or the employer of any person who is an insured under this provision.

Anyone using your equipment with permission is an insured

Any person driving your mobile equipment on public roads with your permission is an insured while doing so. Any other person or organization responsible for the driver of such mobile equipment will also be an insured with respect to operation of the equipment, but only if no other liability insurance is available to that person or organization for this exposure. However, no other person or organization is an insured with respect to injury to a co-worker of the person driving the mobile equipment, or for damage to property owned by, rented to, in the charge of, or occupied by the named insured or the employer of any person who is an "insured" under this provision.

A caveat: This section may duplicate liability coverage offered by your business auto policy. If you have different insurance companies for these coverages, they may disagree about who's responsible when you make a claim. This may be a good reason to buy a single commercial package instead of several different monoline policies.

INSURING THE BOTTOM LINE

Newly formed or acquired businesses may be covered

4. Any organization you newly acquire or form, other than a partnership or joint venture, and over which you maintain ownership or majority interest, will qualify as a Named Insured if there is no other similar Insurance available to that organization. However:
a. Coverage under this provision is afforded only until the 90th day after you acquire or form the organization or the end of the policy period, whichever is earlier;
b. Coverage A does not apply to "bodily injury", or "property damage" that occurred before you acquired or formed the organization; and
c. Coverage B does not apply to "personal injury" or "advertising injury" arising out of an offense committed before you acquired or formed the organization.
No person or organization is an insured with respect to the conduct of any current or past partnership or joint venture that is not shown as a Named insured in the Declarations.

CGL coverage will automatically be extended to cover newly acquired or formed organizations as "named insureds," if the insured owns or holds a majority interest in such organizations and no other similar insurance covers them. This automatic coverage is provided only for 90 days or until the end of the policy period—whichever is earlier. Coverages A and B will not apply to any injury or damage that occurred, or any offense that was committed, before the organization was acquired or formed.

No person or entity is an insured with respect to any past or present partnerships or joint ventures unless these are shown as named insureds in the declarations.

SECTION III LIMITS OF INSURANCE
1. The Limits of Insurance shown in the Declarations and the rules below fix the most we will pay regardless of the number of:
a. Insureds;
b. Claims-made or "suits" brought; or
c. Persons or organizations making claims or bringing "suits"
2. The General Aggregate Limit is the most we will pay for the sum of:
a. Medical expenses under Coverage C;
b. Damages under Coverage A, except damages because of "bodily injury" or "property damage" included in the "products-completed" operations hazard;" and
c. Damages under Coverage B.
3. The Products-Completed Operations Aggregate Limit is the most we will pay under Coverage A for damages because of "bodily injury" and "property damage" included in the "products completed operations hazard."
4. Subject to 2. above, the Personal and Advertising Injury Limit is the most we will pay under Coverage B for the sum of all damages because of all the "personal injury" and all "advertising injury" sustained by any one person or organization.

Chapter Eight: General Liability and Product Liability

> Limit is the most we will pay for the sum of:
> a. Damages under Coverage A; and
> b. Medical expenses under Coverage C
> because of all "bodily injury" and "property damage" arising out of any one "occurrence."
> 6. Subject to 5. above, the Fire Damage Limit is the most we will pay under Coverage A for damages because of "property damage" to premises rented to you arising out of any one fire.
> 7. Subject to 5. above. The Medical Expense Limit is the most we will pay under Coverage C for all medical expenses because of "bodily injury," sustained by any one person.
> The limits of this Coverage Part apply separately to each consecutive annual period and to any remaining period of less than 12 months, starting with the beginning of the policy period shown in the Declarations, unless the policy period is extended after issuance for an additional period of less than 12 months. In that case, the additional period will be deemed part of the last preceding period for purposes of determining the Limits of Insurance.

These limits apply for a policy year so, if a policy is written for more than one year, the limits are renewed each year. If a policy was issued for a term of 30 months, a new set of limits would apply to the final six months of the policy term. However, if a policy was issued for one year and extended by endorsement for an additional three months, either during the policy term or at expiration, then the extension period would be considered part of the original policy period and be subject to the original set of limits.

Six different sets of limits to CGL insurance

There are six different sets of limits of liability. The primary limits are the general aggregate limit and the products/completed operations aggregate limit. The remaining four limits are sublimits which are subject to either of the primary aggregate limits. These limits are not affected or increased by the number of insureds, the number of claims or suits made, or the number of persons making the claims or bringing the suits.

The general aggregate limit is a critical number. All coverages and sublimits are subject to this overall limit with the single exception of the products/completed operations aggregate limit. This is the total amount that will be paid in the policy year except for products/completed operations coverage.

The products/completed operations aggregate limit is the other major aggregate. It is a separate aggregate and not limited by the general aggregate, but it does have an affect on several of the sublimits.

The sublimit applying to "personal injury" and "advertising liability" is the most that will be paid for all damages claimed by any one person or organization. It is also subject to the general aggregate limit.

The occurrence limit controls the amount that will be paid for bodily injury, property damage, and medical payments arising from a single occurrence. It is also subject to either the general aggregate limit or the products/completed operations aggregate limit depending on which coverage applies to the claim.

The medical expense limit is the most that will be paid to one person for medical expenses arising out of a bodily injury. It is also subject to the occurrence limit and the general aggregate limit.

> **SECTION IV—COMMERCIAL GENERAL LIABILITY CONDITIONS**
> 1. Bankruptcy.
> Bankruptcy or insolvency of the insured or of the insured's estate will not relieve us of our obligations under this Coverage Part.

If you go bankrupt, the insurance company still has to offer coverage

The Bankruptcy condition states clearly that your insolvency or bankruptcy or that of your estate does not relieve the insurance company of its obligation under the policy to pay damages for which you're found liable, to defend any suit against you for such damages, or to investigate any offense or occurrence that might result in a claim.

> 2. Duties In The Event Of Occurrence, Claim Or Suit.
> a. You must see to it that we are notified as soon as practicable of an "occurrence" or offense which may result in a claim. To the extent possible, notice should include:
> (1) How, when and where the "occurrence" or offense took place;
> (2) The names and addresses of any injured 2 persons and witnesses; and
> (3) The nature and location of any injury or damage arising out of the "occurrence" or offense.
> Notice of an "occurrence" is not notice of a claim.
> b. If a claim is received by any insured you must:
> (1) immediately record the specifics of the claim and the date received; and
> (2) Notify us as soon as practicable.
> You must see to it that we receive written notice of the claim as soon as practicable.
> c. You and any other involved insured must:
> (1) Immediately send us copies of any demands, notices, summonses or legal papers received in connection with the claim or a "suit";
> (2) Authorize us to obtain records and other information;
> (3) Cooperate with us in the investigation, settlement or defense of the claim or "suit"; and

Obligations you have to the insurance company

You have certain obligations to the insurance company with respect to claims and occurrences or offenses which "may result in a claim." Under both the claims-made and occurrence coverage forms, when you have knowledge of an occurrence or offense, a complete documentation should be made of what happened, the names and ad-

Chapter Eight: General Liability and Product Liability

dresses of any injured persons and witnesses, and a description of the nature of any injury or damage.

When any other person or organization included under the "Named Insured" designation of the policy reports a claim to you, it is your duty to record and report the pertinent details—including the date you were notified—and advise the insurance company immediately. It is then your duty, as soon as is practicable, to provide the company written notice of the claim.

The statement, "Notice of an occurrence is not notice of a claim," appears only on the claims-made form because the distinction is important—claims-made coverage applies to claims which are actually made during the policy period, and not necessarily to injury or damage that occurs during the policy period. If you terminate coverage, you must file a claim quickly to avoid missing the end of the policy period or other relevant deadlines.

Most of the wording in condition 2.b. is the same on the claims-made and occurrence forms, except that in three places where the claims-made form refers to a "claim" the occurrence form refers to a "claim or suit." You are required to record immediately the specifics of any claim, notify the insurance company as soon as practicable, and then follow up with written notice of the claim.

> (4) Assist us, upon our request, in the enforcement of any right against any person or organization which may be liable to the insured because of injury or damage to which this insurance may also apply.
> d. No insureds will, except at their own cost, voluntarily make a payment, assume any obligation, or incur any expense, other than for first aid, without our consent.

You have to report everything to the insurance company

Under both CGL coverage forms, you must send copies of all legal papers received, authorize the insurance company to obtain information, cooperate in the investigation and defense of the claim, and assist the insurance company in enforcing any right of recovery from another person or organization who may be liable for damages. You are not permitted to make payments voluntarily, assume obligations, or incur expenses (except for first aid at the time of an accident) without the consent of the insurance company.

> 3. Legal Action Against Us.
> No person or organization has a right under this Coverage Part:
> a. To join us as a party or otherwise bring us into a "suit" asking for damages from an insured; or
> b. To sue us on this Coverage Part unless all of its terms have been fully complied with.
> A person or organization may sue us to recover on an agreed settlement or on a final judgment against an insured obtained after an actual trial; but we will not be liable for damages that are not payable under

INSURING THE BOTTOM LINE

the terms of this Coverage Part or that are in excess of the applicable limit of insurance. An agreed settlement means a settlement and release of liability signed by us, the insured and the claimant or the claimant's legal representative.

You can only sue the insurance company in certain situations

These paragraphs limit the ability of anyone—including you—to sue the insurance company for any reason related to settlement of a lawsuit.

An important note: This section states that someone who believes he has been wronged by you can't name your insurance company in any lawsuit he files. This means the insurance company avoids being a party to the suit—at least initially. (The insurance company can be sued if it doesn't pay a settlement of judgment against a policyholder.)

4. Other Insurance.
If other valid and collectible insurance is available to the insured for a loss we cover under Coverages A or B of this Coverage Part, our obligations are limited as follows:
a. Primary Insurance
This insurance is primary except when b. below applies. If this insurance is primary, our obligations are not affected unless any of the other insurance is also primary. Then, we will share with all that other insurance by the method described in c. below.

How excess insurance applies to liability issues

b. Excess Insurance
This insurance is excess over any of the other insurance, whether primary, excess, contingent or on any other basis:
(1) That is effective prior to the beginning of the policy period shown in the Declarations of this insurance and applies to "bodily injury" or "property damage" on other than a claims-made basis, if:
(a) No Retroactive Date is shown in the Declarations of this insurance; or
(b) The other insurance has a policy period which continues after the Retroactive Date shown in the Declarations of this insurance;
(2) That is Fire, Extended Coverage, Builders, Risk, Installation Risk or similar coverage for "your work";
(3) That is Fire insurance for premises rented to you; or
(4) If the loss arises out of the maintenance or use of aircraft, "autos" or watercraft to the extent not subject to Exclusion g. of Coverage A (Section I).
When this insurance is excess, we will have no duty under Coverages A or B to defend any claim or "suit" that any other insurer has a duty to defend. If no other insurer defends, we will undertake to do so, but we will be entitled to the insured's rights against all those other insurers.
When this insurance is excess over other insurance, we will pay only our share of the amount of the loss, if any, that exceeds the sum of:
(1) The total amount that all such other insurance would pay for the loss in the absence of this insurance; and
(2) The total of all deductible and self-insured amounts under all that other insurance.

> We will share the remaining loss, if any, with any other insurance that is not described in this Excess Insurance provision and was not bought specifically to apply in excess of the Limits of Insurance shown in the Declarations of this Coverage Part.

This condition specifies how Coverages A and B apply when other valid insurance is available for the same loss. Paragraph a. states that the coverage will be primary in all cases except when the provisions of the following paragraph specify that it will apply as excess. When coverage is primary, it is usually not affected by other insurance. But if other insurance is also primary, the insurance companies will share the loss.

Claims made coverage is excess over prior occurrence coverage

Claims-made coverage will be excess over any prior "occurrence" coverage if the claims-made coverage has no retroactive date or if the occurrence coverage continues beyond the retroactive date (this shaded provision is found only in the claims-made form). Under both the claims-made and occurrence forms, coverage also applies as excess over (1) any fire insurance for a premises you have rented; any fire and extended coverage, builders risk, or installation risk coverage for your work; and (3) any other insurance covering losses arising out of aircraft, autos or watercraft to the extent that these losses are not excluded under Coverage A.

Example: A business auto policy may serve as primary coverage in the event that you haven't adequately maintained the brakes of covered auto. CGL would serve as excess beyond the business auto policy's limits.

When CGL coverage applies as excess, the insurance company will only pay the amount of a loss that exceeds the sum of all other insurance payments and all deductibles and self-insured amounts under that other insurance. If any other insurance and the CGL coverage both apply as excess, the insurance companies will share the remaining portion of the loss after all primary insurance has been exhausted.

> c. Method of Sharing
> If all of the other insurance permits contribution by equal shares, we will follow this method also. Under this approach each insurer contributes equal amounts until it has paid its applicable limit of insurance or none of the loss remains, whichever comes first.
> If any of the other insurance does not permit contribution by equal shares, we will contribute by limits. Under this method, each insurer's share is based on the ratio of its applicable limit of insurance to the total applicable limits of insurance of all insurers.

Paragraph c. describes the method of sharing when CGL coverage and other insurance apply on the same basis, whether primary or excess. If other insurance permits sharing by equal shares, each in-

surance company will contribute equal dollar amounts until policy limits are exhausted or the loss is fully paid. If other insurance does not permit contribution by equal shares, the insurance companies will share the loss based on limits, and each will contribute to the loss in the proportion that its limit of insurance bears to the total of all applicable limits. This is sometimes called the pro rata liability clause.

An excess vs. primary coverage dispute

The relationship between commercial liability and umbrella liability frequently causes primary-versus-excess coverage disputes among insurance companies. The 1990 federal district court decision *Hartford Accident and Indemnity Co. v. Commercial Union Insurance Co. and Minuteman Press* offers a useful illustration.

Hartford issued an umbrella liability policy to Minuteman Press International. The policy provided, among other things, watercraft liability coverage to Minuteman for all owned and non-owned watercraft.

Massachusetts-based Commercial Union (CU) issued a commercial yacht insurance policy to Minuteman that pertained to a 1982 Striker fifty-foot sport fishing boat. The policy provided commercial liability coverage in the amount of $500,000. Although the policy covered bodily injury to third parties, it contained an exclusion which provided that "[n]otwithstanding anything contained herein to the contrary, it is further understood and agreed that this Company will not pay for any loss, damage, expense, or claim with respect to paid employees of [Minuteman] and paid members of the crew."

Michael Jutt, an employee of Minuteman, was injured while on a fishing expedition aboard the boat. Jutt was on vacation at the time. When he returned from the vacation, Jutt notified Minuteman that he would be filing a claim for personal injury. Minuteman in turn notified its insurance broker, the J. Nicholas Krug Agency.

On the date of the injury, both the Hartford and CU policies were in effect.

After Jutt filed his claim, a marine claims adjuster for CU wrote to the Krug Agency that, since Jutt was an employee of Minuteman, the policy would not cover his injuries. The agency replied that "[i]t is our understanding that the exclusion would not apply to employees on vacation that are on the boat as guests of their employer." He wrote further that "[a]n employee on the boat as a guest would not be able to claim workers compensation benefits."

CU continued to deny coverage and informed Minuteman that, based on the same exclusion, it had no duty to defend or indemnify Minuteman in the suit brought by Jutt.

Hartford, informed of CU's position, informed Minuteman that the umbrella liability policy would provide coverage with respect to the lawsuit—even though the primary carrier was denying coverage. How-

ever, Hartford reserved the right to take actions against CU until a factual investigation could be accomplished.

CU sought a court declaration that it had no liability under the terms and conditions of the yacht policy based on the employee exclusion. That action was later terminated after Minuteman gave a release to CU, which absolved the insurance company of any duty to defend or indemnify Minuteman in the Jutt action.

The Jutt action was eventually settled for the sum of $145,000. Minuteman paid its $10,000 deductible, and Hartford paid the remaining $135,000. Hartford then filed suit against CU, alleging that CU had breached its fiduciary obligation. Hartford sought damages in the amount of the $135,000 paid to Jutt for the settlement as well as $30,000 in legal fees.

Both insurance companies asked the court for summary orders supporting their arguments.

The primary policy was written after the excess policy had been

Hartford argued that CU was a primary carrier according to Hartford's umbrella liability policy and therefore had a duty to defend Minuteman in the suit brought by Jutt. CU argued that it was not a primary carrier under the umbrella policy and, in support of its position, pointed to the failure of Hartford to list the CU policy on the schedule of underlying insurance. Hartford answered that the CU policy was not listed on the schedule because it had been issued after the umbrella policy was written.

The court stepped in to resolve this squabble:

> Assuming that Commercial Union, despite its position to the contrary, can be characterized as the issuer of a primary insurance policy which would have to be exhausted prior to Hartford's coverage being implicated, Hartford appeared to have sufficiently stated a claim....

> Certainly, there was a question of fact regarding the parties' intent as to whether the Commercial Union policy had to be exhausted prior to Hartford's coverage being implicated. The presence of the issue of fact was confirmed by a clause in the Hartford umbrella liability policy which states that the policy is in excess "over any other valid and collectible insurance... available to the insured... whether or not described in the Extension Schedule of Underlying Insurance Policies...." Accordingly, it cannot be said that Commercial Union, as the moving party for summary judgment, adequately met its burden on the issue.

Meanwhile, Hartford was arguing that the exclusion in the CU policy would not apply to an employee aboard the vessel while on vacation. CU countered this by arguing that the exclusion was clear and unambiguous, and that it had no duty to defend or indemnify Minuteman.

The court declined to define the exclusion but—in an unusual move—admitted it might be ambiguous. It wrote:

> ...by way of illustration, a reasonable interpretation of the parties' intentions would support the view that an employee on vacation, and therefore not able to collect workers compensation, should be treated as any other passenger on the boat, thus implicating the Commercial Union policy.

The court concluded that an exclusion "might be" ambiguous

However, it ruled that this definition would have to be resolved in front of a jury. As is so often the case in insurance disputes, CU and Hartford came to a settlement before they had to face a jury. The terms were private—but they implied some concession on CU's part.

> 5. Premium Audit.
> a. We will compute all premiums for this Coverage Part in accordance with our rules and rates.
> b. Premium shown in this Coverage Part as advance premium is a deposit premium only. At the close of each audit period we will compute the earned premium for that period.
> Audit premiums are due and payable on notice to the first Named Insured. If the sum of the advance and audit premiums paid for the policy term is greater than the earned premiums we will return the excess to the first Named Insured.
> c. The first Named Insured must keep records of the information we need for premium computation, and send us copies at such times as we may request.

The insurance company has the right to examine and audit your records to the extent that they relate to the policy. (This right is also extended to rate service organizations.) These records can be in a variety of forms, from ledgers to computer data. The audits, made in regular business hours, can occur during the policy period and for some period after its expiration.

The final audit billing should never be a "surprise" to you, yet audits often develop unexpected additional premiums.

> 6. Representations
> By accepting this policy, you agree:
> a. The statements in the Declarations are accurate and complete;
> b. Those statements are based upon representations you made to us; and
> c. We have issued this policy in reliance upon your representations.

This statement is to affirm that the insurance company has issued the policy in reliance on the information given by you and that the information is accurate and complete to the best of your knowledge. The effect of this condition is questionable as it would usually require a material misrepresentation by you to void coverage.

> 7. Separation Of Insureds.
> Except with respect to the Limits of Insurance, and any rights or duties specifically assigned to the first Named Insured, this insurance applies:
> a. As if each Named Insured were the only Named Insured; and
> b. Separately to each insured against whom claim is made or "suit" is brought.

Except with respect to the limits of insurance, and rights and duties specifically assigned to the "first named insured," CGL coverage applies as if each named insured were the only named insured, and applies separately to each insured against whom a claim is made or a suit is brought.

This means that the insurance company will defend each insured, cover supplementary payments related to a claim against each insured, and extend any other rights under the coverage to each insured. However, this provision does not increase any limits of insurance shown in the declarations.

> 8. Transfer Of Rights Of Recovery Against Others To Us.
> If the insured has rights to recover all or part of any payment we have made under this Coverage Part, those rights are transferred to us. The insured must do nothing after loss to impair them. At our request, the insured will bring "suit" or transfer those rights to us and help us enforce them.

Subrogation—always complicated—can be hard to understand in liability coverage

This is the subrogation clause which transfers your rights against a third party to the insurance company. If the insurance company pays a claim under the policy on your behalf, there may be a third party who can be held responsible. When a claim payment is made by the insurance company, it "inherits" any rights you may have against the responsible third party. You agree to assist the insurance company in recovering, from the third party, any amounts paid on your behalf by the insurance company.

Recoveries, if any, will be distributed in the reverse order from the method in which the claim was assessed. In other words, your deductible—if you've paid one—will be reimbursed after the insurance company has recovered its settlement.

> 9. When We Do Not Renew.
> If we decide not to renew this Coverage Part, we will mail or deliver to the first Named Insured shown in the Declarations written notice of the nonrenewal not less than 30 days before the expiration date.
> If notice is mailed, proof of mailing will be sufficient proof of notice.

The common policy conditions provide for 30 days notice of cancellation (10 days for nonpayment of premium) for all coverage parts of the policy. This condition broadens the obligation of the insurance

company to give 30 days notice of nonrenewal. Note that this additional requirement applies only to the CGL coverage part. Certified mail is sufficient proof that notice of cancellation was received.

> 10. Your Right to Claim and "Occurrence" Information.
> We will provide the first Named Insured shown in the Declarations the following information relating to this and any preceding general liability claims-made Coverage Part we have issued to you during the previous three years:
> a. A list or other record of each "occurrence" not previously reported to any other insurer, of which we were notified in accordance with paragraph 2.a. of this Section. We will include, the date and brief description of the "occurrence" if that information was in the notice we received.
> b. A summary by policy year, of payments made and amounts reserved, stated separately, under any applicable General Aggregate Limit and Products-Completed Operations Aggregate Limit.
> Amounts reserved are based on our judgment. They are subject to change and should not be regarded as ultimate settlement values.
> You must not disclose this information to any claimant or any claimant's representative without our consent.
> If we cancel or elect not to renew this Coverage Part, we will provide such information no later, than 30 days before the date of policy termination. In other circumstances, we will provide this information only if we receive a written request from the first Named Insured within 60 days after the end of the policy period. In this case, we will provide this information within 45 days of receipt of the request.
> We compile claim and "occurrence" information for our own business purposes and exercise reasonable care in doing so. In providing this information to the first Named Insured, we make no representations or warranties to insureds, insurers, or others to whom this information is furnished by or on behalf of any insured. Cancellation or non-renewal will be effective even if we inadvertently provide inaccurate information.

The insurance company has to inform you of cancellation 30 days before the end of a policy period

This condition is found only on the claims-made form. If a claims-made policy is canceled or nonrenewed, either by you or by the insurance company, it is important that any claims or potential claims information be made available in order to replace the coverage with another carrier. A new carrier will want this information to evaluate accurately the risks you present.

If the cancellation or nonrenewal is by the company, the information must be provided to you at least 30 days in advance of the termination date. If the nonrenewal or cancellation is by you, a request in writing must be made by you within 60 days of the termination date, and the company must respond within 45 days after the written request is received by it.

> **SECTION V—EXTENDED REPORTING PERIODS**
> 1. We will provide one or more Extended Reporting Periods, as described below, if:
> a. This Coverage Part is canceled or not renewed; or
> b. We renew or replace this Coverage Part with insurance that:
> (1) Has a Retroactive Date later than the date shown in the Declarations of this Coverage or Part; or
> (2) Does not apply to "bodily injury" "property damage," "personal injury" or "advertising injury" on a claims-made basis.
> 2. Extended Reporting Periods do not extend the policy period or change the scope of coverage provided. They apply only to claims for:
> a. "Bodily injury" or "property damage" that occurs before the end of the policy period but not before the Retroactive Date, if any, shown in the Declarations; or
> b. "Personal injury" or "advertising injury" caused by an offense committed before the end of the policy period but not before the Retroactive Date, if any, shown in the Declarations.
> Once in effect, Extended Reporting Periods may not be canceled.

How a claims-made "trigger" works

Under the claims-made form, the "trigger" for coverage is when a claim is made to the insurance company. For some losses, a considerable gap may exist between the time when injury or damage occurs and when the claim is first made. In some cases, there may even be a gap between when an injury occurs and when it is discovered or first becomes known to you. This potential gap is known as a "claims tail"—it may take a period of years for all losses arising out of a given exposure to be realized.

Example: A slip and fall that occurs on your property may cause a back injury that takes some time to manifest itself. In this case, it is not until the back injury is reported that a determination of coverage will be made. ERPs allow you to obtain coverage long after the policy period has ended—and that's useful in situations like these.

If claims-made coverage is continuously renewed without advancing the retroactive date, future claims will be covered regardless of when the injury or damage actually occurred. But if the continuity of claims-made coverage is disturbed by cancellation, nonrenewal, or replacement by a policy with a later retroactive date, a gap in coverage is created. This gap may be filled by an ERP, which provides "tail coverage."

Under an ERP, the insurance company agrees to provide one or more extended reporting periods if claims-made coverage is (1) canceled, (2) not renewed, (3) replaced by coverage that has a later retroactive date, or (4) replaced by coverage that is not written on a claims-made basis. Extended reporting periods do not extend the policy period. An ERP simply extends the period for reporting claims—the injury or damage must still have occurred, or the offense causing injury must still have been committed, before the end of the policy period. An

important feature of extended reporting periods is that once in effect, an ERP may not be canceled.

> 3. A Basic Extended Reporting Period is automatically provided without additional charge. This period starts with the end of the policy period and lasts for:
> a. Five years for claims because of "bodily injury," and "property damage" arising out of an "occurrences reported to us, not later than 60 days after the end of the policy period, in accordance with paragraph 2.a. of Commercial General Liability Conditions (Section IV);
> b. Five years because of claims for "personal injury" and "advertising injury" arising out of an offense reported to us, not later than 60 days after the end of the policy period, in accordance with paragraph 2.a. of Commercial General Liability Conditions (Section IV); or
> c. Sixty days for all other claims.
> The Basic Extended Reporting Period does not apply to claims that are covered under any subsequent insurance you purchase, or that would be covered but for exhaustion of the amount of insurance applicable to such claims.

A possible gap in liability coverage

A basic ERP is provided automatically without charge in any of the situations mentioned previously which might create a gap in coverage. It has two parts: a period of 60 days after the end of the policy period is provided for reporting any claims (whether or not the "occurrence" or "offense" was previously reported); and a period of five years after the end of the policy period is provided for reporting any claims for which the "occurrence" or "offense" has been reported to the insurance company no later than 60 days after the end of the policy period. This means that you have a long time to file a formal claim—as long as you have notified the insurance company within 60 days that something has happened.

The basic extended reporting period does not apply to any claims which are covered by any subsequent insurance purchased by you, or which would have been covered except for the exhaustion of policy limits.

> 4. A Supplemental Extended Reporting Period of unlimited duration is available, but only by an endorsement and for an extra charge. This supplemental period starts when the Basic Extended Reporting Period, set forth in paragraph 3. above, ends.
> You must give us a written request for the endorsement within 60 days after the end of the policy period. The Supplemental Extended Reporting Period will not go into effect unless you pay the additional premium promptly when due.
> We will determine additional premium in accordance with our rules and rates. In doing so, we may take into account the following:
> a. The exposures insured;
> b. Previous types and amounts of insurance;

c. Limits of Insurance available under this Coverage Part for future payment of damages; and
d. Other related factors.

The additional premium will not exceed 200% of the annual premium for this Coverage Part.

This endorsement shall set forth the terms, not inconsistent with this Section, applicable to the Supplemental Extended Reporting Period, including a provision to the effect that the insurance afforded for claims first received during such period is excess over any other valid and collectible insurance available under policies in force after the Supplemental Extended Reporting Period starts.

Extended ERPs cost more money

The basic ERP does not provide complete protection for an insured. If an occurrence which could lead to a claim first becomes known to you more than 60 days after the end of the policy period, it could not be reported to the insurance company within the required time period, and there would be no coverage under the basic ERP. If an occurrence is known to you and is reported to the insurance company during the policy period or within 60 days after expiration, but the claim is first made more than five years after the expiration date, there would be no coverage under the basic ERP.

Limits of insurance are not reinstated or increased

A supplemental ERP of unlimited duration is available for an additional charge. When purchased, the supplemental extended reporting period picks up where the basic ERP leaves off—it would cover claims arising out of an occurrence first reported more than 60 days after expiration, and it would cover claims-made more than five years after expiration. In some ways, this converts the policy into an occurrence policy. It gives you an unlimited time to report—and the insurance company will make you pay more for that privilege.

The supplemental ERP must be requested by you in writing within 60 days after expiration. The additional premium for this coverage cannot exceed 200 percent of the last annual premium charged for the claims-made CGL coverage. Supplemental ERP coverage is put into effect by attaching an endorsement to the policy, and it will be excess over any other coverage in effect after the supplemental extended reporting period starts.

5. The Basic Extended Reporting Period does not reinstate or increase the Limits of Insurance.
6. If the Supplemental Extended Reporting Period is in effect, we will provide the separate aggregate limits of insurance described below, but only for claims first received and recorded during the Supplemental Extended Reporting Period.

The separate aggregate limits of insurance will be equal to the dollar amount shown in the Declarations in effect at the end of the policy period for such of the following limits of insurance for which a dollar amount has been entered:
General Aggregate Limit

> Products-Completed Operations Aggregate Limit
>
> Paragraphs 2. and 3. of Limits of Insurance; (Section III) will be amended accordingly. The Personal and Advertising Injury Limit, the Each Occurrence Limit and the Fire Damage Limit" shown in the Declarations will then continue to apply, as set forth in paragraphs 4., 5. and 6. of that Section.

The basic ERP is treated as an extension of the original policy, and does not change or reinstate any limits of insurance—if any part of the aggregate limits has been used up, coverage is limited to the unused portion of those limits. Under the supplemental ERP, the two aggregate limits are reinstated in full, and the sublimits (for each occurrence, personal or advertising injury claims, and fire damage) continue to apply as they did during the policy period.

> **SECTION VI—DEFINITIONS**
>
> 1. "Advertising injury" means injury arising out of one or more of the following offenses:
>
> a. Oral or written publication of material that slanders or libels a person or organization or disparages a person's or organization's goods, products or services;
>
> b. Oral or written publication of material that violates a person's right of privacy;
>
> c. Misappropriation of advertising ideas or style of doing business; or
>
> d. Infringement of copyright, title or slogan.

Definitions control contract language

Definitions clarify the meaning of a word or group of words. As you may have noticed from earlier cases, settlement of claims may hinge on nuances in these policy definitions. In addition to telling us specifically what something is, definitions also frequently tell us what something is not. In this sense, a definition serves to limit a meaning as well as to define it.

Definitions that appear in insurance policies are important because each policy is a legal contract, and definitions are part of the contract language. Terms that have specific definitions appear in quotation marks throughout the CGL coverage forms. It is important to keep this in mind when examining insuring agreements, exclusions and conditions, because the definitions may broaden coverage in some areas and limit coverage in others.

The definitions that appear in the CGL coverage forms are exactly the same on the "occurrence" and "claims-made" forms. However, they appear as Section V of the occurrence form and as Section VI of the claims-made form because of the additional section for extended reporting periods.

The first definition deals with the acts which come within the coverage of "advertising injury." Coverage B of the CGL policy describes the coverage for these acts and the kinds of advertising injuries that are excluded.

Chapter Eight: General Liability and Product Liability

> 2. "Auto" means a land motor vehicle, trailer or semitrailer designed for travel on public roads, including any attached machinery or equipment. But "auto" does not include "mobile equipment."

This definition is important because CGL coverage forms exclude almost all losses arising out of automobile exposures (an exception is made for parking nonowned autos on your premises). Notice that "auto" does not include "mobile equipment"—these terms are mutually exclusive, because losses arising out of the operation or use of mobile equipment are covered.

> 3. "Bodily injury" means bodily injury, sickness or disease sustained by a person, including death resulting from any of these at any time.

"Bodily injury" can be an important term

The definition of "bodily injury" includes sickness or disease and death resulting from the bodily injury. Under the occurrence form, if death results at a later date as a result of a bodily injury, the policy covering the death would be the one in effect at the time of the injury. If coverage applies under the claims-made form, the policy in force at the time the claim is made to the insurance company provides coverage.

> 4. "Coverage territory" means:
> a. The United States of America (including its territories and possessions), Puerto Rico and Canada;
> b. International waters or airspace, provided the injury or damage does not occur in the course of travel or transportation to or from any place not included in a. above; or
> c. All parts of the world if:
> (1) The injury or damage arises out of:
> (a) Goods or products made or sold by you in the territory described in a. above; or
> (b) The activities of a person whose home is in the territory described in a. above, but is away for a short time on your business; and
> (2) The insured's responsibility to pay damages is determined in a "suit" on the merits, in the territory described in a. above or in a settlement we agree to.

The land territories covered by the policy include the air space and international waters between them but do not include travel to or from other countries which are not covered territories. Injury caused by goods or products that are sold or made in the covered territories are covered in other parts of the world, but the suit for the injury must be brought in a covered territory. Note that coverage only applies for products and not for completed operations. Incidental activities of an employee traveling on the business of an employer are covered worldwide if the employee's home is in the covered territory.

Example: While traveling on business, you go to a shopping mall and

accidently bump someone down a flight of stairs. Any damages resulting from the accident would be covered.

Impaired property can apply to a number of situations

> 5. "Impaired property" means tangible property, other than "your product" or "your work," that cannot be used or is less useful because:
> a. It incorporates "your product" or "your work" that is known or thought to be defective, deficient, inadequate or dangerous; or
> b. You have failed to fulfill the terms of a contract or agreement;
> if such property can be restored to use by:
> a. The repair, replacement, adjustment or removal of "your product" or "your work;" or
> b. Your fulfilling the terms of the contract or agreement.

This definition relates to the "impaired property exclusion." It clarifies the meaning of "impaired property" by stating that "impaired property" is property which is rendered useless or less useful because of some defect or deficiency in your product or your failure to complete a contract. "Impaired property" must be undamaged and capable of being restored to use, or put to its intended use by repair or replacement of your product or by you completing the contract.

> 6. "Insured contract" means:
> a. A lease of premises;
> b. A sidetrack agreement;
> c. Any easement or license agreement, except in connection with construction or demolition operation on or within 50 feet of a railroad;
> d. An obligation, as required by ordinance, to indemnify a municipality, except in connection with work for a municipality;
> e. An elevator maintenance agreement;

Defining an "insured contract" under CGL coverage

This is an important definition because it defines what is and is not an "insured contract." Although Coverage A has a contractual liability exclusion, it makes an exception for liability that would have existed anyway in the absence of an agreement, and an exception for "insured contracts." Since the definition includes many of the most common types of contracts under which liability is assumed, the CGL forms actually do provide a rather broad degree of contractual liability coverage.

Common types of contracts which are covered include a lease of premises, a sidetrack agreement (manufacturers and suppliers of goods or materials frequently take responsibility for use of a railroad sidetrack which connects their premises with a rail line), and an elevator maintenance agreement.

Certain easement and license agreements are covered, but an exception is made for construction or demolition operations within 50 feet of a railroad. This is potentially a very hazardous exposure, because of complicated ownership issues (the federal government owns many rail lines) and the potential for causing a disasterous derailment.

f. That part of any other contract or agreement pertaining to your business (including an indemnification of a municipality in connection with work performed for a municipality) under which you assume the tort liability of another party to pay for "bodily injury" or "property damage" to a third person or organization. Tort liability means a liability that would be imposed by law in the absence of any contract or agreement.

An "insured contract" does not include that part of any contract or agreement:

a. That indemnifies any person or organization for "bodily injury" or "property damage" arising out of construction or demolition operations, within 50 feet of any railroad property and affecting any railroad bridge or trestle, tracks, road beds, tunnel, underpass or crossing;

b. That indemnifies an architect, engineer or surveyor for injury or damage arising out of:

(1) Preparing, approving or failing to prepare or approve maps, drawings, opinions, reports, surveys, change orders, designs or specifications; or

(2) Giving directions or instructions, or failing to give them, if that is the primary cause of the injury or damage;

c. Under which the insured, if an architect, engineer or surveyor, assumes liability for an injury or damage arising out of the insured's rendering or failure to render professional services, including those listed in b. above and supervisory, inspection or engineering services; or

d. That indemnifies any person or organization for damage by fire to premises rented or loaned to you.

Insuring any contract or agreement relating to the business

The broadest category of insured contracts is reflected by part 6.f.—it includes any other contract or agreement pertaining to your business under which the tort liability of another party is assumed. Because this is so broad, the remaining portions of the definition limit coverage by describing particular types of contracts or agreements that are not insured contracts. There is no coverage for an agreement to indemnify any party for construction or demolition operations within 50 feet of a railroad affecting bridges, tunnels or road beds. There is no coverage for an agreement to indemnify an architect, engineer or surveyor for providing or failing to provide professional services or giving or failing to give instructions.

If you are an architect, engineer or surveyor, there is no coverage for an agreement under which you assume liability for your rendering or failing to render professional services. All of these exposures are particularly hazardous and you or other party performing the operations or services should make separate arrangements for specialized insurance coverage.

The last paragraph states that any agreement to indemnify another for fire damage to a premises rented to or used by you is not an "insured contract." However, as mentioned earlier, general liability insurance does include fire legal liability coverage (subject to the fire damage limit) if you are negligent or responsible for the damage (but

it will not cover an obligation to pay fire damages assumed under contract when negligence is not involved).

> 7. "Loading or unloading" means the handling of property;
> a. After it is moved from the place where it is accepted for movement into or onto an aircraft water craft or "auto";
> b. While it is in or on an aircraft, watercraft or "auto", or
> c. While it is being moved from an aircraft, water craft or "auto" to the place where it is finally delivered;
> but "loading or unloading" does not include the movement of property by means of a mechanical device, other than a hand truck, that is not attached to the aircraft, water craft or "auto."

Liabilities posed by loading and unloading property

"Loading or unloading" is defined because it is included as part of the use and operation of autos, watercraft or aircraft, and this exposure is excluded under general liability coverage. This definition is necessary to clarify where CGL coverage ends and other coverages (especially coverage for automobiles) begin. At one time, the wording of policy provisions left some confusion as to whether auto liability or general liability insurance provided coverage for loading and unloading.

Today, consistent use of the same definitions in both types of policies has eliminated that problem. Automobile insurance covers the loading and unloading of vehicles; general liability insurance does not cover loading and unloading of vehicles. In order to determine which coverage applies to a particular exposure, all that remains is to determine when loading and unloading begins and ends.

Loading or unloading begins as soon as property is accepted for movement into or onto an auto (or aircraft or watercraft), continues while the property remains in or on the auto, and ends when it is removed from the auto to the place where it is finally delivered.

Example: Ajax Industries has its employees stack boxes of parts on its loading dock for pickup by Wilson Shipping Company. The delivery truck arrives, backs up to the loading dock, and Wilson employees pick up the boxes and carry them onto the truck. As soon as the Wilson employees begin handling the boxes, Ajax's CGL exposure ends and Wilson's automobile liability insurance applies to the exposure of loading the boxes.

However, "loading or unloading" does not include movement by a mechanical device (other than a hand truck) that is not attached to the vehicle. If Ajax's forklifts were used to load the boxes on the truck, Ajax's CGL exposure would continue until the boxes were on the truck. But if hand trucks are used or the boxes are raised by a mechanical lift attached to the truck, Wilson's auto liability exposure begins as soon as the first box is moved. These distinctions are important in cases where an accident occurs during the process of loading or unloading.

"Auto" and "mobile equipment" are mutually exclusive terms

8. "Mobile equipment" means any of the following types of land vehicles, including any attached machinery or equipment:
a. Bulldozers, farm machinery, forklifts and other vehicles designed for use principally off public roads;
b. Vehicles maintained for use solely on or next to premises you own or rent;
c. Vehicles that travel on crawler treads;
d. Vehicles, whether self-propelled or not, maintained primarily to provide mobility to permanently mounted:
(1) Power Cranes, shovels, loaders, diggers or drills; or
(2) Road construction or resurfacing equipment such as graders, scrapers or rollers;
e. Vehicles not described in a., b., c. or d. above that are not self-propelled and are maintained primarily to provide mobility to permanently attached equipment of the following types:
(1) Air compressors, pumps and generators, including spraying, welding, building cleaning, geophysical exploration, lighting and well servicing equipment; or
(2) Cherry pickers and similar devices used to raise or lower workers,
f. Vehicles not described in a., b., c. or d. above maintained primarily for purposes other than the transportation of persons or cargo.

As mentioned earlier, the definitions of "auto" and "mobile equipment" are mutually exclusive. "Autos" are intended to be covered by automobile insurance, while "mobile equipment" is covered by general liability insurance.

Parts a. through f. describe the many types of mobile equipment which are covered. Generally, these are land vehicles, designed for use principally off public roads, such as bulldozers, forklifts, and construction equipment. Vehicles designed to provide mobility to permanently mounted cranes, shovels, loaders, differs, drills, graders, rollers, compressors, pumps, generators, cherry pickers, and other types of equipment are included in this definition. In some cases, these vehicles may not be self-propelled. The last part of this definition (paragraph f.) says that mobile equipment also includes other vehicles not described, which are maintained primarily for purposes "other than" the transportation of persons or cargo (basically this means vehicles other than typical cars and trucks).

Liabilities arising from "self-propelled vehicles"

Certain self-propelled vehicles with permanently attached equipment are treated as "autos" and not mobile equipment. Snow plows, road maintenance and street cleaning vehicles are "autos" because they operate and perform their special functions on public roads, and the exposure is covered by auto insurance. Self-propelled vehicles with permanently mounted cherry pickers, compressors, pumps, generators, spraying, welding, and other equipment are also treated as "autos" with respect to their automobile liability exposure while being driven on public roads.

> However, self-propelled vehicles with the following types of permanently attached equipment are not "mobile equipment" but will be considered "autos"
> (1) Equipment designed primarily for:
> (a) Snow removal;
> (b) Road maintenance, but not construction or resurfacing;
> (c) Street cleaning;
> (2) Cherry pickers and similar devices mounted on automobile or truck chassis and used to raise or lower workers; and
> (3) Air compressors, pumps and generators, including spraying, welding, building cleaning, geophysical exploration, lighting and well servicing equipment.

Liability arising out of the actual use of this specialized equipment is covered by general liability insurance and is not covered by automobile insurance. The CGL exclusion for the use of autos does not apply to liability arising out of the use of the mobile equipment defined in paragraphs f.(2) and f.(3), so this is covered.

The business auto form covers the automobile liability exposure of this equipment, but specifically excludes liability arising out of the actual operation of the equipment. The point to remember: If the mobile equipment is being driven on a public road, it is covered under business auto insurance.

> 9. "Occurrence" means an accident, including continuous or repeated exposure to substantially the same general harmful conditions.

All accidents are occurrences—but "occurrence" can mean a lot more

An accident is an occurrence, but "occurrence" also means continuous or repeated exposure to the same harmful conditions. Example: Repeated vibrations from operation of your bulldozer cause cracks in the walls of a nearby building, eventually leading to collapse of part of the building. This property damage qualifies as an occurrence, and all such damage would result from one occurrence even if the vibrations contributing to the loss took place over a period of days or weeks.

While the two CGL coverage forms are known as the "claims-made" and "occurrence" forms, both forms cover occurrences. The insuring agreements of both forms say that injury or damage must be caused by an occurrence that takes place in the coverage territory. The greatest difference between the two forms is that the "trigger" of coverage may determine which policy period will apply to a particular claim.

> 10. "Personal injury" means injury, other than "bodily injury," arising out of one or more of the following offenses:
> a. False arrest, detention or imprisonment;
> b. Malicious prosecution;
> c. The wrongful eviction from, wrongful entry into, or invasion of the right of private occupancy of a room, dwelling or premises that a per-

son occupies by or on behalf of its owner, landlord or lessor.
d. Oral or written publication of material that slanders or libels a person or organization or disparages a person's or organization's goods, products or services; or
e. Oral or written publication of material that violates a person's right of privacy.

Personal injury under a CGL policy

The definition of "personal injury" starts out by saying that it does not include bodily injury, so Coverage B is separated from Coverage A. It specifically states the forms of personal injury that are covered, and the offenses listed within the definition of "personal injury" have specific legal meanings, so the coverage would be interpreted from these legal meanings. There are other kinds of offenses which could result in personal injury, but if the injury doesn't arise out of one of the listed items, the intent of the policy is not to provide coverage.

11.a. "Products-completed operations hazard" includes all "bodily injury" and "property damage" occurring away from premises you own or rent and arising out of "your product" or "your work" except:
(1) Products that are still in your physical possession; or
(2) Work that has not yet been completed or abandoned.
b. "Your work" will be deemed completed at the earliest of the following times
(1) When all of the work called for in your contract has been completed.
(2) When all of the work to be done at the site has been completed if your contract calls for work at more than one site.
(3) When that part of the work done at a job site had been put to its intended use by any person or organization other than another contractor or subcontractor working on the same project.
Work that may need service, maintenance correction, repair or replacement, but which is otherwise complete, will be treated as completed.
c. This hazard does not include "bodily injury" or "property damage" arising out of:
(1) The transportation of property, unless the injury or damage arises out of a condition in or on a vehicle created by the loading or unloading of it;
(2) The existence of tools, uninstalled equipment or abandoned or unused materials;
(3) Products or operations for which the classification in this Coverage Part or in our manual of rules includes products or completed operations.

Defining "products" and "completed operations"

Products and completed operations are defined here, and although they are related for coverage purposes, they need to be treated separately. A product is sold by a manufacturer, wholesaler or retailer, or some other entity in the merchandising chain. Coverage for products liability does not begin until you have physically relinquished possession of the item to another, and once this occurs, there is coverage

for products liability. This coverage can travel back through the distribution chain all the way to the manufacturer so that a customer may make a claim against everybody involved in distribution of the product.

For example, a customer in a furniture store sits on a chair to see if it is comfortable, and the chair collapses injuring the customer. The customer's claims for injuries would fall under the store's premises liability and not products liability, since the chair had not been sold and possession of it relinquished to the customer. If a suit involved both the store and the manufacturer, coverage for the manufacturer would fall under its products liability since possession of the chair had been relinquished to the store.

Completed operations coverage involves work being done or a service being performed, such as a repair or maintenance. While the work is being performed, coverage is provided by the premises/operations part of the liability policy. When the work is completed, coverage applies under completed operations. It is necessary to define when work is completed in order to determine which coverage will respond to a claim, and this definition sets forth the criteria for determining when work is completed.

The definition also includes circumstances which would not be included as part of the products/completed operations hazard.

> 12. "Property damage" means:
> a. Physical Injury to tangible property, including all resulting loss of use of that property. All such loss of use shall be deemed to occur at the time of the physical injury that caused it; or
> b. Loss of use of tangible property that is not physically injured. All such loss of use shall be deemed to occur at the time of the "occurrence" that caused it.

Coverage for damage to tangible property

The definition of property damage makes it clear that coverage is for damage to tangible property and includes loss of use of the damaged property. Furthermore, it also covers loss of use of tangible property that is not damaged.

For example, a painting contractor is painting a gift shop in a multiple occupancy mini-mall and due to careless handling of materials causes an explosion and fire which not only damages the gift shop, but damages the plumbing and electrical systems for the entire building. The property damage and loss of use (i.e., loss of business) to the gift shop would be covered. The remaining businesses in the mini-mall were not damaged but were not able to operate until the plumbing and electrical systems were repaired. Their loss of business would also be covered as property damage. All loss of use is deemed to have occurred at the time of the original property damage.

> 13. "Suit" means a civil proceeding in which damage because of "bodily injury," "property damage," "personal injury" or "advertising injury" to which this insurance applies are alleged. "Suit" includes:
> a. An arbitration proceeding in which such damages are claimed and to which you must submit or do submit with our consent; or
> b. Any other alternative dispute resolution proceeding in which such damages are claimed and to which you submit with our consent.

The word "suit" was not defined in early general liability forms, and then was initially defined to include any arbitration proceeding. This newer definition adds "Any other alternative dispute resolution proceeding . . . " as long as the insurance company agrees to it. This addition to the definition would include newer forms of dispute resolution, such as "rent-a judge" agreements or proceedings which may be less formal than court trials or arbitration.

> 14. "Your product" means:
> a. Any goods or products, other than real property, manufactured, sold, handled, distributed or disposed of by:
> (1) You;
> (2) Others trading under your name; or
> (3) A person or organization whose business or assets you have acquired; and
> b. Containers (other than vehicles), materials, parts or equipment furnished in connection with such goods or products.
> "Your product" includes:
> a. Warranties or representations made at any time with respect to the fitness, quality, durability, performance or use of "your product"; and
> b. The providing of or failure to provide warnings or instructions.
> "Your product" does not include vending machines or other property rented to or located for, the use of others but not sold.

Defining "products" in the context of liability risks

Products are goods manufactured, sold, handled, or distributed by you or others trading under your name; or the products of any newly acquired organization. Real property is excluded from the definition; therefore, "products" refers to personal property only. The exclusion of real property also makes it definite that completed buildings or other structures considered part of realty are to be covered as "your work" and not "your product." Included as part of the product are the containers associated with the product, as well as any warranties or representations with respect to it.

Failure to provide warnings or instructions has been added to the definition of products, because in the past some courts have held that the omission of warnings or instructions was covered under premises/operations.

Vending machines are not covered as products, even though you have relinquished possession of them, because their ownership is retained by you and should be covered as premises/operations exposures.

Leasing of machines such as copiers, computer equipment, telephone systems, and even heavy industrial equipment is common today, and these items should be covered under premises/operations as existence hazards.

"Your work" defines differences between product liability and operations liability

> 15. "Your work" means:
> a. Work or operations performed by you or o, your behalf; and
> b. Materials, parts or equipment furnished in connection with such work or operations.
> "Your work" includes:
> a. Warranties or representations made at any time with respect to the fitness, quality, durability, performance or use of "your work"; and
> b. The providing of or failure to provide warnings or instructions.

The definition of "your work" clarifies the differences between products liability and completed operations liability. "Your work" refers to completed operations. Included in the definition are materials, parts, or equipment used for the work, as well as warranties, representations, and providing or failing to provide warnings or instructions.

Endorsements

As mentioned at the beginning of this chapter, CGL forms are very flexible in the sense that endorsements may be used to remove a number of major coverages (such as products and completed operations, personal injury and advertising injury, medical payments and fire legal liability), and endorsements and other coverage forms may be used to add some important coverages (such as liquor liability and pollution liability). Yet a significant number of additional endorsements are available to tailor the coverage in more subtle ways—by imposing deductibles, adding coverage for additional interests, excluding specific exposures, and amending coverages and limits of insurance. Adding endorsements will result in higher premiums, while adding exclusions will result in lower premiums.

Endorsements can serve a number of purposes

Endorsements may be added to general liability coverage for a variety of reasons. Amendatory endorsements are required whenever provisions of printed policies have been changed by more recent filings, and whenever policy provisions are inconsistent with state laws or regulations. An insured may voluntarily request endorsements that add or reduce coverage in order to meet the actual insurance needs of the business. In some cases, insurance underwriters require certain endorsements as a condition of accepting the risk.

Nuclear energy liability exclusion endorsement

This endorsement must be part of every general liability coverage part. It excludes coverage for bodily injury, property damage, and medical payments resulting from the hazardous properties of nuclear material related to the operations of any nuclear facility. Anyone who owns,

operates, supplies or services a nuclear facility, or who handles, transports, or disposes of nuclear waste material may apply for special coverages written by nuclear risk insurance companies.

Nuclear energy liability policies are written by the Nuclear Energy Liability Insurance Association, the Mutual Atomic Energy Liability Underwriters, and the Nuclear Insurance Association of Canada. The broad form exclusion attached to every CGL form states that there is no coverage for any insured who is also an insured under a policy issued by one of the nuclear risk insurance companies. It also excludes nuclear liability coverage with respect to any person who is required to maintain financial protection under the Atomic Energy Act of 1954, or who is entitled to indemnity from the United States of America or any of its agencies under an agreement involving nuclear materials.

Laser beam exclusion endorsement

An endorsement to the claims-made form permits the insurance company to exclude coverage for specific accidents, products, work or locations. Because the endorsement allows the insurance company to zero in with a sharp focus to eliminate a specific exposure, it has been nicknamed the "laser beam" endorsement.

The laser beam has a number of purposes. It may be used to remove an exposure so extreme that the insurance company would not otherwise be willing to write the risk. When replacing "occurrence" coverage with "claims-made" coverage, an insurance company may wish to use the laser beam exclusion of a previous accident instead of a retroactive date—it would dump all claims from that accident back on the occurrence policy, and not affect claims-made coverage for other occurrences.

The "laser beam" endorsement allows the insurance company to restrict coverage terms

The most common use of the exclusion is likely to be at renewal of claims-made coverage after you have had a serious accident or known occurrence. If insurance limits are inadequate for expected claims (which may come in future years), you might request higher limits at renewal—in effect, attempting to buy more protection after the loss has occurred. The laser beam endorsement allows the insurance company to "lock in" the current insurance limits for known exposures and occurrences. Higher policy limits in the future would only apply to future exposures or unknown occurrences.

When written, the laser beam endorsement allows the insurance company to schedule the accident(s), product(s), work or location(s) to be excluded. There are two key provisions of the endorsement. The first part simply states that "Section I Coverage A" does not apply to any of the exposures described in the schedule. The second part says that if the policy is a renewal of claims-made coverage issued by the same insurance company, and if the previous claims-made coverage applied to BI or PD arising out of the described exposure, the insur-

ance company will provide an extended reporting period for the excluded exposure. Endorsements are used to provide the basic and, if desired, a supplemental extended reporting period, which will apply only to the exposure being excluded on renewal.

Deductible liability insurance

Using separate deductibles to lower premiums

This endorsement may be used to establish separate deductible amounts for bodily injury liability and property damage liability, or to establish a single deductible amount for BI and PD combined. When attached to a policy, the insurance company's obligation to pay on behalf of you applies only to the amount of damages in excess of the deductibles shown in the schedule, and the limits of insurance applicable to the coverages will be reduced by the amount of the deductibles.

In either case, the deductibles may be scheduled on a "per claim" or a "per occurrence" basis. If the deductibles apply per claim, the deductibles shown apply to all damages sustained by any one person or organization as the result of any one occurrence. If the deductibles apply per occurrence, the deductibles shown apply to all damages sustained as the result of any one occurrence regardless of the number of persons or organizations who sustain damages.

Additional insureds or vendors

Various endorsements may be used to attach coverage for other entities or interests who may be held liable for acting on behalf or, in the name of, or for having some business relationship with the named insured.

Example: Coverage may be added for club members for their liability for activities of the named insured, or their activities performed on behalf of the club.

Endorsements may be used to add as additional insureds concessionaires who are trading under your name, for the managers or lessors of premises which are leased to you, and for vendors with respect to injury or damages which arise out of your products which are shown in the schedule and are sold or distributed by such vendors.

Numerous other endorsements may be used to add coverage for individual condominium unit owners of an insured condominium, any party who owns or controls premises leased or occupied by you, volunteer workers who act at your direction, co-owners of leased premises, lessors of leased equipment which you lease or use, or specifically designated persons or organizations with respect to their liability which may arise out of your premises or operations.

A variety of endorsements exist to cover situations under which additional interests might have a liability exposure arising out of or some how related to the activities of the named insured.

Using endorsements to drop coverage—or add to existing coverage

Exclusionary and special risk endorsements

Endorsements that may be used to remove all coverage for the products-completed operations subline, or all personal and advertising injury coverage, or all medical payments coverage. But lesser endorsements exist to eliminate just portions of the coverages. For example, an endorsement may be used to retain products liability coverage while eliminating coverage for designated products, and another may be used to retain completed operations coverage while eliminating coverage for designated work. For specified operations, another endorsement may be used to exclude coverage for the explosion, collapse and underground property damage hazard (this is often referred to as XCU in the insurance business). Endorsements may also be used to eliminate all coverage in connection with a designated premises, or to exclude bodily injury coverage for any participants in athletic or sports events which you sponsor.

Amendments to coverages or limits

Some coverages may be expanded by using endorsements to delete or modify certain policy exclusions. As noted earlier, limited pollution coverage may be provided by attaching an endorsement that removes part of the pollution exclusion. Another endorsement may be attached which expands liquor liability coverage by completely removing the standard liquor liability exclusion (it simply states that Exclusion c. of Coverage A, Section I does not apply). Such an endorsement would be purchased by a bar or liquor store.

An endorsement may be used to amend the contractual liability exclusion for personal injury. Various other endorsements may be used to modify coverages and exclusions.

A number of amendment of limits endorsements are used to change the coverage amount for the remainder of the policy period or for specific projects, premises or locations. The standard amendment of limits endorsement may be used to revise the policy limits—it contains a schedule which simply replaces the limits shown in the declarations. A variation of the endorsement may be used to amend limits for a designated project or premises only. Separate endorsements are also available to amend aggregate limits so that the policy's general aggregate will apply on a "per project" or "per location" basis, rather than to your entire operations.

Other coverage forms

Separate forms are also available for exposures which are not covered by CGL forms. A CGL form excludes nearly all pollution coverage, and does not include liquor liability coverage for insureds who manufacture, sell, distribute, serve or furnish alcoholic beverages. Both exclusions may be endorsed to narrow or broaden coverage, or separate pollution and liquor liability coverage forms may be issued.

INSURING THE BOTTOM LINE

The mother of all liability problems: pollution

Pollution liability coverage

Commercial general liability forms exclude virtually all pollution originating from your premises or operations, and from the handling, treatment or disposal of waste materials. Clean-up costs are also excluded. The only pollution exposure covered by CGL forms falls within products-completed operations—liability for emissions is covered only away from your premises and work sites, and only when resulting from use by others of your finished work or products.

Not all insurance companies are willing to write pollution coverage. In the tight pollution insurance marketplace, the premiums are likely to be high and the risk will be carefully underwritten, because of the special nature of the exposure. To the extent that pollution risks are written, an insured has the following options for purchasing coverage under the commercial lines program:

- pollution liability extension endorsement,
- limited pollution liability extension endorsement,
- total pollution exclusion endorsement,
- pollution liability coverage form, and
- limited pollution liability coverage form.

Pollution liability extension coverage endorsement

This endorsement may be attached to either the "occurrence" or "claims-made" version of the CGL coverage part. It deletes the first part of the pollution exclusion, which refers to BI or PD resulting from pollution. As a result, the endorsement creates liability insurance for third party injury or damage caused by pollutants. But the endorsement leaves the second part of the pollution exclusion intact—clean-up costs are still excluded when this endorsement is attached.

The 1991 federal district court decision *Aetna Casualty and Surety Co. v. General Dynamics Corp.* considered some of the technical aspects of pollution liability exclusions in CGL policies—and the reasons many companies add pollution endorsements.

A defense contractor faces costs limited to all elements of a pollution investigation

Aetna sued General Dynamics, seeking a court declaration that it was not obligated to defend, pay or indemnify General Dynamics under several CGL policies for liability arising for hazardous waste cleanup and damages to natural resources.

In the late 1980s, giant defense contractor General Dynamics had been notified that—as a potentially responsible party under CERCLA—it could be liable for costs related to investigation, planning, cleanup and enforcement activities. Separately, a number of municipal governments filed suit against General Dynamics for damaging their natural resources.

The disputed damages resulted from the hazardous waste contamination of sixteen sites located in eight states—but the case principally involved pollution to several sites in the New York City area.

Aetna and General Dynamics both asked for summary judgments on several issues. These included:

- whether Aetna was obligated to pay expenses incurred by General Dynamics in defending and paying as settlement amounts for state statutory clean-up costs;

- whether Aetna was obligated to pay expenses incurred by General Dynamics in defending and paying settlement payments pertaining to state common law actions;

- whether Aetna was obligated to pay expenses incurred by General Dynamics in defending CERCLA-related actions; and,

- whether Aetna was obligated to pay expenses incurred by General Dynamics in defending and paying settlement amounts pertaining to state and CERCLA actions for damages to natural resources.

With respect to the state statutory actions, several state agencies had agreed not to proceed if General Dynamics paid a proportionate share of clean-up costs for the sites—which it did. Since no suit was filed, no duty to defend arose on the part of Aetna.

A court defines the duty to defend in pollution cases

The court noted that:

> The standard for determining whether an insurer owes a duty to defend is based on a comparison of the policy language with the allegations of the plaintiff's complaint(s), and when those allegations state a claim which is potentially or arguably within the policy's coverage, then the insurer must defend the suit.

So, to begin its analysis of the other questions, the court looked to the Aetna CGL policy form. The form provided coverage for damages incurred by the named insured for property damage—but excluded coverage under the pollution exclusion clause, as follows:

> To bodily injury or property damage arising out of the discharge, dispersal, release or escape of smoke, vapors, soot, fumes, acids, alkalies, toxic chemicals, liquids, or gases, wastes materials or other irritants, contaminants, all pollutants into or upon land, the atmosphere or any water course or body of water....

This is the so-called "absolute" pollution exclusion. However, the pollution exclusion provided that insurance coverage excluded by the pollution exclusion:

> ...does not apply if such discharge, dispersals, release or escape is sudden and accidental.

A dispute over whether toxic releases were "sudden and accidental"

Aetna had some doubt as to whether the disputed releases were sudden and accidental.

Aetna argued that the releases were not sudden. It claimed that term "sudden" as in the policy was unambiguous and meant instantaneous or abrupt, containing a temporal aspect of immediacy, abruptness, suddenness, quickness and brevity. It then cited stipulations—to which General Dynamics had agreed—which stated that, in at least one site, toxic waste containers stored by General Dynamics had been corroding and had leaked toxic material for several years.

Aetna also claimed that—in at least one of the pollution sites—General Dynamics had contracted with Northeast Oil, a waste disposal company, to dispose of 300,000 gallons of bilge water. Northeast Oil's owner later pleaded guilty to conspiring to bribe a New York City Department of Sanitation employee for the purpose of unlawfully disposing of the bilge water at the General Dynamics site.

General Dynamics claimed it had no knowledge that toxic wastes were designated to be stored improperly or disposed of illegally. It argued that the evidence established that it neither expected nor intended the illegal and improper activity that resulted in hazardous waste contamination. Consequently, the releases of toxic or hazardous wastes at its various sites constituted an "occurrence" as defined in the insurance policies.

The Aetna policy defined "occurrence" as an accident with continuous or repeated exposure to conditions that result in bodily injury, or property damage.

The court sided with General Dynamics. It found that the insurance policies at issue did not define the term sudden clearly:

> ...it appears to this Court that there exists no single plain meaning of the term "sudden" as used in the instant CGL policies. ...Aetna failed to establish that the parties intended that the term "sudden" to mean anything other than all accidental pollution occurrences causing injury where the pollution event was neither expected nor intended by defendant.

This ruling suggested that coverage would not be provided for intended acts and intended results of such acts—but would be provided for unintended results of an intentional act.

The court also ruled that the frequency of dumping or leakage did not determine whether the occurrence was sudden and accidental, regardless of how many deposits or dispersals or spills may have occurred. It wrote:

> Although the permeation of pollution into the ground damaging the natural resources may have been gradual rather than instantaneous, the behavior of the pollutants or their seepage into the ground is accidental if the permeation was unexpected.

Consequently, General Dynamics' liability for natural resource destruction attached when the first drop of waste hit the ground. This meant General Dynamics was entitled to summary judgment with respect to Aetna's duty to defend it in the common law litigation for damages to the natural resources of the city of New York and other cities.

However, the court found Aetna could defend General Dynamics while reserving its right to withdraw coverage at a later date. This defense satisfied the insurance company's initial duty to participate in a named insured's defense.

Limited pollution liability extension endorsement

Other pollution endorsements usually limit coverage

This endorsement differs from the Pollution Liability Extension Endorsement in that it creates a separate aggregate limit of liability with respect to all pollution liability coverage. It also excludes any liability arising out of discharges from underground storage tanks.

Total pollution exclusion endorsement

This endorsement eliminates any and all coverage from the basic policy for pollution.

Pollution liability coverage

The pollution liability coverage form provides insurance on a claims-made basis only. It may be attached as part of a commercial package policy that also includes a CGL coverage part. The pollution coverage form duplicates many of the provisions found on the CGL form, but it has its own limits (independent from CGL limits) and a different insuring agreement as well as a number of exclusions and definitions that are unique to the pollution exposure.

The form includes two insuring agreements. The first states that the insurance applies only to BI or PD caused by a "pollution incident" that commences after the retroactive date. The incident must arise from an "insured site" or "waste facility" in the "coverage territory." The insurance applies only if a claim is first made against you during the policy period. The second agreement establishes coverage for mandated "off site clean-up costs" resulting from a "pollution incident" that has actually caused "environmental damage." Clean-up costs are covered only when your obligation for such costs is imposed under the statutory authority of any governmental entity or agency of the United States of America or Canada. Therefore, expenses incurred as a result of a voluntary decision on the part of the policyholder to clean up would not be covered.

Among the exclusions specifically applicable to the pollution exposure are those removing coverage for emissions from a closed or abandoned site, and excluding all injury or damage arising out of acid rain. Another exclusion eliminates coverage for the escape of drilling

fluids, oil, gas and other fluids from any oil, gas, mineral, water or geothermal well.

A one-year extended reporting period

The pollution liability form provides for a one-year extended reporting period if the insurance company cancels or non-renews the coverage, renews it with a later retroactive date, or replaces it with coverage other than claims-made coverage. This ERP is not automatically provided—you must make a written request for it within 30 days after the policy period and pay an additional premium. Longer tail coverage and full tails are generally not available for pollution coverage. This is because every storage facility will eventually leak—even if this takes centuries. The insurance company doesn't want to be responsible for these costs in the far future.

An endorsement may be attached to the pollution liability form to provide for reimbursement of voluntary clean-up costs. When attached, the endorsement adds a third insuring agreement providing coverage for clean-up costs which are "necessary and reasonable" to curtail or prevent a pollution incident that poses a substantial danger of causing injury or damage. Voluntary clean-up coverage applies only if you receive prior written consent from the insurance company granting permission to make the clean-up.

Limited pollution liability coverage

The limited pollution coverage form is also written only on a claims-made basis. It is identical to the pollution form just discussed except that it does not cover clean-up and related costs. It has only one insuring agreement, which provides coverage for BI and PD arising from pollution incidents. It specifically excludes clean-up costs and obligations imposed by government authority. All other conditions, provisions and exclusions are the same as the more complete pollution coverage form.

Liquor liability coverage

Historically, liquor liability laws were known as dram shop laws, and liquor liability insurance has been called dram shop liability insurance. A "dram" is simply a unit of fluid measurement (one-eighth of one ounce). Dictionaries usually define "dram shop" as a barroom. Although the term "dram shop" continues to have some legal and historical significance, it is no longer used as widely as it once was. Today, we are not likely to find references to drams on the packaging and labeling of alcoholic beverages. However, you should be aware that whenever you come across the terms dram shop laws and dram shop liability, the topic being addressed is liquor liability.

Forms that provide coverage for incidental exposure

CGL forms provide "host liquor liability" coverage, which applies only to the incidental exposures of those who are not engaged in the business of manufacturing, distributing, selling, serving or furnishing alcoholic beverages. The CGL liquor liability exclusion applies to

insureds who are engaged in such businesses, but liquor liability coverage may be purchased for these exposures. A liquor liability coverage part may be attached to a commercial package policy that also includes a CGL coverage part. Two variations of the liquor liability coverage are available—there is an occurrence form and a claims-made form. Except for the sections that specifically focus on the liquor liability exposure, the two forms are very similar to their CGL counterparts.

Covering you for "selling, serving or furnishing" alcohol

The insuring agreement of both versions of the liquor liability coverage form state that the insurance applies to damages for "injury" if the liability "is imposed on you by reason of selling, serving or furnishing any alcoholic beverage." Injury is later defined as including bodily injury, property damage, and damages for care, loss of services, or loss of support. The injury must occur in the coverage territory, and the insurance company has a duty to defend suits.

The only difference between the insuring agreements is that the "occurrence form" applies to injury that occurs during the policy period, and the "claims-made" form applies to claims first made against you during the policy period provided that the injury does not occur before the retroactive date or after the policy period.

Both versions of coverage have the same exclusions. Some of the exclusions, such as expected or intentional injury, obligations falling under workers compensation, and bodily injury to employees, are also found on the CGL forms. The liquor liability forms have some unique exclusions, but have fewer exclusions than the CGL because the coverage has a more narrow focus.

The insurance does not apply to injury arising out of selling, serving or furnishing any alcoholic beverage while any required license is suspended, nor does it apply after any such license is expired, cancelled or revoked.

An exclusion applies to injury arising out of your product, but the exclusion does not apply to liability resulting from causing or contributing to a person's intoxication, or furnishing alcohol to someone under the legal age or already under the influence of alcohol, or under laws regulating the distribution or use of alcoholic beverages. This exclusion clarifies that the coverage is not products liability insurance. Injury resulting from a bad batch of an alcoholic beverage that poisoned someone is excluded, but injuries resulting from the use, distribution and known intoxicating effects of the product are not excluded.

INSURING THE BOTTOM LINE

Chapter Nine:

Professional Liability and Directors and Officers' Liability

Professional liability

In many small businesses, the business owner provides advice or professional services for which customers pay a fee. However, if these services are in some way unsatisfactory, the customer may sue the service provider for professional negligence. Accountants, attorneys, financial planners or anyone who provides professional services may find themselves as the defendant in a lawsuit. While many of these suits are unsuccessful, legal defense costs and potential settlement awards are ample reason for extensive professional liability coverage.

Due to the growing frequency of malpractice suits and the sympathies of courts, professional people are now held more accountable for their mistakes than ever before. As time passes, higher and higher sums are being awarded to plaintiffs in malpractice suits. The need for professional liability insurance, written with adequate limits, has grown in direct proportion to these trends.

Professional liability coverage protects you against legal liability resulting from negligence, errors and omissions, and other aspects of rendering or failing to render professional services. It does not cover fraudulent, dishonest, or criminal acts. Many professional liability policies contain exclusions which are commonly found on general liability forms, such as liability you assume or obligations which fall under a workers compensation law.

In the medical field, professional liability coverage is often referred to as malpractice insurance. In other areas, the coverage is generally known as errors and omissions insurance, particularly where there is no coverage for bodily injury. However, all professional liability is a form of malpractice insurance.

Professional liability policies used to be written on an occurrence basis. This meant that the policy in effect when the error, omission, or negligent act originally "occurred" obligated the insurer to provide a defense and cover the claim.

Although insureds often increased their limits of insurance on renewal policies to keep up with inflation and other economic changes, occurrence coverage for this type of exposure raised two potential

problems. On one hand, you might have inadequate coverage even after raising limits if a claim is made for an act that occurred many years in the past. On the other hand, the insurance company might have to defend a claim and incur substantial legal expenses many years later even when the amount of coverage—and the premium collected—for the policy is relatively low.

To remedy these problems, insurers began shifting to claims-made coverage, which obligates the carrier of the policy currently in effect when a claim is made, even if the negligent act or error occurred many years before (provided it did not occur before any retroactive date shown on the policy). Most professional liability policies today are written on a "claims-made" basis. The concept of "claims-made" coverage and related coverage features (such as retroactive dates and extended reporting periods) is reviewed in greater detail in the General Liability chapter.

Medical malpractice coverage

Rendering—or failing to render—professional services

In the medical field, malpractice insurance applies to bodily injuries arising out of the rendering or failure to render professional services. Bodily injuries are covered because medical, surgical, dental, and nursing treatments, medicines, and services have physical consequences for patients. Various forms provide professional liability coverage for:

- hospitals,
- physicians, surgeons, and dentists,
- nurses,
- opticians,
- optometrists,
- chiropractors, and
- veterinarians.

Medical malpractice insurance—like many forms of professional liability coverage—is sometimes misused by professionals who operate on the margins of their field. The 1993 Louisiana appeals court decision *Mary Case v. Louisiana Medical Mutual Insurance Co. et al.* offers an appropriately tortuous example of a medical malpratice claim.

Mary Case alleged that, in September 1986, orthopedic surgeon Walter Deacon negligently severed the ulna and radial nerves in her thumb. Case and her husband filed claims with the Louisiana Commissioner of Insurance against Deacon and Woodview Regional Hospital.

The Commissioner informed the Cases that Deacon had been insured under "a reporting endorsement from LAMMICO covering him for any accident occurring while he had coverage." In other words, LAMMICO had issued a claims-made policy to Deacon.

But even this turned out to be a mistake. LAMMICO later denied any coverage because Deacon had never actually paid for the insurance.

In November 1987, Deacon filed a voluntary bankruptcy petition, listing Mary Case as a creditor and providing the name and address of her attorney for inclusion on the correspondence list. Notice of the bankruptcy proceeding was forwarded to Mary Case's attorney on November 2, 1987. The creditors initially were advised "no assets" existed in Deacon's bankruptcy case.

(Later, the creditors were notified that the bankruptcy trustee had discovered assets, unknown previously, which might result in a distribution. In accordance with the notice instructions, the Cases filed a proof of claim form with the United States Bankruptcy Court specifying the alleged act of malpractice committed by Deacon.)

The details of a medical malpractice claim

On March 11, 1988, the Cases' lawyer sent a letter to LAMMICO requesting that it designate an attorney to defend the claims pending before the Commissioner of Insurance. LAMMICO responded that the policy it had issued to Deacon did not cover the alleged act of malpractice.

On May 12, 1988, the Commissioner of Insurance sent a letter to the Cases' attorney spelling out the error it had made:

> In our letter of September 25, 1987 we indicated that Dr. Deacon had purchased a reporting endorsement from LAMMICO which entitled him to protection under Act 817.
>
> We have since been advised by LAMMICO that the defendant was given a quote for the tail but did not purchase the reporting endorsement.
>
> Based on this information we are amending Dr. Deacon's status to "NOT QUALIFIED" and notifying him and all involved parties of this amendment.

The Cases sued LAMMICO, arguing two theories of liability. The first theory suggested as a consequence of LAMMICO's failure to promptly disclose the absence of coverage, it could not deny the existence of coverage. The second theory posed (without articulating a firm legal basis) that LAMMICO, as a result of its inaction, "pure and simple should be held liable in solido with Dr. Deacon for the harm" allegedly caused by his negligence.

The Cases' suit also named the Louisiana Commissioner of Insurance as a defendant, alleging that the erroneous coverage information initially forwarded by the Commissioner caused them to forego intervening in Deacon's bankruptcy proceeding.

LAMMICO filed a motion for summary judgment and contended that no genuine issues of material facts existed and as a matter of law it was entitled to judgment dismissing the Cases' claims.

Attached to the motion was an affidavit from LAMMICO's executive vice president, attesting that a true copy of the insurance policy issued to Deacon was attached reflecting its coverage period from August 1986 to July 1987. The affidavit further stated that Deacon did not purchase any tail coverage.

The trial judge denied LAMMICO's motion and noted:

> The Court finds that summary judgment is inappropriate because there exists a genuine issue as to a material fact, specifically whether a claim was made to LAMMICO, the insurer of Dr. Walter E. Deacon, during the effective period of the insurance policy. The movant's affidavit filed in this matter does not state that a claim was not made against LAMMICO during the period the policy was in effect.

The claim was not made during the effective period of the policy

LAMMICO modified its argument to make this claim. It was undisputed that Case and her husband did not provide oral or written notice to LAMMICO during the policy's effective period advising it of the alleged act of malpractice.

The first recorded notice of their claims occurred on September 25, 1987—when they filed a petition with the Commissioner of Insurance naming Deacon as a defendant. LAMMICO acknowledged receiving a copy of the petition on October 5, 1987, long after the effective period of coverage.

The court then considered the policy in question:

> The policy...is more commonly referred to as a "claims-made" policy. In accordance with its expressed terms, coverage attaches only if the negligent harm is discovered and reported within the policy period in contrast with "an occurrence" policy which merely requires the commission of the negligent act during the policy's effective period regardless of the date of discovery and reporting.

The Cases also argued that their claims against LAMMICO were maintainable, even if the act of negligence was not covered by the policy, because "as a matter of law" LAMMICO's failure to communicate the lack of coverage promptly to them should prevent it from raising lack of coverage as a defense.

The court didn't buy this argument at all:

> LAMMICO did not overtly represent to [the Cases] that its policy provided coverage for the alleged negligent act. Although the letter forwarded to [Mary Case] from the Commissioner's office mistakenly advised that Dr. Deacon had acquired a reporting endorsement from LAMMICO, [the Cases] do not allege the letter resulted from LAMMICO's representations to the Commissioner's office. Furthermore, LAMMICO's failure to promptly advise [the Cases] that coverage was not available does not constitute an "omission" on which they were entitled to rely.

The complaint originally filed by Case and her husband with the Commissioner of Insurance named only Deacon and Woodview Regional Hospital as defendants. Since no grounds for coverage had been established, LAMMICO did not have a duty to respond to their claims or provide a legal representative to Deacon.

Other professional liability coverages

Many non-medical practitioners have liability exposures arising out of the knowledge, skill or advice they sell, and the professional activities they engage in. Professional liability policies are available for:

- advertisers, broadcasters and publishers,
- insurance agents and brokers,
- accountants,
- architects and engineers,
- attorneys,
- pension plan fiduciaries,
- stockbrokers, and
- directors and officers of corporations.

Other common types of professional liability coverage

Many other types of professional liability coverages are available. In most cases, errors and omissions insurance excludes coverage for bodily injury and damage to tangible property—forms covering insurance agents, accountants, and attorneys exclude BI and PD. The negligence, errors and omissions of many professionals will only generate claims for financial damages. But the nature of a profession determines the nature of malpractice claims, and the insuring agreements reflect this fact.

For example, forms covering architects and engineers do cover claims for BI and PD, because errors or negligence in the design of buildings or products can lead to bodily injury and property damage.

Engineers professional liability insurance usually has many layers of coverage and is particularly prone to disputes between primary and excess insurers. The 1992 federal district court decision *Commercial Union Insurance Co. v. Walbrook Insurance Co., et al.* considered several complex issues.

Between July 1973 and July 1975, Commercial Union (CU) conducted a number of safety inspections through its agent, Warren Bailey, at an aerosol packing plant owned by Peterson/Puritan, Inc.

In January 1976, there was an explosion and fire at the plant. Four people were killed and a number of others were injured. The victims or their representatives first filed suit against CU in January 1978. The complaints alleged negligence by CU based upon its inspections.

A major case involving engineers liability insurance

On the date of the explosion, CU's primary liability coverage was provided by Travelers Insurance Company on an "occurrence" basis. The Travelers policy was extended by endorsement to provide coverage for engineers professional liability on a "claims-made" basis, limited to $1,000,000 for each claim.

Travelers defended CU in January 1978 and continued such defense until June 1982—when Travelers and CU discovered that no claim had been made within the Travelers policy period. CU released Travelers from any further defense or indemnity obligations arising from the Peterson/Puritan incident.

At the time of the accident, CU also carried an insurance policy issued by the Weavers Group (one of the many co-defendants in the case). The Weavers policy provided excess general liability coverage on an "occurrence" basis; the policy was also extended by endorsement to provide excess coverage for engineers professional liability. Among other things, the Weavers endorsement provided:

> [T]his policy is extended to include Engineers Professional Liability... and that as respects such coverage this policy is subject to the same warranties, terms and conditions (except as regards the premium, the obligation to investigate and defend, the amount and limits of liability and renewal agreement, if any) as are contained in the said underlying policy/ies prior to the happening of an occurrence for which claim is made hereunder.

Shortly after releasing Travelers from liability in June 1982, CU notified Weavers that the Peterson/Puritan claims had not been timely filed within the terms of the Travelers policy. Weavers advised CU that there was no coverage under its policy because the professional liability endorsement was subject to the same conditions contained in the underlying Travelers policy.

In response, CU filed a lawsuit seeking a declaratory judgment holding Weavers liable. Weavers filed a motion seeking to have CU's claims dismissed. The lawsuits inched through procedural hearing and review for almost ten years.

When the complaints finally made it to trial, the court defined the following issues as relevant to the case:

> 1) whether CU's liability from the explosion fell exclusively within the engineers professional liability endorsement;
>
> (2) whether the Weavers engineers professional liability endorsement was "claims-made" or "occurrence" based; and
>
> (3) whether Weavers is estopped from denying coverage as a result of its "participation" in the Peterson/Puritan litigation until June 1982.

The Weavers policy specifically addressed engineers professional li-

ability claims in the endorsement attached to the policy. There was no other reference to engineers professional liability in the policy.

The court concluded that engineers professional liability claims were covered under the policy endorsement or not at all:

> ...the policy was unambiguous in this respect. This was consistent with the intention of the parties because it was unreasonable for Commercial Union, a sophisticated policyholder, to purchase a special endorsement to provide coverage it already had.

A related question was whether CU's liability should have been covered under engineers professional liability or general liability insurance. On this point, the court looked back to the decision CU had made to release Travelers from any liability:

Professional liability or ordinary negligence?

> Commercial Union would not have released Travelers had its liability arisen from non-professional negligence. In addition, when [this] complaint was filed..., Commercial Union sought coverage only under the EPL endorsement. The complaint relied almost exclusively upon passages quoted from the endorsement; language regarding coverage for general negligence was neither referenced nor attached as an exhibit to the complaint. Nor did Commercial Union dispute the characterization of their claims as "EPL" claims in its opposition to the defendant's motion to dismiss. The parties did not direct discovery to this "new" issue during the ten year life span of the case.

CU urged the court to invoke the presumption against the insurer in cases of ambiguity and rule against Weavers. The court refused. The first paragraph of the Weavers EPL endorsement explicitly incorporated the limits on the underlying Travelers policy, with several specific exceptions. The self-insured retention language was equally explicit.

Because Weavers defined the excess professional liability coverage to end when the underlying coverage ended, there was no insurance against which CU could make a claim. CU's argument about limits was moot. The court agreed with this conclusion, noting that both parties were sophisticated insurance companies and should have recognized the potential problem.

The court ruled in favor of Weavers and—putting an end to a decade-long legal war of attrition—dismissed the case.

A final note: Weavers may have had to stand by its coverage if CU had not released Travelers from liability in 1982.

Coverage for insurance agents and brokers has become an important necessity for operating an insurance business. Agents and brokers may be sued by insureds who claim financial losses because of errors or omissions in risk management, exposure evaluation and professional recommendations.

Insurance producers also have an exposure from the companies with which they place business. An agent's errors or omissions (E&O), or negligence, could cause losses for the insurance company that he or she represents. Insurance producers usually cannot afford to operate without E&O coverage. Obtaining adequate coverage and a reasonable price for the insurance have become major issues.

The 1991 federal district court decision *Electro Battery Manufacturing Co. and Fireman's Fund Insurance v. Commercial Union Insurance* offers a colorful example of why insurance brokers need E&O coverage.

Electro distributed automobile and truck batteries. Its insurance policies for primary and excess automobile liability insurance were issued through its insurance broker, Daniel & Henry Co. Daniel.

Commercial Union (CU) provided Electro with primary automobile insurance coverage. Mission Insurance Company provided Electro with excess or umbrella automobile insurance coverage. Fireman's Fund provided Daniel with coverage for errors and omissions.

Why insurance brokers need errors and omissions coverage

There were approximately thirty insurers with which Daniel brokers could place insurance. Daniel was compensated with a commission paid by those insurers. In almost all cases, the commission was a percentage of the insurance premium paid by the purchaser.

The brokers at Daniel would complete applications for clients. The broker then had the authority to bind the insurer while the insurer considered the application of the prospective insured. The insurer, however, ultimately decided whether to issue insurance coverage to the applicant.

CU provided primary automobile liability insurance coverage to Electro between October 1976 and June 1981. For each annual period, CU issued insurance policies to Electro which provided split liability coverage of $250,000 per person, $500,000 per occurrence, and $100,000 property damage ("250/500/100").

For the annual periods beginning in July 1979 and July 1980, Mission provided excess coverage to Electro. Mission required Electro to have primary coverage of $500,000 combined single limit (500 CSL)—that is, for each accident Electro should have primary coverage of $500,000.00 regardless of the number of persons involved. Mission provided excess coverage of $5 million over and above an underlying 500 CSL.

Daniel employee James Mangan was assigned the task of renewing Electro's account for the annual periods beginning in July 1979 and July 1980. It was Mangan's intention for the annual period beginning in July 1979 to change CU's primary coverage of Electro to 500 CSL.

Mangan intended to notify CU of the change in coverage but failed to inform CU orally or in writing of the change. He probably forgot. Therefore, CU renewed Electro's policy with the split coverage of 250/500/100. Mangan, however, indicated on Electro's application to Mission

for excess insurance coverage that the underlying coverage issued by Commercial Union was going to change from 250/500/100 to 500 CSL.

Mangan renewed Electro's policies for the annual period beginning in July 1980 on the same terms as the previous annual period. Again, he failed to inform CU of any intended change in coverage. Therefore, CU renewed the policy at 250/500/100. Mission renewed its excess coverage on the assumption that the underlying coverage was 500 CSL.

An automobile accident quickly turns into a professional liability dispute

On December 3, 1980 Howard Kutermier, an employee of Electro, was involved in an automobile accident with Ricardo Gonzales, M.D. Gonzales filed a lawsuit against Electro which was eventually settled for $300,000.

CU paid $250,000 toward the settlement. Mission refused to pay the $50,000 remainder because it was only liable for the amount of a settlement in excess of $500,000 under the terms of its policy with Electro. Fireman's Fund, which insured Daniel for errors and omissions, contributed the $50,000 necessary to settle Gonzales' case.

Daniel requested that Mission reform its insurance policy to close the gap. Mission refused. Mission was later declared to be insolvent. Fireman's Fund then demanded that CU reform its insurance policy to close the gap. CU also refused.

So, Fireman's Fund sued CU to force it to cover the gap between primary and excess insurance amounts. Otherwise it—as the E&O insurer—might have to make up the $50,000 again, if a similar loss occurred.

The court determined that Daniel, not CU, was at fault for the gap in coverage:

> ...Commercial Union was not notified either orally or in writing, as required by the Agency Agreement between Daniel and Commercial Union, that Daniel sought to change Electro's primary coverage from 250/500/100 to 500 CSL.

> ...In fact, Commercial Union was the only party that could not have discovered the gap in coverage. Daniel, Electro, and Mission received a declarations page from Commercial Union and Mission which set forth the coverage each provided. If Daniel, Electro, or Mission compared the policies, they would have discovered a gap. Commercial Union, however, did not receive a declarations page from Mission and therefore did not know the terms of the excess coverage....

The critical difference between an "agent" and a "broker"

CU denied any liability for Daniel's errors because Daniel was the agent of Electro when the auto policy was written and renewed. To determine whether Daniel was the agent of Commercial Union, the court had to characterize Mangan as either an insurance agent or insurance broker. The general rule was that an insurance broker is the agent of the insured.

Daniel considered itself an insurance brokerage firm—and Mangan, an insurance broker. But the court focused on other issues:

> ...it is the acts of the person, and not what he calls himself, that determine whether he is a broker or an agent.
>
> An insurance broker is an independent middleman not tied to a particular insurance company. The insurance broker may shop around for the insured to obtain the most favorable terms from competing insurance companies.
>
> The insurance agent, however, is captive to one insurance company and is bound to place insurance with that company.
>
> ...it is clear that Mr. Mangan was an insurance broker rather than an insurance agent. Although Daniel had placed Electro's primary automobile liability insurance with Commercial Union since 1976, Daniel placed insurance with approximately 30 insurance companies and Mr. Mangan was free to switch insurers if another insurer offered Electro better terms for its coverage.

A request for "reformation"—rewriting an insurance contract

Having lost the first argument, Fireman's Fund asked the court to order CU to reform its policy for the annual period beginning July 1989—to provide primary coverage to Electro of 500 CSL instead of 250/500/100.

The court considered the request:

> The remedy of reformation is applicable to insurance contracts. A written instrument which does not conform to the contract agreed to by the parties will be reformed in equity to reflect the contract agreed to. The party seeking reformation has the burden to establish by clear and convincing evidence that a mutual mistake common to both parties has been made. It must be clear that the instrument has done what neither party intended.

CU was a party to the insurance contract that Fireman's Fund sought to have reformed. However, CU renewed the policy in accordance with the instructions of Daniel—which failed to communicate Electro's desired coverage changes.

The court concluded that, because CU intended to renew the policy with the split coverage of 250/500/100, it made no mistake warranting reformation of the contract.

Fireman's Fund would remain liable for any damages caused by coverage gaps that occurred because of the Daniel brokerage's errors.

Liability coverage for lawyers is another important type of professional insurance. One of the reasons why there has been an increase in attorney malpractice claims and a trend toward higher awards has been the advancing tendency to sue. Lawyers are partly responsible for the trend, but they are not immune to the consequences of it.

A lawyer who loses a court case could be sued by the dissatisfied

client. Lawyers give advice on financial issues, drawing up of contracts, business organization and a wide range of other matters. They also may serve in a fiduciary capacity when they handle trusts and estates. All of this opens up a broad exposure to potential liability claims.

Today, liability coverage has also become essential for directors and officers of corporations. They are sometimes sued as individuals by disgruntled stockholders. This special coverage is necessary because general liability coverage of the business will not cover their personal liability, and personal liability coverage will not cover their exposure related to business activities. Yet claims for financial losses could be filed against them as individuals for liability resulting from their decisions, actions, inactions, errors and omissions. Policies may include two different types of coverage: the first covers the legal liability of directors and officers and pays directly on their behalf; the second is a reimbursement coverage for the business, and it reimburses the business for any amounts which it is required to pay because of the errors and omissions or wrongful acts of officers and directors.

Coverage is also written for pension plan fiduciaries and those who serve as employee benefit plan fiduciaries. These people administer plans and manage funds in the interest of plan participants and their beneficiaries. Errors or omissions, negligence, or poor or incompetent management of the funds, could lead to serious losses or deficiencies in benefits which will generate claims against the fiduciaries. As individuals, the fiduciaries cannot be insured for their intentional acts or dishonesty, but insurance can be written to cover their professional liability.

Commercial umbrella coverage

Umbrella policies are written to provide insurance on an excess basis, above underlying insurance or a self-insured retention (a layer of losses absorbed by the insured business). This is, in some ways, like a large deductible.

Some umbrellas are written to "follow form," which means they do not provide broader coverage than the primary insurance. Many umbrellas are designed to fill coverage gaps by providing coverages not included in the underlying insurance. For losses which are covered by the primary insurance, the umbrella coverage begins to apply only after the primary coverage is exhausted by payment of the per occurrence or aggregate limit. For losses which are covered by the umbrella and not by the primary policies, the umbrella coverage begins to apply after a loss exceeds an amount which you have agreed to retain.

Umbrella insurance doesn't have standard forms

There are no standard umbrella policy forms. Early umbrella policies were extremely broad and contained few exclusions. After experiencing problems, insurance companies narrowed the coverage by creat-

ing more specific insuring agreements and exclusions. The intent is to provide affordable and comprehensive coverage for catastrophic losses, incidental exposures, and modest insurance gaps, but not to provide blanket all risk coverage in multiple areas where there is no primary insurance.

For this reason, underwriters usually require you to maintain an adequate range of underlying coverages before providing the umbrella coverage. Umbrella insurance applications always require disclosure of the underlying primary insurance coverages.

To a degree, the exclusions and limitations of an umbrella often follow the underlying policies. However, the umbrella will usually have fewer exclusions than the primary coverage, less restrictive exclusions, and a broader insuring agreement.

Coverage for worst-case lawsuit scenarios

For many businesses, an umbrella policy protects business assets which could be threatened by multimillion dollar liability lawsuits. Usually, commercial umbrella forms provide a minimum of $1 million of insurance, but they are frequently written with limits of $10 million to $50 million or more. The policies may include per occurrence and aggregate limits of liability.

Commercial umbrellas also help to fill two types of insurance gaps—those created by oversights, and those resulting from exposures which may not be fully insurable under traditional policies. Where no primary insurance exists, the required self-insured retention will be at least $10,000, but $25,000 is more common. For particularly risky exposures, the insurer may require a retention of $50,000 or $100,000 or more.

Underwriters usually require you to maintain, at a minimum, underlying commercial general liability, automobile liability, and statutory employers liability coverages. Depending upon the type of risk, the underwriters may also insist that you carry other coverages.

Because there are no standard forms, umbrellas do not always provide broader coverage than the underlying policies. Some contracts are written on a straight excess basis. But most are broader than the primary coverage because the insuring agreement refers to personal injury rather than bodily injury. Unlike the CGL, umbrellas do not define personal injury to mean injury "other than bodily injury," so it means bodily injury and more. This expands the insurance to include a wide range of torts other than negligence, such as discrimination, defamation of character, libel, slander, invasion of privacy, false arrest, humiliation, wrongful detention, and mental injury. Department stores have often been sued for false arrest and wrongful detention. Real estate firms have been subject to charges of discrimination. The employment and credit practices of any business create personal injury exposures. Many umbrellas are also written to include advertising liability.

Commercial umbrella policies may fill gaps in existing insurance

In many areas, a commercial umbrella may be written to provide coverages which are not included in the underlying insurance. Such coverages apply above the self-insured retention. Umbrellas commonly provide worldwide coverage for products liability, which is an important coverage for any firm selling to international markets. Blanket contractual liability coverage, for both oral and written contracts, may be included. Umbrellas frequently provide liability insurance for incidental malpractice, non-owned aircraft, and non-owned watercraft exposures. It is not uncommon for umbrellas to provide employees liability coverage, by making employees part of the definition of "named insured." Employees could be sued as individuals for acts or omissions related to their employment. Underlying liability policies usually exclude damage to property which is in your care, custody or control—or which you rent or occupy—and these coverages are available under umbrella policies. Umbrellas may be written to provide liquor law liability and many other liability coverages.

Excess and surplus lines

Certificates of authority and licenses

Generally, an insurer is not permitted to transact business in a state without having a current Certificate of Authority or license issued by the Insurance Department specifically authorizing the insurer to transact particular lines of business. These insurers are known as authorized insurers, or as admitted insurers, and they transact traditional lines of business. In most states, the law prohibits anyone from acting as agent for an unauthorized company, and prohibits an insurer from transacting any line of business for which it is not authorized.

In almost every state the insurance law makes exemptions which apply to certain transactions which are permitted without a Certificate of Authority being required of the insurer. These transactions may be legally conducted by unauthorized insurers, also known as nonadmitted insurers (some states use one term or the other, some use both, and the two are considered to be synonymous). Such permitted transactions by unauthorized insurers usually include those involving subjects of insurance located or to be performed outside of the state, certain types of transportation and ocean marine risks, reinsurance, and coverages which are classified as surplus lines.

Although the insurance laws are different in each state, they usually spell out conditions for transacting surplus lines business and for the licensing of surplus lines brokers.

Surplus lines are considered unregulated

Surplus lines coverages are those that are not available or cannot be procured from authorized insurers within a state. Although "surplus lines" are considered an unregulated area of insurance, the business must be procured and conducted in accordance with the surplus lines (or surplus and excess lines) insurance law of the state.

Each state usually has specific conditions which must be met for the procurement of surplus lines business. There are variations from one

state to another, but generally three types of conditions must be met before surplus lines insurance may be procured from an unauthorized insurer:

- the business must be procured through a licensed surplus lines broker,
- the full amount of the insurance to be written as surplus lines must not be procurable, after diligent effort to procure it, from authorized insurers who actually market the kind of insurance in the state, and
- the insurance must not be procured as surplus lines solely for the purpose of securing advantages in either the terms of the insurance contract or a lower premium than what would be acceptable to an authorized insurer.

Surplus lines business may only be transacted by a licensed surplus lines broker. If an agent or broker is not licensed to transact surplus lines, any surplus lines business transacted must be negotiated through a licensed surplus lines broker. An agent or broker who must resort to the surplus lines market is called the "originating" agent or broker, and the surplus lines broker accepting and placing the risk is the "accepting" broker.

In most states, the originating agent or broker must first make a diligent effort to place the business with authorized insurers. If any portion of the risk can be written with an authorized insurer, that portion must usually be written in the admitted market. The amount of insurance placed with an unauthorized insurer as surplus lines coverage is usually only the balance over any amount procurable from authorized insurers.

Each surplus lines broker is usually required to keep complete and accurate records of every surplus line contract procured. In most cases the records must show the amount of the insurance transacted, the gross premium charged, the effective date of the contract, a brief description of the property insured and where it is located, the name and address of the insurance company, and your name and address. These records are to be available for examination by the Insurance Department, and in many cases must be kept for a specific number of years after termination of the insurance contract.

Surplus lines brokers are usually required to file annual statements showing gross amounts of each kind of surplus lines insurance transacted, aggregate gross premiums charged, aggregate return premiums paid to insureds, aggregate net premiums and other relevant information about the business transacted.

A surplus company should be on an approved list

Although surplus lines insurers are "unauthorized," many states issue an "approved list" of surplus lines carriers and require brokers to place surplus lines business only with those insurers. The National Association of Insurance Commissioners (NAIC) issues a quarterly

Chapter Nine: Professional Liability and Directors and Officers' Liability

listing of nonadmitted insurers which are considered to be acceptable for the placing of surplus lines business.

In many states the "approved list" of surplus lines carriers includes those insurers on the NAIC list plus those additional carriers which have been identified by the state's Insurance Department or Commissioner. In evaluating surplus lines carriers, such things as capital and surplus, licenses held in other states, and other factors are usually considered.

A caveat: Do not confuse this use of the word "approved" with the statutory definition of "authorized insurer." Even though a surplus lines insurer may be approved, it is not required to have a Certificate of Authority and by definition it is an "unauthorized" and "nonadmitted" insurer.

Difference in conditions (DIC)

Difference in conditions (DIC) insurance is frequently written with fire and property coverages to supplement the protection and fill insurance gaps. It is often used to provide a specific type of coverage which is excluded on traditional property insurance forms. One of its advantages is that it may provide coverage for a wide variety of unanticipated miscellaneous perils at a relatively low cost. It is sometimes used to provide a layer of excess coverage over whatever limits are available in the normal market.

Difference in conditions coverage assumes an "all risk" basis

The coverage varies because there are no standard forms, and individual insurers often use their own forms. Generally, DIC coverage is written on an "all risk" basis—it covers all losses which are not excluded. Because it is intended to supplement more traditional coverages, it usually excludes losses which are commonly insured on other policies (such as loss by fire, lightning, wind, hail, explosion, riot, smoke, vehicles, aircraft, vandalism and malicious mischief). This is why it is called "difference in conditions"—it does not cover what is covered elsewhere, while it covers almost everything else.

Coverage is often written specifically to provide insurance against one or more particular perils which are excluded on most property insurance policies (such as flood, earthquake, mysterious disappearance, or weather conditions). DIC policies may be written to cover direct losses and consequential losses. In addition to filling specific insurance gaps, broad coverage for loss by unknown perils is a great advantage to you. There are a number of potential loss exposures that might not be anticipated or might simply be overlooked, which a DIC policy may cover.

The covered property on DIC policies is similar to what may be insured by fire insurance forms. Coverage may be written on buildings, machinery, and business personal property including "stock." A DIC policy will usually exclude coverage for the same types of property not covered by fire insurance (such as money, securities, growing

crops, aircraft, and vehicles), because these are subjects for other types of insurance and specific policies exist to cover those items.

Picking up DIC coverage for specific perils

DIC insurance may be used to fill insurance gaps which cannot be filled using traditional policy forms, and it may also be used to close gaps which are created by underwriting decisions. For some hazardous risks, underwriters may not want to provide the broadest coverage available, or insure against a given peril, or write the high limits you request. In these cases, DIC is often the answer to your needs.

Originally, DIC coverage was available only for very large risks. Gradually it became available for medium- and small-sized business risks. Because it provides broad coverage over other insurance or with a high deductible, it actually provides a considerable amount of protection at a minimum cost.

One of the most frequent reasons for purchasing a DIC policy is to pick up coverage for a specific peril, notably earthquake coverage. When written for this purpose, the policy will exclude the "covered causes of loss" attached to the traditional commercial property coverage, and will be written to cover all other risks including earthquake. Although earthquake coverage may be attached to traditional property policies, it is often obtainable on a DIC policy at a lower rate and lower deductible, and with the added advantage of having no coinsurance clause.

DIC coverage and limits may be structured in different ways for different purposes. In some cases, a DIC policy may be written as a low-limit supplement to a greater amount of property coverage.

Example: You have a personal property exposure in the amount of $2,000,000 which must be insured for loss by fire and other major perils. However, the realistic exposure to other types of miscellaneous losses is only $50,000. A DIC policy covering these other exposures could be written for $50,000—probably at a substantial savings over attaching the coverage to the other policy with the higher limit.

In other cases, DIC coverage may be written as excess over an underlying layer of basic property coverages—in which case the common perils would not be excluded. When written as an excess policy, the coverage might carry substantial deductibles ($10,000 or more) for losses which are not covered by the underlying insurance.

DIC insurance might also be written as excess coverage for a particular peril for which underlying insurance is limited, such as flood insurance. You might buy the maximum amount of flood coverage available under the flood insurance program, and then buy a DIC policy including flood insurance to be excess over the amount written under the flood program.

Difference in conditions insurance is an uncontrolled line, and nearly all carriers are free to write the coverage. In reality, it has been offered only by a limited number of carriers. Although a number of

traditional property insurers will write the coverage, they tend to be conservative in their approach to both underwriting and pricing. For this reason, the coverage is most frequently written in the excess and surplus lines market, where underwriters tend to have a more realistic view of the coverage and the pricing tends to be more favorable for policyholders.

Directors and officers' liability

D&O coverage has become a major liability issue

In the course of business, management makes mistakes. If these mistakes cause financial losses and appear to be the result of gross negligence or willful misrepresentation, a lawsuit may ensue. In today's litigious environment, angry shareholders or other claimants will pursue recourse for financial losses caused by alleged wrongdoing or mismanagement. This is where directors and officers liability insurance comes to the rescue.

D&O coverage provides for legal defense and judgment/settlement expenses (up to the policy limits) in the event that someone brings suit against the company and/or its individual directors and officers. Most public companies provide their directors and officers with protection against lawsuits that result from their actions carried out in the course of their position. If companies did not provide D&O coverage, many executives would either change careers or require additional compensation to offset the risk of serving in a position of responsibility.

For directors and officers in the United States, 1985 was an important year. That year, the Delaware Supreme Court reversed the finding of a trial judge and imposed liability on the directors of Trans Union Corporation, a railcar leasing company, for negligence in connection with the adoption and recommendation of a merger. Apparently, the decision to merge was made in the span of a two-hour meeting and without soliciting the advice of an investment banker.

The Trans Union case forced the directors of that company to pay a $27 million settlement out of their own pockets to shareholders unhappy with the sale price of the company. Shareholders successfully argued the open market would have brought them more than the $55 per share offer approved by the directors.

Strangely enough, not only was there no disaster for Trans Union or its stockholders, for all intents and purposes the merger was an unqualified success. Nevertheless, Trans Union Corporation's directors were found liable for mismanagement. The case was the first in which personal liability was imposed against outside directors for performing actions in which they had no real personal stake.

Throughout the decades, the Business Judgment Rule has served as a protective shield for directors, deflecting challenges by stockholders over decisions which, in retrospect, turned out to be incorrect. The rule has sought to establish the fact that courts really aren't

equipped to decide, after the fact, whether decisions by directors (which often must be made with less than perfect information) were right or wrong.

The controversial "Business Judgment Rule"

In recent years, however, some courts have stopped a number of takeover defenses because of directors' alleged breaches of fiduciary responsibility. Other courts have maintained that the Business Judgment Rule doesn't actually apply in takeover cases because the interests of the directors are, to some extent, necessarily inconsistent or at odds with the interests of stockholders.

Takeovers, in theory, are supposed to be good for everyone. They tighten the belts of management. And, after all, the marketplace should dictate who stays in business and who doesn't....

The 1995 federal appeals court decision *Safeway Stores v. National Union Fire Insurance Co. of Pittsburgh* is a classic example of a shareholder suit creating a D&O issue.

In the late 1980s, the Dart Group Corp. launched a hostile takeover attempt by acquiring 5.9 percent of Safeway's stock. Dart then offered to buy the remaining Safeway stock it did not already own at $58 per share.

Safeway—a chain of grocery stores—began negotiating with Kohlberg Kravis Roberts and Co. (KKR) about the possibility of undergoing a leveraged buy out. Safeway's board of directors provided confidential business information to KKR, but—at KKR's insistence—withheld the information from Dart.

Dart eventually raised its offer to $64 per share but refused to raise its price further without access to the information.

Rejecting an attractive offer

Safeway's board rejected Dart's final offer. Safeway and KKR executed a merger agreement that set out the terms of a buy out. Under the terms, KKR would purchase up to 73 percent of Safeway's stock at $69 per share; the remaining shares would later be exchanged for debt securities and warrants.

Safeway paid a $15 million signing fee to KKR and agreed that, if the deal fell through, it would pay a $45 million termination fee as well.

After the KKR agreement was signed, Dart was given access to the confidential information.

The buy-out agreement authorized Safeway to pay its regular quarterly dividend of $26.2 million. Because the dividend date fell after the closing date of KKR's offer, KKR would receive 73 percent of that dividend.

Following the announcement of the LBO, six shareholder class-action lawsuits were filed against Safeway. The complaints alleged that Safeway's directors and officers had breached their fiduciary duty to shareholders by approving the buy out, and that KKR had aided and

abetted them. The complaint also alleged violations of federal securities and racketeering laws.

Safeway and the class-action groups entered into a memorandum of understanding. As a result, Safeway agreed to change its agreement with KKR so that the dividend date for a portion of Safeway's quarterly dividend would occur prior to the closing of KKR's tender offer. Therefore, the payment would go to existing shareholders rather than to KKR.

The company settles one lawsuit and falls into another

The federal action was dismissed shortly thereafter. With a settlement reached, Safeway filed a claim for the associated costs under its D&O policy with National Union. The insurance company declined to pay the claim.

Safeway brought suit in federal district court seeking reimbursement of $11.5 million for the early dividend, approximately $1.8 million in shareholder attorney's fees and costs, and approximately $230,000 in defense costs and attorney's fees.

National Union filed for a summary judgment dismissing Safeway's claims. It argued that the D&O policy didn't cover costs associated with corporate transactions.

The court granted National Union's motion for summary judgment on the $11.5 million dividend, finding that Safeway could not show that it constituted a covered loss under the D&O policy.

However, the court did grant Safeway's motion that the settlement and defense costs were covered losses. It ruled that the $1.8 million in settlement costs and $230,000 in defense costs would be allocated three-quarters to the covered directors and officers and one-quarter to Safeway and KKR. The result was approximately $1.5 million payable by National Union, minus the $1 million policy deductible, resulting in judgment for Safeway of about $500,000.

Safeway and National Union both appealed.

Safeway contended that the $11.5 million early dividend was a loss covered by the terms of the D&O policy. The appeals court didn't agree:

> It is difficult to see how a corporation's payment of a dividend could ever be a "loss" under the terms of an insurance policy. Neither the owners of that corporation nor its directors suffered a loss. The effect of a dividend is simply to transfer corporate profits from one part of the corporation to another, that is, from the purse of the corporate entity into the pockets of the corporation's owners, the shareholders. Safeway is not entitled to reimbursement for a payment made, in essence, to itself.

The fact that Safeway arranged to pay the dividend to its shareholders, rather than to KKR as originally anticipated, was irrelevant.

The appeals court also agreed with the lower court that Safeway should pay the shareholder attorney's fees pursuant to the settlement agreement. The lawyers got that money, not the shareholders. Therefore, unlike the dividend, the settlement costs were covered by the D&O policy.

Safeway then made a compelling argument against the 25 percent/75 percent split of these costs. It claimed that the lower court's decision to allocate some of the costs to Safeway and KKR lacked any legal or factual basis. The appeals court agreed with this argument:

> Under the larger settlement rule, a corporation is entitled to reimbursement of all settlement costs where the corporation's liability is purely derivative of the liability of the insured directors and officers.
>
> ...the D&O policy expressly provides coverage for "all loss... which the Insured Person has become legally obligated to pay on account of any claim... for a Wrongful Act committed [by] such Insured Person(s) [during the Policy Period]."
>
> The settlement costs were fully recoverable under the policy, unless the insurer could show that the corporation's liability had increased the amount of the settlement.

National Union attempted to circumvent this result by contending that the D&O policy mandated allocation between Safeway and its officers and directors. The language of the policy stated:

> With respect to the settlement of any claim made against the Company and the Insureds, the Company and the Insureds and the Insurer agree to use their best efforts to determine a fair and proper allocation of the settlement amount as between the Company and the Insureds.

The D&O coverage applies to all fees and costs related to a loss

Safeway also argued that allocation of its defense costs was improper, since all those costs were related to defense of the officers and directors. It also prevailed on this issue. The appeals court noted:

> Defense costs are covered by a D&O policy if they are reasonably related to the defense of the insured directors and officers, even though they may also have been useful in defense of the uninsured corporation. Safeway had already reduced its claim to exclude fees attributable to the defense of KKR. In addition, National Union conceded at oral argument that the defense costs were covered by the D&O policy. Thus, we find that Safeway's defense costs were reasonably related to the defense of its officers and directors in the class-action suits and were therefore fully covered by the D&O policy....

The court concluded that, "district court's judgment allocating one-quarter of the settlement and defense costs to Safeway and KKR is reversed and remanded for entry of summary judgment allocating all

settlement and defense costs to National Union." It also allowed Safeway to claim prejudgment interest and other related costs.

D&O problems linger

A study commissioned by Peat Marwick, an international accounting and consulting firm, found that more than 90 percent of the chief executives of America's leading institutions believe that the country is experiencing an incipient crisis with respect to the D&O liability issue.

Overall, nine in 10 of those surveyed expressed their beliefs that problems in the area of D&O liability were damaging the quality of organizational governance in the United States. One in 10 stated that "considerable" damage had already been done—from large corporations to small, non-profit organizations.

"The whole situation is scaring a lot of directors and would-be directors," said H. J. Zoffer, dean of the University of Pittsburgh's Graduate School of Business," both because of the liability and insurance situations, and because directors are beginning to realize that it is no longer a kind of whitewash operation where you just sort of show up and get a directors' fee and vote whichever way the management tells you."

Zoffer believes that many of the problems which arise in the area of D&O liability stem more from a lack of communication between an organization's management and its board than any sort of duplicity. And often, he says, these breakdowns in communication are unintentional.

"There is a sort of day-to-day operational pattern that is almost impossible for outside directors to be sensitized to unless someone from the management side takes the time to do so," Zoffer said.

Communication will, no doubt, become a key factor in relaxing the whole D&O liability situation.

Based on a 1986 survey conducted by the National Association of Corporate Directors (NACD), the average director spends approximately 300 hours per year on board duties.

An average of 6.6 years to solve a D&O claim

According to the NACD survey, it takes an average of 6.6 years to resolve a D&O claim. Claims that were filed years ago have surfaced and payment is due. And the insurance carriers haven't the funds, thanks to years of under-priced policies, to pay off.

The NACD survey reported that average limits of liability coverage range between $14,382,000 and $20,378,000. Average deductibles range from $84,000 to $340,000, with average premiums for D&O policies falling between $219,666 and $386,317.

It is important to note, however, that the survey's figures are based upon a cross-section of American corporations. Figures for non-profit

organizations are markedly lower, though many non-profits have found it difficult to obtain D&O liability coverage for that very reason—it is less lucrative for carriers and therefore not entirely worth their risk.

Stephen Sills, senior vice president in charge of underwriting for Executive Risk Insurance Company, admits that many D&O liability premiums have jumped by 1,000 percent since the mid-1980s. But he is concerned that the reasons for this are constantly overshadowed by the sheer visceral impact of the percentage figure.

"The rates for this type of insurance were obscenely low to begin with," said Sills. "And there has been a lot of activity in the area of mergers, acquisitions and LBOs which has resulted in multimillion-dollar litigation. This really didn't exist years ago."

D&O liability lawsuits are born when a lawyer who specializes in such issues finds a stockholder, often times one with comparatively small holdings, who was a stockholder at the time of an alleged impropriety. He then offers his legal services for free. His fee will be based, eventually, on a cut of the settlement.

That lawyer doesn't care about the stockholder. But he's an expert on SEC statements and reading proxy statements. If there is anything that is misleading, he can drive a truck through it. He is more expert on the subject than an ordinary lawyer working for the corporation.

The 1994 federal district court decision *Raychem Corporation v. Federal Insurance Co.* dealt with a troubling D&O lawsuit.

Raychem purchased an executive liability and defense coverage insurance policy from Federal in the late 1980s. The policy's liability limit was $25 million, with a $1 million deductible. "Insuring Clause 2" of the policy obligated Federal to reimburse Raychem for certain losses for which Raychem indemnified its officers, directors and certain other insured executives.

Angry shareholders initiate another typical D&O case

In December 1989, shareholders of Raychem filed a class action lawsuit in federal court against Raychem and twelve of its present or former directors and officers—each of whom were insured persons under the policy at the relevant times. The suit alleged common law fraud, negligent misrepresentation and violations of state statutes.

The trial court dismissed the state statute claims in the action. After that ruling, only the negligent misrepresentation claim was left. That claim alleged that the insured officers caused Raychem to issue at least 13 false or misleading statements regarding Raychem's fiscal year 1988 earnings and fiscal year 1989 prospects. The shareholders alleged that Raychem's management made these misrepresentations in order to enrich themselves.

Select employees could convert options granted under a company incentive plan into Raychem common stock within five years—if the company's performance reached certain target levels. The shareholder's complaint alleged that:

Raychem's management had a strong incentive to maximize Raychem's reported income in its 1988 fiscal year in order to permit conversion of their [options] in 1988, to increase the number of shares received on conversion, and to inflate the market price of Raychem stock to increase the amounts they would receive when they sold their stock following conversion.

...[T]he individual defendants and other Raychem managerial employees embarked upon a scheme to artificially inflate Raychem's reported income for its 1988 fiscal year by various manipulative devices including the postponement of and failure to record expenditures, improper capitalization of costs that would otherwise be recorded as expense, the shipping of merchandise as much as six months before the scheduled shipping date and improperly recording revenues from such shipments, and the structuring of the receipt of...revenues so that...expenses would be offset in fiscal 1988 rather than in subsequent years....

Again, the company settles one lawsuit but still faces legal problems

Raychem's Board of Directors ended up settling the class-action lawsuit for $8.25 million—and it incurred another $1.65 million in legal defense fees. It authorized Raychem to indemnify the individual defendants for settlement obligations and defense costs associated with the lawsuit. When it tried to make a claim for these costs under its D&O policy, Federal denied the claim.

Raychem sued Federal, alleging breach of contract. It requested a judgment in the amount of $8,896,887, representing $8.25 million in unreimbursed settlement costs plus $1,646,887 in defense costs, minus the policy's $1 million deductible.

Federal argued that settlement costs couldn't be included in the policy's definition of an insurable loss.

However, the court supported Raychem's right to make its claims:

...the courts have allowed indemnification costs for settlement payments and defense costs. Allowing a corporation to indemnify its officers and directors for settlement payments and defense costs supports two competing public policies: encouraging qualified individuals to serve as corporate officers and directors, and encouraging settlement of class action lawsuits. Thus, federal law does not prohibit Raychem's indemnification of its officers and directors for settlement payments and defense costs.

Federal also argued that allocation of settlement payments and defense costs was necessary because the policy did not cover conduct committed by the corporation or by other uninsured parties, namely non-D&O employees of Raychem or its outside accountants.

On this issue, the court noted that some federal courts addressing the issue of settlement payments had adopted "relative exposure" approaches to allocation. This entailed allocating settlement payments according to the relative risk of exposure of the various parties involved. But there were some reservations to this conclusion:

> The best reasoned of those cases...hold that allocation is appropriate only if, and only to the extent that, the defense or settlement costs of the litigation were, by virtue of the wrongful acts of uninsured parties, higher than they would have been had only the insured parties been defended or settled. This is referred to as the "larger settlement rule."

Federal argued that allocation should take into account the actions of Raychem's accounting firm, which was not insured under the D&O policy. The accounting firm, however, was not a defendant in the class-action lawsuit. In fact, it was not mentioned anywhere in the complaint. For this reason, the court rejected the insurance company's argument:

> Allocation is to be based on the claims that were actually settled, not on claims that could have been brought or that the class plaintiffs might have chosen to pursue, but did not.
>
> ...Allocation is improper and Raychem is entitled to summary adjudication on the issue.

Finally, Federal pointed out that the policy's definition of "wrongful acts" was limited to actions taken in a director or officer's "insured capacity." It argued that there were significant questions regarding whether the defendants were acting in their capacities as officers and directors in performing the acts giving rise to the underlying complaint. It contended that the officers and directors were acting primarily in their best interests as shareholders and were therefore not insured.

The court ruled that none of the evidence Federal sought was related to the claim that the named insureds did not undertake actions in their capacities as officers and directors. It dismissed this argument.

In this case, a policyholder was able to make the coverage apply

In short, the court ruled that Federal would have to indemnify Raychem against the costs of settling the shareholder lawsuit. The D&O coverage applied.

Insurance for directors and officers of companies shouldn't be seen as a cure-all for potential law suits but rather as a small part of a corporation's overall risk management practice.

Most policies have a long list of exclusions. The list of issues "not covered" includes: leveraged buy outs, tender offers, mergers and acquisitions, outside directors, joint ventures and greenmail.

Liability insurance started becoming scarce in the mid-1980s because many court cases found in favor of plaintiff shareholders and held the directors personally liable.

Some companies are simply doing without the insurance while others have banded together with other industry groups to form their own D&O insurance mechanisms.

A 1985 Wyatt Survey showed 18.5 percent of the companies surveyed experienced claims against their directors compared to 7.1 percent 10 years earlier.

The percentage of claims paying more than $1 million has risen from 4.8 percent to 8.3 percent during the same period. The average settlement award jumped from $385,000 to $583,000. In addition, the average cost of defending claims has skyrocketed from $181,500 per claim 10 years ago to $461,000 in 1985, according to the survey.

High premiums, high deductibles and all sorts of exclusions

"It takes three to six months for companies to even receive quotes, if they can even get quotes," said Fred Shadrick, president of Frank B. Hall & Co. of Michigan. "There are now, perhaps, four companies in the country even quoting D&O coverage and it's very, very expensive. And because of some of the conditions of the offering, it's almost no coverage because of the exclusions."

Directors and officers liability insurance is as tough as ever to find for many types of corporations across the country, and it's particularly scarce for financial institutions in the oil patch.

Either the premiums demanded by a dwindling number of insurance companies willing to write directors and officers policies in this region of the country were deemed exorbitant, or the coverage wasn't available at any price.

Insurance companies burned by losses on directors and officers policies throughout the nation are requiring insured institutions to pay much higher deductibles, are asking companies to cover an additional percentage of losses over and above the deductible themselves, and are excluding certain types of claims from D&O policies altogether.

"The insurance companies are writing policies, but they are being very selective," said insurance consultant Robert Lazarus, who keeps his finger on the pulse of the D&O market from his office near Dallas.

"Some insurers have pulled out of the market altogether, and those companies still writing policies want to do business with the cream of the crop—the top 10 percent of financial institutions," Lazarus said. "In general, the availability of the insurance is extremely limited."

The frequency of such lawsuits has led most insurance companies writing D&O policies today to exclude coverage for claims arising out of a federal regulatory agency's lawsuit.

In such cases, even when a director wins the lawsuit and proves he handled his responsibilities properly, he loses. The cost of defense in such complicated lawsuits can run into the hundreds of thousands of dollars per director, attorneys familiar with that area of the law say. And when there's no insurance coverage a director bears the cost of defense himself.

Insurance industry experts say many policies also don't cover claims

incurred when one director or officer of an institution sues a fellow director (that's called the "insured-versus insured" exclusion), claims arising out of merger or acquisition squabbles or even lawsuits that might arise in connection with loans that have been classified by a financial institution as non-performing (generally cases in which a borrower is 90 days or more past due on payments).

In fact, there are so many exclusions in D&O policies that bankers and insurance agents are wondering if they're buying any coverage at all when they plunk down big bucks for a new policy.

In many cases, outside directors have the most to lose in the event of a claim arising from a lawsuit for which they don't have insurance coverage. Their personal assets or the assets of companies they own can be at risk.

Recently, many companies have set up so-called "directors' indemnification funds" to protect current and former directors and officers from claims that might not be covered under a traditional D&O policy. This maintains full protection for key employees of the company—especially when other forms of protection are not available or have been exhausted.

Directors, officers and pollution

Directors and officers can be found liable for environmental impairment

The prospect of being held personally liable for the results of an environmental impairment is enough to send a chill up the spine of even the most seasoned director or officer. The liability can attach easily (in some cases, unavoidably), and the exposure can be monumental.

Although this threat is not new, the combination of recent events in environment circles with a developing line of court decisions has brought the risks to directors and officers to the forefront.

Courts continue to hold directors and officers personally liable for costs of investigating and remediating environmental impairments. Albeit less frequently, directors and officers are also subject to criminal penalties arising out of hazardous-waste disposal practices.

Enhanced judicial scrutiny of director and officer decisions has worked to gradually, but surely, erode the protections afforded by the Business Judgment Rule—a rebuttable judicial presumption that directors act on an informed basis and in good faith.

The Securities and Exchange Commission has developed new requirements as to disclosure of environmental liability. Failure to comply can subject a company and its directors and officers to the imposition of fines as well as spur civil action by investors. The commission has also vowed to step up enforcement actions based upon lacking or misleading environmental disclosures in annual reports.

In fact, "disclosure" cases against directors and officers in general

are on the rise as compared to other types of D&O claims, which have largely leveled off, according to the latest D&O survey done by the Boston-based Wyatt Co.

Disclosure claims are prevalent in the environmental D&O arena, perhaps because they are an easy way to target even those directors and officers who may have no connection to the company's environmental operations.

Against this backdrop, board members and top management of large and small companies are justifiably concerned.

Two types of environmental D&O claims

Recently, there have been essentially two types of environmental D&O claims. The first are actions aimed at requiring the directors and officers to share in funding the investigation and remediation of an impairment.

Many environmental statutes provide the framework for this type of claim. The most commonly employed is the Comprehensive Environmental Response, Compensation and Liability Act, also known as "CERCLA" or "Superfund." One of the four groups of "potentially responsible parties" who may be found liable to clean up an impairment under CERCLA are "owners" or "operators" if they participate in management, particularly if they participate in managing the company's handling or disposal of waste or other toxins.

The other type of claim has emerged in the form of a more "traditional" D&O action. Board members and management of companies suffering losses as a result of a pollution incident can be the target of shareholder complaints. Attempts to hold executives responsible for a hit a company takes in resolving a pollution problem arise from the perception that something could have been done to prevent the incident and/or management did not properly respond once the impairment occurred.

Possible claimants include shareholders, employees and even creditors or parties to corporate contracts (if they can prove fault and some duty owed).

Although it would seem that not much can be done to prevent the CERCLA type of D&O claim (except perhaps to insulate certain directors and officers from the type of management or control that would trigger liability), pro-active environmental risk management can do much to prevent the inclusion of directors and officers in such claims and to short-circuit the shareholder type of claim. Good environmental risk management strategy involves:

> A tailored prevention program that the organization can live up to. Worse than not having any program at all is having one that is ignored by all. A good prevention plan incorporates environmental housekeeping standards, waste minimization programs, employee safety concerns and public relations efforts.

In D&O policies, however, the absolute pollution exclusion has, by and large, been enforced by the courts. This means that without modification by endorsement, a standard D&O policy may not apply to either the CERCLA or shareholder type of environmental claim discussed here.

A director or officer may be entitled to coverage under the corporation's environmental impairment liability policy. But in the case of a series of claims, the director or officer may be at risk by sharing the aggregate limits with the corporate entity. Neither CGL, EIL nor D&O policies are likely to cover fines, penalties or multiplied damages that are sometimes a component of an environmental statutory claim.

The insurance industry is responding by offering D&O coverage by endorsement for certain specified or limited environmental liability in certain cases. The most recent development in this regard is a new domestic policy offering specific D&O pollution liability coverage. The policy would not cover a cleanup or CERCLA-type claim. But it would respond to a shareholder-type claim that relates to a pollution incident.

Chapter Ten:

Businessowners Policies

Introduction

A businessowners policy (BOP) provides a broad package of coverages for small and medium-sized apartment buildings, offices, and retail stores. Each policy includes mandatory property and liability coverages, and offers optional coverages. Many standard conditions and exclusions apply. A BOP is a self-contained, complete package policy.

BOPs were included in the commercial lines modernization and simplification program implemented by the Insurance Services Office during the 1980s. BOP forms were modernized in 1987, and minor coverage clarifications were incorporated into 1989 and 1992 revisions of the policy forms. Prior to the recent policy revisions, the organization and wording of businessowners policies resembled homeowners policies, with a few additional business coverages sprinkled in. Both types of forms were similarly divided into coverage sections—Section I being property coverage and Section II being liability coverage.

The current BOP forms are modeled after the monoline coverage components of the commercial package policy program. The same wording, organization of coverages, and design are followed. Businessowners coverage parts are attached to the policy declarations and a businessowners common conditions form. Various adjustments have been made in policy provisions to make the coverages consistent with what is provided by commercial monoline coverage forms. The revised BOP offers a combination of coverages which are similar to what might be provided by the commercial property coverage part and the commercial general liability coverage part, along with optional crime and boiler and machinery coverages.

The current policy forms allow for a modular approach to constructing a policy. Minor revisions have been made in the coverages, but the nature of the major coverages has not changed. There has been an expansion of the eligibility requirements. New types of risks, larger buildings and risks occupying larger areas of floor space are now eligible for businessowners coverage.

Eligibility

The types of risks which are eligible for a BOP include:

- apartment buildings which do not exceed six stories in height and do not have more than 60 dwelling units (incidental mercantile, service or processing risks which do not exceed 15,000 square feet, and incidental offices are permitted);

- office buildings which do not exceed six stories in height and do not exceed 100,000 square feet in total area (incidental mercantile, service or processing risks which do not exceed 15,000 square feet, and apartments within the office building are permitted);

- mercantile risks which do not exceed 15,000 square feet and do not have annual gross sales in excess of $1 million;

- service or processing risks which do not exceed 15,000 square feet and do not have annual gross sales in excess of $1 million, provided that no more than 25 percent of their gross sales is derived from off-premises operations; and

- building owners and business operators who are tenants are eligible. Residential condominium associations and office condominium associations are eligible. Service and processing risks are newly eligible for coverage (previously, mercantile risks involving retail sales of merchandise were eligible, but risks involving service or processing were not eligible).

Who qualifies for a BOP

The businessowners program is designed to provide coverage for a variety of landlords and business operators who have moderate insurance exposures. For this reason, eligibility is defined to exclude certain risks which do not fit the intended exposure pattern.

The following risks are ineligible for coverage under the program: bars, grills and restaurants, automobile dealers and all types of automotive repair and service operations, banks and all types of financial institutions, places of amusement, contractors and wholesalers.

These types of risks all have special insurance exposures, and must be insured outside of the businessowners program.

Components of a businessowners policy

Each BOP is a complete contract and must include the following parts:

- the businessowners policy declarations,
- the businessowners common policy conditions,
- a standard or special property coverage form (one or the other),
- the businessowners liability coverage form, and

- endorsements as required.

Policy declarations and conditions

The policy declarations will show the policy number, name of the insurance company, name of producer, name and address of the named insured, and the policy period. Spaces are provided for a description of the business, the form of business, locations of described premises, and name and address of any mortgage holder.

Limits of insurance will be shown for buildings and for business personal property. Limits of insurance for optional coverages will be shown, and optional coverages will apply, only if the appropriate boxes are checked indicating that optional coverages apply.

Conditions that shape BOP coverage

There are 11 common policy conditions that are attached to every BOP. The form includes the same six common conditions that apply to a commercial package policy, plus five additional conditions. Other applicable conditions will be found separately in the property and liability forms which are part of the complete policy. A sample of the businessowners common policy coverages and endorsements is included at the end of this chapter for you to review.

The first condition addresses cancellation. The "first named insured" shown in the declarations may cancel at any time by giving advance written notice to the insurance company. If the insurance company cancels, it must give written notice to the first named insured at least five days in advance if special circumstances apply, or 10 days in advance if the reason is nonpayment of premium, and at least 30 days in advance if cancelling for any other reason.

The provisions allowing for only five days notice in special circumstances are built in to the businessowners form (these are attached to other commercial property coverages by endorsement). The shorter notice time is permitted if the building has been vacant or unoccupied for 60 or more consecutive days, or if repairs for insured damages have not been started or contracted for within 30 days after payment for a loss, or if the building has been declared unsafe or has an outstanding order to be vacated or demolished. Reduced notice is also allowed when property taxes are more than one year overdue (unless the taxes are in dispute), or if certain items are being removed, or if heat, water, sewer service or electricity have not been furnished for 30 days. These cancellation provisions may be amended by endorsement in certain states to satisfy state regulations.

The second condition concerns policy changes. All agreements between the parties to the contract are contained in the policy. The first named insured shown in the declarations is authorized to make changes in the policy terms only with the insurance company's consent. Terms can be changed or waived only by endorsement issued by the insurance company and attached to the policy.

Concealment, misrepresentation and fraud are addressed by the next condition. The policy will be void in the case of fraud by the named insured. It will also be void if any insured intentionally conceals or misrepresents a material fact concerning the policy, the covered property, insurable interest in the covered property, or a claim under the policy.

A brief condition mentions that the insurance company may, to the extent that it relates to the insurance, examine the books and records of the named insured, and may make an audit, during the policy period and up to three years afterward.

The insurance company can make inspections and surveys

The next condition establishes the right of the insurance company and rating organizations to make inspections and surveys, to report on findings, and make recommendations for the purpose of establishing insurability and determining premium charges. An inspection will not constitute a warranty that the property or operations are safe, healthful, or in compliance with any law.

If two or more coverages of the policy apply to the same loss or damage, the insurance company will not pay more than the actual loss or damage.

A liberalization condition states that the insurance company will automatically and immediately apply to the policy any revisions made during the policy period or within 45 days prior to the effective date if those revisions broaden the coverage without additional premium.

In the event of other insurance covering the same loss or damage as this policy, the insurance company will only pay the amount of covered loss or damage in excess of the amount due from the other insurance company, whether collectible or not. Liability coverage will always be excess over any coverage that insures for direct loss or damage. When the insurance is excess, the insurance company has no duty to defend any claim or suit that any other insurance company has a duty to defend, but will undertake to do so if no other insurance company defends.

A condition on premiums specifies that the first named insured shown in the declarations is responsible for all premium payments, and will be paid any return premiums. The premium shown in the declarations is based on rates in effect and exposures known at the time the policy was issued. At each renewal or anniversary date, the insurance company will compute the premium due based on rates and rules then in effect. Any undeclared exposures or change in business operations may require an additional premium, which will also be determined in accordance with rules and rates then in effect.

The next condition involves transfer of rights of recovery, which is the standard subrogation clause. If any person or organization to or for whom payment is made under the policy has rights of recovery against another, those rights must be transferred to the insurance company

to the extent of the payment made. That person must do everything necessary to secure those rights and do nothing after a loss to impair them. However, you may waive rights against another party in writing prior to a loss, or after a loss—if that other party is insured under the policy or a business owned or controlled by you or your tenant.

The final condition prohibits a transfer of rights under the policy without the insurance company's consent, except in the case of death of a named insured. In earlier policies this provision was known as an "assignment clause." If a named insured dies, his or her rights and duties under the policy are automatically transferred to his or her legal representative, or to anyone having temporary custody of the property until a legal representative is appointed.

Standard or special property coverage

Two types of property coverage under a BOP

Property coverage must be written on either the standard or the special property coverage form. The two forms may not be combined. Most coverages provided by the two forms are identical. The major differences are in the "covered causes of loss"—"standard" coverage is similar to "basic" coverage provided by other commercial forms, while "special" coverage means the same "all risk" type coverage provided by the special causes of loss form. There are minor differences in the optional coverages available with each form.

However, the major property coverages are the same and businessowners property coverage can be discussed as a single topic.

Both businessowners forms provide the following two major coverages:

- Coverage A—Building(s), and
- Coverage B—Business personal property.

A limit of insurance must be shown in the declarations for each type of property covered. For example, an insured business that is a tenant would not require the building coverage.

Building coverage means the buildings and structures described in the declarations. The coverage also applies to completed additions; fixtures, machinery and equipment which are permanently installed; your personal property in apartments or rooms furnished by you as landlord; outdoor fixtures; and your personal property used for service or maintenance of the building or its premises (such as fire extinguishers, outdoor furniture, floor coverings and appliances used for refrigerating, ventilating, cooking, dishwashing or laundering).

If not covered by other insurance, building coverage also includes additions under construction, building alterations and repairs, and materials, equipment, supplies and temporary structures on or within 100 feet of the premises used for making additions, alterations or repairs to the buildings or structures.

Coverage for business personal property has traditionally been known as "contents" coverage. But it includes more than building contents because it applies to property of the named insured located in or on the described building, or within 100 feet of the described premises while in a vehicle or out in the open.

Personal property includes property owned by you and used in your business; property of others in your care, custody or control; and your interest as a tenant in "improvements and betterments" made at your own expense but which cannot be legally removed. Coverage for the property of others is limited to the amount for which you are legally liable, plus the cost of labor, materials or services furnished by you.

Providing additional coverage under a BOP

In addition to the coverage for direct loss to insured property by covered causes of loss, a BOP provides a number of additional coverages. The standard policy form has six additional coverages, and the special form adds two more for a total of eight. The additional coverages are:

- debris removal expenses,
- loss to property while removed from the premises to preserve it from loss,
- fire department service charges,
- business income,
- extra expense,
- pollutant cleanup and removal,
- collapse (special form only), and
- damage by water or other substances (special form only).

Expenses of removing the debris of covered property will be covered when the debris results from a covered property loss. These expenses are paid only if reported to the insurance company in writing within 180 days of the date of loss. The most the insurance company will pay for debris removal is 25 percent of the amount paid for direct loss plus the applicable deductible. However, if debris removal expense exceeds that 25 percent threshold, or if the combined amount of loss and debris removal expense exceeds the policy limit, the insurance company will pay up to an additional $5,000 for debris removal at each location.

The preservation of property coverage, traditionally called removal coverage, applies to direct loss or damage to covered property while it is being moved or temporarily stored at another location for the purpose of protecting it from a covered cause of loss. This coverage applies only for loss or damage occurring within 10 days after the property is first moved.

If the fire department is called to protect covered property from a covered loss, the insurance company will pay up to $1,000 of your liability for fire department service charges if those charges are required by local ordinance or are assumed by contract or agreement prior to the loss.

Removal, restoration and collapse coverages

If it is necessary to suspend operations because of direct physical loss caused by a covered cause of loss, the insurance company will pay for loss of business income during a period of restoration. It will only pay for loss of business income that occurs within 12 consecutive months after the date of loss. This additional coverage is not subject to the limits of insurance shown on the policy.

The insurance company will also pay extra expenses incurred during a period of restoration for the purpose of avoiding or minimizing a suspension of operations. This coverage also applies only during the 12 consecutive months following a direct loss, and is not subject to the limits of insurance.

The insurance company will pay the expenses to extract pollutants from land and water at the described premises if the release or discharge of pollutants is caused by a covered cause of loss during the policy period. These expenses are paid only if reported to the insurance company in writing within 180 days of the date of loss. The most the insurance company will pay for loss at each location is $10,000 for all such expenses during each 12-month period of the policy.

Coverage for loss caused by collapse of a building or part of one is provided only on the special form. This is standard collapse coverage which is provided by broad forms and special forms of the commercial property policy. It applies only to loss involving collapse caused by a cause of loss which is not excluded, or by the specific perils of breakage of building glass, hidden decay, hidden insect or vermin damage, weight of people or personal property, weight of rain that collects on a roof, or defective building materials or building methods.

If a covered loss by water or other liquid, powder or molten material occurs, the special form also covers the cost to tear out and replace any part of the building or structure to repair damage to the system or appliance from which the water or other substance escaped. It will not pay the cost of repairing any defect in the system which caused the damage, except for repair or replacement of damaged parts of fire extinguishing equipment if the damage resulted in discharge of any substance from such system or is directly caused by freezing.

Coverage extensions

The businessowners standard and special property forms provide the same four extensions of coverage, which are in addition to the limits

of insurance shown on the policy. The extensions of coverage available are:

- personal property at newly acquired premises,
- personal property off premises,
- outdoor property, and
- valuable papers and records.

Using the BOP to cover recent acquisitions and other property

You may extend the coverage for business personal property to apply at any premises newly acquired. The most the insurance company will pay under this extension is $10,000 at each premises. Coverage under this extension will end as soon as any of the following occur: the policy expires, you report actual values to the insurance company, or 30 days expire after the date the premises is acquired or construction begins. An additional premium will be charged from the date of acquisition for the new values reported.

You may extend the coverage for personal property to apply to covered business personal property, other than money or securities, while off premises in the course of transit or temporarily at a premises you do not own, lease or operate. The most the insurance company will pay for loss or damage under this extension is $1,000.

You may extend the insurance to apply to outdoor property, such as fences, radio and television antennas, signs which are not attached to buildings, trees, shrubs, plants, including debris removal expense, for losses resulting from the specific perils of (1) fire, (2) lightning, (3) explosion, (4) riot or civil commotion, or (5) aircraft. The most the insurance company will pay for loss under this extension is $1,000, and not more than $250 for any one tree, shrub or plant.

You may extend the coverage that applies to business personal property to apply to the costs of researching, replacing or restoring the lost information on valuable papers and records which have suffered loss or damage, including those which exist on electronic or magnetic media for which duplicates do not exist. The most the insurance company will pay under this extension is $1,000 at each described premises.

Property that is not covered by a BOP

Both businessowners forms list the same items as "property not covered." Some items are not insurable (i.e., contraband), while others are more appropriately the subject for other types of insurance (i.e., automobiles). Covered property does not include:

- aircraft, automobiles, motor trucks and other vehicles subject to motor vehicle registration,
- bullion, money and securities,
- contraband, or property in the course of illegal transportation or trade,

Chapter Ten: Businessowners Policies

- land (including land on which the property is located), water, growing crops or lawns,
- outdoor fences, radio or television antennas, including lead-in wires, masts or towers, signs which are not attached to buildings, trees, shrubs or plants, except as provided in the extension of coverage for outdoor property, or the outdoor signs optional coverage, and
- watercraft (including motors, equipment and accessories) while afloat.

Covered causes of loss—standard policy

A named perils form Businessowners property coverage forms include "causes of loss" sections, and separate causes of loss forms are not attached. The businessowners standard property coverage form is a named perils form, and the covered causes of loss listed are:

- fire,
- lightning,
- explosion, including explosion of gases or fuel within the furnace or flues of any fired vessel,
- windstorm or hail damage to building exteriors,
- smoke damage which is sudden and accidental,
- aircraft or vehicle damage resulting from direct physical contact with an aircraft, missile, object falling from an aircraft, vehicle or object thrown up by a vehicle (but not damage caused by vehicles the named insured owns or operates),
- riot or civil commotion including acts of striking employees while occupying the described premises, and looting at the time and place of a riot or civil commotion,
- vandalism meaning willful and malicious damage to property, including damage caused by burglars breaking in or exiting, and including damage to glass building blocks,
- sprinkler leakage or discharge from any automatic fire protective sprinkler system, including collapse of a tank that is part of the system,
- sinkhole collapse, meaning the sudden sinking or collapse of land into underground empty spaces created by the action of water on limestone or dolomite (but the cost of filling sinkholes is not an insured loss, and coverage does not apply to sinking or collapse of land into man-made underground cavities),
- volcanic action, meaning direct loss resulting from volcanic

eruption when the loss is caused by lava, ash, dust, particulate matter, or airborne shock waves or volcanic blast (the cost of removing ash, dust or particulate matter that does not cause direct loss or damage is not covered). All volcanic eruptions that occur within any 168-hour period constitute a single occurrence,

The BOP does offer transportation coverage

- transportation, meaning loss or damage caused by collision, derailment or overturn of a vehicle, the stranding or sinking of vessels, and collapse of bridges, culverts, piers, wharves or docks (this applies only to covered property in course of transit).

Except for the last, the above causes of loss are identical to those listed on the commercial property "basic" causes of loss form, and the meanings of the terms and limitations are the same. The businessowner form has an additional cause of loss, "transportation," which is included because the policy specifically covers personal property off premises while it is being transported.

Exclusions—standard policy

The standard BOP includes a number of typical property insurance exclusions, which have the same meaning as they do on other forms. Loss or damage caused directly or indirectly by any of the following is excluded:

Standard BOP exclusions are familiar from other coverages

- building ordinance or law,
- earth movement (other than sinkhole collapse), including earthquake, volcanic eruption, landslide and mine subsidence,
- governmental action,
- nuclear hazard,
- power failure,
- war and military action, and
- water (flood, waves, mudflow, etc.).

The standard form also excludes loss or damage caused by the following items, which may be slightly different than similar exclusions on other policies because of the nature of businessowners coverage:

- electrical apparatus, including artificially generated current and arcing that disturbs electrical devices, appliances, or wires,
- rupture or bursting of water piping (other than automatic sprinkler systems), unless caused by a covered cause of loss,
- leakage or discharge of water or steam from the breaking or cracking of any part of a system or appliance containing

water or steam (other than an automatic sprinkler system), unless first damaged by a covered cause of loss,

- explosion of steam boilers, steam pipes, steam engines or steam turbines which are owned, leased, operated or controlled by the named insured, and

- mechanical breakdown, including rupture or bursting caused by centrifugal force.

With respect to business income and extra expense coverages, the insurance company will not pay for any increase in the business income loss or the amount of the extra expenses resulting from (1) a delay in repairing, rebuilding or replacing property or restoring operations due to interference by strikers or other persons, or (2) suspension, lapse or cancellation of any license, lease or contract, or (3) any other consequential loss.

Covered causes of loss—special policy

Additional exclusions under the special policy

Because the special form is an all risks policy, coverage provided by the special form is shaped by policy exclusions and limitations. The special policy form excludes loss or damage caused by or resulting from:

- building ordinance or law,
- earth movement (other than sinkhole collapse), including earthquake, volcanic eruption, landslide and mine subsidence,
- governmental action,
- nuclear hazard,
- power failure,
- war and military action,
- water (flood, waves, mudflow, etc.),
- electrical apparatus, including artificially generated current and arcing that disturbs electrical devices, appliances, or wires,
- consequential losses, including delay, loss of use, or loss of market,
- smoke, vapor or gas from agricultural smudging or industrial operations,
- explosion of steam boilers, steam pipes, steam engines or steam turbines which are owned, leased, operated or controlled by the named insured,
- frozen plumbing, including damage by leaking water, other liquids, powder or molten material from plumbing, heating,

air conditioning or other equipment (except fire protective systems), unless you attempted to maintain heat in the building, or shut off the water supply and drained the equipment,

- dishonesty or criminal acts by the named insured, or your partners, employees, directors, trustees, authorized representatives, or anyone entrusted with property,
- voluntary parting with property if induced to do so by any fraudulent scheme, trick, device or false pretense,
- rain, snow, ice or sleet to personal property out in the open,
- collapse, except as provided in the additional coverage for collapse,
- the release, discharge, dispersal, seepage, migration or release of pollutants, unless it is caused by one of the "specified causes of loss" which are defined in the policy (fire, lightning, extended coverage perils, vandalism, leakage from fire extinguishing equipment, sinkhole collapse, volcanic action, falling objects, weight of snow or ice or sleet, or water damage),

Maintenance losses and normal wear and tear are not covered

- maintenance types of losses, such as wear and tear, rust, corrosion, fungus, hidden defects, smog, settling or cracking, infestation by insects or birds or small animals, mechanical breakdown, dampness or dryness, changes in or extremes of temperature, and marring or scratching,
- weather conditions,
- acts or decisions, or the failure to act or decide, of any person, group, organization or government body, and
- faulty, inadequate or defective planning, zoning, development, design, workmanship, construction or repair (or materials used in construction, repair or remodeling), or maintenance.

With respect to business income and extra expense coverages, the insurance company will not pay for any increase in the business income loss or the amount of the extra expenses resulting from (1) a delay in repairing, rebuilding or replacing property or restoring operations due to interference by strikers or other persons, or (2) suspension, lapse or cancellation of any license, lease or contract, or (3) any other consequential loss.

In addition to the applicable exclusions, the special form has the following limitations which either exclude certain types of losses or cap the amount of particular coverages. The policy will not pay for loss or damage:

- to steam boilers, steam pipes, steam engines or steam tur-

bines caused by or resulting from any condition or event inside such equipment (except the explosion of gases or fuel within a fired vessel, which is covered),

- to hot water boilers or water heating equipment caused by any internal condition other than an explosion,
- to property that is missing if there is no evidence to show what happened to it, such as an inventory shortage (this does not apply to optional coverage for money and securities),
- to property that has been transferred to a person or place outside the described premises on the basis of unauthorized instructions,
- to glass parts of a building or structure (other than glass building blocks) in excess of $100 per plate, pane, insulating unit, radiant or solar panel, or in excess of $500 per occurrence for all such losses (this does not apply to losses by the "specified causes of loss," except vandalism),
- to fragile articles, such as glassware, statuary, marbles, chinaware or porcelains, if broken, unless caused by the "specified causes of loss," or to building glass breakage (but this restriction does not apply to glass parts of a building or structure, containers of property held for sale, or photographic or scientific instrument lenses), and
- for loss by theft (1) in excess of $2,500 for furs, fur garments, and garments trimmed with fur, or (2) in excess of $2,500 for jewelry, watches, watch movements, jewels, pearls, precious and semi-precious stones, bullion, gold, silver, platinum, and other precious alloys or metals, or (3) in excess of $2,500 for patterns, dies, molds, and forms.

Limits and deductibles

On both businessowners coverage forms, the most the insurance company will pay for loss or damage in any one occurrence is the applicable limit of insurance shown in the declarations. However, there are some exceptions: the limit for loss or damage to outdoor signs attached to buildings is $1,000 per sign, per occurrence; and the limits stated in the additional coverages for "fire department service charges" and "pollutant cleanup and removal," plus all limits applicable to the "coverage extensions" are in addition to the limits of insurance.

A built-in automatic increase in limits

To allow for inflation, businessowners policies have a built-in automatic increase in the building limit. On each policy anniversary date, the limit of insurance for buildings will automatically increase by 8 percent unless a lower or higher percentage is shown in the declarations. Permissible percentages range from 2 percent to 16 percent

and the percentage shown must be an even increment of 2 percent. If any building was added or policy limits were changed during a policy year, the annual increase in limit will be adjusted by dividing the number of days since the last policy change by 365.

The limit for business personal property will automatically increase by 25 percent to provide for seasonal variations, but only if the limit of insurance written is at least equal to 100 percent of your average monthly values during the 12 months immediately before the date of loss, or during the period of time you have been in business if less than 12 months.

The standard deductible for property losses is $250 per occurrence, but no deductible applies to the additional coverages for fire department service charges, business income loss and extra expenses. Higher deductibles may be written, and the premium will be adjusted accordingly. Regardless of the amount of the deductible written, the most the insurance company will deduct for loss or damage under optional coverages for money and securities, employee dishonesty, exterior or interior glass, and outdoor signs is $250 for any one occurrence.

Property coverage conditions

Each businessowners property form has two sets of conditions—a set of property loss conditions, and a set of property general conditions.

Loss conditions that apply to BOP property coverage

Under loss conditions, the forms contain standard property insurance provisions regarding abandonment, appraisal, insured's duties in the event of loss, legal action against the insurance company, and payment of losses. A special limitation applies to business income losses resulting from loss or damage to electronic records—such losses will not be covered beyond the longer of 60 days from the date of loss, or the end of the period necessary to repair or replace property other than records.

Valuation of buildings will normally be at replacement cost, but if the "actual cash value" option applies, buildings will be valued at ACV. Some types of property will always be valued at ACV. If a valuable papers and records loss occurs, coverage will be limited to the cost of blank materials and the cost of labor to transcribe or copy the records.

After payment of a loss, if any party recovers property, the other party must be promptly notified. The insurance company may allow you to retain recovered property, but any amount paid for loss will have to be returned to the insurance company. A condition on resumption of operations says that the insurance company will reduce business income losses and extra expense losses to the extent that operations can be resumed.

A vacancy condition states that if a building where loss occurs has

been vacant for more than 60 days, there will be no coverage for loss by vandalism, sprinkler leakage (unless precautions were taken against freezing), building glass breakage, water damage, theft or attempted theft, and the insurance company will reduce by 15 percent the amount of any other losses covered by the policy. This is because a vacant building represents a greater exposure than one that is occupied.

Under the general conditions, the forms include standard provisions concerning control of property (acts or neglect by a person outside of your control will not affect the insurance), mortgage holders, no benefit to bailee, policy period and coverage territory.

Optional coverages

Other coverages that a BOP can offer

Each form includes a number of optional coverages which may be activated by declarations entries. Most of these are the same on the standard and special coverage forms, but there is one exception—coverage for "burglary and robbery" is available only under the standard form, while broader coverage for "money and securities" is available only under the special form. The optional coverages are:

- outdoor signs,
- exterior glass,
- interior glass,
- burglary and robbery (standard form only),
- money and securities (special form only),
- employee dishonesty, and
- mechanical breakdown.

The coverage forms only provide limited coverage for outdoor signs (coverage for those attached to buildings is limited to $1,000 per sign, while under the extensions of coverage signs not attached to buildings are covered for $1,000 subject to limited perils). You may purchase additional coverage for outdoor signs, in which case a limit of insurance will be shown in the declarations.

Separate coverages may be written for exterior and interior building glass. When either coverage is written, it supersedes the $100 per pane and $500 per occurrence policy limitations that otherwise apply to glass losses. Exterior glass coverage applies to glass that is part of the exterior of a covered building or structure, including lettering and ornamentation. Interior glass coverage applies to glass items that are permanently affixed to the interior walls, floors or ceilings of a covered building or structure, and which are described in the declarations. Both glass coverages also include coverage for the expenses incurred to put up temporary frames, to board up openings, to repair or replace frames, and to remove obstructions.

The standard coverage form has an option for burglary and robbery coverage. Inside the premises, coverage applies to loss or damage to business personal property, including money and securities, because of a burglary or a robbery. Outside the premises, coverage applies to money and securities while at a bank or savings institution, within the living quarters of the named insured or someone having lawful custody of the property, and in transit between any of these places and the insured premises.

Providing coverage for money and securities

The special coverage form also has an option for money and securities coverage, which provides broader protection for this type of property. Coverage applies to money and securities while at the described premises, while at a bank or savings institution, while at the quarters of the named insured or a partner or an employee, and while in transit between any of these locations. Losses resulting from theft, destruction or disappearance are covered—this includes many more perils than "burglary and robbery," and even includes mysterious disappearance.

Both BOP forms offer the same optional coverage for employee dishonesty. Coverage applies to loss of business personal property, including money and securities, resulting from dishonest acts of employees. Losses that result from any criminal or dishonest acts of the named insured or any partners are not covered. This coverage carries a "discovery period" of one year after the policy expiration date, and losses discovered after that time will not be covered.

Both BOP forms also offer optional coverage for mechanical breakdown, which is a boiler and machinery coverage. This coverage applies to direct damage to covered property caused by the sudden and accidental breakdown of an "object" which results in actual physical damage to the object and necessitates repair or replacement. "Object" means boiler and pressure vessels, including expansion tanks, piping and valves, and air conditioning units having a capacity of 60,000 BTU's or more.

An "accident" does not include deterioration, wear and tear, breakdown of a computer, the functioning of any safety or protective device, or the explosion of gases or fuel. This coverage, like other boiler and machinery coverages, gives the insurance company the right to suspend the insurance when a defect, dangerous condition or special risk of loss is known to exist. Whenever an object is known to be exposed to such a condition or risk, the insurance company or any of its representatives may immediately suspend the coverage.[1]

BOP property definitions

Key definitions in a BOP

As stated in previous chapters, definitions in an insurance policy are very important—especially when disputes over coverage arise.

[1] For a more detailed discussion of boiler and machinery coverage, see Chapter 3.

Chapter Ten: Businessowners Policies

"Money" means currency, coins, bank notes in current use and having a face value, travelers checks, register checks, and money orders held for sale to the public.

"Operations" means your business activities occurring at the described premises.

"Period of restoration" means the period of time that:

- begins with the date of physical loss or damage caused by or resulting from any covered cause of loss at the described premises, and
- ends on the date when the property at the described premises should be repaired, rebuilt or replaced with reasonable speed and similar quality.

"Period of restoration" does not include any increased period required due to the enforcement of any law that regulates the construction, use or repair of property, or requires the tearing down of any property, or that requires you or others to test for, monitor, clean up, remove, contain, detoxify or assess the effects of pollutants.

Business income and extra expense coverage is not affected by policy expiration, and the expiration date of the policy will not cut short any "period of restoration."

Pollutants means any solid, liquid, gaseous or thermal irritant or contaminant, including smoke, vapor, soot, fumes, acids, alkalis, chemicals and waste. "Waste" includes materials to be recycled, reconditioned or reclaimed.

Securities means negotiable and non-negotiable instruments or contracts representing money or other property. This term includes tokens, tickets, revenue stamps and other stamps in current use, and evidences of credit card debt, but does not include "money."

The specified causes of loss in a BOP

Specified causes of loss means only the following—fire, lightning, explosion, windstorm or hail, smoke, aircraft or vehicles, riot or civil commotion, vandalism, leakage from fire extinguishing equipment, sinkhole collapse, volcanic action, falling objects, weight of snow, ice or sleet, and water damage.

Sinkhole collapse means the sudden sinking or collapse of land into underground empty spaces created by the action of water on limestone or dolomite. Coverage does not include the cost of filling sinkholes, or losses resulting from the sinking or collapse of land into man-made underground cavities.

Coverage for falling objects does not include loss of or damage to personal property out in the open, or to the interior of a building or structure and contents within a building or structure unless the roof or an outside wall is first damaged by a falling object.

Water damage means accidental discharge or leakage of water or steam

as the direct result of the breaking or cracking of any part of a system or appliance containing water or steam.

BOP property endorsements

Some optional coverages are not activated by declarations entries, and endorsements must be attached to make the coverage effective.

An endorsement may be used to attach accounts receivable coverage to a BOP. The coverage is very similar to what is provided by the monoline accounts receivable coverage form. When applicable, it will pay amounts due from your customers which cannot be collected because of loss or damage to records by a covered cause of loss, plus interest charges on loans required to offset uncollectible accounts due, and collection expenses in excess of normal amounts.

Another endorsement provides valuable papers and records coverage, which is also similar to its monoline counterpart. Valuable papers and records coverage has traditionally been used to insure against loss or damage to inscribed, printed or written documents, manuscripts and records, such as books, deeds, drawings, films and mortgages. Coverage does not apply to money or securities.

With the latest revision of the policy forms, optional coverage is now also available for electronic media and records, such as data processing storage media, stored data, and programming records.

An earthquake form may be attached to a BOP to add coverage for earthquake and volcanic eruption losses. Coverage will continue for up to 168 hours after policy expiration if an earthquake or volcanic eruption "event" begins before the policy expires.

Among the other available endorsements are a number of forms for condominium risks. One provides condominium association coverage, while another provides coverage for condominium commercial unit-owners coverage. These forms follow their commercial property counterparts and alter certain policy provisions to address the unique ownership situation when condominiums are insured. Commercial condominium unit owners may also purchase a unit-owners optional coverages endorsement.

Liability coverages

The businessowners liability coverage form provides the following two major coverages:

- business liability, and
- medical payments.

How a BOP handles liability issues

The business liability insurance covers your legal liability for damages because of bodily injury or property damage, and it also covers personal injury and advertising injury. This broad definition of "business liability" is very similar to the combination of Coverages A and B

in a commercial general liability form. Businessowners coverage for BI and PD is always written on an "occurrence" basis. Coverage includes fire legal liability coverage, for which a separate limit of insurance for any one fire or explosion will be shown in the declarations.

The insurance company provides defense costs and the standard set of supplementary payments found on liability policies (i.e., cost of bail bonds, settlement expenses, loss of earnings, prejudgment and postjudgment interest on amounts awarded).

The medical expense insurance covers medical expenses for bodily injury caused by an accident on premises you own or rent, including the ways next to such premises, or an accident because of your operations. Medical expenses incurred within one year of the accident date are covered, and payments are made without regard to fault or negligence.

The businessowners liability form includes a long list of exclusions. In total these are similar to the combined exclusions applicable to bodily injury and property damage liability, personal injury, advertising injury, and medical payment coverages found on commercial general liability forms. You should be aware of the types of exclusions applicable to these coverages. Some of the exclusions are complex and very detailed. Rather than repeat the entire exclusions, the following list is presented in summary fashion.

BOP liability coverage comes with a long list of exclusions

The businessowners liability coverage form does not cover:

- bodily injury or property damage expected or intended by you,
- bodily injury or property damage assumed under contract or agreement other than an "insured contract,"
- liquor liability (this only applies to an insured business that manufactures, distributes, sells, serves or furnishes alcoholic beverages),
- obligations under any workers compensation, disability benefits, unemployment compensation law or similar law,
- bodily injury to any employee arising out of and in the course of employment by you,
- bodily injury or property damage arising out of actual, alleged or threatened discharge, release or escape of pollutants,
- bodily injury or property damage arising out of the ownership, maintenance, use or entrustment to others of any aircraft, auto or watercraft owned or operated by, or rented or loaned to, an insured businessowner,
- bodily injury or property damage arising out of the transportation of mobile equipment by an auto owned or operated by, or rented or loaned to, an insured businessowner,

- bodily injury or property damage arising out of the use of mobile equipment in, or while in practice or preparation for, any prearranged race, speed or demolition contest, or any stunting activity,
- bodily injury or property damage due to war,
- bodily injury or property damage due to rendering or failing to render professional services,
- property damage to property you own, rent or occupy, or property in your care, custody or control,
- property damage to your product,
- property damage to your work arising out of any part of it and included in the "products-completed operations hazard,"
- property damage to "impaired property" or to property that has not been physically injured arising out of a defect or deficiency in your product or work, or a delay or failure to perform a contract or agreement,
- damages claimed for any loss, cost or expense because of loss of use, withdrawal, recall, repair, removal or disposal of your product, work, or impaired property,

More BOP liability exclusions

- personal or advertising injury arising out of publication of material by or at your direction with the knowledge that it is false, or arising out of any willful violation of a penal statute or ordinance by or with your consent,
- personal or advertising injury arising out of any material first published before the beginning of the policy period, or for which you have assumed liability under a contract or agreement,
- advertising injury arising out of breach of contract, or failure of goods, products or services to conform with advertised performance, or the wrong description of the price of goods, products or services,
- advertising injury arising out of an offense committed by an insured businessowner who is in the business of advertising, broadcasting, publishing or telecasting,
- medical expenses for bodily injury to you, or a person hired to work for you, or a tenant of any insured businessowner,
- medical expenses for bodily injury to a person injured on that part of your premises that the person normally occupies,
- medical expenses for bodily injury to any person if the bodily injury is covered by a workers compensation or disability benefits law, or similar law,

- medical expenses for bodily injury to any person injured while taking part in athletics,

- medical expenses for bodily injury to any person if the injury is excluded under the "business liability" coverage, or is included within the "products-completed operations hazard," or is caused by war, and

- business liability or medical expenses resulting from the hazardous properties of nuclear materials (this exclusion is not found on a CGL form, but the broad form nuclear energy liability exclusion endorsement is always attached to CGL coverage).

A case involving the liquor liability in a BOP

The 1995 federal district court decision *Audubon Insurance Co. v. Terry Road Wine and Liquor et al.* is a good example of how BOP disputes occur. The case involved the liquor liability exclusion.

Audubon issued Terry Road, a retailer licensed by the state of Mississippi to sell alcoholic beverages, a businessowners insurance policy. This policy provided for a period of coverage extending from September 22, 1993, to September 22, 1994.

Around April 1, 1994, Melissa and Donald May—a married couple—filed two separate lawsuits in the Circuit Court of the First Judicial District of Hinds County, Mississippi. Terry Road was named as a defendant in both of these suits.

In both of these lawsuits, the Mays alleged that on or about November 24, 1993, Terry Road:

> [S]old a fifth of tequila to Donald R. May, a minor, who was under twenty-one (21) years of age, without asking for any identification or checking in any fashion or taking any reasonable steps to determine whether said minor was old enough to purchase beer or determine the minor's age. Said sale was in violation of [Mississippi state law].

In view of the alleged illegal sale of alcohol to Donald May, the Mays asserted that Terry Road was liable for the injuries that they both suffered when Ronnie White, the driver of the automobile in which the Mays were riding as passengers, consumed the ill-gotten alcohol.

The Mays alleged that White became intoxicated to the point that his ability to drive became impaired and he lost control of the automobile, ran off the roadway and collided with a tree.

By alleging that the illegal sale of alcohol was the direct and proximate cause of the automobile accident, the Mays argued for a ruling of liability against Terry Road on various theories of negligence, including the theory of negligence per se based upon violation of statute.

In each of their complaints, the Mays asked for monetary relief in the

form of both compensatory damages for their actual injuries and punitive damages for the alleged recklessness or gross negligence of Terry Road and its employees in selling Donald May the tequila.

Audubon, reserving the right to deny coverage later, undertook the defense of Terry Road in the two Circuit Court actions.

On June 9, 1994, Audubon filed the present action seeking a declaration that it is under no duty under the terms of its insurance policy to either defend or indemnify Terry Road with respect to either of the Mays' two actions.

The Audubon BOP issued to Terry Road set the following general coverage provision:

> We will pay those sums that the insured becomes legally obligated to pay as damages because of "bodily injury," "property damage," "personal injury" or "advertising injury" to which this insurance applies. We will have the right and duty to defend any "suit" seeking those damages.

Despite that condition, the Audubon policy contained the following policy exclusion:

> This insurance does not apply to:
>
> ..."Bodily injury" ...for which any insured may be held liable by reason of:
>
> 1) Causing or contributing to the intoxication of any person;
>
> 2) The furnishing of alcoholic beverages to a person under the legal drinking age or under the influence of alcohol; or
>
> 3) Any statute, ordinance or regulation relating to the sale, gift, distribution or use of alcoholic beverages.
>
> This exclusion applies only if you are in the business of manufacturing, distributing, selling, serving or furnishing alcoholic beverages.

The policy defined the term "bodily injury" as "bodily injury, sickness or disease sustained by a person, including death resulting from any of these at any time."

The illegal sale of alcohol to a minor

The first of the May complaints alleged that as a result of the illegal sale of an alcoholic beverage to a minor, Melissa May suffered severe injury when the automobile in which she was a passenger was involved in an accident. The complaint sought compensation on the basis of the following allegations of injury resulting from this accident:

> [T]he plaintiff, Melissa A. May, has suffered serious and permanent bodily injury consisting of a severe fracture to the neck which has left her permanently paralyzed, numerous bruises, abrasions and contusions to other parts of her body, along with injury to her

skeletal system, muscular system and nervous system. That as a result of her injuries she has had to be treated by doctors and other practitioners and has been caused to suffer great pain, severe shock and intense mental anguish and will suffer more of the same in the future. That after everything has been done that medical science can do, the plaintiff, Melissa A. May, will be permanently paralyzed for the rest of her life. The defendant's negligence has directly caused the plaintiff to have already incurred hospital, medical and drug bills in a large amount and she can reasonably expect to incur extensive medical and medical related expenses in the future for her treatment and care for the rest of her life. Plaintiff would further show that because of her paralysis she has suffered a permanent loss of wage earning capacity as a result of this accident due to the fact that she will never be gainfully employed.

The Mays argued that the exclusion found in the alcohol/intoxication clause was ambiguous. The court found that this argument without merit, ruling:

> Clearly, Melissa May's allegations of injury comprises the types of injuries for which the alcohol/intoxication clause in the Audubon policy excludes coverage.

Accordingly, the court ruled that Audubon had no duty under the terms of its policy to defend or indemnify Terry Road.

Allegations of injury were excluded by the policy

The second May complaint included allegations regarding the cause of Donald May's injuries which were virtually identical to those included in the first complaint.

Likewise, in terms of the specific injuries which Donald May alleged he suffered as a result of the illegal sale of alcohol and the subsequent accident, Donald May's complaint also contained detailed accounts of physical and mental injury and suffering.

These injuries also clearly fell within the scope of the alcohol/intoxication exclusion. The court ruled that Audubon had no duty to indemnify Terry Road.

Donald May's complaint, however, also prays for compensation for loss of consortium and loss of the household services of his wife. The court found this argument more compelling:

> Bearing in mind the well recognized principle that in the insurance context, the contract of insurance is to be strictly construed against the drafter, the Court rules that injuries for loss of consortium do not fit within the definition of "bodily injury" included in the policy. Simply put, they do not qualify as "bodily injury, sickness or disease sustained by a person, including death resulting from any of these at any time." Therefore, they do not fit within the scope of the alcohol/intoxication clause....

INSURING THE BOTTOM LINE

By its express terms, the general coverage provision in the Audubon policy stated that Audubon would pay "those sums that the insured becomes legally obligated to pay as damages because of bodily injury... to which [the] insurance applies."

The court concluded that loss of consortium could occur as the result of physical injury to a spouse. In this sense, damages for loss of consortium could be said to be because of the bodily injury (as the term "bodily injury" was defined in the Audubon policy) suffered by Donald May's wife.

> Therefore, under the express terms of its policy, Audubon is under a legal obligation to indemnify Terry Road should Terry Road become obligated to pay damages to Donald May for his loss of consortium claim.

As a result, the court ruled that Audubon was under a duty to provide a defense to Terry Road with respect to the whole of Donald May's suit. It cited an earlier federal decision:

> "[T]he duty to defend is broader than the insurer's duty to indemnify under its policy of insurance: the insurer has a duty to defend when there is any basis for potential liability under the policy."

In its ruling that Audubon had a duty to defend Terry Road against all possible liabilities, the court quotes the testimony of John Leach, the liquor store's owner and manager:

> The withdrawal of insurance coverage and payment of my attorneys' fees in defending these...lawsuits would have a catastrophic financial impact on my business in the form of an unaffordable expense. I am unable to estimate the upper limits of cost of defending these law suits. A judgment against my business, which is also impossible to estimate, could bankrupt my business.

A court advises an insurance company on how to write its policy

The court recognized that Audubon may have intended to exclude coverage for the type of loss involved in Donald May's loss of consortium claim. However:

> Audubon used language in its policy which failed to achieve this result. For example, Audubon could have accomplished such a result by using the preposition "for" in place of the words "because of" in paragraph A.1.a. of the policy. Such a word choice would have narrowed the scope of coverage to only those damages consisting of "bodily injury," "property damage," "personal injury" or "advertising injury" as those terms are defined in the policy. Alternatively, Audubon could have begun the first sentence of paragraph B.1.c. with the phrase "Any injury or loss, including 'bodily injury' or 'property damage'," instead of beginning that sentence with only the terms "Bodily injury" and "Property Damage."

As is often the case in dramatic liability claims, the court couldn't resist advising the insurance company on how to rewrite its policy.

Audubon would have to defend Terry Road—that ruling was tantamount to decision on the facts. The insurance company had little choice but to pursue settlement with the Mays.

Who is an insured

If you buy this insurance as an individual—rather than as a corporate entity—your spouse is also an insured with respect to conduct involved with your business. If the named insured is a partnership or joint venture, all members and partners and their spouses are insured with respect to their business activities. If the named insured is a corporation or organization other than a partnership or joint venture, all officers and directors are insured with respect to their duties as officers and directors, and stockholders are insured with respect to their liability as stockholders.

Who is covered as an insured person under a BOP

Employees are insured with respect to their activities as employees, and any person or organization acting as your real estate manager, or having custody of your property, or operating mobile equipment with permission is insured, but only with respect to their exposure in that capacity.

The declarations will show three separate limits of insurance. The first limit is for liability and medical expenses. It is a combined single limit and is the most the insurance company will pay for all bodily injury, property damage and medical expenses arising out of one occurrence, and all personal injury and advertising injury sustained by any one person or organization. Note that the BI and PD coverage is on an "occurrence" basis, while the personal and advertising injury coverage is on a "per person or entity" basis.

The next limit is a per person limit for medical expenses. The per person medical expense limit is a sublimit that applies within the overall liability per occurrence limit.

The third limit is for fire legal liability and it applies on a per fire or explosion basis. This is a separate limit of insurance that applies only to liability for damages to a premises rented by you and arising out of a fire or explosion.

While not shown on the declarations, the coverage form defines two aggregate limits that apply:

> The policy period aggregate for all injury and damage under the products/completed operations hazard is the liability and medical expense limit shown.
>
> The aggregate for all other injury or damage (except fire legal liability) and all medical expenses is twice the limit shown in the policy for liability and medical expenses.

If the policy is written for more than a one-year period, the aggregates will apply separately to each annual period.

Conditions and definitions

Businessowners liability coverage is subject to a number of standard policy conditions. Bankruptcy of the named insured will not relieve the insurance company of any obligations. In the event of an occurrence, claim or suit, you must notify the insurance company, provide information, and submit copies of any demands or legal papers. With respect to any vehicles or mobile equipment subject to a financial responsibility law, the policy will provide the minimum coverage required by law. Legal action against the insurance company may not be taken unless all terms of the policy have been fully complied with.

> The BOP mandates a "separation of insureds" to limit claims

There will be a so-called "separation of insureds," with respect to rights, duties, claims and suits under the policy. This means that everyone covered by the policy will be treated separately except with respect to the limits of insurance.

The policy also includes a number of standard commercial liability definitions. "Advertising injury," "auto," "coverage territory," "impaired property," "insured contract," "mobile equipment," "personal injury," "products-completed operations," "your product" and "your work" mean the same things they do on a CGL form.

BOP endorsements

Endorsements may be used to alter the coverage or to provide additional coverages.

A hired auto and non-owned auto liability endorsement may be used to add coverage for either or both of these automobile exposures if you do not have a commercial auto policy. If you have a commercial auto policy, the endorsement is not available for attachment to a BOP.

A comprehensive business liability exclusion endorsement may be used to exclude specific operations or locations from coverage. A limitation of coverage to designated premises or project endorsement may be used to exclude coverage except for the premises or projects specifically designated in the declarations.

A variety of different endorsements may be used to add additional insured parties to the policy. Special endorsements exist for managers or lessors, state or political subdivisions, townhouse associations, co-owners of premises, engineers, architects and surveyors, and others.

Chapter Ten: Businessowners Policies

BUSINESSOWNERS POLICY

	Standard	Special
Coverages		
A—Building	X	X
B—Business personal property (limit must be shown on dec. sheet for coverages desired)	X	X
Additional Coverages		
Debris removal (25% of loss + deductible; addl. $5,000 per location if limit exhausted)	X	X
Removal (10 days)	X	X
Fire Dept. service charge ($1,000)	X	X
Business income (no $ limit—up to 12 months)	X	X
Extra expense (no $ limit—up to 12 months)	X	X
Pollutant cleanup ($10,000 each 12-month period)	X	X
Collapse of building		X
Water damage		X
Coverage Extensions		
Business personal property at newly acquired premises ($10,000—30 days)	X	X
Business personal property off premises ($1,000)	X	X
Outdoor property		
Specified perils only (fire, lightning, explosion, riot, aircraft) $1,000 max; $250 max per tree, shrub or plant	X	X
Valuable papers & records ($1,000)	X	X
Perils	Fire, lightning, "EC" perils, vandalism, sprinkler leakage, sinkhole collapse, volcanic action, transportation	"All risks" (buildings & business pers. prop)
Limits		
Signs attached to building	$1,000	$1,000
Automatic increase in building (prorated over 12 months)	8% annually	8% annually
Seasonal increase—business personal property (only if business personal property limit for past 12 months is at least 100% of average monthly values)	25%	25%
Deductible	$250 standard	$250 standard
Money & securities, employee dishonesty, exterior or interior glass & outdoor signs	$250 maximum	$250 maximum
Fire dept. service charge, business income, ext. exp.	0	0
Valuation		
Buildings (unless ACV is chosen)	Replacement cost	Replacement cost
Business personal property	Replacement cost	Replacement cost
Vacancy (more than 60 consecutive days)		No coverage for: vandalism, sprinkler leakage (unless system protected against freezing), building glass breakage, water damage, theft or attempted theft. Amount for all other losses reduced by 15%
Optional Coverages		
Outdoor signs	X	X
Exterior glass	X	X
Interior glass	X	X
Employee dishonesty	X	X
Mechanical breakdown	X	X
Burglary & robbery	X	
Money & securities		X
Actual cash value - buildings	X	X
Business Liability		Identical in both forms
Includes:		
BI & PD, Personal injury & Advertising injury, Fire legal liability ($50,000 per fire), Medical expense ($5,000 per person)		
Limits:		
Liability & medical expenses limit—includes BI & PD, medical expense, personal injury, advertising injury		
Aggregate limits (per 12 months):		
Products & completed operations aggregate = liability & medical expenses limit		
Aggregate for all other claims = twice liability & medical expenses limit		
Optional Endorsements		
Accounts receivable	X	X
Valuable papers & records	X	X
Earthquake	X	X
Condo association coverage	X	X
Condo unit-owners coverage	X	X
Hired auto liability	X	X
Non-owned auto liability	X	X
Limitation of coverage to designated premises or project (liability)	X	X
Additional insured (liability)	X	X

403

INSURING THE BOTTOM LINE

Chapter Eleven:

Common Policy Conditions

Introduction

Not so long ago, dozens of insurance bureaus developed coverage forms for various lines of property and casualty insurance. One bureau developed only fire policies and endorsements, another only liability. There were two bureaus for auto forms; one for auto liability, one for physical damage. Inland marine forms for mutual insurance companies were developed by one bureau while another developed inland marine forms for stock companies.

The diversity of all these policies and forms, each in its own variation of legalese, confused policyholders and led to conflicting interpretations by the legal system. And these problems were only compounded when different coverage forms were combined in a package policy.

In the 1970s, many of the property and casualty insurance bureaus merged to form the Insurance Services Office, which became the country's largest insurance statistical and advisory organization. In 1986, in response to consumer and industry demands, ISO introduced new, simplified commercial property and casualty forms that were more flexible and responsive to general industry needs. Finally, compatible forms with common terms and conditions were available for use in monoline policies as well as in the increasingly more popular commercial package.

Curently there are seven lines of coverage in ISO's simplified commercial lines program—property, liability, auto, crime, inland marine, boiler and machinery, and farm coverages—that can be written singly or as part of a package policy. And several common policy conditions apply to all seven.

Under ISO's simplified commercial lines program, the policy conditions that apply to all seven coverages were consolidated in a single form called the Common Policy Conditions, which is attached to any policy containing one or more of these commercial coverages. Let's look at this form, a clause at a time.

> All Coverage Parts included in this policy are subject to the following conditions.

INSURING THE BOTTOM LINE

The conditions listed here apply whether the policy contains a single coverage part (i.e., a monoline policy) or more than one (i.e., a package policy). But some of these conditions may be modified by separate provisions within a specific coverage part.

Cancellation is an important issue

> A. Cancellation
> 1. The first Named Insured shown in the Declarations may cancel this policy by mailing or delivering to us advance written notice of cancellation.

Throughout the conditions, we'll see references to "the first named insured." When a policy has multiple named insureds, the first one listed acts on behalf of all others. For this reason, it's important to list the appropriate, responsible party first. This prevents multiple named insureds giving conflicting instructions to the insurer.

Standard conditions for cancelling insurance coverage

Your cancellation request must be in writing (to minimize the chances of error), and the requested effective date of cancellation, under most circumstances, must be for a future, not past date.

> 2. We may cancel this policy by mailing or delivering to the first Named Insured written notice of cancellation at least:
> a. 10 days before the effective date of cancellation if we cancel for nonpayment of premium; or
> b. 30 days before the effective date of cancellation if we cancel for any other reason.

The insurance company may also cancel the policy, with a written notice to the first named insured. But the insurance company is required to give a minimum period of time between the issuance of the notice and the effective date of the cancellation. This prescribed time period (ten days for nonpayment of premium or 30 days for any other reasons) allows you time to reconcile your problems with the insurance company or to obtain insurance elsewhere.

Note: If state law requires a different period of notice, an endorsement will be attached to amend the cancellation clause.

> 3. We will mail or deliver our notice to the first Named Insured's last mailing address known to us.

The policy doesn't require the insurance company to search for you. A written cancellation notice mailed or delivered to the first named insured's last known mailing address is sufficient. If mailed, proof of mailing—such a certified mail—is considered proof that notice was given.

> 4. Notice of cancellation will state the effective date of cancellation. The policy period will end on that date.
> 5. If this policy is cancelled, we will send the first Named Insured any premium refund due. If we cancel, the refund will be pro rata. If the first Named Insured cancels, the refund may be less than pro rata. The cancellation will be effective even if we have not made or offered a refund.
> 6. If notice is mailed, proof of mailing will be sufficient proof of notice.

When the insurance company cancels a policy, it will send notice to the named insured's last mailing address on record. Notice must state the cancellation date—the date on which coverage ends.

When a policy is canceled before the end of the policy period, the premiums paid may not be fully earned. In such cases, you are entitled to a premium refund. Any refund will be pro rata (proportional to the time coverage was in effect) if the insurance company cancelled the policy. A slight penalty (usually called a short rate) may be charged if the named insured requests cancellation.

The mechanics of changing policy terms

> B. Changes
> This policy contains all the agreements between you and us concerning the insurance afforded. The first Named Insured shown in the Declarations is authorized to make changes in the terms of this policy with our consent. This policy's terms can be amended or waived only by endorsement issued by us and made a part of this policy.

Because insurance is a contractual relationship, making changes to a policy is difficult

The policy is a legal contract between you and the insurance company. After issuance, the policy's conditions can be changed only by written endorsements (which become part of the policy) issued by the insurance company. The first named insured is the only insured allowed to make changes in the policy.

> C. Examination of Your Books and Records
> We may examine and audit your books and records as they relate to this policy at any time during the policy period and up to three years afterward.

The insurance company has the right to examine your books and records as they relate to the insurance. This is usually done for premium adjustment purposes. Premiums for commercial coverages are often based on accounting records (such as gross receipts, payroll or schedules of assets, which may fluctuate throughout the year).

> D. Inspections and Surveys
> We have the right but are not obligated to:
> 1. Make inspections and surveys at any time;

> 2. Give you reports on the conditions we find; and
> 3. Recommend changes.
> Any inspections, surveys, reports or recommendations relate only to insurability and the premiums to be charged. We do not make safety inspections. We do not undertake to perform the duty of any person or organization to provide for the health or safety of workers or the public. And we do not warrant that conditions:
> 1. Are safe or healthful; or
> 2. Comply with laws, regulations, codes or standards.
> This condition applies not only to us, but also to any rating, advisory, rate service or similar organization which makes insurance inspections, surveys, reports or recommendations.

The insurance company has the right to inspect and survey your operations, but only for the purpose of determining insurability and premium charges. It is not required to make any survey.

An inspection, report, or recommendation by the insurance company does not guarantee that workplace conditions are safe or comply with any law or regulation.

> E. Premiums
> The first Named Insured shown in the Declarations:
> 1. Is responsible for the payment of all premiums; and
> 2. Will be the payee for any return premiums we pay.

Who is responsible for paying the premiums?

The "first named insured" is responsible for all premium payments and is the authorized recipient of any return premiums. This clause keeps the insurance company out of internal disputes when multiple named insureds disagree over who gets what monies.

> F. Transfer of Your Rights and Duties Under this Policy
> Your rights and duties under this policy may not be transferred without our written consent except in the case of death of an individual named insured.
> If you die, your rights and duties will be transferred to your legal representative but only while acting within the scope of duties as your legal representative. Until your legal representative is appointed, anyone having proper temporary custody of your property will have your rights and duties but only with respect to that property.

Only by the insurer's written consent can the policy be assigned to another. The only exception occurs when the named insured is an individual, and that individual dies. Then the insurance will cover your legal representative (or temporary proper custodian pending appointment of a legal representative).

For example, John Smith insured his office supply store under a package policy with Acme Insurance Company. Even though John sold

his store to Bill Brown and gave him the Acme policy, Bill Brown has no coverage under the policy unless Acme agrees, in writing, to the transfer. Acme has the right to examine the operations and history of the new owner before accepting the risk.

But should John Smith die before selling the store, Acme would cover the trustee of John's estate, but only while that person was acting as John's trustee.

INSURING THE BOTTOM LINE

Conclusion

How to Buy Business Insurance Well

Using brokers and agents

Insurance for small businesses, like most personal lines of insurance, is usually sold by agents. These agents may represent one company (exclusive agents) or they represent several different companies (independent agents). The one thing to remember is that the agent represents the company, not you or your business. While most agents are honest, some agents may not put your interests first. They are usually independent business people who earn a living based on premium volume.

Insurance agents receive compensation from their services in the form of commissions from the company who writes the coverage. The commission structure varies considerably between lines of insurance, with variation in the percentage of premium paid to the agent. Life insurance commissions are weighted heavily towards "up front" commission or first year commission, as opposed to renewal commissions, which are more important in the property/casualty market.

Insurance for medium and large businesses is often purchased through an insurance broker. Brokers represent insurance buyers and shop the insurance market for the best combination of rate and coverage for their clients. Brokers are compensated in one of two ways: by charging fees to their clients or by earning a commission from the insurance company with which they place their clients' coverage.

Established insurance brokers may use their own policy forms for large clients rather than the ones created by ISO. However, these internally generated forms are essentially combinations of the ISO forms contained in this book and insurance companies rate these risks in similar ways. Therefore, coverages and exclusions found in the ISO forms will also apply to a broker generated policy form.

Another method of insurance distribution is the direct writer. Direct writers sell insurance through their own employees who are compensated largely by salary rather than commission. These companies use direct writing primarily because distribution through their own employees lowers distribution costs and increases the company's control over its sales force.

Whether you buy coverage through agents, brokers or direct writers, your salesperson should help you determine your needs. You should document these needs in writing to the agent/broker/direct writer after conducting your own risk management analysis. The salesperson will likely suggest a few exposures you hadn't thought of. Remember: Relying totally on the services of someone outside the company means some of your needs may not be addressed.

Shopping for coverage

The market for business insurance is competitive but you should not assume that all insurers offer the same premiums or coverage that is even close to being the same. Insurers have different market strategies and some insurers purposely price their insurance above or below their competitors to reflect market share goals. Insurers will often write insurance at a loss to gain sales momentum in a particular market or all markets.

Disasters in the early 1990s affected coverage today

Since Hurricane Andrew hit the Florida coast in 1993 and the Northridge earthquake hit Los Angeles a year later, insurers have reevaluated their market shares in many markets. The lessons learned from those two events have affected nearly all insurance markets. Business insurance policyholders shocked insurers with a much higher than expected number and severity of claims; the result was a reckoning that insurers had concentrated too much exposure in certain areas.

In the mid-1990s, businesses in states like Florida and California have experienced a dramatic tightening of insurance availability and price increases as insurers seek cuts in their market shares in these two markets. However, insurers have increased availability in lower risk areas like the northern plains states and the Pacific Northwest, where prices have fallen. Moreover, the Casualty/Liability insurance market has experienced a dramatic decrease in prices from time to time as insurers pursue sales goals in a relatively benign claims environment.

Market dynamics affect the costs of insurance as they do any product or service. Prices and trends can change for a particular type of insurance or for all insurance markets at the same time. Regardless of your needs, insurance is a sufficiently dynamic and competitive market and you should review your insurance costs regularly for potential savings.

Negotiating on price

Depending on the size of your business, agents, brokers and direct writers may be prepared to negotiate a lower price than they initially quote you. Although you may be uncomfortable about negotiating the price of something that appears to have a fixed price, you should realize that the potential is there to reward your discomfort.

Using your leverage to bring down the cost of risk

Where does this savings originate? If your account is large, the commission on your coverages will be substantial and agents or brokers will have a strong incentive to secure your business. As a result, they may be willing to forego some of that commission in order to make the sale. Often, insurers will match the agent or broker's foregone commission in order to support the sales effort. Only in Florida and California are outright rebates of commissions legal. However, discounts of up to 25 percent can be obtained in every state as the result of lower commissions and occasionally lower underwriting risk classification.

You should know that easy-to-sell coverages that are required by state law such as workers compensation and commercial automobile coverage carry lower commissions and lower margins for the insurer. On these coverages, the commission may be as low as five percent and the agent or broker may be unwilling to negotiate away what little he or she receives on these policies. However, they might be willing to take a lower commission on these policies in order to sell a package of coverages that carry substantially higher sales incentives.

Since most coverage is sold in a package, you should be prepared to pressure the agent or broker on price. While the agent or broker must be compensated in order to offer adequate service, there is no reason why they should get rich solely off of your business. Smaller accounts should expect to receive smaller percentage reductions since small accounts carry smaller commissions without a commensurate reduction in agent/broker effort.

Group health and disability

Some kinds of insurance you may choose to buy—even though you don't have to

This book has focused on the property/casualty insurance issues that business decision makers have to consider. But there are some kinds of insurance that businesses choose to buy in order to accomplish management goals. Chief among these: group health and disability insurance for employees.

Any firm that wants to attract and retain good employees must offer an attractive compensation package. While high labor costs can hurt a firm's competitiveness, the turnover that may result from unappealing pay and benefits may be even more damaging. The cliche "good help is hard to find" should be accompanied by "...and even harder to retain."

Sophisticated employees look beyond the cash compensation to the benefits package an employer offers. Ever since American employers used private pensions as a way around World War II wage controls, employee benefits have grown to become almost as important as cash salaries that companies pay.

Employee benefits now account for up to 30 percent of employee compensation. While President Bill Clinton's health care reform effort of 1993 was stillborn, both employers and employees have not stopped

seeking ways to reduce health care expenses or to shift the cost burden to each other or government.

Group insurance is popular amongst employers and employees alike for one reason: it is relatively cheap. Several factors contribute to the low net cost of group insurance. First, most group insurance expenses are tax-deductible for the employer, but non-taxable for the employee. This amounts to a tax subsidy for most employee benefits, indicating that Congress views employee benefits as socially desirable. Second, group insurance is issued under a single master policy, reducing the administrative headaches that individuals policies can cause.

Home-office endorsements

Insurance for business based in the home

With the rise in the number of small businesses operated at home and an explosion in the number of employee/independent contractors who "telecommute" via modem, more people need to consider the risks of working at home. Contrary to popular belief, homeowners policies do not normally cover business related losses that occur at home. These losses include the destruction or theft of business equipment and documents. Liability for customer injury in the home-office is not included in the typical homeowners policy nor is damage or theft of inventory.

Fortunately, many insurers have recognized the need for home-office coverage and offer home-office endorsements on homeowners policies. The home-office endorsement extends some of the homeowners coverage to business activity and expands some policy limits to accommodate the increased needs of a commercial organization.

According to an October 1994 article in *Business Week* magazine, insurers like Aetna, The Hartford, and Continental offer increased policy limits on losses from accounts receivable, credit card theft, and unauthorized cellular phone usage as part of a home-office endorsement. Most home-office endorsements also include a substantial amount of general coverage for losses as the result of product liability, advertising injury, and bodily injury. However, professional liability is usually excluded. Policy limits on the home-office endorsement can often be expanded through use of a umbrella policy, which provides additional coverage beyond the limits of the base policy.

The bare essentials, near essentials and options

Three categories of commercial insurance

In short, most business decision makers have limited insurance dollars to allocate among a variety of coverages. The priorities are different for every company, but a general hierarchy of essential insurance, near-essential insurance and optional insurance does emerge from the marketplace.

In the following chart, you can see the distinctions.

Conclusion: How to Buy Business Insurance Well

The Essentials
Building and Personal Property
Business Auto
General Liability
Workers Compensation
The Crime Package

The Near Essentials
Boiler and Machinery Insurance
Business Interruption
Directors and Officers Liability
Inland Marine
Professional Liability

The Options
Employment Practices Liability
Environmental Impairment Liability
Group Health and Disability
Group Life
Other specialized liability

The unpleasantness: filing claims

In the unhappy event that you file a claim, you are entitled by law to prompt settlement of your losses. Most claims are standard procedure and insurance companies want to satisfy their policyholders with fast claims service.

Some claims do not fit so nicely into the covered category, but rather they seem to fall into that gray area between covered and those losses listed in the exclusions. In these cases, claims disputes often arise. Insurance companies do not want to go to court, but they will not hesitate to do so if they believe a claim falls outside the coverage boundaries. Insurance companies are not in the business of being nice guys, though they will sometimes pay dubious claims to avoid the costs and ill will generated by denial. But they will not pay a claim if they genuinely believe that the contract provisions do not include such losses. If they haven't charged premiums for such losses, why should they pay such claims?

The "duty to defend" remains a hot issue

In this book, we have illustrated several cases that have pitted policyholders against their insurance carriers in disputes over coverage. Since legal defense costs are included in liability coverage, the "duty to defend" has also been a point of dispute. Nevertheless, this book should give you a better understanding of what your insurance carrier should provide you and what the courts have said in other disputes.

If you have a question, submit it in writing to your broker or insur-

ance company. Agents and brokers will usually take up your cause with the insurance company if your claim dispute seems legitimate. They know that your dissatisfaction means you might take your business elsewhere. Their response should be requested in writing so that you can bind them in the event of a future dispute.

Reducing insurance confusion

Now that you have a general idea of how to determine your own needs and who to contact about insurance, you probably need to know more about the specifics. Each of the chapters in this book describes an insurance coverage designed to insure against a specific set of perils. Some will be more important to your particular business needs than others.

Hopefully, the examples and cases will demonstrate how each coverage might apply, if at all, to your business. Some coverages may seem to overlap, while there might appear to be no coverage under any of these forms for one of your needs. If, after reading the relevant passages, you still can't figure it out, write to your producer. You might be able to purchase an endorsement that protects your new machinery or extends your coverage to a newly opened office.

By documenting every communication with your insurance agent or broker, you will have a much better chance of accomplishing your objective: insuring your bottom line.

INDEX

accident 5, 61, 63, 71, 79, 81, 84, 86, 88, 116-118, 120-121, 123-124, 126-127, 135, 138-141, 143, 145, 147-148, 151-155, 157-159, 161-162, 164-174, 176, 178-183, 186-192, 194-195, 231, 281-283, 291, 294, 303, 307-309, 312, 314, 319, 331, 334, 336, 341, 344-346, 350, 354, 356-357, 385, 392-393, 395, 397-399
accounting or arithmetical errors or omissions 232, 242
accounts receivable 3, 6, 104, 263-264, 265, 269, 277, 279, 394, 414
acts of employees, directors, trustees or representatives 232
actual cash value (ACV) 38, 40, 46-48, 56, 116, 152-153, 170, 224, 260, 270, 275, 390
additional coverage 9, 16, 25-26, 47, 50, 63, 70-75, 80, 85, 88, 96, 101, 107, 115, 123, 131, 155, 264-272, 274, 277-278, 282, 382-383, 388-391, 402, 414
additional coverage—collapse 70, 73, 75, 85
adequate insurance 102
advertising injury 282, 287, 291-292, 304-306, 314, 325-326, 328, 337-338, 341, 394-396, 398, 400-403, 414
　　advertising injury liability 287, 291
Aetna Casualty and Surety v. General Dynamics 342
agreed value 33, 45-46, 108
aircraft or vehicles 73, 86, 393
allocation 368, 371-372
amendments to coverages or limits 341
assigned risk pools 172, 179
assumption of risk 174
Audubon Insurance Co. v. Terry Road Wine and Liquor et al. 397
auto 5, 10, 129-172, 296-298, 313, 319, 329, 332-334, 357, 395, 402-403, 405, 415
　　acquired autos 137
banking premises 230-231, 234-235
bankruptcy 156, 185-186, 195, 216-218, 226, 239, 253, 316, 351
benefits 6, 63, 133-134, 143-144, 168-169, 175-176, 178, 180-190, 194-199, 201, 205-207, 217, 222, 244, 253-254, 294, 308, 310, 320, 359, 395-396, 413-414
　　medical benefits 182, 207, 310
　　income benefits 182-183
　　death benefits 182
　　rehabilitation benefits 182
blanket coverage 32
bodily injury 160

boiler and machinery insurance 67, 82, 85, 122
　　boiler and machinery coverage form 122-123
　　boiler and machinery definition endorsement 126
　　small business B&M broad form 115, 123
　　small business B&M form 115
bonds 83, 116, 143, 176, 183, 193, 228, 237, 245-253, 275, 310-311, 395
　　bail bonds 143, 252, 310, 311, 395
　　blanket bond 247
　　contract bond 248, 250
　　fiduciary bond 252, 253
　　individual bond 247
　　lost instrument bond (securities bond) 253
　　motor vehicle bond 253
　　name schedule bond 247
　　payment bond 249-250
　　performance bond 249-251
　　position schedule bond 247
　　public official bond 253
　　supply bond 250-252
　　workers compensation self-insurers bond 253
bookkeeping, accounting or billing errors 265
Breshears, Inc. v. Federated Mutual Insurance 26
brokerage sheet 12, 14
building and personal property coverage form 16, 21, 28, 38, 50, 55, 70
building coverage 11, 20, 40, 47, 58, 381
burglary 83, 210-212, 228-230, 236-237, 391-392
　　safe burglary 210-211
business auto conditions 152
business auto policy (BAP) 129, 168, 313, 319
　　business auto coverage form 130-132, 144, 149, 152, 161, 165, 167, 170
　　business auto coverage physical damage form 130
　　garage coverage form 130
　　truckers coverage form 170
　　motor carrier coverage form 170-171
business income (and expense) coverage 67, 91
　　alterations and new buildings 97
　　business income 16-17, 68, 81, 92, 96-98, 101-104, 107-108, 382-383, 387-390, 403
　　civil authority 97
　　extra expense 15, 17, 68, 81, 92, 95-99, 101, 103-104, 117, 121-124, 382-383, 387-390, 393
　　extended business income 97-98, 107
business income coverage (without extra expense) 17
Businessowners policy (BOP) 377-378
　　BOP endorsements 402
　　BOP property definitions 392

BOP property endorsements 394
Caldor, Inc. v. A-P-A Transport Corp. v. The North River Insurance Co. 255
camera and musical instrument dealers 263, 266-267
cancellation changes endorsement 55
Case v. Louisiana Medical Mutual Insurance Co. 350
causes of loss form 11, 15, 24, 31, 33, 50-52, 57-58, 64, 67, 69-70, 72, 75, 79, 84, 88-90, 93, 381, 385-386
 basic form 57-58, 67, 70, 73, 77-78, 81, 90
 broad form 57, 70-88, 115, 124-125, 282, 285, 300-301, 339, 383, 397
 special form 57, 64, 75-88, 266, 273, 277, 382-383, 387-388, 391
 earthquake form 57-58, 88, 90-92, 394
CERCLA 342-343, 375-376
Childs et al. v. State Farm Fire and Casualty 109
Code of Federal Regulations (CFR) 172
coinsurance 28, 33, 40, 42-43, 46, 53-54, 101-103, 107-108, 265-266, 268-272, 277-279, 364
 coinsurance condition 101, 272, 279
 coinsurance penalty 42, 54, 108, 272
collapse 58, 62-63, 65, 72-76, 80-81, 85, 86-88, 147, 191, 264-267, 269-270, 272, 274, 277-278, 334, 336, 341, 382-383, 385-388, 393, 403
 hidden decay 74, 264, 383
 hidden insect or vermin damage 74, 383
 weight of people or personal property 74, 264, 383
 weight of rain that collects on a roof 74, 264, 383
 use of defective materials or methods 74
Colson Services Corp. v. Insurance Company of North America 225
commercial articles 263, 268
commercial carrier regulation 171
 Motor Carrier Act (MCA) 171-172
commercial crime coverages 210
commercial fine arts 263, 269
commercial general liability (CGL) forms 281
commercial package policy (CPP program) 114, 129-130, 152, 210, 257, 285, 345, 347, 377, 379
 common policy conditions 15, 34, 54, 57, 101, 130, 152, 257-258, 285, 378-379, 405
 common policy declarations 15, 130, 257, 285
 coverage parts 15-16, 114, 129, 177, 181, 196, 229, 284, 323, 377
commercial property 10-16, 20, 24, 27, 34, 38, 45, 52, 54, 56-57, 95, 101, 107, 146, 212, 270, 364, 377, 379, 383, 386, 394, 405

commercial property coverage forms 16, 52, 54
 builders risk coverage form 16
 building and personal property coverage form 16, 21, 28, 38, 50, 55, 70
 business income coverage form 17
 condominium association coverage form 17
 extra expense coverage form 67, 91-92
 glass coverage form 17
 leasehold interest coverage form 17, 69
 legal liability coverage form 16, 69
 tobacco sales warehouses coverage form 17
Commercial Property Coverage Part 54, 377
commercial umbrella coverage 359
Commercial Union Insurance v. Sky, Inc. and Kimberly Cluck 290
Commercial Union Insurance v. Walbrook Insurance Co., et al. 353
common endorsements 54
Common Policy Conditions 15, 34, 54, 57, 101, 130, 152, 257-258, 285, 378-379, 405
Common Policy Declarations 15, 130-131, 257, 285
completed operations aggregate limit of liability 403
concealment, misrepresentation or fraud 155
conditions 7, 15-16, 34, 36, 41-42, 44, 54-55, 57, 80-81, 88, 101, 110, 115, 122, 126, 130, 132, 148, 152, 156, 158, 160-161, 171, 176-177, 181, 186, 190, 203-204, 211, 213, 215-216, 220, 227, 232, 236-237, 241, 250, 255, 257-258, 260, 265, 267, 270-272, 282, 284-285, 287, 321, 328, 334, 344, 346, 354, 361-364, 373, 377-379, 388, 390-391, 402, 405-408
 cancellation 44-45, 54-55, 68-69, 123-124, 178-180, 201-202, 204, 219-220, 229, 241, 272, 279, 323-325, 379, 387-388, 406-407
 inspection 4, 35, 113, 125-127, 203, 303, 331, 380, 408
 long term policy 203
 sole representative 204
 transfer of your rights and duties 203, 408
consequential loss coverages 95
contents coverage 14
contributory negligence 174
Cooper Sportswear Manufacturing v. Hartford Casualty 242
coverage for commercial property 15
 causes of loss forms 11, 15, 24, 31, 33, 50-52, 57-58, 64, 67, 69-70, 72, 75, 79, 84, 88-90, 93, 381, 385-386

endorsements 9, 15, 50-51, 54, 57, 105, 114, 117, 130, 132, 149, 165, 170, 177-178, 193, 201, 204, 210-211, 229-230, 258, 279, 282, 285, 299, 338, 340-342, 345, 379, 394, 402, 405, 407, 414
 property conditions 16, 34, 41
 property coverage forms 15-16, 34, 52, 54, 385
 property declarations 20, 45
coverage extensions 22, 75, 122-124, 143, 171, 389
 containers of covered property 235
 newly acquired, constructed property 384
 outdoor property 28, 31, 33, 384-385
 outside the premises 229-232, 235-236
 personal effects, property of others 28, 30
 premises damage 231
 property off-premises 28
 valuable papers and records 21, 22, 28, 30, 41, 84, 264, 278-279, 384, 390, 394
coverage forms 15-16, 22, 34, 45, 52, 54-57, 67-68, 70, 76, 81, 83-84, 90, 92, 115, 117, 120, 130-131, 159, 164, 165, 172, 210, 211-212, 214, 228, 237, 258, 263-264, 271-272, 279, 284, 287, 296, 316-317, 328-329, 334, 338, 341, 377, 385, 389, 391, 405
coverage, optional 16, 45, 88, 107, 124, 145, 377, 379, 381, 385, 389,
 agreed value 33, 45-46, 108
 inflation guard 46-47
 replacement cost 38-41, 45-48, 50-51, 55, 105, 116, 122, 124, 390
coverage parts 15-16, 114, 129, 177, 181, 196, 229, 284, 323, 377
coverage territory 85, 159, 240, 289, 291, 305, 307, 334, 345, 347, 391, 402
covered causes of loss 37, 70, 75-76, 78, 80, 96, 264, 272, 364, 381-382, 385
covered pollution cost or expense 138, 145, 147-148, 160-161, 163, 165
Civil Rights Act (CRA) 290
crime forms 79, 210-212, 215, 219, 236
crime insurance 209, 222-223, 230, 236
 burglary 83, 210-212, 228-230, 236-237, 391
 employee dishonesty 5, 209, 216, 218, 230, 236-238, 242, 245-247, 390-392, 403
 forgery 209, 216, 245-246
 robbery 210, 212, 229-230, 235-237, 391, 403
 theft 25, 30, 37, 48, 50, 62, 79, 82-84, 86, 88, 149-150, 153-154, 209-210, 212, 216-217, 223, 226-227, 230-232, 234, 236,-237, 242, 246, 266-267, 271, 274, 277, 389, 391, 403, 414

crime insurance policy 238
criminal act 79, 87, 209, 212-213, 232, 349, 388
Curtis-Hale, Inc. et al. v. James Geltz and Aetna Casualty & Surety 179
custodian 408
debris removal 24-25, 31, 33, 56, 270-271, 382, 384
declarations 11, 15, 19-20, 24, 28, 32-33, 45-47, 52-54, 57, 91-92, 96, 98, 101, 107-108, 114-117, 120, 123-124, 130-133, 137, 148-150, 152, 159, 165, 168, 177-178, 211, 221-222, 232, 240, 257-260, 266-267, 269-270, 272, 274, 275-279, 285-286, 304, 312, 314, 323, 341, 357, 377-381, 389, 391, 394-395, 401-402
deductible 6, 9, 24, 25, 33-34, 38, 41-42, 48, 88-89, 92, 102, 115, 120, 122, 131, 150, 152, 169-170, 207, 211, 221-223, 232, 240-241, 258, 267, 269, 271-272, 277-279, 318-319, 321, 323, 338, 340, 359, 364, 367, 369, 370-371, 373, 382, 390, 403, 414
deductible liability insurance 340
Dickler et al. v. CIGNA Property and Casualty et al. 38
difference in conditions (DIC) 363-364
direct damage form 16
 buildings 6, 11-15, 21-22, 29, 31-33, 37-38, 44, 46-47, 50-51, 58, 71, 82, 92, 97, 98, 103, 115, 216-217, 258, 266, 271, 274, 277-278, 299, 337, 353, 363, 377-379, 381, 384, 389, 403
 business personal property 12, 14-15, 29, 37, 56, 363, 379, 382, 384, 390, 392
 personal property of others 14-16, 20-21, 30
directors and officer's liability 349
discovery period for loss 218
duty 27, 40, 138-139, 143, 183, 193, 203, 215, 227, 239, 252, 288, 290-292, 300, 303-305, 309-310, 317-318, 320-321, 343, 345, 347, 353, 366, 375, 380, 398-400, 408, 415
 duties after loss 48
 duties if injury occurs 176
 duty to defend 27, 138-139, 183, 193, 288, 290, 292, 304-305, 318, 320-321, 343, 345, 347, 380, 398, 400
earth movement 64-65, 70, 72, 74-77, 88-90, 121, 386-387
Electro Battery Manufacturing Co. and Fireman's Fund Insurance v. Commercial Union Insurance 356
employee 2-3, 5-6, 26, 79, 136, 139-140, 144-145, 167, 169, 170, 173-175, 178, 180-182, 184, 186-189, 192, 195, 209, 211, 213, 216, 218-219, 225, 228-230, 236-247, 274, 290-291, 294, 308, 312-313, 320-322, 329, 344, 356-357, 359, 375, 390-392, 395, 403

employee dishonesty coverage 233, 237, 241
employee indemnification and employer's liability 144
employers liability 145, 174, 177-178, 186-189, 193-195, 203-205, 295, 360
employers liability insurance 186-188, 193, 203
endorsements 9, 15, 50-51, 54, 57, 105, 114, 117, 130, 132, 149, 165, 170, 177-178, 193, 201, 204, 210-211, 229-230, 258, 279, 282, 285, 299, 338, 340-342, 345, 379, 394, 402, 405, 407, 414
 cancellation and nonrenewal 229
 miscellaneous endorsements 117, 230
 policy changes endorsement 229
equipment dealers 263, 270-271, 273
errors and omissions 57, 81, 349, 353, 356-357, 359
evaluating losses and claims 38
excess lines 361
exchange or purchases 234
exclusionary and special risk endorsements 341
exclusions 9, 11, 16, 21, 22, 27-28, 31, 50-51, 64, 67, 69,-70-73, 75-79, 81-82, 87, 88, 90, 96, 117, 119, 121-124, 139-140, 144-147, 161, 164, 170-171, 181, 188, 193, 205, 207, 216, 226, 232, 236-237, 241, 242, 261, 262, 264, 269, 271, 272, 276, 278, 281, 284, 288, 290, 299-306, 308, 328, 338, 341-342, 345-347, 349, 359-360, 372-374, 377, 386-388, 395, 396, 411, 415
explosion 23, 31, 59-61, 65-67, 72-73, 76-78, 81-82, 85-86, 89-90, 105, 113-114, 120-121, 127, 149, 151, 171, 214, 262, 267, 269, 278, 336, 341, 353-354, 363, 384-385, 387, 389, 392-393, 395, 401, 403
extended reporting periods (ERPs) 284, 286-287, 289, 305, 325-328, 340, 346, 350
 supplemental extended reporting period 327, 340
extortion 210, 229, 235
extra expense coverage form 67, 91-92
Fairhaven Power v. Hartford Steam Boiler Inspection & Insurance 125
falling objects 71, 73, 86-87, 149-150, 264, 388, 393
Federal Black Lung Compensation Insurance 205
Federal Motor Carrier Act (FMCA) 172
fellow servant rule 173, 174
fidelity bonds 83, 237, 246
fiduciary 227, 239, 252, 253, 321, 359, 366
film coverage 263

fire 1, 5-6, 9, 11-14, 20, 23-26, 31, 36, 39-40, 58, 59, 60-86, 90, 95, 105-106, 120-121, 150, 152, 171, 212-213, 234, 262-264, 266-267, 269, 271, 274, 278, 282, 295-296, 304, 315, 319, 328, 331-332, 336, 338, 353, 363-364, 381, 382-385, 388-390, 393, 395, 401, 403, 405
fire department service charge 25, 382-383, 389-390
floor plan merchandise 263
glass 15, 17, 37, 57, 60, 62, 70-73, 76,-78, 83-87, 149-150, 264, 266-267, 269, 271, 274, 383, 385, 389, 390-391, 403
governmental action 65, 69, 77, 89, 214
Green Lawn Systems v. American Economy Insurance 22
guarantor 246, 248-249
Hammond v. Grange Mutual Casualty Co. 308
handling of property 145-146, 332
Hartford Accident and Indemnity Co. v. Commercial Union Insurance Co. and Minuteman Press 320
impaired property 302-304, 330, 396, 402
improvements and betterments 14, 20, 41, 266, 270, 277-278, 382
injury 5, 60, 117, 138-139, 144-145, 147-148, 154, 160-166, 169, 171, 173-177, 180-181, 184-198, 207, 265, 279, 282, 283, 286-308, 312-320, 325-326, 328-329, 331, 334-349, 353, 360, 394-403, 414
 expected or intended injury 144
inflation guard 46-47
inspections and surveys 380, 407
Insurance Services Office (ISO) 9, 15, 54, 114, 130, 210, 257, 377, 405
insured 4, 11-32, 35, 38, 44, 46, 50, 52, 55, 57, 60, 73-75, 82, 85-92, 99-101, 104-106, 109, 114-132, 137-150, 153-157, 160-170, 178-181, 185-187, 196, 199, 201, 203-204, 211-212, 216-217, 219, 228-229, 233, 238-239, 241, 245-246, 250, 256, 258, 260-263, 265-266, 268-269, 271, 273-275, 277-278, 281-282, 285-327, 330-331, 338-340, 342-343, 345, 350, 355-364, 368, 370, 372-374, 378-382, 385, 387-388, 392, 394-408
insured contract 144-145, 155-156, 162, 201, 293-294, 297, 303-304, 306, 330-331, 395, 402
insuring agreement 31, 76, 116, 138, 149, 182, 187, 246, 281, 284, 286, 288, 304, 328, 334, 345, 346, 347, 353, 360
inventory shortages 242

jewelers block 263, 273-275
joint insured 219
Jones Act 193, 205
Kopff v. Economy Radiator Service and Northern Insurance 12
laser beam exclusion endorsement 339
Leasehold Interest Coverage Form 69
legal expenses 214, 350
Legal Liability Coverage Form 16, 69
Lexington Insurance v. Reliance Insurance 121
liability exclusions 145, 147, 164, 342, 396
liberalization 109, 156, 380
lightning 31, 58, 73, 85, 86, 121, 149, 150, 152, 264, 265, 269, 363, 384, 385, 388, 393, 403
limitations 75, 82, 84, 158, 360, 386, 387, 388, 391
limits of insurance
 24, 33, 74, 101, 122, 124, 177, 211, 220, 258, 267, 269, 272, 277, 278, 279, 311, 319, 323, 327, 328, 338, 340, 349, 383, 389, 401-402
liquor liability coverage 293, 341, 347
loading or unloading 296-297, 332, 335
loss 2-13, 15-16, 19-126, 137, 143, 147-165, 170, 172, 177-179, 182-184, 187-188, 191, 193-194, 206-207, 209-247, 250, 256, 258-279, 283-289, 293, 295, 303, 311, 318-323, 334, 336, 339, 347, 357, 359, 363-364, 367-368, 371, 379-396, 399-400, 403, 412
 covered causes of loss 37, 70, 75-76, 78, 80, 96, 264, 272, 364, 381-382, 385
 direct loss 11, 16, 24-25, 63, 68, 75-77, 95-96, 98-99, 103-105, 107, 117, 121, 210, 246, 265, 267, 271, 278, 363, 380, 382-383, 385-386
 indirect loss 16, 68, 95, 96, 104, 117, 121
 loss of securities 224
loss conditions 152, 258, 270, 390
 abandonment 34, 258, 390
 appraisal 34-36, 103, 109-111, 152, 259, 390
 appraisal for physical damage loss 152
 duties in the event of accident, claim, suit or loss 153
 duties in the event of loss or damage 35
 legal action 154, 186, 187, 196, 214-215, 220, 223, 252, 260, 279, 390
 loss payment 36, 44, 154, 279
 loss payment—physical damage coverage 154
 recovered property 37, 390
 transfer of rights of recovery 155, 380
 vacancy 37, 48-49, 51, 390

valuation 4, 45-48, 51, 53, 55, 107, 189, 223, 260, 265, 267, 270-272, 275, 355
mail coverage 263, 275-276, 279
malpractice insurance 349-350
marine coverage 255, 257, 260, 263, 272, 279
 commercial inland marine conditions 258, 265
 commercial inland marine coverage forms 258, 264
 commercial inland marine declarations 258
 inland marine insurance 255-257, 260, 263
Maritime Coverage Endorsement 205
Marwick, Peat 369
Maryland Casualty Co. v. George Wayne Reeder 299
medical expenses 288, 304, 307-309, 315-316, 395-397, 401, 403
medical malpractice coverage 350
medical payments coverage 165, 308-310, 341
Merchant Marine Act 205
messenger 230, 231, 235-236, 274, 276
mobile equipment 137, 145-147, 160-161, 163-164, 169-270, 297-298, 311, 313, 329, 333-334, 395-396, 401-402
money 8, 21, 27, 128, 139, 209-211, 218, 222-237, 245-246, 248, 251-252, 266, 270, 273, 275, 278, 281, 327, 363, 368, 384, 389,-394
 money operated devices 234
monoline policy 16, 114, 130-131, 210-211, 257, 284-285, 406
mortgage holder 17, 44-45, 57, 115, 379, 391
movement of property by mechanical device 145
National American Insurance Co. v. Central States Carriers 140
National Association of Corporate Directors (NACD) 369
National Council on Compensation Insurance (NCCI) 176
negligence 157, 172-175, 187, 226, 261, 294, 304, 309, 332, 349, 351-353, 355-356, 359-360, 365, 395, 397, 398, 399
Newman, Trustee in Bankruptcy of Wallace & Orth, Inc. v. Hartford Insurance Company of Illinois 215
no benefit to bailee 391
Notice of Termination 180
nuclear hazard 120, 151, 214, 264, 266, 386-387
 broad form nuclear energy liability exclusion endorsement 285, 397
 object 61, 71, 86, 87, 114, 116-125, 149-150, 385, 392-393

pressure and refrigeration objects 117
mechanical objects 117
electrical objects 117
turbine objects 118
comprehensive coverage 118
obligation 7, 20, 33, 40, 45, 49, 69, 96, 110, 144, 146, 152-154, 161, 174, 179, 185-186, 189, 197, 225-226, 246, 248-249, 259, 281, 288, 291-292, 294, 304, 310, 312, 316-317, 321, 323, 330, 332, 340, 345, 354, 400
obligee 246, 248-252
Occidental Chemical Corp. v. American Manufacturers Mutual Insurance 118
occurrence 24, 32-33, 64, 70-71, 76, 83, 91, 96, 100, 104, 126, 157, 189, 199, 214, 232, 236-237, 240, 241, 245, 271, 276, 282-293, 298, 304-307, 315-319, 324, 326-329, 334, 336, 339-340, 342, 344, 347, 349, 352, 354, 356, 359-360, 386, 389-391, 395, 401-402
off-premises services 65, 77, 89
Ohio Casualty Insurance Co. v. Gail Aron 167
operations 4, 37, 61, 68, 78, 87, 95-98, 101, 103-104, 107-109, 123-124, 126, 128, 130-131, 141, 145, 147, 161-162, 164, 177-178, 196-197, 215, 257, 278, 281-282, 287, 295-296, 298-299, 302, 307-09, 314-315, 329-331, 335-342, 375, 378, 380, 383, 387-388, 390, 395-397, 401-403, 408-409
completed operations 147, 282, 287, 299, 302, 308, 314-315, 329, 335-336, 338, 341-342, 396-397, 401-402
ordinance or law coverage 64
other states insurance 196, 197
owners and contractors protective (OPC) liability insurance 282
ownership of property 221
peak season endorsement 56
personal injury 287-288, 291-292, 300, 304-306, 312, 314-315, 320, 325-326, 335, 337-338, 341, 360, 394-395, 398, 400-403
personal injury liability 305
personal property 11-16, 20-21, 23, 28-30, 32, 37-39, 46-47, 50, 52-53, 55-56, 58, 68, 70-71, 73-74, 78, 80-81, 85-87, 92, 96, 99, 103, 246, 248, 264, 299, 337, 363-364, 379, 381-384, 386, 388, 390, 392-393, 403, 415
coverage for personal property of others 20
physical damage coverage 129-130, 134, 152, 156, 166, 169, 170-171

physicians and surgeons equipment 276-277
policy period 24, 26, 32, 52, 92, 108-109, 115, 131, 136, 159, 176-179, 181, 186-187, 200, 202-204, 206, 211, 215, 218, 222, 258, 260, 268, 271, 283-284, 286-287, 289, 291, 305-307, 314-315, 317-318, 322, 324-328, 334, 341, 345-347, 352, 354, 379-380, 383, 391, 396, 401, 407
pollutants 10, 24-28, 80, 87-88, 96, 147, 160-161, 164, 271, 295-296, 342-344, 383, 388, 393, 395
pollution 25-28, 50, 59-60, 138-139, 145, 147-148, 160-161, 163-165, 170, 172, 271, 290, 295-296, 338, 341-346, 375-376
limited pollution liability coverage form 342
pollution liability coverage 50, 290, 296, 342, 345, 376
pollution liability coverage form 296, 342, 345
total pollution exclusion endorsement 342
Polytech, Inc. v. Affiliated FM Insurance Co. 105
premises 11, 14-16, 19-23, 25-30, 47-48, 51-52, 56, 60-62, 65-66, 72, 77, 80-86, 89-91, 96-99, 106, 125, 130, 147, 160-163, 165, 209-210, 215, 224-225, 228-232, 234-236, 246, 258, 263-264, 273-276, 278, 281-282, 287, 292-299, 302, 304, 307-309, 315, 318-319, 329, 330-342, 378-379, 381-386, 389, 392-393, 395-396, 401-403
premises and operations exposure 281
owners, landlords and tenants (OL&T) 281
manufacturers and contractors (M&C) 281
premium 7-8, 22, 28-29, 33, 42, 44, 51-56, 102, 109, 113, 115-116, 131, 133, 135-136, 149, 155-156, 158-159, 165, 176-177, 179, 195, 200, -202, 204, 206-207, 215, 246, 249, 258, 260, 269, 285-286, 293, 322-323, 326-327, 346, 350, 354, 356, 362, 379-380, 384, 390, 406-408, 411
audit 159, 202-203, 264, 322, 380, 407
classifications 172, 175, 178, 200-201, 203, 206
final premium 52, 158, 159, 176, 201, 202, 207
manuals 200, 202
premium audit 159
premium payments 380, 408
remuneration 200
records 3-4, 6, 21-22, 28, 30, 35, 41, 83-84, 95, 97, 103-104, 151, 153-154, 201-203, 259, 264-265, 268, 271, 273, 275, 278-279, 283, 316, 322, 362, 380, 384, 390, 394, 403, 407
principal 44, 176, 246, 248-249, 250-253
products-completed operations hazard 302, 308, 396
professional liability 307, 349, 353-355, 357, 359, 414

Index

profits insurance 105
property 3-4, 6, 8, 10-16, 19-65, 68, 70-92, 95-109, 113-116, 120-125, 138-155, 160-166, 169-172, 209-216, 221-225, 228,-237, 246-252, 255-282, 287-304, 312-318, 325-326, 330-344, 347, 353, 356, 361-365, 377-415
 Business Personal Property 12, 14-15, 29, 37, 56, 363, 379, 382, 384, 390, 392
 Covered Property 16, 19, 24-25, 30, 36-37, 42, 47, 51-52, 63, 72, 230-231, 233, 235-237, 258, 260, 266, 268-272, 274-277, 279, 363, 380-383, 386, 390, 392
 leased personal property 14-15
 preservation of property 25, 382
 property damage 28, 38, 50, 95, 97, 113, 116, 123, 138, 139, 144, 145, 147, 148, 160-163, 165-166, 169, 172, 235, 282, 287-289, 291, 293-304, 314-318, 325-326, 331-344, 347, 353, 356, 394-396, 398, 400-401
 Property Not Covered 30-31, 70, 228, 269, 276-277, 363, 384
proximate cause 60-61, 67, 75, 80, 127, 397
Prudential LMI Commercial Insurance Co. v. Colleton Enterprises 99
public liability 172
punitive damages 27, 191, 309, 398
 exemplary damages 188
Raychem Corporation v. Federal Insurance Co. 370
recovery from others 185, 195
Redux, Ltd. v. Commercial Union Insurance 212
reformation 13, 358
removal coverage 33, 51, 264, 382
rental reimbursement coverage endorsement 170
rental value 13, 48-50, 96-98
replacement cost 38-48, 50-51, 55, 105, 116, 122, 124, 390
 schedule coverage 32, 237
retroactive date 285-287, 289, 305-306, 319, 325, 339, 345-347, 350
riot 31, 62, 73, 85-86, 363, 384-385, 393, 403
 civil commotion 31, 62, 73, 85-86, 384-385, 393
 looting 214, 385
 striking 62, 385
 vandalism 37, 48, 51, 58, 60, 62, 73, 83, 85-86, 149-150, 230, 235, 363, 385, 388-389, 391, 393, 403
Safeway Stores v. National Union Fire Insurance Co. of Pittsburgh 366

Santiago v. Pennsylvania National Mutual Insurance 190
Scott and Motorists Mutual Insurance v. Mt. Orab Ford 156
Scott Management, Inc. v. Commerce and Industry Insurance 48
sexual harassment 290-292
Sibley v. Adjustco, Inc. 198
signs (signs, lamps and mechanical parts) 263
sinkhole collapse 58, 63, 65, 72-73, 76, 86-87, 385-388, 393, 403
smoke damage 385
snow 61, 71, 73, 80-83, 86-87, 164, 264, 388, 393
 ice or sleet 71, 73, 80, 82, 86, 264, 388, 393
sold property 268, 271-272
special exclusions 70, 90
special multi-peril (SMP) policies 114
special property coverage form 378, 381
specific coverage 34, 70, 90, 279, 406
specified causes of loss 78, 80, 83-85, 87-88, 149-150, 388-389, 393
sprinkler leakage 37, 51, 385, 391, 403
state 12, 16, 22, 34, 53-55, 109, 133-134, 143-144, 152-153, 155-156, 166, 168, 171, 173, 175, 178-187, 190-198, 202, 204-207, 216, 229, 252-253, 257, 279, 338, 343, 347, 352, 361-362, 370
statutory provisions 229
Stella Jewelry v. Naviga Belgamar through Penem International 233
stock 14, 20-25, 30-32, 47, 50, 56, 105, 243, 266, 268, 270-273, 275, 363, 366, 370-371
sublimit 33, 305, 315
suit 39, 135, 138, 140-141, 143, 153, 160-161, 164-165, 167, 220, 288, 292, 295-296, 304, 310-311, 316-318, 320-321, 323, 329, 336-337, 342-343, 351, 353, 365-367, 370
Sulzer v. Northern Contractors Co. v. Reliance Insurance Company 260
Supplemental Declarations Endorsement 12
supplementary payments 289, 323
Surety Association of America (SAA) 210, 237
surety bonds 245-246, 248-249
suretyships 248
surplus lines 172, 361, 362-363, 365
territory 85, 159, 162, 178, 186-187, 215, 240, 289, 291, 305, 307, 329, 334, 345, 347, 391, 402
theatrical property 264, 277-278
theft, disappearance and destruction coverage form 226
time element coverages 95-96, 104

trailer 139, 142, 155-156, 160, 165, 167, 256, 329
trailers, mobile equipment and
 temporary substitue autos 137
transfer or surrender of property 234
truckers coverage form 170
T.S.I. Holdings and New progress, Inc. v. John Buckingham and Cincinnati Insurance Company 238
24-hour coverage 207
U.S. Longshore and Harbor Worker's Compensation Act (USL&HW Act) 178, 193
underinsurance 32, 42, 52
unilateral mistake 13
valuable papers and records 21-22, 28, 30, 41, 84, 264, 278-279, 384, 390, 394
valuation clause
 45, 46, 223, 260, 267, 271, 272, 275
valuation endorsements 55
 functional building valuation 55
 functional personal property valuation 55
value reporting forms 53, 317
 daily reports (DR) 53
 monthly reports (MR) 53
 policy reports (PR) 317
 quarterly reports (QR) 53
 weekly reports (WR) 53
vandalism 37, 48, 51, 58, 60, 62, 73, 83, 85-86, 149,-150, 230, 235, 363, 385, 388-389, 391, 393, 403
Volkswagen of America, Greg Harmon et al. v. Hartford Insurance 134
voluntary parting of title to or possession of property 235
war, military action 9, 66, 77, 89-90, 120, 147-148, 151, 214, 264, 267, 276, 298, 308, 355, 386-387, 396-397
water damage 37, 60, 72-73, 75, 79, 84, 86-87, 124, 264, 388, 391, 393
watercraft 22, 270, 296-297, 319-320, 332, 361, 385, 395
windstorm or hail 73, 85-86, 385, 393
workers compensation 144-145, 165, 173-178, 181-189, 193,-194, 196, 198, 200-201, 204-207, 290, 294-295, 308, 347, 349, 395-396, 413
 employers liability policy 204, 295
 job classification codes 206
 workers compensation laws 174-175, 187, 294
 workers compensation rating 200

Also Available from Merritt Publishing

TAKING CONTROL SERIES

WORKERS' COMP FOR EMPLOYERS
How to Cut Claims, Reduce Premiums, and Stay Out of Trouble

BUSINESS PLANS TO GAME PLANS
A Practical System for Turning Strategies Into Action

MASTERING DIVERSITY
Managing Your Work Force Under ADA and Other Anti-Discrimination Laws

OSHA IN THE REAL WORLD
Cutting Through the Regulatory Knot

RIGHTFUL TERMINATION
Defensive Strategies for Hiring and Firing in the Lawsuit-Happy 90's

CONSUMER INTEREST

HOW TO INSURE YOUR CAR
A Step by Step Guide to Buying the Coverage You Need at Prices You Can Afford

HOW TO INSURE YOUR HOME
A Step by Step Guide to Buying the Coverage You Need at Prices You Can Afford

HOW TO INSURE YOUR LIFE
A Step by Step Guide to Buying the Coverage You Need at Prices You Can Afford

THE UNDER 40 FINANCIAL PLANNING GUIDE
From Graduation to Your First Home

THE OVER 50 INSURANCE SURVIVAL GUIDE
How to Know What You Need, Get What You Want and Avoid Rip-offs

TRUE ODDS
How Risk Affects Your Everyday Life

TAMING THE LAWYERS
What to Expect in a Lawsuit and How to Make Sure Your Attorney Gets Results

"WHAT DO YOU MEAN IT'S NOT COVERED?"
A Practical Guide to Understanding Insurance

BUSINESS INTEREST

HOW TO FINANCE A GROWING BUSINESS
An Insider's Guide to Negotiating the Capital Markets

MAKE UP YOUR MIND
Entrepreneurs Talk About Decision Making

MANAGING GENERATION X
How to Bring Out the Best in Young Talent

AND MORE!

20% OFF
MERRITT PUBLISHING BOOKS

Merritt features a full line of books on key topics for today's smart consumers and small businesses. Times are changing fast – find out how our books can help keep you **ahead** of the times.

☐ **Yes!** Please send me a **FREE** Merritt Publishing Catalog, plus a 20% discount coupon good towards any book purchase from the catalog.

Name _____
Company _____
Address _____
City _____ State _____ Zip _____
Phone _____

Merritt Publishing • Post Office Box 955 • Dept. SWAM • Santa Monica, CA 90406-0955 • 1-800-638-7597

SWAM

20% OFF
MERRITT PUBLISHING BOOKS

Merritt features a full line of books on key topics for today's smart consumers and small businesses. Times are changing fast – find out how our books can help keep you **ahead** of the times.

☐ **Yes!** Please send me a **FREE** Merritt Publishing Catalog, plus a 20% discount coupon good towards any book purchase from the catalog.

Name _____
Company _____
Address _____
City _____ State _____ Zip _____
Phone _____

Merritt Publishing • Post Office Box 955 • Dept. SWAM • Santa Monica, CA 90406-0955 • 1-800-638-7597

SWAM

BUSINESS REPLY CARD
FIRST-CLASS MAIL PERMIT NO. 243 SANTA MONICA CA

POSTAGE WILL BE PAID BY ADDRESSEE

MERRITT PUBLISHING
POST OFFICE BOX 955
SANTA MONICA CA 90406-9875

NO POSTAGE
NECESSARY
IF MAILED
IN THE
UNITED STATES

BUSINESS REPLY CARD
FIRST-CLASS MAIL PERMIT NO. 243 SANTA MONICA CA

POSTAGE WILL BE PAID BY ADDRESSEE

MERRITT PUBLISHING
POST OFFICE BOX 955
SANTA MONICA CA 90406-9875

NO POSTAGE
NECESSARY
IF MAILED
IN THE
UNITED STATES